70s

All-American Ads

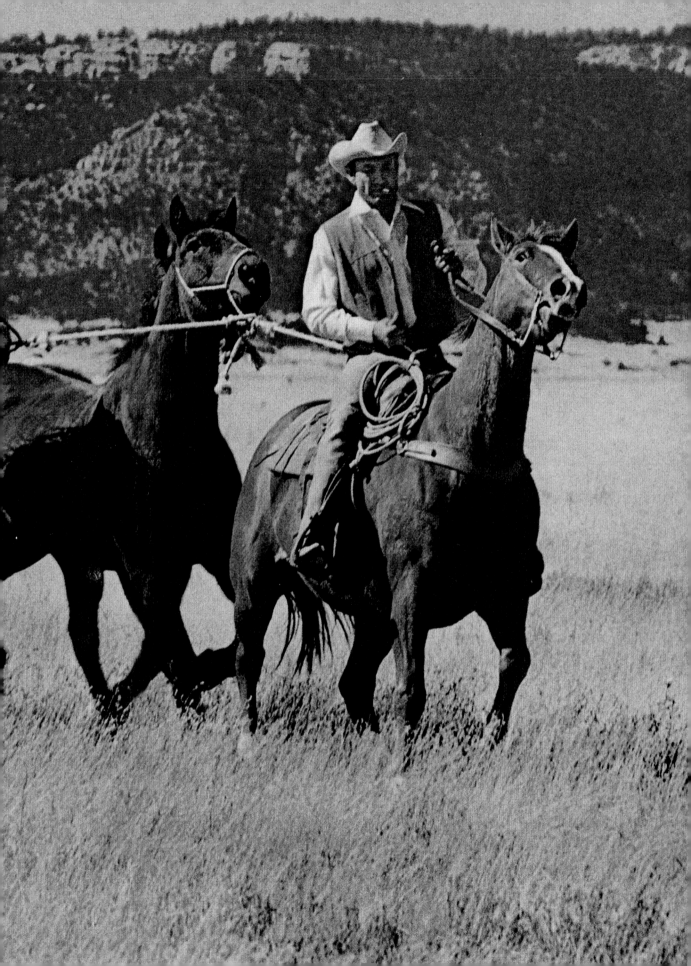

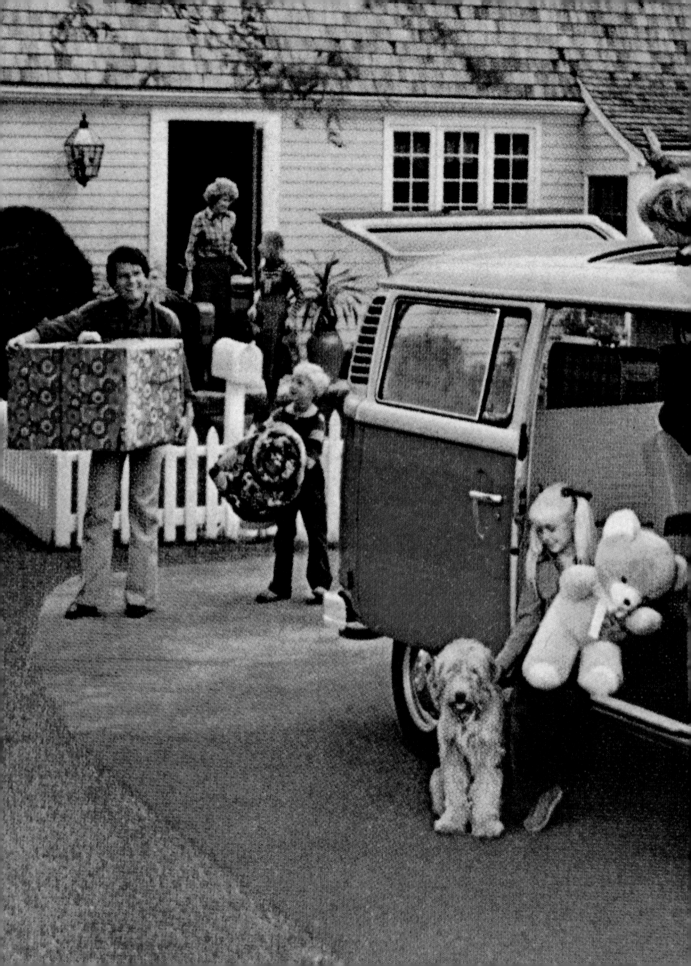

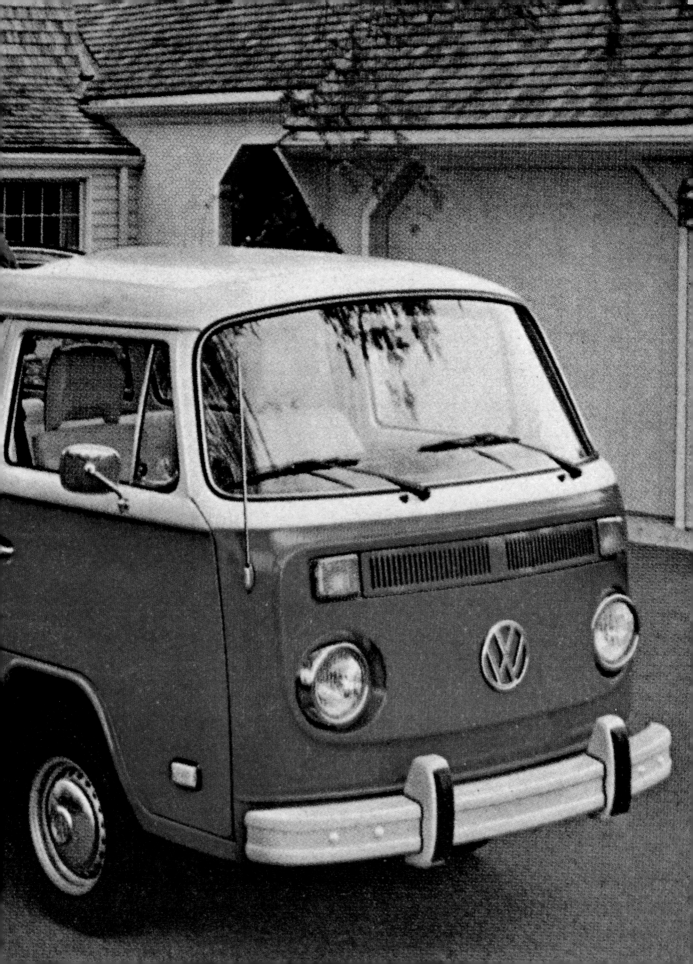

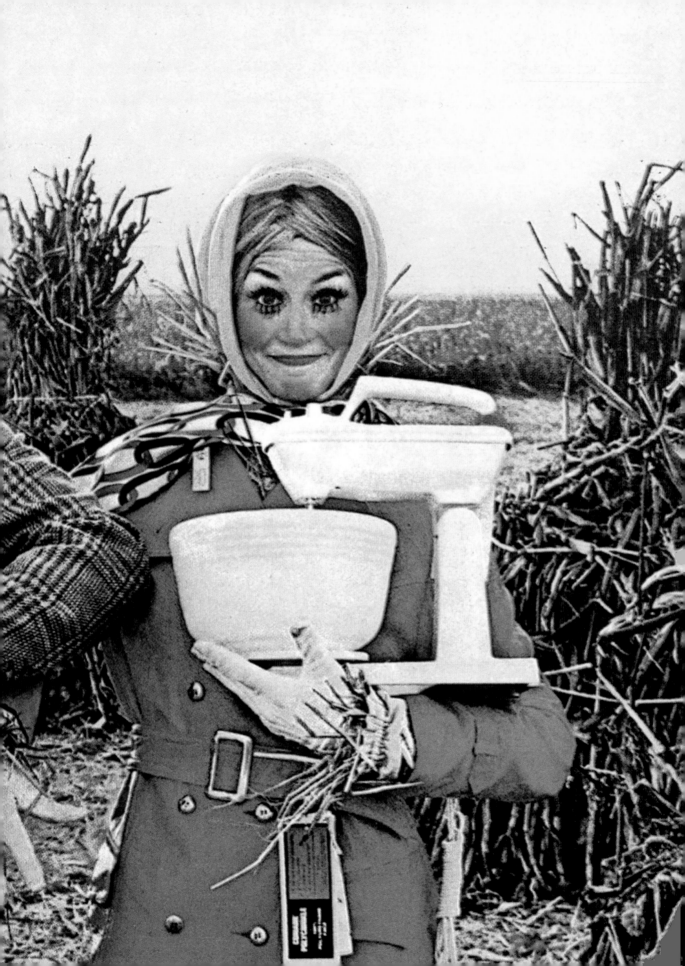

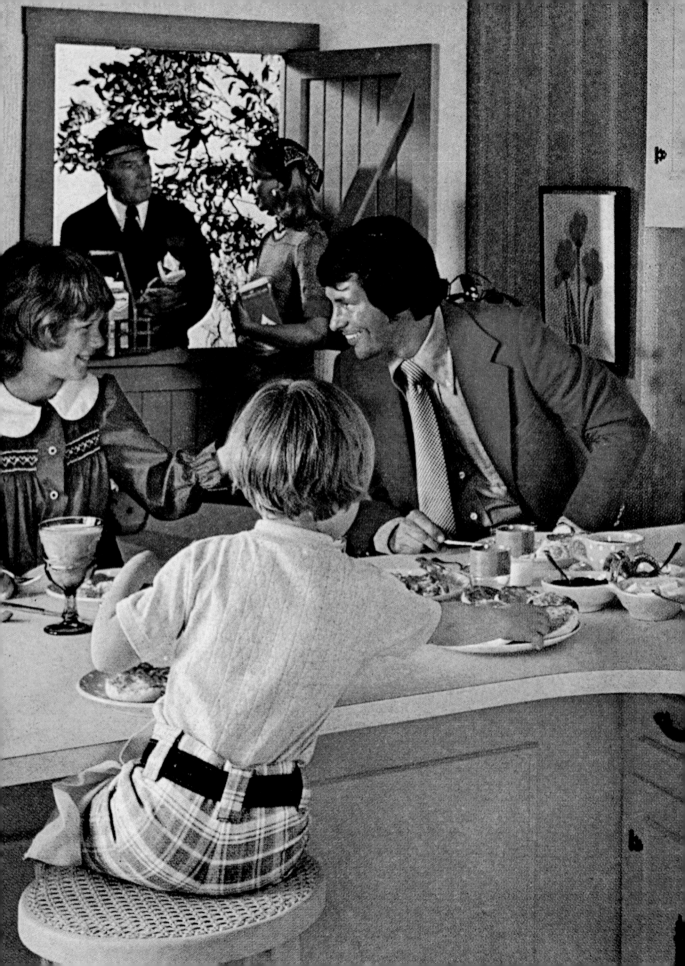

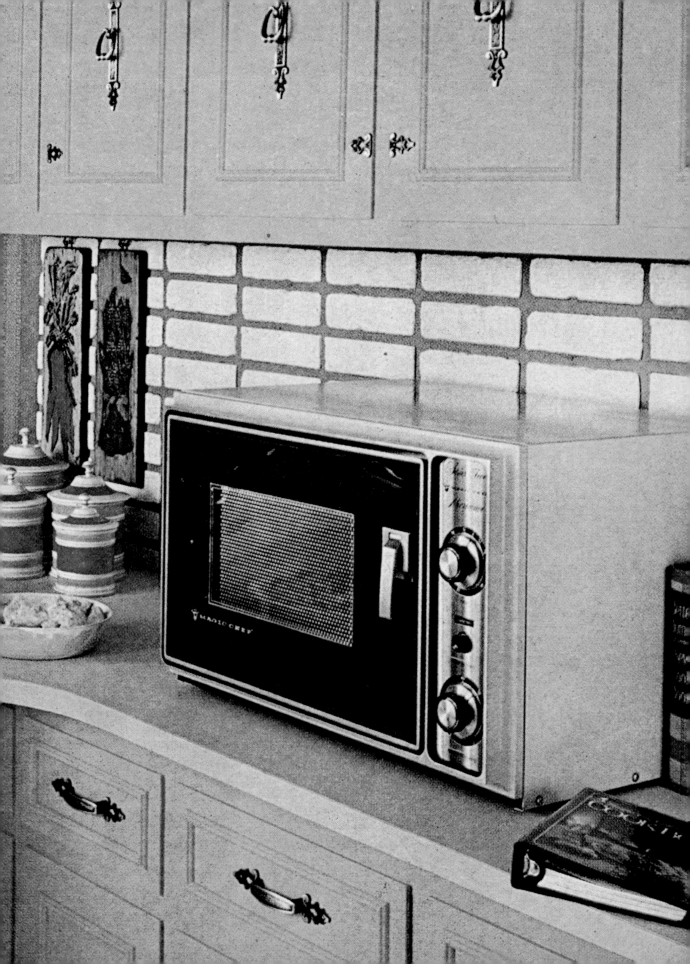

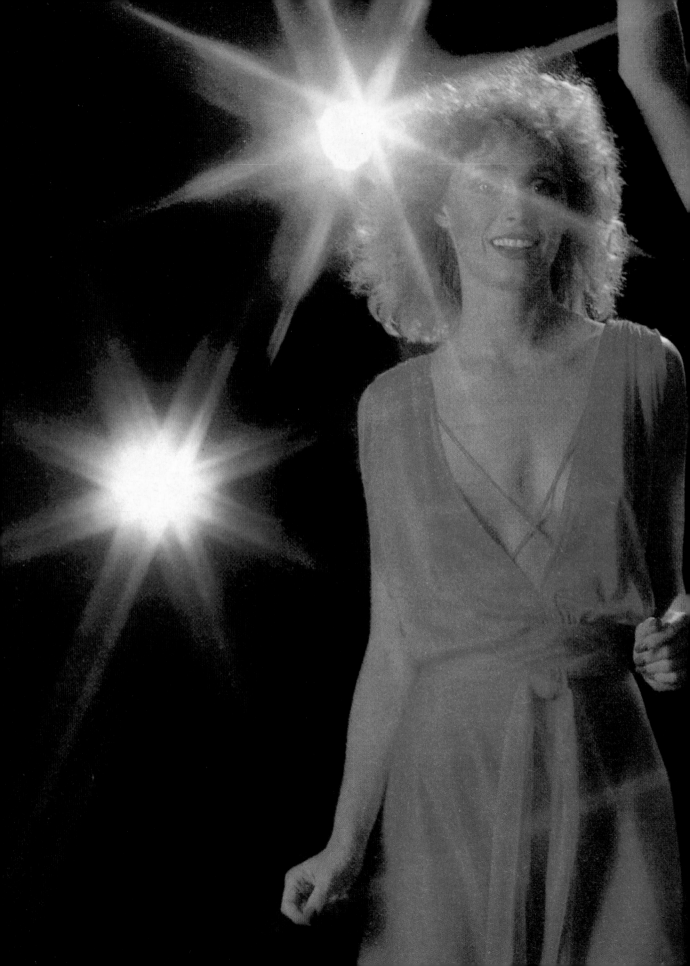

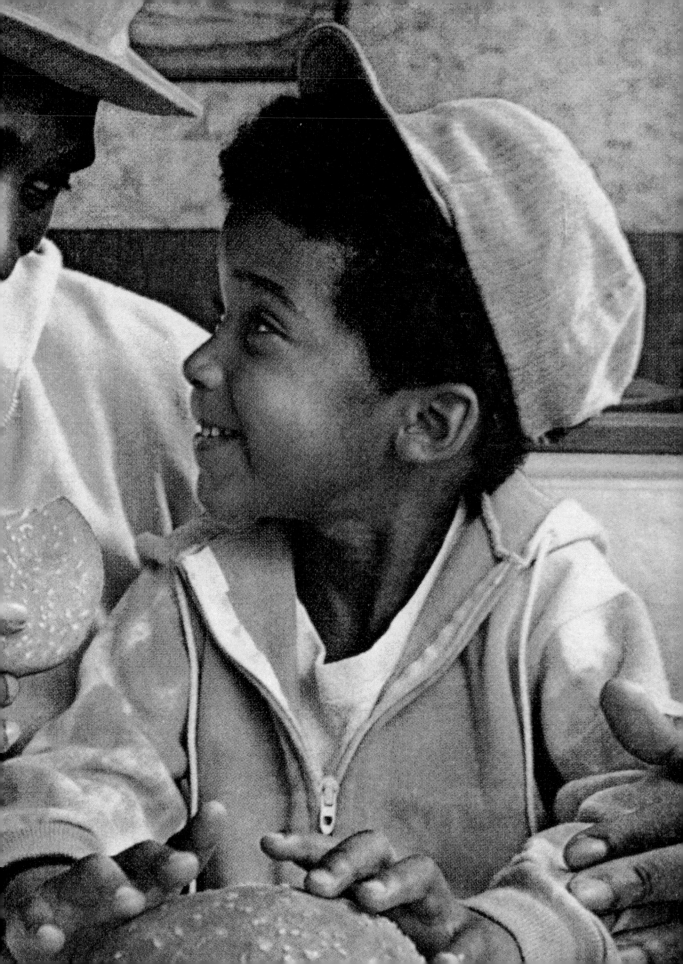

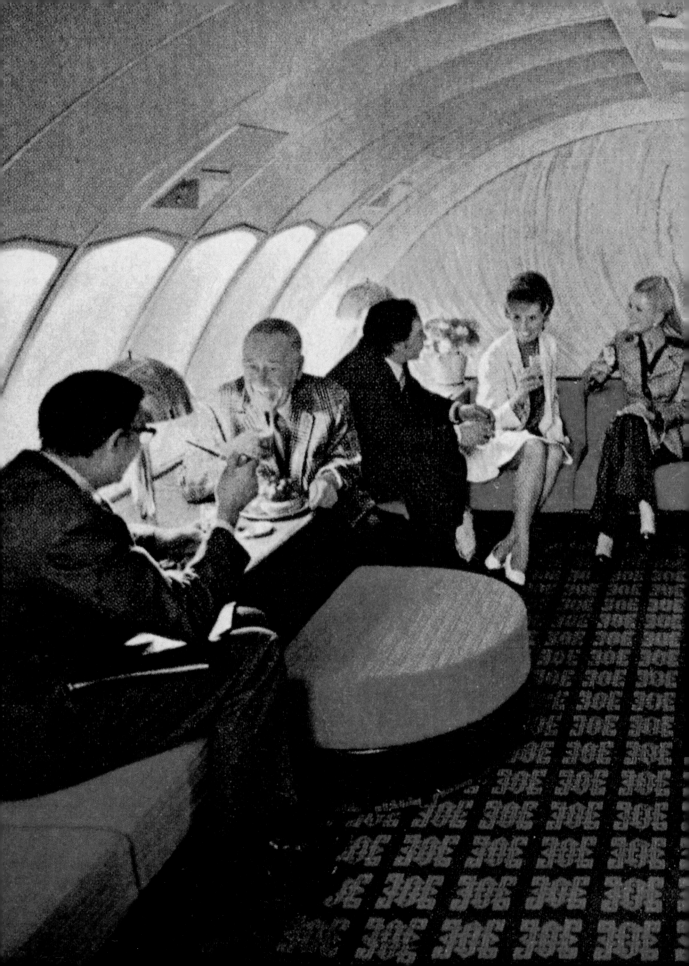

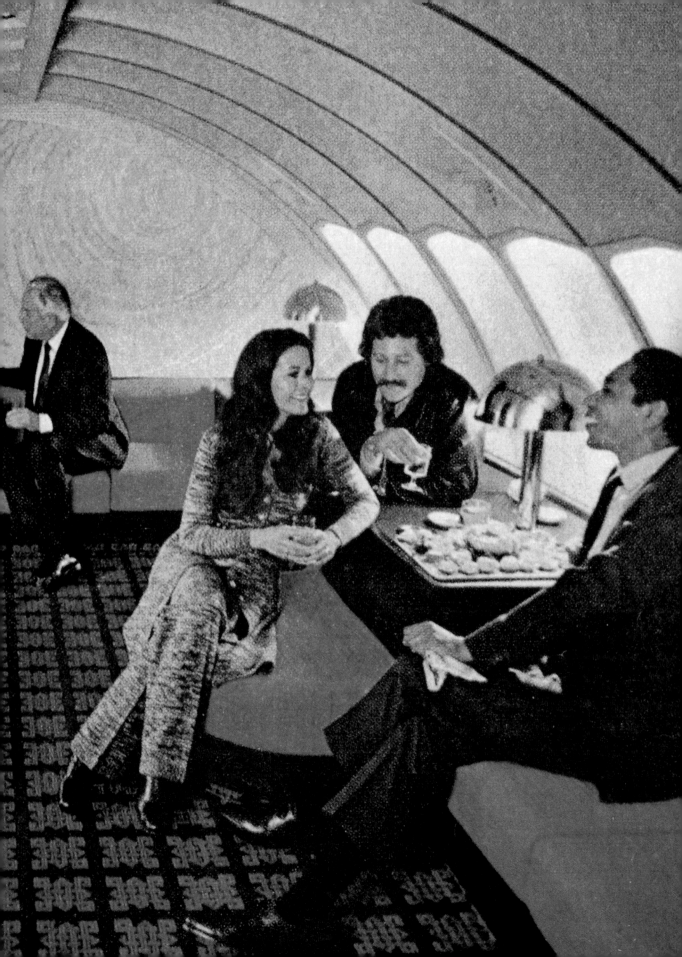

Acknowledgements

This volume of historical material would never have been completed without the help of numerous individuals. Among them are Cindy Vance of Modern Art & Design who continues to labor on these massive volumes with her enthusiasm intact while infusing them with her design and image-editing expertise; Nina Wiener who managed to keep this project and countless others at TASCHEN on track, in order and beautifully edited; Steven Heller for his impeccable and swift writing; and Sonja Altmeppen, Tina Ciborowius, Andy Disl, Horst Neuzner, and the rest of the Taschen staff in Cologne for their help and guidance in consistently producing a quality product.

As always, a special thanks is due to all of those who provided the magazines and material that eventually wound up in this book including Dan DePalma, Ralph Bowman, Gary Fredericks, Jeff and Pat Carr, Jerry Aboud, Cindy and Steve Vance, and all the other dealers of paper ephemera. I couldn't have done it without you.

And lastly, a big Bronx cheer to Benedikt Taschen for his continued friendship and support.

Jim Heimann, Los Angeles

Cover: Dexter Shoes, 1971
Endpapers: Blue Jeans Cologne, 1978
Page 1: The Art Institute, 1979
Page 2–3: Marlboro Cigarettes, 1972
Page 4–5: Volkswagen Bus, 1978
Page 6–7: Master Charge, 1970
Page 8–9: Magic Chef Microwave Oven, 1974
Page 10–11: Funky Fashions, 1978
Page 12–13: After Six Accessories, 1972
Page 14–15: Burger King, 1972
Page 16–17: Armstrong Floors, 1973
Page 18–19: American Airlines, 1971

Imprint

To stay informed about upcoming TASCHEN titles, please request our magazine at www.taschen.com or write to TASCHEN, Hohenzollernring 53, D–50672 Cologne, Germany, Fax: +49-221-254919. We will be happy to send you a free copy of our magazine which is filled with information about all of our books.

© 2004 TASCHEN GmbH
Hohenzollernring 53, D–50672 Köln
www.taschen.com

Art direction & design: Jim Heimann, L.A.
Digital composition & design: Cindy Vance, Modern Art & Design, L.A.
Cover design: Sense/Net, Andy Disl, Cologne
Production: Tina Ciborowius, Cologne
Project management: Sonja Altmeppen, Cologne
German translation: Anke Caroline Burger, Berlin
French translation: Philippe Safavi, Paris
Spanish translation: Gemma Deza Guil for LocTeam, S. L., Barcelona
Japanese translation: Mari Kiyomya, Chiba

Printed in Spain
ISBN: 3–8228–1265–X

70s

All-American Ads

**Edited by Jim Heimann
with an introduction by Steven Heller**

TASCHEN

KÖLN LONDON LOS ANGELES MADRID PARIS TOKYO

Steven Heller:

The Seventies:
Not Quite the Sixties – 24

Die Siebziger:
Fast so gut wie die Sechziger – 28

Les Années 70 :
pas tout à fait les années 60 – 32

Los años setenta:
nada que ver con los sesenta – 36

Alcohol &
Tobacco
44

ALL-AM

Automobiles
92

Business
& Industry
164

Consumer
Products
200

Entertainment
350

Fashion &
Beauty
420

Food &
Beverage
542

Travel
650

Interiors
602

RICAN

The Seventies
Not Quite the Sixties

by Steven Heller

Sixties movies, music, art, and advertising were infinitely more innovative than seventies fare in every way. Such high points as disco, glam rock, The Village People, *Dirty Harry*, *Love Story*, and *The Brady Bunch*® notwithstanding, the seventies were a cultural sinkhole, and this goes triple for print advertising, which reflected at least some of the zeitgeist. The collective American memory may vividly recall a decade of great ad campaigns and slogans, memorable jingles, and cute trade mascots, but television was its medium, not print. There were many great commercials playing on all three U.S. networks – and devoted Americans watched them day and night, night and day.

To wit: Budweiser's® omnipresent "This Bud's for you," McDonald's® "You deserve a break today at McDonald's," Burger King's® "Have it your way," Merrill Lynch's® "Merrill Lynch is Bullish on America," and kosher frank manufacturer Hebrew National's® "We answer to a higher authority." These and other brilliant slogans were such potent verbal weapons that media buyers bought huge blocks of time in order to repeat the commercials over and over on each network, forever embedding these pearls into the consumer's malleable mind. Such invasive messages captured the public's consciousness, while the print versions for many of the same products were often uninspired.

Of course, there were exceptions to the rule like "The Jordache® Look" (p.516), which started the denim revolution when it was launched on TV and continued its fetching foray into semi-nude exhibitionism through magazines and billboards across the nation, circa 1979. For the most part, however, watching real actors and hearing real voice-overs, like the dulcet-toned narrator for BMW's® 1975 "The ultimate driving machine," brought shrewd slogans to life in more seductive ways. Even the most annoying of commercial slogans – "Ladies, please don't squeeze the Charmin®!" (Benton & Bowles' brainchild that launched in 1964, but continued ad nauseam throughout the seventies) – was far more effective when seen on the small screen than in lackluster print equivalents.

During the fifties and sixties, print art directors were the advertising industry's luminaries. These masters of "creative" designed the memorably beautiful ads of the era. Back then, high-circulation national magazines such as *Look, Life, Collier's,* and *The Saturday Evening Post* were stuffed with multitudinous pages. Advertising art directors competed with editorial designers to see who could make the most conceptually startling and typographically attractive pages, and there was no paucity of "Big Ideas" in the art directors' annuals. Television, however, was another story.

Although TV began to reach large audiences in the late fifties and early sixties, advertising agencies had not yet translated the revolutionary "Big Idea" strategy from the page to the screen. Most commercials had a tentative, even amateurish, tenor until the mid-sixties, when major advertising dollars were pulled from behemoth magazines and diverted to the newer form. General magazines simply carried too much overhead to be cost-effective and, with larger numbers of readers than their ad revenues could efficiently support, most began to fold. Having ceased to be magnets for mass-market national campaigns, *Collier's* and *The Saturday Evening Post* were the first to fail; *Look* followed after an admirable push to modernize; and *Life* ultimately succumbed to the ad drain, initially reducing to a monthly circula-

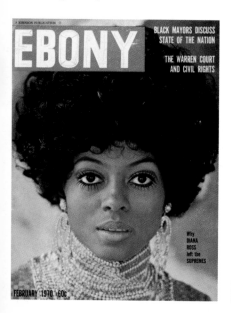

tion and eventually ceasing altogether. Meanwhile, leading brands massively invested in prime airtime, thus siphoning off the agencies' top ad executives from print to TV. The bar was rapidly raised for one medium and incrementally lowered for the other, which ultimately had a discernible impact on the disparate quality of the talent pool between the two classes of art directors.

A sea change in the late sixties grew into a tidal wave by the early seventies, with certain stylistic mannerisms also being washed away. Initially, print advertising looked toward editorial design as a model. Typographic sophistication was at a high level, but soon print turned into a mélange of editorial and TV sensibilities. Consciously or not, the cathode ray screen rather than the magazine page became the new design paradigm, and the short attention span of its audience became that of the new reader. Where once-generous margins of white space framed clever headlines and photographs, in the seventies, full-page photographs filled the entire page and headlines were dropped willy-nilly onto the pictures. Advertisements like "Feel Clean All Over" (p. 620), hawking the benefits of gas heat, used colorful, tightly cropped photographs to hit the viewer between the eyes, just like on TV – which is exactly where that campaign began.

Print had its own requisites, but innovation appeared to be less important than the status quo. An ad for the new, subcompact Honda Civic® – headlined "Women only drive automatic transmissions" (p. 163), an ironic pseudo-feminist concept – recalled the look of the great era of the Doyle Dane Bernbach® (DDB) Volkswagen Beetle® ads. Conversely, the text for VW's own "Volkswagen Does It Again," hawking its new Rabbit® (p. 127), did not live up to the refined copy of its predecessors. While this late-model VW ad attempted to reprise the same witty tone of the earlier classic campaigns (showing that a seven-foot-one-inch NBA legend, Wilt Chamberlain, could easily fit into the subcompact car), it was a smaller idea than the famous "Lemon" ad that pioneered the use of irony to make VW an acceptable, sought-after, alternative driving machine for gas-guzzling Americans.

During the sixties, inventive (often surreal) photography had eclipsed realistic illustration as the visual red meat of print advertising, an aesthetic that was carried through into the seventies. By this time, however, audiences were becoming conditioned to the flow of images on TV and seemed to have less patience for the static picture. So the photographic nuance and subtlety common to fifties and sixties print ads were overshadowed in their turn by unambiguous studio reality. The photograph of a beautiful African-American woman for Kent® cigarettes (p. 75) stares passively but unambiguously at the viewer. While this ad was significant for its employ of a black fashion model, the "I Want You" style was also notable because it was a standard manner of complementing a persuasive TV barrage. Of course, there were also exceptions to the typical photographs: in one of the most arresting ads in this book, Time Inc.'s "As long as the still picture can move... we're in the right business," a dramatic photograph of U. S. Army troops carrying a wounded comrade off the battlefield defiantly shows the power of the frozen moment. This ad made a convincing case, but few other print advertisements were so effective.

Illustration made a minor comeback in the seventies, but the result was often stylized and decorative rather than intellectual

and conceptual. The illustration for Clairol's® ad announcing its first foray into herbal essence shampoos (p. 438) was an appropriate use of a light-hearted, fairy-tale style, but did not challenge the perceptions of its audience in the same way as the classic Miss Clairol ("Does She ... or Doesn't She?") back in 1959. Likewise, the sprightly-looking ad for Alcoa Aluminum borrows the linear quality, color palette, and radical psychedelic style of the progressive Push Pin Studios, yet reduces the form to cutesy insignificance. When irony is absent, what results is safe ... which is not to say that all commercial advertising should be so bold and revolutionary – after all, grabbing attention by whatever means is the ultimate goal, and imparting a positive message outweighs all other purposes. Yet seventies' practice relied on the tried-and-true rather than the challenging and new.

Advertising historians note that the decade marked a period when slavish adherence to market testing and focus groups reigned. Advertising and brand development were becoming too competitively risky to be left to chance. In order to determine the effectiveness of TV and print promotion, the agencies relied on focus groups, which often had a say in altering (or mutilating) campaigns to conform to mass opinion. While certain firms – like DDB; Ammirati Puris; Foote, Cone & Belding; Lord, Geller, Federico, Einstein; and George Lois – retained enough creative influence to overcome the mass dumbing-down with the products they handled, other less-established or more mass-market agencies acceded to the will of the focus experts. And it was easy to spot the lesser lights. Advertisements that packed too much into a page, like "Sisters are different from brothers," for African-American hair products (p. 431), were doubtless the result of too many focus sessions and committee decisions.

The seventies constituted a wellspring of a different sort, however. It was the decade when natural product lines, including shampoos and foods, were first advertised on a national stage. Racial and ethnic barriers were also falling rapidly. While different groups were targeted with distinct "ethnic" campaigns, African Americans and other "minorities" were participating more in general advertising, which led to more integrated commercials in the eighties. There was a further significant milestone: cigarette TV commercials were banned in the seventies, relegating tobacco advertisements exclusively to print until they, too, were censored in the nineties.

The purpose of advertising is to serve clients in their quest for profit; it was never intended as an engine for culture. It is therefore unrealistic to expect the majority of ads in any period to transcend this basic function. At certain points in history, however, owing to the creative force of brilliantly artistic and driven people, advertising has defined the cultural gestalt every bit as much as music, film, and literature; more frequently, it has incorporated and mainstreamed certain elements of these. Even the most progressive aspects of advertising build upon other cultural foundations. Avant-gardes, for example, are drafted into service by advertising agencies only after they have become more or less mainstream. It is therefore the job of an acute advertising executive to determine when to start riding the wave of a unique phenomenon, before it crests. He or she must also know the media that will best serve as a vehicle for such a ride. During the seventies, creative teams pumped out thou-

sands of ads and commercials, but print was no longer the best means by which to reach a mass audience, magazines having become more specialized.

To survive in a competitive market, magazines had to target smaller niche groups of focused consumers, which certainly appealed to advertisers. While major brands continued to follow traditional advertising formulas and built campaigns around TV exposure, this new strategy of specialization forced reevaluation. Even in print advertising, the clients demanded more vitality to increase their fortunes. So, despite this essay's lament of the dearth of creativity, print advertising was poised to recoup some of its losses through placement in a host of smaller venues. This, in turn, helped launch a revival of more ambitious and inventive approaches in the eighties and nineties – a time, incidentally, when regulations and taboos about content in advertising were being reevaluated once again.

Steven Heller is art director of the *New York Times Book Review* and co-chair of the MFA/ Design program at the School of Visual Arts. He is also the author and editor of over eighty books on graphic design and popular culture, including *The Graphic Design Reader, Paul Rand, From Merz to Emigre and Beyond: Avant-Garde Magazine Design of the 20th Century*, and *Citizen Design: Perspectives on Design Responsibility*.

Die Siebziger:

Fast so gut wie die Sechziger

von Steven Heller

In den Sechzigern waren Film, Musik, Kunst und Werbung in jeder Hinsicht innovativer als in den Siebzigern. Trotz Highlights wie Disco, Glamrock, *Village People*, *Dirty Harry*, *Love Story* und *The Brady Bunch*® waren die Jahre von 1970 bis 1980 eine kulturelle Talsohle sondergleichen, was doppelt und dreifach für die Printwerbung gilt, wodurch sie aber wenigstens den Zeitgeist widerspiegelt. Das kollektive amerikanische Gedächtnis mag sich lebhaft an ein Jahrzehnt großartiger Werbekampagnen, einprägsamer Slogans und süßer Werbefiguren erinnern – das Medium dieser Dekade war das Fernsehen, nicht das gedruckte Wort. Viele hervorragende Werbespots liefen auf allen drei großen amerikanischen Sendern gleichzeitig und ihre treuen Fans sahen sich Tag für Tag an.

Ich denke an den allgegenwärtigen Budweiser®-Slogan „This Bud's for you", McDonald's® „You deserve a break today at McDonald's", die Sprüche von Burger King® „Have it your way" und Merrill Lynch® „Merrill Lynch is Bullish on America" oder an Hebrew National®, den Hersteller koscherer Würstchen, der mit „We answer to a higher authority" warb. Die Werbeabteilun-

gen kauften große Zeitblöcke, um die Spots auf allen Sendern ständig zu wiederholen. So prägten diese allgegenwärtigen Werbespots das Bewusstsein der breiten Öffentlichkeit, während die gedruckten Versionen, die oft für dieselben Produkte warben, von wenig Inspiration zeugten.

Natürlich gab es Ausnahmen von dieser Regel, wie etwa die Kampagne „The Jordache® Look" (S. 516), mit deren Fernsehausstrahlung die Jeansrevolution eingeleitet wurde. Meist wirkten raffinierte Slogans jedoch verführerischer, wenn echte Schauspieler zu sehen und echte Stimmen zu hören waren, wie die sonore Erzählerstimme in der BMW®-Werbung von 1975: „The ultimate driving machine". Selbst nervtötende Werbesprüche wie „Ladies, please don't squeeze the Charmin®!" (diese Toilettenpapierwerbung, Kopfgeburt von Benton & Bowles, kam 1964 heraus, lief aber die gesamten Siebziger hindurch weiter, bis sie niemand mehr hören konnte) wirkten auf der Mattscheibe wesentlich ansprechender als in den langweilig gestalteten Anzeigen.

In den fünfziger und sechziger Jahren waren die Artdirectors aus dem Printbereich die Stars der Werbebranche. Diese Topkreati-

ven entwarfen die schönen und unvergesslichen Anzeigen jener Ära. Damals hatten die großen Zeitschriften *Look*, *Life*, *Collier's* und *The Saturday Evening Post* hohe Auflagen und unglaublich viele Seiten. Die Kreativdirektoren aus der Werbeabteilung lagen mit den Leuten vom redaktionellen Layout im Wettstreit, wer die konzeptionell und typographisch attraktivsten Seiten gestalten konnte. Im TV-Bereich sah es jedoch noch ganz anders aus.

In den USA erreichte das Fernsehen ab den späten Fünfzigern ein Massenpublikum, doch die Werbeagenturen hatten es noch nicht geschafft, die revolutionäre Strategie der „Big Idea", der zentralen Werbebotschaft, von der gedruckten Seite auf den Bildschirm zu übertragen. Das Werbefernsehen hatte bis Mitte der sechziger Jahre einen zögernden, ja amateurhaften Charakter, doch dann wurde schließlich ein Großteil der Werbedollars aus den monströs dicken Zeitschriften abgezogen und in das neue Medium gesteckt. Viele Zeitschriften hatten zu hohe laufende Kosten, um rentabel zu sein, und die meisten mussten ihr Erscheinen einstellen. *Collier's* und *The Saturday Evening* Post gingen als Erste ein; *Look* folgte nach einem bewun-

dernswerten Versuch der Modernisierung, und *Life* fiel schließlich ebenfalls dem Inseratschwund zum Opfer, nachdem sie zunächst statt wöchentlich nur noch monatlich erschienen war. Währenddessen investierten die führenden Marken in Werbeblöcke zur besten Sendezeit, was zu einer Abwanderung der führenden Köpfe der Werbeagenturen vom Druckbereich zum Fernsehen führte. Die Ansprüche in dem einen Medium stiegen schnell, während sie in dem anderen immer niedriger wurden.

Was Ende der Sechziger noch eine allmähliche Wandlung gewesen war, wuchs sich Anfang der Siebziger zu einer wahren Flutwelle der Veränderung aus, in deren Verlauf auch gewisse stilistische Eigenheiten verloren gingen. Der Standard in der Typographie war hoch, doch bald setzte sich auch in den Druckerzeugnissen eine Mischung aus den Ansprüchen des Grafikdesigns und des Fernsehens durch. Die Mattscheibe wurde zum neuen gestalterischen Paradigma, die Zeitschriftenseite hatte ausgedient und die Aufmerksamkeitsspanne des neuen Lesers wurde so kurz wie die des Fernsehzuschauers. Wo früher großzügige weiße Ränder clevere Überschriften und Fotos um-

rahmt hatten, füllten in den Siebzigern großformatige Fotos die gesamte Seite, die Schriftzüge wurden einfach irgendwo auf das Bild geklatscht. Werbekampagnen wie „Feel Clean All Over" (S. 620) setzten bunte, knapp beschnittene Fotos ein, die den Betrachter wie ein Faustschlag trafen, genau wie im Fernsehen – wo die Kampagne natürlich auch herkam.

Der Druckbereich hatte seine eigenen Anforderungen, doch Innovation schien dort weniger wichtig zu sein als Aufrechterhaltung des Status quo. Eine Anzeige für den neuen Kleinwagen Honda Civic® mit dem ironischen, pseudofeministischen Slogan „Women only drive automatic transmissions" (S. 163) erinnerte an die große Ära der Anzeigen von Doyle Dane Bernbach® (DDB) für den VW Käfer®. Der Text, mit dem VW seinen neuen Rabbit® (S. 127) bewarb – „Volkswagen Does It Again" – erreichte nicht das hohe Niveau seiner Vorgänger. Diese Werbung versuchte zwar, den geistreichen Tonfall der legendären früheren Kampagnen zu treffen (hier wurde gezeigt, mit welcher Leichtigkeit die 2,13 Meter große Basketball-Legende Wilt Chamberlain in dem Kleinwagen Platz fand), war von der Idee her je-

doch wesentlich blasser als die berühmte „Lemon"-Werbung. In dieser Werbung wurde zum ersten Mal Ironie eingesetzt, um den VW zu einer akzeptablen, ja begehrten Alternative für die benzinsaufenden amerikanischen Straßenkreuzern zu machen.

In den Sechzigern hatten einfallsreiche (oft surreale) Fotos realistische Zeichnungen als visuellen Hauptbestandteil der Printwerbung ersetzt, eine Ästhetik, die auch in den Siebzigern weitergeführt wurde. Zu diesem Zeitpunkt waren die Zuschauer jedoch bereits an den ständigen Wechsel der Bilder im Fernsehen gewöhnt und schienen nur noch wenig Geduld für das statische Foto aufzubringen. Das führte dazu, dass die Subtilität der Werbefotografie in den fünfziger und sechziger Jahren der unzweideutigen Studiorealität weichen musste. In einer Anzeige für Kent®-Zigaretten (S. 75) starrt eine schöne afroamerikanische Frau den Betrachter passiv, aber völlig unzweideutig an. Diese Anzeige war insofern wichtig, als sie ein schwarzes Fotomodell zeigte; der „I Want You"-Stil war die Standardantwort auf das Werbefernseh-Bombardement. Es gab natürlich auch Ausnahmen von den stereotypen Fotos: Eine der bemerkenswer-

testen Anzeigen in diesem Buch, die Time Inc.-Werbung „As long as the still picture can move ... we're in the right business", zeigt ein dramatisches Foto amerikanischer Soldaten, die einen verwundeten Kameraden vom Schlachtfeld tragen, ein Bild, das trotzig die Überzeugungskraft des eingefrorenen Augenblicks unter Beweis stellt. Diese Anzeige vermittelte eine einprägsame Botschaft.

Illustrationen erlebten in den Siebzigern ein kleines Comeback, waren jedoch oft eher stilisiert und dekorativ als intellektuell oder konzeptionell. Die Zeichnungen in der Clairol®-Werbung (S. 438), mit der das erste Kräutershampoo eingeführt wurde, setzte den verspielt-märchenhaften Stil zwar angemessen ein, forderte die Intelligenz des Publikums aber nicht in gleicher Weise heraus, wie es die klassische Miss Clairol 1959 noch getan hatte („Does She ... or Doesn't She?"). Die spritzig aussehenden Anzeigen für Alcoa Aluminum liehen sich die grafische Qualität, Farbpalette und den radikal psychedelischen Stil der progressiven Push Pin Studios aus, reduzierten sie jedoch auf niedliche Bedeutungslosigkeit: Fehlt die Ironie, tut das Ergebnis niemandem weh. Was nicht heißen soll, dass alle kommerzielle Werbung mutig

und revolutionär sein muss – oberstes Ziel ist es, Aufmerksamkeit zu erregen und eine positive Aussage zu vermitteln, gleichgültig mit welchen Mitteln. In der Praxis setzte man in den Siebzigern jedoch lieber auf Altbewährtes als auf Innovation.

Werbehistoriker wissen, dass in diesem Jahrzehnt ein sklavischer Glaube an Meinungsumfragen und Zielgruppen herrschte. Um die Wirksamkeit von Fernseh- und Printwerbung zu ermitteln, stützten die Werbeagenturen sich auf bestimmte Zielgruppen, die oft ihren Anteil an der Abwandlung (oder Verstümmelung) von Kampagnen hatten, um sie dem Massengeschmack entsprechend anzupassen. Während gewisse Werbefirmen wie DDB, Ammirati Puris, Foote, Cone & Belding, Lord, Geller, Federico, Einstein und George Lois genug kreativen Einfluss behielten, um sich der Verdummung der von ihnen betreuten Produkte zu widersetzen, unterwarfen sich weniger etablierte Agenturen dem Willen der Marktforschung. Die kleineren Lichter sind leicht zu erkennen. Anzeigen, die zu viel auf einer Seite unterzubringen versuchten, wie „Sisters are different from brothers" für afroamerikanische Haarpflegeprodukte (S. 431)

waren zweifelsohne das Resultat zu vieler Marktforscherei.

In anderer Hinsicht stellten die Siebziger allerdings einen Jungbrunnen neuer Ideen dar. Es war das Jahrzehnt, in dem Naturprodukte sowie Shampoos und Nahrungsmittel zum ersten Mal USA-weit vermarktet wurden. Auch rassische und ethnische Schranken fielen rasch. Während stark eingegrenzte Zielgruppen mit eindeutig „ethnischen" Kampagnen angesprochen wurden, waren Afroamerikaner und andere „Minderheiten" häufiger in der allgemeinen Werbung zu sehen, was zu der ethnisch integrierten Werbung der Achtziger führte. Einen weiteren wichtigen Meilenstein stellte das Verbot der Zigarettenwerbung im Fernsehen dar; der Tabakindustrie blieb nur noch die Printwerbung, bis auch diese in den Neunzigern verboten wurde.

Werbung wird zum Zweck der Gewinnmaximierung gemacht; sie war nie als kulturelle Triebkraft gedacht. Die Erwartung, dass der größere Teil der Werbung über diese Basisfunktion hinausgeht, ist daher zu jeder Zeit unrealistisch. In gewissen Sternstunden beeinflusst die Werbung allerdings Dank der Kreativität brillanter Künstler die

Gesamtkultur nicht minder stark als Musik, Film und Literatur. Meistens vereinnahmt die Werbung jedoch gewisse Aspekte der Kultur für sich und schleust sie in den Zeitgeist ein. Selbst in ihren progressivsten Momenten bedient sich die Werbung immer bei anderen kulturellen Erscheinungen. Avantgardebewegungen werden beispielsweise erst dann von Werbeagenturen benutzt, wenn sie mehr oder minder Allgemeingut geworden sind. Aufgabe wacher Werbefachleute ist daher zu entscheiden, wann sie auf der Welle eines bestimmten Phänomens reiten sollen, bevor dieses seinen Höhepunkt überschritten hat. Sie müssen außerdem entscheiden, welches Medium das beste Vehikel für diesen Wellenritt abgeben wird. In den Siebzigern produzierten kreative Teams Tausende von Anzeigen und Werbespots, doch Druckerzeugnisse waren nicht mehr die beste Methode, um das Massenpublikum zu erreichen.

Um sich auf einem hart umkämpften Markt behaupten zu können, mussten die Zeitschriften sich auf Spezialinteressen konzentrieren, was allerdings ganz im Sinne der Werbeindustrie war. Während die großen Marken weiterhin bei den altbewährten Rezepten blieben und ihre Kampagnen auf stetiger TV-Präsenz aufbauten, verlangte die Spezialisierung im Zeitschriftenbereich nach ganz neuen Strategien. Insgesamt gelang es der Printwerbung jedoch – trotz des in diesem Essay beklagten Verlusts ihrer Kreativität –, einige ihrer Defizite durch Platzierung in einer Vielzahl kleinerer Publikationen wieder wettzumachen. Das wiederum schuf die Ausgangsbasis für die Wiederbelebung anspruchsvollerer und innovativer Ansätze in den Achtzigern und Neunzigern – eine Zeit, in der sich viele gesetzliche Vorschriften und Tabus in Bezug auf Werbeinhalte änderten.

Steven Heller ist Artdirector der *New York Times Book Review* und Vorsitzender der Fakultät Gestaltung (MFA/Design) an der School of Visual Arts in New York. Er ist außerdem Autor und Herausgeber von mehr als 80 Büchern über Grafikdesign und Populärkultur, u. a. *The Graphic Design Reader, Paul Rand, From Merz to Emigre and Beyond: Avant-Garde Magazine Design of the 20th Century* und *Citizen Design: Perspectives on Design Responsibility.*

Les Années 70 :
pas tout à fait les années 60

de Steven Heller

Le cinéma, la musique, l'art et la publicité des années 60 furent, à tous les égards, infiniment plus féconds que ceux des années 70. En dépit de points forts comme le disco, le glam-rock, les *Village People*, *L'inspecteur Harry*, *Love Story* et *The Brady Bunch*®, les années 70 furent un gouffre culturel, particulièrement dans le domaine de la publicité imprimée, reflet partiel de l'esprit d'une époque. Certes, au cours de cette décennie, de belles campagnes, de bons slogans, des jingles efficaces, de craquantes mascottes de marque ont laissé leur empreinte dans la mémoire collective américaine, mais leur vecteur était la télévision, pas le papier. De nombreuses pubs excellentes passaient sur les trois grandes chaînes nationales, que les fidèles téléspectateurs américains regardaient jour et nuit.

Pour n'en citer que quelques-unes : Budweiser® avec son omniprésent : « Cette Bud est pour toi » ; McDonald® : « Vous avez mérité une pause aujourd'hui chez McDonald » ; Burger King® : « Prenez-le comme vous voudrez » ; Merrill Lynch® : « Merrill Lynch remonte les bretelles de l'Amérique ». Ces slogans brillants et bien d'autres s'avérèrent des armes si puissantes que les acheteurs de média investirent massivement dans des temps d'antenne afin de pouvoir rediffuser inlassablement leurs pubs sur les chaînes nationales, gravant à jamais ces perles dans l'esprit malléable du consommateur. Le grand public retint ces messages envahissants alors que, souvent, les versions imprimées correspondant aux mêmes produits étaient ternes.

Naturellement, il y eut des exceptions à la règle, comme l'alléchant « look Jordache® » (p. 516) qui, lors de son lancement à la télévision vers 1979, déclencha la révolution du jean avant de poursuivre avec succès son incursion dans la semi nudité dans les magazines et sur les panneaux d'affichage de tout le pays. Toutefois, la présence de vrais acteurs et de commentaires en voix off, comme celui du narrateur au timbre suave de la pub de 1975 de BMW® : « La quintessence de la machine à conduire », donnait plus de relief aux messages. Même les slogans les plus agaçants tels que celui pour le papier hygiénique Charmin® : « Mesdames, merci de ne pas froisser le Charmin® » (une idée de l'agence Benton & Bowles de 1964 mais répétée jusqu'à plus soif tout au long des années 70) étaient nettement plus efficaces à la télévision.

Au cours des années 50 et 60, les directeurs artistiques étaient les vraies sommités de la publicité imprimée. Ces maîtres de la « créativité » conçurent les belles et mémorables pubs de cette époque. Les magazines nationaux à grande diffusion tels que *Look*, *Life*, *Collier's* et *The Saturday Evening Post* étaient truffés d'innombrables annonces. Les directeurs artistiques publicitaires rivalisaient avec les graphistes et les maquettistes de ces revues pour créer les pages les plus saisissantes au niveau du concept et les plus séduisantes au niveau de la typographie. Ils ne manquaient pas alors de « grandes idées », et ce n'était pas le cas à la télévision.

Cette dernière commença à toucher de vastes audiences dès la fin des années 50 et au début des années 60, mais les agences de pub ne surent pas tout de suite transposer leur stratégie révolutionnaire de la « grande idée » de la page à l'écran. La plupart des spots conservèrent un côté hésitant, amateur même, jusqu'au milieu des années 60, date à laquelle les gros budgets publicitaires furent détournés des magazines au profit du nouveau média. Les revues non spécialisées, écrasées par leurs

frais généraux, n'étaient plus rentables. Ayant cessé d'attirer les campagnes nationales destinées au marché de masse, *Collier's* et *The Saturday Evening Post* furent les premières à disparaître. *Look* suivit, malgré un formidable effort de modernisation. *Life* succomba à son tour, passant d'abord d'hebdomadaire à mensuel puis cessant définitivement de paraître. Entre-temps, les grandes marques avaient investi massivement dans les tranches horaires de grande écoute, débauchant les meilleurs cadres des agences de publicité qui travaillaient autrefois sur le support papier.

Ces premiers remous apparus dans les années 60 se convertirent en raz de marée au début des années 70, balayant au passage certains maniérismes stylistiques. Au début, la publicité imprimée s'inspirait du graphisme éditorial. La sophistication typographique était d'un niveau élevé mais des sensibilités télévisuelles ne tardèrent pas à l'influencer également. Consciemment ou pas, l'écran du poste de télévision supplanta la page comme modèle stylistique et la faible capacité de concentration du téléspectateur devint celle du nouveau lecteur des années 70. Là où, autrefois, de généreuses marges blanches

encadraient des photos et des textes intelligents, la page se remplit d'images et de textes lâchés un peu n'importe comment dans la composition. Des pubs comme « Sentez-vous propre de partout » (p. 620), vantant les bienfaits du chauffage au gaz, utilisaient des photos censées frapper le lecteur entre les deux yeux, comme à la télé (où cette campagne avait précisément commencé).

La publicité imprimée avait ses propres exigences, mais le statut quo primait sur l'innovation. Une pub pour la nouvelle petite Honda Civic® proclamait : « Les femmes ne conduisent que des automatiques » (p. 163), un concept pseudo-féministe ironique rappelant le look de la grande époque des pubs de la Volkswagen Beetle® (la Coccinelle) par l'agence Doyle Dane Bernbach®. Inversement, le texte de la pub VW, « Volkswagen remet ça », vantant sa nouvelle Rabbit® (p. 127), n'était pas à la hauteur de ceux de ses prédécesseurs. Si cette pub de VW tentait de renouer avec le ton spirituel des campagnes classiques antérieures, l'idée ne valait pas le célèbre « Citron » qui avait inauguré le recours à l'ironie pour faire de VW une automobile acceptable et désirable pour les Américains.

Au cours des années 60, une photographie ingénieuse (souvent surréaliste) avait éclipsé l'illustration réaliste dans la publicité imprimée, créant une esthétique qui perdura tout au long des années 70. Cependant, le public de plus en plus conditionné par le flot des images de la télévision, semblait moins patient devant une représentation statique. Les nuances et les subtilités photographiques qui étaient le propre des pubs imprimées des années 50 et 60 furent donc à leur tour éclipsées par la réalité sans ambiguïté du studio. Dans une pub pour les cigarettes Kent® (p. 75), un beau mannequin afro-américain fixe l'objectif d'une manière passive mais sans équivoque. Si cette pub a son importance pour son recours à une femme noire, son style « coup de poing » est également intéressant parce qu'il complète le matraquage télévisuel. Naturellement, il y avait des exceptions. L'une des pubs les plus saisissantes de cette compilation, pour Time Inc., illustre le pouvoir d'un moment figé : « Tant qu'une image fixe peut faire bouger… nous sommes sur la bonne voie », et l'on voit des soldats américains transportant un camarade blessé hors du champ de bataille. Mais si celle-ci est convaincante, peu de

pubs imprimées furent aussi efficaces.

L'illustration fit un vague come-back dans les années 70, mais d'une manière souvent stylisée et décorative. La pub Clairol® annonçant la première incursion de la marque dans les shampoings à essences végétales (p. 438) adoptait un style approprié, léger, féerique, mais sans remettre en question les perceptions du public comme le faisait la pub classique de Miss Clairol de 1959 (« Le fait-elle... ou ne le fait-elle pas ? ») De même, l'illustration pour Alcoa Aluminum emprunte la qualité linéaire, la palette de couleurs et le style psychédélique radical des studios progressistes Push Pin mais réduit la formule à une insignifiance mièvre. Lorsque l'ironie est absente, le résultat est sans risque. Ce qui ne signifie pas que toutes les publicités devraient être audacieuses et révolutionnaires. Après tout, le but ultime est de retenir l'attention par tous les moyens, et transmettre un message positif l'emporte sur tous les autres objectifs.

Les historiens de la publicité observent que les années 70 furent marquées par une adhérence servile aux études de marché et aux panels de consommateurs. La publicité et le développement des marques devenaient trop compétitifs pour être laissés au hasard. Afin de déterminer l'efficacité d'une campagne à la télévision ou dans les journaux, les agences se reposaient sur des groupes de discussions, qui intervenaient souvent en altérant (ou mutilant) les projets afin de les rendre conformes à l'opinion de masse. Si certaines firmes (comme DDB, Ammirati Puris, Foote, Cone & Belding, Lord, Geller, Federico, Einstein et George Lois) conservaient assez d'influence créative sur les produits qu'on leur confiait pour surmonter ce nivellement par le bas, d'autres agences moins établies ou plus orientées vers le marché de masse se plièrent à la volonté des experts. Les pubs qui en mettaient trop sur la page, comme « Les sœurs sont différentes des frères », pour des produits capillaires (p. 431), étaient généralement le produit de trop de réunions et de décisions.

Durant les années 70 les lignes de produits naturels, qu'il s'agisse de shampoings ou d'aliments, firent l'objet de campagnes nationales. Les barrières raciales et ethniques tombaient rapidement. Si les différents groupes continuaient à être ciblés avec des campagnes « ethniques » distinctes, les Afro-américains et d'autres « minorités » furent davantage inclus dans la publicité générale. Il y eut un autre virage important : vanter les mérites des cigarettes fut interdit à la télévision, reléguant les pubs au support papier jusqu'à ce que, là aussi, elles soient interdites dans les années 90.

L'objectif de la publicité est de servir les annonceurs dans leur quête de profits, elle n'a jamais eu pour but d'être un véhicule culturel. Il n'est donc pas réaliste d'attendre de la majorité des pubs qu'elles transcendent leur fonction de base. Néanmoins, à certaines époques, du fait de la créativité d'artistes inspirés, la publicité a contribué à modeler la culture au même titre que la musique, le cinéma et la littérature. Le plus souvent, elle a incorporé leurs éléments dans la culture de masse. Même dans ses aspects les plus progressistes, elle s'édifie sur d'autres bases culturelles. Les avant-gardes, par exemple, sont mobilisées par les agences publicitaires uniquement après avoir été plus ou moins digérées par le grand public. La mission d'un publicitaire de pointe est donc de déterminer à quel moment surfer sur la vague d'un phénomène unique avant qu'elle ne se brise. Il doit également savoir quel média offrira le véhicule

le plus efficace pour un tel exercice. Au cours des années 70, les équipes créatives ont produit des milliers de pubs imprimées et de spots publicitaires, mais le papier n'était plus le meilleur support pour toucher un public de masse, les magazines étant devenus trop spécialisés.

Pour survivre sur un marché compétitif, les revues durent cibler des créneaux plus petits de consommateurs, ce qui n'était pas pour déplaire aux publicistes. Tandis que les grandes marques continuaient d'appliquer les formules publicitaires traditionnelles et construisaient leurs campagnes autour d'une diffusion télévisuelle, cette nouvelle stratégie de spécialisation nécessita une réévaluation. Même dans la publicité imprimée, les annonceurs exigeaient plus de vitalité. Aussi, en dépit de mes lamentations sur la baisse de créativité dans cette introduction, la publicité imprimée était prête à récupérer une partie de ses pertes en réinvestissant dans une légion de projets plus petits. Ceci favorisa un regain d'approches plus ambitieuses et inventives dans les années 80 et 90, une époque où, d'ailleurs, les règles et les tabous sur le contenu en publicité devaient à nouveau être réévalués.

Steven Heller est directeur artistique du *New York Times Book Review* et codirecteur du programme MFA/Design de la School of Visual Arts. Il est également l'auteur et l'éditeur de plus de quatre-vingt livres sur le graphisme et la culture populaire, dont *The Graphic Design Reader, Paul Rand, From Merz to Emigre and Beyond : Avant-Garde Magazine Design of the 20th Century* y *Citizen Design : Perspectives on Design Responsibility.*

Beetle, Rabbit y Volkswagen sont des marques déposées de Volkswagenwerk Aktiengesellschaft.
BMW est une marque déposée de Bayerische Motoren Werke Aktiengesellschaft.
The Brady Bunch est une marque déposée de Paramount Picture Corp.
Budweiser est une marque déposée d'Anheuser-Busch, Inc.
Burger King est une marque déposée de Burger King Brands, Inc.
Charmin est une marque déposée de The Procter & Gamble Co.
Clairol est une marque déposée de Clairol Inc.
Doyle Dane Bernbach est une marque déposée d'Omnicom International Holdings Inc.
Foote, Cone & Belding est une marque déposée d'Interpublic Group of Companies, Inc.
Hebrew National est une marque déposée de ConAgra Brands, Inc.
Honda and Civic sont des marques déposées de Honda Motor Co.
Jordache est une marque déposée de Jordache Enterprises, Inc.
Kent est une marque déposée de Lorillard Licensing Co., L.L.C.
McDonald est une marque déposée de McDonald's Corp.
Merrill Lynch est une marque déposée de Merrill Lynch & Co., Inc.
NBA est une marque déposée de NBA Properties, Inc.

Los años setenta:

nada que ver con los sesenta

por Steven Heller

El cine, la música, la publicidad y el arte en los años sesenta fueron infinitamente más innovadores que en los setenta. Con las notables excepciones de la música disco, el *glam rock*, los *Village People*, *Harry el Sucio*, *Love Story* y *La tribu de los Brady*®, la década de los setenta fue culturalmente yerma, en especial en cuanto a publicidad impresa se refiere, lo cual refleja en cierto modo el espíritu de los tiempos. Y aunque en la memoria colectiva de los norteamericanos pervive una década de grandes campañas y eslóganes publicitarios, de sintonías memorables y de graciosas mascotas comerciales, lo cierto es que todo eso tuvo lugar en el medio televisivo, no en prensa. Anuncios excelentes inundaban las parrillas de las tres cadenas de televisión de Estados Unidos y los norteamericanos permanecían devotamente frente a la pantalla día y noche, noche y día.

Entre las frases publicitarias más célebres se cuentan la omnipresente «Esta Bud es para ti», de Budweiser®; «Hoy usted se lo merece, venga a McDonald's», de McDonald's®; «A tu manera», de Burger King®; «Merrill Lynch, al alza en América», de la consultora financiera Merrill Lynch®, y «Respondemos a una autoridad superior», del fabricante de productos *kosher* Hebrew National®. Estos y otros eslóganes brillantes constituían armas verbales tan potentes que los anunciantes adquirían enormes bloques de espacio televisivo para proyectarlos una y otra vez, hasta incrustar para siempre estas joyas en la mente maleable del consumidor. Y mientras que estos mensajes calaban en la conciencia del público, con frecuencia las versiones impresas de muchos de los mismos productos mostraban una carencia absoluta de inspiración.

Evidentemente, hubo excepciones, como por ejemplo la campaña de «El look Jordache®» (p. 516), que hacia 1979 inició la revolución de los vaqueros con su lanzamiento en televisión y continuó su seductor coqueteo con el semidesnudo en las páginas de las revistas y en las vallas publicitarias de todo Estados Unidos. Sin embargo, ver a actores de carne y hueso y oír sus voces superpuestas a las imágenes –como la del narrador de la campaña de BMW® que en 1975 incitaba con tono dulce al espectador a disfrutar de «El placer de conducir»– contribuía a que estos audaces eslóganes resultaran mucho más llamativos para el gran público. Incluso la más bochornosa de las frases publicitarias, «Por favor, no aprieten el Charmin®» (eslogan que Benton & Bowles acuñó en 1964 para anunciar su papel higiénico y que continuó explotando *ad nauseam* a lo largo de la década de los setenta) resultaba infinitamente más eficaz cuando se proyectaba en la pequeña pantalla que cuando aparecía en las deslucidas páginas de las revistas.

Durante los años cincuenta y sesenta, los directores de arte de la prensa impresa se erigieron como las lumbreras de la industria publicitaria. Estos maestros de la «creatividad» diseñaron los memorables anuncios de una era. En aquella época, las revistas de amplia circulación nacional, como *Look*, *Life*, *Collier's* y *The Saturday Evening Post*, contaban con infinidad de páginas y los directores de arte publicitarios colaboraban con los diseñadores editoriales para crear las composiciones tipográficamente más atractivas y conceptualmente más sorprendentes. Por entonces, los anuarios de los directores de arte jamás reflejaban una falta de «grandes ideas»; en cambio, la televisión era otra historia.

Cuando la televisión empezó a llegar al gran público a finales de los años cincuenta y principios de los sesenta, las agencias de

publicidad aún no habían trasladado la revolucionaria estrategia de la «gran idea» de la página impresa a la pantalla. La mayor parte de los anuncios presentaba un corte vacilante, incluso *amateur*, hasta mediados de la década de los sesenta, cuando el dinero que se invertía en las revistas mamotreto empezó a desviarse al nuevo medio. Los gastos de las publicaciones empezaron a ser mayores que sus beneficios y muchas de ellas cerraron. Habiendo dejado de servir de imán para las campañas comerciales nacionales, las primeras en abdicar fueron *Collier's* y *The Saturday Evening Post*, a las que siguió *Look*, no sin antes realizar un admirable intento por modernizarse; finalmente, *Life* sucumbió a la sequía de publicidad y, tras reducir su circulación a una publicación mensual, acabó por cerrar sus puertas. Entre tanto, las grandes marcas invertían cantidades ingentes en las franjas horarias de máxima audiencia, desviando con ello a los mejores creativos publicitarios de la prensa impresa a la televisión. Pronto, el baremo aumentó en un medio y descendió cada vez más en el otro, lo cual, en última instancia, tuvo un impacto ostensible en la calidad dispar de talento entre ambos tipos de directores de arte.

El cambio de oleaje de finales de los años sesenta se convirtió a principios de los setenta en una agitada marea que se llevó consigo todo rastro de peculiaridad estilística. En un principio, la publicidad impresa buscó en el diseño editorial un modelo a seguir. Y si bien la sofisticación tipográfica se hallaba en un momento álgido, las publicaciones no tardaron en transformarse en una mezcla de sensibilidades editoriales y televisivas. De manera consciente o inconsciente, la pantalla de rayos catódicos fue restando protagonismo a la página impresa como paradigma de diseño y el breve lapso de atención de su audiencia pasó a sustituir al del lector. Los generosos márgenes blancos que otrora habían enmarcado ingeniosas frases publicitarias y deslumbrantes fotografías fueron reemplazados en los años setenta por imágenes a toda página en las cuales se insertaban los eslóganes de cualquier manera. Anuncios como «El calor limpio» (p. 620), que pregonaba los beneficios de la calefacción de gas, utilizaron fotografías a sangre a todo color para atraer la mirada del espectador, imitando la técnica de la televisión, medio en el cual, por otro lado, se había iniciado la campaña.

Y aunque la prensa tenía sus propios requisitos, lo cierto es que la innovación parecía ser menos importante que el *status quo*. Un anuncio del nuevo subcompacto Honda Civic®–cuyo titular rezaba «Las mujeres sólo conducen transmisiones automáticas» (p. 163), un irónico concepto pseudofeminista– retomaba el aspecto de la gran era de los anuncios del Escarabajo® de Volkswagen creados por Doyle Dane Bernbach® (DDB). No obstante, el eslogan «Volkswagen vuelve a hacerlo», con el que se presentaba el nuevo Rabbit® (p. 127), no tenía ni punto de comparación con sus refinados antecesores. Así, aunque el anuncio del último modelo de la empresa intentaba recrear el tono audaz de sus clásicas campañas (mostrando que una leyenda de la NBA de dos metros quince, Wilt Chamberlain, cabía perfectamente en un automóvil compacto), la idea subyacente era muy inferior a la del célebre anuncio «Limón», que utilizó por primera vez la ironía para convertir un Volkswagen en una alternativa aceptable y deseada a las esponjas de gasolina que eran los automóviles norteamericanos.

Durante los años sesenta, la fotografía inventiva (con frecuencia surrealista) había

eclipsado a la ilustración realista como plato fuerte de la publicidad impresa, tendencia que se perpetuó a lo largo de los setenta. No obstante, el público empezaba a estar condicionado por el flujo de imágenes en televisión y demostraba menos interés por las imágenes estáticas. Así, la sutileza y los matices fotográficos propios de la publicidad en prensa de los años cincuenta y sesenta quedaron ensombrecidos por la realidad aplastante de los estudios. La bella mujer afroamericana cuya imagen se utilizó para vender cigarrillos Kent® (p. 75) miraba de manera pasiva pero inequívoca al lector. Y pese a que este anuncio fue rompedor por utilizar a una modelo negra, el estilo «Te deseo» se hacía palpable como medio estándar de complementar al persuasor bombardeo televisivo. Por descontado, también hubo excepciones a las fotografías típicas. En uno de los anuncios más arrebatadores de este volumen, el de Time Inc.: «Mientras la imagen estática conmueva... seguiremos en la brecha», una fotografía sensacional de las tropas estadounidenses transportando a un soldado herido fuera del campo de batalla muestra el poder de las instantáneas. Mas, pese a la innegable calidad de este anuncio,

muy pocos ejemplos impresos más resultaron tan eficaces.

La ilustración volvió a ponerse ligeramente de moda en la década de los setenta, aunque el resultado solía ser más estilizado y decorativo que intelectual y conceptual. La ilustración del anuncio de Clairol® que presentaba su primera incursión en los champús de esencias vegetales (p. 438) hacía un uso adecuado de un estilo desenfadado y fantasioso, si bien no desafiaba la percepción del público tal y como lo había hecho el clásico Miss Clairol («¿Utiliza... o no?») en 1959. Eso no quiere decir que toda la publicidad comercial debería de ser radical y revolucionaria, ya que, a fin de cuentas, lo importante es atraer la atención del espectador y el objetivo de transmitir un mensaje positivo pesa más que cualquier otro fin. Con todo, en los años setenta se apostó más por las opciones seguras y de eficacia demostrada que por la novedad y los retos.

Los estudiosos de la publicidad señalan que en la década de los setenta reinó la adherencia incondicional y baldía a las pruebas de mercado y a los *targets* de público. La publicidad y la aparición de marcas se estaban convirtiendo en algo demasiado arries-

gado y competitivo como para dejar su curso al azar. Para poder determinar la eficacia de la publicidad en televisión y prensa, las agencias se marcaban un público objetivo, que, con frecuencia, podía alterar (o mutilar) campañas para adecuarlas a la opinión general. Mientras que ciertas firmas, como DDB; Ammirati Puris; Foote, Cone & Belding; Lord, Geller, Federico, Einstein; y George Lois, retuvieron la suficiente influencia creativa para imponerse a los dictámenes del mercado, otras agencias menos establecidas y de corte más general se sometieron a los deseos de los expertos en técnicas de público objetivo. Y no resulta difícil distinguir sus frutos. Los anuncios que condensaban demasiado en una página, como «Las hermanas son diferentes de los hermanos», de productos para el cabello dirigidos a afroamericanos (p. 431), eran sin duda el resultado de demasiadas sesiones con público objetivo.

Por otro lado, los años setenta fueron testigo del surgimiento de una nueva publicidad. En esa época se empezaron a anunciar líneas de productos naturales, champús y alimentos inclusive, a escala nacional. Las barreras raciales y étnicas caían rápidamente. Se diri-

gían campañas «étnicas» diferentes a grupos distintos y los afroamericanos y otras «minorías» participaban cada vez más en la publicidad general. Además, se registró un nuevo hito: en la década de los setenta se prohibió la publicidad de tabaco en televisión y se relegó exclusivamente a la prensa impresa, de donde se suprimió también en los años noventa.

El objetivo de la publicidad es ayudar a los clientes a obtener beneficios. La publicidad nunca se ha concebido como un motor cultural, por lo que no tiene sentido esperar que el conjunto de anuncios de cualquier período trascienda su función básica. En cambio, en algunos momentos de la historia, debido a la fuerza creativa de personas con una sensibilidad artística excepcional, la publicidad ha definido la cultura tanto como la música, el cine y la literatura. A menudo, además, ha incorporado y difundido ciertos elementos de esas otras disciplinas. Incluso los aspectos más progresistas de la publicidad se construyen sobre otros fundamentos culturales. Por ejemplo, los publicistas únicamente utilizan las vanguardias cuando ya se han popularizado. Así, la labor de un creativo publicitario con vista consiste en deter-

minar cuándo agitar la marea de un fenómeno único antes de que se coloque en la cresta de la ola. El creativo debe, asimismo, saber qué medio resultará más adecuado para canalizar dicha sacudida.

Para sobrevivir en un mercado competitivo, las revistas se dirigieron a un público cada vez más restringido, lo cual resultaba atractivo para los anunciantes. Mientras que las grandes marcas continuaron aplicando las fórmulas tradicionales de la publicidad y crearon campañas para la televisión, la nueva estrategia de la especialización hizo necesario un replanteamiento global. Incluso en la publicidad impresa, los clientes demandaban una mayor vitalidad para aumentar sus fortunas. Y pese a que aquí se lamente la escasez de creatividad, lo cierto es que en la década de los setenta la publicidad impresa se propuso recuperar parte de sus pérdidas restringiendo su aparición a espacios más reducidos. Eso contribuyó a la aparición de enfoques más ambiciosos e imaginativos en los años ochenta y noventa, épocas en las que, por cierto, las regulaciones y los tabúes referentes al contenido en publicidad volvieron a someterse a examen una vez más.

Steven Heller es director de arte del suplemento «Book Review» del *New York Times* y codirector del programa de máster en Bellas Artes y Diseño de la School of Visual Arts. Es también autor y editor de más de ochenta libros sobre diseño gráfico y cultura popular, entre los que se cuentan: *The Graphic Design Reader, Paul Rand, From Merz to Emigre and Beyond: Avant-Garde Magazine Design of the 20th Century* y *Citizen Design: Perspectives on Design Responsibility*.

70 年代：60 年代とは異なるその事情

スティーヴン・ヘラー

映画も、音楽やアート、そして広告も、60年代に生みだされた作品のほうが、70年代のそれよりも、あらゆる意味ではかりしれないほど革新的だった。ディスコ、グラム・ロック、ヴィレッジ・ピープル、『ダーティハリー』、『ある愛の詩』、あるいは『ゆかいなブレディー家』。そうしたハイライトがないわけではなかったが、それでもやはり70年代は文化的な空洞であり、それは、時代の精神を反映しやすい広告の世界ではとりわけ顕著だった。おおかたのアメリカ人は、大がかりな広告キャンペーンやスローガン、耳に残るジングル、そしてかわいらしい企業マスコットの時代として70年代を記憶しているかもしれない。しかし、それは印刷媒体ではなく、テレビの世界の話だった。アメリカの3大ネットワークでは、たくさんのすばらしいコマーシャルが流れていた。そして、テレビに魂を奪われたアメリカ人は、連日連夜、それを見つづけていたのだ。

すなわちそれは、人々のあいだにあまねく浸透したバドワイザーの「このバドをあなたに」であり、マクドナルドの「あなたには、マクドナルドで一息いれる資格がある」であり、あるいはバーガーキングの「お好きなように作ります」、メリルリンチの「メリルリンチはアメリカを楽観する」、そしてソーセージのヒーブルーナショナルの「より舌の肥えた

方たちの要求に応えています」だった。きわめて強力な言葉の武器と化したこれらのみごとなスローガンは、広告代理店が各ネットワークから購入した膨大な時間のコマーシャル枠のなかで繰り返し流され、永遠に忘れられない言葉として、影響されやすい視聴者の頭のなかに組み込まれていった。こうした侵略的なメッセージが大衆を攻略していくなか、まったく同じ製品が印刷媒体で扱われると、とたんに退屈になってしまうこともしばしばだった。

もちろん、規則には例外がつきもので、「ジョーダッシュ・ルック」（p. 516）のようなケースもある。1979年頃にテレビから始まったこのキャンペーンは、一大デニム革命を引き起こし、その魅惑的な快進撃は、人目をひくセミヌードのビジュアルを起用した広告として雑誌や全米中のビルボードへとつづいた。しかしながら、やはりたいていの場合、生身の役者を目で見ること、そして、たとえば1975年のBMWのコマーシャルのように、甘い声をしたナレーターが「究極のドライビング・マシーン」と唱えるのを聞くことのほうが、考えぬかれたコピーもさらに魅力的なかたちで息づき始めるのは確かだった。もっとも腹立たしいスローガンでさえ——「ご婦人がた！　チャーミンを握りつぶさな

いでください！」（広告代理店ベントン・アンド・ボウルズの考案で1964年に始まったキャンペーンは、うんざりすることに、そのまま70年代に入ってからも継続された）——、ぱっとしない印刷バージョンよりは、小さなスクリーンで見たほうがはるかに効果的だった。

50年代から60年代にかけて、広告業界をリードしたのは印刷媒体のアート・ディレクターだった。すぐれたクリエイティブたちが、時代を代表する美しく印象的な広告をデザインしていた。当時、高い発行部数を誇っていた『ルック』、『ライフ』、『コリアーズ』、『サタデー・イヴニング・ポスト』といった全国誌は、どれも非常に大部だった。その誌面を舞台に、広告のアート・ディレクターとエディトリアル・デザイナーは、誰がもっとも斬新なコンセプトと魅力的なタイポグラフィをもったページを作りだせるかを競っていたのだ。アート・ディレクター年鑑から「ビッグ・アイデア」が不足することはなかった。しかし、テレビとなるとまた話は別である。

50年代後半以降、テレビは多くの家庭に普及しつつあったが、この時点では、革命的な「ビッグ・アイデア」戦略を紙からモニターへと適用することに、広告代理店はまだ着手していなかった。巨大な雑誌群に投下されていた広告費が縮小され、その

分を新たな表現様式に流用するようになった60年代のなかば頃までは、ほとんどのテレビコマーシャルが素人っぽいといってもいいような試作品レベルのものだった。その一方で、諸経費がかかりすぎていた一般誌は、とうてい費用効果が高いとはいえない状態にあり、広告収入で効率的にまかなえる範囲を超える読者数をかかえた各誌は、やがて事業をたたみ始めた。全国的な大衆市場向けのキャンペーンを行う場としての吸引力を失い、最初に廃刊したのは『コリアーズ』と『サタデー・イヴニング・ポスト』だった。『ルック』は、称賛に値する近代化への試みをはかりはしたものの、そのかいなく前者につづいた。最後の砦だった『ライフ』も広告費の枯渇には勝てず、月刊誌へと姿を変えたのち、最終的には廃刊となった。その頃、主要ブランド各社はこぞってテレビのゴールデンタイムに投資し、それにともなって、広告業界のトップの座も、印刷媒体からテレビへと移行していった。ひとつのメディアに対する障壁が見る見るうちに高くなる一方で、また別のメディアのそれは徐々に低くなっていったことになるが、最終的にそれは、そのふたつの階級に属するアート・ディレクターの質のばらつきという、目に見えるかたちでの影響をもたらした。

60年代後半に生じたこうした変化のさざなみは、70年代には高波となって、それまで主流だったいくつかの作風や様式を押し流していった。当初、印刷媒体の広告は、エディトリアル・デザインを模範とみなしてその跡を追っていた。タイポグラフィ的にきわめて高い水準に達していた広告は、しかし、やがてエディトリアルとテレビ的感性の混合体となっていく。意識的か否かはともかく、新たなデザインのパラダイムとして雑誌のページにとって代わったのがブラウン管であり、同時に、雑誌の読者の意識もテレビの視聴者のそれに近くなった。つまり、集中力が持続する時間が短くなったのだ。70年代になると、かつて、巧妙な見出しと写真を囲む白い枠があったところにも、ページ全体を埋めつくすような写真と、写真の上だろうとおかまいなく手当たりしだいに配置された見出しが見られるようになった。たとえば、ガス暖房の利点を売りこんだ「どこもかしこも清浄感でいっぱい」(p. 620)のような広告は、ページいっぱいにトリミングされたカラフルな写真が、テレビさながらの──このキャンペーンが始まった場所である──強烈な印象を見る者に与える。

むろん、印刷媒体ならではの特性を模索する道もあったはずだが、革新よりも、現状を維持する

ことのほうが重視された。ホンダの新しい準小型車、シビックの広告──「女はオートマチック車しか運転しない」(p. 163)という皮肉っぽく似非フェミニスト的なコピーがついているが──は、ドイル・デイン・ベルンバッハ(DDB)が手がけた一連の卓抜したフォルクスワーゲン・ビートルの広告を想起させる。しかし逆に、フォルクスワーゲンの新型車ラビットのために考案された「フォルクスワーゲンがまたやりました」(p.127)というフレーズは、先達が作りあげてきた洗練されたコピーからはほど遠い。フォルクスワーゲン初期のウィットに富んだ名キャンペーン(NBAの伝説的なバスケットボール選手、身長2m16cmのウィルト・チェンバレンだって、この小型車に楽々乗れることを証明してみせた)を再現しようと試みたこの広告は、しかし、広告におけるアイロニーの使用に関する先駆的な存在となった同社の有名な「レモン」の広告にはまるでおよばない。それまで巨大な高燃費車を乗り回していたアメリカ人が、フォルクスワーゲンのような小型車を受けいれたばかりか、こぞって追い求めるようになったのは、そうしたかつてのキャンペーンの功績だったのだ。

60年代、創意に富んだ(多くの場合、シュールでもあった)写真が、それまで主流だったリアルな

イラストに代わって印刷媒体の広告を埋めつくすようになったが、その傾向は70年代に入ってもつづいていた。しかし、テレビのなかの映像の氾濫に慣れ親しんだ人々は、ここにきて、静止画像をじっくり鑑賞する根気を失ってしまったようだった。わかりやすくてリアルな写真の台頭によって、影が薄くなっていったのは、50年代と60年代の広告で多用された微妙なニュアンスのある写真のほうだった。ケントの広告（p. 75）の美しいアフリカ系アメリカ人の女性は、控えめだがはっきりとその視線を見る者のほうに向けている。黒人のファッションモデルを起用したという点においても有意義だったこの広告は、その「あなたが欲しい」方式とでも言おうか、テレビが説得力のあるコマーシャルの集中砲火を浴びせる際の標準的な態度を身につけていることも注目に値する。もちろん、「典型的な写真の使い方」にも例外はある。本書のなかでもきわめて印象的な広告のひとつ、タイム社の「スチール写真が人を動かすかぎり、我々はこの仕事に誇りをもちつづける」には、負傷した仲間を戦場から連れ出す米軍の兵士の姿をとらえた写真が使われているが、それは、凍結された瞬間の力強さを挑戦的に誇示している。しかし、この作品のように効果的で説得力のあるケースは、印刷媒体の広告では希少だった。

イラストレーションも、70年代になって少し復活のきざしを見せたが、その成果は、知的でコンセプチュアルというよりは、型にはまった装飾的なものだった。クレイロール社初のハーブ・エッセンス・シャンプーへの進出を謳ったイラスト（p. 438）は、快活でおとぎ話風のスタイルが商品によく合ってはいるものの、かつての名作、1959年の染髪剤「ミス・クレイロール」（「彼女はやってる？　それとも？」）のように、見る者の知覚に挑戦するようなものではない。同様に、アルコア・アルミニウムの陽気な広告の場合も、その線の感じや色彩感覚、サイケデリックなスタイルは、進歩的なデザイン集団「プッシュピンスタジオ」の模倣を試みたものだが、オリジナルの表層のみなぞらえた、きれいなだけの仕上がりとなっている。そこにアイロニーが存在しなければ、結果は無難なものにしかならないのだ。だからといって、すべての広告が大胆かつ革命的であれと言っているわけではない——結局、手段はどうあれ人々の心をとらえることが究極の目的であり、それに加えてポジティブなメッセージを発信することが、なによりも重要なのだ。それにしても、70年代のやり方は、挑戦や新しい発見よりも、確実な安全策に頼りすぎていた。

70年代は、市場テストとフォーカスグループ

への卑屈な依存に支配された時代だと広告史の研究家は指摘する。広告もブランド開発も、もはや運にまかせるのは危険な時代になっていた。広告代理店は、テレビおよび印刷媒体におけるプロモーションの効果を判断する材料として、フォーカスグループに頼ったが、その結果、大衆の意見に適合させようと、多くのキャンペーンが改ざん（あるいはずたずたにされること）を余儀なくされた。一部の代理店——DDB、アミラティ・プリス、フット・コーン&ベルディング、ロード・ゲラー・フェデリコ・アインシュタイン、そしてジョージ・ロイス——は、彼らが広告を扱う商品に関して、大衆が口を出すことによって生じるレベルの低下を克服するだけのクリエイティブな影響力を維持しつづけたが、そうした基盤のない代理店、もしくは最初から大衆市場を相手にしていた代理店は、フォーカスグループのうるさ型の意見に賛同の意を表した。そして、そういうあまり輝かしくない例は、簡単に見分けることができる。さまざまな要素を詰めこみすぎている広告、たとえばアフリカン・アメリカン・ヘアプロダクツの「シスターは、ブラザーとは違う」（p.431）は、疑いなく、フォーカスグループのセッションと、それを受けた会議をやりすぎた結果である。

しかしながら、70年代は、さまざまに異なる

が表面へと吸いあげられた時代でもあった。た
えば、シャンプーや食品を含む自然派の製品が、
めて全国的な広告に登場したのもこの頃だ。人
的・民族的な壁も急速に崩壊しようとしていた。
れぞれの民族にターゲットを絞ったキャンペー
が作られる一方で、全国区の一般広告にも、より
くのアフリカ系アメリカ人およびその他の「少数
族」が起用されるようになり、この動きは80年代
入ってさらに加速していく。そして、特筆すべき
期的な事件が起こったのも70年代である。タバ
のテレビコマーシャルが全面的に禁止された
。この時点で印刷媒体上での広告しか展開でき
くなったタバコは、しかし、それすらも90年代に
ると検閲を受けるようになる。

　広告の目的は、利益を追い求めようとする顧
の要求を満たすことにある。それはけっして文化
な手段になるべくして生み出されたものではな
。したがって、いかなる時代であろうと、大多数
広告にその基本的な機能を超える輝きを期待す
のは非現実的なことだ。それでも、すばらしく
ーティスティックで情熱的な人々の創造性のおか
で、歴史のなかのある時点では、広告が、音楽や
画や文学がそうしたのと同じように、文化の形態
定義しえたこともあるのだ。加えて、音楽や映画

や文学の要素を自らのうちに取り込み、主流へと押
し上げることなら、広告が得意とし、頻繁に行って
きたことだ。基本的に、広告は、そのもっとも革新
的な側面でさえ、ほかの文化の基盤の上に成り立っ
ている。たとえば、前衛芸術にしても、多少なりと
もメインストリームとして認知されて初めて、広告
代理店はそれの採用について考え始めるのだ。だ
からこそ、ユニークな現象があったとき、その波が
頂点に達してしまう前の、いつの段階でそれに乗
るべきかを見きわめるのが明敏な広告マンの重要
な仕事になってくる。そして、彼もしくは彼女は、そ
の波に乗るにあたって最適な媒体を選ぶ目をもた
なければならない。70年代を通して、クリエイティ
ブ・チームは無数の広告とコマーシャルを世に送り
だしてきたが、大衆に訴えかけたいときに最適だ
と思われる媒体はもはや印刷物ではなかった。雑
誌は専門化・分化の方向に向かっていた。

　競争的な市場で生き残るためには、それぞれ
の雑誌がより焦点の絞りこまれたニッチをターゲッ
トにするしかなかったが、それはそれで広告主
の興味をそそることになった。主要ブランドが従来
通りの広告の方法論を採用し、テレビへの露出を
中心としたキャンペーンを構築する一方で、こうし
た新しい特化戦略の登場が、印刷媒体の再評価へ

とつながった。そして、クライアントは、彼らの財
産を増やすためにも、平面広告の活性化を求める
ようになったのだ。つまり、私はこのエッセイのな
かで、クリエイティヴィティの欠如についてさんざ
ん嘆いてきたわけだが、ここにきて、印刷媒体の広
告は、たくさんの小さな表現の場を舞台に、失われ
たものをふたたび取り戻すための準備を整え始め
た。それはやがて、80年代と90年代に復活する野
心的で創意に富んだアプローチへと結びついてい
く――偶然にも、それはまた、広告の内容に関する
規制とタブーがふたたび見直されることになる時
代でもあった。

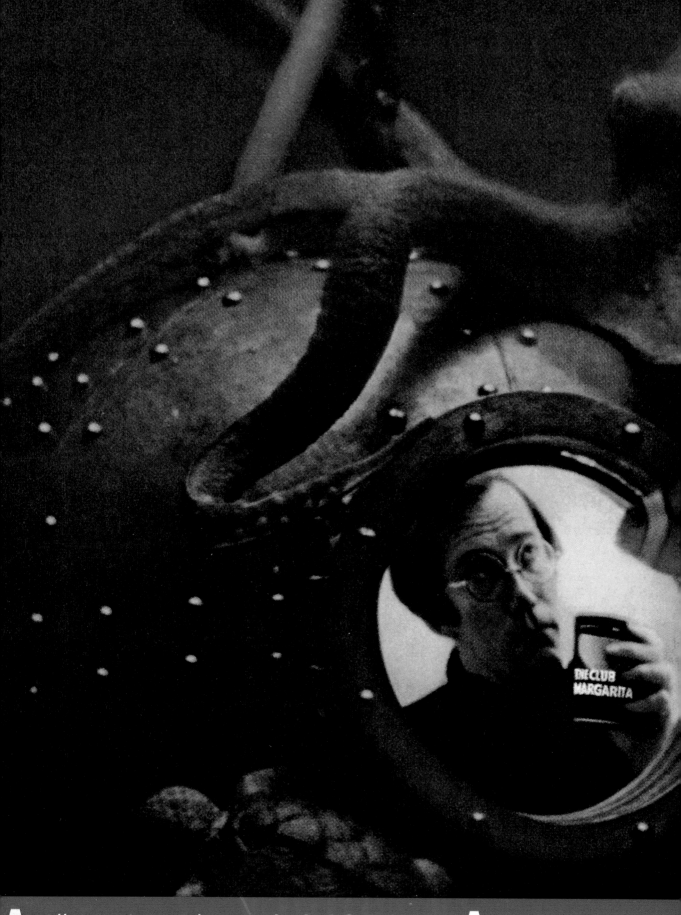

THE CLUB
MARGARITA

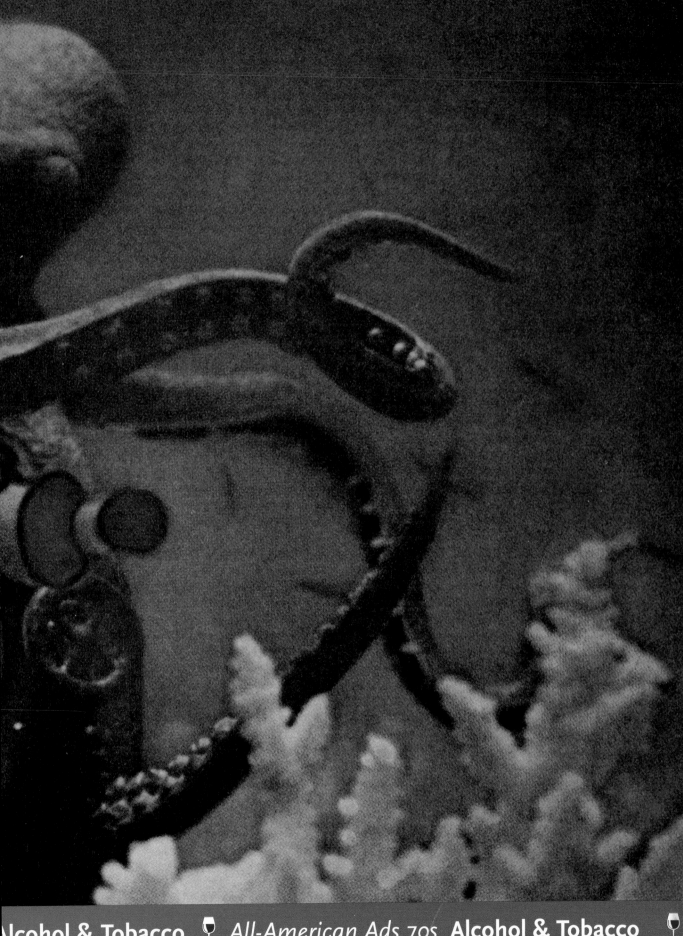

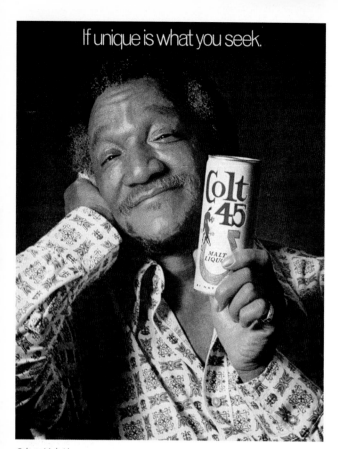

Colt 45 Malt Liquor, 1974

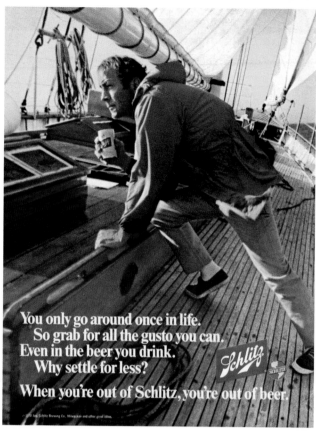

Schlitz Beer, 1970

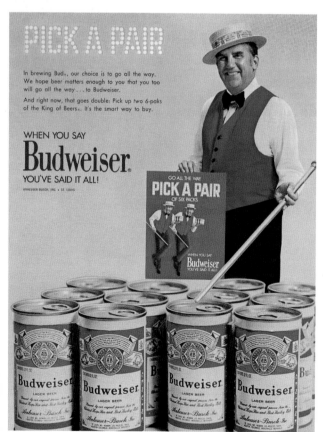

The Club Premixed Cocktails, 1975 ◄ *Budweiser Beer, 1971*

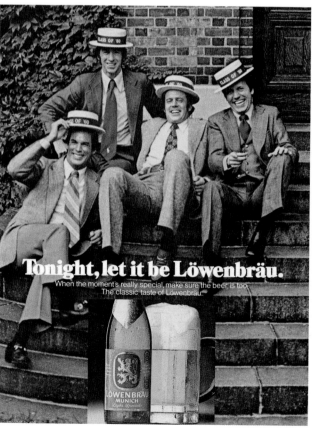

Löwenbräu Beer, 1976

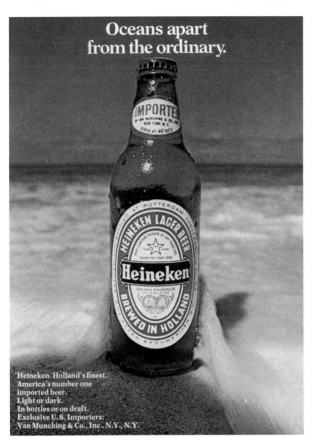

Heineken Beer, 1975

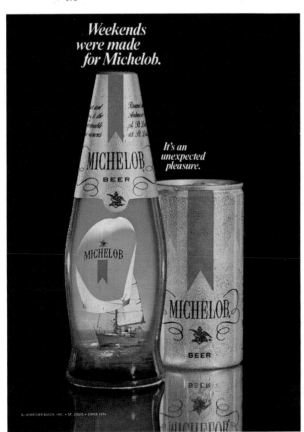

Michelob Beer, 1976

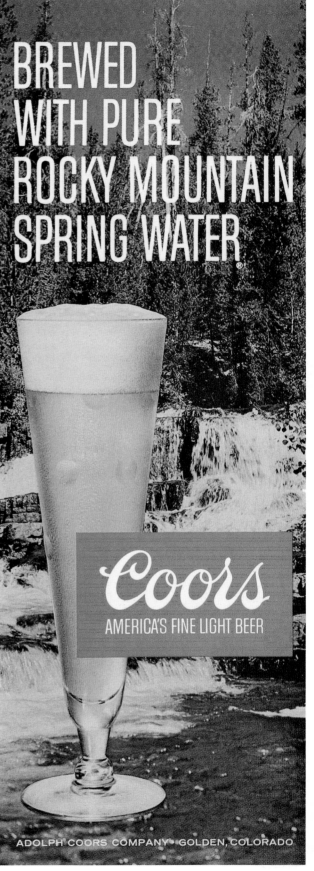

Coors Beer, 1970

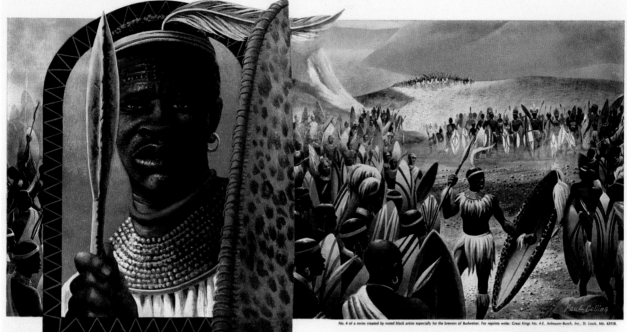

Great Kings of Africa

No. 4 of a series created by noted black artists especially for the brewers of Budweiser. For reprints write: Great Kings No. 4-E, Anheuser-Busch, Inc., St. Louis, Mo. 63118.

Shaka–King of the Zulus (1818-1828)

A strong leader and military innovator, Shaka is noted for revolutionizing 19th century Bantu warfare.

He was first to group regiments by age, and to train his men to use standardized weapons and special tactics. He developed the "assegai," a short stabbing spear, and marched his regiments in tight formation, using large shields to fend off the enemies' throwing spears. Over the years, Shaka's troops earned such a reputation that many enemies would flee at the sight of them.

With cunning and confidence as his tools, Shaka built a small Zulu tribe into a powerful nation of more than one million people, and united all tribes in South Africa against Colonial rule.

The King of Beers,
for a Hundred Years

Budweiser Beer, 1976

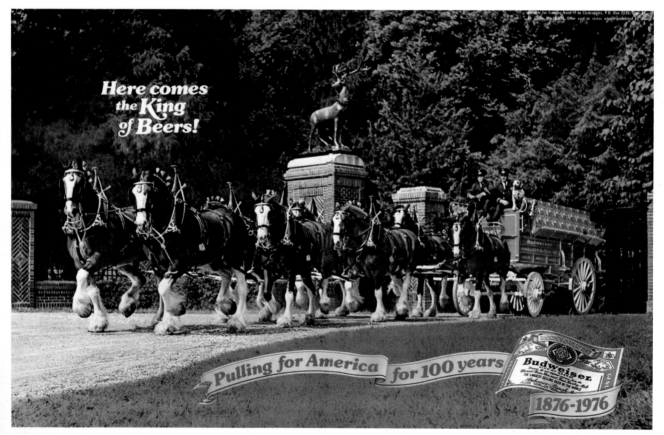

Budweiser Beer, 1976

▶ *Budweiser Beer, 1976*

Grapes, like children, mature at different times.

Some we gather at an early age, while the glow of summer is still on the
vine. With others we sit patiently by 'til the hues of autumn manifest themselves.
A sensitive and painstaking art, this parenting of grapes.
Yet well worth our labor of love to produce a wine the calibre
of our Johannisberg Riesling.
Careful harvesting has yielded a Riesling of remarkable
bouquet and truly distinguished class.
Yes, we are very proud parents.

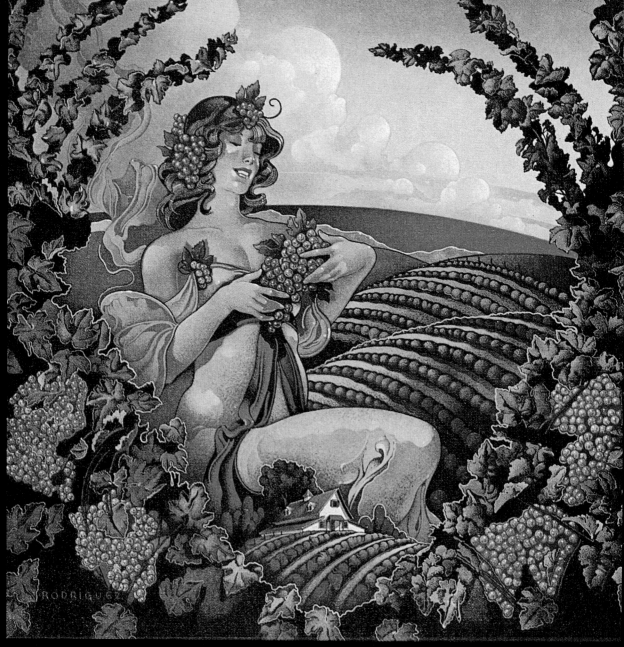

Almadén

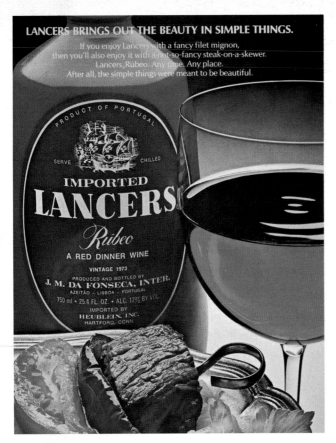

Lancers Wine, 1978

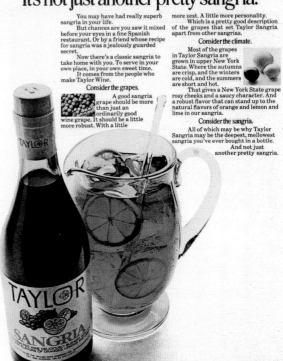

Taylor Sangria, 1973

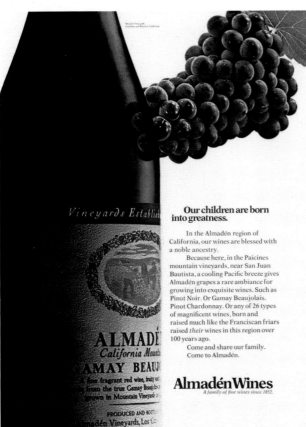

Almadén Wines, 1977 ◄ *Almadén Wines, 1972*

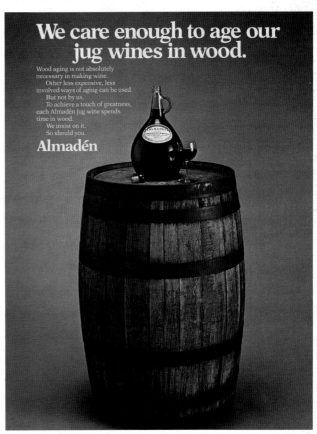

Almadén Wines, 1975

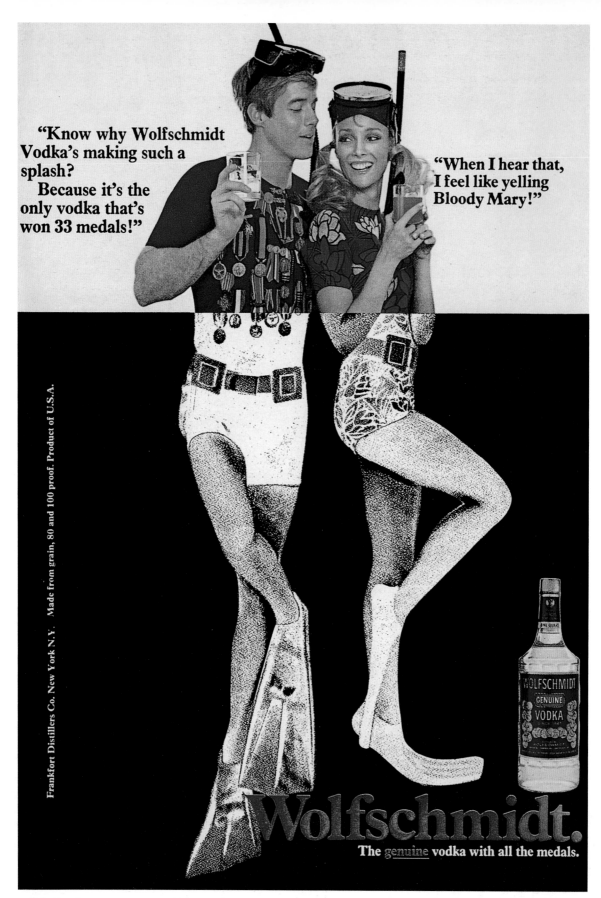

Wolfschmidt Vodka, 1971

▶ *Ronrico Rum, 1970*

Ron Rico. Didn't he pioneer the topless bathing suit?

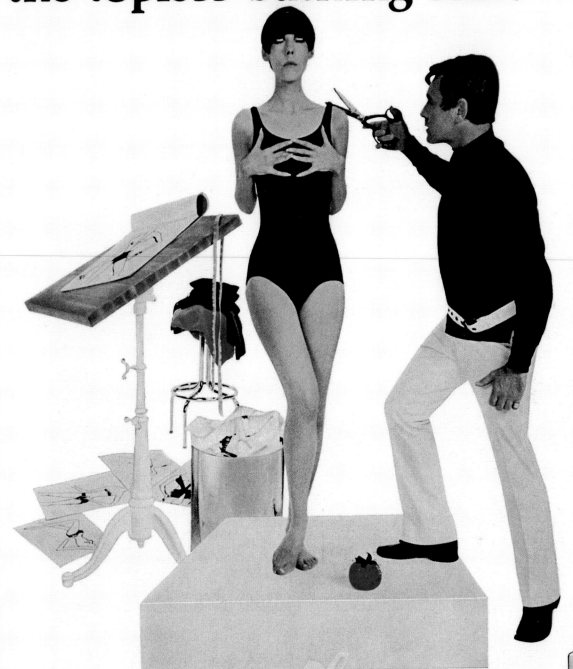

Take it from the top.
Ronrico's a rum. Altogether smooth,
light and very versatile. Untopped
at parties for 112 years. Anyone with eyes knows.

Ronrico. A rum to remember.

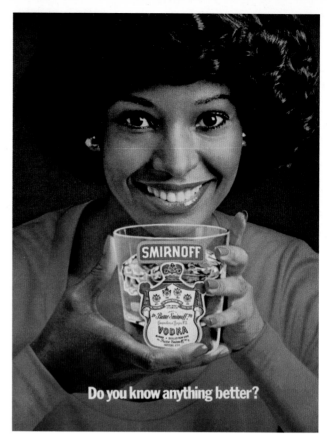

Stolichnaya Vodka, 1973

Smirnoff Vodka, 1975

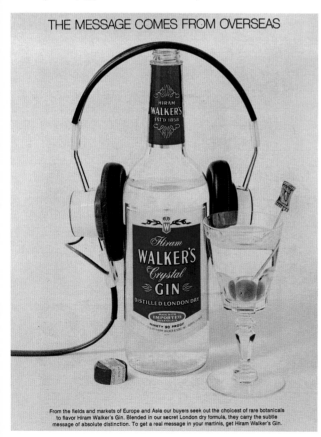

Walker's Gin, 1972

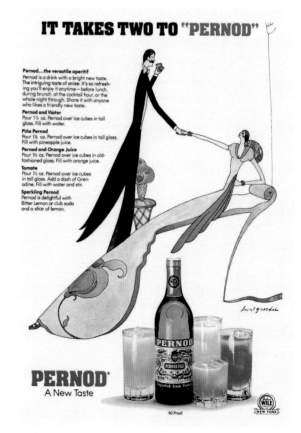

Pernod, 1974

Seagram's 7 Crown and company. Now, that's a party.

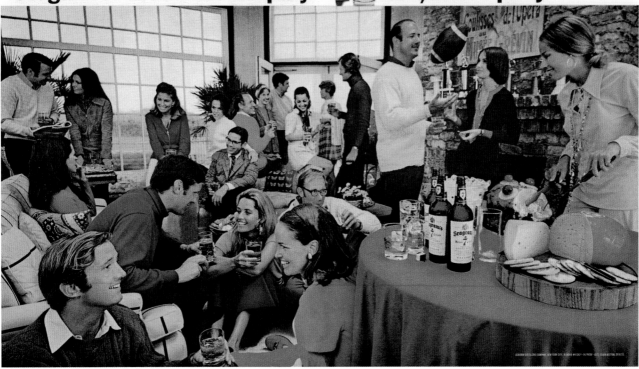

Seagram's 7 Crown Whiskey, 1970

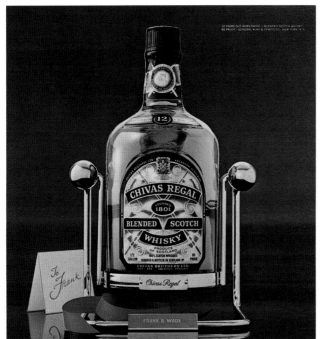

For the surprise of his life: leave a cradle on the doorstep.

The Chivas half-gallon Cradle, or pouring stand, is a most loving way to baby his Chivas. It's designed to dazzle anybody, especially the man who thought he had everything.

It's economical, too, since it eliminates costly spilling of the Chivas. Just tilt and pour neatly.

To get the personalized Cradle, send $9.98*—

together with the name you want imprinted on the nameplate (no more than 20 letters, please)— to Chivas Regal Cradle-A, P.O. Box 5061, Smithtown, New York 11787.

Or get one as a gift to yourself.

The Chivas Cradle. Is there a more appropriate way to show off a precious 12-year-old?

Plus local and state sales tax where applicable. Offer good in U.S.A. only, except where prohibited or restricted by law. Allow four to six weeks for delivery. Offer may be withdrawn without notice.

Chivas Regal Scotch, 1976

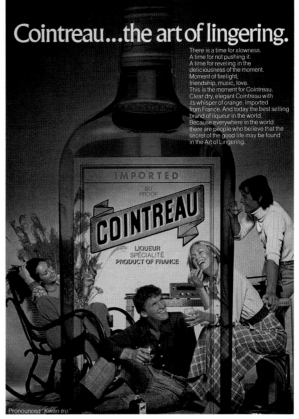

Cointreau...the art of lingering.

There is a time for slowness. A time for not pushing it. A time for reveling in the deliciousness of the moment. Moment of firelight, friendship, music, love. This is the moment for Cointreau. Clear dry, elegant Cointreau with its whisper of orange. Imported from France. And today the best selling brand of liqueur in the world. Because everywhere in the world there are people who believe that the secret of the good life may be found in the Art of Lingering.

Pronounced "Kwan-tro"

Cointreau Liqueur, 1974

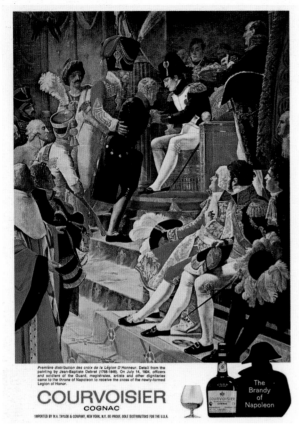

Courvoisier Cognac, 1974

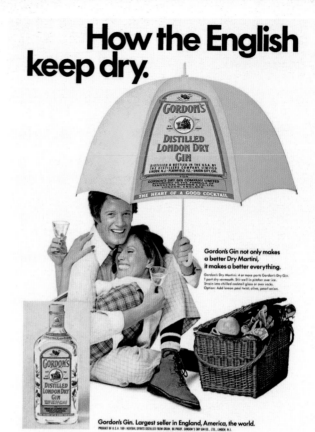

Gordon's Gin, 1974

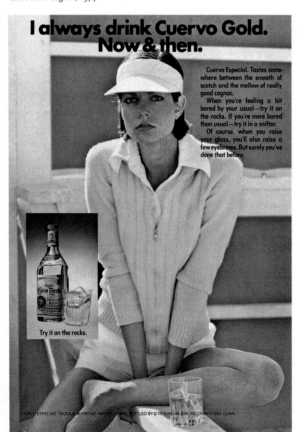

Cuervo Especial Tequila, 1976

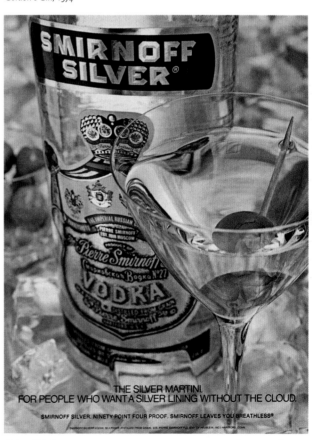

Smirnoff Vodka, 1974 ▶ *Seagram's Gin, 1974*

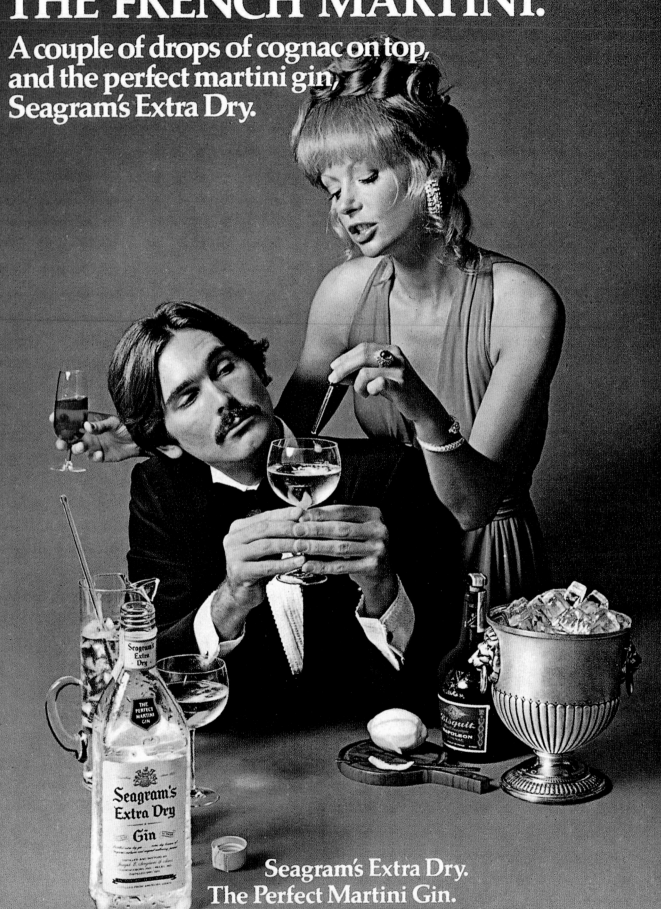

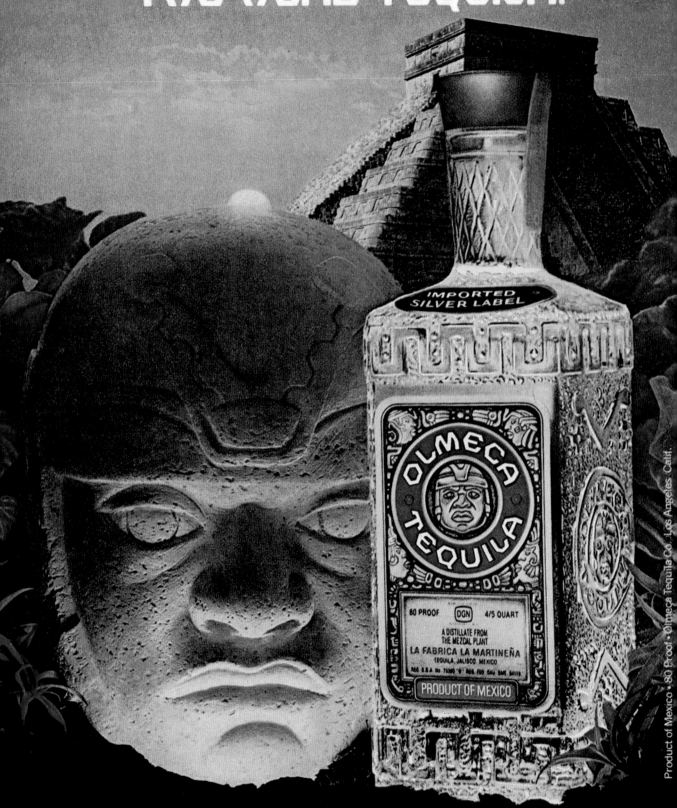

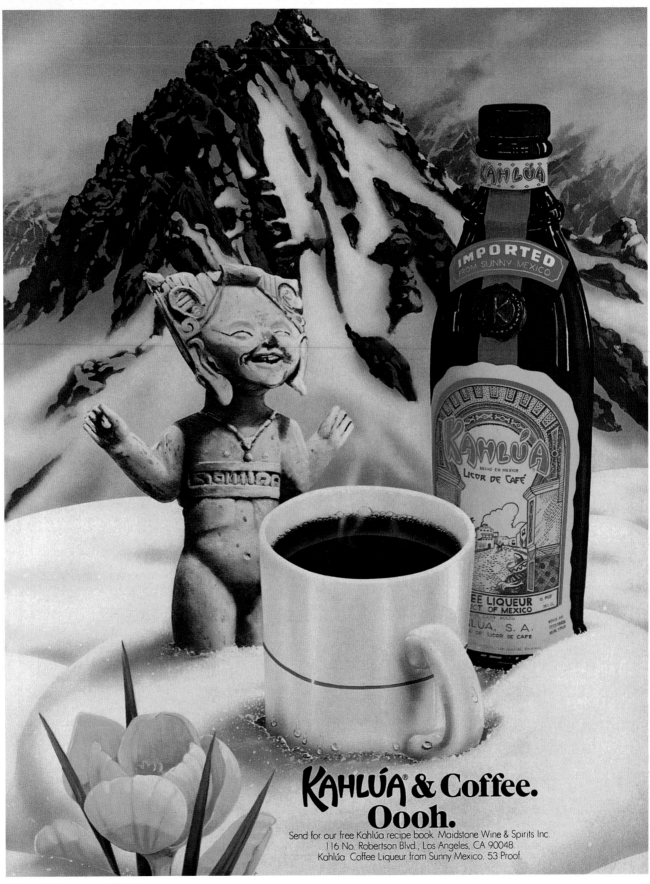

KAHLÚA® & Coffee.
Oooh.

Send for our free Kahlúa recipe book. Maidstone Wine & Spirits Inc.
116 No. Robertson Blvd., Los Angeles, CA 90048.
Kahlúa: Coffee Liqueur from Sunny Mexico. 53 Proof.

Olmeca Tequila, 1977 ◄ *Kahlúa Liqueur, 1979*

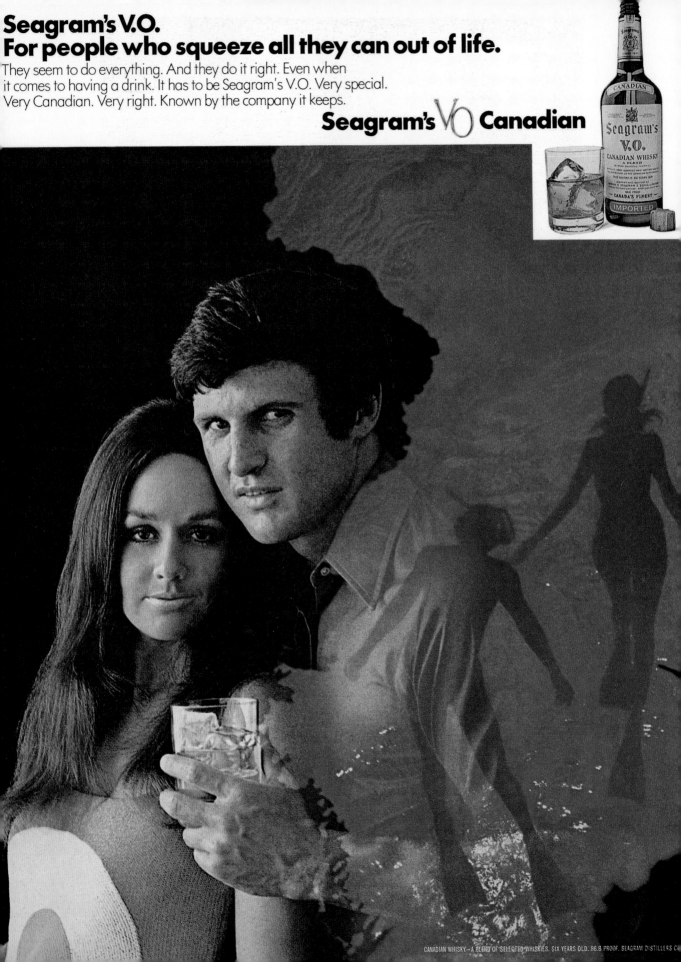

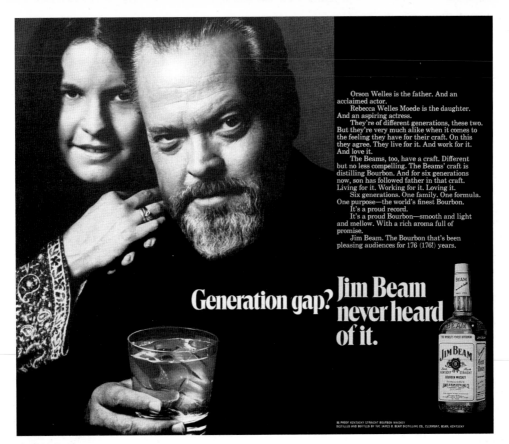

Orson Welles is the father. And an acclaimed actor.

Rebecca Welles Moede is the daughter. And an aspiring actress.

They're of different generations, these two. But they're very much alike when it comes to the feeling they have for their craft. On this they agree. They live for it. And work for it. And love it.

The Beams, too, have a craft. Different but no less compelling. The Beams' craft is distilling Bourbon. And for six generations now, son has followed father in that craft. Living for it. Working for it. Loving it.

Six generations. One family. One formula. One purpose—the world's finest Bourbon.

It's a proud record.

It's a proud Bourbon—smooth and light and mellow. With a rich aroma full of promise.

Jim Beam. The Bourbon that's been pleasing audiences for 176 (176!) years.

Generation gap? Jim Beam never heard of it.

86 PROOF KENTUCKY STRAIGHT BOURBON WHISKEY
DISTILLED AND BOTTLED BY THE JAMES B. BEAM DISTILLING CO., CLERMONT, BEAM, KENTUCKY

Jim Beam Bourbon, 1971

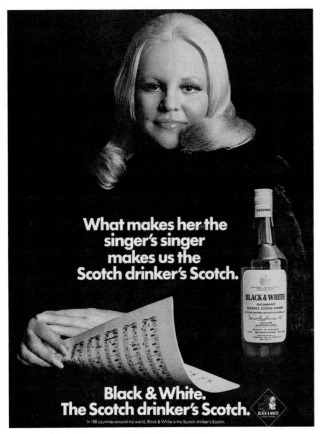

What makes her the singer's singer makes us the Scotch drinker's Scotch.

Black & White. The Scotch drinker's Scotch.

In 188 countries around the world, Black & White is the Scotch drinker's Scotch.

Seagram's V.O. Whisky, 1971 ◄ *Black & White Scotch, 1972*

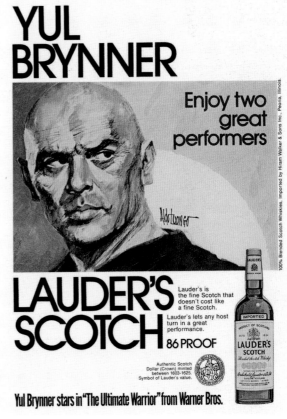

YUL BRYNNER

Enjoy two great performers

100% Blended Scotch Whiskies. Imported by Hiram Walker & Sons Inc., Peoria, Illinois.

LAUDER'S SCOTCH

Lauder's is the fine Scotch that doesn't cost like a fine Scotch.

Lauder's lets any host turn in a great performance.

86 PROOF

Authentic Scotch Dollar (Crown) minted between 1603-1625. Symbol of Lauder's value.

Yul Brynner stars in "The Ultimate Warrior" from Warner Bros.

Lauder's Scotch, 1975

61

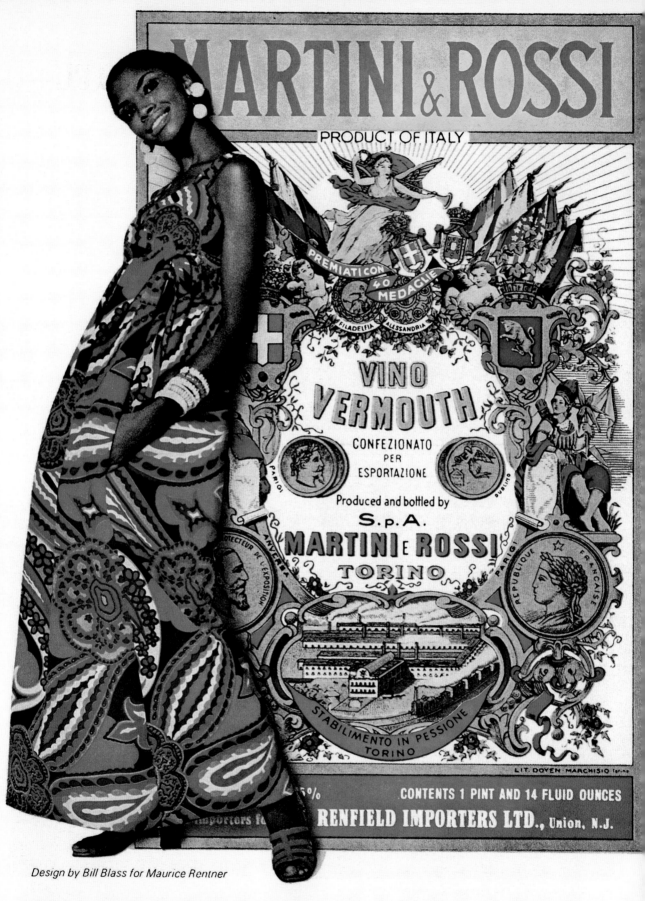

Design by Bill Blass for Maurice Rentner

The nation's favorite vermouth...sweet or extra dry.

Scotch and the single girl.

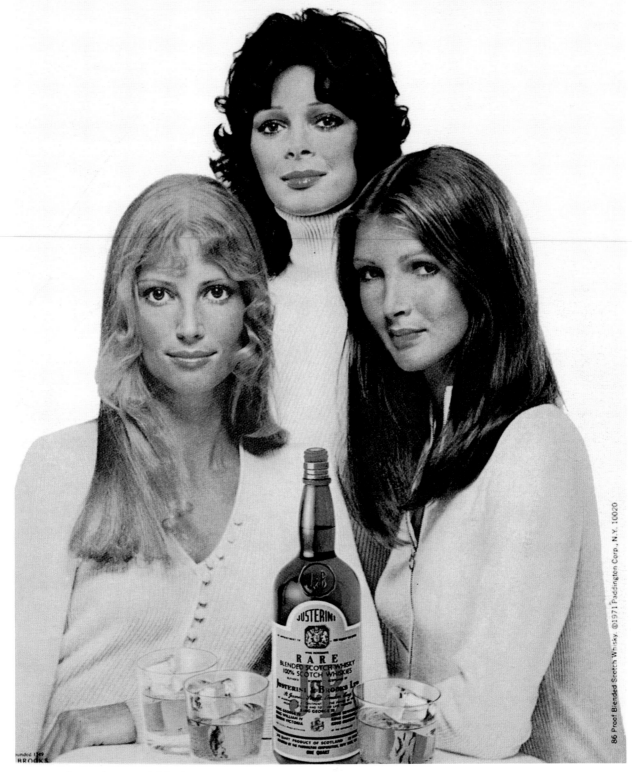

Martini & Rossi Vermouth, 1970 ◄ *J&B Scotch, 1971*

86 Proof Blended Scotch Whisky. ©1971 Paddington Corp., N.Y. 10020

63

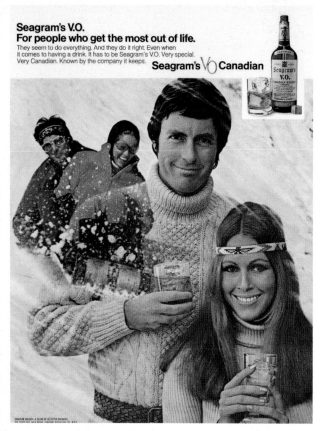

Seagram's V.O. Whisky, 1971

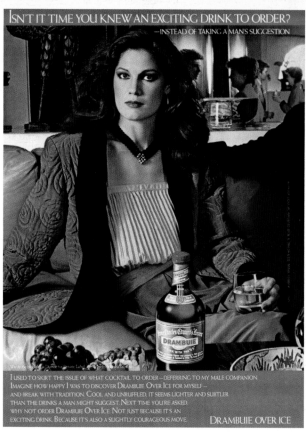

Drambuie Liqueur, 1979

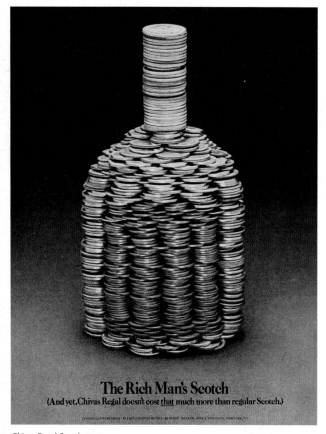

Chivas Regal Scotch, 1973

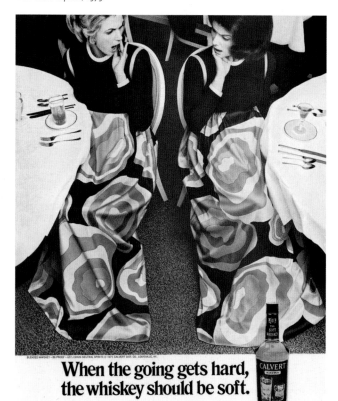

Calvert Whiskey, 1971

▶ *Galaxy Whiskey, 1972*

BORN IN ISRAEL

Sabra Liqueur

The essence of the Jaffa orange with just a hint of fine chocolate.

Sabra Liqueur, 1977

The Hiram Walker Sour Ball.
For kids over 21.

Didn't you once love the zing of a sour ball? Remember the citrus snap that made you pucker your lips? Remember the cool taste on your tongue?

Now that you've grown up, you're ready to discover the delights of the *Hiram Walker* Sour Ball.

It's a quick treat to mix. (But remember to take it easy. *This Sour Ball's*

not child's play.)

Just pack your glass with lots of ice, pour in 1½ ounces of Hiram Walker Apricot Flavored Brandy, top it off with the juices of half a lemon and half an orange and stir.

Now relax and savor that Sour Ball. It's tart to start, tart to finish.

You'll be surprised how something sour can sweeten up your day.

HIRAM WALKER
APRICOT FLAVORED BRANDY

Suntory Royal Whisky, 1971 ◄ Hiram Walker Brandy, 1978

A happy DuBouchett to you, too.

27 naturally flavored cordials, all irresistible.

Just say "Doo-Boo-Shay."

DuBouchett Brandy, 1970

67

The Come As You Are Party Tyme.

Get your friends off the ski slope, out of the barber chair, out of the deep blue sea, and over to your place for a last minute crazy fun party.

To go with the dazzling array of outfits, a dazzling array of Party Tyme Cocktails.

Banana Daiquiris, rich with a sweet tropical banana flavor. Fruity Mai Tais, Whiskey Sours, Margaritas. 13 different Party Tyme Cocktail Mixes in all.

And they're all so easy to fix, they practically come as they are.

Party Tyme®
Cocktail Mixes

Anytime is Party Tyme.

Party Tyme Cocktail Mixes, 1971

▶ *Heublein Cocktails, 1979*

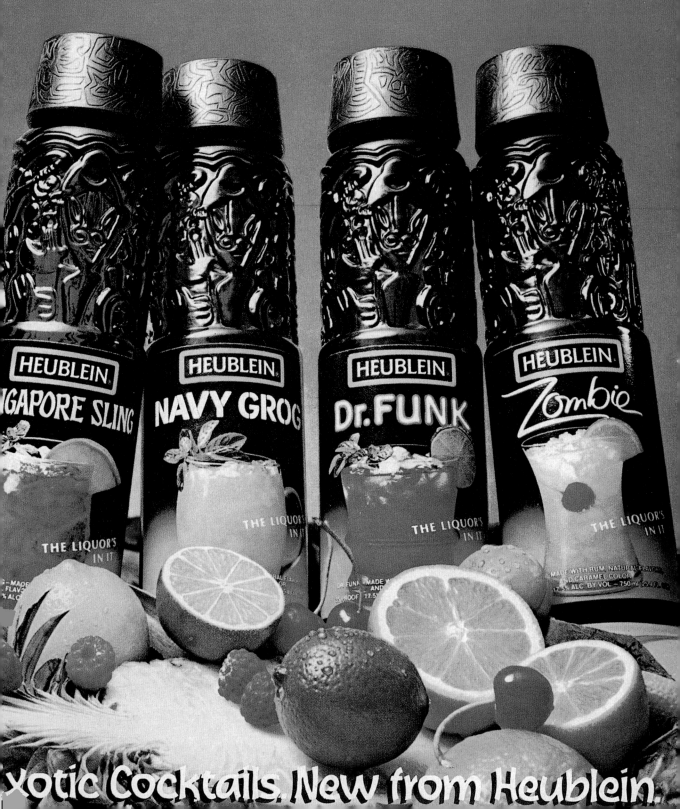

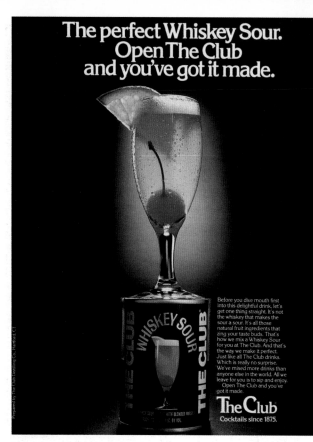

The perfect Whiskey Sour. Open The Club and you've got it made.

Before you dive mouth first into this delightful drink, let's get one thing straight. It's not the whiskey that makes the sour a sour. It's all those natural fruit ingredients that zing your taste buds. That's how we mix a Whiskey Sour for you at The Club. And that's the way we make it perfect. Just like all The Club drinks. Which is really no surprise. We've mixed more drinks than anyone else in the world. All we leave for you is to sip and enjoy. Open The Club and you've got it made.

The Club
Cocktails since 1875.

The Club Premixed Cocktails, 1978

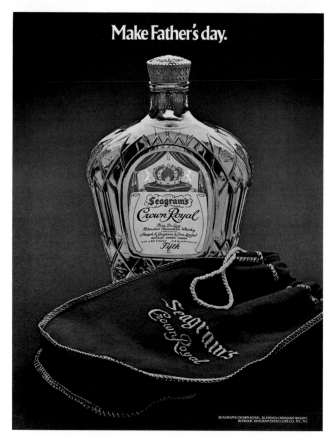

Make Father's day.

SEAGRAM'S CROWN ROYAL, BLENDED CANADIAN WHISKY, 80 PROOF. SEAGRAM DISTILLERS CO., N.Y., N.Y.

Seagram's Crown Royal Whiskey, 1977

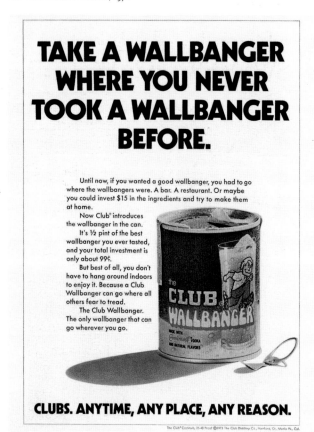

TAKE A WALLBANGER WHERE YOU NEVER TOOK A WALLBANGER BEFORE.

Until now, if you wanted a good wallbanger, you had to go where the wallbangers were. A bar. A restaurant. Or maybe you could invest $15 in the ingredients and try to make them at home.

Now Club® introduces the wallbanger in the can.

It's ½ pint of the best wallbanger you ever tasted, and your total investment is only about 99¢.

But best of all, you don't have to hang around indoors to enjoy it. Because a Club Wallbanger can go where all others fear to tread.

The Club Wallbanger. The only wallbanger that can go wherever you go.

CLUBS. ANYTIME, ANY PLACE, ANY REASON.

The Club® Cocktails, 25-48 Proof ©1973 The Club Distilling Co., Hartford, Ct., Menlo Pk., Cal.

The Club Premixed Cocktails, 1974

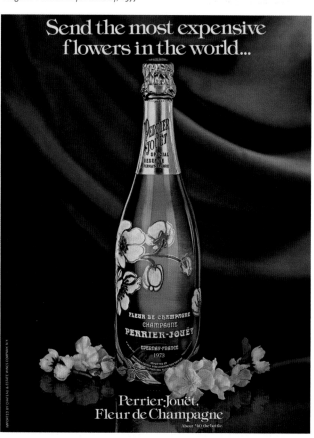

Send the most expensive flowers in the world...

Perrier-Jouët. Fleur de Champagne
About $40 the bottle.

Perrier-Jouët Champagne, 1979

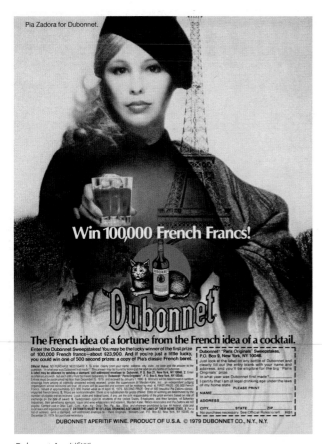

Dubonnet Aperitif Wine, 1979

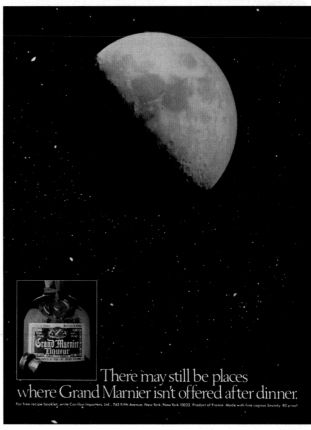

Grand Marnier Liqueur, 1974

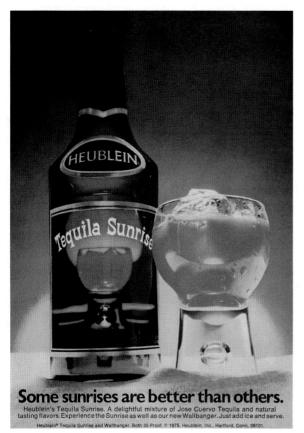

Heublein Cocktails, 1975

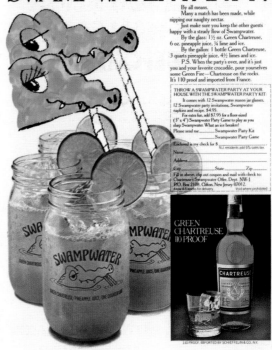

Chartreuse Liqueur, 1978

There's only one Liquore Galliano

And now, one Sambuca di Galliano.

and one Amaretto di Galliano.

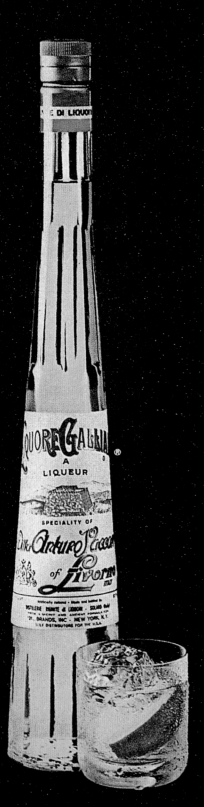

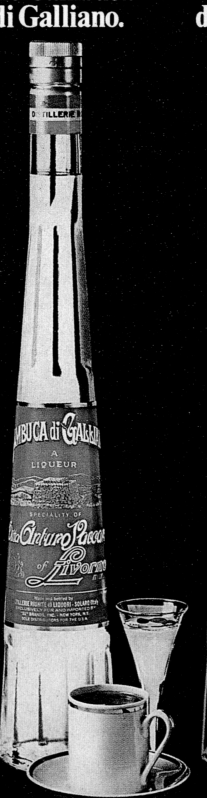

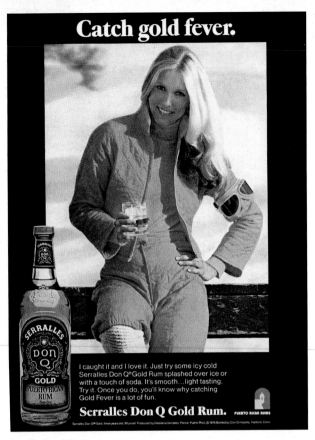

Catch gold fever.

I caught it and I love it. Just try some icy cold Serralles Don Q®Gold Rum splashed over ice or with a touch of soda. It's smooth...light tasting. Try it. Once you do, you'll know why catching Gold Fever is a lot of fun.

Serralles Don Q Gold Rum.

Serralles Don Q Rum, 1977

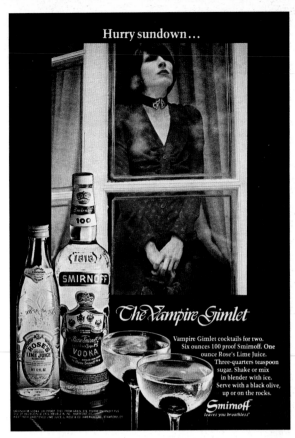

Hurry sundown...

The Vampire Gimlet

Vampire Gimlet cocktails for two. Six ounces 100 proof Smirnoff. One ounce Rose's Lime Juice. Three-quarters teaspoon sugar. Shake or mix in blender with ice. Serve with a black olive, up or on the rocks.

Smirnoff
leaves you breathless®

Smirnoff Vodka, 1972

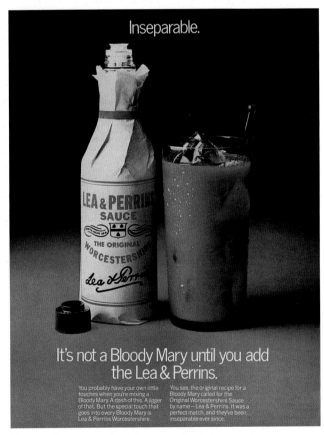

Inseparable.

LEA & PERRINS SAUCE
THE ORIGINAL WORCESTERSHIRE

It's not a Bloody Mary until you add the Lea & Perrins.

You probably have your own little touches when you're mixing a Bloody Mary. A dash of this. A jigger of that. But the special touch that goes into every Bloody Mary is Lea & Perrins Worcestershire.

You see, the original recipe for a Bloody Mary called for the Original Worcestershire Sauce by name—Lea & Perrins. It was a perfect match, and they've been inseparable ever since.

Liquore Galliano, 1977 ◄ Lea & Perrins Worcestershire Sauce, 1979

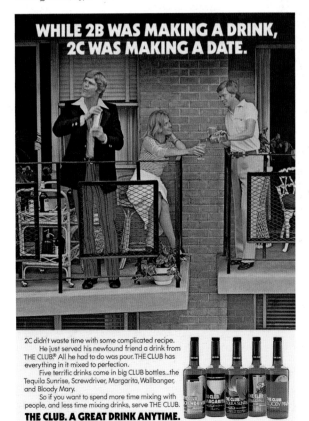

WHILE 2B WAS MAKING A DRINK, 2C WAS MAKING A DATE.

2C didn't waste time with some complicated recipe. He just served his newfound friend a drink from THE CLUB® All he had to do was pour. THE CLUB has everything in it mixed to perfection.

Five terrific drinks come in big CLUB bottles...the Tequila Sunrise, Screwdriver, Margarita, Wallbanger, and Bloody Mary.

So if you want to spend more time mixing with people, and less time mixing drinks, serve THE CLUB.

THE CLUB. A GREAT DRINK ANYTIME.

THE CLUB COCKTAILS: SCREWDRIVER, MARGARITA, TEQUILA SUNRISE, WALLBANGER, BLOODY MARY, 25 PROOF. ©1975 THE CLUB DISTILLING CO., HARTFORD, CT., MENLO PK., CA.

The Club Premixed Cocktails, 1976

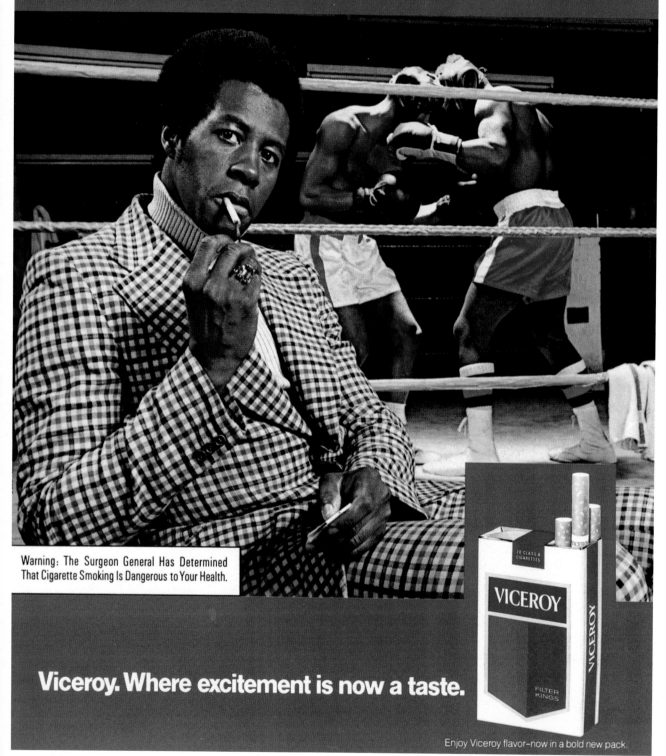

He's the brains behind the next heavyweight champ. He'd never smoke a boring cigarette.

Warning: The Surgeon General Has Determined That Cigarette Smoking Is Dangerous to Your Health.

Viceroy. Where excitement is now a taste.

VICEROY

Enjoy Viceroy flavor—now in a bold new pack.

Viceroy Cigarettes, 1976

▶ *Kent Cigarettes, 1970*

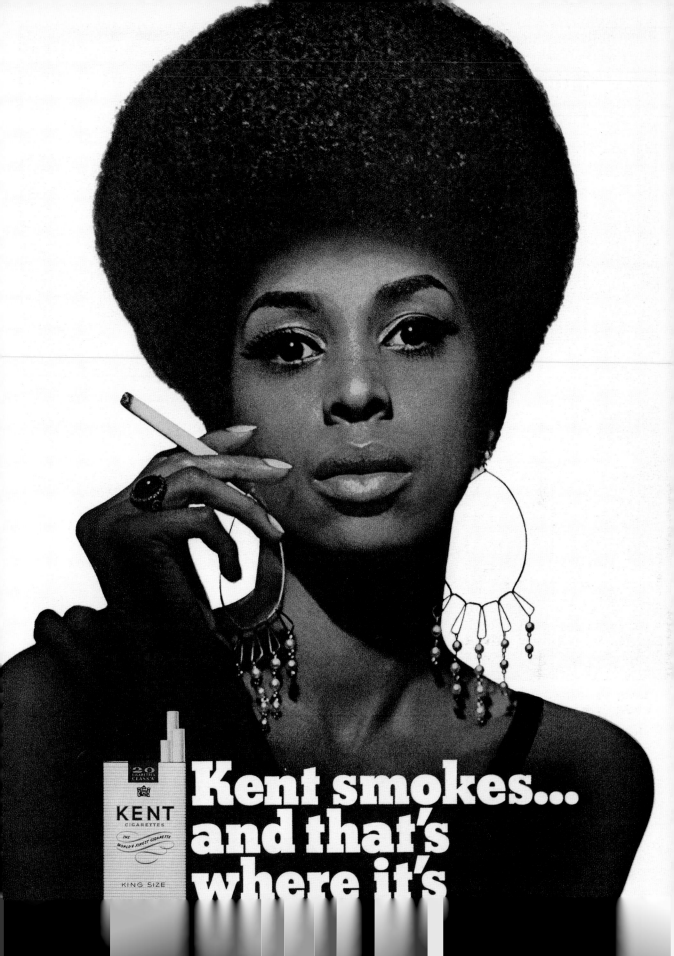

Kent smokes... and that's where it's

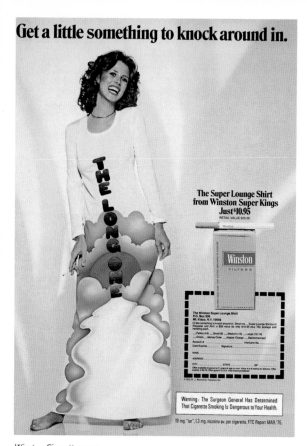

Winston Cigarettes, 1975

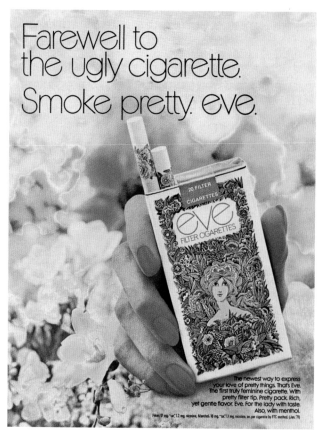

Eve Cigarettes, 1971

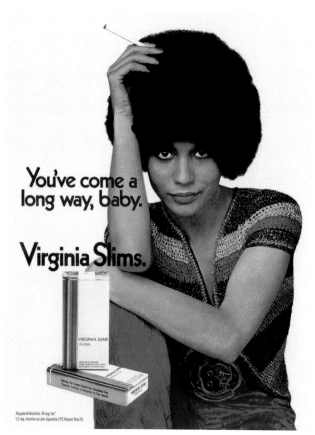

Virgina Slims Cigarettes, 1971

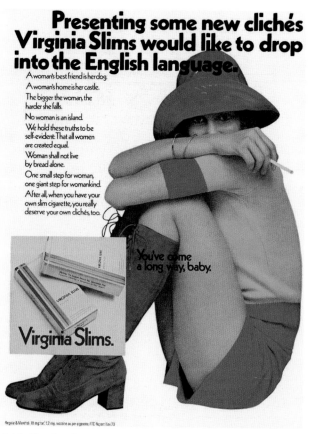

Virginia Slims Cigarettes, 1971

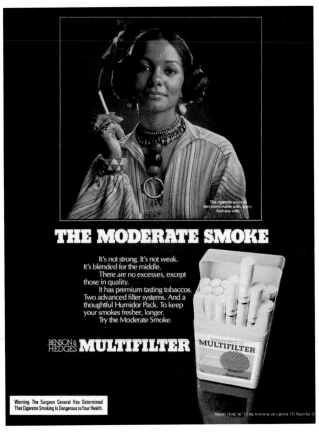

Benson & Hedges Cigarettes, 1972

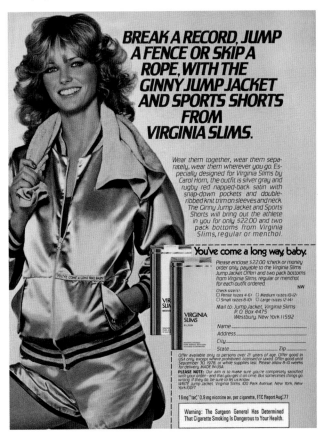

Viceroy Cigarettes, 1974

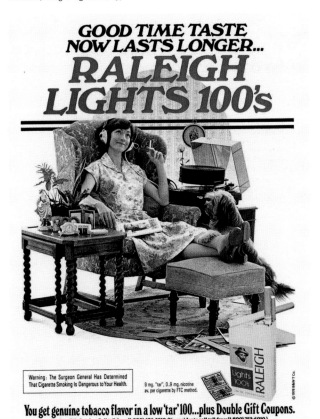

Raleigh Cigarettes, 1978

Virginia Slims Cigarettes, 1978

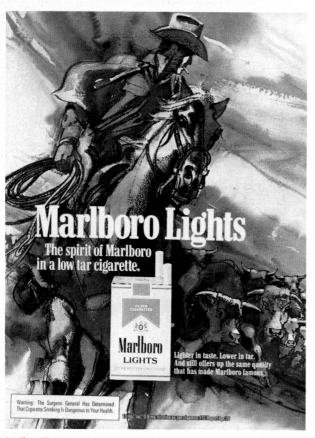

Marlboro Cigarettes, 1977

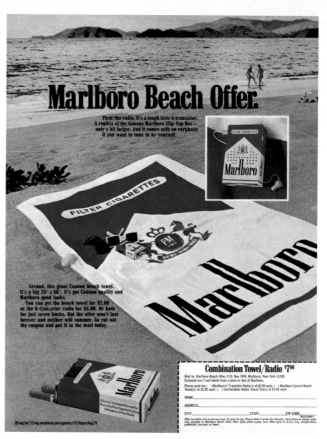

Marlboro Cigarettes, 1972

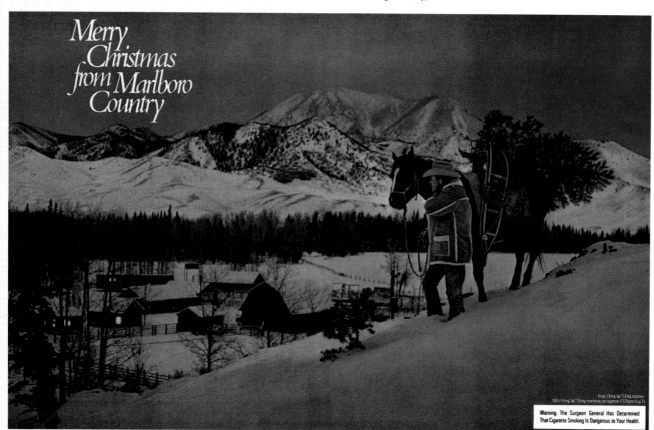

Marlboro Cigarettes, 1972

▶ *Marlboro Cigarettes, 1973*

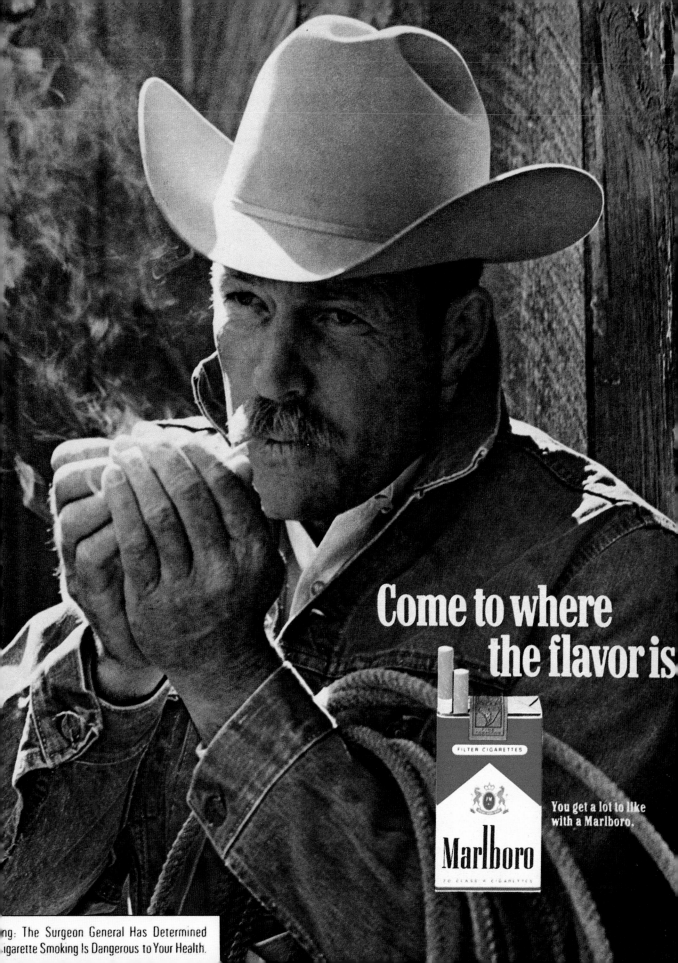

Come to where
the flavor is

You get a lot to like
with a Marlboro.

Marlboro

America's favorite cigarette break.

Benson & Hedges 100's *Regular or Menthol*

Benson & Hedges Cigarettes, 1971

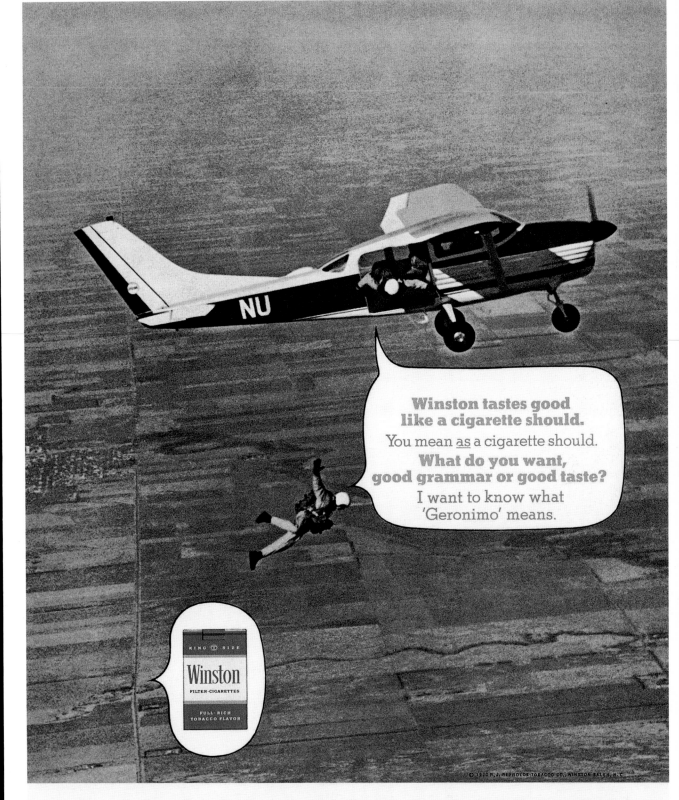

Winston Cigarettes, 1971

With every pair of Mr. Stanley's Hot Pants goes a free pack of short-short filter cigarettes.

Now everybody will be wearing hot pants and smoking short-short filter cigarettes

...almost everybody.

Camel Filters.
They're not for everybody.
(But then, they don't try to be.)

Camel Cigarettes, 1972

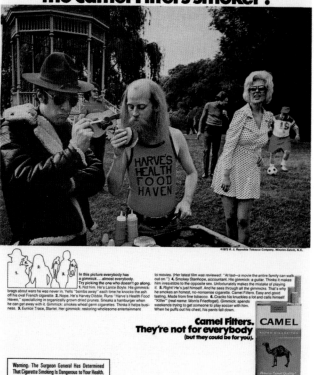

Can you spot the Camel Filters smoker?

Camel Filters.
They're not for everybody
(but they could be for you).

Camel Cigarettes, 1972

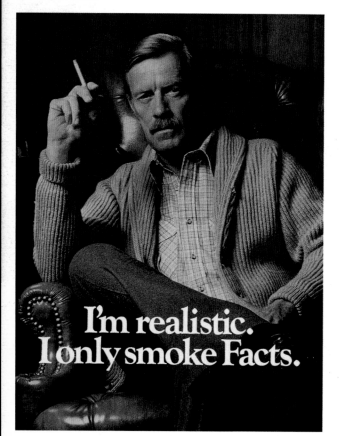

I'm realistic.
I only smoke Facts.

Facts Cigarettes, 1977

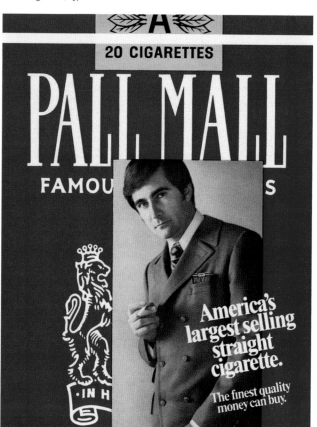

PALL MALL
20 CIGARETTES
FAMOUS CIGARETTES

America's largest selling straight cigarette.

The finest quality money can buy.

Pall Mall Cigarettes, 1970

▶ *Benson & Hedges Cigarettes, 1971*

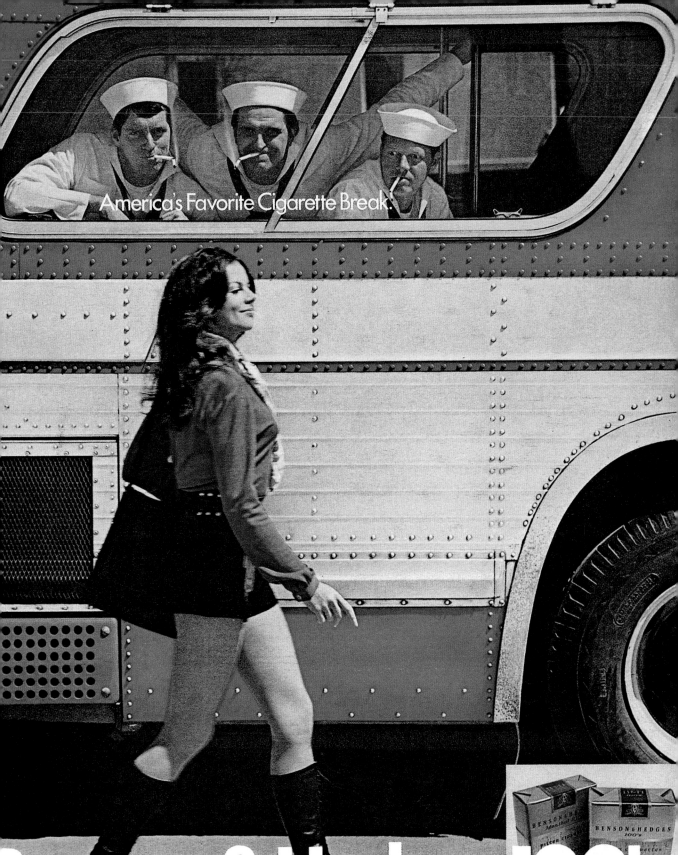

America's Favorite Cigarette Break.

Benson & Hedges 100's.

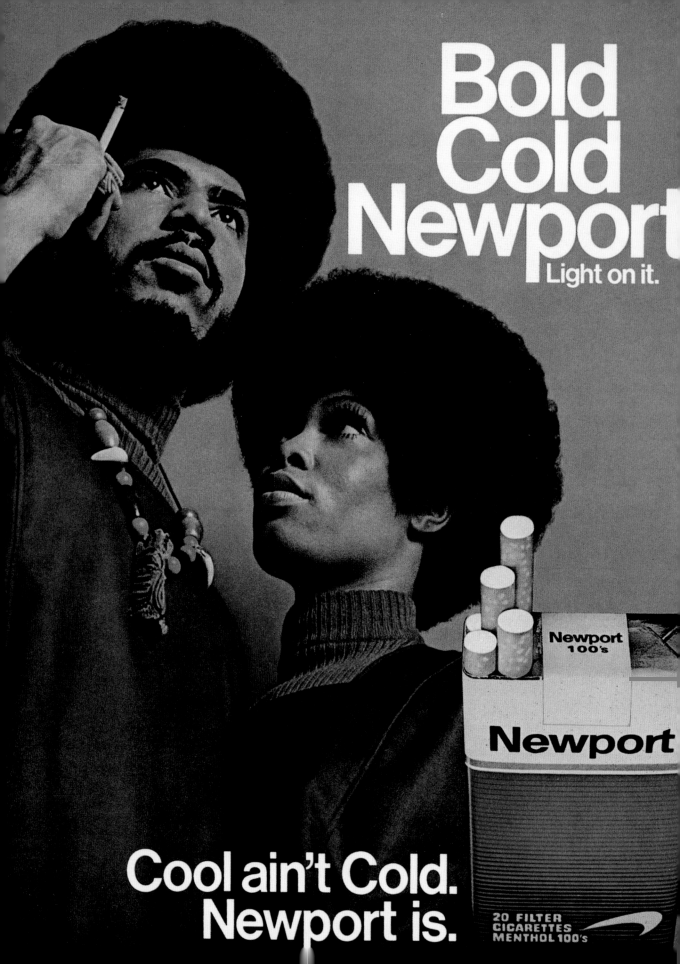

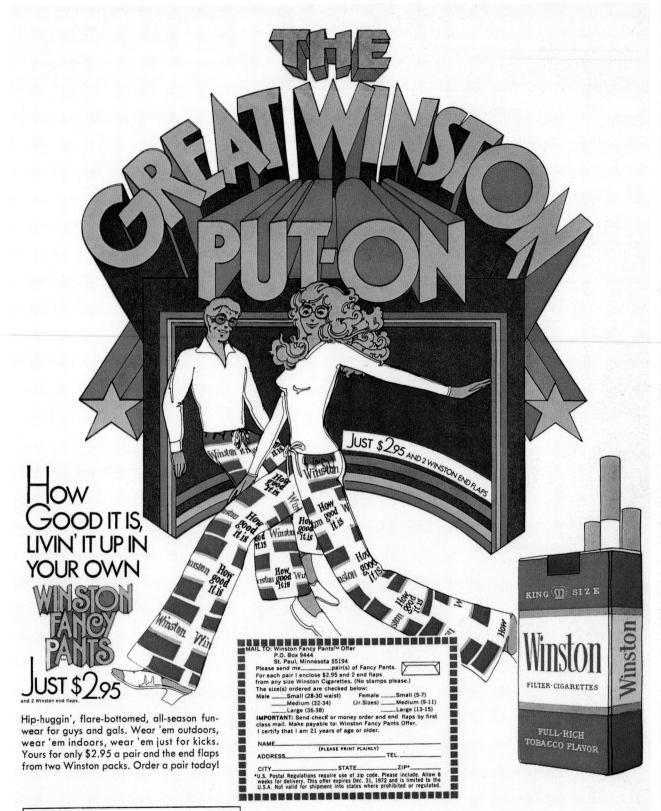

THE GREAT WINSTON PUT-ON

JUST $2.95 AND 2 WINSTON END FLAPS

HOW GOOD IT IS, LIVIN' IT UP IN YOUR OWN WINSTON FANCY PANTS

JUST $2.95
and 2 Winston end flaps.

Hip-huggin', flare-bottomed, all-season fun-wear for guys and gals. Wear 'em outdoors, wear 'em indoors, wear 'em just for kicks. Yours for only $2.95 a pair and the end flaps from two Winston packs. Order a pair today!

KING SIZE

Winston
FILTER · CIGARETTES

FULL · RICH TOBACCO FLAVOR

Winston

© 1972 R J REYNOLDS TOBACCO COMPANY, WINSTON-SALEM, N C.

20 mg. "tar", 1.4 mg. nicotine av. per cigarette, FTC Report APR.'72.

Newport Cigarettes, 1970 ◄ *Winston Cigarettes, 1972*

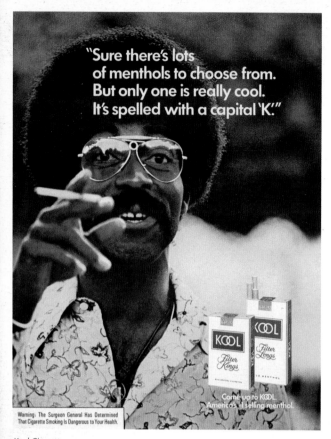

Kool Cigarettes, 1974

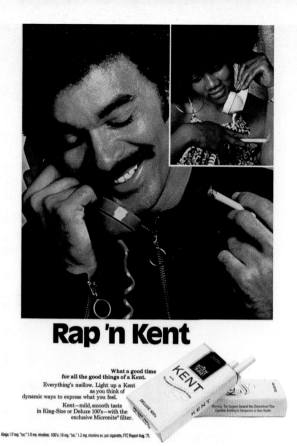

Kent Cigarettes, 1971

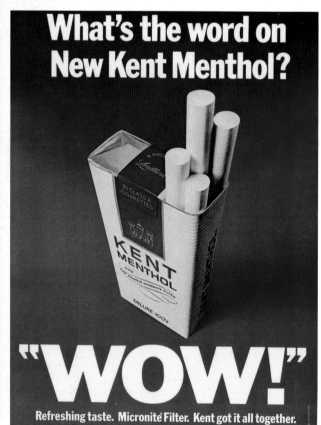

Kent Cigarettes, 1971

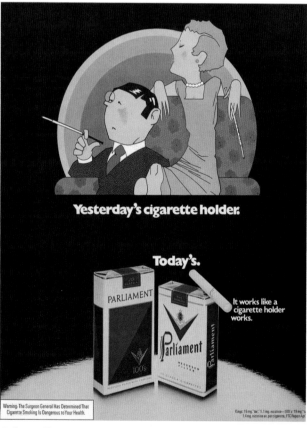

Parliament Cigarettes, 1972 ▶ *Tareyton Cigarettes, 1973*

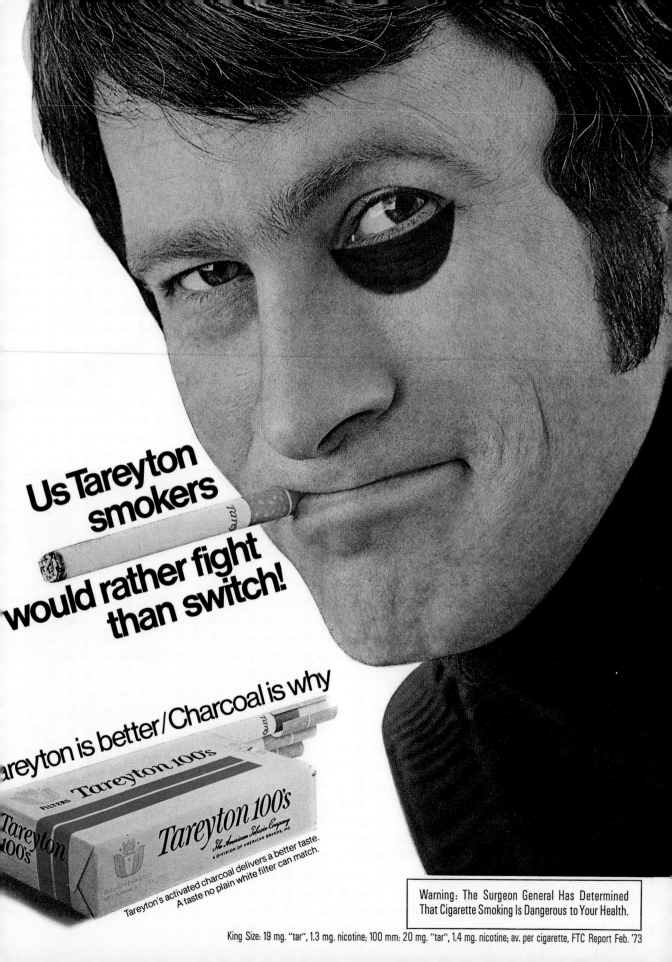

Us Tareyton smokers would rather fight than switch!

Tareyton is better/Charcoal is why

Tareyton 100's
The American Tobacco Company
A DIVISION OF AMERICAN BRANDS, INC.

Tareyton's activated charcoal delivers a better taste.
A taste no plain white filter can match.

The match was a great invention until...

dispoz-a-lite.

The disposable butane lighter by Garrity

Revolutionary! The match is overthrown by a replacement that gives you none of the problems of old-fashioned lighters! And now you enjoy real convenience – the lighter you never refill, never reflint, never repair.

Dispoz-a-lite lights first time. Every time. You get up to 3,000 lights – at a cost of less than a penny a pack. No wonder it's already the world's best-selling lighter! And it sure beats matches for style, economy and convenience.

Only $**1**49

Another fine product from GARRITY INDUSTRIES, INC., Stamford, Conn. 06907

Dispoz-a-lite Lighters, 1972

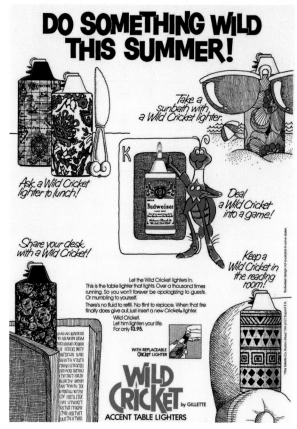

DO SOMETHING WILD THIS SUMMER!

Take a sunbath with a Wild Cricket lighter.

Ask a Wild Cricket lighter to lunch!

Deal a Wild Cricket into a game!

Share your desk with a Wild Cricket!

Keep a Wild Cricket in the reading room!

Let the Wild Cricket lighters in. This is the table lighter that lights. Over a thousand times running. So you won't forever be apologizing to guests. Or mumbling to yourself. There's no fluid to refill. No flint to replace. When that fire finally does give out, just insert a new Cricket® lighter. Wild Cricket. Let him lighten your life. For only $3.95.

WITH REPLACEABLE CRICKET LIGHTER

WILD CRICKET by GILLETTE
ACCENT TABLE LIGHTERS

Wild Cricket Lighters, 1974

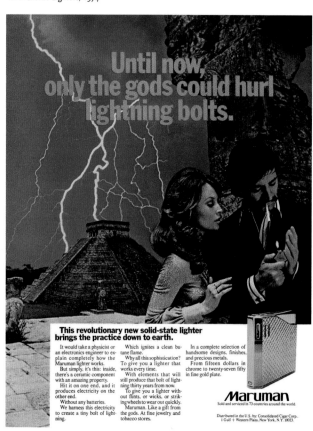

Until now, only the gods could hurl lightning bolts.

This revolutionary new solid-state lighter brings the practice down to earth.

It would take a physicist or an electronics engineer to explain completely how the Maruman lighter works.

But simply, it's this: inside, there's a ceramic component with an amazing property. Hit it on one end, and it produces electricity on the other end.

Without any batteries. We harness this electricity to create a tiny bolt of lightning.

Which ignites a clean butane flame.

Why all this sophistication? To give you a lighter that works every time. With elements that will still produce that bolt of lightning thirty years from now.

To give you a lighter without flints, or wicks, or striking wheels to wear out quickly.

Maruman. Like a gift from the gods. At fine jewelry and tobacco stores.

In a complete selection of handsome designs, finishes, and precious metals.

From fifteen dollars in chrome to twenty-seven fifty in fine gold plate.

Maruman
Sold and serviced in 73 countries around the world.

Distributed in the U.S. by: Consolidated Cigar Corp.
1 Gulf + Western Plaza, New York, N.Y. 10023.

Maruman Lighters, 1970 ▶ *Virginia Slims Cigarettes, 1972*

1913, [1] Mary Patrick got on the train in Boston, got the urge to smoke in New York, [2] decided to light near Trenton, [3] was caught outside of Wilmington, [4] and was put off the train somewhere ...tween Baltimore and Laurel.

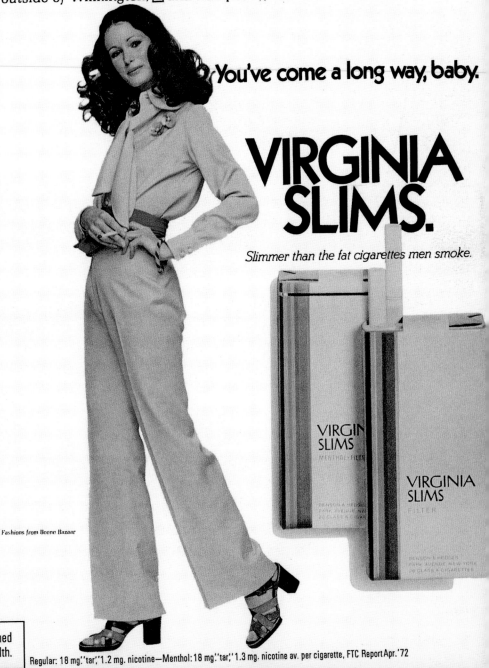

You've come a long way, baby.

VIRGINIA SLIMS.

Slimmer than the fat cigarettes men smoke.

Fashions from Beene Bazaar

Regular: 18 mg. "tar;" 1.2 mg. nicotine—Menthol: 18 mg. "tar;" 1.3 mg. nicotine av. per cigarette, FTC Report Apr. '72

And the winner is...

It's a Black Thing

Seeking a broader market, many cigarette advertisers in the seventies addressed a growing minority demographic with specialized ads that flaunted hip jargon and attitude. Exploiting every cliché of the Black lexicon of the era, this L&M ad tried desperately to address young African American customers. Yet this "out-of-sight" moment failed to live up to its "super bad" image when it came to the actual cigarette package, which compromised its message by featuring a white couple in a setting that was anything but hip.

Blaxploitation

In den Siebzigern versuchten viele Zigarettenhersteller, ihren Marktanteil auszuweiten; sie benutzten dazu spezifisch auf Minderheiten, einem wachsenden Anteil an der amerikanischen Bevölkerung, abzielende Werbungen, die hippe Szenesprache und ein cooles Lebensgefühl zum Besten gaben. Diese L&M-Werbung beutet jedes Stereotyp des schwarzen Lexikons der Zeit aus und versucht verzweifelt, junge afroamerikanische Konsumenten anzusprechen. Doch dieser „Wahnsinns"-Augenblick schaffte es nicht, sein Image als „super bad" durchzuhalten – auf der Zigarettenschachtel ist ein der Werbebotschaft völlig widersprechendes Bild eines weißen Paares in einem alles andere als coolen Ambiente zu sehen.

Un truc de blacks

Cherchant à élargir leur marché, de nombreux annonceurs de marques de cigarettes se tournèrent vers les minorités avec des pubs ciblées utilisant un jargon et une attitude qui se voulaient « dans le vent ». Exploitant tous les clichés et les expressions en vogue dans l'argot noir de l'époque, cette pub pour L&M tentait désespérément de séduire une clientèle de jeunes afro-américains mais son message sonnait plutôt creux compte tenu du paquet, qui montrait un couple de blancs dans un décor qui n'avait vraiment rien de branché.

Black power

En los años setenta, con la intención de llegar a un público más amplio, muchas marcas de tabaco dirigieron sus campañas publicitarias a una minoría demográfica creciente, creando anuncios que hacían ostentación de la jerga y la actitud de moda entre la población negra. Explotando todos y cada uno de los clichés del léxico negro de la época, este anuncio de L&M pretendía desesperadamente captar a la juventud afroamericana. Pero L&M no supo reflejar este momento *cool* en sus paquetes de cigarrillos, decorados con una pareja blanca en un entorno que resultaba ser de todo menos moderno.

ブラックな感じ

70年代、市場の拡大を求めていたタバコ会社の多くが、増加するマイノリティ人口に向けて、彼ら独自の流行り言葉や流儀をこれみよがしにちりばめた広告を打ち出した。当時の黒人言葉のなかから、思いつく限りの陳腐な決まり文句を集めて構成したL&Mの広告は、アフロ・アメリカンの若者たちに呼びかけようと必死である。しかし、その"いかした"雰囲気も、タバコのパッケージそのものを見てしまうと、謳っているほど"スーパー・バッド"だとは思えない。なにしろそこに登場するのは、最新の流行からはほど遠い場所にたたずむ白人カップルなのだから。

This is L&M – super bad

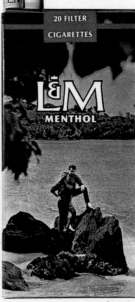

That show was out-of-sight.
You can still feel every note.
They played hot and hard.
They gave you the truth.
And now
you're both ripe for L&M.

Ah, the taste of an L&M menthol cigarette–super bad.

Warning: The Surgeon General Has Determined That Cigarette Smoking Is Dangerous to Your Health.

L&M Menthol,
19 mg. "tar," 1.2 mg. nicotine
av. per cigarette by FTC method.

L&M Cigarettes, 1971

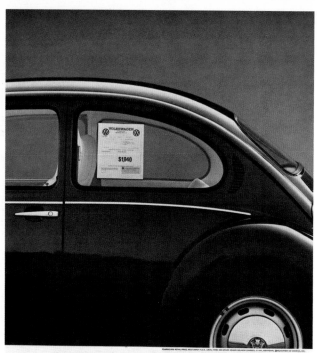

For 1971, we improved the left side rear window.

At last, a Volkswagen improvement you can see.

Along with our 25 hidden improvements for 1971, we proudly announce a new price.

$1840 will now put you behind the wheel of a Volkswagen 111 sedan.*

You see, we found little things to take out of our little car that won't affect what you get out of it.

(After 25 years of perfecting one model, you can do ingenious things like that.)

For even though it now runs around on a new, more powerful engine, it still runs

around on around 26 miles to a gallon. It still abstains from antifreeze.

It still survives on pints of oil instead of quarts.

And in case you couldn't tell from the picture above, it still looks like a Beetle.

Volkswagen, 1970

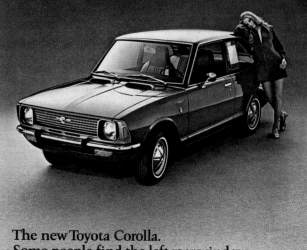

The new Toyota Corolla. Some people find the left rear window its most beautiful feature.

$1798* That's the beauty mark you'll find on the sticker of every Corolla Sedan. But the sedan is just one version of a beautiful Corolla price.

Two other Corollas have left rear windows that are just as appealing. The sporty Corolla Fastback at $1918. The roomy Corolla Wagon at a mere $1958.

Yet, as inexpensive as it is, the Toyota Corolla doesn't rely on price alone. It has fully reclining bucket seats. It has

thick wall-to-wall nylon carpeting. It has an all-vinyl interior. To make it all the more beautiful.

But one of the most beautiful surprises in the Toyota Corolla is the amount of legroom. There's not an economy car around that comes close.

As for being practical, the Toyota Corolla does a beautiful job there, too. With carpets that snap in and out so you can clean them easily. With front disc brakes for safer stopping. With undercoating to prevent rust, corrosion and noise. With unit construction and a lined trunk to

prevent rattles and squeaks. And with a very practical sealed lubrication system to end chassis lubes forever.

An economy car that comes loaded. That's the real beauty of the Toyota Corolla.

But with the beautiful price of $1798, we can't blame you for being attracted to the left rear window.

TOYOTA
We're quality oriented

Toyota Corolla, 1970

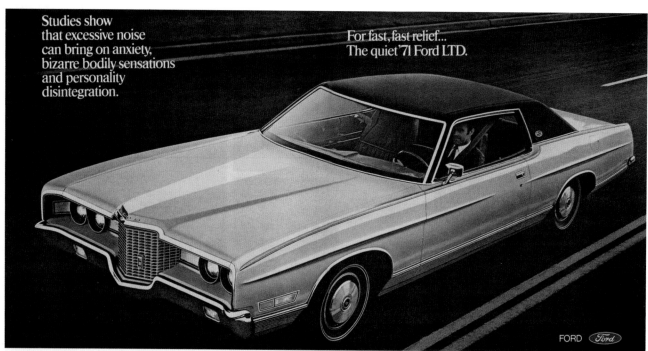

Studies show that excessive noise can bring on anxiety, bizarre bodily sensations and personality disintegration.

For fast, fast relief... The quiet '71 Ford LTD.

1971 LTD Brougham 2-door Hardtop

Outside, it's getting noisier and noisier. Inside a 1971 Ford LTD it's another world.

A quiet world born of strength. A world where road shock is turned off. Where vibrations aren't allowed in. Where bumps and potholes are smoothed over.

Start with the Ford frame. A computer is used to locate vibration-free body mounts—so the harshness stays out and the quiet stays in.

The body itself is made of heavy gauge steel and insulated to muffle road sounds. Doors and win-

dows are weather-sealed against wind noise. And there's new Power Ventilation so you can stay comfortable with the windows up—while the loud sounds stay out.

The Ford LTD is not only one of the strongest and quietest Fords ever built—it is also the most luxurious.

Look into Ford's famous Front Room. An all new instrument panel and luxurious trim tell you that this is fine car elegance at its best.

And you can add such features as: air condition-

ing with automatic temperature control. A Tilt-Steering Wheel that adjusts to five different driving positions. Fingertip Speed Control. HighBack Seats for easychair comfort. A Stereo-sonic tape system with speakers front and rear. Cornering lights. SelectShift transmission. Not to mention five V-8's including our new 400 cu. in. regular fuel V-8.

A 351 cubic inch V-8 is standard on LTD. So are: 3-speed Synchro-Smooth Shift. Front power disc brakes. New protective Steel Guard Rails. All-

nylon carpeting. Easy-to-use Uni-Lock Harness. Even a self-regulating electric clock.

There are 18 new Fords to choose from in 1971 including the 2-door LTD Brougham Hardtop (illustrated) and an all-new luxury LTD Convertible—all available at your Ford Dealer's now.

This year, come to where the strength is...the luxury is...the quiet is...

Ford gives you better ideas.

Take a Quiet Break...'71 Ford.

Better idea for safety...Buckle up.

Toyota Celica, 1974 ◄ *Ford LTD, 1970*

Capri for 1971.
The first sexy European under $2400.

Manufacturer's suggested retail price. Does not include transportation charges, dealer preparation, if any, state and local taxes.

There used to be two kinds of imports. Beautiful, sporty and expensive, or plain, dull and inexpensive. Now there's something better than either: its beautiful and inexpensive. It's Europe's biggest success car in years, and now it's imported for Lincoln-Mercury in limited quantities. Compare it to other imports or new small cars.

Capri offers an extravagant collection of exciting features as standard equipment. Features that are usually optional. Radial tires. Styled steel wheels. Soft vinyl front buckets. Luxurious carpeting. A European-type instrument panel with wood grain effect. Flow-thru ventilation.

Sound unfamiliar for a low-priced car? It is. And there's still more that's standard. Lots of room for four big adults. Easy maintenance (with lots of do-it-yourself tips in the owner's manual). Power disc brakes up front. Four-speed synchromesh transmission. And small car gas economy.

There's only one word for it. Sexy. And that's unheard of at less than $2400. Until now.

Imported for Lincoln-Mercury.

LINCOLN·MERCURY — Ford

Capri Sport Coupe

Lincoln-Mercury Capri, 1970

Better ideas make better cars: 1971 Mercury Montego.

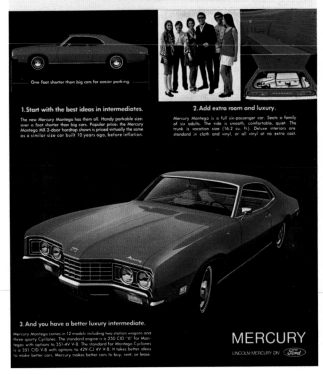

One foot shorter than big cars for easier parking.

1. Start with the best ideas in intermediates.
The new Mercury Montego has them all. Handy parkable size: over a foot shorter than big cars. Popular price: the Mercury Montego MX 2-door hardtop shown is priced virtually the same as a similar size car built 10 years ago, before inflation.

2. Add extra room and luxury.
Mercury Montego is a full six-passenger car. Seats a family of six adults. The ride is smooth, comfortable, quiet. The trunk is vacation size (16.2 cu. ft.). Deluxe interiors are standard in cloth and vinyl, or all vinyl at no extra cost.

3. And you have a better luxury intermediate.
Mercury Montego comes in 12 models including two station wagons and three sporty Cyclones. The standard engine is a 250 CID "6" for Montegos with options to 351-4V-8. The standard for Montego Cyclones is a 351 CID V-8 with options to 429-CJ 4V-8. It takes better ideas to make better cars. Mercury makes better cars to buy, rent, or lease.

MERCURY
LINCOLN-MERCURY DIV — Ford

Mercury Montego, 1970

The exciting new Sedan deVille and Fleetwood Sixty Special Brougham

Never has the introduction of a new Cadillac so dramatically established Cadillac's undeniable leadership in the world of fine motor cars.

All nine of the magnificent 1971 Cadillacs are totally new. They are completely new in looks—with crisper, more classic contours, greater glass area and doors designed to permit easier entry and exit.

They are new in luxury—with a completely redesigned instrument panel, new lower profile seats and a wide selection of rich new fabrics. And they are new in convenience, including a unique light monitoring system available on all models.

You will discover new performance, too. The superb Cadillac ride has never been smoother. The quietness of operation will impress even long-time Cadillac owners. And all Cadillac V-8 engines deliver their famed performance on the new no-lead, low-lead fuels.

See—and drive—the brilliant new 1971 Standard of the World, now at your authorized dealer's. Leadership has never been so elegantly presented.

The new Eldorado...the world's most elegant personal cars.

In the Eldorado Coupe and Convertible, Cadillac presents two completely new and completely distinctive automobiles. A new, longer wheelbase provides superb riding qualities and new, more impressive beauty.

Individual touches, such as the jewel-like stand-up crest and the exclusive coach windows on the Coupe, typify the Eldorado's many styling innovations.

The Convertible, now the only luxury convertible built in America, comes equipped with an ingenious new inward-folding Hideaway Top. It provides a more graceful top-down appearance and allows greater room for rear-seat passengers.

Both Eldorados share the same 8.2 litre V-8 (the world's largest production passenger car engine) in combination with the precise handling of front-wheel drive, variable-ratio power steering, power front disc brakes and Automatic Level Control.

Surely, these are the two most excitingly luxurious automobiles in the world of personal motoring . . . the Fleetwood Eldorados by Cadillac.

Cadillac for 1971 the New Look of Leadership

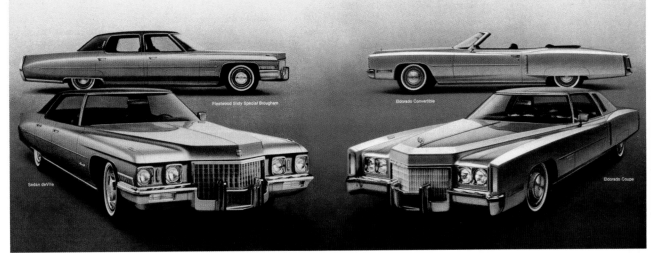

Fleetwood Sixty Special Brougham

Eldorado Convertible

Sedan deVille

Eldorado Coupe

Cadillac, 1970

▶ *Ford Wagons, 1970*

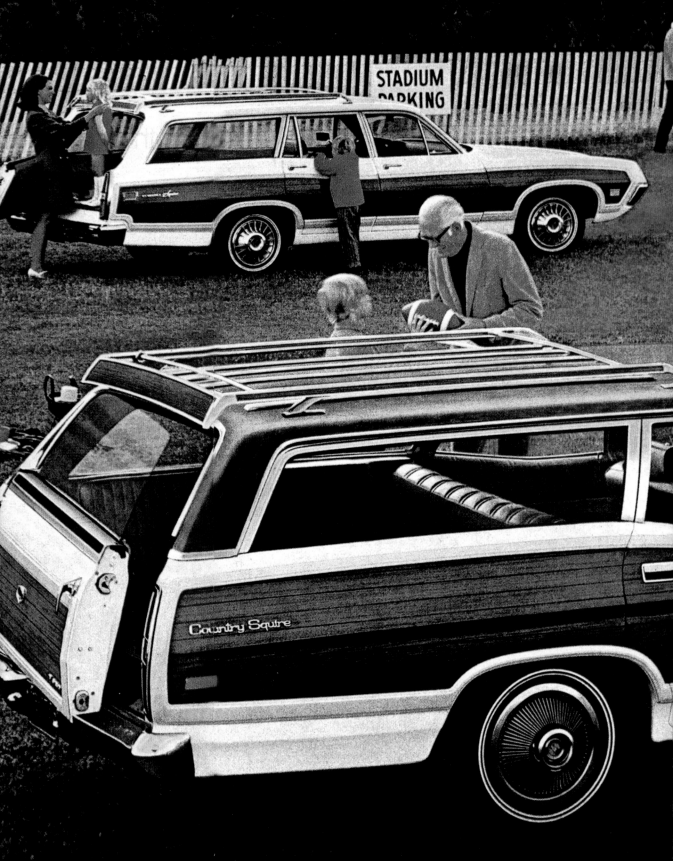

STADIUM PARKING

Country Squire

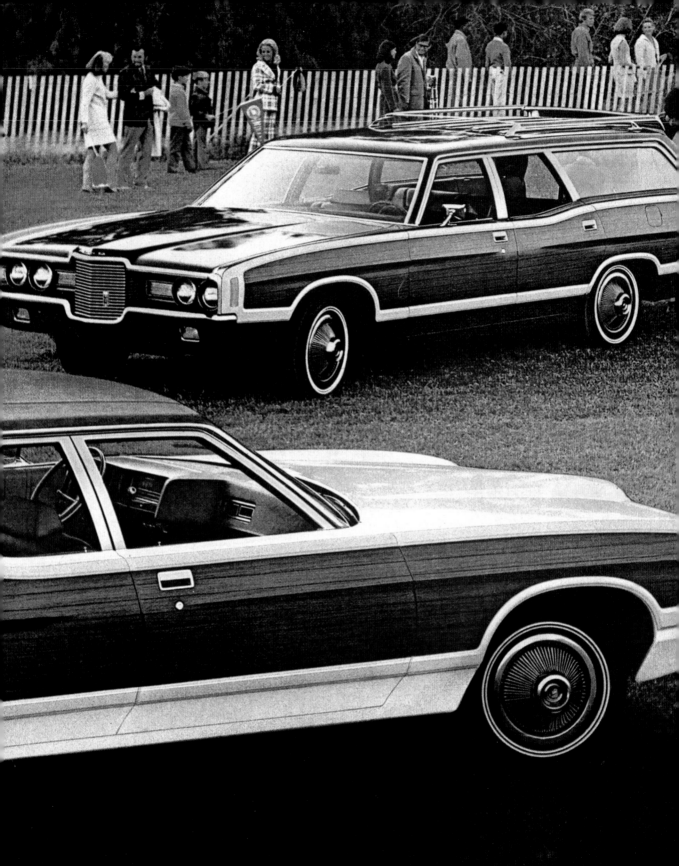

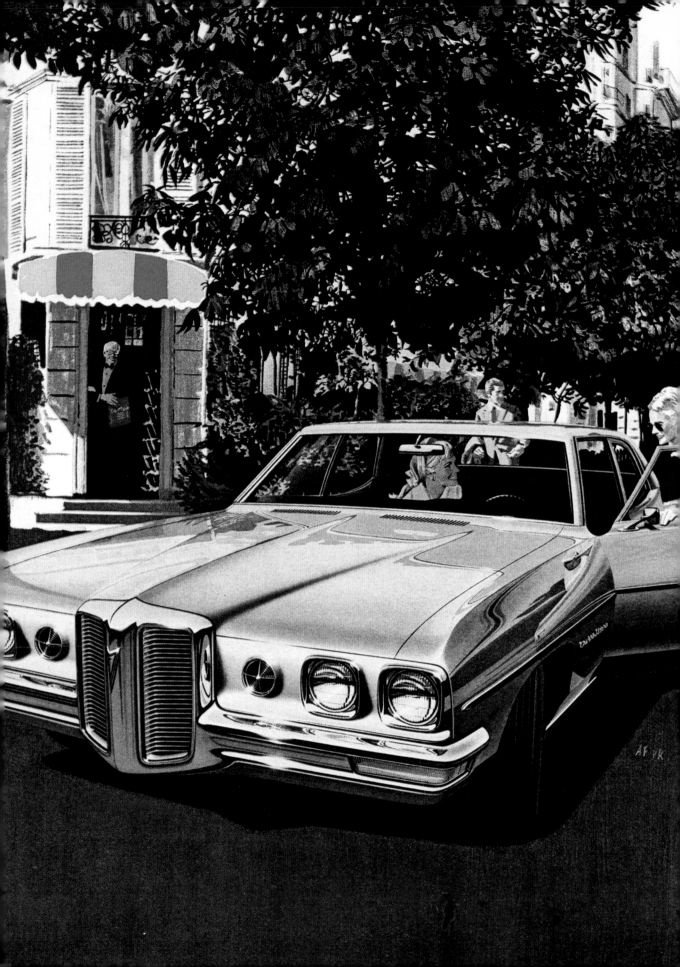

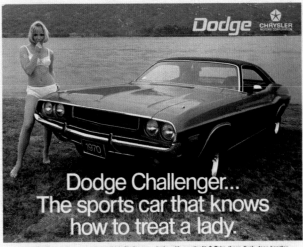

Dodge Challenger, 1970

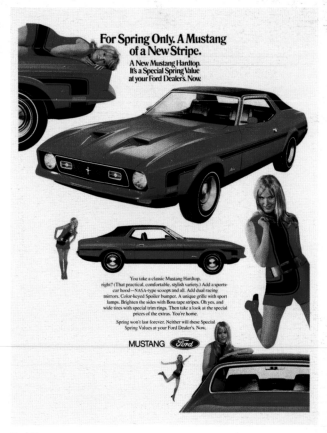

Ford Mustang, 1971

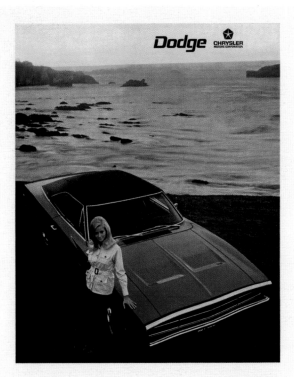

We were talking about Charger, and your name came up.

Pontiac, 1971 ◄ Dodge Charger, 1970

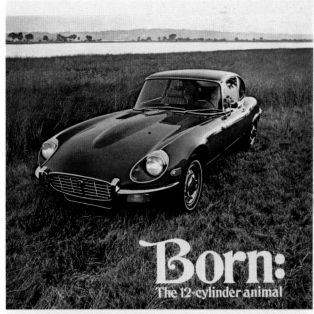

Jaguar V-12, 1971

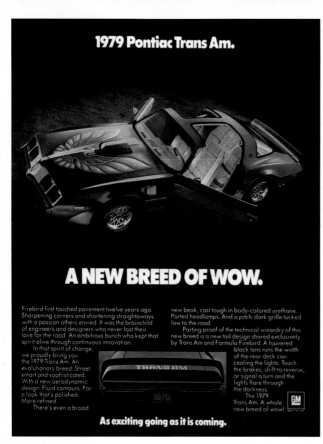

A NEW BREED OF WOW.

1979 Pontiac Trans Am.

Firebird first touched pavement twelve years ago. Sharpening corners and shortening straightaways with a passion others envied. It was the brainchild of engineers and designers who never lost their love for the road. An ambitious bunch who kept that spirit alive through continuous innovation.

In that spirit of change, we proudly bring you the 1979 Trans Am. An evolutionary breed. Street smart and sophisticated. With a new aerodynamic design. Fluid contours. For a look that's polished. More refined.

There's even a broad new beak, cast tough in body-colored urethane. Ported headlamps. And a pitch-dark grille tucked low to the road.

Parting proof of the technical wizardry of this new breed is a new tail design shared exclusively by Trans Am and Formula Firebird. A louvered black lens runs the width of the rear deck concealing the lights. Touch the brakes, shift to reverse, or signal a turn and the lights flare through the darkness.

The 1979 Trans Am. A whole new breed of wow!

As exciting going as it is coming.

GM

Pontiac Trans Am, 1979

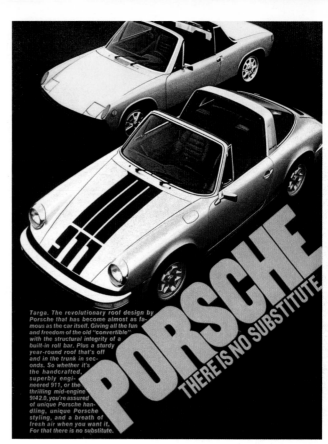

Targa. The revolutionary roof design by Porsche that has become almost as famous as the car itself. Giving all the fun and freedom of the old "convertible" with the structural integrity of a built-in roll bar. Plus a sturdy year-round roof that's off and in the trunk in seconds. So whether it's the handcrafted, superbly engineered 911, or the thrilling mid-engine 914/2.0, you're assured of unique Porsche handling, unique Porsche styling, and a breath of fresh air when you want it. For that there is no substitute.

PORSCHE
THERE IS NO SUBSTITUTE

Porsche, 1974

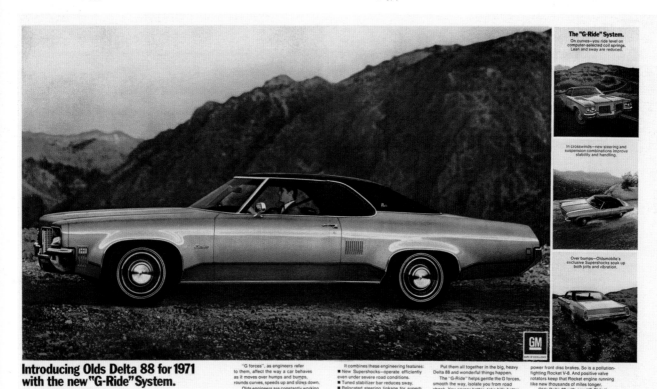

The "G-Ride" System.

On curves—you ride level on computer-selected coil springs. Lean and sway are reduced.

In crosswinds—new steering and suspension combinations improve stability and handling.

Over bumps—Oldsmobile's exclusive Supershocks soak up both jolts and vibration.

GM

Introducing Olds Delta 88 for 1971 with the new "G-Ride" System.

"G forces", as engineers refer to them, affect the way a car behaves as it moves over humps and bumps, rounds curves, speeds up and slows down.

Olds engineers are constantly working to reduce the effect of these forces on cars so that drivers and passengers get a smoother, more balanced ride.

For 1971, a new ride system has been developed for the Delta 88. It's called the "G-Ride" System.

It combines these engineering features:
■ New Supershocks—operate efficiently even under severe road conditions.
■ Tuned stabilizer bar reduces sway.
■ Relocated steering linkage for superb straight-line stability.
■ Full-foam front seat soaks up shock.
■ Larger rear control arm bushings isolate you better from road impact.
■ Improved spring rates for a constantly comfortable ride.

Put them all together in the big, heavy Delta 88 and wonderful things happen.

The "G-Ride" helps gentle the G forces, smooth the way, isolate you from road shock. You corner better, take hills better, handle better in stiff crosswinds. You feel comfortable, whatever the road.

Delta 88 for 1971. Longer and more graceful outside. Roomier and more elegant inside. More car in every way. Power steering is standard. So are

power front disc brakes. So is a pollution-fighting Rocket V-8. And positive valve rotators keep that Rocket engine running like new thousands of miles longer.

Olds Delta 88 with new "G-Ride." You have to drive it to believe it.

Oldsmobile
ALWAYS A STEP AHEAD

Oldsmobile Delta 88, 1970

► *Chrysler, 1970*

$3,986.65.*

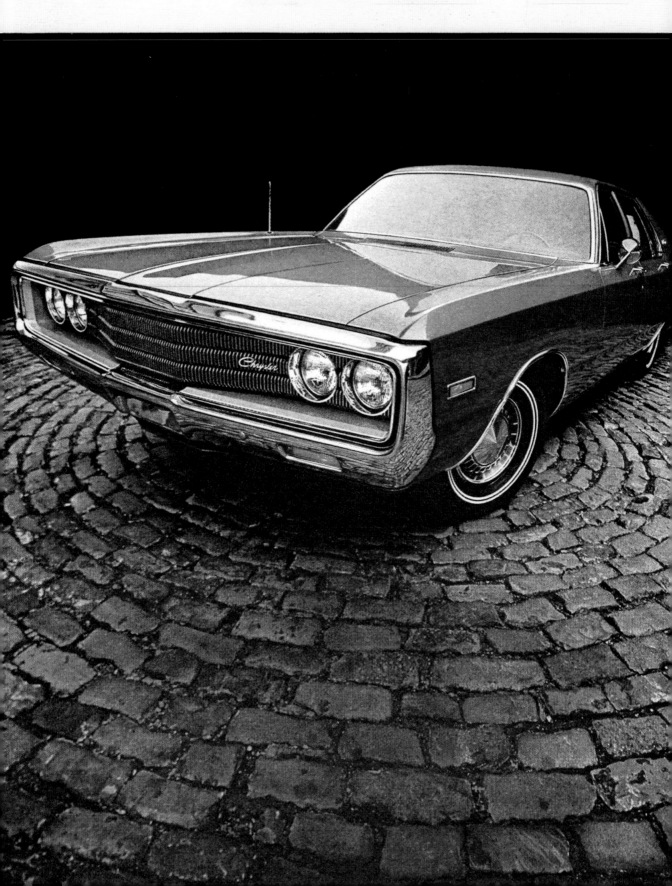

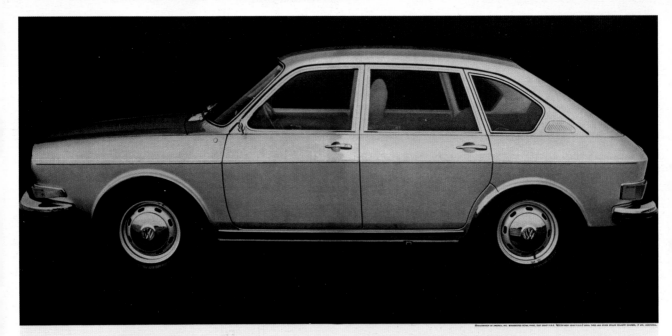

Finally. A big car as good as a Volkswagen.

Have you noticed how everyone's trying to build a small car as good as a Volkswagen? Well, we think it's time someone built a big car as good as a Volkswagen.

So we did. And there it is.

The 411 Volkswagen 4-Door sedan. The biggest VW sedan you've ever seen. And the first VW with four doors.

So now that we've told you what our big surprise is, we'll tell you what it isn't.

The 411 is not a big Beetle.

Because it was built from the ground up to be a different kind of Volkswagen.

With all the comfort and styling of a big car.

And the 411 is not just another big car that eats gas and hogs parking spaces.

So what kind of automobile is it?

It's a big car with plenty of power. Because we put the most powerful air-cooled engine we've ever built in back.

But it still goes about 22 miles on a gallon.

It's a big car that's as nimble as many small cars. But doesn't need power steering.

It's a big car with plenty of room inside.

But it's only a foot and a half longer than our Beetle outside.

It's a big car with a lot of extras you don't pay extra for:

Like an automatic transmission. Radial tires. Front disc brakes. Reclining bucket seats. Rear-window defogger. Electronic fuel injection. Metallic finish. Undercoating. And more.

Finally, it's a big car just as reliable and sturdy as our little car.

Because since 1965, we've been designing, building and testing the 411 VW 4-Door.

And for the past two years it's been driven millions of miles all over Europe and Africa. Under every road condition imaginable. By thousands of owners.

Now it's here in America. For only $2999.*

So now, after all these years, you can drive a big car as good as our little car.

And now everyone else can start all over again.

Trying to build a big car as good as our big car.

Volkswagen, 1971

We do our thing.

The funny thing is, we didn't even know we had a "thing".

We've been perfecting one car for 25 years, steering clear of the idiocy of annual model changes.

Our only worry has been how to make the VW work better, not look different.

And we haven't done badly at all. The 1970 VW is faster and quieter with a longer-lasting engine than any other beetle.

But you still need a scorecard to tell the '70 from other years. Or any year from any other year.

Nobody in the world makes and serv-ices a car as well as we do. Because no-body's been doing it as long as we have on one model.

We still use old-fashioned words like "nifty," "peachy" and "swell".

And we stick to old-fashioned ideas like craftsmanship and ded-ication and skill.

You do yours.

Then, for $1839*, our thing becomes your thing. And what happens is wild.

People treat VWs like something else.

They polish them, scrub them, stripe them and flower them in very far-out ways.

Why? Why mostly on Volkswagens?

We think it's affection, pure and simple.

A VW is a new member of the family who happens to live in the garage.

And when a VW moves in, people flip out.

Driving a VW, we are told, is a groove.

You don't get zapped with freaky running costs. Or zonked with kinky maintenance bills. Or clobbered with crazy depreciation.

We've built the VW durably enough to withstand heat, cold, flood, snow, sand, mud.

Yet it's durable enough to withstand a whole new generation.

Maybe you thought we were in a rut. When all the time we were really in the groove.

Volkswagen, 1970

▶ *American Motors Gremlin, 1970* ▶▶ *Chevrolet Impala, 1972*

If you can afford a car you can afford two Gremlins.

Until April 1, 1970, only an imported economy car could make that statement.

Then American Motors introduced the Gremlin. And America had a car priced to compete with the imports. The two-passenger Gremlin lists for $1,879[1], the four-passenger for $1,959[1].

The Gremlin gets the best mileage of any car made in America. It goes about 500 miles on a tank of gas. It normally goes 6,000 miles between oil changes, 24,000 between lube jobs.

From bumper to bumper, it's just 2½ inches longer than a Volkswagen. Yet its turning circle is 3 feet less than VW's. Which makes the Gremlin about the easiest car in the world to park and handle.

For a car this size, the Gremlin does surprisingly well on expressways. It is 10 inches wider, 7 inches lower and 765 pounds heavier than a VW, which means a smoother more stable ride. And its 128 hp engine goes from 0 to 60 in 15.3 seconds.

Aside from all these practical advantages, the Gremlin gives you something no imported economy car could ever offer.

The fun of driving the new American car.

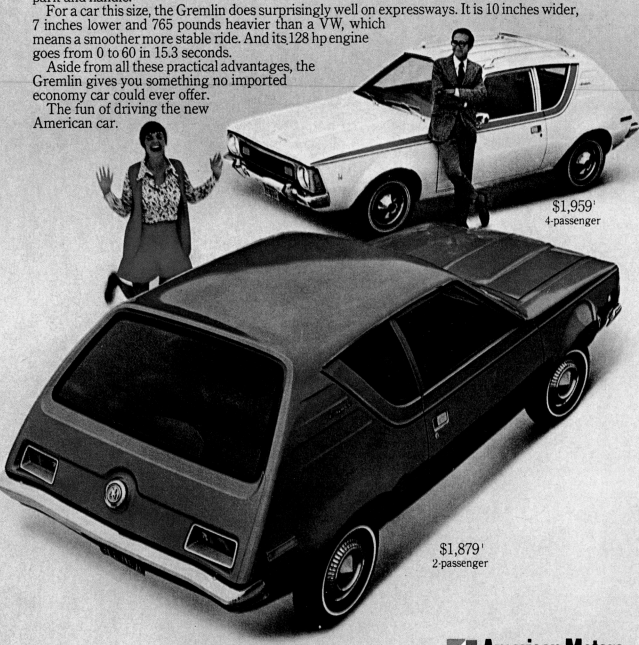

$1,959[1]
4-passenger

$1,879[1]
2-passenger

◣ **American Motors**

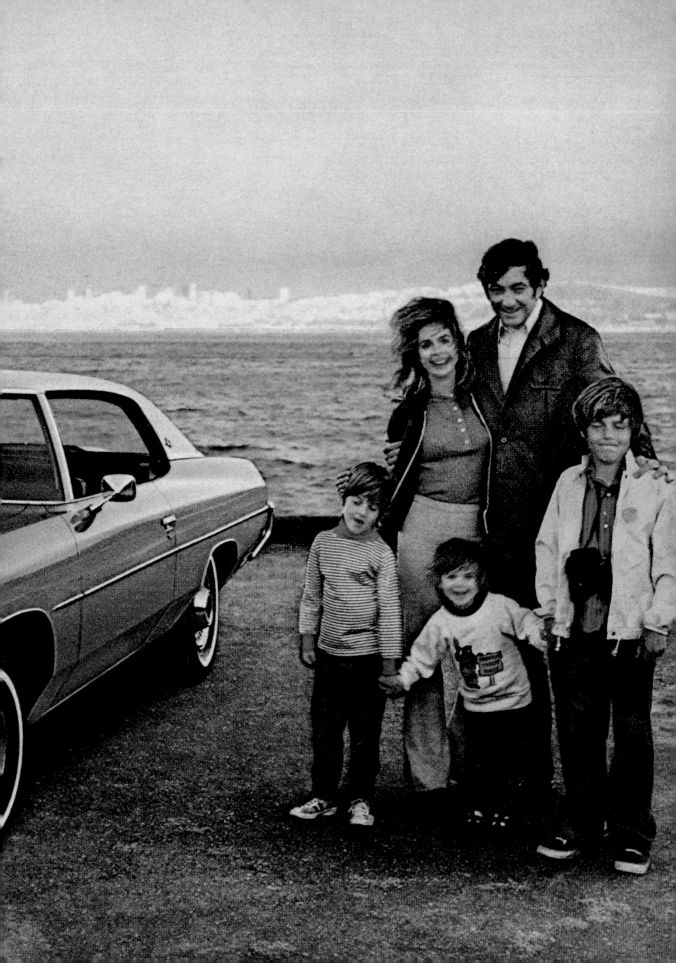

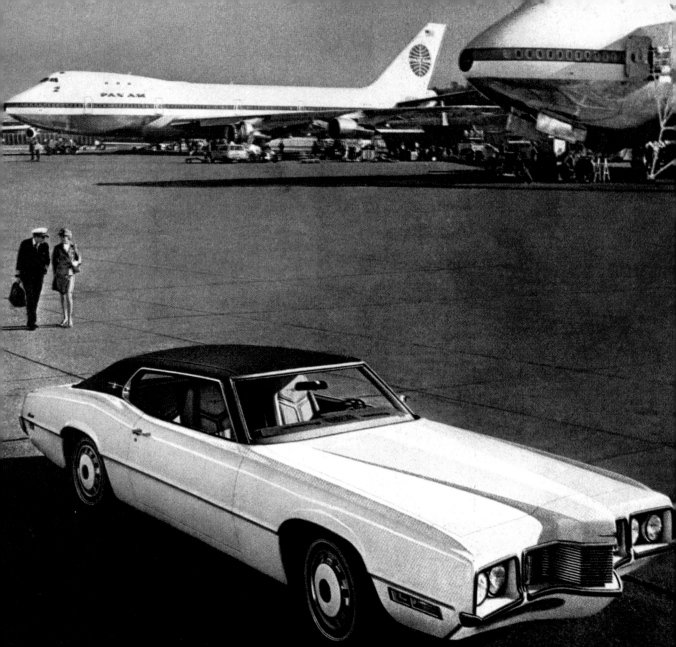

FOR 1970:
A NEW FLIGHT
OF BIRDS

Soaring into the '70's far ahead of the rest…
1970 Thunderbird. With dramatic new front-
end styling, shaped to slice the wind.
Longer, lower and wider for '70. Yet, still uniquely
Thunderbird. With its impressive list of standard
luxury features you'd pay extra for in other
cars. Options other cars don't even offer. And
standards of quality most others only aspire to.
Choose from three distinctive models.
The New Flight of Birds is ready for take-off.

Above: Pan Am's Boeing 747 Jet and the 1970 Thunderbird
2-Door Landau with Special Brougham interior.

THUNDERBIRD

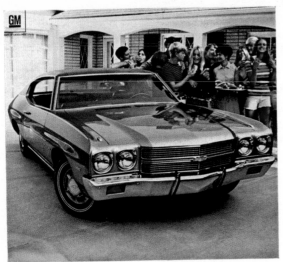

1970 Chevelle Malibu. We built it tough.

New steel guard beams inside the sides. New finned drums on the rear brakes. New bias belted ply tires.

We added new authority. Bigger standard six (155-hp).

Engine choices up to a 330-hp Turbo-Jet 400 V8.

Wider stance.

An advanced body mounting system.

Obviously, we built a looker. Long hood. Bold new grille. Clean lines.

Inside, many upholstery choices. Carpeted floors color-keyed to match. New cockpit-styled instrument panel.

Talk to your Chevrolet dealer.

Putting you first, keeps us first.

CHEVROLET **On The Move.**

We built more car into the car.

Chevelle Malibu, 1970

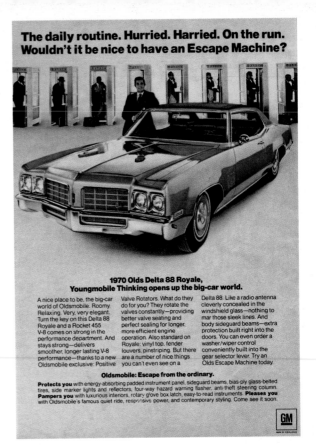

The daily routine. Hurried. Harried. On the run. Wouldn't it be nice to have an Escape Machine?

**1970 Olds Delta 88 Royale,
Youngmobile Thinking opens up the big-car world.**

A nice place to be, the big-car world of Oldsmobile. Roomy. Relaxing. Very, very elegant. Turn the key on this Delta 88 Royale and a Rocket 455 V-8 comes on strong in the performance department. And stays strong—delivers smoother, longer lasting V-8 performance—thanks to a new Oldsmobile exclusive: Positive Valve Rotators. What do they do for you? They rotate the valves constantly—providing better valve seating and perfect sealing for longer, more efficient engine operation. Also standard on Royale: vinyl top, fender louvers, pinstriping. But there are a number of nice things you can't even see on a Delta 88. Like a radio antenna cleverly concealed in the windshield glass—nothing to mar those sleek lines. And body sideguard beams—extra protection built right into the doors. You can even order a washer/wiper control conveniently built into the gear selector lever. Try an Olds Escape Machine today.

Oldsmobile: Escape from the ordinary.

Protects you with energy-absorbing padded instrument panel, sideguard beams, bias-ply glass-belted tires, side marker lights and reflectors, four-way hazard warning flasher, anti-theft steering column. **Pampers you** with luxurious interiors, rotary glove box latch, easy-to-read instruments. **Pleases you** with Oldsmobile's famous quiet ride, responsive power, and contemporary styling. Come see it soon.

Oldsmobile Delta 88, 1970

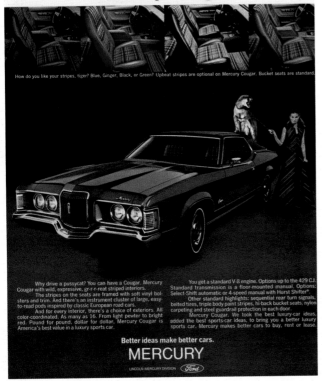

Stripes bring out the tiger in Cougar.
Mercury Cougar.

How do you like your stripes, tiger? Blue, Ginger, Black, or Green? Upbeat stripes are optional on Mercury Cougar. Bucket seats are standard.

Why drive a pussycat? You can have a Cougar. Mercury Cougar with wild, expressive, gr-r-r-reat striped interiors.

The stripes on the seats are framed with soft vinyl bolsters and trim. And there's an instrument cluster of large, easy-to-read pods inspired by classic European road cars.

And for every interior, there's a choice of exteriors. All color-coordinated. As many as 16. From light pewter to bright red. Pound for pound, dollar for dollar, Mercury Cougar is America's best value in a luxury sports car.

You get a standard V-8 engine. Options up to the 429 CJ. Standard transmission is a floor-mounted manual. Options: Select-Shift automatic or 4-speed manual with Hurst Shifter®.

Other standard highlights: sequential rear turn signals, belted tires, triple body paint stripes, hi-back bucket seats, nylon carpeting and steel guardrail protection in each door.

Mercury Cougar. We took the best luxury-car ideas, added the best sports-car ideas, to bring you a better luxury sports car. Mercury makes better cars to buy, rent or lease.

Better ideas make better cars.

MERCURY

LINCOLN-MERCURY DIVISION Ford

Ford Thunderbird, 1970 ◄ *Mercury Cougar, 1971*

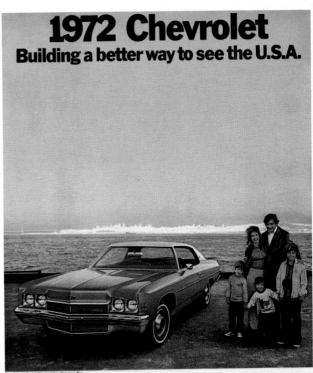

1972 Chevrolet
Building a better way to see the U.S.A.

Impala Custom Coupe at San Francisco Bay.

Impala for 1972: It can put 1,000 miles between you and home before you feel it.

Sometimes you get an itch. An itch to get out. An urge to handle freshly minted roadmaps and feel strange pavement.

Scratch that itch and you rediscover what it was you loved most about driving. It remains to be discovered what car you'd most love to drive.

A 1972 Impala? We'd be pleased. But then, so would you.

You'd take comfort in Impala's quiet. Its roominess. Its Full Coil-spring ride. You'd take it easy. With built-ins like power steering, power front disc brakes.

You'd take a lot with you in Impala. Including lots of pride. Yours and ours.

Impala is still the nation's favorite way to get away. We announce it proudly. Because we build it that way.

Chevrolet Impala, 1972

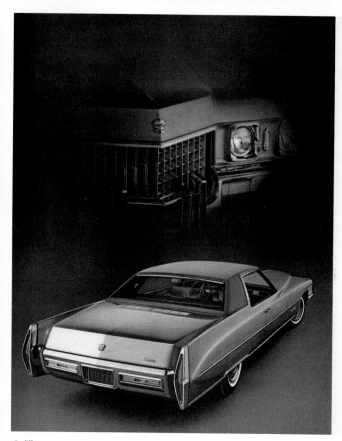

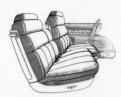

Your second impression will be even greater than your first.

Even though you might already be impressed by Cadillac's remarkable new beauty, you can't fully appreciate its extraordinary newness until you have been in the driver's seat.

You immediately begin to sense the uniqueness of this Cadillac when you place yourself behind the wheel. You'll find entry has been made remarkably easy, thanks to its new door-sill design. The richly upholstered lower profile seats offer new, contoured comfort that will delight and surprise even the most loyal of Cadillac owners.

A completely redesigned instrument panel shows proper concern for you and your front-seat companion. The panel's many controls are readily at hand, and gauges have been carefully positioned and canted for easy reading.

Turn the key, and Cadillac's renowned V-8 performance stands ready to serve . . . with a smoothness and quiet never before known to the American luxury automobile. That power, incidentally, is delivered just as reliably with the new no-lead, low-lead fuels. And, as you take to the highway, you are gently reminded that a number of power assists are at your disposal: variable-ratio power steering, pioneered by Cadillac; power disc brakes at the front wheels; the incomparable smoothness of Turbo Hydra-matic transmission and the pleasant convenience of power windows. All are standard equipment, as you might expect of Cadillac.

To make your driving even more enjoyable, Cadillac offers a Dual Comfort front seat (standard on the Sixty Special Brougham and available on

Shown opposite is the 1971 Coupe deVille.

DeVille models) which provides individual adjustment for both you and your passenger. There is Automatic Climate Control, a highly sophisticated and reliable heating and air conditioning system that controls interior comfort with the simple setting of a dial—and keeps it that way until ordered otherwise. There is Automatic Cruise Control which enables you to preselect your road speed with the touch of a fingertip.

Available, also, is Cadillac's marvelous selection of radios, including this year, a combined AM/FM pushbutton stereo system with eight-track cartridge—an instrument capable of providing sound of amazing tone and fidelity. And, there is a new lamp-

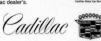

monitoring system to remind you that driving lights are in working condition, as well as to warn you of the fluid level in your windshield washer reservoir.

The 1971 Cadillac . . . by any standard the finest possible example of the automaker's art.

Why not discover for yourself why Cadillac is the world's finest automobile. Do it today . . . at your authorized Cadillac dealer's.

Cadillac

Cadillac, 1971

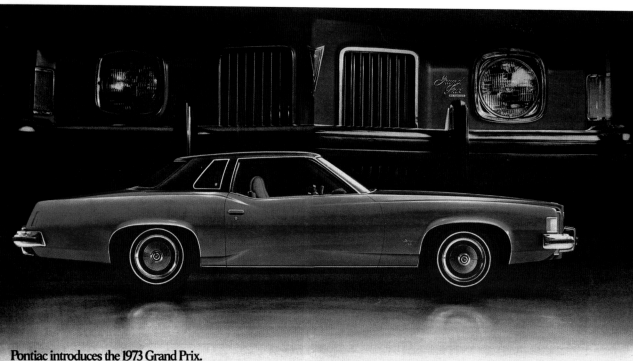

Pontiac introduces the 1973 Grand Prix.

And you thought the days of the great cars were gone forever.

Stutz...Bugatti...Duesenberg...they're all museum pieces now. But each was great in its own way. Because each was fervently designed around a single principle. Spare nothing, compromise nothing, the driver is all-important.

Frankly, not all cars today are built with the same dedication. The 1973 Grand Prix is an honest contender.

Its body is new. But we've retained the classic look.

And it performs with exceptional toughness.

The instrument panel, doors and console are accented with genuine African crossfire mahogany.

The front bucket seats have a totally new design. With deep contours for supreme comfort.

Small points, perhaps. But indicative of our feeling for Grand Prix...and Grand Prix owners.

There are imitators, of course. There always will be. But there's only one Grand Prix. We build it because we understand the pure pleasure one can derive from an extraordinary automobile.

Now the days of the great cars will live for you.

The Wide-Track people have a way with cars.

Pontiac Grand Prix, 1973

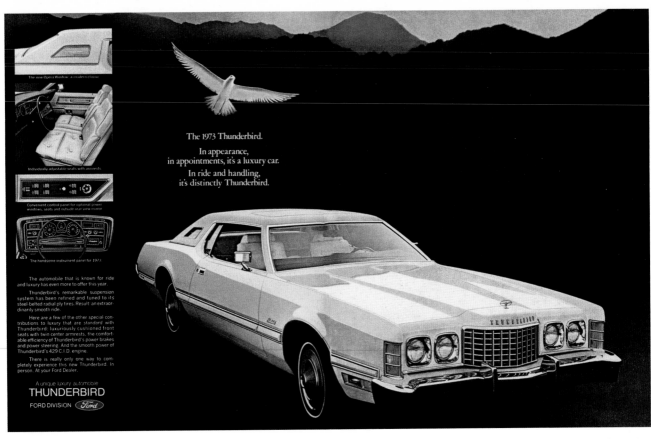

The 1973 Thunderbird.
In appearance,
in appointments, it's a luxury car.
In ride and handling,
it's distinctly Thunderbird.

The automobile that is known for ride
and luxury has even more to offer this year.

Thunderbird's remarkable suspension
system has been refined and tuned to its
steel-belted radial ply tires. Result: an extraor-
dinarily smooth ride.

Here are a few of the other special con-
tributions to luxury that are standard with
Thunderbird: luxuriously cushioned front
seats with twin center armrests, the comfort-
able efficiency of Thunderbird's power brakes
and power steering. And the smooth power of
Thunderbird's 429 C.I.D. engine.

There is really only one way to com-
pletely experience this new Thunderbird. In
person. At your Ford Dealer.

A unique luxury automobile
THUNDERBIRD
FORD DIVISION *Ford*

Ford Thunderbird, 1973

Mercury's ride rated better than two of the world's most expensive luxury cars.

Official results of blindfold tests show 57 people picked Mercury to 33 for a $16,000 limousine. 59 favored Mercury to 31 for a $26,000 European touring car.

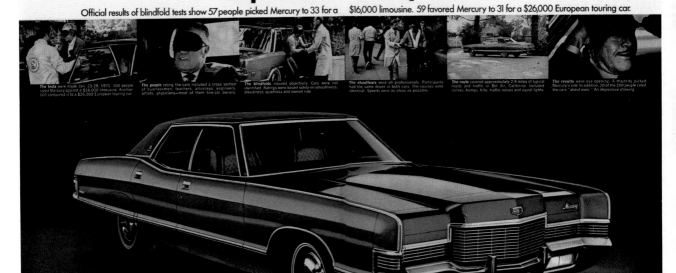

Write for Official Test Report
The complete document detailing test
procedures, names of participants and
results is available. Write: Nationwide
Consumer Testing Institute, P.O. Box
34235, Washington, D.C. 20034.

1. Mercury Marquis starts with a ride that's superior to some of the world's most prestigious cars. That's not just a claim. It's now part of the official record. Tests conducted and cer-tified accurate by the Nationwide Consumer Testing Institute.

2. Then adds the best styling ideas from the luxury class. The elegantly textured grille set off by concealed headlamps. The imposing powerdome hood. The long unbroken sweep afforded by fender skirts. And the Brougham's chrome-edged vinyl roof.

3. Result: a better medium-priced car. The Marquis Brougham (shown above) has many features: 429 cu. in. V-8, automatic transmission, power steering, power brakes, power windows. All standard. Mercury makes better cars to buy, rent or lease.

Better ideas make better cars.
MERCURY
LINCOLN-MERCURY DIVISION *Ford*

A better idea
for safety:
Buckle up!

Mercury, 1971

"Forward Motion"

© Peter Max Enterprises, Inc.

New Datsun 1200 Sport Coupe.
An original portrait by Peter Max.

The new Datsun 1200 is today's kind of car. It's an economical package of motion and fun that's nice for you...and for the world around you. So when we commissioned its portrait, we went to today's kind of artist — Peter Max — probably the best known artist of his generation, a creative genius who made colorful visions an exciting part of everyday life.

The new Datsun 1200 Sport Coupe gave him a subject that's exciting on several levels. For the ecology minded, it's a car that doesn't cost much money, doesn't take up much space and gets around 30 miles out of every gallon of gasoline. At the same time it has quick handling and spirited performance. Finally, it comes with all the niceties you could want — fully reclining bucket seats, safety front disc brakes, flow-through ventilation — and a few you didn't expect — a fold-down rear seat storage area, whitewalls and tinted glass, for instance. Peter Max has captured the spirit of our 1200, a Datsun Original. Capture it for yourself in real, everyday terms at your Datsun dealer. Drive a Datsun...then decide.

Own a Datsun Original.
From Nissan with Pride

The AMC Gremlin.
More fun than a barrel of gas bills.

The Gremlin is an economical small car with the room, ride and comfort of a bigger car. It's economical because it has an efficient 4-cylinder engine and 4-speed gear box, which manage to be very thrifty and very peppy at the same time.

The Gremlin also comes with a lot of things that make it more fun to drive. 4 on the floor, wide-track handling and easy maneuverability, give the Gremlin quite a sporty feel. And casual Levi seats, racing stripes and slot style wheels give the Gremlin X quite a sporty look to go with it.

You also get AMC's exclusive BUYER PROTECTION PLAN, with the only full 12 month/12,000 mile warranty. That means AMC will fix, or replace free any part, except tires, for 12 months or 12,000 miles whether the part is defective, or just plain wears out under normal use and service.

Discover how much fun, and how economical, driving can be with a perky, practical Gremlin.

Based on EPA estimated ratings, 35 highway, 22 city, 27 combined for the optional 4-cylinder engine with 4-speed manual transmission. Your actual mileage may vary depending on your car's condition, optional equipment, and how and where you drive. California figures lower.

AMC Gremlin
The fun Americans want.
The size America needs.

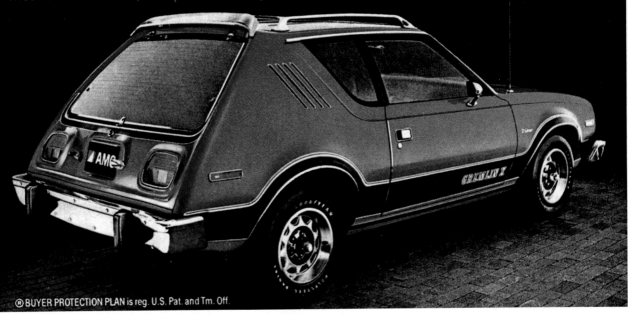

Datsun 1200, 1973 ◄ American Motors Gremlin, 1977

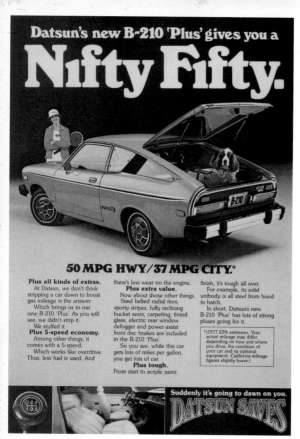

Datsun B-210, 1977

Anatomy of a Gremlin

American Motors Gremlin, 1973

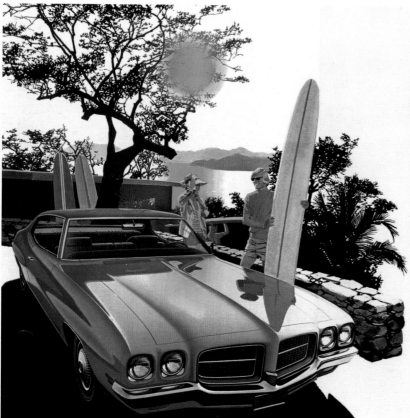

It used to be easy to spot a low-priced car. But now there's a low-priced Pontiac LeMans.

Pure Pontiac!

Pontiac LeMans, 1971

▶ *Volvo, 1974*

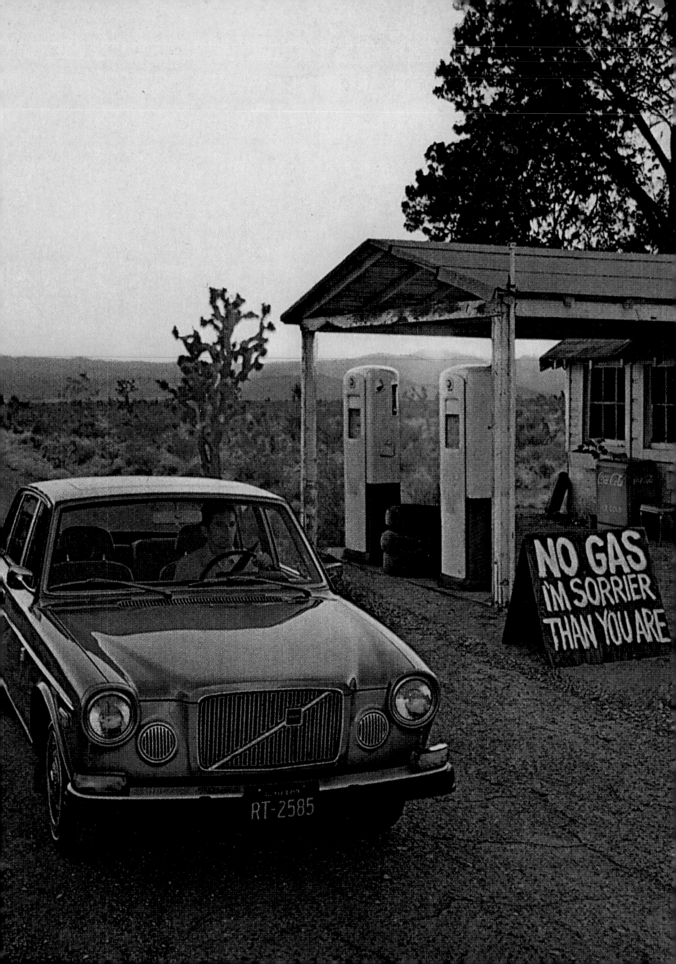

We have a very strong respect for other people's money.

The 1972 mid-size Ford Torino is very strong proof of it.

The new Torino now has a rugged body/frame construction like our quiet Ford LTD.

And a tough new rear suspension.

Torino's even built a little heavier and a little wider this year.

It's so solid on the road, steady on the curves and

smooth on the bumps, we've been calling it the "Easy Handler."

Torino's even bigger inside.

With Torino's standard front disc brakes, you stop. Really Stop!

And you'll like the reassuring positive feel of Torino's new

integral power steering. (It's optional.)

And Ford did all this to make Torino a better value for you...quite possibly more car than you expected.

And quiet because it's a Ford.

Find out at your local Ford Dealer's.

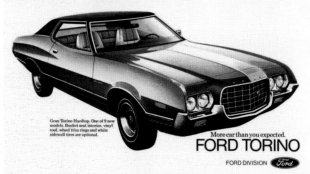

Gran Torino Hardtop. One of 9 new models. Bucket seat interior, vinyl roof, wheel trim rings and white sidewall tires are optional.

More car than you expected.

FORD TORINO

FORD DIVISION *Ford*

Ford Torino, 1972

The answer to low cost transportation is simplicity itself.

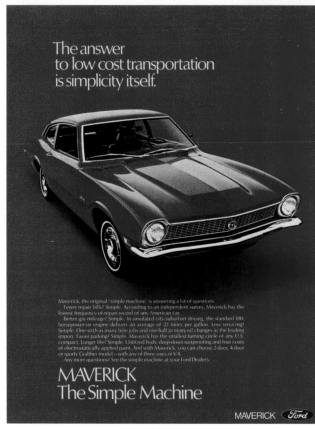

Maverick, the original "simple machine," is answering a lot of questions.

Fewer repair bills? Simple. According to an independent survey, Maverick has the lowest frequency-of-repair record of any American car.

Better gas mileage? Simple. In simulated city/suburban driving, the standard 100-horsepower-six engine delivers an average of 22 miles per gallon. Less servicing? Simple. One-sixth as many lube jobs and one-half as many oil changes as the leading import. Easier parking? Simple. Maverick has the smallest turning circle of any U.S. compact. Longer life? Simple. Unitized body, deep-down rustproofing and four coats of electrostatically applied paint. And with Maverick, you can choose 2-door, 4-door or sporty Grabber model—with any of three sizes of V-8.

Any more questions? See the simple machine at your Ford Dealer's.

MAVERICK
The Simple Machine

MAVERICK *Ford*

Ford Maverick, 1971

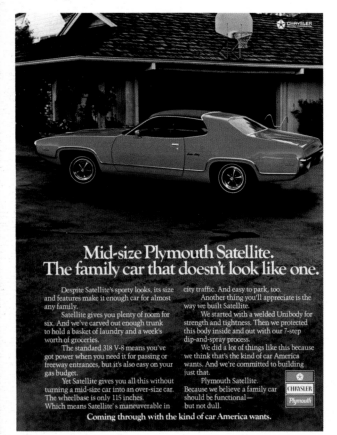

Mid-size Plymouth Satellite.
The family car that doesn't look like one.

Despite Satellite's sporty looks, its size and features make it enough car for almost any family.

Satellite gives you plenty of room for six. And we've carved out enough trunk to hold a basket of laundry and a week's worth of groceries.

The standard 318 V-8 means you've got power when you need it for passing or freeway entrances, but it's also easy on your gas budget.

Yet Satellite gives you all this without turning a mid-size car into an over-size car. The wheelbase is only 115 inches. Which means Satellite's maneuverable in

city traffic. And easy to park, too.

Another thing you'll appreciate is the way we built Satellite.

We started with a welded Unibody for strength and tightness. Then we protected this body inside and out with our 7-step dip-and-spray process.

We did a lot of things like this because we think that's the kind of car America wants. And we're committed to building just that.

Plymouth Satellite. Because we believe a family car should be functional— but not dull.

CHRYSLER *Plymouth*

Coming through with the kind of car America wants.

Plymouth Satellite, 1972

We've come a long way from basic black.

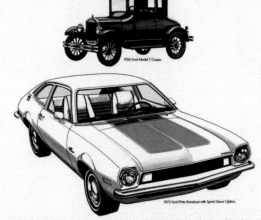

1926 Ford Model T Coupe.

If you find yourself staring whenever you see a Model "T" go by, we don't blame you. It was some kind of car. (Even if it did come mostly in black.) It was simple. It was tough. And if something went wrong, you could probably fix it with a screwdriver and a pair of pliers.

Pinto has many of those same qualities. Which is good to know if you're the kind of person who likes cars, and likes to work on them. Pinto is the kind of car you can work on, without having to be some kind of master mechanic. It's also a car you can work with. There are lots of things you can

add—both from Pinto's list of options and from the specialty equipment people. If you start with the Sprint Option we've shown, you don't even have to start with basic black.

Sprint Decor Group includes the following equipment: Red, White and Blue Exterior Accents. Trim Rings with Color-Keyed Hubcaps. Dual Racing Mirrors. Red, White and Blue Cloth and Vinyl Bucket Seats. Full Carpeting. Deluxe 2-Spoke Steering Wheel. Stars and Stripes Decal. A78 x 13 White Sidewall Tires. Blackout Grille.

When you get back to basics, you get back to Ford.

FORD PINTO
FORD DIVISION *Ford*

Better idea for safety...buckle up!

Ford Pinto, 1972 ▶ *Ford Mustang, 1972* ▶▶ *Volvo, 1971*

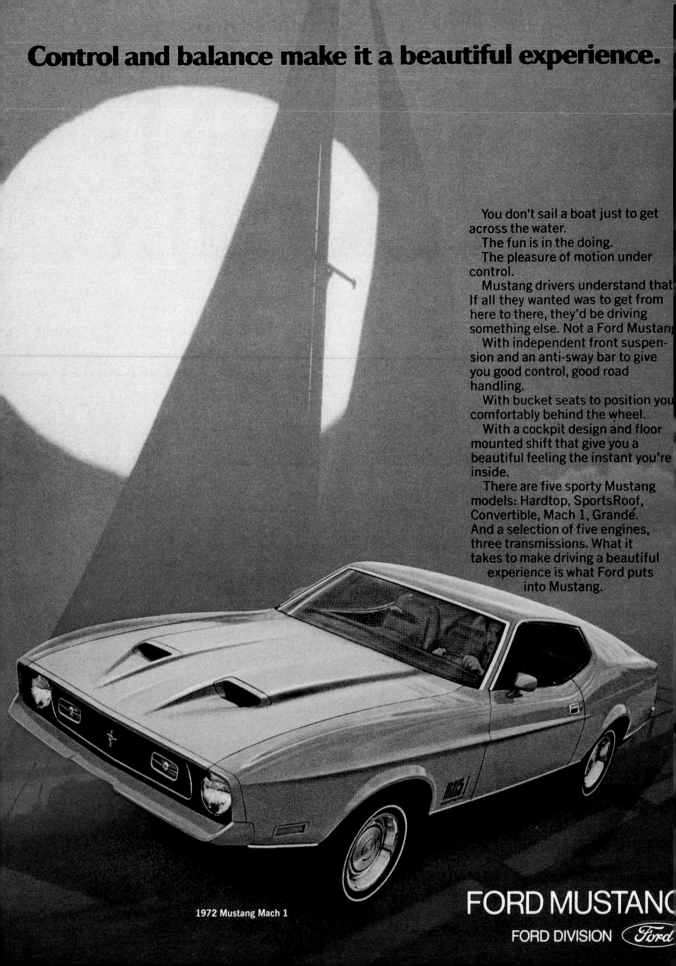

Control and balance make it a beautiful experience.

You don't sail a boat just to get across the water.

The fun is in the doing.

The pleasure of motion under control.

Mustang drivers understand that. If all they wanted was to get from here to there, they'd be driving something else. Not a Ford Mustang.

With independent front suspension and an anti-sway bar to give you good control, good road handling.

With bucket seats to position you comfortably behind the wheel.

With a cockpit design and floor mounted shift that give you a beautiful feeling the instant you're inside.

There are five sporty Mustang models: Hardtop, SportsRoof, Convertible, Mach 1, Grandé. And a selection of five engines, three transmissions. What it takes to make driving a beautiful experience is what Ford puts into Mustang.

1972 Mustang Mach 1

FORD MUSTANG

FORD DIVISION *Ford*

BEAT THE SYSTEM. BUY A VOLVO.

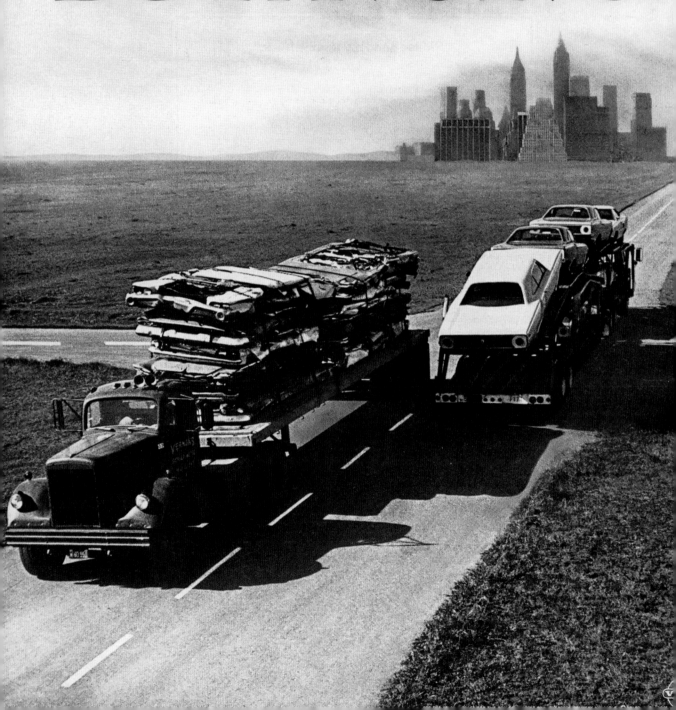

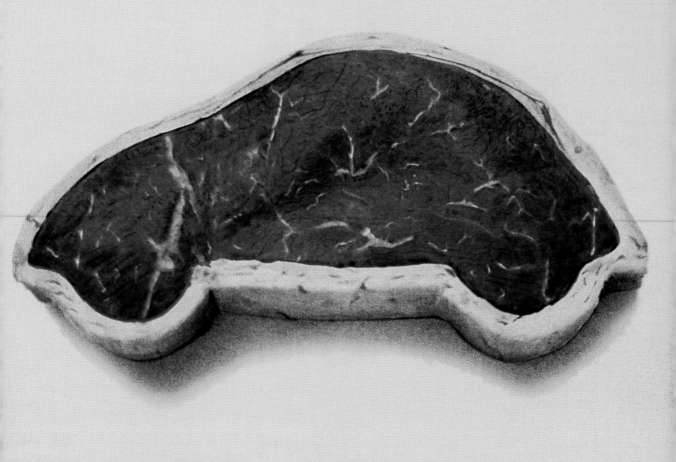

Can you still get prime quality for $1.26 a pound?

A pound of Volkswagen isn't cheap compared to other cars. But what you pay for is the quality. Prime quality.

Just look at what you get for your money:

13 pounds of paint, some of it in places you can't even see. (So you can leave a Volkswagen out overnight and it won't spoil.)

A watertight, airtight, sealed steel bottom that protects against rocks, rain, rust and rot.

Over 1,000 inspections per one Beetle.

1,014 inspectors who are so finicky that they reject parts you could easily ride around with and not even detect there was anything wrong.

Electronic Diagnosis that tells you what's right and wrong with important parts of your car.

A 1600 cc aluminum-magnesium engine that gets 25* miles to a gallon of regular gasoline.

Volkswagen's traditionally high resale value.

Over 22,000 changes and improvements on a car that was well built to begin with.

What with all the care we take in building every single Volkswagen, we'd like to call it a filet mignon of a car. Only one problem. It's too tough.

Few things in life work as well as a Volkswagen.

IN 70030

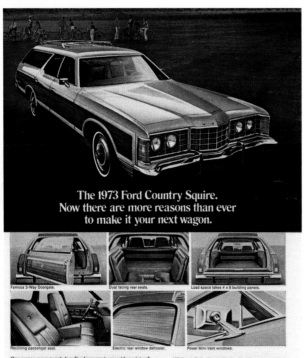

The 1973 Ford Country Squire.
Now there are more reasons than ever to make it your next wagon.

Famous 3-Way Doorgate.

Dual facing rear seats.

Load space takes 4 x 8 building panels.

Reclining passenger seat.

Electric rear window defroster.

Power Mini-Vent windows.

One reason more people buy Ford wagons is our wide variety of features. Like the 3-Way Doorgate that opens out for people and down for cargo, and Ford's dual facing rear seats. Now we've added windshield washer jets mounted on the wiper arms. A spare tire extractor. Optional Power Mini-Vent windows. Ford wagons include the full-size Country Squire (above), mid-size Torinos and little Pintos. All with energy-absorbing bumpers and optional steel-belted radial ply tires tested to give the average driver 40,000 miles of tread life with normal driving. At your Ford Dealer.

LTD Country Squire. Standard features include woodgrain bodyside, tailgate treatment, 3-Way Doorgate, automatic transmission, power steering and brakes. Other equipment shown is optional.

When it comes to wagons, nobody swings like Ford.

FORD WAGONS

FORD DIVISION *Ford*

Ford Wagons, 1973

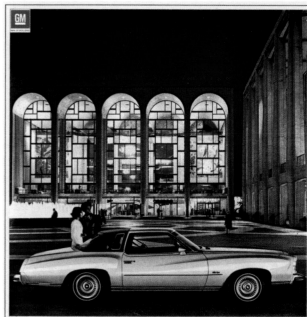

Monte Carlo Landau at Lincoln Center for the Performing Arts, New York City.

A look at Monte Carlo from the other side.

What you see before you, ladies and gentlemen, is a car of obvious elegance and taste, an artfully sculptured automobile designed to draw admiring glances even in fancy surroundings.

But what the picture cannot show is Monte Carlo's other side. The driving side. That aspect of this car's personality which many

people consider even more elegant than the beauty of its lines.

What we're saying is this: Monte Carlo handles with a finesse which will quite likely surprise you. Steel-belted radial tires combine with a radial-tuned suspension and ride stabilizers to make this a remarkably satisfying and enjoyable car to drive.

Variable-ratio power steering and power front disc brakes heighten the pleasure.

We suggest that you visit your Chevrolet dealer, find a worthy stretch of road, and find out once and for all what this stately automobile is all about.

And now, back to the picture. **Chevrolet**

CHEVROLET MAKES SENSE FOR AMERICA.

Chevrolet Monte Carlo, 1974

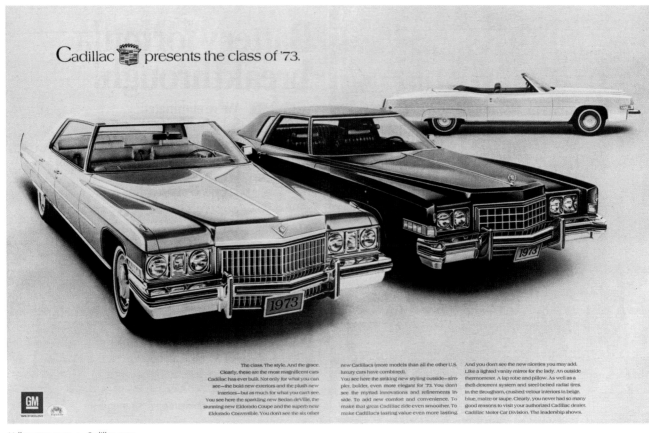

Cadillac presents the class of '73.

The class. The style. And the grace. Clearly, these are the most magnificent cars Cadillac has ever built. Not only for what you can see—the bold new exteriors and the plush new interiors—but as much for what you can't see. You see here the sparkling new Sedan deVille, the stunning new Eldorado Coupe and the superb new Eldorado Convertible. You don't see the six other

new Cadillacs (more models than all the other U.S. luxury cars have combined).

You see here the striking new styling outside—simpler, bolder, even more elegant for '73. You don't see the myriad innovations and refinements inside. To add new comfort and convenience. To make that great Cadillac ride even smoother. To make Cadillac's lasting value even more lasting.

And you don't see the new niceties you may add. Like a lighted vanity mirror for the lady. An outside thermometer. A lap robe and pillow. As well as a theft-deterrent system and steel-belted radial tires. In the brougham, crushed velour interiors in beige, blue, maize or taupe. Clearly, you never had so many good reasons to visit your authorized Cadillac dealer. Cadillac Motor Car Division. The leadership shows.

Volkswagen, 1973 ◄ *Cadillac, 1973*

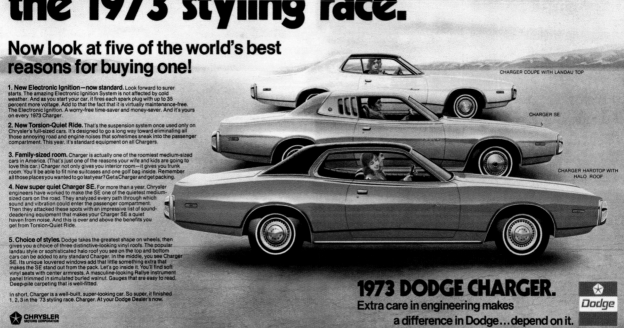

Dodge Charger, 1973

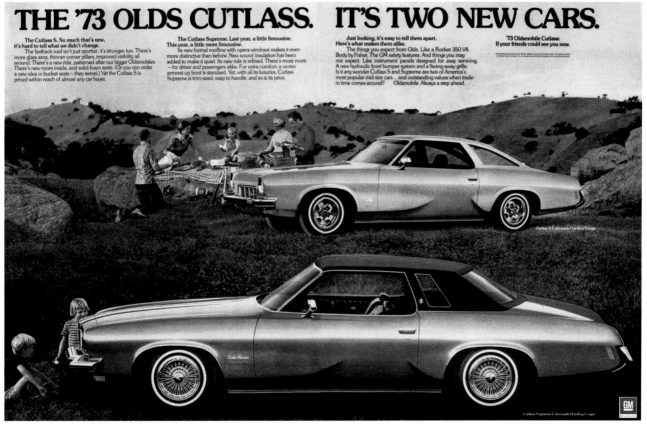

Oldsmobile Cutlass, 1973

Quiet is the sound of a well -made car. 1973 Ford LTD.

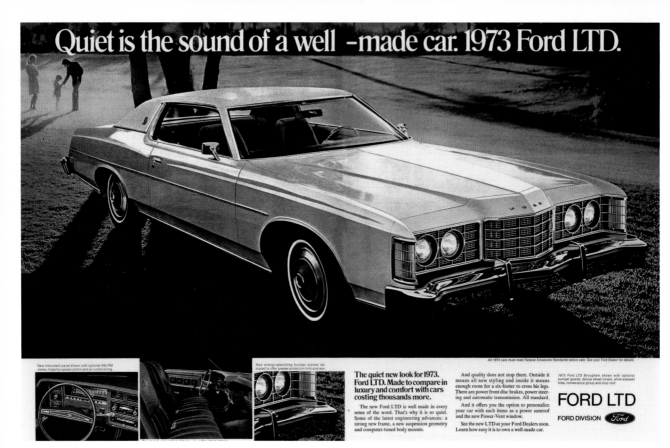

The quiet new look for 1973. Ford LTD. Made to compare in luxury and comfort with cars costing thousands more.

The new Ford LTD is well made in every sense of the word. That's why it is so quiet. Some of the latest engineering advances: a strong new frame, a new suspension geometry and computer-tuned body mounts.

And quality does not stop there. Outside it means all new styling and inside it means enough room for a six-footer to cross his legs. There are power front disc brakes, power steering and automatic transmission. All standard.

And it offers you the option to personalize your car with such items as a power sunroof and the new Power-Vent window.

See the new LTD at your Ford Dealers soon. Learn how easy it is to own a well-made car.

FORD LTD
FORD DIVISION

Ford LTD, 1973

American comfort, European handling. They meet in Monte Carlo.

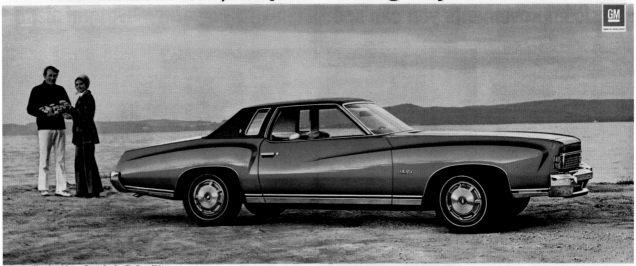

Monte Carlo S Coupe at Sleeping Bear Bay, Glen Haven, Michigan.

Monte Carlo has always been a car unlike any other.

Yet, our '73 Monte Carlo S is even more unique. Its elegance, silence, comfort and handling make the best of two worlds.

Chassis, frame, and suspension geometry were extensively modified and redesigned to achieve special handling characteristics like those found in the great road cars of Europe.

Coach windows, molded full foam seats, rich upholstery and a classic instrument panel reflect Monte Carlo's individuality.

The new flow-through power ventilation system and double-panel roof add to its quietness.

Power front disc brakes, power steering and a big V8 are standard of course.

A power-operated sky roof and swing-out front bucket seats can be added.

We think you'll find Monte Carlo S one of the most superb road cars you've ever driven.

A personal luxury car unto itself. Unlike any other.

Chevrolet

1973 Chevrolet. Building a better way to see the U.S.A.

Chevrolet Monte Carlo, 1973

Cutlass Salon.

Built in the Grand Touring tradition.
from Oldsmobile

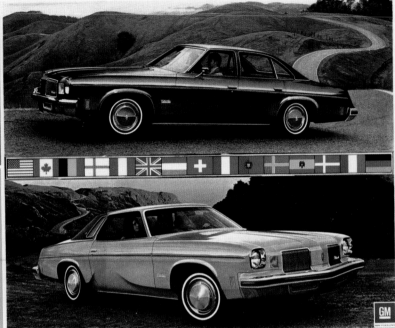

The Grand Touring touches found in this sedan...

can now be found in this coupe.

Last year we created the Cutlass Salon sedan—Oldsmobile's version of a Grand Touring car. For '74, we've added a coupe.

Ever ridden in a real Grand Touring car? It makes you prefer winding side roads to busy freeways. Drive a Cutlass Salon and you'll see. There's a new, lower steering ratio for quicker response. Steel-belted radial tires. And front and rear anti-sway bars.

Now picture the inside of one of those expensive Grand Touring jobs. Contoured lounge seats, right? And they recline, right? So do Salon's. The upholstery is plush ribbed velour. And the console is the kind that makes you want to put nifty things in it.

There's also a Salon idea you won't find in those other cars. An Oldsmobile Rocket V8 teamed with Turbo Hydra-matic.

Oh, yes. Money. Salon doesn't have a Grand Touring price.

Oldsmobile Cutlass Salon, 1973

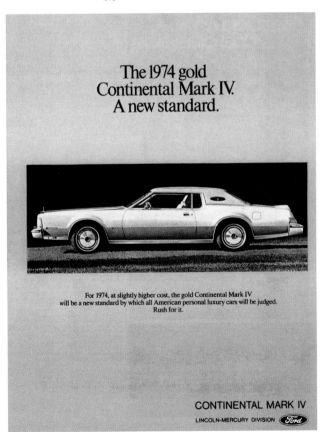

The 1974 gold Continental Mark IV. A new standard.

For 1974, at slightly higher cost, the gold Continental Mark IV will be a new standard by which all American personal luxury cars will be judged. Rush for it.

CONTINENTAL MARK IV

LINCOLN-MERCURY DIVISION · Ford

Lincoln Continental Mark IV, 1974

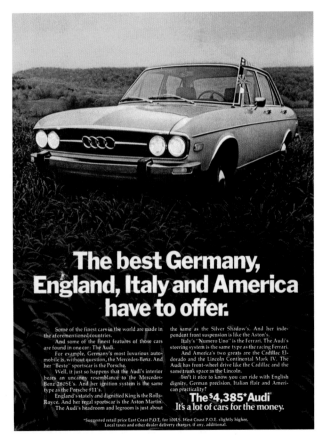

The best Germany, England, Italy and America have to offer.

Some of the finest cars in the world are made in the aforementioned countries.

And some of the finest features of those cars are found in one car: The Audi.

For example, Germany's most luxurious automobile is, without question, the Mercedes-Benz. And her "Beste" sportscar is the Porsche.

Well, it just so happens that the Audi's interior bears an uncanny resemblance to the Mercedes-Benz 280SE's. And her ignition system is the same type as the Porsche 911's.

England's stately and dignified King is the Rolls-Royce. And her regal sportscar is the Aston Martin. The Audi's headroom and legroom is just about the same as the Silver Shadow's. And her independent front suspension is like the Aston's.

Italy's "Numero Uno" is the Ferrari. The Audi's steering system is the same type as the racing Ferrari.

And America's two greats are the Cadillac Eldorado and the Lincoln Continental Mark IV. The Audi has front-wheel drive like the Cadillac and the same trunk space as the Lincoln.

Isn't it nice to know you can ride with English dignity, German precision, Italian flair and American practicality?

The $4,385* Audi
It's a lot of cars for the money.

*Suggested retail price East Coast P.O.E. for 100LS. West Coast P.O.E. slightly higher. Local taxes and other dealer delivery charges, if any, additional.

Audi, 1973

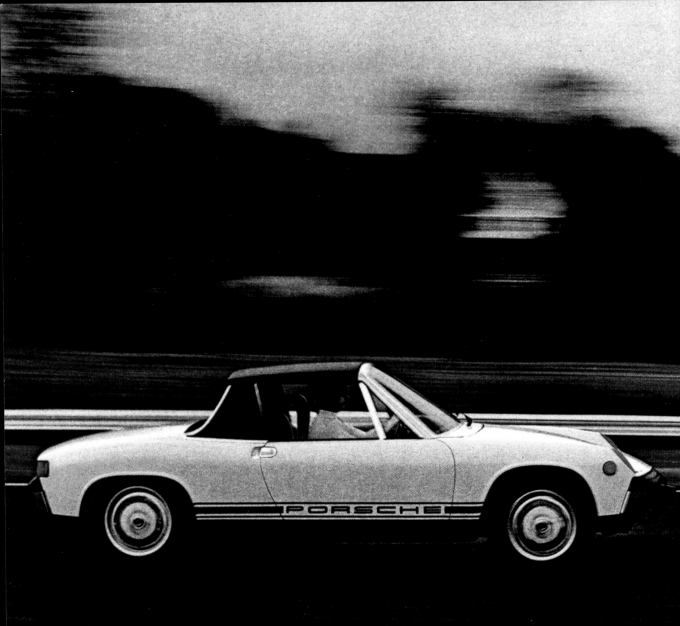

Action is having an electronic fuel-injected 2.0-liter engine take you from 0 to 60 in 11.0 seconds.

Action is stopping on radial tires with 4-wheel disc brakes.

Action is taking a corner with rack-and-pinion steering in a mid-engine car and feeling closer to the road than the white line.

The Action

Action is a 5-speed gearbox.

Action is a light, fiberglass roof you can take off in less than a minute.

Action is sporting a built-in roll bar.

Action is 13 of the wildest colors you've ever seen. From Zambezi Green to Signal Orange.

Action is 29 miles to the gal-

lon and a cruising range of more than 400 miles on one tank of gas.

Action is finally stopping for gas and having all the station attendants wanting to wait on you.

Action is what you get every time you step into a mid-engine Porsche 914.

Porsche

Lotus Esprit, 1977

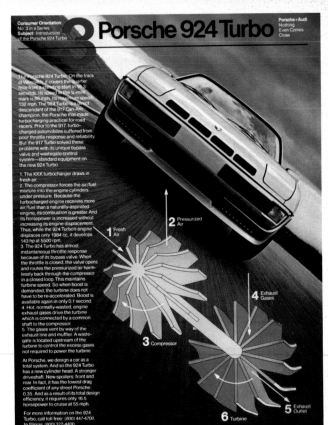

Porsche 924, 1979

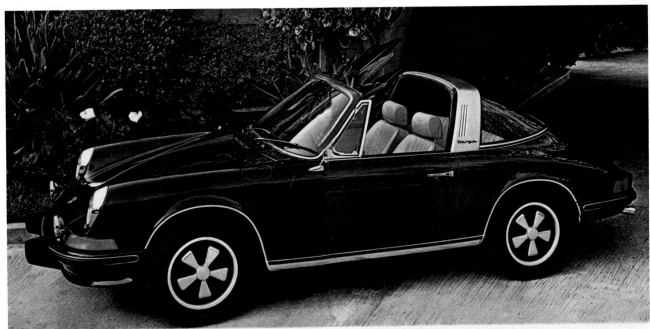

"That's IT"

Just as a great painting is more than canvas and paints, there are some things that go beyond the sum of their parts. The Porsche Targa is such an object.

It is a piece of machinery whose purpose far exceeds transporting you from one point to another. The Targa's goal is to afford the ultimate driving experience. In performance, in engineering, in comfort.

The Targa has come amazingly close to that goal; each year, with subtle improvements, a bit more.

First, consider its superbly thought-out features. It has a built-in roll bar, and a huge fixed rear window. To give the car the practicality of a hardtop coupe. And you the exhilarating experience of a roadster.

It has an aerodynamic shape, to protect you from wind blast. And a rear-engine design that has been steadily improved upon for 25 years.

All controls are meticulously engineered to be functional and logically accessible.

Yet it is the total effect of these innovations that impresses.

With the removable top stored in the trunk, cushioned in luxurious bucket seats, you ride in "Belle Epoque" comfort.

But the grandest feature of the Targa is the experience of driving it.

The handling is quick, correct, precise, because of Porsche's legendary engineering. Putting the driver and car in perfect collaboration. It is almost as if you just "think" where you want the car to go.

The Targa is available in all three 911 models: 911T, 911E, and 911S.

But be warned.

It is very difficult to be humble about owning any Porsche. And if it's a Targa, that's IT.

Porsche 914, 1973 ◄ *Porsche Targa, 1973*

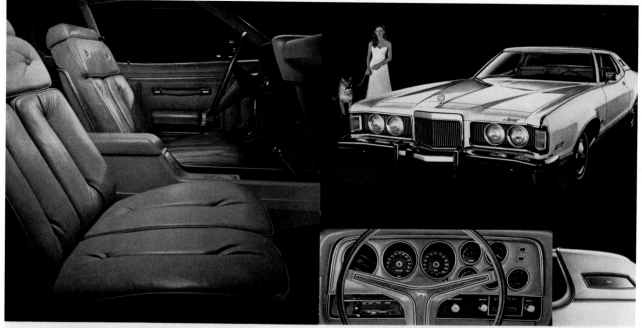

1974 MERCURY COUGAR XR-7

In size, this new breed of Cougar is like Grand Prix and Monte Carlo. In every other way, it's like nobody else's car.

You're looking at the all new Cougar for '74. It's more than a new car. It's moved up one whole class. In fact Cougar is the only new choice among the mid-size personal luxury cars.

There's new styling, inside and out. New dash with tachometer and hooded gauges mounted in deeply padded vinyl. Elegant new opera window. Distinctive new Landau roof. Steel-belted radials. All standard. There's power steering. And front disc brakes, automatic floor shift and bucket seats, also standard. Plus the same type suspension system as Lincoln-Mercury's most expensive luxury car. Other features shown are optional.

And along with Cougar's new size class comes a whole new class of comfort for you. Because we felt this much luxury deserved a little more room.

MERCURY COUGAR

LINCOLN-MERCURY DIVISION

Mercury Cougar, 1974

Rolls-Royce brings back a great name. Silver Wraith II.

The last of the Silver Wraiths was built in 1959. Or so it seemed at the time.

But the richest of Rolls-Royce memories have a way of living on in the newest of Rolls-Royce motor cars. And so it is with the Silver Wraith II of 1977.

The Timeless Pleasure
The long, sleek look of the Silver Wraith II reflects a time gone by.

You can sense it in the graceful lines, the contrasting top, the gleaming bright work, the tasteful craftsmanship and the roomy interior.

And, for the most up-to-date reasons, the Silver Wraith II is a new air of comfort, a new sense of quiet and a new feeling of command.

A new rack-and-pinion steering system makes the Silver Wraith II quick to respond and rewarding to drive, no matter how narrow the road or sudden the curve.

A unique automatic air-conditioning system maintains any temperature you desire at two levels of the interior. And, because the system creates a rarefied atmosphere all your own, its built-in sensors alert you to outside temperatures as well as icy roads.

The Silver Wraith II also offers you the sophistication of an advanced electrical system, the performance of a quiet V-8 engine, the security of a dual braking system and the sensitivity of a self-leveling suspension.

And, to name one of the many other subtle details you'll discover, the electronic odometer will contemplate recording the miles from 000000.0 to 999999.9.

The Priceless Asset
From the distinctive radiator grille to the matching walnut veneers, the Silver Wraith II is built almost entirely by hand.

In tribute to this enduring Rolls-Royce tradition, it is no coincidence that more than half of all the motor cars we have ever built remain very much on the road. And, in return for the purchase price of $49,000,* it is little wonder that a Silver Wraith II speaks so warmly of the past and so surely of the future.

A collection of Rolls-Royce masterpieces is waiting at your nearest Authorized Rolls-Royce Dealership. For further information, call 800-325-6000 and give this ID number: 1000.

*Suggested U.S. Retail Price March 1, 1977. The names "Rolls-Royce" and "Silver Wraith" and the mascot, badge and radiator grille are all Rolls-Royce trademarks.
© Rolls-Royce Motors Inc. 1977.

The heart and soul of a masterpiece

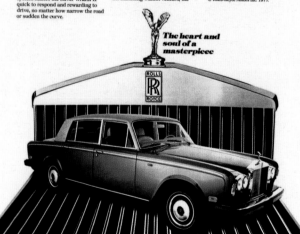

Rolls-Royce, 1977

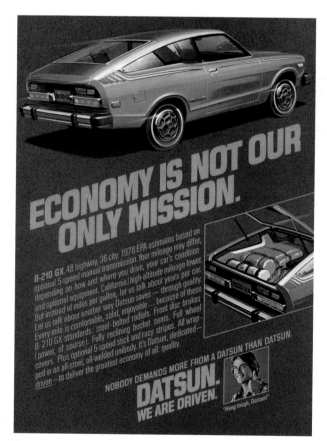

ECONOMY IS NOT OUR ONLY MISSION.

B-210 GX. 48 highway, 36 city. 1978 EPA estimates based on optional 5-speed manual transmission. Your mileage may differ, depending on how and where you drive, your car's condition and optional equipment. California/high-altitude mileage lower.

But instead of miles per gallon, let us talk about years per car. Let us talk about another way Datsun saves — through quality. Every mile is comfortable, solid, enjoyable — because of these B-210 GX standards: steel-belted radials. Front disc brakes (power, of course). Fully reclining bucket seats. Full wheel covers. Plus optional 5-speed stick and racy stripes. All wrapped in an all-steel, all-welded unibody. It's Datsun, dedicated—driven—to deliver the greatest economy of all: quality.

NOBODY DEMANDS MORE FROM A DATSUN THAN DATSUN.

DATSUN. WE ARE DRIVEN.

"Hang tough, Datsun"

Datsun, 1978

▶ *Cadillac, 1975*

Determination has its rewards.

A tradition of building great cars like the 1933 Cadillac 355 Phaeton has its advantages—and rewards—for today's luxury car buyer. First, we stubbornly maintain that a luxury car should be a thing of beauty. This is reflected in all nine Cadillacs—including Eldorado, the only American-built luxury convertible. Then, there's Total Cadillac Value. Because of it, Cadillac resale is traditionally the highest of any U.S. luxury car make…and its repeat ownership the greatest of any U.S. car make. Cadillac. **Then and Now…an American Standard for the World.**

Cadillac '75

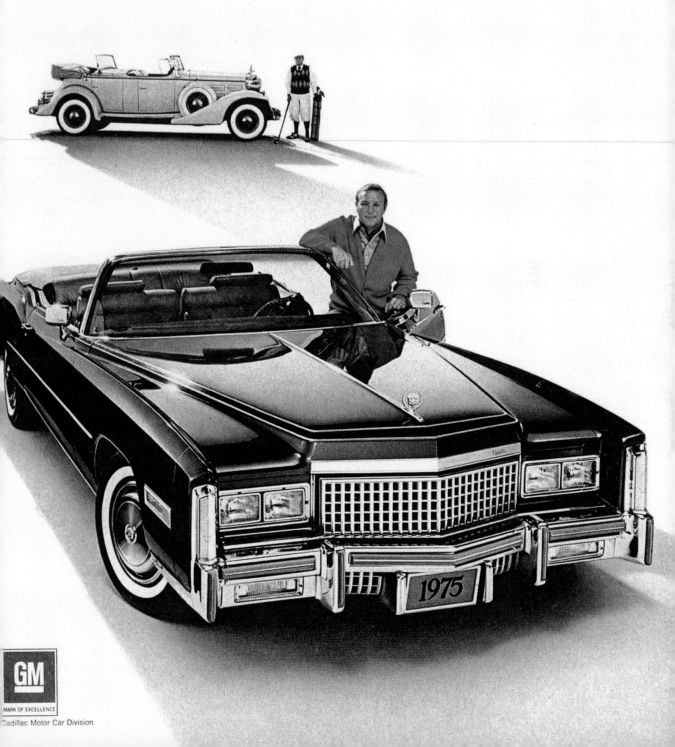

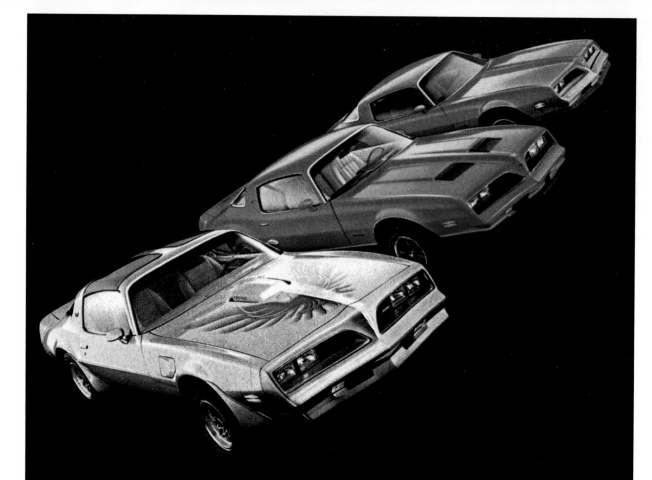

There's a Firebird for every purpose. Except standing still.

Esprit offers luxury that doesn't get in the way of sport. Individually-cushioned buckets of supple vinyl. A rosewood-vinyl accented dash. Plush cut-pile carpet underfoot. Plus an available "Sky Bird" Package with sky blue paint, matching wheels and special trim throughout.

Formula Firebird is for people who are driven by a love of driving. Who are forever inspired by dual simulated air scoops atop a 5.0 litre V-8. Who can appreciate stabilizer bars and steel-belted radials.

Trans Am is the ultimate Firebird. Built to go all the way. An eye-catching, head-turning, heart-wrenching, awe-inspiring legend.

A lot of it has to do with the ominous air extractors, deflectors and air dam. The shrieking bird available for the hood. And the 6.6 litre V-8 underneath.

Even the base Firebird has a purpose. To deliver Firebird's fire at an appealing price.

Firebirds are equipped with GM-built engines produced by various divisions. Your dealer has details. He also has a Firebird for whatever you like to do.

Unless you like standing still.

Pontiac ▼ The Mark of Great Cars

1978 ▼ Pontiac's best year yet!

Pontiac Firebird, 1978

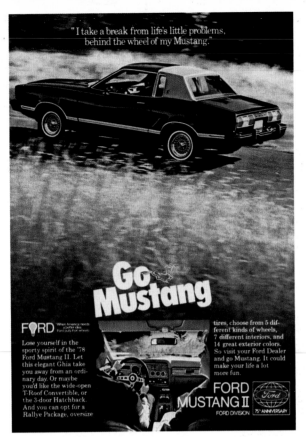

Renault Le Car, 1978

Ford Mustang, 1977

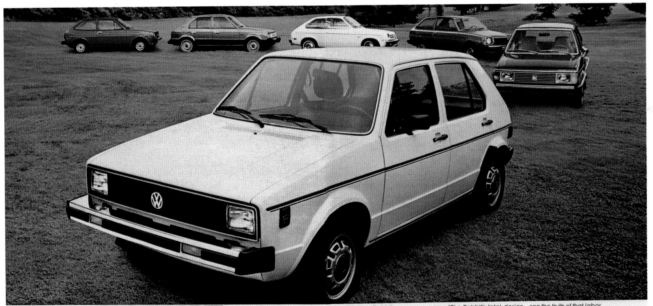

Volkswagen Rabbit, 1979

"THE BEST PUT-TOGETHER CARS OUT OF DETROIT THIS YEAR MAY COME OUT OF WISCONSIN.

AMBASSADOR

Still the only car in its class to offer air-conditioning, V-8 engine, power brakes and automatic transmission as standard equipment.

HORNET

The tough little compact that made a 38,000-mile endurance run throughout North and South America.

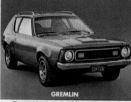

GREMLIN

The original American subcompact. Still heavier, wider and more horsepower than any car near its price.

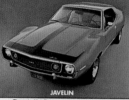

JAVELIN

The car that Mark Donohue and Roger Penske modified to win 7 of 9 Trans-Am races and the 1971 Season Championship.

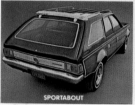

SPORTABOUT

The only wagon made in America that offers 60.8 cubic feet of cargo space, a rear lift gate, four doors and sleek, racy looks.

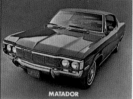

MATADOR

The mid-size car chosen for a 500-car fleet by the Los Angeles Police Department on the basis of quality, performance and price.

General Motors, 1972

WE'RE LOOKING FOR PEOPLE WHO LOVE TO DRIVE.

We realize that, for some of you, driving an automobile is about as exhilarating as riding an escalator. That's sad.

Because with the right kind of car in your hands, the act of driving can be one of the truly pleasant things you do each day.

Which brings us to Camaro. In fact it brings lots of us to Camaro.

People who love to drive love Camaro because it's definitely a driver's car. It sits low and stands wide and moves like it really means it. Camaro is quick, quiet, tight and tough. All of which translates to a very special "feel". The spirit of Camaro. The lift the car can give you, even just driving to work.

If you love to drive, or would like to, take a turn in a '77 Camaro one day real soon.

Your Chevy dealer has one all gassed up and ready to go.

Driving gloves are optional.

Chevrolet
CAMARO

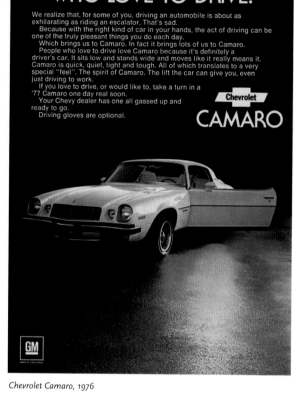

Chevrolet Camaro, 1976

"SPIRIT OF AMERICA"

The colors are red, white and blue. The cars are Limited Edition Impalas, Novas and Vegas.

They're the special Spirit of America Chevrolets arriving at your Chevy dealer's right now.

They're cars known for their value. Distinctly styled with special interiors and equipment. Packaged like no Chevrolet before. Available for a limited time only.

Get the Spirit at your Chevy dealer's while they last.

The Spirit of America Impala package: • White or blue exterior. • Special white padded vinyl roof. • Special striping. • Special white wheels with paint stripes and trim rings. • Spirit of America crests. • Dual Sport mirrors, LH remote-control. • Wheel-opening moldings and fender skirts. • Bumper impact strips. • White all-vinyl interior trim with blue or red accents and carpeting. • Deluxe seat and shoulder belts. • Quiet Sound Group body insulation.

The Spirit of America Nova package: • White exterior. • Black touring-style vinyl roof. • Special striping. • Spirit of America decals. • White rally wheels with trim rings and special hubs. • Black dual Sport mirrors, LH remote-control. • Black grille. • E78-14 white-stripe tires. • White all-vinyl bucket seat interior. • Red carpeting.

The Spirit of America Vega package: • White exterior. • White vinyl roof. • Special striping. • Spirit of America decals. • White GT wheels with trim rings. • Custom Exterior. • Black-finished body sills. • White LH remote Sport mirror. • A70-13 white-lettered tires. • White all-vinyl Custom Interior. • Red carpeting.

Chevrolet

A limited edition of Chevrolets in America's favorite colors.

Spirit of America Nova

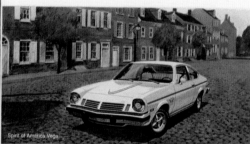

Spirit of America Vega

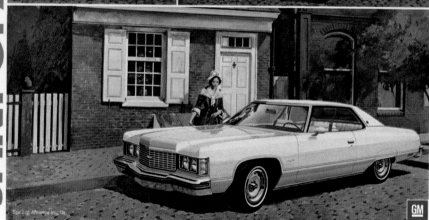

Spirit of America Impala

Chevrolet, 1974

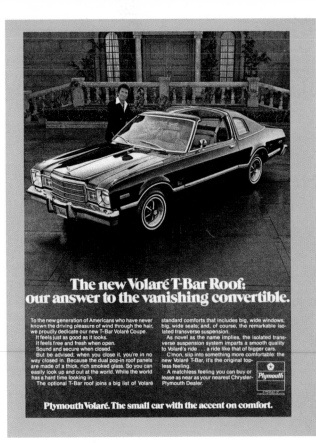

The new Volaré T-Bar Roof: our answer to the vanishing convertible.

To the new generation of Americans who have never known the driving pleasure of wind through the hair, we proudly dedicate our new T-Bar Volaré Coupe.
It feels just as good as it looks.
It feels free and fresh when open.
Sound and secure when closed.
But be advised; when you close it, you're in no way closed in. Because the dual pop-in roof panels are made of a thick, rich smoked glass. So you can easily look up and out at the world. While the world has a hard time looking in.
The optional T-Bar roof joins a big list of Volaré

standard comforts that includes big, wide windows; big, wide seats; and, of course, the remarkable isolated transverse suspension.
As novel as the name implies, the isolated transverse suspension system imparts a smooth quality to Volaré's ride . . . a ride like that of bigger cars.
C'mon, slip into something more comfortable: the new Volaré T-Bar, it's the original topless feeling.
A matchless feeling you can buy or lease as near as your nearest Chrysler-Plymouth Dealer.

Plymouth Volaré. The small car with the accent on comfort.

Plymouth Volaré, 1977

Miles & Miles of Heart me & my Arrow

It's a special kind of day. Just you and your friends. No pressures. No boss. Just a good feeling, lay back kind of time.
And you like it.
Oh, you can be serious. You have to be, when it comes to a major expense like a new car. That's partially why we built the Plymouth Arrow. Arrow's got a lean, crisp look. No excess weight or bulk. And that wide, piston-assisted hatch and fold-down rear seat sure come in handy.
Let's face it. Arrow's the kind of car that just makes you feel good about driving. But there's more to owning a car than just feeling good. You've got to ask yourself some simple economic questions. And Arrow answers . . . beautifully. That little yellow beauty you see in the background is our lowest-priced Arrow. Or you can step all the

way up to our Arrow GT, with its standard 5-speed transmission and Silent Shaft engine, designed to be one of the smoothest and quietest 4-cylinder engines available anywhere. And there are two other Arrows priced between the Arrow and the Arrow GT.
But once you buy the car . . . you've got to buy the gas. And you want to buy as little as possible.
For 1978, every Arrow features our new MCA Jet System, an air injection system that gives you great mileage *and* great performance. **39** HWY **29** CITY
The 1978 Plymouth Arrows. They all give you tinted glass, tilt wheel, reclining buckets . . . and a special kind of feeling on a special kind of day. They give you . . . miles and miles of heart. Buy or Lease at your Chrysler-Plymouth Dealer.

Based on EPA estimates for Arrow's 1.6 litre engine and manual transmission. Your actual mileage may differ depending on your driving habits, your car's condition, and its optional equipment. California mileage lower.

THE PLYMOUTH ARROWS FOR '78

Plymouth Arrow, 1978

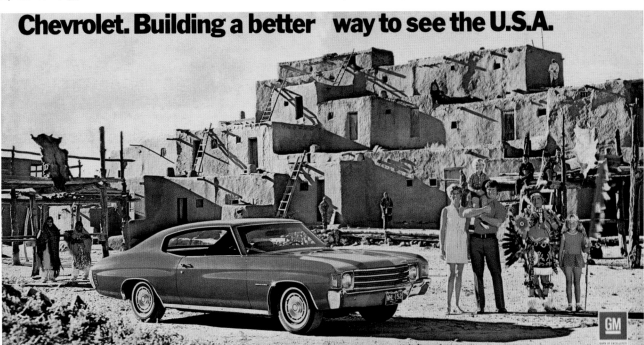

Chevrolet. Building a better way to see the U.S.A.

Chevelle Malibu Sport Coupe at the Taos Pueblo in Northern New Mexico.

Your new Chevelle. For the full-size family with the mid-size budget.

Taos, New Mexico. Where the Pueblo civilization was old when Coronado arrived more than four hundred years ago.
Little has changed over the centuries. Ancient Indians made the most of available space by building up. At Taos Pueblo, the thick adobe walls climb five stories high. America. There's so much to see.

And Chevrolet is building a better way to see the U.S.A.
Like the 1972 Chevelle. It has the size you need for long trip comfort. And it's inside, where it counts.
Compared to most big cars, Chevelle has every bit as much leg room up front. And just a few inches less in back. In a car

that's nearly two feet shorter.
Which brings us to handling. Chevelle gives you a secure, solid feeling. Partly because of its trim size, wide tread and Full Coil suspension.
After all, we want your new Chevelle to be the best car you ever owned. Try one on your family and your

budget for size. At your Chevrolet dealer's. You're likely to discover why Chevelle is America's most popular mid-size car. **Chevrolet**

There's so much to see, make sure you're around to see it. Buckle up.

Chevrolet Chevelle, 1977

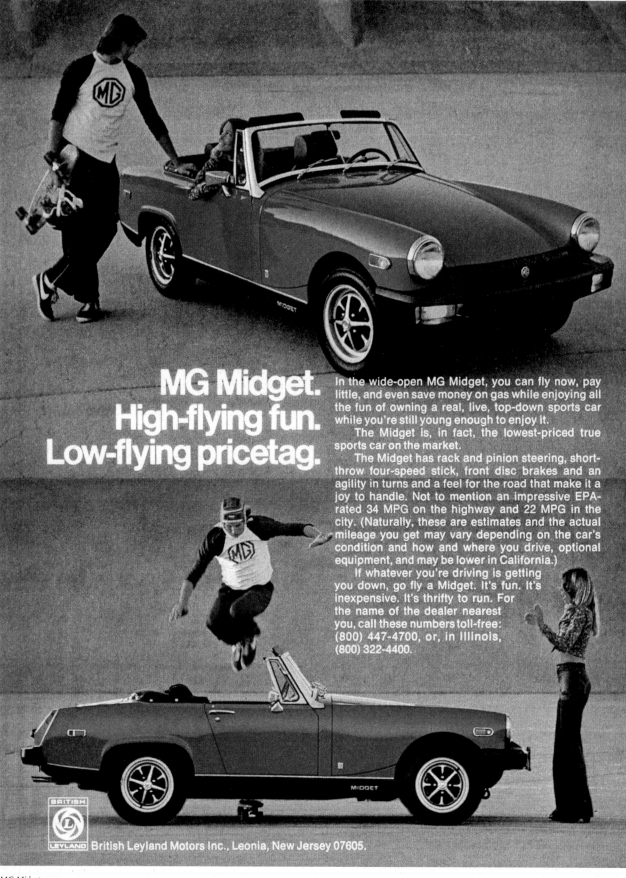

MG Midget.
High-flying fun.
Low-flying pricetag.

In the wide-open MG Midget, you can fly now, pay little, and even save money on gas while enjoying all the fun of owning a real, live, top-down sports car while you're still young enough to enjoy it.

The Midget is, in fact, the lowest-priced true sports car on the market.

The Midget has rack and pinion steering, short-throw four-speed stick, front disc brakes and an agility in turns and a feel for the road that make it a joy to handle. Not to mention an impressive EPA-rated 34 MPG on the highway and 22 MPG in the city. (Naturally, these are estimates and the actual mileage you get may vary depending on the car's condition and how and where you drive, optional equipment, and may be lower in California.)

If whatever you're driving is getting you down, go fly a Midget. It's fun. It's inexpensive. It's thrifty to run. For the name of the dealer nearest you, call these numbers toll-free: (800) 447-4700, or, in Illinois, (800) 322-4400.

British Leyland Motors Inc., Leonia, New Jersey 07605.

MG Midget, 1977

▶ *Porsche 924, 1979*

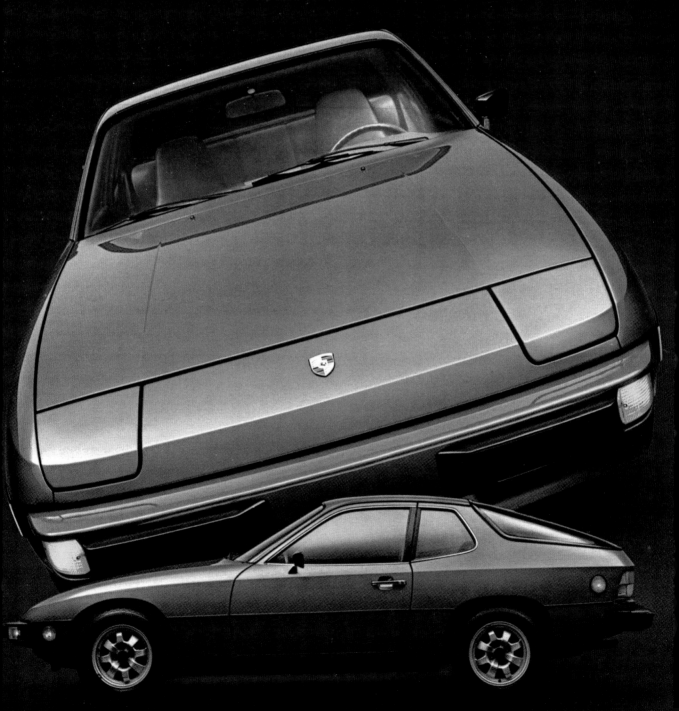

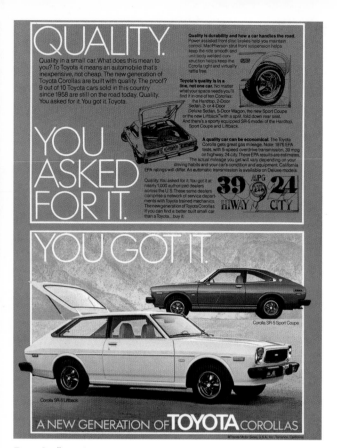

Toyota Corolla, 1976

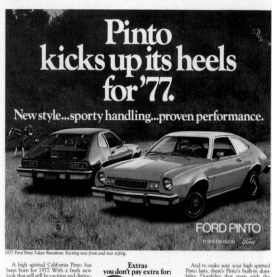

Ford Pinto, 1977

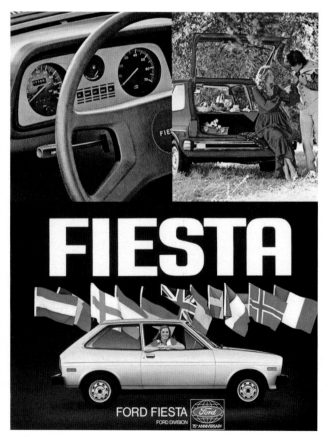

Ford Fiesta, 1978

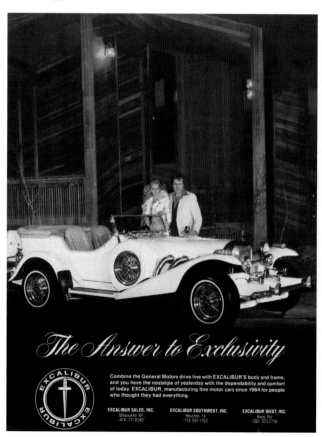

Excalibur, 1979

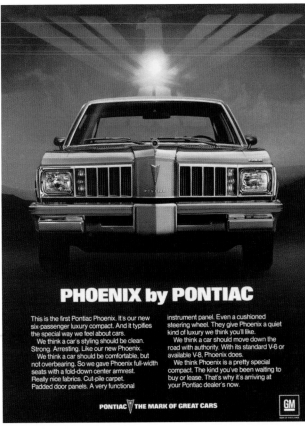

PHOENIX by PONTIAC

This is the first Pontiac Phoenix. It's our new six-passenger luxury compact. And it typifies the special way we feel about cars. Like our new Phoenix.

We think a car's styling should be clean. Strong. Arresting. Like our new Phoenix.

We think a car should be comfortable, but not overbearing. So we gave Phoenix full-width seats with a fold-down center armrest. Really nice fabrics. Cut-pile carpet. Padded door panels. A very functional instrument panel. Even a cushioned steering wheel. They give Phoenix a quiet kind of luxury we think you'll like.

We think a car should move down the road with authority. With its standard V-6 or available V-8, Phoenix does.

We think Phoenix is a pretty special compact. The kind you've been waiting to buy or lease. That's why it's arriving at your Pontiac dealer's now.

PONTIAC ▽ THE MARK OF GREAT CARS [GM]

Pontiac Phoenix, 1977

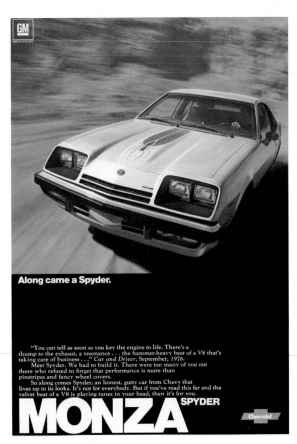

Along came a Spyder.

"You can tell as soon as you key the engine to life. There's a thump to the exhaust, a resonance . . . the hammer-heavy beat of a V8 that's taking care of business . . ." *Car and Driver*, September, 1976.

Meet Spyder. We had to build it. There were too many of you out there who refused to forget that performance is more than pinstripes and fancy wheel covers.

So along comes Spyder, an honest, gutty car from Chevy that lives up to its looks. It's not for everybody. But if you've read this far and the velvet beat of a V8 is playing tunes in your head, then it's for you.

MONZA SPYDER [Chevrolet]

Chevrolet Monza, 1976

The new AMC Concord D/L.
Now you don't have to pay extra for
the luxury of a luxury compact.

The Concord D/L is a new luxury compact that comes with all its luxury intact. Not tacked on as extras for an extra few hundred dollars.

For no extra charge you get: a landau roof with opera windows. Color-keyed wheel covers and whitewalls. Crushed velour individual reclining seats. A wood-grained dash with a digital clock. And lots of other luxury features that you'd expect to be charged extra for.

Perhaps the nicest luxury of all is the smooth, quiet ride that AMC has engineered into the Concord D/L, with a new suspension system and insulation network against road shock and sound.

You also get AMC's exclusive BUYER PROTECTION PLAN,® with the only full 12 month/12,000 mile warranty. That means AMC will fix, or replace free any part, except tires, for 12 months or 12,000 miles whether the part is defective, or just plain wears out under normal use and service. AMC also has a plan to provide a free loaner car should guaranteed repairs take overnight.

So if you've been thinking about a Volare, or Granada, or another luxury compact, think about this: the new Concord D/L is the luxury compact with no extra charge for the luxury.

AMC ▬ Concord D/L
*The luxury Americans want.
The size America needs.*

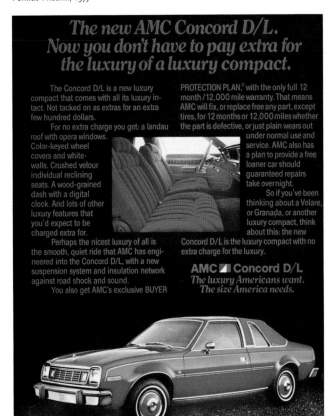

AMC Concord, 1977

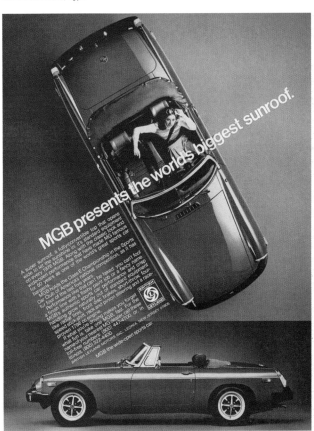

MGB presents the worlds biggest sunroof.

A super sunroof, a fully convertible top that opens wide to let the sunshine in. It's standard equipment on every 1976 MGB. Along with the classic look and proven performance that have made MG famous for 50 years, as one of the world's great sports car bargains.

MGB holds the Class E Championship in the Sports Car Club of America's national competition, as it has for four of the last five years.

Performance like this can be taken for granted. MGB's authentic sports car performance and crisp handling grow out of standard equipment four-speed stick shift, rack and pinion steering and a race-proven 1798 cc engine.

If all this driving makes you forget what fun is, take one MGB, fast. These cars are a blast.

If you're into the nearest MG dealer, call these toll-free numbers: (800) 447-4700, or, in Illinois (800) 322-4400.

MGB, the wide-open sports car

BRITISH LEYLAND MOTORS INC., LEONIA, NEW JERSEY 07605

MGB, 1976

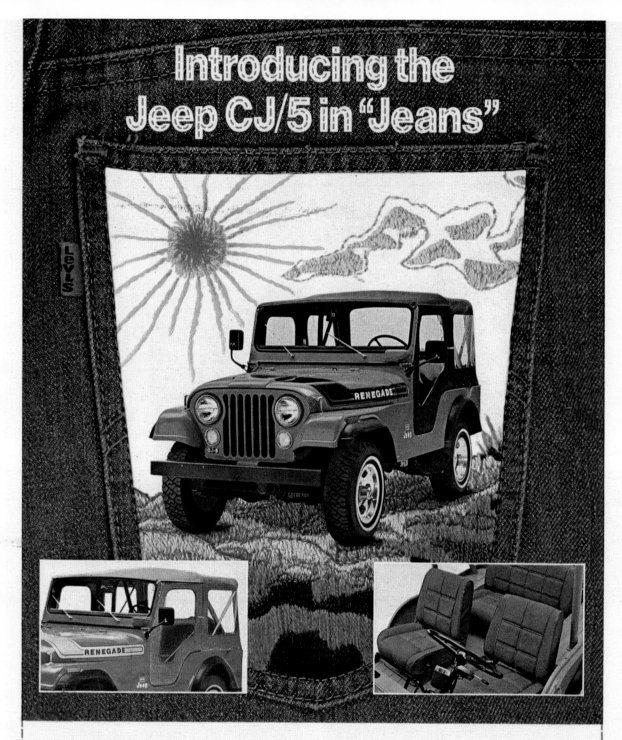

Introducing the Jeep CJ/5 in "Jeans"

Look what the well dressed Jeep CJ/5 is wearing! New Levi's® styled seats with matching fold-down top. Made of rugged, easy to care for vinyl fabric in absolutely authentic styling—right down to the copper rivets. Built to take plenty of rough treatment and most anything the weather can dish out.

Choose Levi's® blue or Levi's® tan—to complement vehicle color.

The Levi's® interior is standard on the Jeep Renegade (shown above) and optional on the standard Jeep CJ/5.

Levi's® and Jeep Corporation—two names at home in the great outdoors—waiting for you! Jeep wrote the book on 4-wheel drive.

Jeep. CJ/5

From a Subsidiary of
American Motors Corporation

Jeep CJ/5, 1974

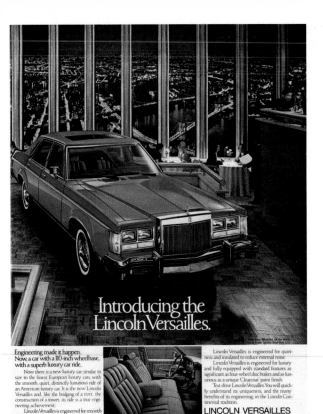

Lincoln Versailles, 1977

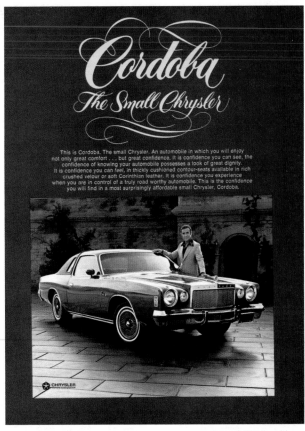

Chrysler Cordoba, 1975

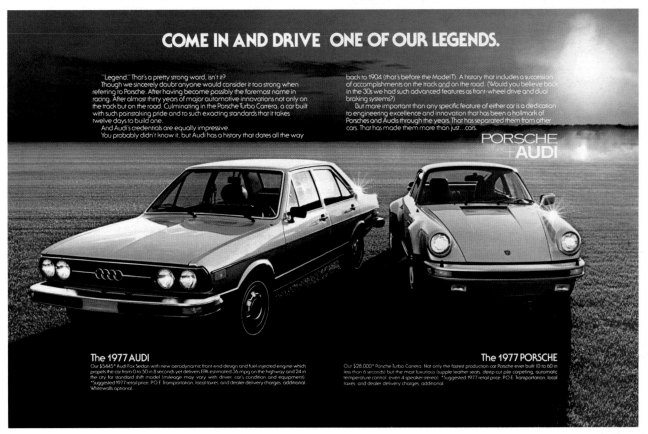

Porsche & Audi, 1977

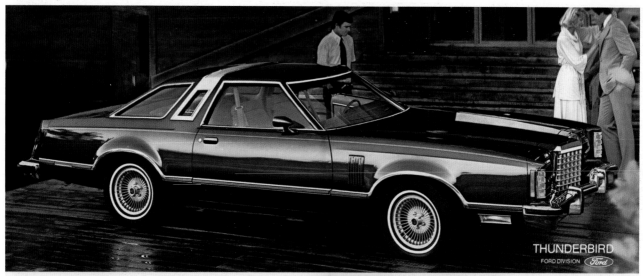

Introducing the Town Landau: the most expensive, most luxurious Thunderbird you can buy.

The Town Landau is the ultimate Thunderbird, from the distinctive wrapover brushed aluminum tiara to the translucent hood ornament and tasteful accent stripes. Inside, all the personal luxury you'd expect from Thunderbird: crushed velour split bench seats, AM-FM stereo search radio, special sound insulation package, personalized 22 K gold finish plaque for the instrument panel and much more. And you can tailor this distinctive Thunderbird to your personal tastes. Town Landau—another classic Thunderbird is here.

FORD When America needs a better idea. Ford puts it on wheels.

Ford Thunderbird, 1977

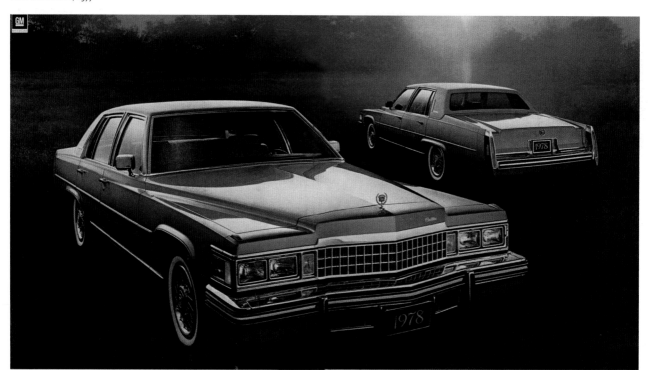

Behind the great name... a great car.

A car of classic elegance—with all the comfort, all the luxury, all the quality you expect of Cadillac. And yet, the 1978 Fleetwood Brougham (pictured), Coupe deVille and Sedan deVille are beautifully agile. Responsive. Lively. Maneuverable.

It's luxury all the way—but luxury you can feel good about. Because Cadillac 1978 is designed for efficient use of space and engineered for the changing world of today—while preserving traditional Cadillac legroom and headroom.

The luxury leaders have arrived. See them. Drive them. And for another kind of luxury, consider Seville by Cadillac . . . it stands alone among the world's great cars. And the 1978 Eldorado with front-wheel drive and a flair all its own.
At your Cadillac dealer now.

Cadillac 1978

Cadillac, 1977

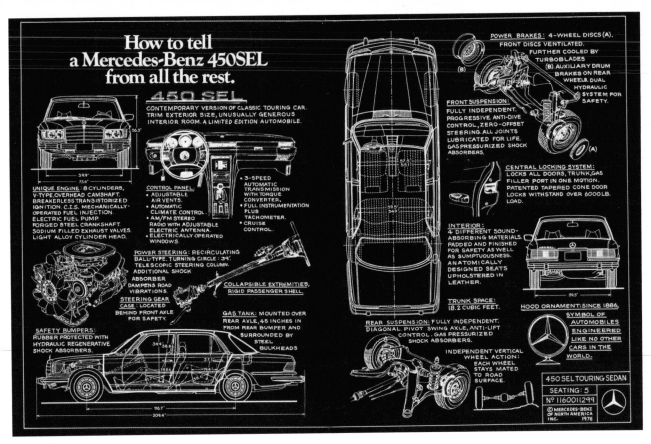

Mercedes-Benz, 1976

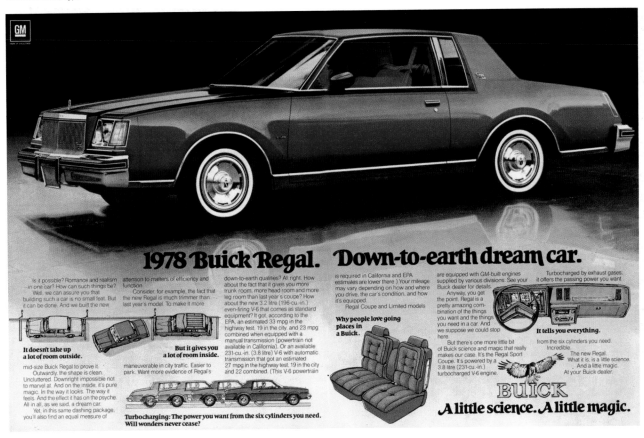

Buick Regal, 1978

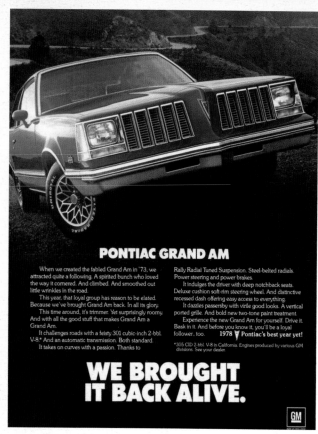

PONTIAC GRAND AM

When we created the fabled Grand Am in '73, we attracted quite a following. A spirited bunch who loved the way it cornered. And climbed. And smoothed out little wrinkles in the road.

This year, that loyal group has reason to be elated. Because we've brought Grand Am back. In all its glory.

This time around, it's trimmer. Yet surprisingly roomy. And with all the good stuff that makes Grand Am a Grand Am.

It challenges roads with a feisty 301 cubic-inch 2-bbl. V-8.* And an automatic transmission. Both standard.

It takes on curves with a passion. Thanks to Rally Radial Tuned Suspension. Steel-belted radials. Power steering and power brakes.

It indulges the driver with deep notchback seats. Deluxe cushion soft-rim steering wheel. And distinctive recessed dash offering easy access to everything.

It dazzles passersby with virile good looks. A vertical ported grille. And bold new two-tone paint treatment.

Experience the new Grand Am for yourself. Drive it. Bask in it. And before you know it, you'll be a loyal follower, too. 1978 ▼ Pontiac's best year yet!

*305 CID 2-bbl. V-8 in California. Engines produced by various GM divisions. See your dealer.

WE BROUGHT IT BACK ALIVE.

GM

Pontiac Grand Am, 1978

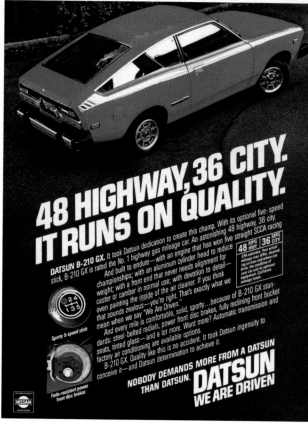

48 HIGHWAY, 36 CITY. IT RUNS ON QUALITY.

DATSUN B-210 GX. It took Datsun dedication to create this champ. With its optional five-speed stick, B-210 GX is rated the No. 1 highway gas mileage car. An astonishing 48 highway, 36 city.

And built to endure—with an engine that has won five straight SCCA racing championships; with an aluminum cylinder head to reduce weight; with a front end that never needs alignment for caster or camber in normal use; with devotion to detail—even painting the inside of the air cleaner. If you think that sounds zealous—you're right. That's exactly what we mean when we say "We Are Driven."

And every mile is comfortable, solid, sporty... because of B-210 GX standards: steel-belted radials, power front disc brakes, fully reclining front bucket seats, tinted glass—and a lot more. Want more? Automatic transmission and factory air conditioning are available options.

B-210 GX. Quality like this is no accident. It took Datsun ingenuity to conceive it—and Datsun determination to achieve it.

| 48 MPG HWY | 36 MPG CITY |

EPA estimates. Your actual mileage may differ depending on how and where you drive, the condition of your car and its optional equipment. California mileage lower.

Sporty 5-speed stick

Fade-resistant power front disc brakes

NOBODY DEMANDS MORE FROM A DATSUN THAN DATSUN.

NISSAN

DATSUN WE ARE DRIVEN

Datsun B-210, 1978

Our lowest priced Honda isn't so simple.

The Honda Civic®1200 Sedan is our lowest priced Honda.* We hope that statement doesn't put you off.

We know that lots of people tend to be suspicious when they see the words "lowest priced." Especially when it's a car. They immediately think of some stripped-down model calculated to snag the unwary buyer by means of a seductive price tag.

That's why we're running this ad. To let you know that, despite its very reasonable price, the Civic 1200 Sedan gives you such traditional Honda engineering refinements as transverse-mounted engine, front-wheel drive, rack and pinion steering, power-assisted dual-diagonal braking system with front discs, and four-wheel independent MacPherson strut suspension.

And that's not all. The Civic 1200 Sedan abounds with standard features that other manufacturers might charge you extra for.

*Not available in Calif. and high altitude areas. Manufacturer's suggested retail price excluding freight, tax, license, title, and options.
©1978 American Honda Motor Co., Inc. Civic 1200 is a Honda trademark.

These include reclining bucket seats, adjustable head rests, wall-to-wall carpeting, opening rear-quarter windows, inside hood release, rear-seat ash tray, plus the instrument cluster shown opposite, a simple layout that nonetheless provides the added convenience of a trip odometer.

Like our other two Honda cars – the Civic CVCC® and the Honda Accord®– the Civic 1200 doesn't need a catalytic converter and runs on unleaded or money-saving regular gasoline.

So there you have it. The Honda Civic 1200 Sedan. Because it's a Honda, it's a simple car. But not so simple as its price would lead you to believe.

HONDA
We make it simple.

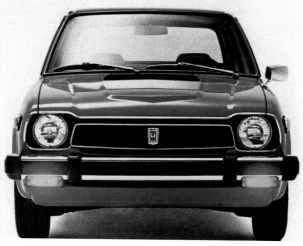

Honda Civic, 1978

▶ *Ford Futura, 1978*

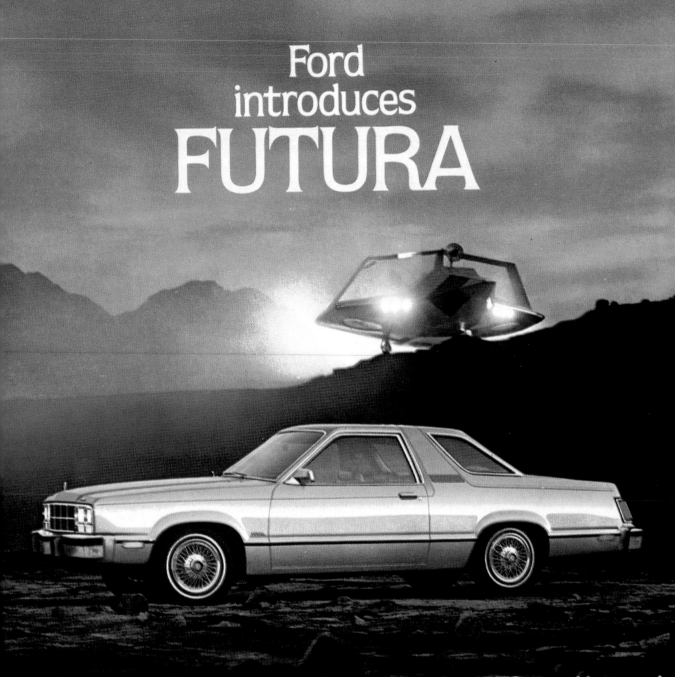

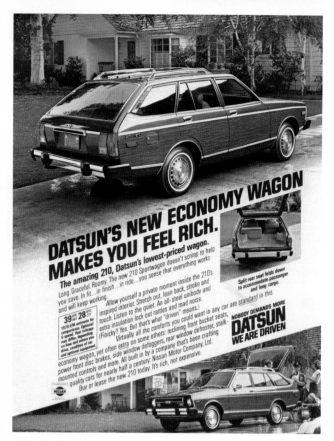

Datsun 210 Wagon, 1979

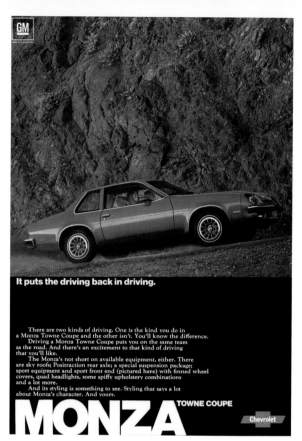

Chevrolet Monza, 1976

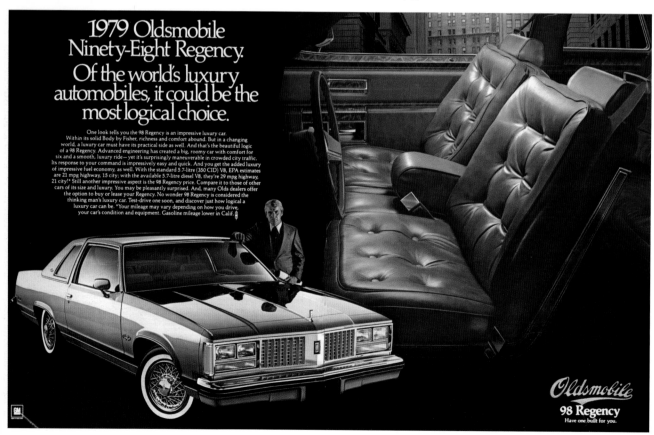

Oldsmobile Regency, 1979

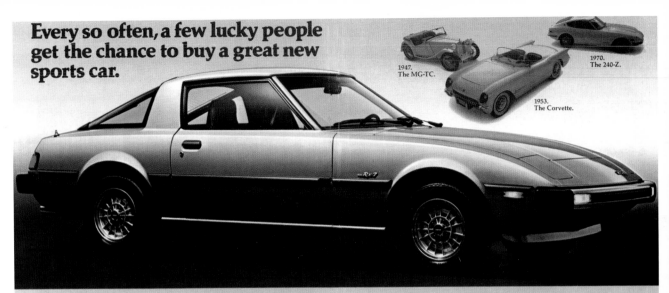

Every so often, a few lucky people get the chance to buy a great new sports car.

1947.
The MG-TC.

1970.
The 240-Z.

1953.
The Corvette.

Now it's your turn.
Mazda RX-7.

A car like this doesn't come along very often. If you ever wished you had been there to shake up the car world with the new MG-TC back in 1947, with a 1953 Corvette when it was heresy on wheels, a 240-Z in 1970 when it turned more heads than hot pants...then you understand.

The 1979 RX-7 is the kind of car that makes your stomach muscles tighten when you start it. That lures you through a corner with a flick of the wrist and a

rap of exhaust. It's the real thing: a sports car with all the traditional virtues and then some.

One of those traditional virtues is performance. Acceleration from 0 to 50 mph in 6.3 seconds. Cornering that comes from its refined suspension, the bite of its fat, steel-belted radial tires. Braking from a power-assisted combination of ventilated discs in front, finned drums in back.

But there are some highly untraditional virtues, too. The RX-7 was designed specifically to take advantage of the Mazda rotary engine's unique combination of compactness,

smoothness and high performance. It made some important differences.

The compactness made possible a front mid-engine design, providing nearly perfect weight distribution for impeccable handling and smooth ride. It also made possible the RX-7's slick, wind-cheating lines.

At the same time, the smooth power and broad, flat torque curve of the Mazda rotary make the RX-7 a real stormer, but one that's easy to get along with at low speeds.

If you thought you'd never own one of the great sports cars, better test drive a Mazda RX-7

GS-Model (shown) or S-Model. You simply have to experience it from the driver's seat to understand what this car is all about: the kind of comfort, versatility and room you've always wanted, the kind of performance you've always dreamed of. And all at a price you'll find hard to believe.

Believe. Your time has come. The Mazda RX-7 is here.

*POE price for S-Model: $6,395. For GS-Model shown: $6,995. (Slightly higher in California.) Taxes, license, freight and optional equipment are extra. (Wide alloy wheels shown above $250 extra.) Mazda's rotary engine licensed by NSU-WANKEL

From $6,395*
GS-Model shown: $6,995.*

The car you've been waiting for is waiting for you.

MAZDA

Mazda RX-7, 1978

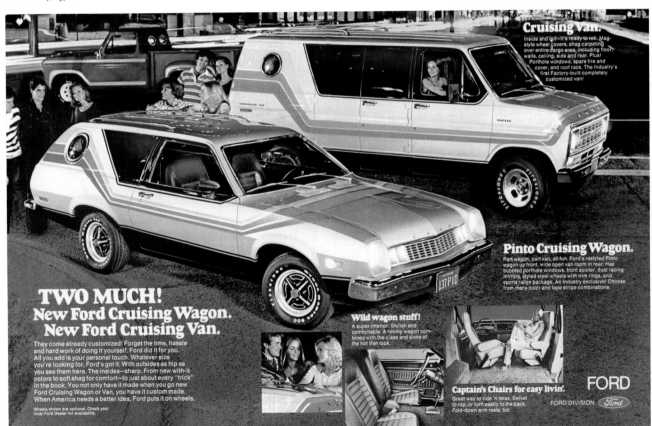

Cruising Van.
Inside and out—it's ready to roll. Mag-style wheel covers, shag carpeting over entire cargo area, including floor, walls, ceiling, side and rear. Plus! Porthole windows, spare tire and cover, and roof rack. The industry's first Factory-built completely customized van!

Pinto Cruising Wagon.
Part wagon, part van, all fun. Ford's restyled Pinto wagon up front, wide open van room in rear. Has bubbled porthole windows, front spoiler, dual racing mirrors, styled steel wheels with trim rings, and sports rallye package. An industry exclusive! Choose from many color and tape stripe combinations.

TWO MUCH!
New Ford Cruising Wagon.
New Ford Cruising Van.

They come already customized! Forget the time, hassle and hard work of doing it yourself. Ford did it for you. All you add is your personal touch. Whatever size you're looking for, Ford's got it. With outsides as hip as you see them here. The insides—sharp. From new with-it colors to soft shag for comfort—to just about every "trick" in the book. You not only have it made when you go new Ford Cruising Wagon or Van, you have it custom made. When America needs a better idea, Ford puts it on wheels.

Wheels shown are optional. Check your local Ford Dealer for availability.

Wild wagon stuff!
A super interior. Stylish and comfortable. A roomy wagon combined with the class and kicks of the hot Van look.

Captain's Chairs for easy livin'.
Great way to ride 'n relax. Swivel to rap, or turn easily to the back. Fold-down arm rests, too.

FORD
FORD DIVISION *Ford*

Ford, 1976

▶ *Plymouth Sapporo, 1978*

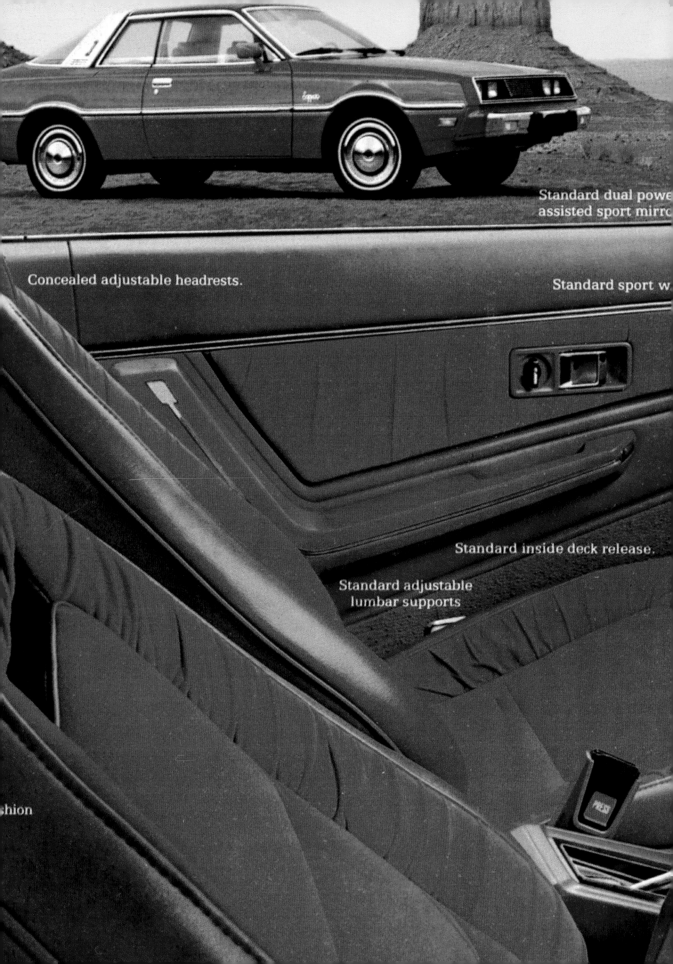

Standard dual power
assisted sport mirro

Concealed adjustable headrests.

Standard sport w.

Standard inside deck release.

Standard adjustable
lumbar supports

shion

Standard tachometer, oil and amp gauges
and trip odometer.

Standard tilt steering column.

Standard forced air
ventilation.

Optional
air conditioning.

Optional AM-FM ra
with cassette.

Standard 5-speed transmission
(Automatic shown, optional).

Optional power windows.

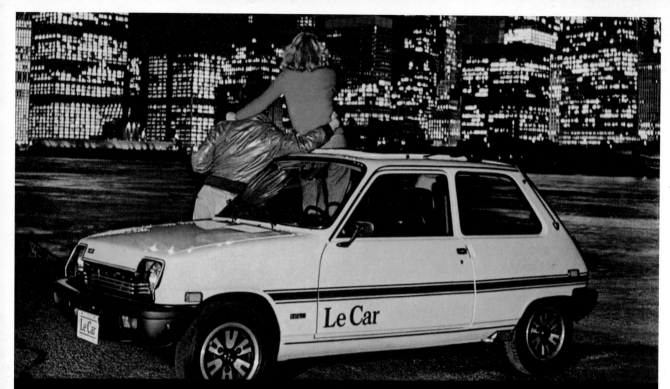

Le City Car

One of the reasons Le Car has caused so much excitement in this country is because of what it can do in the city. There isn't a car in town that can match Le Car for parking, maneuverability, ease of handling and smooth ride.

Le Car fits in a smaller parking space than any other car in its class.

Even though Le Car has a longer wheelbase than Honda Civic or VW Rabbit, it has a shorter overall length. So Le Car will fit in a space

that the others have to pass by. Add to this Le Car's short 32-foot turning circle and you can see why the parking problems of the city are no problem for Le Car.

A highly responsive car that handles with ease.

Parking is not the only difficulty you'll encounter in the city. Driving is another. Le Car is equipped with front-wheel drive, rack and pinion steering, four-wheel independent suspension and Michelin steel-belted radials, all standard. (Honda, Rabbit, Chevette and Fiesta don't offer this combination of standard features.) The result is that Le Car can zip in and out of, around and through traffic.

And Le Car's ride is so remarkably smooth that Car & Driver reported, "The rough-road ride in Le Car is a new standard for small cars. It waltzed across the worst roads we could find — the cratered surfaces of Manhattan — as though it was fresh pavement."

Although Le Car is small on the

outside you could never tell from its roomy inside. Le Car is designed to give you the most interior room while using the least exterior space.

A world of satisfied Le Car owners.

In Europe, nearly two million people drive Le Car with a passion. That's more than Fiesta and Rabbit combined. Here in America, Le Car sales more than doubled in 1977. What's more, in an independent study, Le Car owner satisfaction was rated an amazingly high 95%. The price for all this? A very satisfying $3495.*

Obviously, a lot of people are doing a lot more than just driving Le Car in the city. So if you really want to see how much fun Le Car can be, flip open the giant sun roof (optional) and take Le City Car for a drive in the country. For more information call 800-631-1616 for your nearest dealer. In New Jersey call collect 201-461-6000.

*P.O.E. East Coast: Price excludes transportation, dealer preparation and taxes. Stripe, Mag wheels, Sun roof and Rear wiper/washer optional at extra cost. Prices higher in the West. Renault USA, Inc. ©1978.

Le Car by Renault ◆

Renault Le Car, 1978

▶ *Volkswagen Rabbit, 1979*

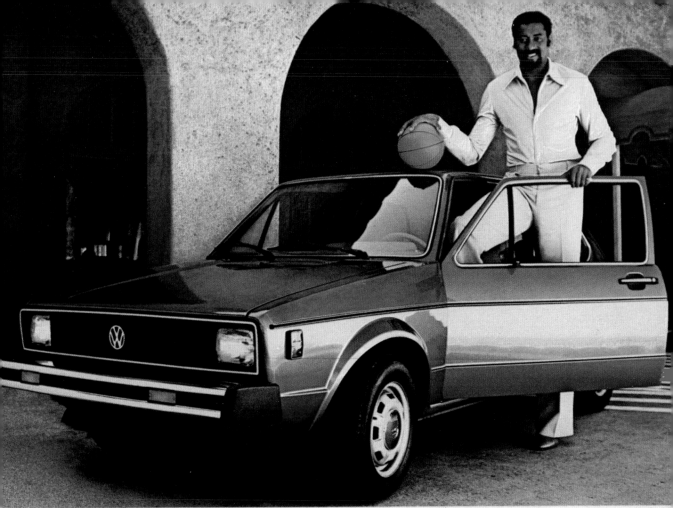

GOOD NEWS FOR PEOPLE 7'2" AND UNDER.

If you've always thought a little car meant a lot of crowding, you've obviously never looked into a Volkswagen Rabbit.

There happens to be so much room in a Rabbit that all 7'2" of Wilt Chamberlain can fit comfortably into the driver's seat.

With space left over.

Because the Rabbit has even more headroom than a Rolls-Royce.

As well as more room for people and things than practically every other imported car in its class.

Including every Datsun. Every Toyota. Every Honda, Mazda, and Renault.

Not to mention every small Ford and Chevy.

And, of course, what's all the more impressive about the room you get in a Rabbit is that it comes surrounded by the Rabbit itself. The car that, according to Car and Driver Magazine, "...does more useful and rewarding things than any other small car in the world..."

So how can you go wrong?

With the Rabbit you not only get the comfort of driving the most copied car in America.

You also get the comfort of driving a very comfortable car.

Because it may look like a Rabbit on the outside.

But it's a Rabbit on the inside.

VOLKSWAGEN DOES IT AGAIN

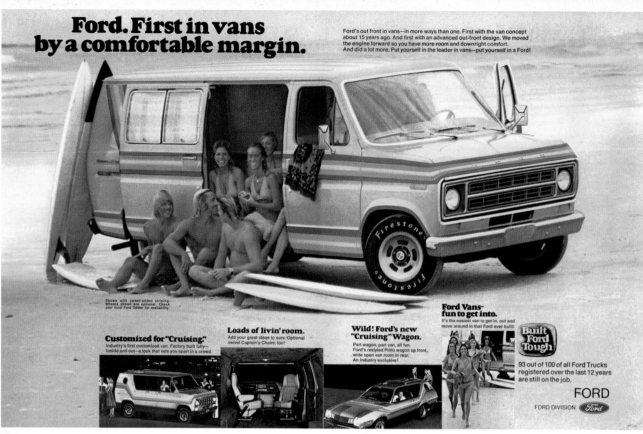

Ford. First in vans by a comfortable margin.

Ford's out front in vans—in more ways than one. First with the van concept about 15 years ago. And first with an advanced out-front design. We moved the engine forward so you have more room and downright comfort. And did a lot more. Put yourself in the leader in vans—put yourself in a Ford!

Shown with owner-added striping. Wheels shown are optional. Check your local Ford Dealer for availability.

Customized for "Cruising."
Industry's first customized van. Factory built fully—inside and out—a look that sets you apart in a crowd.

Loads of livin' room.
Add your great ideas to ours. Optional swivel Captain's Chairs, too!

Wild! Ford's new "Cruising" Wagon.
Part wagon, part van, all fun. Ford's restyled Pinto wagon up front, wide open van room in rear. An industry exclusive!

Ford Vans—fun to get into.
It's the easiest van to get in, out and move around in that Ford ever built!

Built Ford Tough
93 out of 100 of all Ford Trucks registered over the last 12 years are still on the job.

FORD
FORD DIVISION

Ford Cruising Van, 1977

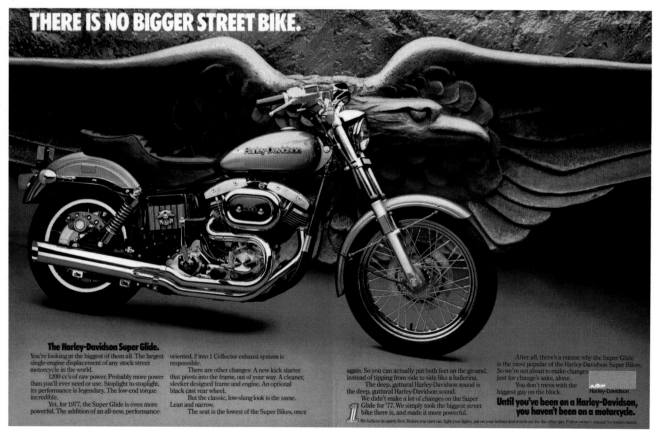

THERE IS NO BIGGER STREET BIKE.

The Harley-Davidson Super Glide.
You're looking at the biggest of them all. The largest single-engine displacement of any stock street motorcycle in the world.

1200 cc's of raw power. Probably more power than you'll ever need or use. Stoplight to stoplight, its performance is legendary. The low-end torque incredible.

Yet, for 1977, the Super Glide is even more powerful. The addition of an all-new, performance-oriented, 2 into 1 Collector exhaust system is responsible.

There are other changes: A new kick starter that pivots into the frame, out of your way. A cleaner, sleeker designed frame and engine. An optional black cast rear wheel.

But the classic, low-slung look is the same. Lean and narrow.

The seat is the lowest of the Super Bikes, once again. So you can actually put both feet on the ground, instead of tipping from side to side like a ballerina.

The deep, guttural Harley-Davidson sound is the deep, guttural Harley-Davidson sound.

We didn't make a lot of changes on the Super Glide for '77. We simply took the biggest street bike there is, and made it more powerful.

After all, there's a reason why the Super Glide is the most popular of the Harley-Davidson Super Bikes. So we're not about to make changes just for change's sake, alone.

You don't mess with the biggest guy on the block.

Until you've been on a Harley-Davidson, you haven't been on a motorcycle.

We believe in safety first. Before you start out, light your lights, put on your helmet and watch out for the other guy. Follow owner's manual for maintenance.

Harley-Davidson, 1977

▶ *Cragar Custom Wheels, 1978*

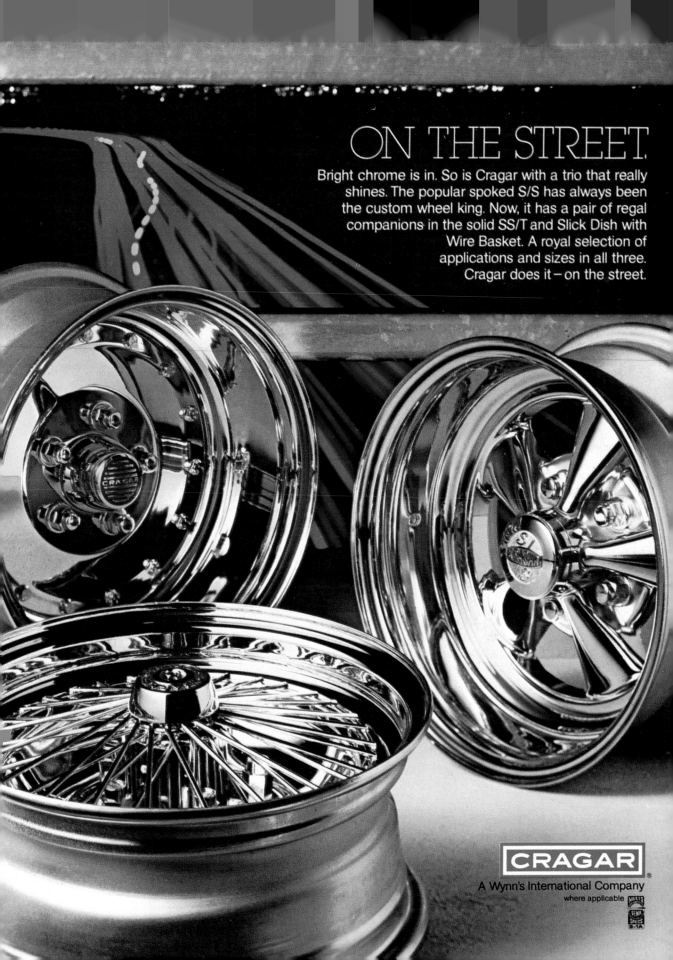

ON THE STREET.

Bright chrome is in. So is Cragar with a trio that really shines. The popular spoked S/S has always been the custom wheel king. Now, it has a pair of regal companions in the solid SS/T and Slick Dish with Wire Basket. A royal selection of applications and sizes in all three. Cragar does it — on the street.

CRAGAR

A Wynn's International Company

where applicable

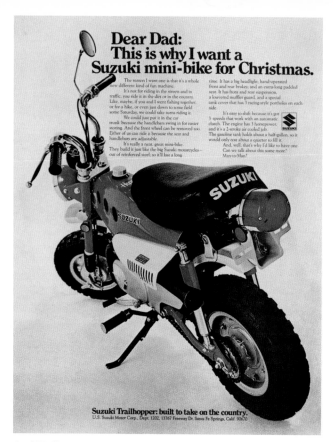

Caption: *Suzuki Trailhopper, 1970*

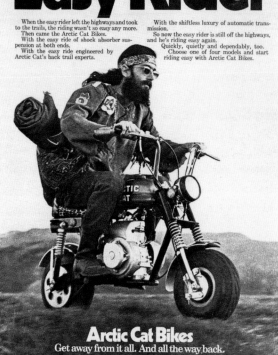

Caption: *Arctic Cat Bikes, 1971*

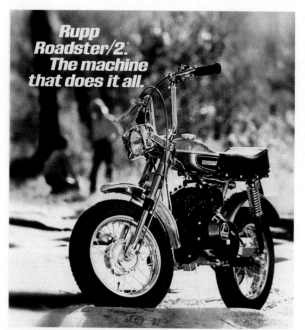

Caption: *Rupp Roadster, 1971*

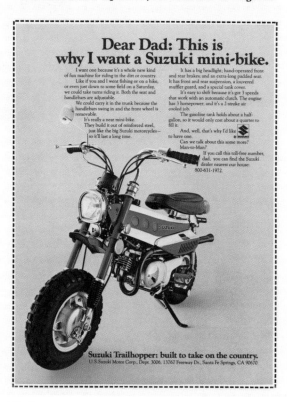

Caption: *Suzuki Trailhopper, 1972*

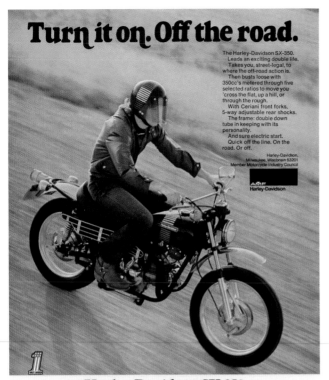

Turn it on. Off the road.

The Harley-Davidson SX-350. Leads an exciting double life. Takes you, street-legal, to where the off-road action is.

Then busts loose with 350cc's metered through five selected ratios to move you 'cross the flat, up a hill, or through the rough.

With Ceriani front forks, 5-way adjustable rear shocks. The frame: double down tube in keeping with its personality.

And sure electric start. Quick off the line. On the road. Or off.

Harley-Davidson,
Milwaukee, Wisconsin 53201
Member Motorcycle Industry Council

AMF
Harley-Davidson

Harley-Davidson SX-350.
The Great American Freedom Machine.

Harley-Davidson, 1973

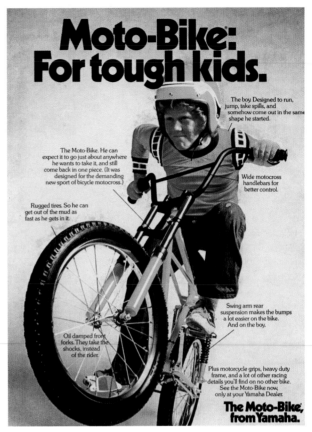

Moto-Bike: For tough kids.

The boy Designed to run, jump, take spills, and somehow come out in the same shape he started.

The Moto-Bike. He can expect it to go just about anywhere he wants to take it, and still come back in one piece. (It was designed for the demanding new sport of bicycle motocross.)

Wide motocross handlebars for better control.

Rugged tires. So he can get out of the mud as fast as he gets in it.

Swing arm rear suspension makes the bumps a lot easier on the bike. And on the boy.

Oil damped front forks. They take the shocks, instead of the rider.

Plus motorcycle grips, heavy duty frame, and a lot of other racing details you'll find on no other bike. See the Moto-Bike now, only at your Yamaha Dealer.

The Moto-Bike, from Yamaha.

Yamaha Moto-Bike, 1974

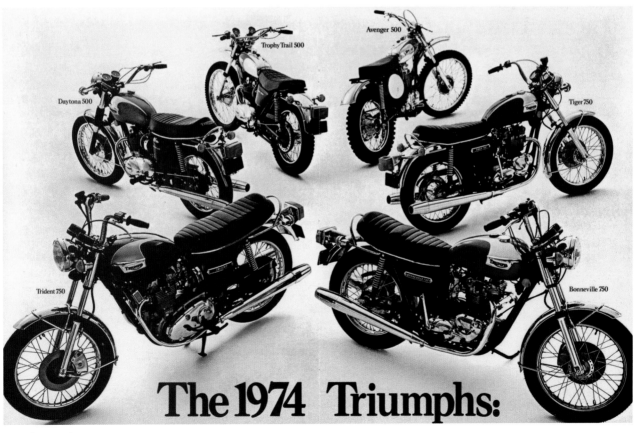

The 1974 Triumphs:

Triumph Motorcycles, 1974

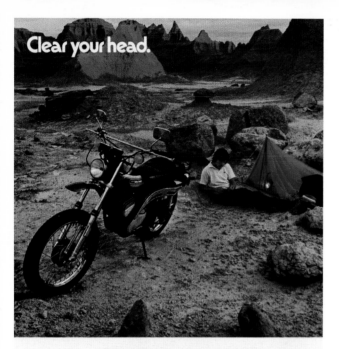

Clear your head.

Harley-Davidson, 1974

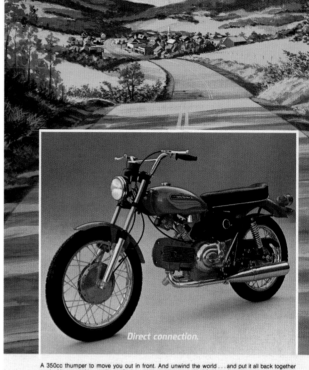

Harley-Davidson, 1972

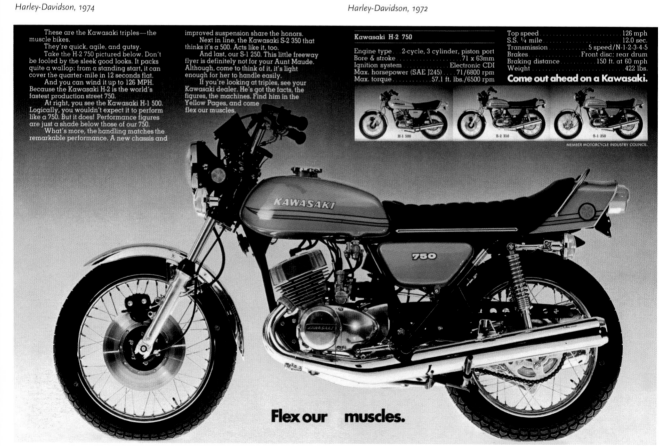

Kawasaki Motorcycle, 1974

Goodyear and advisors an nounce the Eagle M/X II

Goodyear Tires, 1977

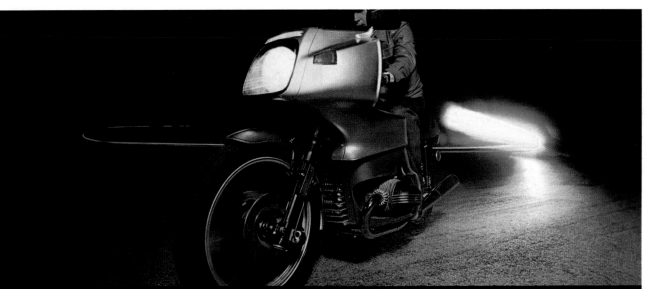

BMW Motorcycle, 1977

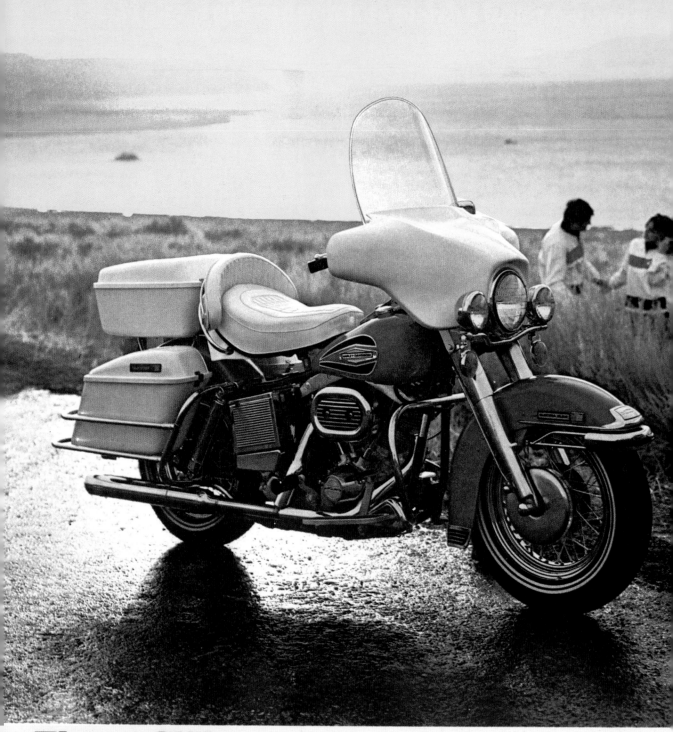

Electra Glide.
On the road it stands alone.

1200cc Electra Glide. Big-twin performance that keeps you hanging in on any tour. Dependable power and comfort on the open highway or heavy country. Cast and polished covers. Trouble-free Bendix carburetor for quick, all weather starts, smooth throttle response. High-output alternator, push-button starter. Timeless elegance of the world's finest motorcycle. Electra Glide. Road riders' choice. From Harley-Davidson. Number one where it counts . . . on the road and in the records. AMF | HARLEY-DAVIDSON, Milwaukee, Wisconsin 53201.

the Harley-Davidson outperformer

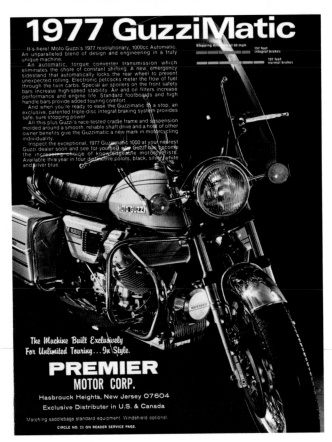

GuzziMatic Motorcycle, 1977

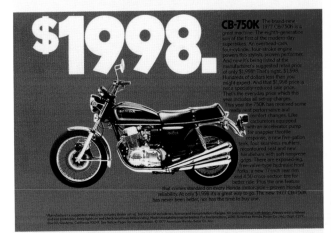

Honda Motorcycle, 1977

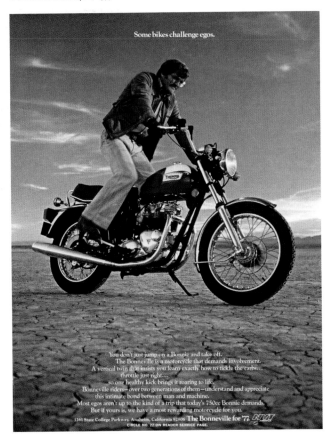

Harley-Davidson, 1971 ◄ *Bonneville Motorcycle, 1977*

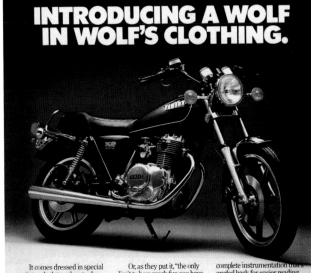

Yamaha Motorcycle, 1979

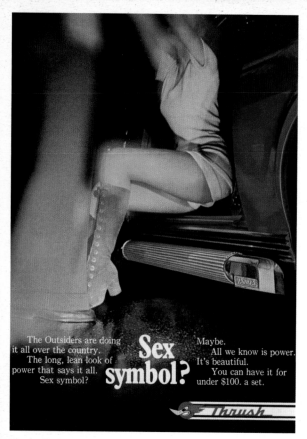

The Outsiders are doing
it all over the country.
The long, lean look of
power that says it all.
Sex symbol?

Sex symbol?

Maybe.
All we know is power.
It's beautiful.
You can have it for
under $100. a set.

Thrush Sidepipes, 1972

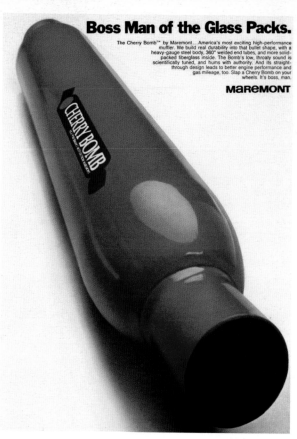

Boss Man of the Glass Packs.

The Cherry Bomb™ by Maremont...America's most exciting high-performance muffler. We build real durability into that bullet shape, with a heavy-gauge steel body, 360° welded end tubes, and more solid-packed fiberglass inside. The Bomb's low, throaty sound is scientifically tuned, and hums with authority. And its straight-through design leads to better engine performance and gas mileage, too. Slap a Cherry Bomb on your wheels. It's boss, man.

MAREMONT

Cherry Bomb Glasspack Muffler, 1972

"along came SPYDER"
...and blew Miss Muffet's doors off

Miss Muffet and lots of other style conscious dollies go for Spyder guys who get "go" plus "show" running street and strip's hottest newcomer — Spyder wheels. Get Spyder, the trick wheel with muscle • Wide Spyder bite (up to 8" widths) • Spoke aluminum centers • Strong triple plated, chromed steel rims • Precision made for good balance • Meets and beats all automotive strength specifications.
Write: Performance Dept. 12129, Motor Wheel Corp., Lansing, Mich. 48914.

MOTOR WHEEL

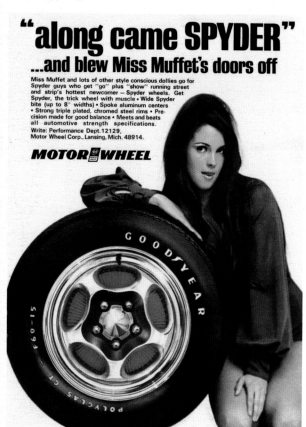

Motor Wheel, 1972

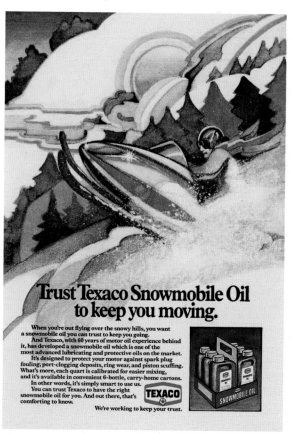

Trust Texaco Snowmobile Oil
to keep you moving.

When you're out flying over the snowy hills, you want a snowmobile oil you can trust to keep you going.

And Texaco, with 60 years of motor oil experience behind it, has developed a snowmobile oil which is one of the most advanced lubricating and protective oils on the market.

It's designed to protect your motor against spark plug fouling, port-clogging deposits, ring wear, and piston scuffing. What's more, each quart is calibrated for easier mixing, and it's available in convenient 6-bottle, carry-home cartons.

In other words, it's simply smart to use us.

You can trust Texaco to have the right snowmobile oil for you. And out there, that's comforting to know.

TEXACO

We're working to keep your trust.

Texaco, 1972

▶ *Appliance Industries Wheels, 1972*

Look for Appliance.

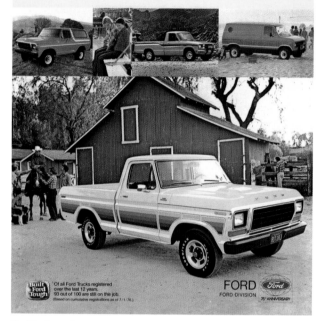
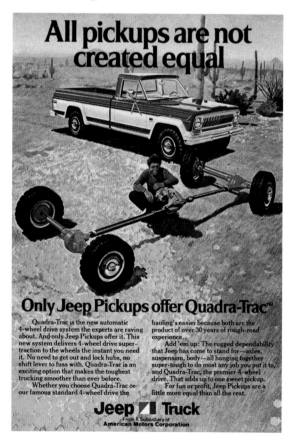
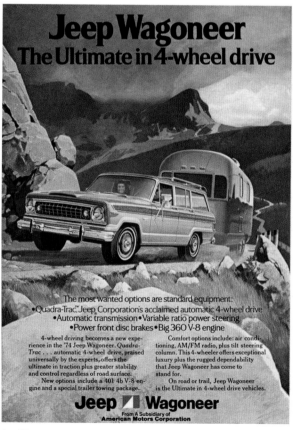

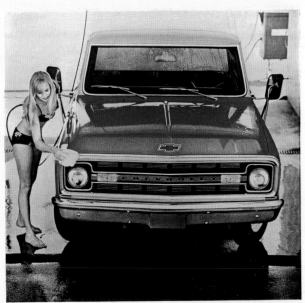

We hate to dampen the spirits of other trucks. But scrappage records show Chevy pickups outlast others.

What makes us so tough? For one thing, we use two pieces of sheet metal in our cab. Double-wall it, for strength.

And we build our independent front suspension to expect the worst from a road. Without getting rattled.

Another thing. We just won't leave well enough alone.

For instance, you can now order a powerful new additive for regular gas: a 400-cubic-inch V8.

It's not that we're out to make it tough for other trucks. We're out to make it easier for you.

Because putting you first, keeps us first.

CHEVROLET
On the move.

You'll still be washing it when other '70's are washed up.

Chevrolet Trucks, 1970

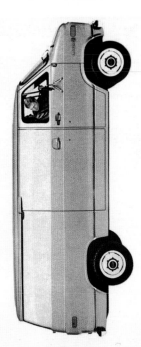

Chevrolet launches the space vehicle. '71 Chevy Van.

Chevrolet Vans, 1971

Tough going? Go Bronco! From its heavy-duty front axle and exclusive Mono-Beam front suspension all the way back, the 4-wheel-drive Bronco is tough—durable—reliable. Maneuverability is outstanding. You can turn in a small 33.6-foot circle. High ground clearance lets you bull through high drifts. The same wide track front and rear provides excellent off-road stability. Bronco's a great family car, too, with well-appointed, comfortable interiors. Easy to handle or park. Doesn't ride like an ordinary 4-wheeler. 6 or V8 engines available (V8 required in California). Make a date with your wife—to see your Ford Dealer.

No roads at all? That's Bronco country.

Smooth highways–Bronco country, too.

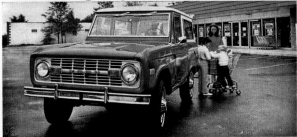

A better idea for safety: Buckle up.

FORD BRONCO *Ford*

Ford Bronco, 1972

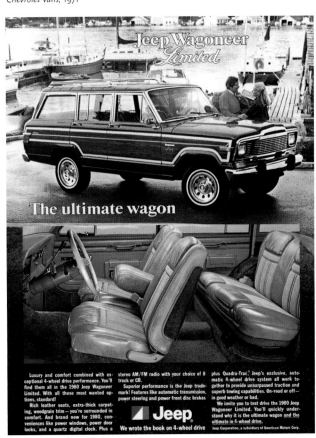

Luxury and comfort combined with exceptional 4-wheel drive performance. You'll find them all in the 1980 Jeep Wagoneer Limited. With all these most wanted options, standard!

Rich leather seats, extra-thick carpeting, woodgrain trim — you're surrounded in comfort. And brand new for 1980, conveniences like power windows, power door locks, and a quartz digital clock. Plus a stereo AM/FM radio with your choice of 8 track or CB.

Superior performance is the Jeep trademark! Features like automatic transmission, power steering and power front disc brakes plus Quadra-Trac,® Jeep's exclusive, automatic 4-wheel drive system all work together to provide unsurpassed traction and superb towing capabilities. On-road or off—in good weather or bad.

We invite you to test drive the 1980 Jeep Wagoneer Limited. You'll quickly understand why it is the ultimate wagon and the ultimate in 4-wheel drive.

Jeep We wrote the book on 4-wheel drive

Jeep Corporation, a subsidiary of American Motors Corp.

Jeep Wagoneer, 1979

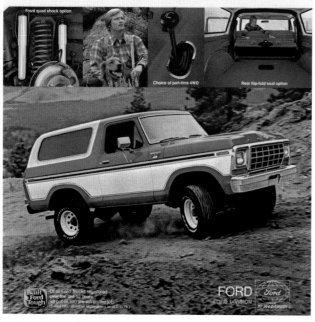

THE '78 FORD BRONCO.

COMPARE IT TO ANY 4-WHEELER, ANYWHERE.

The first 4-wheeler that puts it all together. Introducing Ford's all-new Bronco with... 1. Big cube 5.8L (351) V-8 standard... 2. Choice of part-time 4 WD with optional automatic... 3. Rear foot-well for seating comfort... 4. Rear flip-fold seat option for usable cargo space... 5. Four-speed transmission... 6. Front quad shock option... 7. Free Wheeling package option... 8. Off-road handling package option... 9. Privacy* Glass option... 10. Choice of bucket or optional front bench seats... 11. Front stabilizer bar. Bronco: Winner of the Four Wheeler Of The Year award from Four Wheeler magazine, October 1977.

Front quad shock option

Choice of part-time 4WD

Rear flip-fold seat option

Of all Ford Trucks registered over the last 12 years, 50 out of 100 are still on the job.

FORD
FORD DIVISION

Ford Bronco, 1978

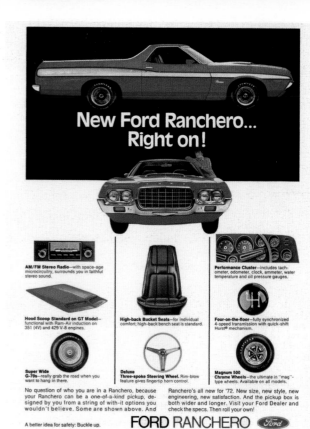

New Ford Ranchero... Right on!

AM/FM Stereo Radio—with space-age microcircuitry, surrounds you in faithful stereo sound.

Performance Cluster—includes tachometer, odometer, clock, ammeter, water temperature and oil pressure gauges.

Hood Scoop Standard on GT Model—functional with Ram-Air induction on 351 (4V) and 429 V-8 engines.

High-back Bucket Seats—for individual comfort; high-back bench seat is standard.

Four-on-the-floor—fully synchronized 4-speed transmission with quick-shift Hurst® mechanism.

Super Wide G-70s—really grab the road when you want to hang in there.

Deluxe Three-spoke Steering Wheel. Rim-blow feature gives fingertip horn control.

Magnum 500 Chrome Wheels—the ultimate in "mag"-type wheels. Available on all models.

No question of who you are in a Ranchero, because your Ranchero can be a one-of-a-kind pickup, designed by you from a string of with-it options you wouldn't believe. Some are shown above. And

Ranchero's all new for '72. New size, new style, new engineering, new satisfaction. And the pickup box is both wider and longer. Visit your Ford Dealer and check the specs. Then roll your own!

A better idea for safety: Buckle up.

FORD RANCHERO

Ford Ranchero, 1972

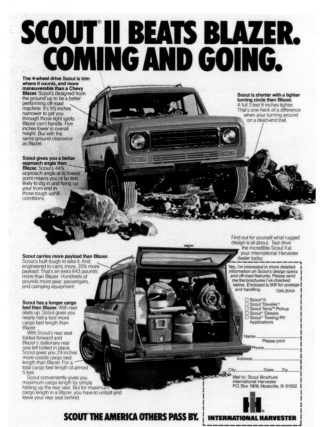

SCOUT II BEATS BLAZER. COMING AND GOING.

The 4-wheel drive Scout is trim where it counts, and more maneuverable than a Chevy Blazer. Scout's designed from the ground up to be a better performing off-road machine. It's 9½ inches narrower to get you through those tight spots Blazer can't handle. Five inches lower in overall height. But with the same ground clearance as Blazer.

Scout gives you a better approach angle than Blazer. Scout's 44% approach angle at its lowest point means you're far less likely to dig in and hang up your front end in those tough uphill conditions.

Scout carries more payload than Blazer. Scout's built tough to take it. And engineered to carry more. 35% more payload. That's an extra 643 pounds more than Blazer. Hundreds of pounds more gear, passengers, and camping material.

Scout has a longer cargo bed than Blazer. With rear seats up, Scout gives you nearly half a foot more cargo bed length than Blazer. With Scout's rear seat folded forward and Blazer's stationary rear seat left bolted in place, Scout gives you 29 inches more usable cargo bed length than Blazer. For a total cargo bed length of almost 5 feet. Scout conveniently gives you maximum cargo length by simply folding up the rear seat. But for maximum cargo length in a Blazer, you have to unbolt and leave your rear seat behind.

Scout is shorter with a tighter turning circle than Blazer. A full 3 feet 8 inches tighter. That's one heck of a difference when your turning around on a dead-end trail.

Find out for yourself what rugged design is all about. Test drive the incredible Scout II at your International Harvester dealer today.

Yes, I'm interested in more detailed information on Scout's design specs and off-road features. Please send me the brochures I've checked below. Enclosed is 50¢ for postage and handling. 706LBAM

☐ Scout II
☐ Scout Traveler*
☐ Scout Terra™ Pickup
☐ Scout Diesels
☐ Scout Towing/RV Applications

Name _____ Please print
Phone _____
Address _____
City _____ State _____ Zip _____

Mail to: Scout Brochure
International Harvester
P.O. Box 1909, Mossville, Ill. 61552

SCOUT THE AMERICA OTHERS PASS BY. INTERNATIONAL HARVESTER

International Harvester Scout, 1977

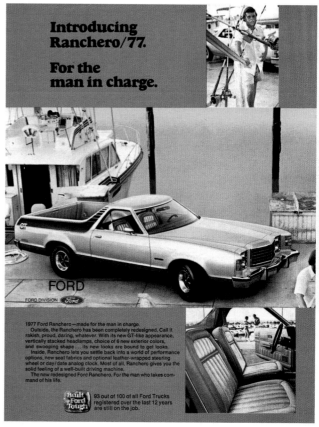

Introducing Ranchero/77.

For the man in charge.

FORD
FORD DIVISION

1977 Ford Ranchero—made for the man in charge.

Outside, the Ranchero has been completely redesigned. Call it rakish, proud, daring, whatever. With its new GT-like appearance, vertically stacked headlamps, choice of 6 new exterior colors, and swooping shape... its new looks are bound to get looks.

Inside, Ranchero lets you settle back into a world of performance options, new seat fabrics and optional leather-wrapped steering wheel or day/date analog clock. Most of all, Ranchero gives you the solid feeling of a well-built driving machine.

The new redesigned Ford Ranchero. For the man who takes command of his life.

93 out of 100 of all Ford Trucks registered over the last 12 years are still on the job.

Ford Ranchero, 1977 ▶ *Ford Ranchero, 1972*

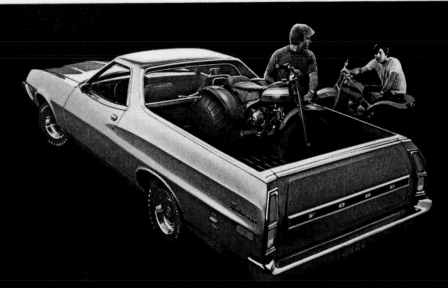

ew Ford Ranchero...the pickup car!

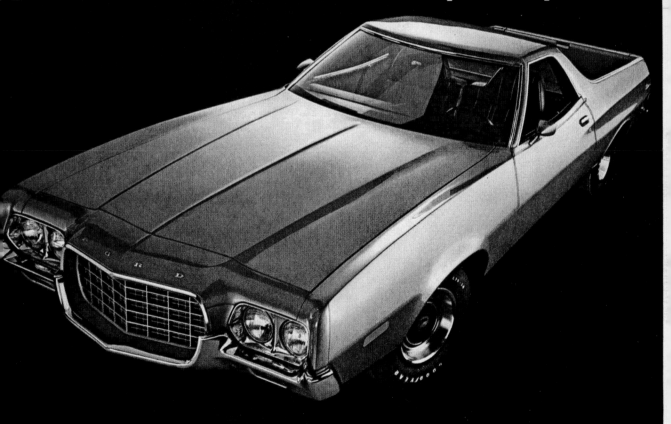

If you've an idea Ford's all-new Ranchero is a high-spirited sports car, you're right. If you think Ranchero is a handy, hard-working pickup, right again. For Ranchero is a beautiful blending of both. It offers a ride that's both smoother and quieter with a wheelbase that's four inches longer than last year. New strength and durability with a solid big-car frame. And clean responsive handling with a new link coil rear suspension. Front disc brakes are standard, and you can choose any of six spirited engines up to a 429 V8. Big new loadspace, too, with a new box that's longer at the rail and wider at the floor. 4-foot panels easily slide between wheelhousings. And campers or boaters will welcome a new towing capacity of up to 6,000 pounds. See a Ranchero 500, GT or Squire at your Ford Dealer's soon. With so much that's so right, you can't go wrong.

A better idea for safety: Buckle up.

All-new FORD RANCHERO

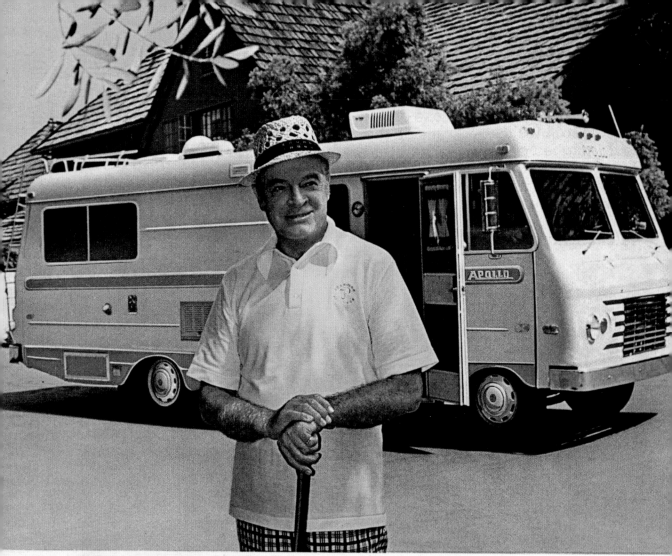

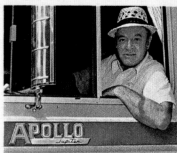

Bob Hope says, "*Cancel My Reservation,* I'll take my Apollo."

Bob Hope, star of Naho Enterprises Productions' "Cancel My Reservation," from Warner Bros., always uses his Apollo Motor Home for motion picture locations, mobile office, golf vacations, and cruising enjoyment. Bob says, "Apollo is the only way to go for safety and luxurious accommodations — it gives me all that privacy and Ring-Of-Steel construction."

You need no reservation to see your Apollo dealer for a new experience in first class living on-the-go. He will be delighted to show you Apollo's exciting, new 1973 line of 22, 25, and 30 foot models in a variety of floor plans and beautiful decorator-coordinated interiors. Features include a bath with sunken tub/shower, sparkling kitchen, and livingroom comfort all contained in a weatherproof, reinforced fiberglass body. Like Bob Hope, drive your Apollo today. For complete information and dealer nearest you, write Apollo Motor Homes, Inc., 9250 Washburn Road, Downey, Calif. 90242.

Select Dealerships available

RING OF STEEL CONSTRUCTION MEANS RING OF SAFETY

APOLLO MOTOR HOMES
a subsidiary of Kalvex Inc.

Watch Bob Hope Specials on NBC-TV

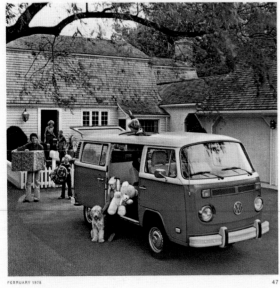

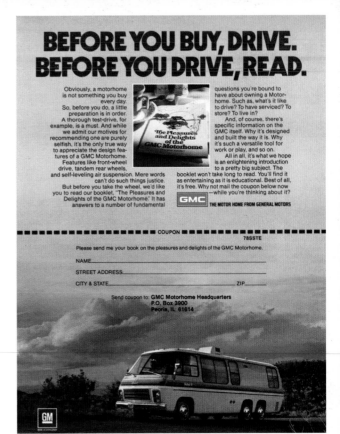

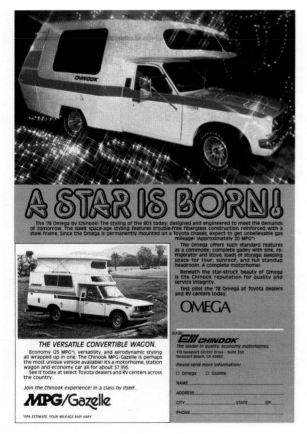

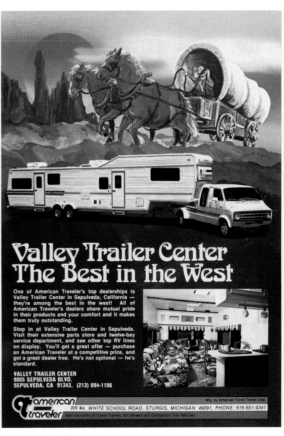

Volkswagen Bus, 1978

GMC Motorhomes, 1978

Apollo Motor Homes, 1972 ◄ Chinook RVs, 1978

American Traveler Trailers, 1979

And the winner is...

Women's Glib

Capitalizing on the jargon of a vibrant and active women's liberation movement, Honda's strategy sought to tap into a new breed of female customers. The advertisement's headline – proclaiming a long-held myth in a male-dominated market – was written to appeal to this emerging, independent consumer. The otherwise progressive text ultimately fell short of its anti-establishment approach with its last-ditch offer of an easy-to-drive Hondamatic transmission model. The woman may have been liberated, but she was still treated like a lady.

Frauen „bewegung"

Die Honda-Werbung macht sich den Jargon der lebendigen, aktiven Frauenrechtsbewegung der Zeit zunutze, um dadurch eine neue Generation von Kundinnen anzusprechen. Der Slogan der Werbung („Frauen fahren nur Automatikwagen") – ein Vorurteil, das auf dem von Männern dominierten Markt lange vorherrschte – sollte diese neue, unabhängige Verbraucherin ansprechen. Der ansonsten progressive Text wird letztendlich seinem establishment-kritischen Ansatz nicht gerecht, indem er, nur für den Fall aller Fälle, doch noch ein leicht zu fahrendes Modell mit Hondamatic Automatikschaltung anpreist. Die Frau war vielleicht gleichberechtigt, aber wie eine Dame wurde sie immer noch behandelt!

Femmes au volant

Exploitant le jargon du MLF, un mouvement dynamique et militant, la stratégie de Honda visait une nouvelle catégorie de consommatrices. Le titre de la publicité, dénonçant un mythe tenace sur un marché machiste « les femmes ne conduisent que des automatiques », était censé attirer une cliente indépendante et autonome. Toutefois, le texte en grande partie progressiste contredisait son approche anticonformiste en proposant en dernier ressort un modèle automatique « plus facile à conduire », la Hondamatic. Ce n'était pas parce que la femme était libérée qu'on ne devait plus faire preuve de galanterie.

Mujeres al volante

Aprovechando el tirón del movimiento activista pro liberación de la mujer, la estrategia de Honda pretendía atraer a una nueva generación de público femenino. El eslogan de este anuncio –una creencia largamente sostenida en un mercado dominado por los hombres: «Las mujeres sólo conducen transmisiones automáticas»–, estaba pensado para captar la atención de estas nuevas consumidoras independientes. Por desgracia, pese al tono progresista con el que intentaba desmoronar el mito machista, Honda cayó en sus propias redes y en su anuncio terminaba ofreciendo a las féminas el Hondamatic, un modelo de transmisión automática fácil de conducir. Las mujeres podían haberse liberado, pero la publicidad seguía tratándolas como a damas.

ウーマンリブもどき

当時、活気に満ちていた女性解放運動に乗じたホンダの戦略は、新しいタイプの女性たちの心に入り込もうというものだった。この広告のメインコピーは──長い間、男性中心の市場で語り継がれてきた神話を揶揄するもの──、独立した女性たちという新興勢力に向けて書かれたものだ。だが、さもなければ進歩的だった全体の文章も、最後の最後で運転が簡単なセミオートマ式「ホンダマティック」を薦めることで、反体制的な姿勢をつらぬき損ねた。女性たちは解放されたかもしれないが、やはり淑女扱いされているのだった。

"Women only drive automatic transmissions."

Some car manufacturers actually believe women buy cars for different reasons than men do.

So they build "a woman's car." Oversized, hopelessly automatic and dull.

At Honda we designed just one thing. A lean, spunky economy car with so much pizzazz it handles like a sports car.

If you're bored with cars designed only to get you from point A to point B, without responding to you the driver, maybe you ought to take the Honda Civic for a spin.

We've got a stick shift with an astonishing amount of zip. Enough to surprise you. We promise.

Or, if you prefer, Hondamatic.™ It's a semi-automatic transmission that gives you convenience, but doesn't rob you of involvement.

Neither one is a woman's car.

Honda Civic.
We don't make "a woman's car."

Honda Civic, 1974

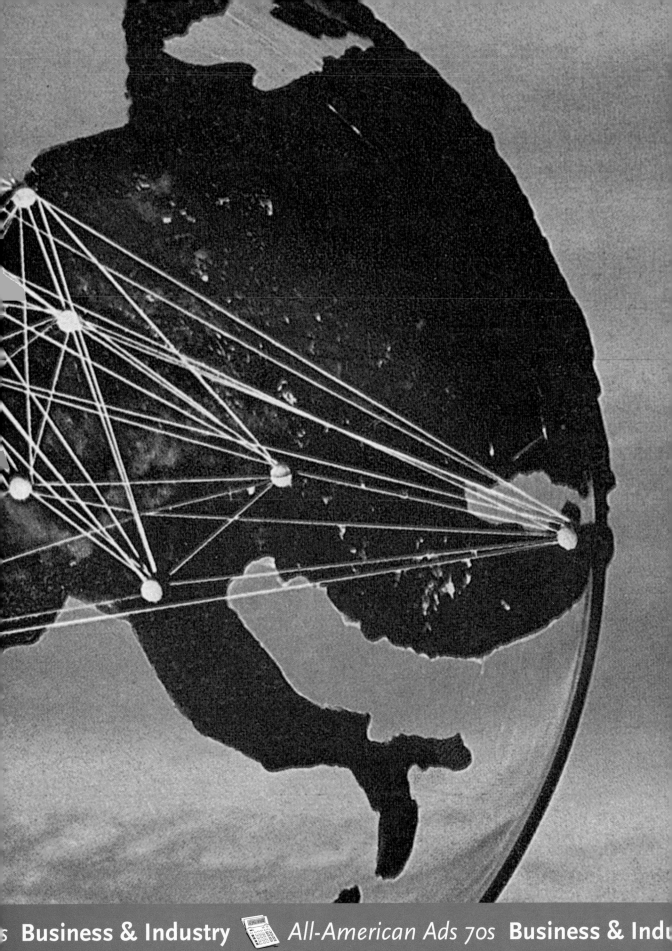

Otis
Elevator Company

Our future is a vertical marketplace FEB 7 6

It's a high-rise shopping center with the excitement of an old world bazaar and the convenience of true one-stop shopping. It's also a cultural center with drama, art and music. It's vertical because that's the best way to use our dwindling supply of urban land.

And because Otis has more than 60 years' experience in safely moving people, automatically, we know how to predict traffic patterns, handle load requirements and plan for the vertical and horizontal transportation requirements for such a marketplace.

When it's built, we'll combine conventional elevators and escalators with self-propelled horizontal elevators to speed you from floor-to-floor and shop-to-shop. Even move you quickly by automated transit from urban transportation and parking facilities into the shopping area.

Because we believe in the future growth of the world's cities, Otis research is working now on ideas to better move people and goods tomorrow.

Otis, a company in motion.

Chase Manhattan Bank, 1970 ◄◄ *Otis Elevator Co., 1974* ◄ *Otis Elevator Co., 1976*

We're providing new ways to move people

Westinghouse, 1970

while we provide new ways to help you prepare food.

Westinghouse is helping to eliminate the long, uncomfortable walk air passengers usually encounter between main terminals and planes.

In the new Tampa Airport our Passenger Transfer System can move over 6700 people to and from their planes in only 10 minutes and in total air-conditioned comfort.

Westinghouse is also helping to move people better in everything from new, fast, intercity Metroliners to new, high-speed elevators.

At the same time, Westinghouse helps you prepare better meals for your family by offering you a wide range of portable appliances, like the new Baconer™ for better tasting bacon.

Westinghouse is also active in pollution control, health services, better and safer lighting, nuclear power and urban redevelopment.

These are a few of the many ways Westinghouse serves you in your community and in your home.

You can be sure...if it's Westinghouse.

Westinghouse...we serve people

White Room Blues

Chased by clean gas heat.

White rugs? White walls? Don't wait, don't worry. The answer is gas heat. Gas has been called the immaculate fuel. It gives you more than a clean house. It's one energy source that doesn't pollute the air. For a clean, comfortable home and a cleaner world, choose thrifty gas heat. Check with your gas company or heating contractor.

Gas gives you a better deal.
AMERICAN GAS ASSOC. INC.

American Gas Association, 1970

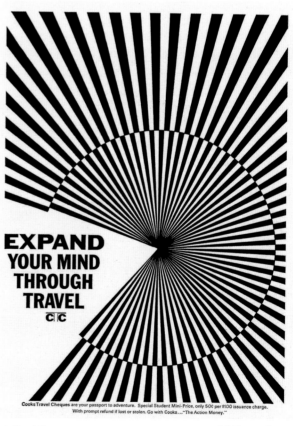

EXPAND YOUR MIND THROUGH TRAVEL
c|c

Cooks Travel Cheques are your passport to adventure. Special Student Mini-Price, only 50¢ per $100 issuance charge. With prompt refund if lost or stolen. Go with Cooks..."The Action Money."

Cooks Travel Cheques, 1970 ▶ *Otis Elevator Co., 1976*

Otis
Elevator Company

Our future is a high-rise health care center

It's a future group of specialty clinics surrounding an established general hospital, designed to provide complete services for preventive medicine as well as treatment of accidents and disease. They're high-rise because inner city hospitals are limited in the amount of land available near existing facilities.

We envision patients moving—in climate-controlled mobile units equipped with the latest life-support systems—on automated guideways from surgery to recovery units and on to recuperation areas.

When the first such high-rise health care complex is built, Otis will combine modern elevators, escalators and moving walks with computer-controlled supply systems and horizontal transporting systems. All designed with the comfort and safety of the patient uppermost in mind.

Because we're concerned with people, Otis research is working now on ideas to help the next generation live longer and better in our urban centers.

Otis, a company in motion.

Otis Elevator Co., 1976 ◄ *Otis Elevator Co., 1976*

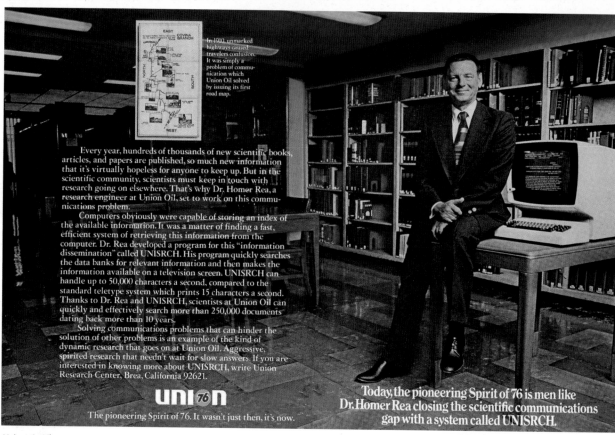

Every year, hundreds of thousands of new scientific books, articles, and papers are published, so much new information that it's virtually hopeless for anyone to keep up. But in the scientific community, scientists must keep in touch with research going on elsewhere. That's why Dr. Homer Rea, a research engineer at Union Oil, set to work on this communications problem.

Computers obviously were capable of storing an index of the available information. It was a matter of finding a fast, efficient system of retrieving this information from the computer. Dr. Rea developed a program for this "information dissemination" called UNISRCH. His program quickly searches the data banks for relevant information and then makes the information available on a television screen. UNISRCH can handle up to 50,000 characters a second, compared to the standard teletype system which prints 15 characters a second. Thanks to Dr. Rea and UNISRCH, scientists at Union Oil can quickly and effectively search more than 250,000 documents dating back more than 10 years.

Solving communications problems that can hinder the solution of other problems is an example of the kind of dynamic research that goes on at Union Oil. Aggressive, spirited research that needn't wait for slow answers. If you are interested in knowing more about UNISRCH, write Union Research Center, Brea, California 92621.

Union 76

The pioneering Spirit of 76. It wasn't just then, it's now.

Today, the pioneering Spirit of 76 is men like Dr. Homer Rea closing the scientific communications gap with a system called UNISRCH.

Union 76 Oil, 1975

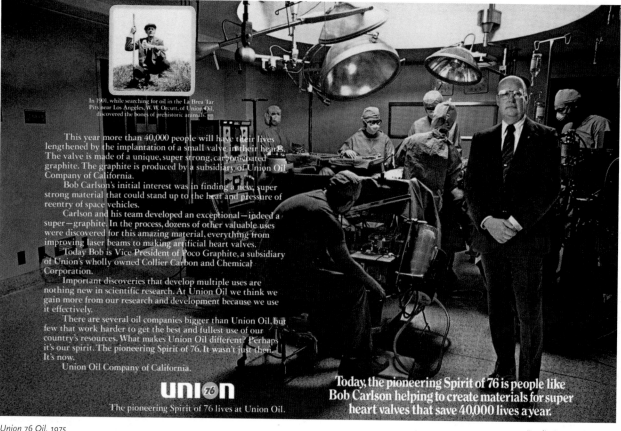

This year more than 40,000 people will have their lives lengthened by the implantation of a small valve in their hearts. The valve is made of a unique, super strong, carbon coated graphite. The graphite is produced by a subsidiary of Union Oil Company of California.

Bob Carlson's initial interest was in finding a new, super strong material that could stand up to the heat and pressure of reentry of space vehicles.

Carlson and his team developed an exceptional—indeed a super—graphite. In the process, dozens of other valuable uses were discovered for this amazing material, everything from improving laser beams to making artificial heart valves.

Today Bob is Vice President of Poco Graphite, a subsidiary of Union's wholly owned Collier Carbon and Chemical Corporation.

Important discoveries that develop multiple uses are nothing new in scientific research. At Union Oil we think we gain more from our research and development because we use it effectively.

There are several oil companies bigger than Union Oil, but few that work harder to get the best and fullest use of our country's resources. What makes Union Oil different? Perhaps it's our spirit. The pioneering Spirit of 76. It wasn't just then. It's now.

Union Oil Company of California.

Union 76

The pioneering Spirit of 76 lives at Union Oil.

Today, the pioneering Spirit of 76 is people like Bob Carlson helping to create materials for super heart valves that save 40,000 lives a year.

Union 76 Oil, 1975

▶ Bendix Corporation, 1970

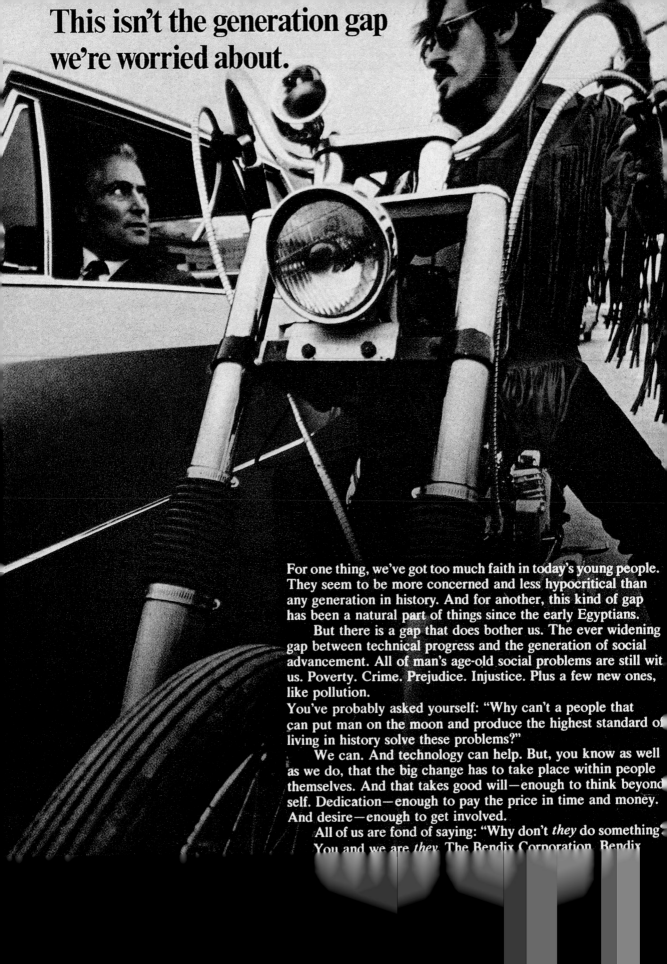

This isn't the generation gap we're worried about.

For one thing, we've got too much faith in today's young people. They seem to be more concerned and less hypocritical than any generation in history. And for another, this kind of gap has been a natural part of things since the early Egyptians.

But there is a gap that does bother us. The ever widening gap between technical progress and the generation of social advancement. All of man's age-old social problems are still wit us. Poverty. Crime. Prejudice. Injustice. Plus a few new ones, like pollution.

You've probably asked yourself: "Why can't a people that can put man on the moon and produce the highest standard of living in history solve these problems?"

We can. And technology can help. But, you know as well as we do, that the big change has to take place within people themselves. And that takes good will—enough to think beyond self. Dedication—enough to pay the price in time and money. And desire—enough to get involved.

All of us are fond of saying: "Why don't *they* do something. You and we are *they*. The Bendix Corporation. Bendix

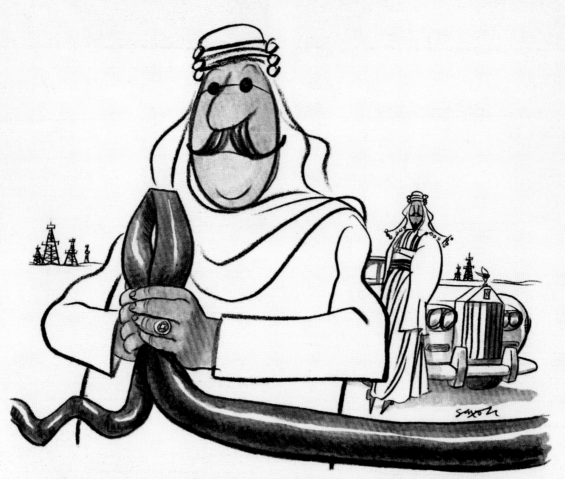

They're trying to tell us something.

We're foolish not to listen.

The Arab nations have indicated their intention to control oil production in order to keep prices up.

They're just not going to let the world use their limited resource as a cheap fuel.

For them it may be the right thing to do. For us it's a chilling signal and we should take warning.

What they're trying to tell us is we'd better stop depending on oil for so many uses. Oil should be used only when there is no practical alternative.

Unlike many nations, we're fortunate. We have a superabundance of coal that can be used instead of precious oil for many of our energy needs.

We're sitting on half the world's known supply of coal—enough for over 500 years.

It may well be impossible for us to become totally independent. But certainly we can reduce our dependence on foreign fuel.

We as a nation must make a commitment to coal. Face and solve any problems that exist.

And ask not if coal has a place in America's future, for coal is America's future. But ask only what needs to be done, by reasonable men, to use this vast and valuable asset.

Let's end this senseless delay. Let's pull our foot off the brake and get America going. Now!

American Electric Power Company, Inc.

Subsidiaries:
Appalachian Power Co., Indiana & Michigan Electric Co., Kentucky Power Co., Kingsport Power Co., Michigan Power Co., Ohio Power Co., Wheeling Electric Co.

American Electric Power Company, 1974

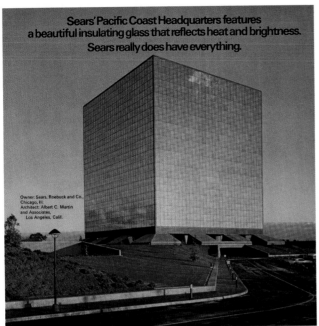

Sears' Pacific Coast Headquarters features a beautiful insulating glass that reflects heat and brightness.
Sears really does have everything.

Owner: Sears, Roebuck and Co.,
Chicago, Ill.
Architect: Albert C. Martin
and Associates,
Los Angeles, Calif.

When the architects of Sears' Pacific Coast Headquarters Building designed a perfect cube for this office/retail complex, they wanted a reflective glass that would satisfy both esthetic demands and long-range cost and comfort considerations.

Which is quite a challenge in southern California, where a building's most powerful enemies are brightness and solar heat.

To simplify the decisionmaking, PPG ran a computer analysis, combining site characteristics with eight

sets of performance figures for the building's skin.

From this analysis, the architects selected the most desirable glass. PPG *Solarban®* 480 *Twindow®* insulating glass.

Result: A cube reflecting 168 feet of cloud, sky, and California sunset. While inside, Sears people have everything. Visual comfort, economically controlled temperature, and an open, space-age quality that complements the building's pristine shape.

Consult your architect about the advantages of *Solarban* 480 *Twindow* insulating glass—or the others in our family of Environmental Glass. Write PPG Industries, Inc., One Gateway Center, Pittsburgh, Pa. 15222.

PPG: a Concern for the Future

 INDUSTRIES

PPG Industries Glass, 1973

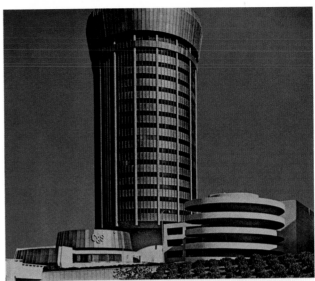

C&S Bank has a real interest in PPG Performance Glass.
It's saving them all kinds of money.

Atlanta's C&S North Avenue Branch Bank uses a PPG Performance Glass. *Solarbronze® Twindow®* Units. To save money.

Solarbronze Twindow Insulating Glass Units lower the burden on the building's central, all-air heating and cooling system. And studies proved that for the C&S Bank, these insulating glass units eliminated the need for supplementary underwindow heating/cooling units.

The result: less money was spent on original equipment. And for a long time to come, less money will be spent on maintenance

and annual operating costs.

Look into the moneysaving benefits of a PPG Performance Glass for your new building. Early in the design stages. The professional people do. Like C&S Bank.

There's a PPG Performance Glass to keep out the heat, keep out the cold, reduce brightness, or reflect like a mirror to enhance a building's beauty. And there are some to do it all. All give you a solid return on investment.

Write: PPG INDUSTRIES. One Gateway Center, Pittsburgh, Pennsylvania 15222.

C&S North Avenue Branch Bank, Atlanta
Architect: Aeck Associates, Inc., Atlanta
Mechanical Engineer:
Lazenby & Borum, Atlanta

PPG is Chemicals, Minerals, Fiber Glass, Paints and Glass. So far.

 INDUSTRIES

PPG Industries Glass, 1970

PPG GLASS: A SPECTACULAR MATERIAL THAT MANAGES ENERGY.

Once, glass was simply a transparent material to separate you from the weather.

But that innocent role has changed. Today, PPG glass is a building material that manages energy and the environment in commercial and residential buildings.

To arrive at this point, PPG pioneered in special coatings and fabrication technology, and we now produce glasses with widely varying characteristics to meet differing building needs with efficient, practical and graceful applications. PPG glass can insulate, reduce solar heat gain, conserve energy, and beautifully reflect the landscape, sky and clouds.

What PPG has been doing is researching, developing and marketing dependable, high-performance energy-management glasses to enhance the quality of our lives. Exactly what you would expect from the world leader in flat glass.

So when you need to manage energy, contact: PPG Industries, Inc., One Gateway Center, Pittsburgh, Pa. 15222.

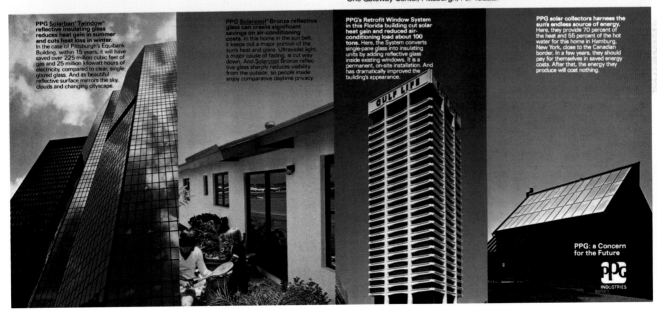

PPG **Solarban®** *Twindow®* reflective insulating glass reduces heat gain in summer and cuts heat loss in winter. In the case of Pittsburgh's Equibank Building, within 15 years, it will have saved over 225 million cubic feet of gas and 25 million kilowatt hours of electricity, compared to clear, single-glazed glass. And its beautiful reflective surface mirrors the sky, clouds and changing cityscape.

PPG **Solarcool®** Bronze reflective glass can create significant savings on air-conditioning costs. In this home in the sun belt, it keeps out a major portion of the sun's heat and glare. Ultraviolet light, a major cause of fading, is cut way down. And *Solarcool* Bronze reflective glass sharply reduces visibility from the outside, so people inside enjoy comparative daytime privacy.

PPG's Retrofit Window System in this Florida building cut solar heat gain and reduced air-conditioning load about 100 tons. Here, the System converts single-pane glass into insulating units by adding reflective glass inside existing windows. It is a permanent, on-site installation. And has dramatically improved the building's appearance.

PPG solar collectors harness the sun's endless source of energy. Here, they provide 70 percent of the heat and 55 percent of the hot water for this home in Hamburg, New York, close to the Canadian border. In a few years, they should pay for themselves in saved energy costs. After that, the energy they produce will cost nothing.

PPG: a Concern for the Future

INDUSTRIES

PPG Industries Glass, 1978

175

Fresh Thinking From The Packaging Company.

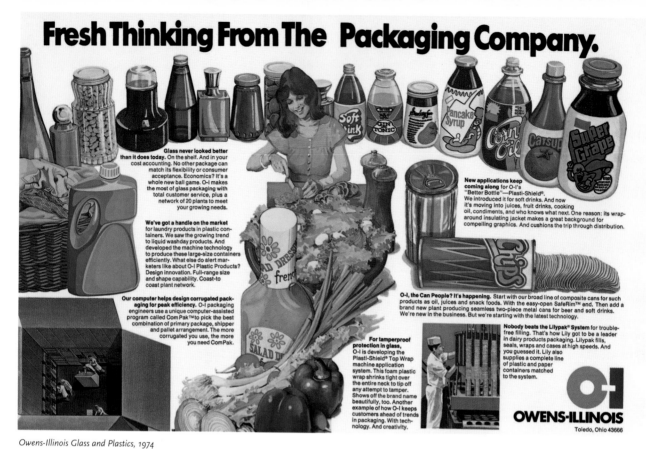

Glass never looked better than it does today. On the shelf. And in your cost accounting. No other package can match its flexibility or consumer acceptance. Economics? It's a whole new ball game. O-I makes the most of glass packaging with total customer service, plus a network of 20 plants to meet your growing needs.

We've got a handle on the market for laundry products in plastic containers. We saw the growing trend to liquid washday products. And developed the machine technology to produce these large-size containers efficiently. What else do alert marketers like about O-I Plastic Products? Design innovation. Full-range size and shape capability. Coast-to coast plant network.

Our computer helps design corrugated packaging for peak efficiency. O-I packaging engineers use a unique computer-assisted program called Com Pak™ to pick the best combination of primary package, shipper and pallet arrangement. The more corrugated you use, the more you need ComPak.

New applications keep coming along for O-I's "Better Bottle"—Plasti-Shield®. We introduced it for soft drinks. And now it's moving into juices, fruit drinks, cooking oil, condiments, and who knows what next. One reason: its wrap-around insulating jacket makes a great background for compelling graphics. And cushions the trip through distribution.

For tamperproof protection in glass, O-I is developing the Plasti-Shield® Top Wrap machine application system. This foam plastic wrap shrinks tight over the entire neck to tip off any attempt to tamper. Shows off the brand name beautifully, too. Another example of how O-I keeps customers ahead of trends in packaging. With technology. And creativity.

O-I, the Can People? It's happening. Start with our broad line of composite cans for such products as oil, juices and snack foods. With the easy-open SafeRim™ end. Then add a brand new plant producing seamless two-piece metal cans for beer and soft drinks. We're new in the business. But we're starting with the latest technology.

Nobody beats the Lilypak® System for trouble-free filling. That's how Lily got to be a leader in dairy products packaging. Lilypak fills, seals, wraps and cases at high speeds. And you guessed it. Lily also supplies a complete line of plastic and paper containers matched to the system.

O-I

OWENS-ILLINOIS
Toledo, Ohio 43666

Owens-Illinois Glass and Plastics, 1974

The Scientific Company And What We Make.

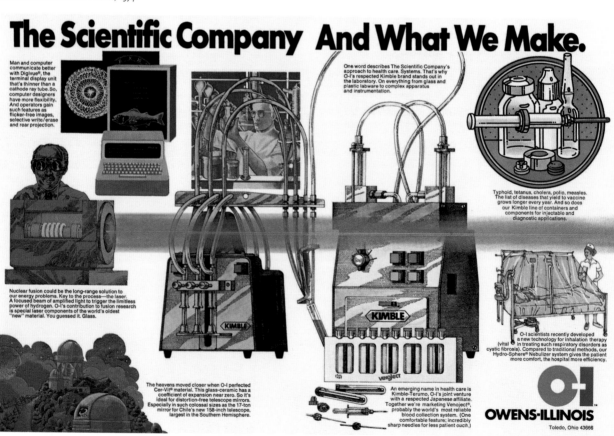

Man and computer communicate better with Digivue®, the terminal display unit that's thinner than a cathode ray tube. So, computer designers have more flexibility. And operators gain such features as flicker-free images, selective write/erase and rear projection.

One word describes The Scientific Company's approach to health care. Systems. That's why O-I's respected Kimble brand stands out in the laboratory. On everything from glass and plastic labware to complex apparatus and instrumentation.

Typhoid, tetanus, cholera, polio, measles. The list of diseases that yield to vaccine grows longer every year. And so does our Kimble line of containers and components for injectable and diagnostic applications.

Nuclear fusion could be the long-range solution to our energy problems. Key to the process—the laser. A focused beam of amplified light to trigger the limitless power of hydrogen. O-I's contribution to fusion research is special laser components of the world's oldest "new" material. You guessed it. Glass.

The heavens moved closer when O-I perfected Cer-Vit® material. This glass-ceramic has a coefficient of expansion near zero. So it's ideal for distortion-free telescope mirrors. Especially in such colossal sizes as the 17-ton mirror for Chile's new 158-inch telescope, largest in the Southern Hemisphere.

An emerging name in health care is Kimble-Terumo, O-I's joint venture with a respected Japanese affiliate. Together we're marketing Venoject®, probably the world's most reliable blood collection system. (One comfortable feature: incredibly sharp needles for less patient ouch.)

O-I scientists recently developed a new technology for inhalation therapy (vital in treating such respiratory disorders as cystic fibrosis). Compared to traditional methods, our Hydro-Sphere® Nebulizer system gives the patient more comfort, the hospital more efficiency.

O-I

OWENS-ILLINOIS
Toledo, Ohio 43666

Owens-Illinois Glass and Plastics, 1974

▶ AT&T Long Distance, 1970

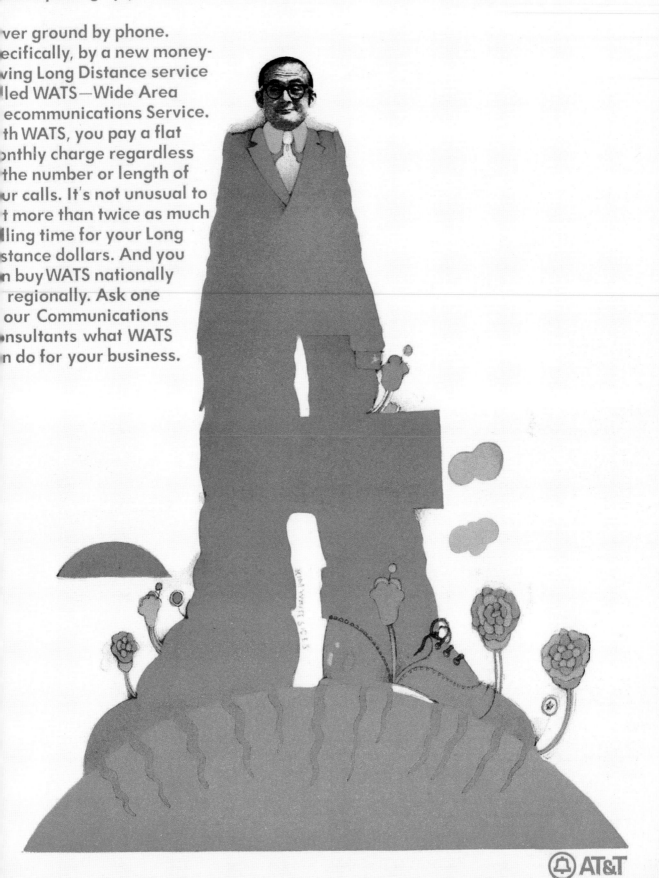

w to branch way out
thout pulling up your roots

ver ground by phone.
ecifically, by a new money-
ving Long Distance service
led WATS—Wide Area
ecommunications Service.
th WATS, you pay a flat
onthly charge regardless
the number or length of
ur calls. It's not unusual to
t more than twice as much
lling time for your Long
stance dollars. And you
n buy WATS nationally
regionally. Ask one
our Communications
nsultants what WATS
n do for your business.

AT&T

We're breaking into more banks than Bonnie and Clyde ever did.

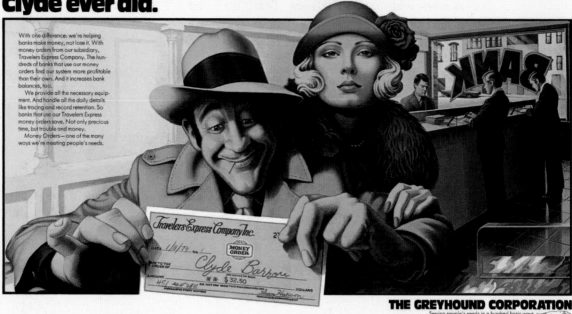

With one difference: we're helping banks make money, not lose it. With money orders from our subsidiary, Travelers Express Company. The hundreds of banks that use our money orders find our system more profitable than their own. And it increases bank balances, too.

We provide all the necessary equipment. And handle all the daily details like tracing and record retention. So banks that use our Travelers Express money orders save. Not only precious time, but trouble and money.

Money Orders—one of the many ways we're meeting people's needs.

THE GREYHOUND CORPORATION
Serving people's needs in a hundred basic ways.

KEY SUBSIDIARIES OF THE GREYHOUND CORPORATION:

TRANSPORTATION			LEASING—FINANCING—COMPUTERS	CONSUMER PRODUCTS AND PHARMACEUTICALS	FOOD	FOOD SERVICE	SERVICES	
Greyhound Lines	Carey Transportation	Loyal Travel Service	Greyhound Leasing & Financial	Armour-Dial	Armour Foods	Greyhound	Aircraft Services International	Florida Export Group
Greyhound Lines of Canada	Florida Parlor Car Tours	Motor Coach Industries	of the U.S., Canada, Switzerland,	Armour Pharmaceutical	Armour le Grys	Food Management	Border Brokers	General Fire & Casualty
Texas, New Mexico & Oklahoma Coaches	Gray Line of New York	Red Top Sedan Service	England, Japan, Hong Kong,		Klarer of Kentucky	Post Houses	Compass Insurance	Greyhound Rent-A-Car
American Sightseeing Tours of Miami	Gray Line of San Francisco	Trade Wind Transportation	Bermuda, Brazil		Moelzer Bros.	Prophet Foods	Consultants & Designers	Greyhound Temporary Personnel
Atlanta Airport Transportation	Greyhound World Tours	Walters Transit	Greyhound Guaranty Ltd., London			Restaura	Dispatch Services	Las Vegas Convention Service
Brewster Transport	Korea Greyhound	Royal Glacier Tours	Greyhound Computer				Freeport Flight Service	Manncraft Exhibitors Service
California Parlor Car Tours								Travelers Express Service

Greyhound Corporation, 1974

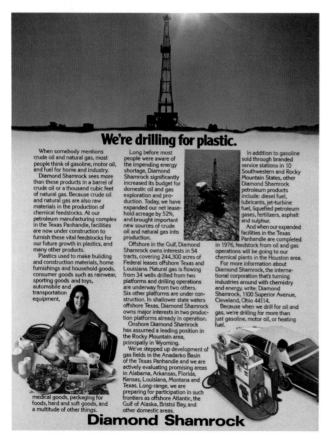

We're drilling for plastic.

When somebody mentions crude oil and natural gas, most people think of gasoline, motor oil, and fuel for home and industry.

Diamond Shamrock sees more than these products in a barrel of crude oil or a thousand cubic feet of natural gas. Because crude oil and natural gas are also raw materials in the production of chemical feedstocks. At our petroleum manufacturing complex in the Texas Panhandle, facilities are now under construction to furnish these vital feedstocks for our future growth in plastics, and many other products.

Plastics used to make building and construction materials, home furnishings and household goods, consumer goods such as rainwear, sporting goods and toys, automobile and transportation equipment,

medical goods, packaging for foods, hard and soft goods, and a multitude of other things.

Long before most people were aware of the impending energy shortage, Diamond Shamrock significantly increased its budget for domestic oil and gas exploration and production. Today, we have expanded our net leasehold acreage by 52%, and brought important new sources of crude oil and natural gas into production.

Offshore in the Gulf, Diamond Shamrock owns interests in 54 tracts, covering 244,300 acres of Federal leases offshore Texas and Louisiana. Natural gas is flowing from 34 wells drilled from two platforms and drilling operations are underway from two others. Six other platforms are under construction. In shallower state waters offshore Texas, Diamond Shamrock owns major interests in two production platforms already in operation.

Onshore Diamond Shamrock has assumed a leading position in the Rocky Mountain area, principally in Wyoming.

We've stepped up development of gas fields in the Anadarko Basin of the Texas Panhandle and we are actively evaluating promising areas in Alabama, Arkansas, Florida, Kansas, Louisiana, Montana and Texas. Long-range, we're preparing for participation in such frontiers as offshore Atlantic, the Gulf of Alaska, Bristol Bay, and other domestic areas.

In addition to gasoline sold through branded service stations in 10 Southwestern and Rocky Mountain States, other Diamond Shamrock petroleum products include: diesel fuel, lubricants, jet-turbine fuel, liquefied petroleum gases, fertilizers, asphalt and sulphur.

And when our expanded facilities in the Texas Panhandle are completed in 1976, feedstock from oil and gas operations will be going to our chemical plants in the Houston area.

For more information about Diamond Shamrock, the international corporation that's turning industries around with chemistry and energy, write: Diamond Shamrock, 1100 Superior Avenue, Cleveland, Ohio 44114.

Because when we drill for oil and gas, we're drilling for more than just gasoline, motor oil, or heating fuel.

Diamond Shamrock

Diamond Shamrock Plastic, 1975

A junkie's parents shouldn't be the last to know.

More and more kids are letting the temptation of drugs get to them. And a lot of them are the kind of kids you'd least expect to become addicts.

If you're a parent and you're frightened, you should be.

Some authorities say that of all the many young people who start experimenting with drugs out of curiosity, one in every three will become a regular user.

Metropolitan Life would like to tell you the facts about

Totally dependent on drugs to get through life.

You could talk to your kids about drugs, but your kids would know more than you do.

Because even if they're not into taking drugs, drugs are a very real part of young people's lives. And all you know are a parent's fears.

drugs you don't know, but definitely should.

We've written a booklet. A parent's primer. What drugs are. What they do. How drug use starts. What to do when you see it.

It's called "To Parents/About Drugs." If you'd like a copy for yourself or copies for your community group, write "Drugs," Metropolitan Life, 1 Madison Avenue, New York, N.Y. 10010.

It's only a booklet. But if you learn from it, it might be a help.

You can't help solve a problem if you don't know what the problem is.

Or that the problem is there. Possibly even closer than you think.

Metropolitan Life
We sell life insurance. But our business is life.

Metropolitan Life Insurance, 1971

How come there's no Moscow Mercantile Exchange?

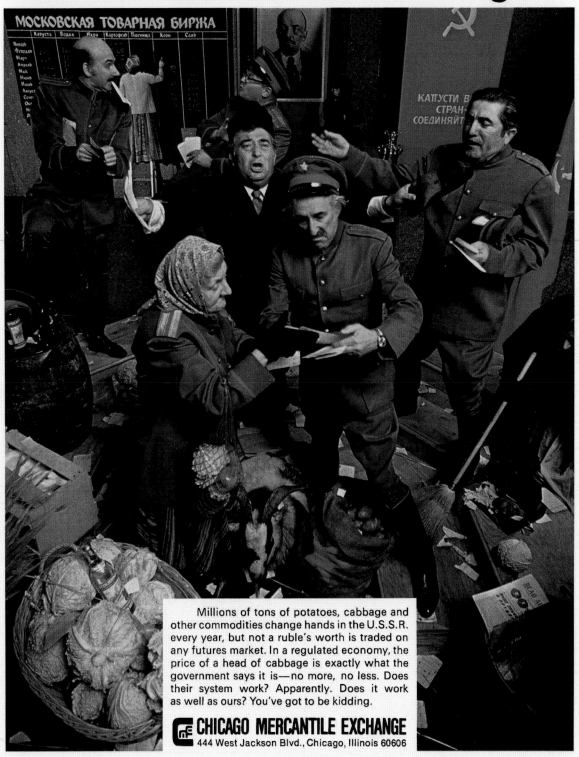

Millions of tons of potatoes, cabbage and other commodities change hands in the U.S.S.R. every year, but not a ruble's worth is traded on any futures market. In a regulated economy, the price of a head of cabbage is exactly what the government says it is—no more, no less. Does their system work? Apparently. Does it work as well as ours? You've got to be kidding.

CHICAGO MERCANTILE EXCHANGE
444 West Jackson Blvd., Chicago, Illinois 60606

Chicago Mercantile Exchange, 1974

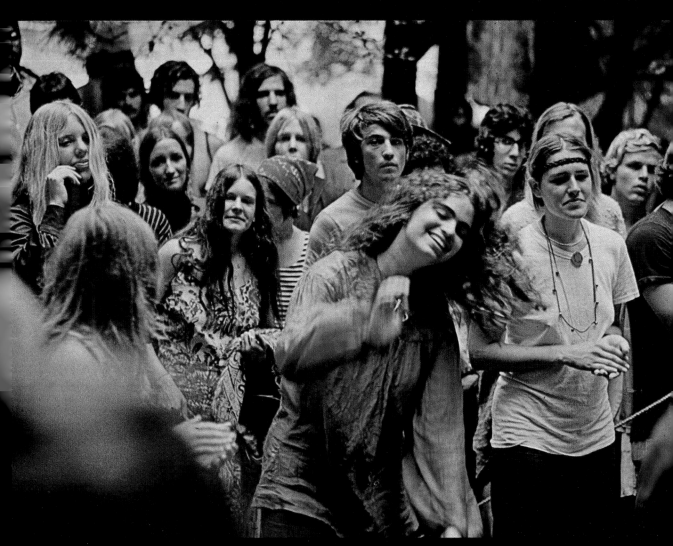

How LIFE deals with all those silly things that interest younger people.

Seriously.

LIFE didn't think last summer's Woodstock Festival was so silly. We sent our reporters and photographers to the Woodstock hills...and ended up with an entire issue devoted to the b rock concert in history.

And we don't see anything silly about college students speaking their minds. We take what say...about the war, about our cities, about our country ...and print it. Because a lot of it makes sense.

Which is the same conscientious way we handle all our stories. Whether they're about the friends of Prince Charles, the boom in astrology, or offbeat ideas in art.

There's nothing very silly about LIFE's low price either. 25 weeks of straight thinking and thorough reporting for just $2.95. Which is less than 12¢ an issue.

We'll even bill you later. After you've seen for yourself some serious coverage of the things that interest you.

Just send in the attached order card today while this bargain price is still in effect. Have y own copy of LIFE sent to you every week, and stay right on top of things.

What has Mr. Nixon ever really done for you?

Unless you want to see the civil rights gains of the 60's sabotaged further—or even wiped out—vote November 7 for George McGovern.

Richard Nixon is the one who went on nation-wide television to arouse anti-busing prejudice. Richard Nixon has talked about the undesirability of "forced integration of the suburbs," as if the right of every American to a home of his choice is somehow a bad thing.

During the Nixon Administration black unemployment has almost doubled—up to 9.7%. Among Black and minority youth in poverty areas, unemployment is up to 40%. And after introducing with great fanfare his "Philadelphia Plan" for requiring government building contractors to hire more minority workers, Nixon backed away from enforcing it.

Mr. Nixon recently vetoed a Health, Education and Welfare Bill that included $15 million for the treatment and prevention of Sickle Cell Anemia.

George McGovern, on the other hand, has always been one of the most steadfast friends of human rights.

• McGovern has co-sponsored every major civil rights bill during his ten years in the Senate.
• McGovern has been for years the leader in the fight to end U.S. involvement in Vietnam—a war that has killed and maimed a disproportionate number of Black Americans.
• McGovern is the only Senator who has fully supported the substance of the Black Caucus Congressional Black Bill of Rights.
• McGovern was the only member of Congress besides Rep. John Conyers to join in the March Against Fear in Atlanta in May, 1970...accepting the personal invitation of Mrs. Martin Luther King.

• McGovern is the principal sponsor in the Senate of the bill to make Rev. Martin Luther King's birthday a national holiday.

If he has done all these things as a Senator, imagine what McGovern will do as President?

• McGovern is committed to the vigorous enforcement of civil rights laws to wipe out discrimination in jobs, schools, housing and voting rights.
• McGovern has pledged full participation of Blacks, Browns, women and young people on all levels of his administration.
• McGovern would urge enactment of a National Health Security Program to guarantee the best possible medical care for every American.

• McGovern has revealed a plan that will guarantee a decent job to every able-bodied person who wants to work...and a decent income for those who are unable to work, including the aged, children, dependent mothers, and the disabled.
• McGovern wants to make quality education available to all Americans. He has proposed an additional $15 billion in new aid to local school systems—to greatly improve education and reduce property taxes at the same time.

Is it any wonder that George McGovern is the choice of Mrs. Coretta King, Rep. Julian Bond, Rev. Ralph Abernathy, Rep. Walter E. Fauntroy, Mayor Richard G. Hatcher, Mayor Ken Gibson, Louis Stokes and William Clay.

All Americans have a big stake in this election. Vote Nov. 7 for George McGovern and Sargent Shriver.

Authorized and paid for by McGovern-Shriver Campaign Committee • 1910 K Street, N.W., Washington, D.C. 20006 • Marian Pearlman, Treasurer

29

George McGovern, 1974

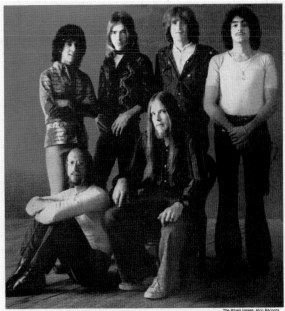

The Blues Image, Atco Records

Look who reads the Bible.

It can make things work for you.
It's that kind of book.
Read your Bible. You'll see.
If you don't have a Bible of your own,
we'll send you one for a dollar.
Hard cover and everything.
Just one should do it.
The Bible lasts a long time.

National Bible Week Committee
P.O. Box 1170, Ansonia Station
New York, New York 10023
Good. I'm sending you one dollar.
Please send me one Bible.

NAME
ADDRESS
CITY STATE ZIP

30th Annual National Bible Week, November 22-29, 1970. An interfaith effort.

National Bible Week Committee, 1970

You'd expect it from National.

The Affordable *Solar-Assisted* Homes.

They can cut your energy costs for space and water heating and cooling up to 60%* compared to an all-electric home.

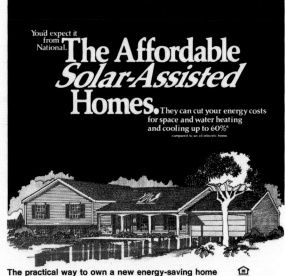

The practical way to own a new energy-saving home that starts saving you money from the very first day.

Here. Today . . . is a truly sensible answer to tomorrow's higher fuel costs. Homes that combine the economies of the sun with advanced energy-saving heating and cooling and insulation methods.

The result is a unique system: Revere's Sun Pride™ Water Heating System—the complete system for heating domestic water with solar energy; General Electric's Weathertron® Heat Pump with Climatuff™ Compressor—an electric system that cools without water, heats without burning fuel; STYROFOAM TG insulation sheathing—the unique insulation from The Dow Chemical Company covering

every square foot of wall (except door and window openings); National's own exclusive Thermo-Shield insulation system.

The energy-savings system is available in hundreds of floor plans in ranches, split-levels and two-story homes.

The energy savings can be significant. It's easy to prove it to yourself. Visit your National Homes Builder today.

*Based on an October, 1977 independent study of 42 cities using ASHRAE calculations comparing an 1161 sq. ft. ranch model on a crawlspace built to FHA Minimum Property Standards using electric resistance space and water heating and electric cooling with an identical house containing the Affordable Solar-Assisted Home package. Data available upon request. Savings will vary depending on climate, home size, type, location and orientation, fuel rates and family size.

CALL TOLL FREE
for the name of your nearest
National Homes Builder

800/621-8318

(In Illinois phone 800/972-8308)
Corporate Offices, Lafayette, IN 47902

National HOMES
THE GROWTH HOUSE COMPANY

MORE FAMILIES LIVE IN
NATIONAL HOMES
THAN ANY OTHER HOMES
IN THE WORLD

 GENERAL ELECTRIC THERMO-SHIELD REVERE STYROFOAM†
†Trademark of The
Dow Chemical Company.

Life Magazine, 1970 ◄ *National Homes, 1978*

"Sailing across the Atlantic we observed oil pollution on 43 out of 57 days"

Thor Heyerdahl, Ra Voyage, 1970

"When I was sailing across the Atlantic on a reed boat I had my nose literally in the water. I saw things no one can see who travels by fast boat.

"Fifty miles off the bulge of Africa we found we could not brush our teeth in the seawater—it was covered with oil. We sailed through this mess for two days, and a week later ran into more.

Oil pollutes the fish we eat

"On a second raft trip we sailed through water filled with lumps of

oil for 43 out of 57 days.

Great whales and many fish which swim with their mouths open, filtering their food, are swallowing this pollution. Some of those fish we shall eat.

The seas will suffocate

"There are people who tell you that oil does not matter, that the sea can absorb and recycle all this pollution. I call them the Sandmen—they want to put you to sleep with calming words. Don't listen!

"Unless you and I—all of us—act now to stop the seas being overloaded with poisonous refuse, they will suffocate and die."

That was 1970, but it goes on today—Nantucket, Cape Cod and Delaware Bay—and you don't see it, except in the press.

That is why World Wildlife Fund is campaigning to save the life and resources of the seas—for our own sakes and those of our children.

You can help

Send for our free information kit or send your tax-deductible contribution to: World Wildlife Fund, Department U-1, 1319 18th Street, Northwest, Washington, D.C. 20036.

THE SEAS
MUST
LIVE

World Wildlife Fund

World Wildlife Fund, 1978

181

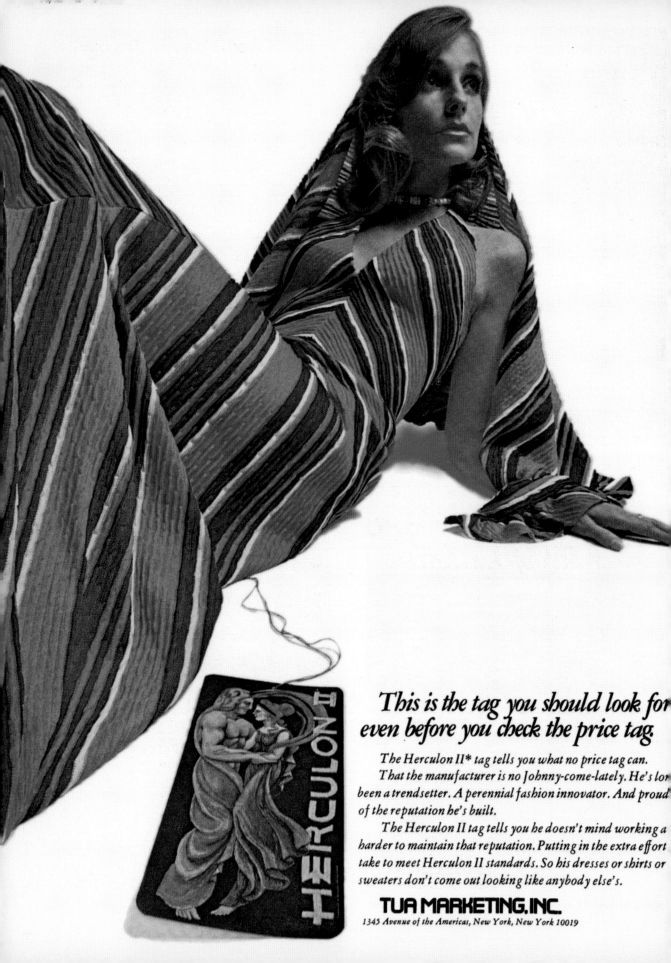

This is the tag you should look for even before you check the price tag.

The Herculon II* tag tells you what no price tag can.

That the manufacturer is no Johnny-come-lately. He's long been a trendsetter. A perennial fashion innovator. And proud of the reputation he's built.

The Herculon II tag tells you he doesn't mind working a harder to maintain that reputation. Putting in the extra effort take to meet Herculon II standards. So his dresses or shirts or sweaters don't come out looking like anybody else's.

TUA MARKETING, INC.
1345 Avenue of the Americas, New York, New York 10019

HERCULON II

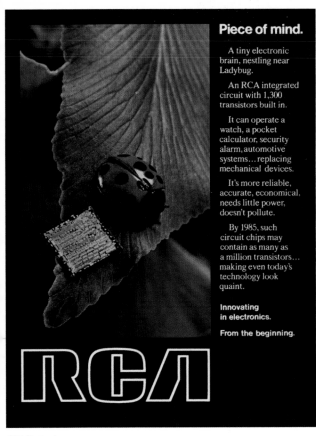

Piece of mind.

A tiny electronic brain, nestling near Ladybug.

An RCA integrated circuit with 1,300 transistors built in.

It can operate a watch, a pocket calculator, security alarm, automotive systems...replacing mechanical devices.

It's more reliable, accurate, economical, needs little power, doesn't pollute.

By 1985, such circuit chips may contain as many as a million transistors... making even today's technology look quaint.

Innovating in electronics.

From the beginning.

RCЛ

RCA Electronics, 1975

What's all this about Ecology?

It's child's play – and fun for adults, too – with Ecology Kits and Games.

The games are SMOG®, DIRTY WATER®, ECOLOGY® and POPULA-TION™. They challenge players of all ages to solve the crises and find the strategies of today's concerned world leaders. $10.00 each.

Ecology Kits help everyone from age 8 to adult uncover provocative natural mysteries. And beginning ecologists can *prove* their discoveries with fascinating experiments and projects. Eight different kits. $6.00 each.

The ecology kits and games are designed by Urban Systems – a team of ecology experts who think learning should be an adventure. And who care about the world our children will know.

BULLOCK'S · BUFFUM'S · MAY CO. · I. MAGNIN · F.A.O. SWARTZ · BROADWAY
and better toy stores

 URBAN SYSTEMS INC.
1033 Massachusetts Ave.
Cambridge, Mass. 02138

Urban Systems Inc., 1971

When you sign something special, think of Textron.

Why? Because whenever you take pen in hand, you're likely to be writing with a fine instrument from Textron's Sheaffer Division—pens, ballpoints and precision pencils crafted in a proud tradition.

Think about it. Textron is Sheaffer writing instruments. And Gorham pewter, silver, china and crystal. And Talon zippers.

And the one thing they all have in common is the very uncommon products they are.

Textron
A COMPANY TO THINK ABOUT.

TUA Marketing, 1972 ◄ Textron, 1975

The phone company wants more installers like Alana MacFarlane.

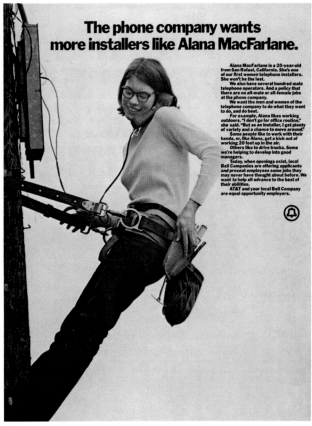

Alana MacFarlane is a 20-year-old from San Rafael, California. She's one of our first women telephone installers. She won't be the last.

We also have several hundred male telephone operators. And a policy that there are no all-male or all-female jobs at the phone company.

We want the men and women of the telephone company to do what they want to do, and do best.

For example, Alana likes working outdoors. "I don't go for office routine," she said. "But as an installer, I get plenty of variety and a chance to move around."

Some people like to work with their hands, or, like Alana, get a kick out of working 20 feet up in the air.

Others like to drive trucks. Some we're helping to develop into good managers.

Today, when openings exist, local Bell Companies are offering applicants and present employees some jobs they may never have thought about before. We want to help all advance to the best of their abilities.

AT&T and your local Bell Company are equal opportunity employers.

AT&T Telephone Services, 1972

AT&T Telephone Services, 1972

Pitney Bowes Copiers, 1974

Bell System PBX, 1974

► Bell System, 1979

"Halo everybody, halo?"

Reach out.
Reach out and touch someone.

Wherever you are, you're never too far to spend a few moments with someone special, someone who's waiting to hear from you. You can make your day by sharing it with faraway family and friends. Call to express your care, even if it's just to say hi. It means so much to keep in touch. So reach out. Reach out to those who make you feel good. You'll both feel good. With a phone call.

Bell System

Honeywell helps the little frogs compete with the big frogs.

Those big guys used to have the advantage. Because they had things like big, sophisticated computers that help them solve all kinds of important business problems.

Now the little guys can have the same advantages. Now you can have a small, sophisticated computer to help you solve all kinds of important business problems.

And Honeywell will make sure your first computer makes sense. We'll show you a small computer that can help you do your payroll, accounts receivable, accounts payable, and general ledger. And then we'll show you how your new Honeywell computer can help you run your business better. Step by step, we'll work with you to get your computer working on those important business problems — like inventory and job scheduling.

So, no matter what kind of business you're in — no matter what size your business is — chances are a Honeywell computer can make you a better businessman. And chances are, after a while, you'll find you're not such a small frog any more. (That's why we designed your computer to grow right along with you.)

If you've got big competition, don't wait another minute to find out more about Honeywell's little computers. Call your local Honeywell representative. Or write Honeywell Information Systems (MS 061), 200 Smith Street, Waltham, Massachusetts 02154.

The Other Computer Company:
Honeywell

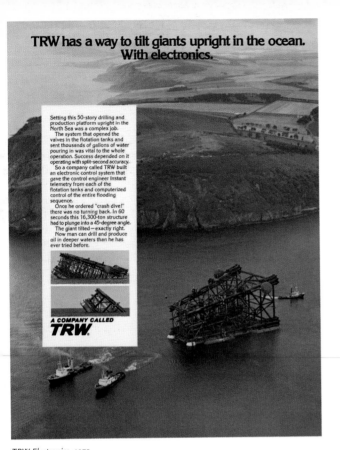

TRW has a way to tilt giants upright in the ocean. With electronics.

Setting this 50-story drilling and production platform upright in the North Sea was a complex job.

The system that opened the valves in the flotation tanks and sent thousands of gallons of water pouring in was vital to the whole operation. Success depended on it operating with split-second accuracy.

So a company called TRW built an electronic control system that gave the control engineer instant telemetry from each of the flotation tanks and computerized control of the entire flooding sequence.

Once he ordered "crash dive!" there was no turning back. In 60 seconds this 16,300-ton structure had to plunge into a 45-degree angle.

The giant tilted—exactly right. Now man can drill and produce oil in deeper waters than he has ever tried before.

A COMPANY CALLED TRW

TODAY ALUMINUM IS SOMETHING ELSE

It's camaraderie. You can take mini-bikes of Alcoa® aluminum anywhere ... any way. Take 'em on trails or beaches. By boat or plane. They're strong and light. Love company.

It's sportiveness. Pools and diving boards of Alcoa aluminum are all fun. Won't crack, split or peel. Don't need constant repainting. Last one is ***.

It's hedonism. Easy-open cans of Alcoa aluminum are part of the good life. Open with one pull. Take it easy. There are other things to work at.

It's epicureanism. Enjoy. Full course meals in Alcoa aluminum formed containers are a banquet without bother. Aluminum holds in fresh flavor. Heats evenly. Serves up a sizzling feast in minutes.

It's serenity. Golf with an easy conscience. Your house covered with Alcoa siding doesn't need you. Needs almost no maintenance. So take it easy. Brush off the brush. Forget the scraper.

It's sensuousness. Sigh. Nothing beats the comfort of Alcoa aluminum lawn furniture. Light and easy to move. Sturdy. It doesn't need painting. Gives you nothing but comfort. Yawn.

And Alcoa is something else again.

ALCOA

TRW Electronics, 1975

Alcoa Aluminum, 1971

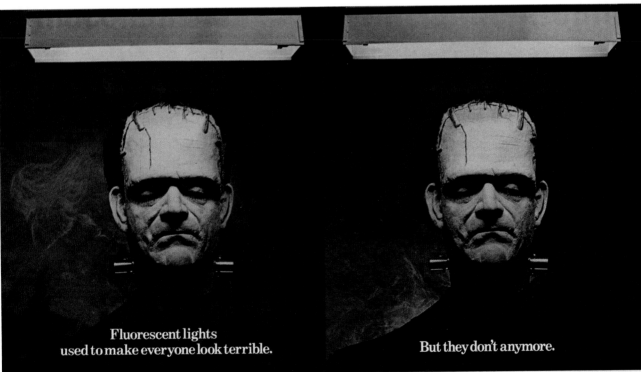

Fluorescent lights used to make everyone look terrible.

But they don't anymore.

ACTUAL FLUORESCENT LIGHTING

On an autumn evening in 1939, thousands of housewives turned on the first fluorescent lights.

That same evening, fluorescent lights turned off thousands of housewives.

The new lights were twice as bright as lightbulbs and could last longer on less electricity. However, they had a glaring disadvantage: They made everything look funny.

Filet mignon looked embalmed. Colors changed color. And even the loveliest of women turned an unlovely shade of blue.

Ever since that night, lightbulb makers have been trying to take the ugliness out of fluorescent lighting.

Finally, one of them did it. Our very own Sylvania company, we're proud to point out.

They came up with a lamp that has all the advantages of a fluorescent—plus the warm friendly glow of a good old lightbulb.

It's called the Incandescent/Fluorescent. And it's the nearest thing yet to a flattering fluorescent.

In the modest words of a Sylvania engineer who worked on it, "It may or may not make people look *better*. But at least it won't make them look worse."

General Telephone & Electronics
730 Third Ave., N.Y., N.Y. 10017

Honeywell Computers, 1973 ◄ *General Telephone & Electronics, 1970*

Most offices are not as productive as they could be.

Today, one big problem facing the office is the rising cost of handling an ever-increasing volume of necessary paperwork.

The average secretary, for example, simply can't get work out faster than the secretary of a generation ago. And yet, the cost of the typical one-page business letter has more than doubled, to the point where it's now in the $4 to $9 range.

In view of this, we have taken a hard look at the question of office productivity, what contributes to it and what detracts from it. And we've found that one of the most critical areas is the way people think about their office equipment and how it functions.

Introducing a new way of thinking about office productivity.

When they look around an office, many businessmen view equipment as an individual typewriter here, an individual dictating machine there, a copying machine somewhere else, without thinking of them as part of a total communications system.

But the fact is, they are the components of a system we call word processing.

In word processing, ideas and words are the starting point and the typed page, ready for signature or distribution, is the result. And the more consciously office equipment is viewed as a part of a word processing system, the more readily it can be drawn together into an efficient system.

Introducing a new terminology.

With all this in mind, we are putting forth some new terminology that reflects the word processing aspect of office equipment more accurately than words like "dictating equipment" or "typewriter". A terminology which, hopefully, encourages a more comprehensive point of view.

First, there is *input*. Ideas and words in their raw form. Input is recorded on *input processing equipment*, such as IBM dictating machines or with something as simple as a stenographer's shorthand pad and pencil.

Second, there is *output*. The raw ideas and words put into finished distributable form. This is accomplished by means of *output processing equipment*, which can be as simple as an IBM typewriter or as sophisticated as the latest IBM magnetic keyboard typewriter and IBM copier.

Third, there is *throughput*. Total productivity, which can be measured in terms of efficiency or cost.

Introducing an expanded line of input processing equipment.

Since input processing equipment can by itself cut the time needed to get material out by more than 25 per cent, and since every office has its own needs, we are now making our input processing equipment available in more models, and more flexible ones, than ever before.

Our new Tone Input System permits an executive to call in from any push-button telephone anytime, anywhere. And an improved Dial Input System and Microphone Input System are also available along with portable and desk-top input units.

Simply call a Representative of our Office Products Division. He'll arrange to give you all the information you need about our expanded line of input processing equipment, and, more important, discuss which combination of input and output processing equipment can best help your office become as productive a place as you would like it to be.

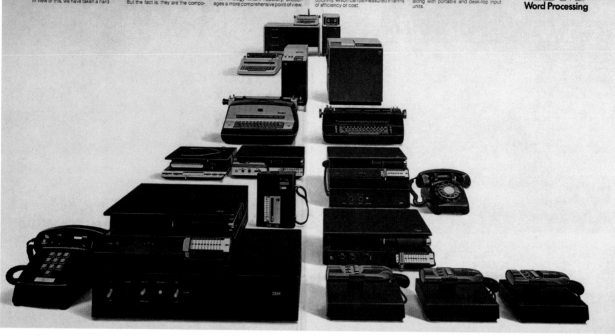

IBM Word Processors, 1972

What do you see when you look at your newspaper?

It depends on your perspective.

You might see a source of information that helps you spend your money wisely, invest your money wisely, act responsibly.

You might see a source of employment for a diversity of people—publishers, printers, journalists, truck drivers, your 12-year old son perhaps.

Or you might see the short-lived ghost of a once-proud tree.

We see all these things, and more.

We see a big part of a business our employees and shareholders depend on.

We're one of the world's largest suppliers of paper products: business, writing, printing, publishing, packaging, forms papers, corrugated and, of course, newsprint.

We also see the trees that stand behind these products, and we recognize that, as the song says, you can't have one without the other.

But we can have both.

We strive to manage our forests in a way that reconciles your perspectives and ours, to provide satisfactory jobs, products, profits and thriving trees.

If we succeed, everybody wins. You the consumer, worker, investor and citizen. And we the employees and shareholders of Boise Cascade.

Reason enough to try, don't you think?

Boise Cascade Corporation
A company worth looking at.

Boise Cascade Corporation Paper Products, 1978

Visitors Center and grounds of the Connecticut Yankee Atomic Power station, Haddam, Connecticut.

"Go play in the nuclear power park."

It's possible, you know.

The grounds adjacent to nuclear power plants are safe and clean enough for children's playgrounds.

In fact, today, most nuclear power plants are places of education and enjoyment for thousands of adults and children who visit them. However, in spite of the visitors and the safety credentials, some people may become uneasy when they hear a nuclear power plant is planned for their vicinity.

They ask questions.

And they want straight answers.

"Is a nuclear reactor in a plant the same kind of thing as an atomic bomb?"

Absolutely not.

It's physically impossible to have an atomic explosion in a reactor, because the heat needed by the plant to make steam is created with very dilute fuel. A nuclear expert couldn't make this dilute fuel produce an atomic explosion if he tried.

Except for the heat source, the process of producing electricity in a nuclear power plant is identical to an ordinary steam electric plant fired by coal, gas or oil.

"If nuclear power plants aren't dangerous, why do some people think they are?"

Partly because there is a great tendency to equate nuclear fuel sources with nuclear explosions. This is the result of far more publicity about bombs than about power-producing nuclear fuel.

The fact is, before the go-ahead is ever given to build a nuclear power plant, the Atomic Energy Commission requires that the potential owner adhere to safety standards that will withstand every conceivable emergency, including natural catastrophies such as earthquakes, tidal waves, tornadoes and the most destructive hurricanes.

How effective are these controls? Never has a utility-operated nuclear power plant in this country adversely affected public health.

There are 19 full-scale nuclear power stations operating in 11 states. After more than 10 years of operating experience (a total of over 100 reactor years of operation), not a single employee of a utility-operated nuclear power plant has ever been injured by radiation.

"Do nuclear power plants pollute the environment with harmful levels of radiation?"

No.

But radiation does exist in widely varying degrees throughout our environment. It's everywhere. It always has been.

— Natural radiogases in the air expose each American to an average of 5 millirems of radiation a year.

A millirem is 1/1000 of a rem, the standard unit of measurement of the biological effect of radiation.

Cosmic rays expose us to another 30 millirems. This varies widely depending at what elevation we live.

— Natural radiation is in the earth. Radioactive materials in the soil and rock expose us to an average 20 millirems each year.

— Natural radiation is in our buildings. A concrete or stone house might expose us to about 55 millirems or more of radiation, a brick house somewhat less, a wooden house very little.

— Natural radiation is also in everything we eat and drink. 25 millirem exposure per year on the average. But this again varies with type of food and locale.

Now, how significant is man-made radiation from nuclear power plants in comparison with this ever-present natural background radiation?

Present operating experience tells us this.

A person living in the vicinity of a typical nuclear power plant, 24 hours a day for a full year, would receive 5 millirems or less of radiation from the plant.

The Atomic Energy Commission has spent millions of dollars researching the nature and effects of radiation: natural, medical and industrial. Developing nuclear power plants which are most compatible with the environment is a major purpose of these studies.

"Why can't electricity be made like it always has without using anything nuclear?"

It can, and is. Right now, only 1% of the electricity generated in this country is produced by nuclear power plants. The other 99% comes from fossil fuel (coal, gas or oil) or hydro (falling water) plants.

However, this ratio will have to change to keep up with future power needs.

Fossil fuels are not available in an inexhaustible quantity. As for hydroelectric plants, falling water must be harnessed to convert into power. Nearly all of these unique hydropower sites have already been developed.

Nuclear power, on the other hand, is the newest, most versatile, and, in some areas, the most economical means of meeting electric energy needs. Without it this nation's energy supply could someday become inadequate.

Our country's ability to do the work that needs to be done will depend on an adequate supply of electricity. There's no time to waste. New generating facilities must be built, and built in a way compatible with our environment.

We'll continue working to do this. But we need your understanding today to meet tomorrow's needs.

The people at your Investor-Owned Electric Light and Power Companies.*

*For names of sponsoring companies, write to: Power Companies, 1345 Avenue of the Americas, New York, New York 10019

Investor-Owned Electric Light & Power Companies, 1971

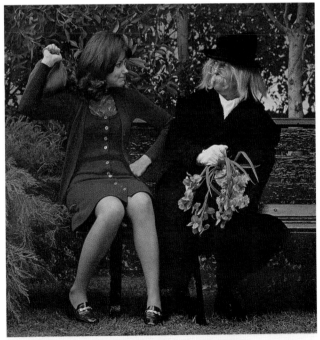

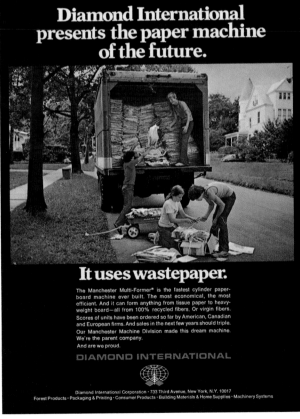

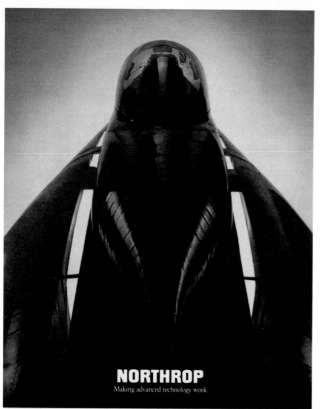

NORTHROP

Making advanced technology work.

Aerodynamically sculptured fuselage and wing of Northrop's prototype of the F-18 strike fighter. Northrop is associated with McDonnell Douglas, prime contractor to the U.S. Navy, for development and production of the F-18. Northrop will be prime contractor for derivatives designed for land-based operations.

Northrop Defense, 1978

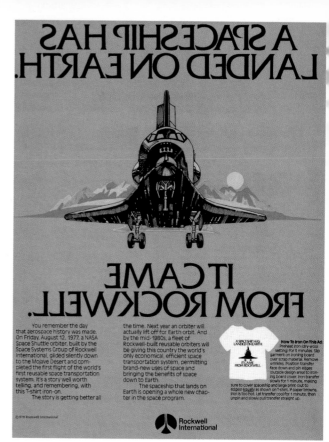

A SPACESHIP HAS LANDED ON EARTH.

IT CAME FROM ROCKWELL.

You remember the day that aerospace history was made. On Friday, August 12, 1977, a NASA Space Shuttle orbiter, built by the Space Systems Group of Rockwell International, glided silently down to the Mojave Desert and completed the first flight of the world's first reusable space transportation system. It's a story well worth telling, and remembering, with this T-shirt iron-on.

The story is getting better all the time. Next year an orbiter will actually lift off for Earth orbit. And by the mid-1980s, a fleet of Rockwell-built reusable orbiters will be giving this country the world's only economical, efficient space transportation system, permitting brand-new uses of space and bringing the benefits of space down to Earth.

The spaceship that lands on Earth is opening a whole new chapter in the space program.

© 1978 Rockwell International

How To Iron On This Ad: Preheat iron to dry-wool setting for 5 minutes. Slip garment on ironing board over scrap material. Remove wrinkles. Position transfer face-down and pin edges (outside design area) to ironing board cover. Iron transfer slowly for 1 minute, making sure to cover spaceship and large print (out to edges) equally as shown on T-shirt. If paper browns, iron is too hot. Let transfer cool for 1 minute, then unpin and slowly pull transfer straight up.

Rockwell International

Rockwell International Defense, 1978

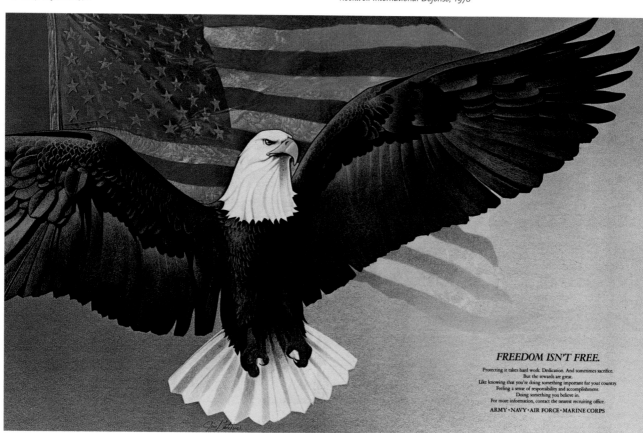

FREEDOM ISN'T FREE.

Protecting it takes hard work. Dedication. And sometimes sacrifice.
But the rewards are great.
Like knowing that you're doing something important for your country.
Feeling a sense of responsibility and accomplishment.
Doing something you believe in.
For more information, contact the nearest recruiting office.
ARMY · NAVY · AIR FORCE · MARINE CORPS

U.S. Armed Forces, 1978

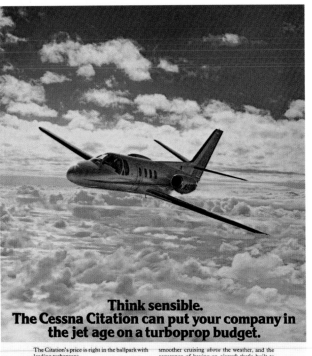

Think sensible.
The Cessna Citation can put your company in the jet age on a turboprop budget.

The Citation's price is right in the ballpark with leading turboprops.

And the Citation's total *operating* cost of about $1.00 per mile (based on 600 hours flying per year), including all fixed expenses and depreciation, is actually *lower* than that of competing turboprops.

Think sensible. The Citation jet also gives you up to 100 mph more speed than turboprops, superior short-field performance, comparable roominess with less noise and vibration, smoother cruising *above* the weather, and the assurance of having an aircraft that's built to the more stringent standards of FAR 25, like *commercial* jetliners.

Would you like a color brochure with more reasons why the sensible Citation is the world's best-selling business jet? Write: James B. Taylor, VP, Cessna, Dept. 16M, Box 1107, Wichita, Kansas 67201.

CESSNA/CITATION
Ⓜ Member of GAMA

Cessna Jets, 1975

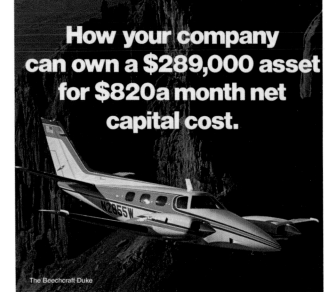

How your company can own a $289,000 asset for $820 a month net capital cost.

The Beechcraft Duke

It's simple. Buy a Beechcraft Duke like the one shown here. You'll be getting an airplane worth every bit of its $289,000 average factory delivered price.

However, when it comes to business airplanes, the list price is but a factor of the true cost of ownership.

You have to consider trade-in value (Beechcrafts historically are at the very top end of the scale). You have to consider Investment Tax Credit. You have to consider tax savings on depreciation.

With the various factors taken into account, for many corporations, the net capital cost of a $289,000 Duke comes to around $820 a month over a 6-year depreciation period.

For this surprisingly low cost, you get one of the most admired high-performance airplanes in aviation. The pressurization and air-conditioning let you fly at high altitudes in a controlled "living room" environment.

With such an airplane at your command, you go where you want to go when you want to go there. You make your own schedules. The savings in executive time alone can make the Duke B60 a sound business investment.

But, please, don't take our figures for granted. Work them out for yourself or with your CPA. We'll be happy to send you the raw materials. Read the information in the coupon on this page.

Of course, we're well aware you might be interested in something other than the Duke B60. By happy coincidence, we offer a whole range of airplanes.

Whatever your company's needs, we think we can provide you an asset that fits them.

You can afford a Beechcraft. Make us prove it.

We want to prove to you the advantages of owning your own Beechcraft. Write us on your company letterhead for our Business Flying Kit complete with the exclusive Beechcraft Capital Recovery Guide. Address: Beech Aircraft Corporation, Department B, Wichita, Kansas 67201. P.S. Please mention if you're a pilot. If you want to call, make it collect. Ask for Art Cross, (316) 689-7080.

Beechcraft

Beechcraft Jets, 1974

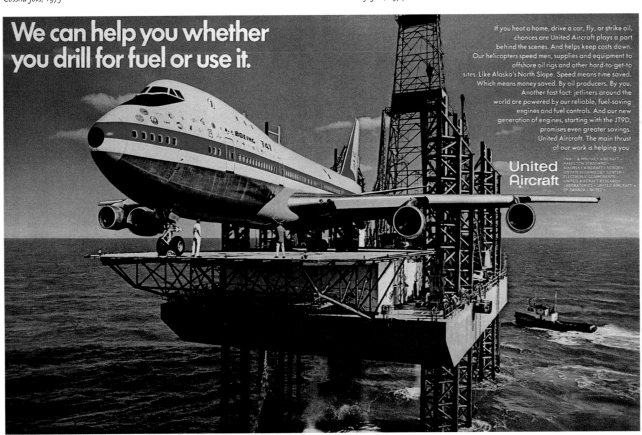

We can help you whether you drill for fuel or use it.

If you heat a home, drive a car, fly, or strike oil, chances are United Aircraft plays a part behind the scenes. And helps keep costs down. Our helicopters speed men, supplies and equipment to offshore oil rigs and other hard-to-get-to sites. Like Alaska's North Slope. Speed means time saved. Which means money saved. By oil producers. By you.

Another fast fact: jetliners around the world are powered by our reliable, fuel-saving engines and fuel controls. And our new generation of engines, starting with the JT9D, promises even greater savings. United Aircraft. The main thrust of our work is helping you.

United Aircraft

PRATT & WHITNEY AIRCRAFT · HAMILTON STANDARD · SIKORSKY AIRCRAFT · NORDEN · UNITED TECHNOLOGY CENTER · ELECTRONIC COMPONENTS · UNITED AIRCRAFT RESEARCH LABORATORIES · UNITED AIRCRAFT OF CANADA LIMITED

United Aircraft Instruments, 1970

191

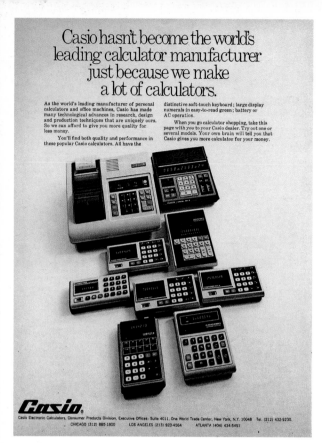
Casio Electronic Calculators, 1974

IBM Computers, 1978

Xerox Copiers, 1975

▶ *Olivetti Typewriters, 1970*

The tree is a beautiful mechanism for storing solar energy. But what's it being stored for?

1. The sun literally bombards the earth with energy. Enough each day to supply America's total energy needs for the next 60 years.

2. Man has dreamed of harnessing and storing the sun's energy for centuries. But now, with the fossil fuel shortage, it's even more urgent. Many solar energy experiments are going on all over the world. This is a solar furnace being constructed in New Mexico.

3. The tree is one of Nature's ways of storing solar energy. It takes in solar energy and carbon dioxide through its leaves, minerals and water through its roots, and stores all this in the form of chemical energy—or wood. And, as a company that does everything from grow the tree to make it into wood and paper products, we believe it's being stored for the benefit of Man as well as Nature.

4. One of the oldest ways of recapturing the solar energy stored in wood is to burn it. This converts wood back into energy, or heat. We actually do this in our mills as part of our maximum utilization program. In Montana, for instance, we burn waste wood, such as sawdust, bark and shavings to make steam and electricity. A major portion of our power comes from this source. In fact, we have enough electricity left over to sell to nearby towns.

5. Obviously, today, wood is used more as a raw material than an energy source. What isn't so obvious is just how good a construction material wood is. For instance, many concrete bridges on rural roads are being replaced with our wooden ones these days. Why? Because wooden bridges can go up in any weather and aren't affected by temperature extremes or winter salting. In short, they hold up better and last longer.

6. As a leading producer of lumber, plywood and doors, we're concerned about not letting any raw material go to waste. That's why we developed a way to join off-sized pieces of lumber with a hot-glued finger joint that's stronger than the surrounding wood. One way or another we try to use every bit of the log.

7. Wood is also the main raw material for making paper. Kraft paper—the kind we use to make the millions of corrugated containers, paper bags and shipping sacks we manufacture every year—is made from wood pulp. And what's left over from the pulping process is burned for fuel. Up to fifty percent of the power in our kraft mills comes from this source.

8. Another paper we make from wood pulp is magazine paper. And with postal rates what they are today, the publishing business needs a paper as light as possible. Recently, our scientists were able to come up with ways of making it lighter than experts only hoped for even a few years ago. And we're not stopping there.

9. Another beauty of wood fiber is that it can be used again and again. Or recycled. Many people don't realize that a lot of folding cartons, like this one, have been made from recycled paper for years. Also candy boxes, book covers and jigsaw puzzles. We estimate a fiber can be reused up to six times.

10. Obviously, the tree is necessary for many of the products that make modern life what it is. Nothing can alter that fact. But unlike many of Man's resources, the forest can be replenished. Which we do in accordance with Nature's laws. So we can supply Man's need for products while fitting in with Nature's plan. And that's why we say we're serving Man and Nature to the benefit of both.

St Regis Paper Company, 1974

The Productivists...

Our corporate lenders work with industry to channel some $13-billion in funds— for raw materials and finished products today, and their replacement for future generations. Consider the source.

Manufacturers Hanover [H]
The $26-billion source. Worldwide.

Manufacturers Hanover, 1974

▶ *U.S. Army National Guard, 1976*

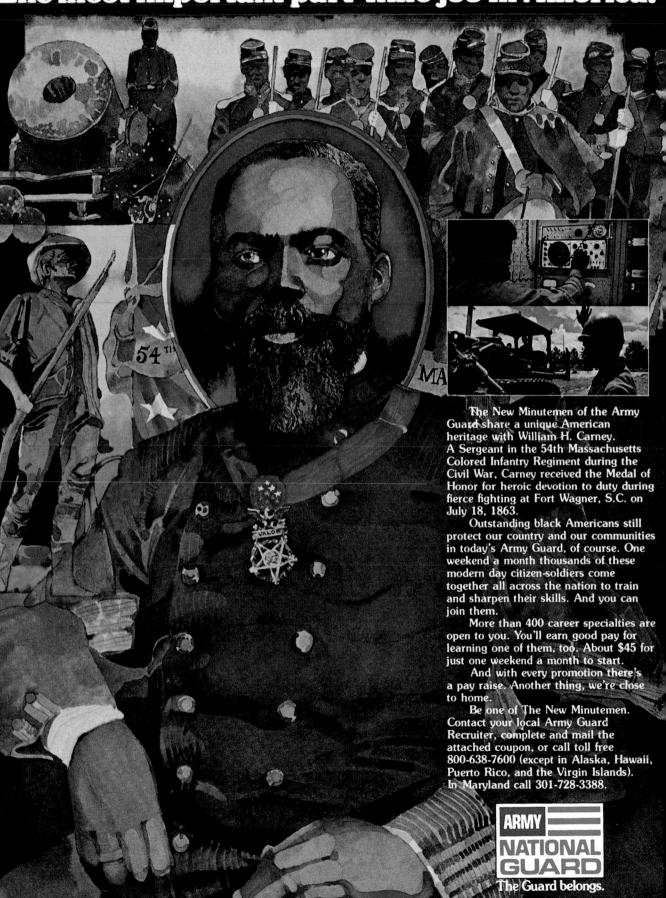

The most important part-time job in America.

The New Minutemen of the Army Guard share a unique American heritage with William H. Carney. A Sergeant in the 54th Massachusetts Colored Infantry Regiment during the Civil War, Carney received the Medal of Honor for heroic devotion to duty during fierce fighting at Fort Wagner, S.C. on July 18, 1863.

Outstanding black Americans still protect our country and our communities in today's Army Guard, of course. One weekend a month thousands of these modern day citizen-soldiers come together all across the nation to train and sharpen their skills. And you can join them.

More than 400 career specialties are open to you. You'll earn good pay for learning one of them, too. About $45 for just one weekend a month to start.

And with every promotion there's a pay raise. Another thing, we're close to home.

Be one of The New Minutemen. Contact your local Army Guard Recruiter, complete and mail the attached coupon, or call toll free 800-638-7600 (except in Alaska, Hawaii, Puerto Rico, and the Virgin Islands). In Maryland call 301-728-3388.

ARMY NATIONAL GUARD
The Guard belongs.

When the World War II Vets came home there were bands, kisses, jobs and education for the asking.

Last year their sons came home from a war which was in many ways far worse. And they're getting cold shoulders, slammed doors, few jobs and less money for education, subsistence or anything else.

It's the basic things that hurt . . . the lack of money for rent or education or even food. But it's the little things that finally break you . . . like the late check that the VA says is due to some computer foul-up or the lack of transportation money to get to job interviews. And you don't want a public dole.

Our forgotten men can't wait. They cannot wait until it gets straightened out in Washington. That's why we've set up the Veteran's Emergency Fund. We won't be around next year asking for your money. We're just what we're called: an Emergency Fund. Set up right now to provide emergency subsistence to the Vietnam Vet while he gets on his own two feet again. Funding will be disbursed in the form of outright grants or short-term no-interest loans and will be administered by the non-profit Kharma Foundation.

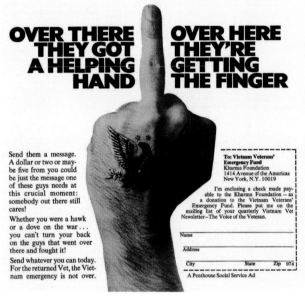

OVER THERE THEY GOT A HELPING HAND OVER HERE THEY'RE GETTING THE FINGER

Send them a message. A dollar or two or maybe five from you could be just the message one of these guys needs at this crucial moment: somebody out there still cares!

Whether you were a hawk or a dove on the war . . . you can't turn your back on the guys that went over there and fought it!

Send whatever you can today. For the returned Vet, the Vietnam emergency is not over.

To: Vietnam Veterans' Emergency Fund
Kharma Foundation
1414 Avenue of the Americas
New York, N.Y. 10019

I'm enclosing a check made payable to the Kharma Foundation — as a donation to the Vietnam Veterans' Emergency Fund. Please put me on the mailing list of your quarterly Vietnam Vet Newsletter—The Voice of the Veteran.

Name ___

Address ___

City ___ State ___ Zip 974

A Penthouse Social Service Ad

Vietnam Veteran's Emergency Fund, 1974

NAVY NUCLEAR PROPULSION.
THE FASTEST WAY UP IN NUCLEAR ENGINEERING.

If you want to get into nuclear engineering, start by getting into the Nuclear Navy.

The Navy operates more than half the reactors in America. So our nuclear training is the most comprehensive you can get. You start by earning your commission as a Navy Officer. Then we give you a year of advanced nuclear technology, training that would cost you thousands if you could get it in graduate school. During your career, you'll get practical, hands-on experience with our nuclear powered fleet. Maybe you'll work on a nuclear submarine, maybe a nuclear cruiser. But wherever you work, you'll really get to prove your worth—as a young Nuclear Propulsion Officer entrusted with the most advanced technical equipment known to man.

If that sounds like the kind of responsibility you're looking for, speak to your Navy recruiter. He can tell you if you qualify as a Nuclear Propulsion Officer Candidate. Or call toll free 800-841-8000. (In Georgia, 800-342-5855.)

Navy Nuclear Propulsion Officer. Some men wait for the future. He lives it now.

NAVY OFFICER.
IT'S NOT JUST A JOB, IT'S AN ADVENTURE.

U.S. Navy, 1977

U.S. Army, 1972

Is this your last summer for a summer job?

Summer jobs between high school years are good-time jobs. A little work, a lot of laughs, and a few extra bucks when you head back to school in September.

But the summer job after graduation is your last summer job. And if you're not going on to college this fall, consider a job in today's Army.

A job that teaches you a skill and pays you as you learn. You start at $288 a month. With free meals, housing, medical and dental care, and 30 days paid vacation each year.

It's a job that lets you live away from home and afford it. Not only in the States, but in places like Europe, Hawaii, Panama, and Alaska.

Finally, if after your 3-year enlistment you're interested in college, there's 36 months of financial assistance at the college of your choice.

If you'd like to know more about this unique combination of job-training, pay and benefits, see your Army Representative. Or send us the coupon.

Today's Army wants to join you.

Army Opportunities
Dept. 200, Hampton, Va. 23369 Date ___
I'd like to know more about the job-training and promotion opportunities in today's Army.

Name ___ Date of birth ___
Address ___
City ___ County ___
State ___ Zip ___ Phone ___
Education ___

7

The day Bill told off his boss

How to tell your parents you want to join the Army.

Cleveland Institute of Electronics, 1970

U.S. Army, 1972

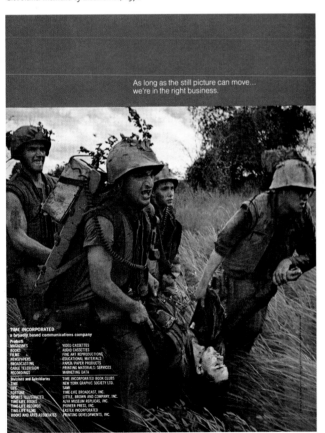

Time Incorporated, 1972

U.S. Airforce National Guard, 1977

And the winner is...

Our Friend, Nuclear Radiation

In the endless drive to convince Americans that atomic power was the wave of the future, energy companies adopted various approaches to sway consumers. While this attempt to make radioactivity palatable to the whole family touted statistics and facts like "virtually everything on earth is radioactive," the advertisement conveniently makes no mention of the potential for the inevitable nuclear disaster or plant contamination that would take place at the end of the decade at Pennsylvania's Three Mile Island.

Unsere Freundin, die radioaktive Strahlung

In dem endlosen Feldzug, mit dem die Amerikaner überzeugt werden sollten, dass Kernkraft die Zukunft war, setzten die Stromerzeuger verschiedene Strategien ein. Während dieser Versuch, Radioaktivität der ganzen Familie schmackhaft zu machen, Statistiken und Fakten wie „praktisch alles auf der Welt ist radioaktiv" anführt, verschweigt die Anzeige praktischerweise die Aussicht auf nahezu unvermeidliche nukleare Katastrophen oder schwerste Störfälle in Kernkraftwerken, wie dem, zu dem es am Ende des Jahrzehnts in Three Mile Island in Pennsylvania kommen sollte.

Nos amies les radiations nucléaires

Dans leur combat sans fin pour convaincre les consommateurs américains que la puissance atomique était la clef de l'avenir, les entreprises énergétiques essayèrent différentes approches. Si cette tentative pour faire avaler l'innocuité de la radioactivité à toute la famille se basait sur des statistiques et des faits comme « pratiquement tout sur terre est radioactif », le texte évite soigneusement toute allusion aux risques de catastrophe nucléaire ou de contamination de l'environnement comme la Pennsylvanie allait en connaître à la fin de la décennie avec l'accident de la centrale de Three Mile Island.

Nuestra amiga, la radiación nuclear

En su insaciable carrera por convencer a los ciudadanos de que la energía atómica era el futuro, las compañías energéticas diseñaron diversas estrategias para influir en la actitud de los consumidores. Este anuncio intentaba convertir la radioactividad en algo aceptable para toda la familia e informaba con datos estadísticos de que «prácticamente todo en la Tierra es radioactivo». Por otra parte, con mucho atino, no hacía mención del potencial de esta energía para ocasionar catástrofes nucleares como la que ocurriría a finales de la década en la central de Three Mile Island, en Pensilvania.

我らが友、核・放射線

原子力こそ未来の波だということをわからせるための、アメリカ国民に対する果てしない説得攻勢のなかで、エネルギー会社はさまざまな方法を使って消費者に揺さぶりをかけてきた。家族全員が放射能の恩恵を受けていると言いたかったこの広告の場合、「地球上のほとんどのものは放射性である」といった統計情報を大げさにまくしたてる一方で、避けることのできない核惨事や放射能汚染の可能性については、まったく都合のいいことに触れていない。ペンシルヴェニア州のスリーマイル島原発で事故が起こったのは、70年代の終わりのことだった。

Radioactivity.
It's been in the family for generations.

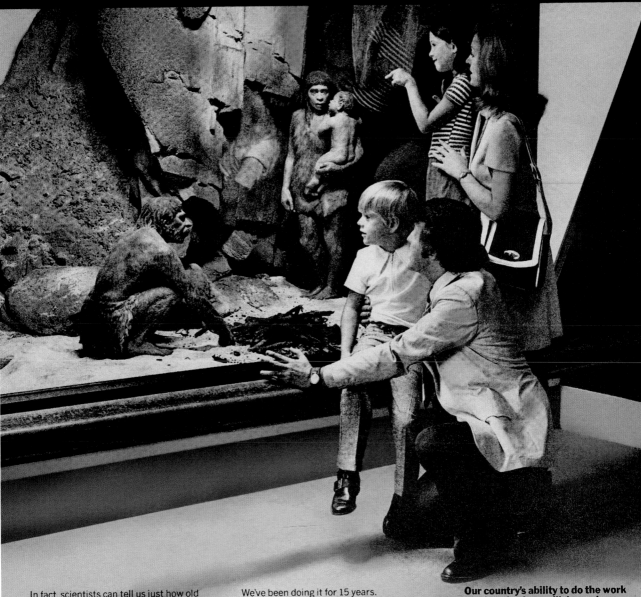

In fact, scientists can tell us just how old our remote ancestors are by measuring the radioactivity still in the bones of prehistoric cave dwellers.

Radioactivity dating is possible because virtually everything on earth—food, air, water, man himself—is radioactive and always has been.

Obviously, radiation is nothing new. Using nuclear power plants to generate electricity isn't exactly new either.

We've been doing it for 15 years.

And experience has shown that a person living next door to a nuclear power plant for a year would be exposed to less additional radiation than by making one round-trip coast-to-coast flight.

Understanding that nuclear power plants are safe, clean places to make electricity is important, because the demand for electric energy continues to grow. And nuclear power is one of the best ways we have for meeting it.

Our country's ability to do the work that needs to be done will depend on an adequate supply of electricity. There's no time to waste. New generating facilities must be built, and built in a way compatible with our environment.

We'll continue working to do this. But we need your understanding today to meet tomorrow's needs.

The people at your Investor-Owned Electric Light and Power Companies:

*For names of sponsoring companies, write to Power Companies, 1045 Avenue of the Americas, New York, New York 10019.

Investor-Owned Electric Light & Power Companies, 1972

a new era in entertainment

Sears Cartridge Television, 1972

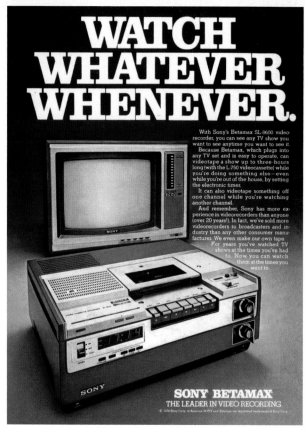

Sony Betamax, 1978

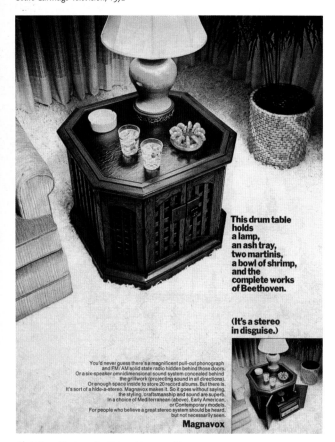

Akai Stereo Equipment, 1974 ◄ *Magnavox Stereos, 1971*

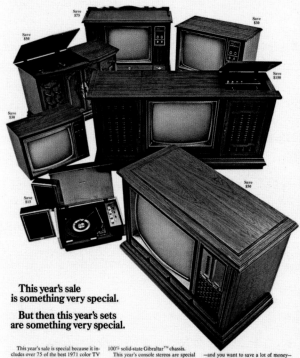

Sylvania Electronics, 1971 ► *General Electric Televisions, 1979*

INTRODUCING A REVOLUTIONARY BIG PICTURE COLOR TELEVISION.

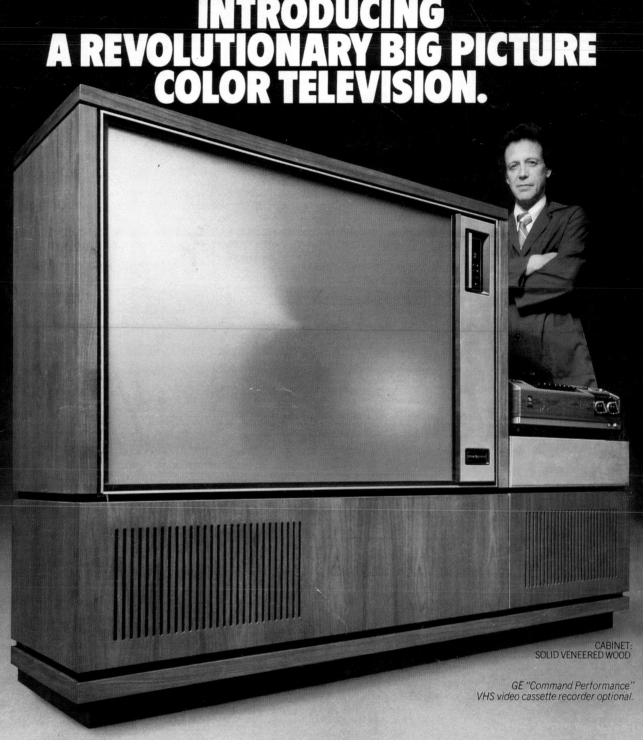

CABINET:
SOLID VENEERED WOOD

GE "Command Performance"
VHS video cassette recorder optional.

You're looking at the new General Electric Widescreen 1000. A super size color TV with a picture three times the size of a 25" diagonal console. A picture that makes you feel like you're at the movies. A set with the advanced performance features you expect from General Electric.

Like VIR. The Emmy award-winning color system that gives you realistic flesh tones, blue skies, green grass. Automatically adjusted by the broadcaster's signal on many programs. GE won the Emmy in 1977 for being the first to use VIR.

And electronic tuning. With the chairside convenience of random access remote control. So you can go from channel 2 to 83 instantly.

See this and other examples of General Electric leadership in television at your GE TV dealer.

THIS IS GE PERFORMANCE TELEVISION.

GENERAL ⓖⓔ ELECTRIC

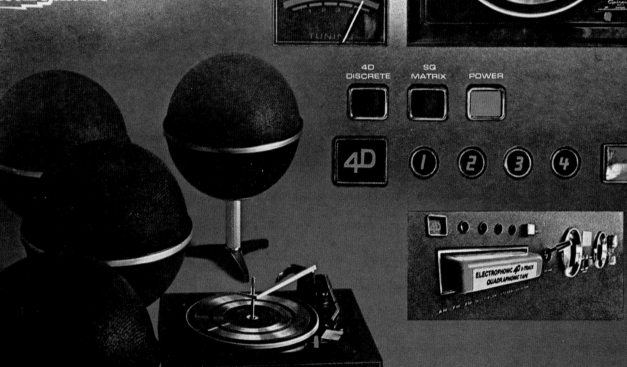

"We are dedicated to the philosophy of putting beautiful sound within everyone's reach. We have achieved this goal by creating and designing a spectrum of Audio Systems that are the ultimate in sophistication but simple to operate. Functionally designed yet exquisitely beautiful. A complete collection of Audio Systems that gives people the opportunity to enrich their lives with magnificent sound. This is why we're number one in stereo and Quadraphonic equipment in America."

Chairman and President
Morse Electro Products Corp.

Electrophonic

Electrophonic presents: True compatible Quadraphonic 400 Watt I.P.P. Audio System plays D
SQ-Matrix and Stereo with built-in 4 channel and 8-track tape, magnetic Garrard o
Super Sphere air suspension speaker system. This week only, Model MAG 487XP, special introd
offer only $400 at leading department stores and Electrophonic dealers listed at right. After sal

"My $3000 lifesize VideoBeam® television has almost paid for itself in the beer my friends have brought me."

T. Barton Carter, Boston, Mass.
Advent VideoBeam owner since Feb. 1977

"I tell my friends they can come and watch basketball, hockey, football, whatever, anytime . . . as long as I don't run out of beer."

We taped a conversation with Barton Carter, teacher of communications law and sports freak, and this is what he said about his VideoBeam television, his friends, and what goes on at his place.

It's like being there.

"I'll have eight or ten people over for a basketball game. What with the immediacy and the way the VideoBeam picture sort of wraps around you and involves you, and all these people together . . . it gets pretty crazy. It's like being at the game.

"Actually what with the different camera perspectives you see more than you would at the game. It shows best in the stuff that goes on underneath the basket. You really see the elbows, people banging around. Anyone who says basketball isn't a contact sport hasn't seen it on VideoBeam. For instance you can see when Cowens gets really mad. All of a sudden there's an extra two feet around him. Nobody wants to get near him, not even his teammates. You wouldn't see that on the little tube. No way.

Better feel for the strategy.

"You can see what people are trying to do, not only what they're accomplishing. You can see when somebody is trying to get the ball around to the weak side, but they can't because somebody has cut off the passing lane. You get a better feel for the strategy of the coaches. You see who they're working on, you know, if they're trying to get

somebody down low, post a tall guard on a short one . . .

You "Feel" the contact.

"Of course, football more than any other sport shows the contact . . . in fact you feel the contact. You see one of these big guys come steaming down the field at full speed and he gets his legs cut out from under him, does a twist and falls, um, you can just feel it. You get that sometimes under the boards in basketball. You can just feel them hitting each other. It's more than just seeing it.

"And if you've got eight or ten people watching it's magnified. And if they're rooting for different teams . . . oh boy . . . I'm thinking of hiring a bouncer for the next game."

VideoBeam television projects brilliant color TV pictures from regular broadcasts and from video cassette recorders on to a six-foot diagonal screen. If you would like to know more and see a demonstration return the coupon, or call toll free 800-225-1035 (in Massachusetts call Customer Relations at (617) 661-9500) for brochures and the name and address of your nearest dealer.

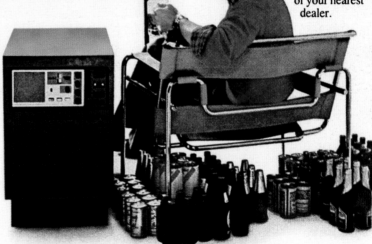

Actual closed circuit television picture.

Advent's VideoBeam® Television
It's beyond TV.

Advent Corporation, 195 Albany Street, Cambridge, Mass. 02139 (617) 661-9500

Electrophonic Audio Systems, 1973 ◄ *Advent VideoBeam Television, 1977*

Now AccuColor goes portable!

AccuColor®, the most accurate, most reliable color TV in RCA history now comes in 19″, 18″, 16″ and 14″ portable sizes! (Measured diagonally.) These are the brightest, sharpest, toughest RCA portables you can buy.

Every AccuColor picture tube is computer designed for richer, more vivid color and sparkle.

The AccuColor tuning system is built for simplicity and pinpoint accuracy. It automatically locks in the correct signal, stabilizes color intensity, and delivers more natural flesh tones and consistent color no matter how often you change channels. It's fiddle-free tuning!

And these tough new AccuColor portables are built to really take it. We've replaced many tubes with dependable solid state components for longer life and fewer repairs.

AccuColor portables. The best news since . . . well, since AccuColor.

RCA AccuColor®

RCA Televisions, 1971

"I bought a Sony for the bedroom so I could watch the ballgame."

We have a big color set in the living room. But my mother, my three daughters, and my wife watched love movies when my games were on.

How can you argue with five women?

So I bought a Sony for the bedroom. I figured, I'll watch my game, they'll watch their movie, and we'll all be happy. I was wrong.

The picture on my little 12-inch* Sony is better than the picture on the big console. All that talk about the Sony

Trinitron system? That it's brighter and sharper and so on? It's more than talk. It works.

The women in my family proved it.

I could watch the games on the console. But after you've seen Sony color, you feel like you're being cheated with anything else.

So I'm back where I started.

Unless I buy another Sony—for the living room.

*Measured diagonally. TV picture simulated.

Trinitron
SONY COLOR TV

Sony Trinitron Color Televisions, 1971

ZENITH INTRODUCES THE COMPLETE COLOR TV

It has everything you want. including a picture even brighter and sharper than famous Zenith Chromacolor.

New Super Chromacolor Picture Tube
Zenith has discovered a way to enlarge the color dot area, and still fully illuminate every dot on a black background. To bring you a giant-screen color picture that is even brighter and sharper than the famous Chromacolor picture that set a new standard of excellence in color TV.

100% Solid-State Chassis
Zenith's new solid-state chassis features plug-in Dura-Modules. They control key set functions, such as color, picture quality, and stability. And each Dura-Module is pre-tested, then tested again in the set, for long life and dependability. There are no tubes to burn out.

One-button Color Tuning
Zenith's new Chromatic Tuning controls picture brightness, contrast, tint, color level and flesh tones. If someone mistunes the color, the touch of a finger retunes it perfectly, instantly.

A Full Year Warranty
Zenith's new warranty covers the cost of all parts and service for one year. And the new Super Chromacolor picture tube is warranted for 2 years, labor covered for the first year.

Zenith Quality and Dependability
Most important of all, you get the kind of built-in quality and dependability that have made Zenith world famous. We call this reputation for excellence *Zenith confidence:* knowing you can't buy a better TV.

We are determined to keep this confidence. If a Zenith product doesn't live up to your expectations, we want to hear from you.

Write directly to the Vice President, Customer Relations, at Zenith Radio Corporation, 1900 N. Austin Avenue, Chicago, Illinois 60639. We want the opportunity to give your problem our personal attention. At Zenith, *the quality goes in before the name goes on.®*

ZENITH SUPER CHROMACOLOR®

Zenith Chromacolor Televisions, 1972

▶ *JVC Videosphere Televisions, 1972*

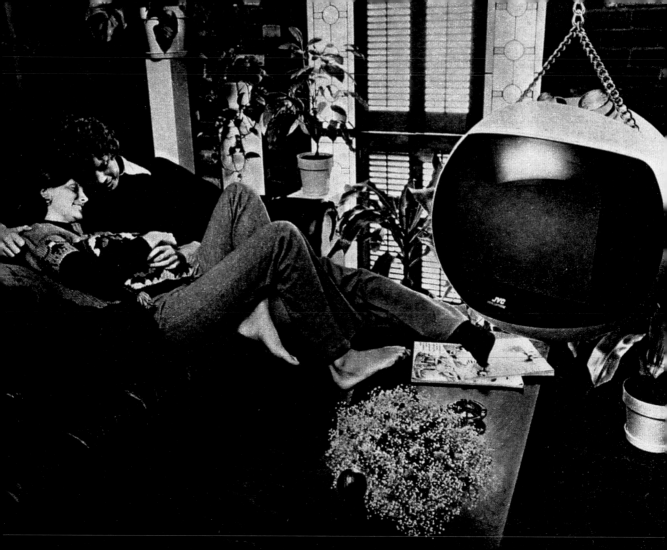

We made the Videosphere look the way it does because when your TV's off you still have to look at it.

The Videosphere by JVC is a new way of looking at television. As part of the total environment of a room.

You don't watch TV all the time. And your television should be just as much a part of the room when it's off as it is when it's on.

But don't get the idea that styling is the only thing futuristic about the Videosphere. Because it isn't.

An advanced Electronic Expander Circuit makes sure you get a clear picture, no matter where you are. And this is important. Because the Videosphere, besides looking great anywhere, can also go anywhere. It's portable. And we do mean portable. It weighs less than 12 pounds. And it's as much at home outdoors as it is indoors.

As a matter of fact, the Videosphere is also available in another model with a clock. So you can wake up to the same thing you're going to sleep with now. Television.

The Videosphere by JVC. It looks better off than most TV's look when they're on.

JVC

JVC America, Inc., 58-75 Queens Midtown Expressway, Maspeth, New York 11378

No two people ever really enjoy all the same things. What turns one on may very well turn the other off. (Which is what happens to your stereo system during Marcus Welby.)

But with Koss Stereophones, you can live and let live. Because both can be turned on at the same time. As loud as you want, without disturbing the other.

And that should be music to any man's ears.

Fact is, nothing else quite matches the sound you hear with Koss Stereophones.

It extends the bass, treble and mid-range of your favorite music farther than the most expensive speaker system.

So you hear more of your music and none of the late show.

If you'd like to see more, write for our free full-color catalog, c/o Virginia Lamm, Dept. ES-O.

And if you'd like to hear the Sound of Koss, try a set at your favorite Stereo Dealer or Department Store . . . from $19.95 to $150. It's a small price to pay for a little peace.

⊕KOSS STEREOPHONES

Koss Corporation, 4129 N. Port Washington Ave., Milwaukee, Wis. 53212
Koss International Ltd. Via Valtorta, 21 20127, Milan, Italy

Live and let live

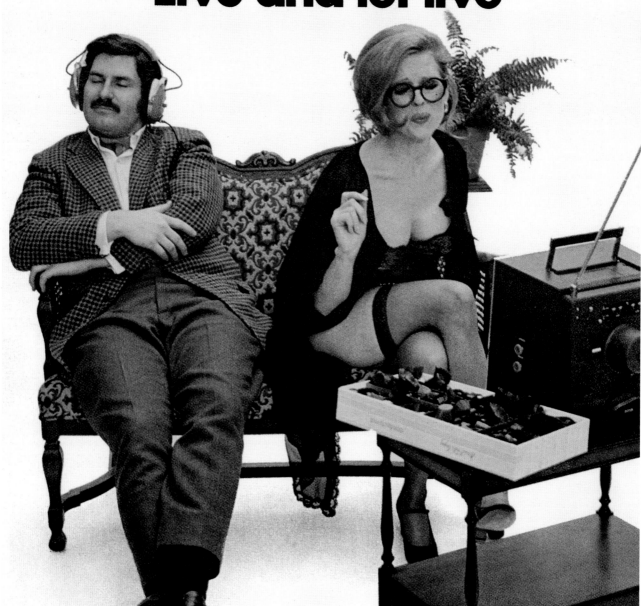

Koss Stereophones, 1971

Sharp Stereos, 1970

Centrex Stereos, 1979

Pioneer Stereos, 1975

Panasonic Stereos, 1976

Andy Warhol's unfinished symphony.

We asked Andy Warhol to paint a picture of a Pioneer high fidelity receiver. He can't seem to finish. He says he gets so wrapped up in the beautiful sound of the subject that he can't concentrate on the way it looks.

Andy is a great artist, film-maker and journalist. And he's a man who appreciates great music. He knows you can't have great music unless you have great equipment.

That's why he owns Pioneer. As far as the portrait goes, he has our unfinished sympathy.

U.S. Pioneer Electronics Corp., 75 Oxford Drive, Moonachie, New Jersey 07074. West: 13300 S. Estrella, Los Angeles 90248 / Midwest: 1500 Greenleaf, Elk Grove Village, Illinois 60007 Canada: S. H. Parker Co.

PIONEER
when you want something better

Pioneer Electronics, 1975

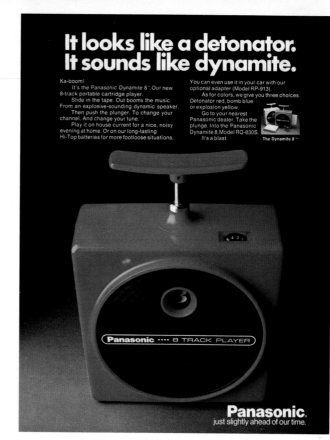

It looks like a detonator.
It sounds like dynamite.

Ka-boom!
It's the Panasonic Dynamite 8™. Our new 8-track portable cartridge player.
Slide in the tape. Out booms the music. From an explosive-sounding dynamic speaker.
Then push the plunger. To change your channel. And change your tune.
Play it on house current for a nice, noisy evening at home. Or on our long-lasting Hi-Top batteries for more footloose situations.

You can even use it in your car with our optional adapter (Model RP-913).
As for colors, we give you three choices. Detonator red, bomb blue or explosion yellow.
Go to your nearest Panasonic dealer. Take the plunge. Into the Panasonic Dynamite 8, Model RQ-830S.
It's a blast.

The Dynamite 8™

Panasonic.
just slightly ahead of our time.

Panasonic 8-Track Player, 1974

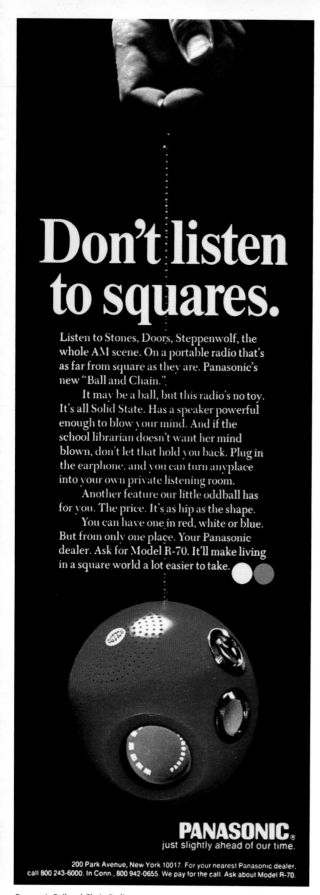

Don't listen to squares.

Listen to Stones, Doors, Steppenwolf, the whole AM scene. On a portable radio that's as far from square as they are. Panasonic's new "Ball and Chain."

It may be a ball, but this radio's no toy. It's all Solid State. Has a speaker powerful enough to blow your mind. And if the school librarian doesn't want her mind blown, don't let that hold you back. Plug in the earphone, and you can turn anyplace into your own private listening room.

Another feature our little oddball has for you. The price. It's as hip as the shape.

You can have one in red, white or blue. But from only one place. Your Panasonic dealer. Ask for Model R-70. It'll make living in a square world a lot easier to take.

PANASONIC.
just slightly ahead of our time.

Panasonic Ball and Chain Radio, 1970

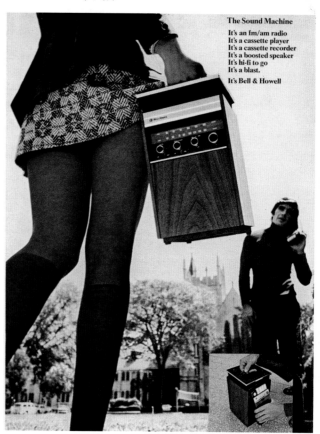

The Sound Machine

It's an fm/am radio
It's a cassette player
It's a cassette recorder
It's a boosted speaker
It's hi-fi to go
It's a blast.

It's Bell & Howell

Bell & Howell Stereo, 1971 ▶ *RCA Electronics, 1971* ▶▶ *Panasonic Electronics, 1973*

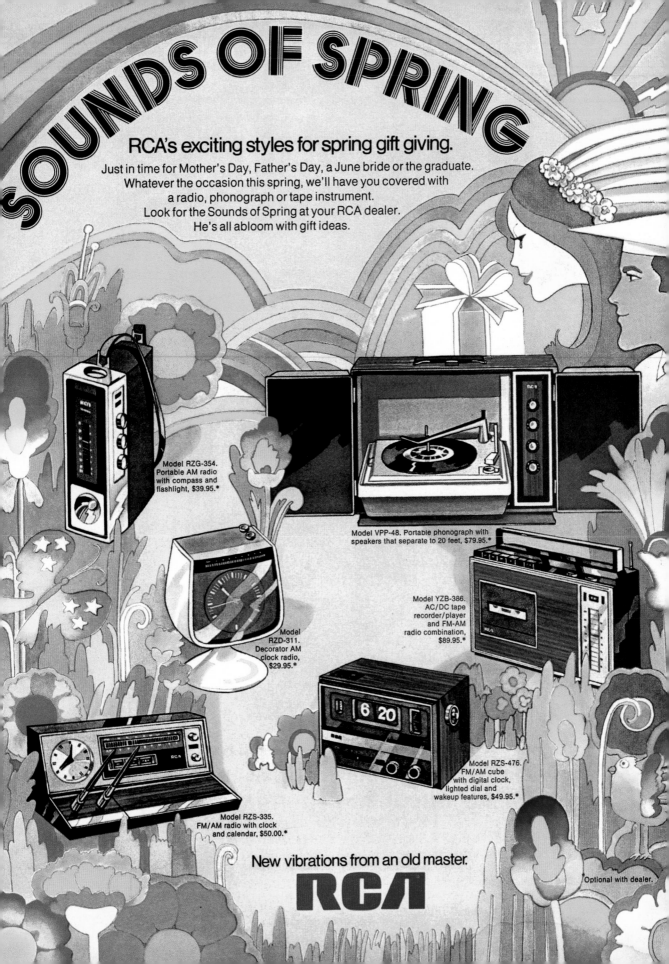

SOUNDS OF SPRING

RCA's exciting styles for spring gift giving.

Just in time for Mother's Day, Father's Day, a June bride or the graduate.
Whatever the occasion this spring, we'll have you covered with
a radio, phonograph or tape instrument.
Look for the Sounds of Spring at your RCA dealer.
He's all abloom with gift ideas.

Model RZG-354.
Portable AM radio
with compass and
flashlight, $39.95.*

Model VPP-48. Portable phonograph with
speakers that separate to 20 feet, $79.95.*

Model YZB-386.
AC/DC tape
recorder/player
and FM-AM
radio combination,
$89.95.*

Model
RZD-311.
Decorator AM
clock radio,
$29.95.*

Model RZS-476.
FM/AM cube
with digital clock,
lighted dial and
wakeup features, $49.95.*

Model RZS-335.
FM/AM radio with clock
and calendar, $50.00.*

New vibrations from an old master.
RCA

*Optional with dealer.

The Crazy C
They evel

Crazy is how they look. Fun-crazy. But when you listen to them, you discover that the Crazy Color Portables are very down to earth. Even though the music they make is out of this world.

And so are the shapes. Like an AM shape that twists and turns and closes around your little wrist. The Toot-A-Loop,™ Model R-72. Or another AM shape that turns, swings and dangles from your little finger. The Ball 'n Chain,™ Model R-70.

You can drink in melodies from the Music Mug,™ Model R-63. Or truck to funky fifties golden oldies on our hip square, the Musicube,™ Model R-47A. Or you might prefer to roll in FM and AM. With the Rolling Tone,™ Model RF-93.

If they're too eccentric for you, you can get Crazy Color Portable radios in a variety of half-crazy, mildly

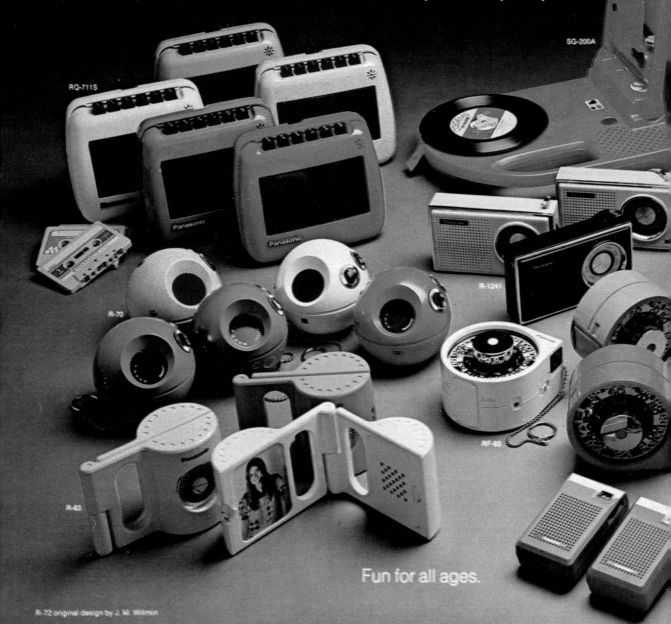

Fun for all ages.

R-72 original design by J. M. Wiltmin

or Portables.
play music.

neurotic and completely straight shapes.

And if you want to make your own kind of music, there's Take 'n Tape™, Model RQ-711S. The portable cassette recorder that looks like something out of 2001.

And for your records, there are Funnygraphs™ Yuk, yuk. That look like space-age waffle irons.

Model SG-200A plays 33 and 45 rpm waffles. While Model SG-400A also cooks up delicious AM.

What's more, you can start hearing things, as well as seeing them, immediately. Because all the Crazy Color Portables come with Panasonic batteries.

The Panasonic Crazy Color Portables. They were made to be seen. And heard.

SG-400A

R-1482

RF-513

R-1052

R-47A

R-72

RF-519

Gifts for all seasons.

R-1026

Panasonic®
just slightly ahead of our time.
200 Park Avenue, New York, N.Y. 10017

Panasonic's Craziest Color Radio and what to do with it.

Wind the Toot-A-Loop around your wrist, and be the first on your block to have a bracelet that plays music.

Twist it open to make the world's craziest hearing device. Hear rock & roll. And music.

Use the Toot-A-Loop to feel a little more secure when your mother takes away your baby blanket.

Share the Toot-A-Loop with a friend. After all, half a radio is better than half a crayon.

Or just sit back and listen. Because the Toot-A-Loop (Model R-72) is also a terrific AM radio. And like all our crazy color portables, the Toot-A-Loop is as much fun to look at as listen to.

Panasonic®
just slightly ahead of our time.

200 Park Avenue, New York 10017. For your nearest Panasonic dealer, call 800 631-1972. In N.J., 800 962-2803. We pay for the call. Ask about Model R-72.

Panasonic Toot-A-Loop Radios, 1972

"The Sony TC-756 set new records for performance of home tape decks."

(Stereo Review, February, 1975)

Hirsch-Houck Laboratories further noted, "The dynamic range, distortion, flutter and frequency-response performance are so far beyond the limitations of conventional program material that its virtues can hardly be appreciated."

The Sony TC-756-2 features a **closed loop dual capstan tape drive system** that reduces wow and flutter to a minimum of 0.03%, **logic controlled transport functions** that permit the feather-touch control buttons to be operated in any sequence, at any time without spilling or damaging tape; an **AC servo control capstan motor** and an eight-pole induction motor for

each of the two reels; a record equalization selector switch for maximum record and playback characteristics with either normal or special tapes; mic attenuators that eliminate distortion caused by overdriving the microphone pre-amplifier stage when using sensitive condenser mics; tape/source monitoring switches that allow instantaneous comparison of program source to the actual recording; a mechanical memory capability that allows the machine to turn itself on and off automatically for unattended recording; and a full, two-year guarantee.*

In addition, the TC-756-2 offers 15 and 7½ ips tape speeds; Ferrite &

Ferrite 2-track/2-channel stereo three-head configuration; and symphase recording that allows you to record FM matrix or SQ** 4-channel sources for playback through a decoder-equipped 4-channel amplifier with virtually non-existent phase differences between channels.

The Sony TC-756-2 is representative of the prestigious Sony 700 Series — the five best three-motor 10¼-inch reel home tape decks that Sony has ever engineered. Available now at your nearest Superscope dealer, from $699.99.

SONY Brought to you by **SUPERSCOPE**

Sony Tape Decks, 1975

Out of this world.

Sony/Superscope tape recorders

A tape recorder is an electronic log of man's most ambitious adventure.

It is the essence of human emotion. Or the fantasy of untold generations suddenly frozen into fact.

A tape recorder is philosophic reflections. Scientific observations. Or the innermost personal impressions of a lunar explorer. Preserved forever.

It is the commerce of everyday living. The earth song of a

folk singer. Or the biology notes of a medical student.

Because your life is so full of sound, our life is building the finest tape recorders in the world. And the most popular.

This year, Sony offers more than 30 totally different models to choose from. Functional. Stereophonic. Portable. Deck. System. Reel-to-reel. Cartridge. And cassette.

How many ways are there to use a tape recorder? Use your imagination...then use Sony.

SONY SUPERSCOPE
You never heard it so good.

Sony Superscope Tape Recorders, 1970

You can pay for someone else's studio or you can invest in your own.

Our new Studio 8000 gives you that choice. And you won't have to sell your soul to get it.*

The eight tracks give you room to spread out your music, and your own studio gives you the option of turning on the equipment whenever you turn on to a good idea... 24 hours a day.

Here's what you get. The TASCAM Series 80-8 half-inch, 15 ips. One speed, one format saves you money but gives

you a final product: professional master tapes, faster and easier than any recorder/reproducer you ever sat behind. Add the DX-8 for up to 30dB of noise reduction.

The Model 5A Mixing Console gives you 8-in and 4-out, and has been studio proven in both mobile and fixed installations. In short, it's uncomplicated and tough. Add the 5EX for 12 inputs and even greater flexibility. The Model 1

(8 in, 2-out) gives you those necessary sub-mixes, without affecting your primary mix.

And for absolute quality stereo mastering, plug in the 25-2. DBX is built in, and so are speed, simplicity and accurate final editing capability.

So why go on paying for time in a studio that someone else owns? Especially when the total dollars involved wouldn't buy much more than a new car at today's prices.

See the Studio 8000 at your authorized TASCAM dealer.

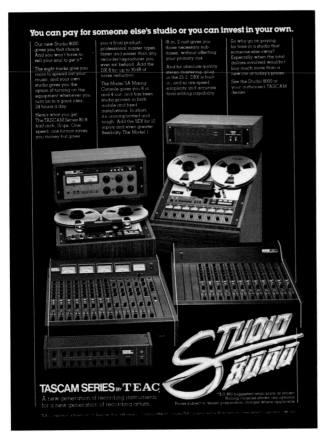

TASCAM SERIES ʙʏ **TEAC**
A new generation of recording instruments for a new generation of recording artists.

Tascam Studio 8000, 1978

Singin' in the rain.

Or heat. Or cold. Those are some of the things the TFM-8100W was made for. Because it's rubber sealed to resist moisture. It can even be knocked down by the wind. Because the heavy-duty, special plastic cabinet is unbreakable.

What's more, this 3-band (FM/AM/VHF weather, 162.55 mc) portable has the newly developed Sony Light Emitting Diode. It's an indicator, right in the tuning needle, that helps you tune the radio by brightening to red when a sta-

tion is properly tuned.

There's a collapsible antenna. A shoulder strap. And a fine, rich sound (but that's nothing new for us).

So next time you plan to spend a lot of time outdoors, take the Sony all-weather portable along. And you'd better take a raincoat, just in case.

Nothing will happen to the radio. But we wouldn't want you to catch cold.

The SONY All-Weather Radio.

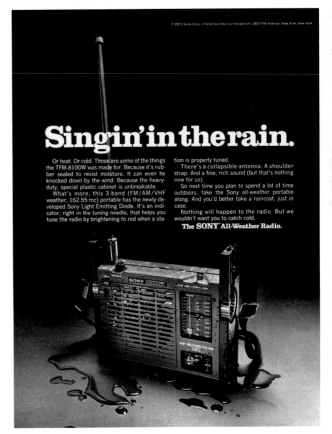

Sony All-Weather Radio, 1971

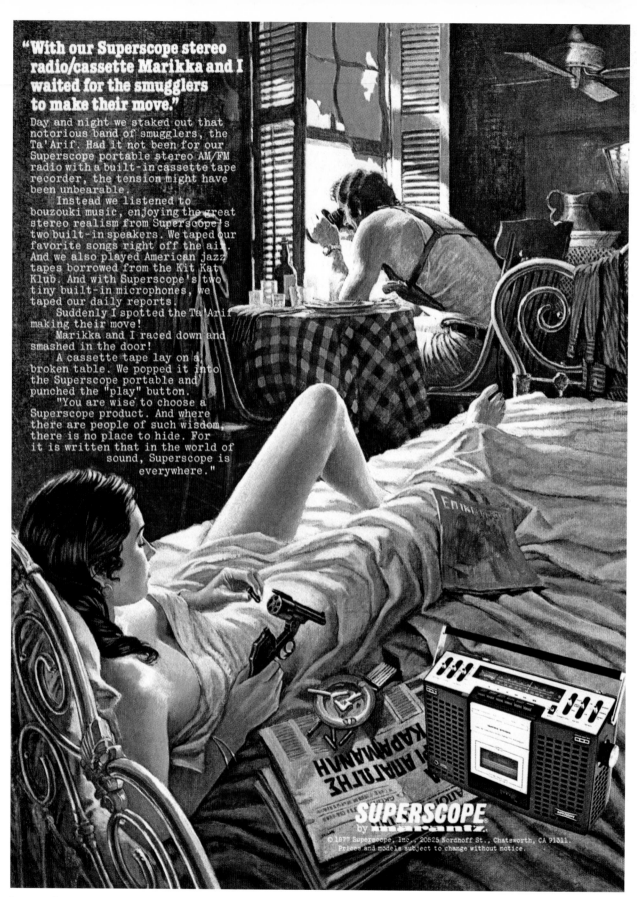

"With our Superscope stereo radio/cassette Marikka and I waited for the smugglers to make their move."

Day and night we staked out that notorious band of smugglers, the Ta'Arif. Had it not been for our Superscope portable stereo AM/FM radio with a built-in cassette tape recorder, the tension might have been unbearable.

Instead we listened to bouzouki music, enjoying the great stereo realism from Superscope's two built-in speakers. We taped our favorite songs right off the air. And we also played American jazz tapes borrowed from the Kit Kat Klub. And with Superscope's two tiny built-in microphones, we taped our daily reports.

Suddenly I spotted the Ta'Arif making their move!

Marikka and I raced down and smashed in the door!

A cassette tape lay on a broken table. We popped it into the Superscope portable and punched the "play" button.

"You are wise to choose a Superscope product. And where there are people of such wisdom, there is no place to hide. For it is written that in the world of sound, Superscope is everywhere."

SUPERSCOPE by MARANTZ®

© 1977 Superscope, Inc., 20525 Nordhoff St., Chatsworth, CA 91311. Prices and models subject to change without notice.

Superscope Stereos, 1977

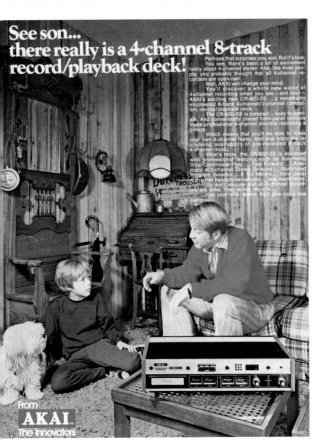

See son...
there really is a 4-channel 8-track record/playback deck!

Perhaps that surprises you, son. But it's true. You see, there's been a lot of excitement lately about 4-channel stereo. And, like most people, you probably thought that all 4-channel recorders are open-reel.

Well, AKAI will change your mind.

You'll discover a whole new world of 4-channel recording when you see—and hear—AKAI's exciting new CR-80D-SS . . . a remarkably engineered 8-track 4-channel/2-channel compatible record/playback deck.

The CR-80D-SS is compact . . . easy to operate. And conveniently placed front-panel controls make professional 4-channel discrete recording a breeze.

Which means that you'll be able to make your own 4-channel tapes. And also enjoy the increasing availability of pre-recorded 8-track 4-channel music.

What's more, the CR-80D-SS is equipped with professional features such as Automatic Stop/Continuous Play . . . Fast Forward . . . Automatic 4/2-channel Stereo Selector . . . Illuminated Program Selector . . . 4 VU Meters . . . front panel 4-channel headphone outputs . . . and much more.

So don't assume that all 4-channel recorders are alike. They're not, my son.

See your AKAI dealer. He'll give you a new outlook.

From AKAI
The Innovators

Akai 8-Track Tape Deck, 1974

The new color portable that won't give you a hernia.

It's a dazzling new concept in color portables: portability.

Most color portables can be moved. As most of your furniture can be moved. If absolutely necessary.

But man, unlike his sofa, does not live in the living room alone.

So Sony made a color portable man can live with.

(Note the famous Sony one-hand carry.)

That man can take to his bedroom. That man's wife can take to the kitchen.

That man's children can take and watch TV in color in any room of the house.

And, man, what color.

Trinitron. It's a different system. No one else has anything like it.

Because, in 19 years of color TV, Sony's the only one to invent a new and better way of getting a color picture on the screen.

(In this particular instance, a brighter, sharper 9" picture, measured diagonally.)

And, of course, the Sony KV-9000U is all solid state. So it's not just small.

Man does not live in the living room alone.

It's good and small.
To see it is to love it.
To lift it is to believe it.
For $309.95,* you can have color TV in every room in the house.
So if you want to see a lot more color TV, get a little less set.

Trinitron
SONY COLOR TV

©1970 SONY CORP. OF AMERICA. VISIT OUR SHOWROOM, 585 FIFTH AVENUE, NEW YORK, NEW YORK 10017. *MFR'S SUGGESTED RETAIL PRICE.

Sony Trinitron Color Televisions, 1970

phone·mate...so you'll get the message

The Phone-mate automatic telephone answerer is so nice to come home to. All your phone messages are there waiting for you . . . crystal clear. You play them back leisurely, enjoying the happy talk, the familiar voices. Phone-mate will even take your calls while you're at home. You can hear who's calling without touching your phone. You can choose to talk or not. If you don't want to be disturbed, let your Phone-mate take the message. Your home is safer, too, when your phone is never left alone and un-answered.

Get the message?
Get Phone-mate, now at a new low price.

model 400
new low price **$129.50**

phone·mate
automatic telephone answerer
Torrance, California 90503

For the name of the Phone-mate store nearest you, call the Phone-mate coast-to-coast HOTLINE collect (213) 320-9800 ext. 751.

Phone-Mate Answering Machine, 1973

Everything you always wanted in a color TV
*** BUT WERE AFRAID YOU COULDN'T AFFORD**

Meet the Cosmos. We believe it's the best color TV value available at any price.

21" (diag.) picture tube. It's the same kind of tube that's in our finest color consoles. That means you get the sharpness and brightness of our most advanced AccuColor® picture.

New self-adjusting tuning system. Makes color tuning virtually foolproof! And it includes our automatic color monitor—called AccuMatic—that will lock in a normal range of color and tint, no matter how often you change channels. So even if the kids twiddle with the color dials, you just push our new AccuMatic button and beautiful color snaps back.

100% solid state. There are no tubes that can wear out and make colors shift or fade, because all tubes in the chassis have been replaced by advanced

solid state components. The results: a cooler running set; a more consistent picture.

Easiest-to-service ever. Most set functions have been grouped on 12 removable circuit boards —we call them AccuCircuit modules. Should an AccuCircuit failure occur, your serviceman simply locates the faulty board and snaps in a replacement. Simple as that.

Priced right. You get the Cosmos for only around $500 (op-

tional with dealer). Not exactly chickenfeed, but when you consider its solid state dependability and performance the Cosmos is really your best buy.

Ask an RCA dealer for a demonstration of the Cosmos. You'll probably find out you can't afford not to have one.

And everything you always wanted in a warranty, too. The Cosmos is backed by RCA Corporation with our one-year "Purchaser Satisfaction" war-

ranty covering parts and labor. Here are the basic provisions:

If anything goes wrong with your new set within a year from the day you buy it, and it's our fault, we'll pay your repair bill— both parts and labor.

You can use any service shop in which you have confidence— you don't have to pick from some special authorized list.

Should the Cosmos fail, your serviceman will come to your home. Just present your warranty registration card and RCA pays his repair bill.

If your picture tube becomes defective during the second year, we will exchange it for a reliable rebuilt tube, and you only pay for the installation.

In short, the warranty covers every set defect. It doesn't cover installation, foreign use, antenna systems or adjustment of customer controls.

RCA Solid State AccuColor

Simulated TV reception

RCA Color Televisions, 1971

I choose my friends very carefully.

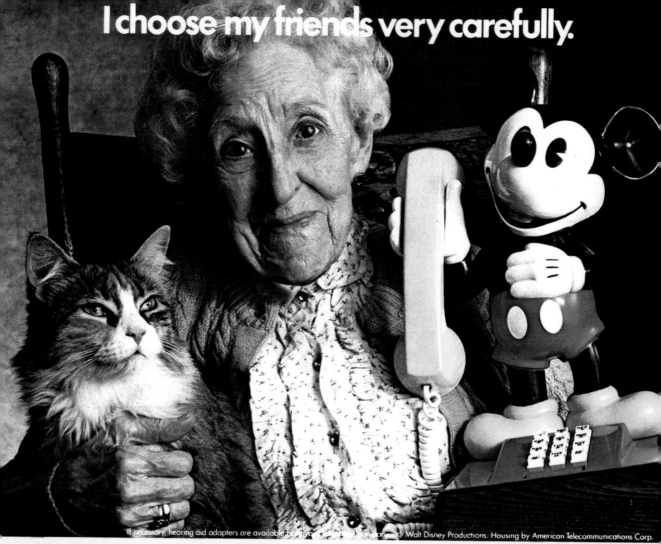

It necessary, hearing aid adapters are available to all types of telephones. © Walt Disney Productions. Housing by American Telecommunications Corp.

Very often, a phone is indeed like a friend. And now you can make it even more so.

There are all sorts of shapes and colors and styles of Bell telephones to choose from, together with all kinds of customized services.

So you can choose a phone you find amusing. Or one that's dashing. Or one you can just feel comfort-able with. In short, you can choose a phone that's genuinely you, and still get a phone that's genuine Bell.

A friend you can like, and a friend you can trust.

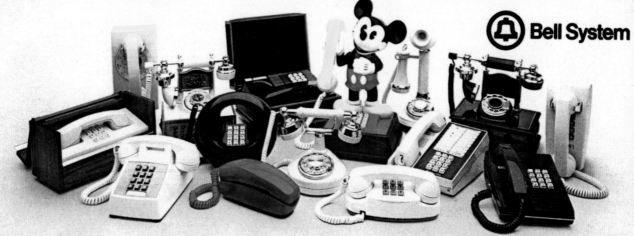

BE CHOOSEY

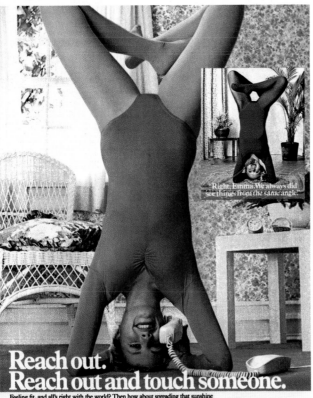

Reach out.
Reach out and touch someone.

Feeling fit, and all's right with the world? Then how about spreading that sunshine to a faraway friend? You can bet your leotards a simple phone call will really brighten her day. So get in touch. That phone call can keep a faraway friend close. Reach out and touch someone who's waiting to share your day.

(B) **Bell System**

Bell System Telephones, 1979

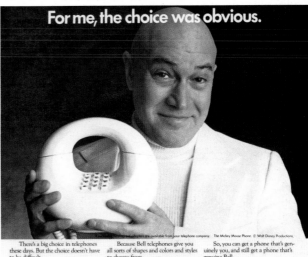

For me, the choice was obvious.

There's a big choice in telephones these days. But the choice doesn't have to be difficult.

To find the right style and the right quality, just come right to Bell.

Because Bell telephones give you all sorts of shapes and colors and styles to choose from.

All Bell quality. And all kinds of customized calling services as well.

So, you can get a phone that's genuinely you, and still get a phone that's genuine Bell.

What could be more obvious?

(B) **Bell System**

BE CHOOSEY

Bell System Telephones, 1978

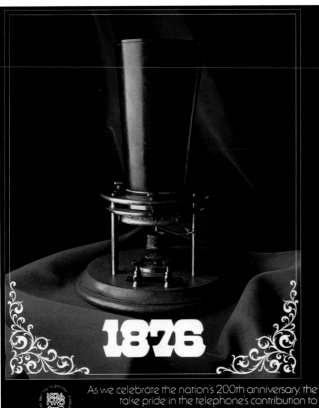

1876

1976

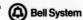

As we celebrate the nation's 200th anniversary, the one million men and women of the Bell System take pride in the telephone's contribution to America's progress over the past 100 years. We intend to continue working—to keep America's phone system the best in the world.

Bell System Telephones, 1978 ◄ *Bell System Telephones, 1976*

223

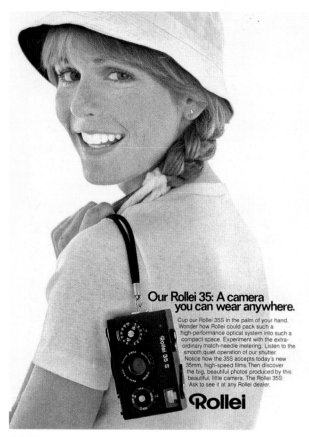

Our Rollei 35: A camera you can wear anywhere.

Cup our Rollei 35S in the palm of your hand. Wonder how Rollei could pack such a high-performance optical system into such a compact space. Experiment with the extra-ordinary match-needle metering. Listen to the smooth, quiet operation of our shutter. Notice how the 35S accepts today's new 35mm, high-speed films. Then discover the big, beautiful photos produced by this beautiful, little camera. The Rollei 35S: Ask to see it at any Rollei dealer.

Rollei

Rollei Cameras, 1977

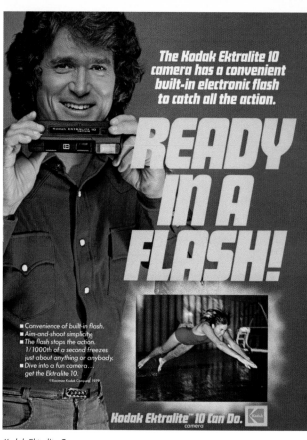

The Kodak Ektralite 10 camera has a convenient built-in electronic flash to catch all the action.

READY IN A FLASH!

- Convenience of built-in flash.
- Aim-and-shoot simplicity.
- The flash stops the action. 1/1000th of a second freezes just about anything or anybody.
- Dive into a fun camera... get the Ektralite 10.

©Eastman Kodak Company 1979

Kodak Ektralite™ 10 Can Do. camera

Kodak Ektralite Camera, 1979

SONAR

Press the button.

Sound waves measure the distance

and the lens whips into focus.

Polaroid Sonar Camera, 1978

©1978 Polaroid Corporation. "Polaroid," "SX-70" and "Pronto." SONAR/OneStep™

Polaroid introduces <u>Sonar</u> automatic focusing.

Life doesn't just sit there waiting for you to focus. So Polaroid has invented a way for sonar to focus for you automatically. You press one button, and that's all. Within a split second, inaudible sound waves dart to the subject and back, and the lens whips into focus. With Polaroid's new Sonar OneStep Land cameras, you can get sharp, precisely focused pictures every time. And see them in minutes.

The Sonar OneSteps from 99⁹⁵*
OneSteps. The World's Simplest Cameras.
*Suggested list. Pronto SONAR/OneStep.

NO DOUBT ABOUT IT.

No flash batteries to worry about. Just pop on a self-powered magicube.

If you try to use a used-up magicube, the camera gives you an automatic no-no.

No threading. Just drop in the film cartridge.

No settings. Just aim and shoot.

No doubt about it. The trim, slim Kodak Instamatic X-15 camera is a joy to use.

Ask about the X-15 in the extra-value Kodak Smile Saver kit, less than $25. Limited time only.

KODAK MAKES YOUR PICTURES COUNT

Kodak Instamatic Camera, 1971

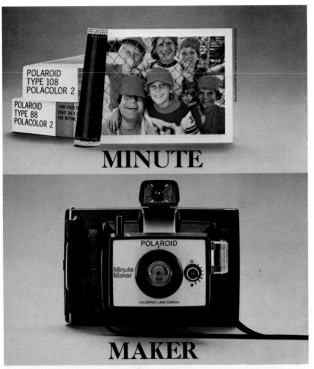

MINUTE

MAKER

You can pass these finished pictures around for everyone to look at and share in just 60 seconds. And Polaroid's deep brilliant colors will last. They're made with our exclusive SX-70 dyes which are among the most fade-resistant ever known to photography.

Our new MinuteMaker gives you the excitement in 2 sizes, our big 3¼" x 4¼" or our economical square film. (The least expensive instant color there is.) This easy automatic sets all exposures for you. You can shoot 'n share in 60 seconds.

Polaroid's new MinuteMaker under $25.

Suggested List Price. ® 1977 Polaroid Corporation. "Polaroid", "SX-70" and Minute Maker"

Polaroid MinuteMaker Camera, 1977

It was only fitting that this camera be bound in fine leather.

By all criteria, the SX-70® Alpha 1 is the unique single-lens reflex camera. Such a camera should also look distinctive. So we bound it in fine leather, as one binds a classic book, and set it off with a velvety chrome

finish. It folds to about 1"x4"x7"so you can carry it gracefully from your shoulder or easily in your pocket. Inside, its sophisticated optics let you focus through the picture-taking lens to as close as 10.4"

You can take instant portraits, sequential pictures as fast as every 1½ seconds, daylight flash pictures, even automatic time exposures to 14 seconds. The Polaroid® SX-70 Alpha 1 Land Camera.

Polaroid's SX-70 Alpha 1

© 1977 Polaroid Corporation

Polaroid SX-70 Alpha Camera, 1971

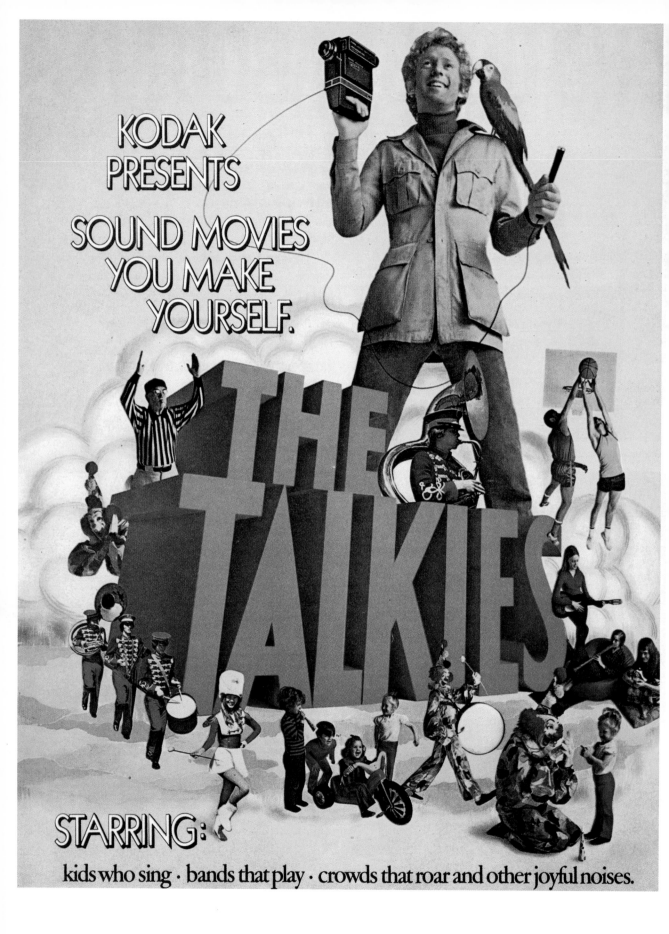

WHEN YOU MAKE SUPER 8 SOUND MOVIES WITH A SOUNDSTAR CAMERA, BELL & HOWELL GUARANTEES THEY'LL BE PERFECT.

The new Bell & Howell SoundStar super 8 sound movie camera has the five camera features people ask for most. Plus one extra no other camera maker offers. The Bell & Howell Perfect Movie Guarantee.*

It means if you make a movie with a SoundStar camera that isn't perfect by *your* standards, Bell & Howell will replace the film.

Is the SoundStar the perfect movie camera for you? A fast f/1.3 lens allows you to take movies indoors without movie lights. A touch of your finger activates the 8.5 to 24mm, 3:1 power zoom. All the sounds as well as the sights are recorded on film. Displays in the through-the-lens viewfinder show recording level, film transport, battery condition—even warn when film supply is low.

These four features make the SoundStar fun and easy to use. Its low price makes it easy to buy. Ask a Bell & Howell dealer for the price and a complete SoundStar demonstration.

"We want you to be completely satisfied, so this offer is separate from any camera or film warranty. And until it expires on January 1, 1980, there's no limit on the number of times you can exercise the Perfect Movie Guarantee.

Any silent or sound Bell & Howell super 8 camera purchased between 3/1/78 and 12/31/78 is covered. Owner must mail unedited, exposed film along with coupon supplied with camera prepaid to Bell & Howell. Exposed film not returned. A fresh roll of film and prepaid processing mailer will be sent to owner in about 3 weeks.

BELL & HOWELL
BELL HOWELL · MAMIYA COMPANY © 1978 All Rights Reserved.
Bell & Howell and Filmosonic are Bell & Howell Company trademarks.

Bell & Howell Super-8 Cameras, 1978

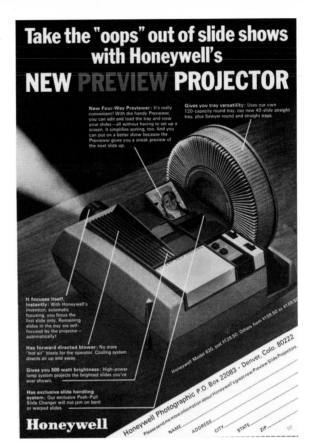

Take the "oops" out of slide shows with Honeywell's
NEW PREVIEW PROJECTOR

New Four-Way Previewer: It's really convenient! With the handy Previewer, you can edit and load the tray and view your slides – all without having to set up a screen. It simplifies sorting, too. And you can put on a better show because the Previewer gives you a sneak preview of the next slide up.

Gives you tray versatility: Uses our own 120-capacity round tray, our new 40-slide straight tray, plus Sawyer round and straight trays.

It focuses itself, instantly: With Honeywell's invention, automatic focusing, you focus the first slide only. Remaining slides in the tray are self-focused by the projector — automatically!

Has forward directed blower: No more "hot air" blasts for the operator. Cooling system directs air up and away.

Gives you 500 watt brightness: High-power lamp system projects the brightest slides you've ever shown.

Has exclusive slide handling system: Our exclusive Push-Pull Slide Changer will not jam on bent or warped slides.

Honeywell Model 620, just $129.50. Others from $109.50 to $169.50.

Honeywell

Honeywell Photographic P.O. Box 22083 · Denver, Colo. 80222
Please send me more information about Honeywell's great new Preview Slide Projectors.

NAME ____ ADDRESS ____ CITY ____ STATE ____ ZIP ____

Honeywell Projectors, 1970

From taking to showing, you need never touch the film.

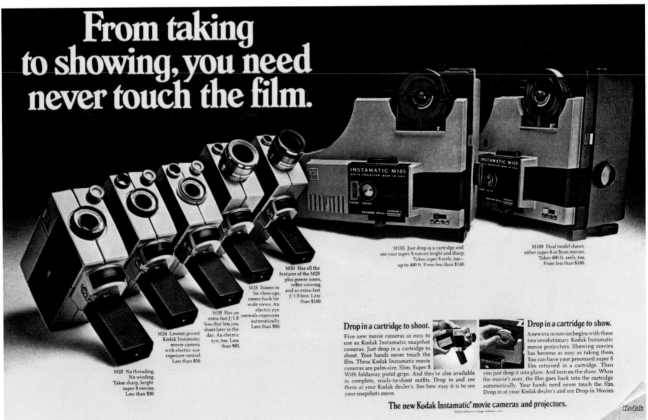

M22 No threading. No winding. Takes sharp, bright super 8 movies. Less than $30.

M24 Lowest-priced Kodak Instamatic movie camera with electric-eye exposure control. Less than $50.

M26 Has an extra-fast f/1.8 lens that lets you shoot later in the day. An electric eye, too. Less than $65.

M28 Zooms in for close-ups, zooms back for wide views. An electric eye controls exposures automatically. Less than $80.

M30 Has all the features of the M28 plus power zoom, reflex viewing, and an extra-fast f/1.9 lens. Less than $100.

M105 Just drop in a cartridge and see your super 8 movies bright and sharp. Takes super 8 reels, too— up to 400 ft. From less than $140.

M109 Dual model shows either super 8 or 8mm movies. Takes 400-ft. reels, too. From less than $160.

Drop in a cartridge to shoot.
Five new movie cameras as easy to use as Kodak Instamatic snapshot cameras. Just drop in a cartridge to shoot. Your hands never touch the film. These Kodak Instamatic movie cameras are palm-size. Slim. Super 8. With foldaway pistol grips. And they're also available in complete, ready-to-shoot outfits. Drop in and see them at your Kodak dealer's. See how easy it is to see your snapshots move.

Drop in a cartridge to show.
A new era in movies begins with these two revolutionary Kodak Instamatic movie projectors. Showing movies has become as easy as taking them. You can have your processed super 8 film returned in a cartridge. Then you just drop it into place. And turn on the show. When the movie's over, the film goes back into the cartridge automatically. Your hands need never touch the film. Drop in at your Kodak dealer's and see Drop-in Movies.

The new Kodak Instamatic® movie cameras and projectors.

Kodak Movie Cameras, 1973 ◄ *Kodak Instamatic Movie Equipment, 1970*

227

THE COMPUTER RADIO.
AT 6:00 AM, IT'S SMARTER THAN YOU ARE.

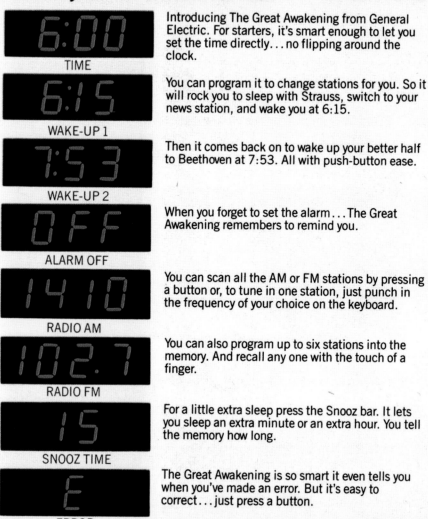

6:00 TIME

6:15 WAKE-UP 1

7:53 WAKE-UP 2

OFF ALARM OFF

1410 RADIO AM

102.7 RADIO FM

15 SNOOZ TIME

E ERROR

Introducing The Great Awakening from General Electric. For starters, it's smart enough to let you set the time directly...no flipping around the clock.

You can program it to change stations for you. So it will rock you to sleep with Strauss, switch to your news station, and wake you at 6:15.

Then it comes back on to wake up your better half to Beethoven at 7:53. All with push-button ease.

When you forget to set the alarm...The Great Awakening remembers to remind you.

You can scan all the AM or FM stations by pressing a button or, to tune in one station, just punch in the frequency of your choice on the keyboard.

You can also program up to six stations into the memory. And recall any one with the touch of a finger.

For a little extra sleep press the Snooz bar. It lets you sleep an extra minute or an extra hour. You tell the memory how long.

The Great Awakening is so smart it even tells you when you've made an error. But it's easy to correct...just press a button.

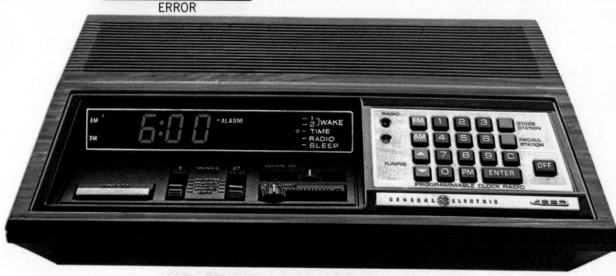

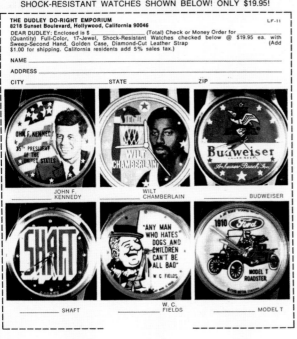
Dudley Do-Right Emporium, 1972

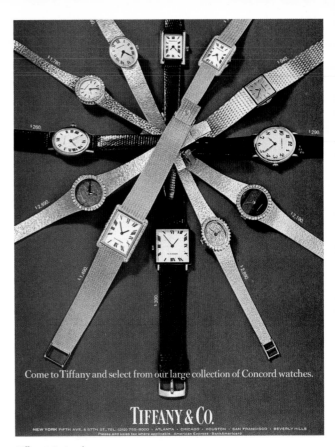
Tiffany & Co. Jewelers, 1975

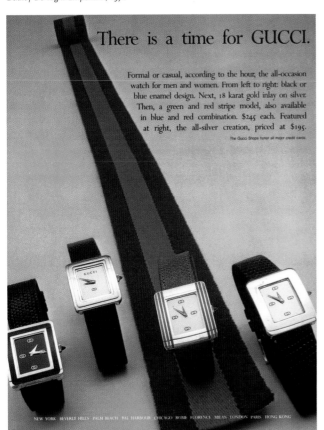
General Electric Clock Radio, 1979 ◄ *Gucci, 1978*

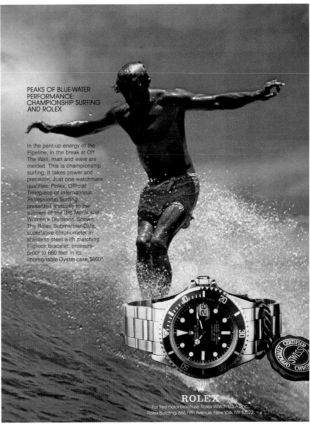
Rolex Watches, 1978

229

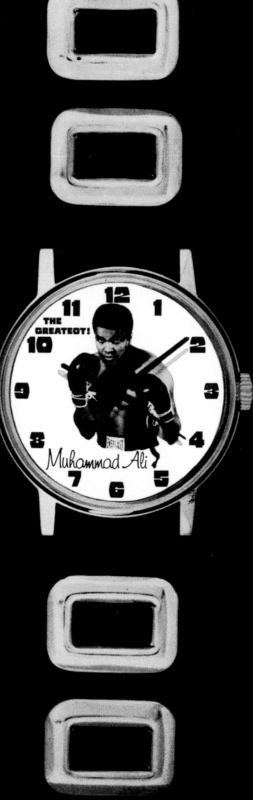

send jay ward $12.95

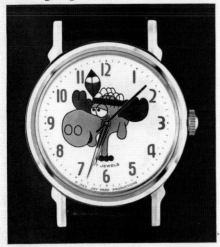

and jay ward'll send you
a BULLWINKLE WATCH

Official Timepiece for the "Sizzling Seventies"! Jay Ward's BULLWINKLE, in five brilliant colors! 17-Jewel wrist watch! Water- and shock-resistant! Sweep-second hand! Chrome case with handsome black leather band! 10-Day Money-Back Guarantee! At $12.95, the greatest Character Watch value ever offered! Terrific gift!

Also available with Dudley Do-Right's picture on the dial! Same great watch! Same great price! Then, there are the GOLDEN BULLWINKLES and the GOLDEN DUDLEYS! These $25 models are extra-nice! Automatic, self-wind, 17-Jewels! Full picture backgrounds with blue skies and snow-capped mountains! Genuine Elephant Leather band! Collector's items all!

Jay Ward Productions, 1970

There are only six
$25 electric watches made in the free world.
TIMEX makes them all.

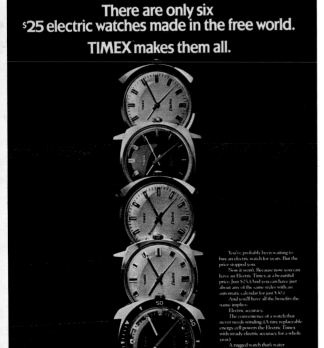

You've probably been waiting to buy an electric watch for years. But the price stopped you.

Now it won't. Because now you can have an Electric Timex at a beautiful price. Just $25. (And you can have just about any of the same styles with an automatic calendar for just $30.)

And you'll have all the benefits the name implies:

Electric accuracy.

The convenience of a watch that never needs winding. (A tiny replaceable energy cell powers the Electric Timex with steady electric accuracy for a whole year.)

A rugged watch that's water resistant and dust resistant.

And a wide choice of styles.

You've been waiting for an affordable price! Now you have it.

The Electric TIMEX.
It never needs winding.

Depraz-Faure Watches, 1971 ◄ Timex Watches, 1971

Liberation

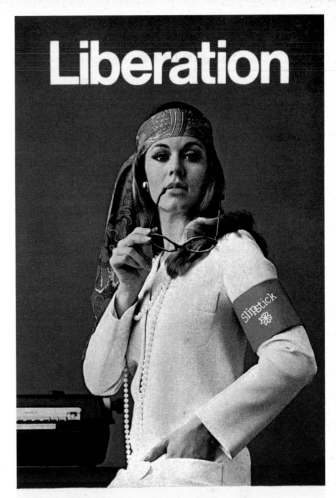

Slipstick is a revolutionary instrument you use like a pen to correct typing errors.

It's a versatile new dimension of something the secretary has known and loved for years: Liquid Paper correction fluid.

New Slipstick offers the best qualities of correction fluid plus the liberating convenience and precision of a pen. Not only for secretaries, but for everyone who uses a typewriter.

One light touch releases the special Slipstick formula — an opaquing fluid that penetrates to become part of the paper itself. Quickly. Permanently. And with intricate control.

You can take out a single character with ease and speed. Make corrections in or out of the typewriter. Retype only once for perfect corrections. Slipstick makes it easy.

These new freedoms have been declared for you by Liquid Paper Corporation.

Liquid Paper
Slipstick™

Liquid Paper Slip Stick, 1970

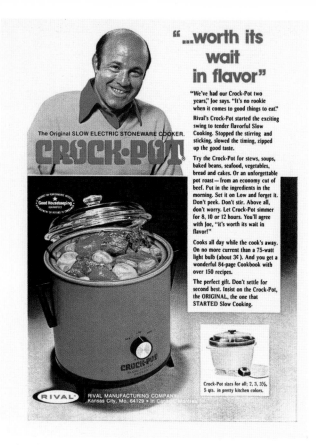

"...worth its wait in flavor"

The Original SLOW ELECTRIC STONEWARE COOKER.

CROCK·POT

"We've had our Crock-Pot two years," Joe says. "It's no rookie when it comes to good things to eat!"

Rival's Crock-Pot started the exciting swing to tender flavorful Slow Cooking. Stopped the stirring and sticking, slowed the timing, zipped up the good taste.

Try the Crock-Pot for stews, soups, baked beans, seafood, vegetables, bread and cakes. Or an unforgettable pot roast — from an economy cut of beef. Put in the ingredients in the morning. Set it on Low and forget it. Don't peek. Don't stir. Above all, don't worry. Let Crock-Pot simmer for 8, 10 or 12 hours. You'll agree with Joe, "it's worth its wait in flavor!"

Cooks all day while the cook's away. On no more current than a 75-watt light bulb (about 3¢). And you get a wonderful 84-page Cookbook with over 150 recipes.

The perfect gift. Don't settle for second best. Insist on the Crock-Pot, the ORIGINAL, the one that STARTED Slow Cooking.

RIVAL RIVAL MANUFACTURING COMPANY, Kansas City, Mo. 64129 • In Canada: Montreal.

Crock-Pot sizes for all; 2, 3, 3½, 5 qts. in pretty kitchen colors.

Rival Crock-Pot, 1971

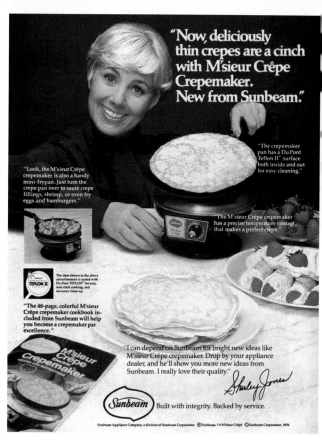

"Now, deliciously thin crepes are a cinch with M'sieur Crêpe Crepemaker. New from Sunbeam."

"The crepemaker pan has a Du Pont Teflon II® surface both inside and out for easy cleaning."

"Look, the M'sieur Crêpe crepemaker is also a handy mini-frypan. Just turn the crepe pan over to sauté crepe fillings, shrimp, or even fry eggs and hamburgers."

"The M'sieur Crêpe crepemaker has a precise temperature control that makes a perfect crepe."

The item shown in the above advertisement is coated with Du Pont TEFLON® for easy, non-stick cooking, and no-scour clean-up.

"The 48-page, colorful M'sieur Crêpe crepemaker cookbook included from Sunbeam will help you become a crepemaker par excellence."

"I can depend on Sunbeam for bright new ideas like M'sieur Crêpe crepemaker. Drop by your appliance dealer, and he'll show you more new ideas from Sunbeam. I really love their quality."

Shirley Jones

Sunbeam Built with integrity. Backed by service.

Sunbeam Appliance Company, a division of Sunbeam Corporation. ®Sunbeam TM/M'sieur Crêpe ©Sunbeam Corporation, 1976

Sunbeam Crepemaker, 1977

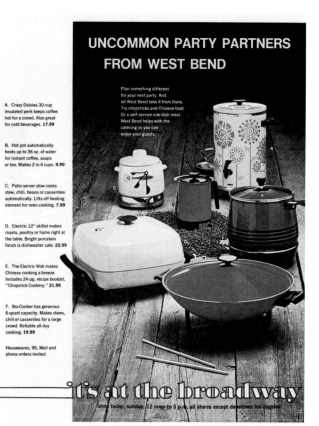

UNCOMMON PARTY PARTNERS FROM WEST BEND

Plan something different for your next party. And let West Bend take it from there. Try chopsticks and Chinese food. Or a self-service one-dish meal. West Bend helps with the catering so you can enjoy your guests.

A. Crazy Daisies 30-cup insulated perk keeps coffee hot for a crowd. Also great for cold beverages. **17.99**

B. Hot pot automatically heats up to 36 oz. of water for instant coffee, soups or tea. Makes 2 to 6 cups. **9.99**

C. Patio server slow-cooks stew, chili, beans or casseroles automatically. Lifts off heating element for oven cooking. **7.99**

D. Electric 12" skillet makes roasts, poultry or hams right at the table. Bright porcelain finish is dishwasher safe. **22.99**

E. The Electric Wok makes Chinese cooking a breeze. Includes 24-pg. recipe booklet, "Chopstick Cookery." **21.99**

F. Slo-Cooker has generous 6-quart capacity. Makes stews, chili or casseroles for a large crowd. Reliable all-day cooking. **19.99**

Housewares, 95, Mail and phone orders invited.

it's at the broadway

shop today, sunday, 12 noon to 5 p.m. all stores except downtown los angeles

West Bend Cookware, 1973

give her our best—

Singer Sewing Machine, 1970

ALL FOOD PROCESSORS ARE NOT CREATED EQUAL.

Of all the food processors around today, none gives you all the features of the GE Food Processor.

The GE Food Processor chops, grinds, shreds, slices, grates, blends, mixes, purees. In less than 60 seconds.

The motor is in the back, not underneath, so it fits under standard kitchen cabinets.

It has a dual-switch panel with on/off and pulse control. A five-inch food chute rather than a four-inch one. And a dual-purpose disc which slices on one side and shreds on the other. There are no extra blades to store outside the bowl.

It usually costs under $90.

It's serviced by a network of 235 service centers.

If you need any more reasons to buy the GE Food Processor, drop in to your local GE dealer. Seeing is believing.

Actual price may vary by dealer.

GENERAL ⓖ ELECTRIC

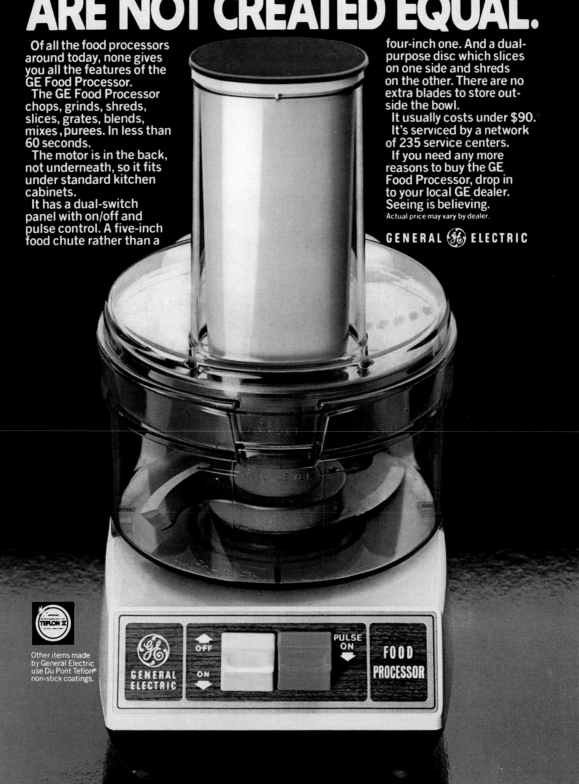

TEFLON II

Other items made by General Electric use Du Pont Teflon® non-stick coatings.

GENERAL ELECTRIC

OFF · ON · PULSE ON

FOOD PROCESSOR

General Electric Food Processors, 1977

The craftsman's touch.

Basic set (1½, 2½ qt. saucepans; 5 qt. Dutch oven; 10" skillet) shown in Harvest.

It's basic: there's a touch of the craftsman in us all.

You pride yourself on your good home cooking. We at West Bend pride ourselves on making good cookware for the home.

Country Inn™ is our classic.

Each piece is crafted of extra-thick aluminum which distributes the heat evenly through sides and bottom. (Ideal for flavor enriching low-temperature cooking.) Interiors have Fired-on no-stick coating for ease of cleaning.

It's beautiful, too. Smooth, unadorned porcelain exterior in a choice of two mellow colors: Harvest and Avocado.

Your West Bend dealer has Country Inn on display now. See it in person and feel for yourself the craftsman's touch.

WEST BEND®

... where craftsmen still care

© 1973, The West Bend Company, Dept. 673, West Bend, Wisconsin 53095. Also available in Canada.

West Bend Cookware, 1973

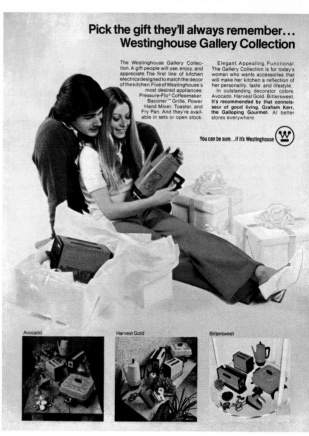

Pick the gift they'll always remember... Westinghouse Gallery Collection

The Westinghouse Gallery Collection. A gift people will use, enjoy, and appreciate. The first line of kitchen electrics designed to match the decor of the kitchen. Five of Westinghouse's most desired appliances: Pressure-Flo® Coffeemaker, Baconer™ Grille, Power Hand Mixer, Toaster, and Fry Pan. And they're available in sets or open stock.

Elegant. Appealing. Functional. The Westinghouse Gallery Collection is for today's woman who wants accessories that will make her kitchen a reflection of her personality, taste, and lifestyle.

In outstanding decorator colors. Avocado. Harvest Gold. Bittersweet. It's recommended by that connoisseur of good living, Graham Kerr, the Galloping Gourmet. At better stores everywhere.

You can be sure...if it's Westinghouse **W**

Avocado — Harvest Gold — Bittersweet

Westinghouse Cookware, 1971

The first informal dinnerware that matches beauty with strength.
Temper-ware
BY LENOX®

Freeze in it, then bake in it, serve in it, run it through the dishwasher. Lenox guarantees Temper-ware in writing against breaking, chipping, cracking and crazing for 2 years of normal home use. You can now purchase Temper-ware, the new super ceramic, at stores where Lenox fine China and Crystal are sold.

Write for your free Temper-ware color pattern brochure to Lenox Inc., Trenton, New Jersey 08605.

Lenox Temper-Ware, 1976

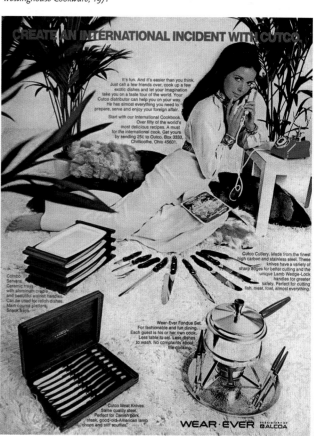

CREATE AN INTERNATIONAL INCIDENT WITH CUTCO

It's fun. And it's easier than you think. Just call a few friends over, cook up a few exotic dishes and let your imagination take you on a taste tour of the world. Your Cutco distributor can help you on your way. He has almost everything you need to prepare, serve and enjoy your foreign affair.

Start with our International Cookbook. Over fifty of the world's most delicious recipes. A must for the international cook. Get yours by sending 25¢ to Cutco, Box 3333, Chillicothe, Ohio 45601.

Cutco Cutlery. Made from the finest high carbon and stainless steel. These knives have a variety of sharp edges for better cutting and the unique Lamb Wedge-Lock handles for greater safety. Perfect for cutting fish, meat, fowl, almost everything.

Combo Servers. Ceramic trays with aluminum cradle and beautiful walnut handles. Can be used for relish dishes. Main course platters. Snack trays.

Wear-Ever Fondue Set. For fashionable and fun dining. Each guest is his or her own cook. Less table to set. Less dishes to wash. No complaints about the cooking.

Cutco Meat Knives. Same quality steel. Perfect for Danish pork, steak, good-old-American lamb chops and stiff soufflés.

WEAR·EVER a design group of **ALCOA**

Wear-Ever Cutlery, 1970

▶ *Lenox Tablewares, 1971*

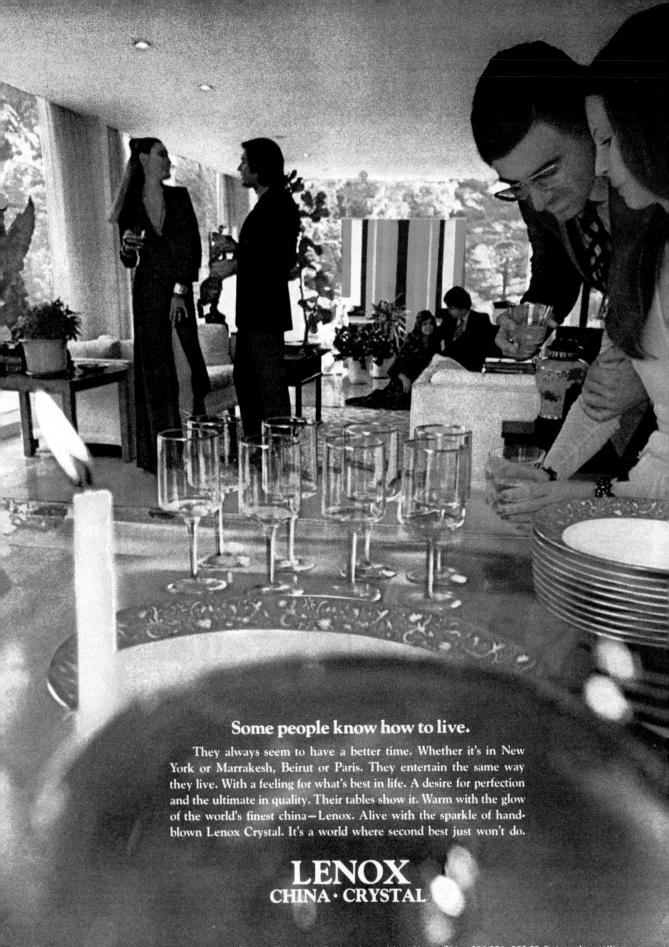

Some people know how to live.

They always seem to have a better time. Whether it's in New York or Marrakesh, Beirut or Paris. They entertain the same way they live. With a feeling for what's best in life. A desire for perfection and the ultimate in quality. Their tables show it. Warm with the glow of the world's finest china—Lenox. Alive with the sparkle of hand-blown Lenox Crystal. It's a world where second best just won't do.

LENOX
CHINA · CRYSTAL

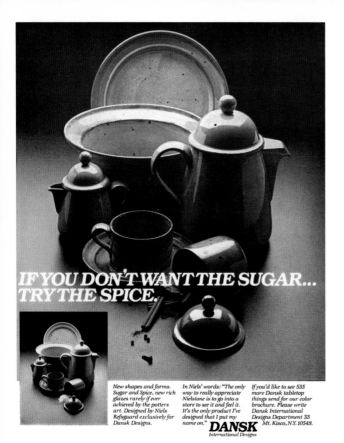

Dansk Tableware, 1977

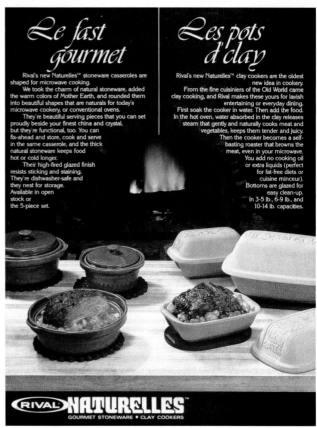

Rival Naturelles Cookwear, 1978

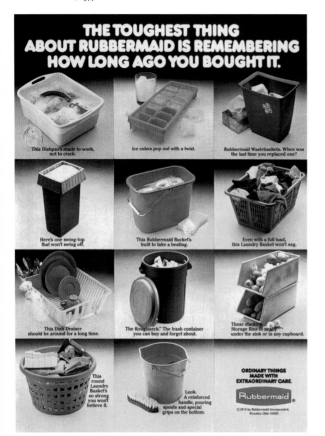

Rubbermaid Housewares, 1978

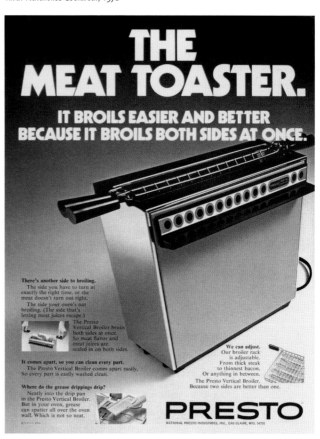

Presto Meat Toaster, 1971

Homemaker's Shopping Service, 1978

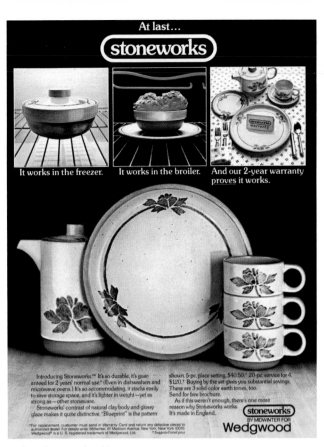

Wedgwood Stoneworks Tableware, 1979

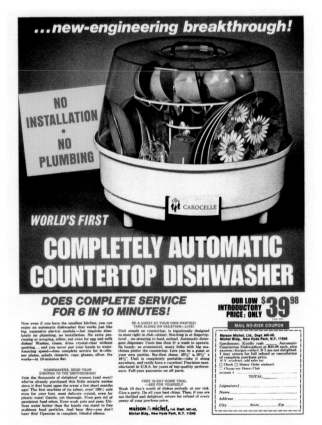

Maison Michel Countertop Dishwasher, 1970

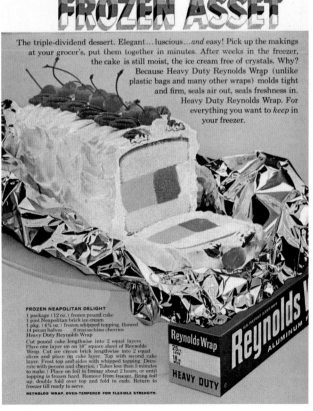

Reynolds Wrap Aluminum Foil, 1970

The Tappan recipe
for a clean gas oven:

Stuff chicken with orange sections and pineapple chunks. Shake a little soy sauce into the pineapple juice, use as a baste. Bake in a Tappan Continuous Cleaning* gas range.

The Continuous Cleaning oven has a special catalytic coating that cleans while the oven cooks. No matter how much your Polynesian Chicken, or barbecued spareribs, or roast pork spatter, your oven stays presentably clean.

If it's time to replace your old gas range, get a Tappan Continuous Cleaning gas range. This Tappan Gallery range with Visulite oven window has a built-in warming shelf and ductless exhaust fan. For clean cooking and good living it's gas—clean energy for today and tomorrow. See all the new Tappan gas ranges at your dealer or write Tappan, 250 Wayne St., Mansfield, Ohio 44902. *A.G.A. Mark

TAPPAN. WHEN YOU HAVE A CHOICE
AMERICAN GAS ASSOCIATION

Tappan Gas Oven, 1972

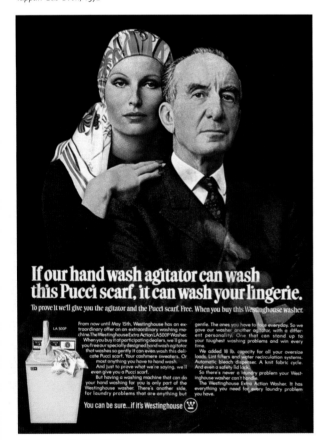

If our hand wash agitator can wash this Pucci scarf, it can wash your lingerie.

To prove it we'll give you the agitator and the Pucci scarf. Free. When you buy this Westinghouse washer.

From now until May 15th, Westinghouse has an extraordinary offer on an extraordinary washing machine. The Westinghouse Extra Action LA500P Washer. When you buy it at participating dealers, we'll give you free our specially designed hand wash agitator that washes so gently it can even wash this delicate Pucci scarf. Your cashmere sweaters. Or most anything you have to hand wash.

And just to prove what we're saying, we'll even give you a Pucci scarf.

But having a washing machine that can do your hand washing for you is only part of the Westinghouse washer. There's another side, for laundry problems that are anything but

gentle. The ones you have to take everyday. So we gave our washer another agitator, with a different personality. One that can stand up to your toughest washing problems and win every time.

We added 18 lb. capacity for all your oversize loads. Lint filters and water recirculation systems. Automatic bleach dispenser. A knit fabric cycle. And even a safety lid lock.

So there's never a laundry problem your Westinghouse washer can't handle.

The Westinghouse Extra Action Washer. It has everything you need for every laundry problem you have.

You can be sure...if it's Westinghouse Ⓦ

Westinghouse Washing Machines, 1972

SPEED QUEEN.
SUPERTWIN.
PORTABLE WASHER & DRYER

Enjoy the convenience of your own laundry appliances, even if you live in an apartment, mobile home or other home where space is a problem.

Speed Queen's compact washer and dryer require only a small amount of floor area and are portable for easy moving and storage. The washer requires no special plumbing, hooks up to almost any faucet for filling. Wash with Speed Queen agitator action in one tub and damp dry your laundry in the separate spin tub.

The electric dryer requires no special wiring, just plug it into any adequately wired 115-volt outlet. And, like the washer, the dryer has easy rolling casters. It can also be mounted on the wall or on an optional chrome stand with room beneath for storing the washer.

Supertwin portable washer and dryer — two new quality products from Speed Queen . . . manufacturers of dependable home laundry equipment since 1908.

THE LAUNDRY EQUIPMENT FOR HOMES WHERE SPACE IS A PROBLEM

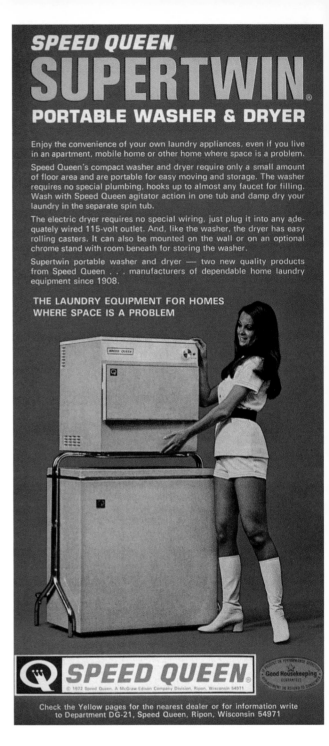

Ⓠ **SPEED QUEEN**
© 1972 Speed Queen. A McGraw Edison Company Division. Ripon, Wisconsin 54971

Check the Yellow pages for the nearest dealer or for information write to Department DG-21, Speed Queen, Ripon, Wisconsin 54971

Speed Queen Portable Washers and Dryers, 1972

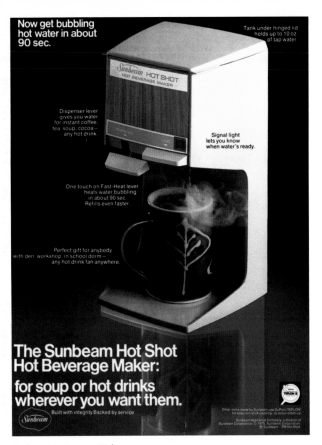

Sunbeam Hot Beverage Maker, 1975

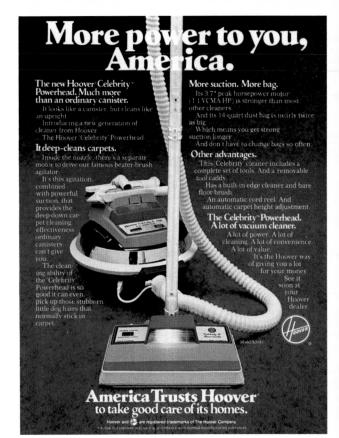

Hoover Vacuum Cleaner, 1979

Dixie Cups, 1974

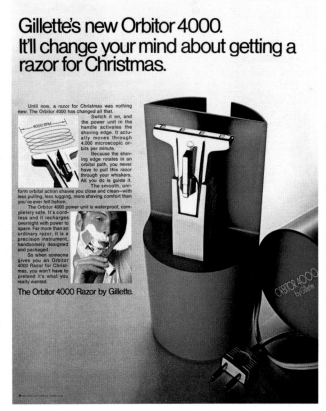

Gillette Orbitor 4000 Razor, 1970

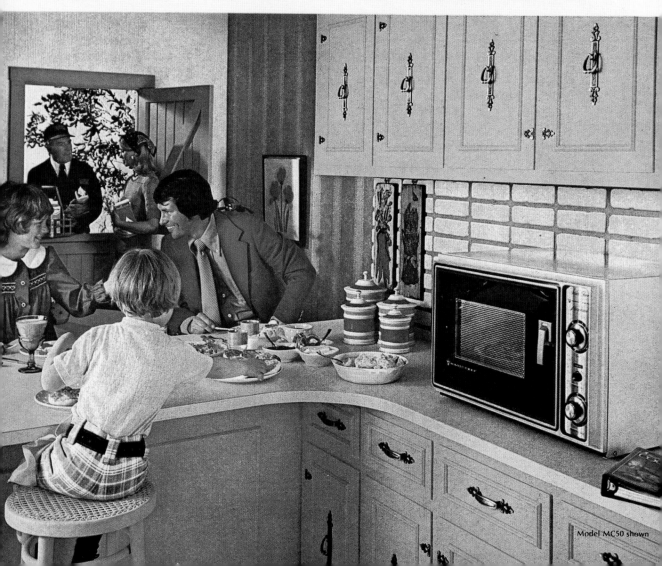

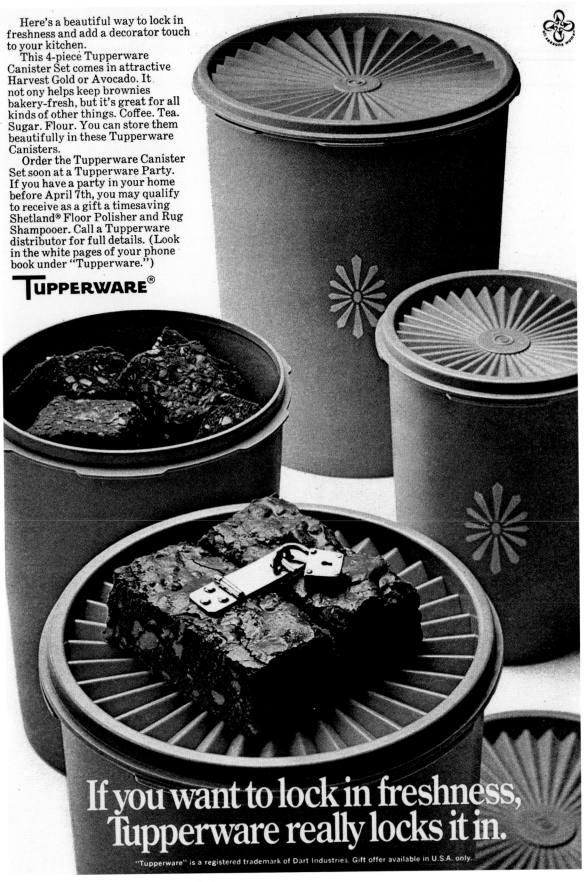

Here's a beautiful way to lock in freshness and add a decorator touch to your kitchen.

This 4-piece Tupperware Canister Set comes in attractive Harvest Gold or Avocado. It not ony helps keep brownies bakery-fresh, but it's great for all kinds of other things. Coffee. Tea. Sugar. Flour. You can store them beautifully in these Tupperware Canisters.

Order the Tupperware Canister Set soon at a Tupperware Party. If you have a party in your home before April 7th, you may qualify to receive as a gift a timesaving Shetland® Floor Polisher and Rug Shampooer. Call a Tupperware distributor for full details. (Look in the white pages of your phone book under "Tupperware.")

TUPPERWARE®

If you want to lock in freshness, Tupperware really locks it in.

Magic Chef Microwave Oven, 1974 ◄ *Tupperware Canisters, 1973*

FOR THRIFTY HOMEMAKERS

Best buys in brand-name housewares are at participating True Value Hardware Stores. Just say 'charge it.'

True Value Hardware, 1978

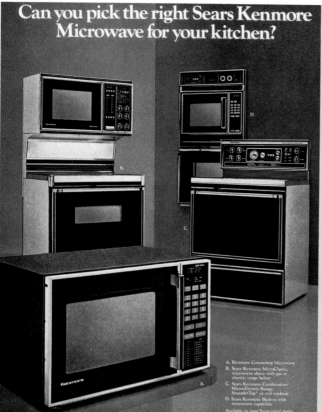

Can you pick the right Sears Kenmore Microwave for your kitchen?

Sears offers you a variety of microwave ovens— and the facts you need to know before you choose one

Ready for a microwave? Make it a Kenmore. Solid as Sears

Sears Kenmore Microwave Ovens, 1978

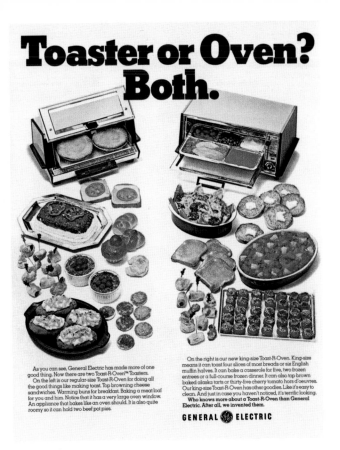

Toaster or Oven? Both.

As you can see, General Electric has made more of one good thing. Now there are two Toast-R-Oven™ Toasters.
On the left is our regular-size Toast-R-Oven for doing all the good things like making toast. Top browning cheese sandwiches. Warming buns for breakfast. Baking a meat loaf for you and him. Notice that it has a very large oven window. An appliance that bakes like an oven should. It is also quite roomy so it can hold two beef pot pies.

On the right is our new king-size Toast-R-Oven. King-size means it can toast four slices of most breads or six English muffin halves. It can bake a casserole for five, two frozen entrees or a full-course frozen dinner. It can also top brown baked alaska tarts or thirty-five cherry tomato hors d'oeuvres. Our king-size Toast-R-Oven has other goodies. Like it's easy to clean. And just in case you haven't noticed, it's terrific looking. **Who knows more about a Toast-R-Oven than General Electric. After all, we invented them.**

GENERAL ● ELECTRIC

GE Toast-R-Oven, 1972

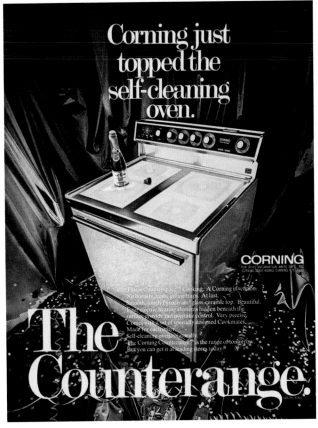

Corning just topped the self-cleaning oven.

CORNING
FOR MORE INFORMATION WRITE DEPT. 700,
CORNING GLASS WORKS, CORNING, N.Y. 14830

This is Counterspace™ Cooking. A Corning invention. No burners, coils, grease traps. At last. Smooth, tough Pyroceram® glass-ceramic top. Beautiful. Four electric heating elements hidden beneath the surface provide thermostatic control. Very precise. Comes with a set of specially designed Cookmates. Made for each other. Self-cleaning oven? Naturally. The Corning Counterange™ is the range of tomorrow. But you can get it at leading stores today.

The Counterange.

Corning Counterange, 1970

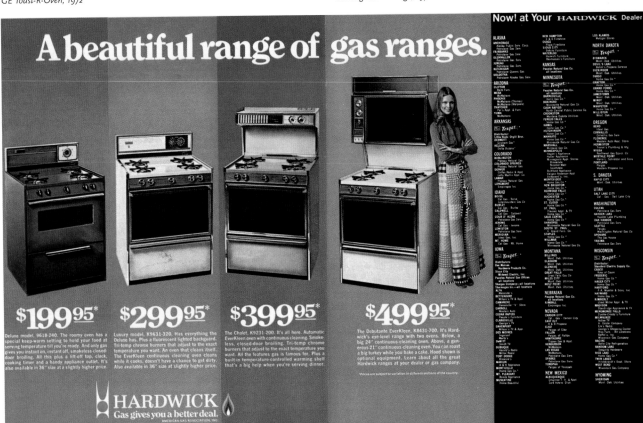

Now! at Your HARDWICK Dealer

A beautiful range of gas ranges.

$199⁹⁵*
Deluxe model, 9618-240. The roomy oven has a special keep-warm setting to hold your food at serving temperature till you're ready. And only gas gives you instant on, instant off, smokeless closed-door broiling. All this plus a lift-off top, clock, cooking timer and a handy appliance outlet. It's also available in 36" size at a slightly higher price.

$299⁹⁵*
Luxury model, K9631-320. Has everything the Deluxe has. Plus a fluorescent lighted backguard. Tri-temp chrome burners that adjust to the exact temperature you want. An oven that cleans itself. The EverKleen continuous cleaning oven cleans while it cooks, doesn't have a chance to get dirty. Also available in 36" size at slightly higher price.

$399⁹⁵*
The Chalet, K9231-200. It's all here. Automatic EverKleen oven with continuous cleaning. Smokeless, closed-door broiling. Tri-temp chrome burners that adjust to the exact temperature you want. All the features gas is famous for. Plus a built-in temperature-controlled warming shelf that's a big help when you're serving dinner.

$499⁹⁵*
The Debutante EverKleen, K8431-700. It's Hardwick's eye-level range with two ovens. Below, a big 24" continuous-cleaning oven. Above, a generous 21" continuous-cleaning oven. You can roast a big turkey while you bake a cake. Hood shown is optional equipment. Learn about all the great Hardwick ranges at your dealer or gas company.

*Prices are subject to variation in different sections of the country.

HARDWICK
Gas gives you a better deal.
AMERICAN GAS ASSOCIATION, INC.

Hardwick Gas Ranges, 1971

243

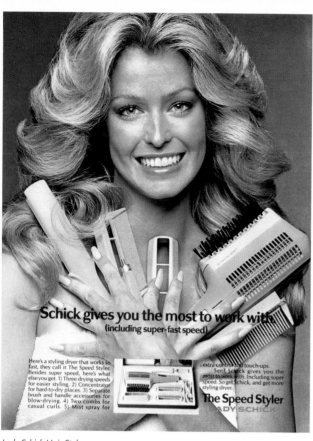

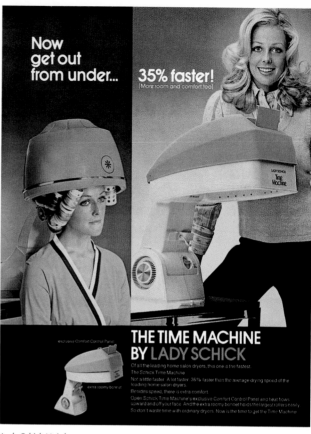

Lady Schick Hair Stylers, 1973

Lady Schick Hairdryer, 1973

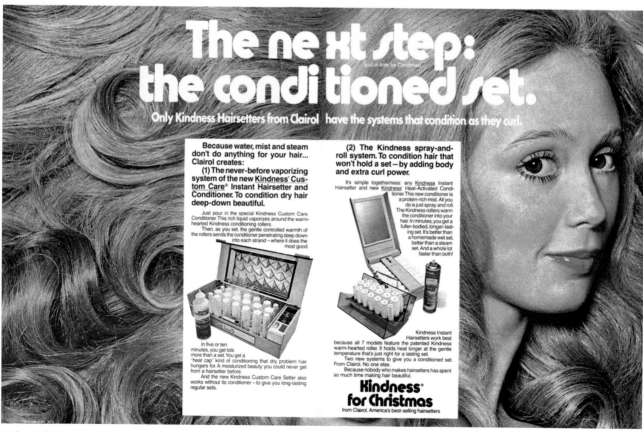

Kindness Rollers, 1970

You've got a lifestyle.
The Beauty-Makers can help you live it.

You work. You keep house. You go to school. Maybe you're into yoga. That's okay. Because that's your lifestyle. And you want to look great every minute. We want you to. We being the people who make the Beauty-Makers. General Electric.

An hour to meet him, and your hair's a wreck. GE's Speedsetter to the rescue. With 20 tangle-free rollers that make setting panic free. Sets hair dry, with mist or with a conditioner.

Lifestyle.
We're with yours.
GENERAL ⊕ ELECTRIC

He's coming for dinner, and you've just washed your hair. Under GE's Speed Dryer you go. Besides being fast, GE's Speed Dryer has Touch 'n Tilt. Touch, it tilts so you can do other things. Like type with two hands.

You're a travel nut. Meet GE's soft-bonnet dryer. Comes in its own carrying case like good, lightweight luggage. With two styling combs and a brush attachment.

You like your hair the way it is, "natural." GE's new styling dryer will dry curly or straight hair, style it the way you want. High-powered. Handy (ours has a special easy-to-hold handle) so you can do other things. Like type with two fingers.

The Beauty-Makers

General Electric Hair Styling Products, 1972

245

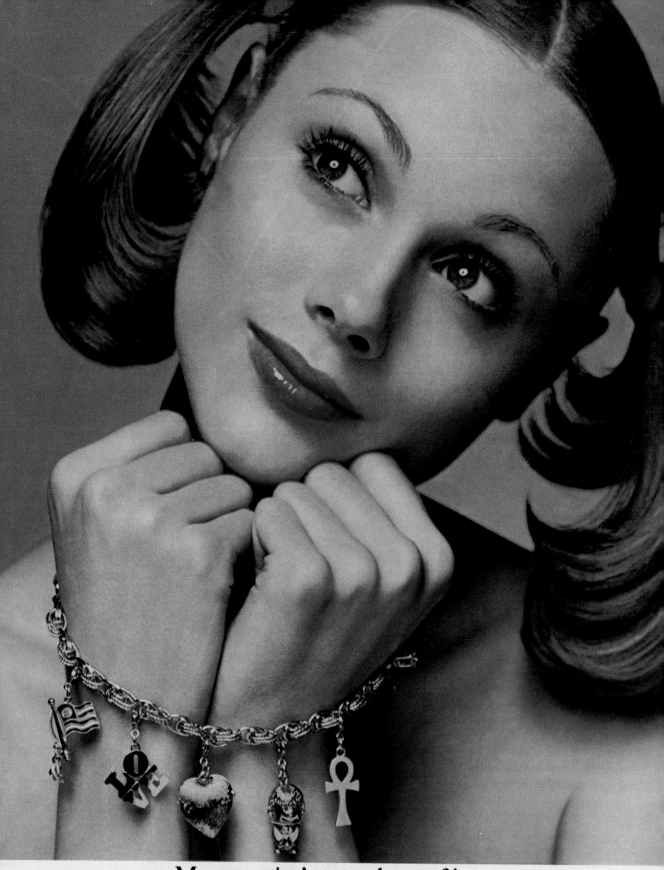

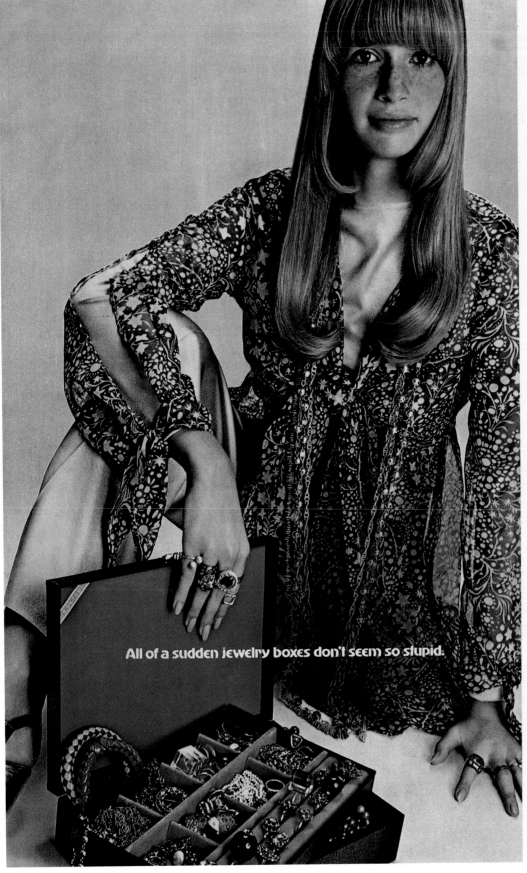

All of a sudden jewelry boxes don't seem so stupid.

All of a sudden jewelry isn't just a ring or two, a bracelet, and maybe a pair of earrings.
It's a ring or nine or ten, bracelets up to here, and earrings, earrings, earrings. Enter Buxton. With more than thirty different kinds of jewelry boxes in almost every color you can think of. From $3.50.

Misty $8.00

Louise $15.00

Gaitor Baitor $12.50

Conquistador $25.00

BUXTON

Monet Jewelers, 1973 ◄ *Buxton Jewelry Boxes, 1970*

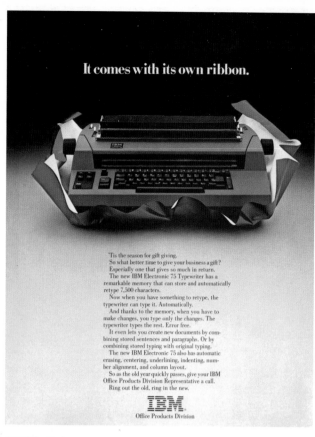

It comes with its own ribbon.

'Tis the season for gift giving.
So what better time to give your business a gift?
Especially one that gives so much in return.
The new IBM Electronic 75 Typewriter has a
remarkable memory that can store and automatically
retype 7,500 characters.
Now when you have something to retype, the
typewriter can type it. Automatically.
And thanks to the memory, when you have to
make changes, you type only the changes. The
typewriter types the rest. Error free.
It even lets you create new documents by com-
bining stored sentences and paragraphs. Or by
combining stored typing with original typing.
The new IBM Electronic 75 also has automatic
erasing, centering, underlining, indenting, num-
ber alignment, and column layout.
So as the old year quickly passes, give your IBM
Office Products Division Representative a call.
Ring out the old, ring in the new.

IBM
Office Products Division

IBM Office Products, 1979

The T-1. The pen is the point.

Look at it.
You've never seen a point like
this. Because you've never seen a
pen like this. With the case
and point in one.
It's the Parker T-1.
One sleek sweep of titanium all
the way to its tip. Strong. Because

titanium's strong as steel.
Durable. Because titanium fights
corrosion longer. Light. Because
titanium's half steel's weight.
Yet it "gives" so you can "feel"
the paper. And it grips the paper
without sliding.
Write with it. Feel it take off.
Fed by ink that flows freely and
easily to its point.
Write and write and write some

more with it. This pen was
made to hold its ink
longer without evaporation.
The T-1 even lets you change
the width of your stroke if you
want. Underneath this point
that doesn't look like a point,
there's a tiny dial. Turn it and
write from fine to medium,
Or from medium to bold.

Come fly the T-1. Now.
The space age of writing is here.

PARKER T-1 $20

Other Parker pens to own or give, from the $1.98 Jotter Ball Pen to the $150 Presidential Fountain Pen.
Parker Maker of the world's most wanted pens

Parker Pens, 1970

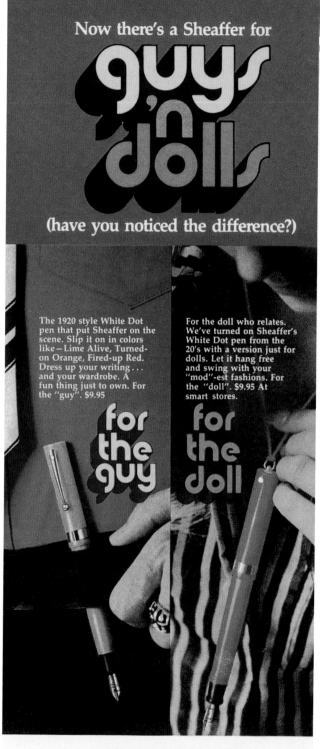

Now there's a Sheaffer for
guys 'n dolls
(have you noticed the difference?)

The 1920 style White Dot
pen that put Sheaffer on the
scene. Slip it on in colors
like—Lime Alive, Turned-
on Orange, Fired-up Red.
Dress up your writing . . .
and your wardrobe. A
fun thing just to own. For
the "guy". $9.95

For the doll who relates.
We've turned on Sheaffer's
White Dot pen from the
20's with a version just for
dolls. Let it hang free
and swing with your
"mod"-est fashions. For
the "doll". $9.95 At
smart stores.

for the guy **for the doll**

SHEAFFER ®
still the proud craftsmen

W. A. SHEAFFER PEN COMPANY, A [textron] COMPANY, FORT MADISON, IOWA 52627

Sheaffer Pens, 1970

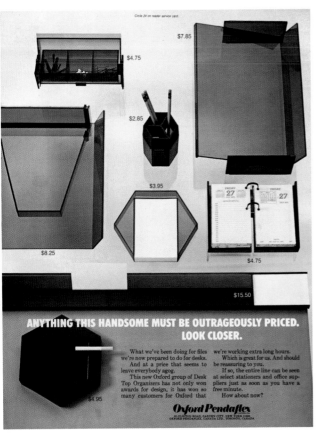

Oxford Pendaflex Desk Accessories, 1973

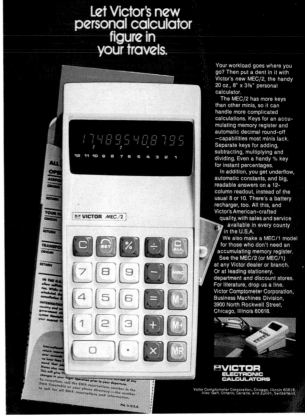

Victor Electronic Calculators, 1972

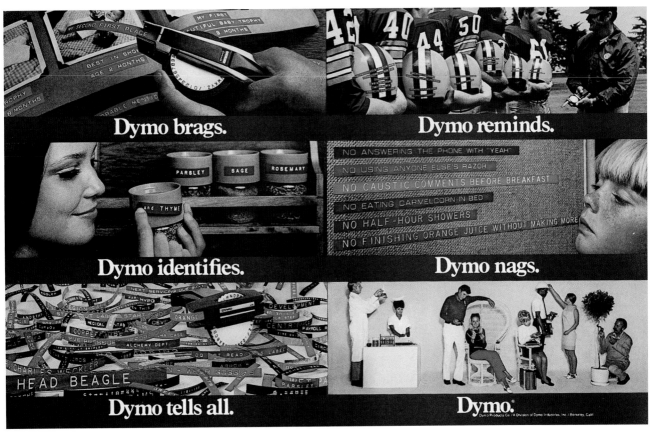

Dymo Label Makers, 1970

YOUR CHILD MAY FALL IN LOVE WITH A BUG.

A pretend bug like Lucy Ladybug, Charlie Cricket, or Katie Caterpillar. Three soft, squeezable creatures who live in Playskool's fantasy-filled Bug World.

Children will love the water faucet elevator and the root chute slide that takes their new friends from their vegetable garden roof into their cozy little home.

They'll also enjoy taking them for rides in the walnut-shell car, putting them in the pea pod hammock at nap time, or making sure they're clean little bugs by pretending to bathe them in the eggshell shower. Brightly colored vegetables are really secret places to hide in.

So, this year, introduce your children to an underground fantasy world. Just be prepared for one thing... they may fall in love with our bugs.

PLAYSKOOL

Playskool, Inc., A Milton Bradley Company

Playskool Toys, 1978

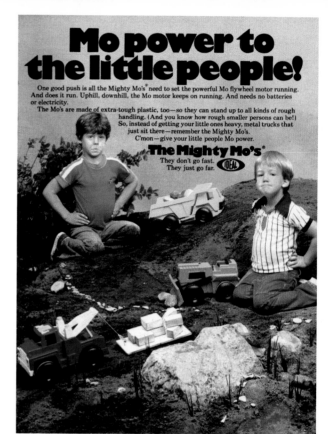

Mo power to the little people!

One good push is all the Mighty Mo's® need to set the powerful Mo flywheel motor running. And does it run. Uphill, downhill, the Mo motor keeps on running. And needs no batteries or electricity.

The Mo's are made of extra-tough plastic, too—so they can stand up to all kinds of rough handling. (And you know how rough smaller persons can be!) So, instead of getting your little ones heavy, metal trucks that just sit there—remember the Mighty Mo's.

C'mon—give your little people Mo power.

The Mighty Mo's®
They don't go fast.
They just go far. **IDEAL**

Ideal Toys, 1978

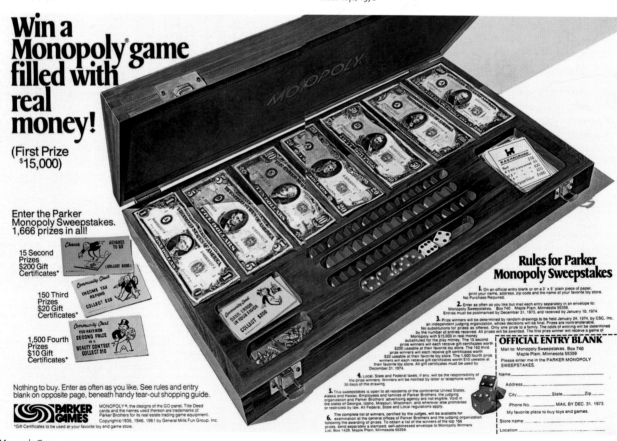

Win a Monopoly® game filled with real money!

(First Prize $15,000)

Enter the Parker Monopoly Sweepstakes. 1,666 prizes in all!

15 Second Prizes $200 Gift Certificates*

150 Third Prizes $20 Gift Certificates*

1,500 Fourth Prizes $10 Gift Certificates*

Nothing to buy. Enter as often as you like. See rules and entry blank on opposite page, beneath handy tear-out shopping guide.

PARKER GAMES

MONOPOLY®, the designs of the GO panel, Title Deed cards and the names used therein are trademarks of Parker Brothers for its real estate trading game equipment. Copyright ©1935, 1946, 1961 by General Mills Fun Group, Inc.
*Gift Certificates to be used at your favorite toy and game store.

Rules for Parker Monopoly Sweepstakes

1. On an official entry blank or on a 3" x 5" plain piece of paper, print your name, address, zip code and the name of your favorite toy store. No Purchase Required.

2. Enter as often as you like but mail each entry separately in an envelope to: Monopoly Sweepstakes, Box 740, Maple Plain, Minnesota 55359. Entries must be postmarked by December 31, 1973, and received by January 10, 1974.

3. Prize winners will be determined by random drawings to be held January 24, 1974, by CSC, Inc., an independent judging organization, whose decisions will be final. Prizes are nontransferable. No substitutions for prizes as offered. Only one prize to a family. The odds of winning will be determined by the number of entries received. All prizes will be awarded. The first prize winner will receive a game of Monopoly with $15,000 in real money substituted for the play money. The 15 second prize winners will each receive gift certificates worth $200 useable at their favorite toy store. The 150 third prize winners will each receive gift certificates worth $20 useable at their favorite toy store. The 1,500 fourth prize winners will each receive gift certificates worth $10 useable at their favorite toy store. All gift certificates must be used by December 31, 1974.

4. Local, State and Federal taxes, if any, will be the responsibility of the prize winners. Winners will be notified by letter or telephone within 30 days of the drawing.

5. This sweepstakes is open to all residents of the continental United States, Alaska and Hawaii. Employees and families of Parker Brothers, the judging organization and Parker Brothers' advertising agency are not eligible. Void in the states of Georgia, Idaho, Missouri, Wisconsin, and wherever else prohibited or restricted by law. All Federal, State and Local regulations apply.

6. The complete list of winners, certified by the judges, will be available for examination at the general offices of Parker Brothers and the judging organization following the awarding of prizes. To obtain a list of the winners of the top 166 prizes, send separately a stamped, self-addressed envelope to Monopoly Winners List, Box 1429, Maple Plain, Minnesota 55359.

OFFICIAL ENTRY BLANK

Mail to: Monopoly Sweepstakes, Box 740
Maple Plain, Minnesota 55359

Please enter me in the PARKER MONOPOLY SWEEPSTAKES.

Name _____

Address _____

City _____ State ____ Zip ____

Phone No. _____ MAIL BY DEC. 31, 1973.

My favorite place to buy toys and games.

Store name: _____

Location: _____

Monopoly Game, 1973

Now your kids can do more than watch Sesame Street.

They can play with it.

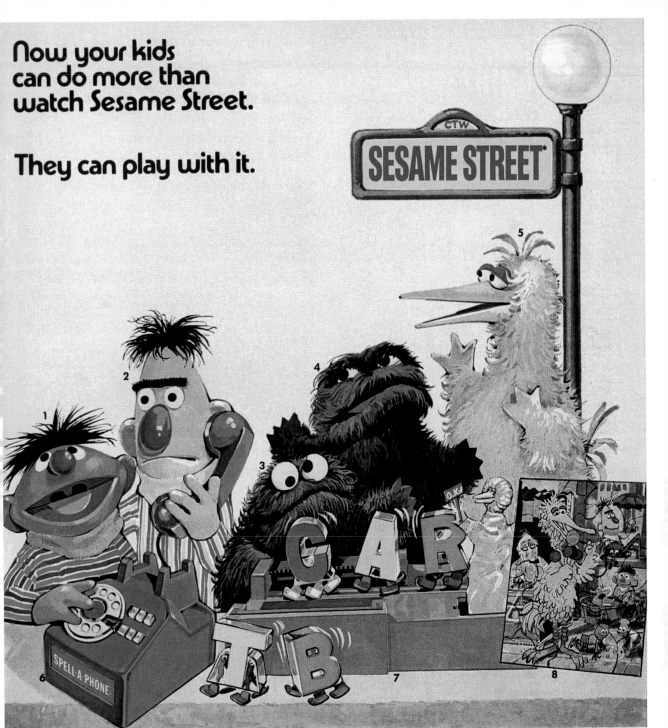

For the first time, educational playthings based on your child's favorite TV series.

1. Ernie Hand Puppet—Almost any child can operate his arms and mouth.

2. Bert Hand Puppet—Ernie's inseparable buddy. Just like Ernie.

3. Cookie Monster Hand Puppet—His arms and mouth move, and you can feed him cookies.

4. Oscar Hand Puppet—The world's most lovable "Grouch."

5. Big Bird— Almost 19 inches tall. Bend him, pose him. Make his beak move and his wings flap.

6. Spell·A·Phone—"Dial" a word, and the "word" will talk to you. Dial characters from Sesame Street, too.

7. Walking Letters—Letters actually "walk" down the ramp as you spell the word. Get it right, and Big Bird pops up to congratulate you. Wrong? The letters fall down!

8. Sherlock Hemlock Magic Puzzles—Complete with the Magic Looking Glass to reveal hidden answers, letters, and numbers. The real fun starts after you put it together.

Each of the above Sesame Street toys is guaranteed for one year from date of purchase against defective materials and workmanship.

This educational product was developed in close cooperation with the producers, researchers and educational advisors of the Children's Television Workshop, creators of the Sesame Street television series.

This product is intended to further the instructional goals of Sesame Street, but it has independent educational value and children do not have to watch the television show to benefit from it. Workshop revenues from this product will be used to help support Sesame Street and other C.T.W. educational projects. Big Bird and the Muppets are Jim Henson creations.

*Trademark of C.T.W. © 1971 Children's Television Workshop. Muppets © Muppets, Inc.

Products of Educational Toys, Inc.,
a subsidiary of TOPPER CORPORATION © 1971, Topper Corp.

Sesame Street Toys, 1971

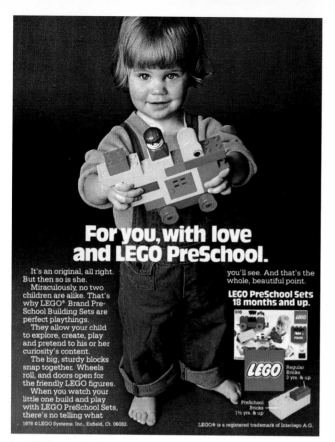

For you, with love and LEGO PreSchool.

It's an original, all right. But then so is she.

Miraculously, no two children are alike. That's why LEGO® Brand Pre-School Building Sets are perfect playthings.

They allow your child to explore, create, play and pretend to his or her curiosity's content.

The big, sturdy blocks snap together. Wheels roll, and doors open for the friendly LEGO figures.

When you watch your little one build and play with LEGO PreSchool Sets, there's no telling what

you'll see. And that's the whole, beautiful point.

LEGO PreSchool Sets 18 months and up.

Regular Bricks 3 yrs. & up

PreSchool Bricks 1½ yrs. & up

1978 ©LEGO Systems, Inc., Enfield, Ct. 06082. LEGO® is a registered trademark of Interlego A.G.

Lego Building Sets, 1978

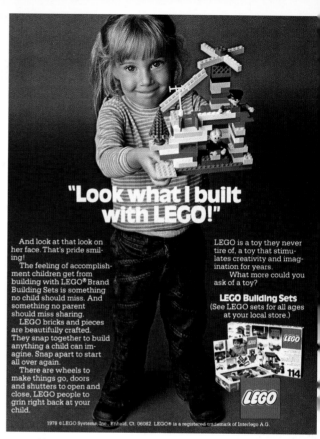

"Look what I built with LEGO!"

And look at that look on her face. That's pride smiling!

The feeling of accomplishment children get from building with LEGO® Brand Building Sets is something no child should miss. And something no parent should miss sharing.

LEGO bricks and pieces are beautifully crafted. They snap together to build anything a child can imagine. Snap apart to start all over again.

There are wheels to make things go, doors and shutters to open and close, LEGO people to grin right back at your child.

LEGO is a toy they never tire of, a toy that stimulates creativity and imagination for years.

What more could you ask of a toy?

LEGO Building Sets (See LEGO sets for all ages at your local store.)

114

1978 ©LEGO Systems, Inc., Enfield, Ct. 06082. LEGO® is a registered trademark of Interlego A.G.

Lego Building Sets, 1978

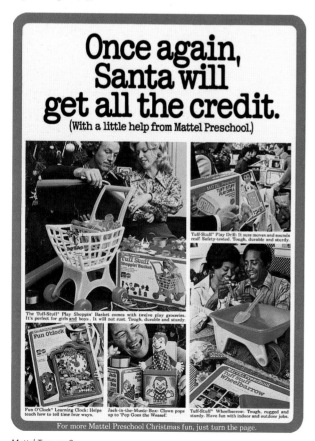

Once again, Santa will get all the credit.
(With a little help from Mattel Preschool.)

The Tuff-Stuff® Play Shoppin' Basket comes with twelve play groceries. It's perfect for girls and boys. It will not rust. Tough, durable and sturdy.

Tuff-Stuff® Play Drill: It sure moves and sounds real! Safety-tested. Tough, durable and sturdy.

Fun O'Clock® Learning Clock: Helps teach how to tell time four ways.

Jack-in-the-Music-Box: Clown pops up to 'Pop Goes the Weasel.'

Tuff-Stuff® Wheelbarrow: Tough, rugged and sturdy. Have fun with indoor and outdoor jobs.

For more Mattel Preschool Christmas fun, just turn the page.

Mattel Toys, 1978

Play favorites.

Your kids will love Schaper games for all the same reasons you did. The excitement. The challenge. The fun.

And for the simple reason that they are ready to play long

before your kids are ready to read. That means even a three-year-old can join the fun.

So play favorites with inexpensive and durable games from Schaper.

© 1978 Schaper Mfg. Co., division of Kusan, Inc.

Schaper Toys

Schaper Toys, 1978

Introducing the Funnygraphs.™ They're tougher than your kids.

You know what happens. Give your kids a little phonograph. And in a few days it becomes a three-piece system. The tone arm off in the corner. The turntable on the dresser. The needle and cartridge under the bed. That's why Panasonic has made two portable record players that should stand up to the roughest tortures a 7 year old can dream up.

We call these one-piece phonos the Funnygraphs.™ They're so simple, even an adult can work them. Select the record speed. Close the cover. And the record automatically starts playing.

No buttons to press. No tone arm to move.

There are two models to choose from. In three crazy colors. The Funnygraph,™ Model SG-200, comes in either tangerine or avocado green. And the Funnygraph II,™ Model SG-400, comes in silver with a built-in AM radio. Both play 33⅓ and 45 rpm records. And are Panasonic solid-state engineered. So they're tough on the inside. As well as the outside.

And when the kids open their present. You won't have to run out for batteries. Because we include Panasonic batteries.

So give your kids something that you'll enjoy too. A Panasonic Funnygraph™ that's tougher than they are.

The Crazy Color Radios

R-72 original design by J. M. Willmin

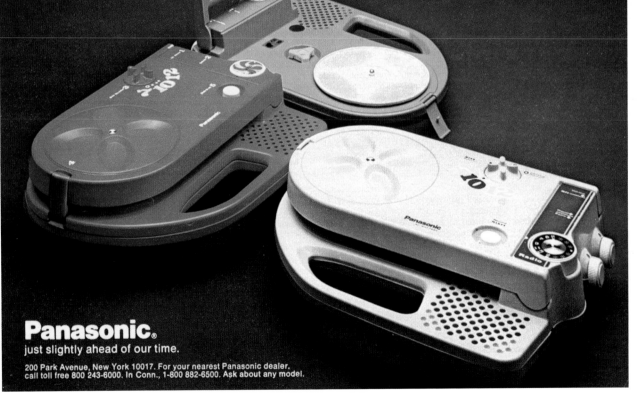

Panasonic.
just slightly ahead of our time.

200 Park Avenue, New York 10017. For your nearest Panasonic dealer. call toll free 800 243-6000. In Conn., 1-800 882-6500. Ask about any model.

Panasonic Funnygraph Radios, 1972

The Fisher-Price Adventure People on Land, Sea and Air.

(For Adventurers from 4 to 9 years old.)

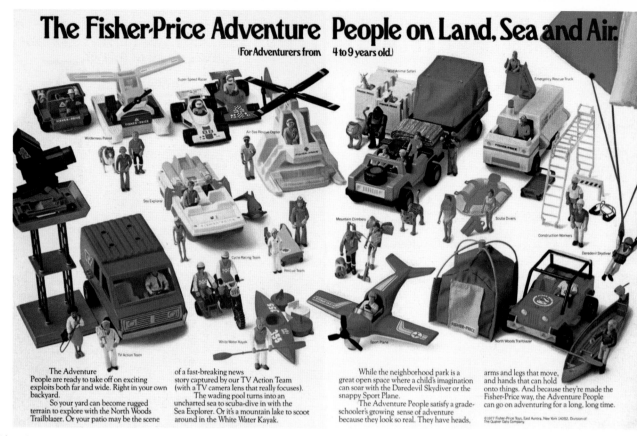

The Adventure People are ready to take off on exciting exploits both far and wide. Right in your own backyard.

So your yard can become rugged terrain to explore with the North Woods Trailblazer. Or your patio may be the scene of a fast-breaking news story captured by our TV Action Team (with a TV camera lens that really focuses).

The wading pool turns into an uncharted sea to scuba-dive in with the Sea Explorer. Or it's a mountain lake to scoot around in with the White Water Kayak.

While the neighborhood park is a great open space where a child's imagination can soar with the Daredevil Skydiver or the snappy Sport Plane.

The Adventure People satisfy a grade-schooler's growing sense of adventure because they look so real. They have heads, arms and legs that move, and hands that can hold onto things. And because they're made the Fisher-Price way, the Adventure People can go on adventuring for a long, long time.

©1977 Fisher-Price Toys, East Aurora, New York 14052. Division of The Quaker Oats Company.

Fisher-Price Toys, 1977

Fisher-Price gives kids a chance to run the show.

You'll enjoy the giggles that erupt when they run our cartoon movies at fast speed, in slow motion and backwards. Just by turning a handle.

First there's our new Movie Viewer Theater. Pictures appear either on its own viewing screen or by projecting them on a wall. It uses a child-safe wall plug that steps down voltage. And there's a handy carrying handle on the back.

Our hand-held Movie Viewer uses only child power. And turning the handle produces the same fast, slow or backwards action.

Each of these entertaining toys comes with one movie cartridge, a full-color Walt Disney cartoon adventure featuring Mickey Mouse. Extra film cartridges are available with other well-loved cartoons. Or Sesame Streets* delightful films.

If you're lucky, the kids will let you watch, too.

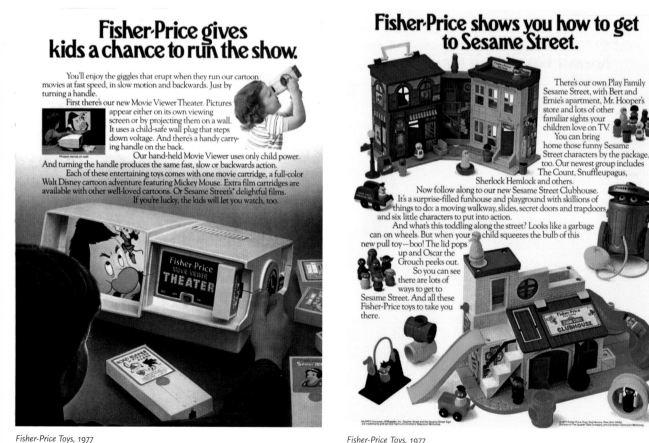

Fisher-Price Toys, 1977

Fisher-Price shows you how to get to Sesame Street.

There's our own Play Family Sesame Street, with Bert and Ernie's apartment, Mr. Hooper's store and lots of other familiar sights your children love on TV.

You can bring home those funny Sesame Street characters by the package, too. Our newest group includes The Count, Snuffleupagus, Sherlock Hemlock and others.

Now follow along to our new Sesame Street Clubhouse. It's a surprise-filled funhouse and playground with skillions of things to do: a moving walkway, slides, secret doors and trapdoors, and six little characters to put into action.

And what's this toddling along the street? Looks like a garbage can on wheels. But when your child squeezes the bulb of this new pull toy—boo! The lid pops up and Oscar the Grouch peeks out.

So you can see there are lots of ways to get to Sesame Street. And all these Fisher-Price toys to take you there.

MUPPET Characters ©Muppets, Inc. Sesame Street and the Sesame Street Sign are trademarks and service marks of Children's Television Workshop.

©1977 Fisher-Price Toys, East Aurora, New York 14052. Division of The Quaker Oats Company and Children's Television Workshop.

Fisher-Price Toys, 1977

Fisher-Price introduces the Play Family Lift & Load Depot.

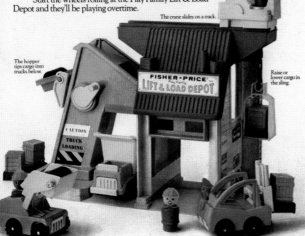

It's the beginning of an exciting new kind of Play Family toy. Because we know that a preschooler's happiest occupation is putting things into things, moving them, dumping them and loading them all over again.

That's the job of our new Lift & Load Depot. There's a crank-operated conveyor and a crane on a track to shuttle crates and oil drums up and down, and back and forth. From warehouse to loading station to trucks.

There's a dump truck, scoop loader and forklift, each with a driver. And lots of cargo to move.

Start the wheels rolling at the Play Family Lift & Load Depot and they'll be playing overtime.

The crane slides on a track.

The hopper tips cargo into trucks below.

Raise or lower cargo in the sling.

Fisher-Price Toys, 1977

Fisher-Price toys keep their heads. Also their wheels, their handles and their great sense of humor.

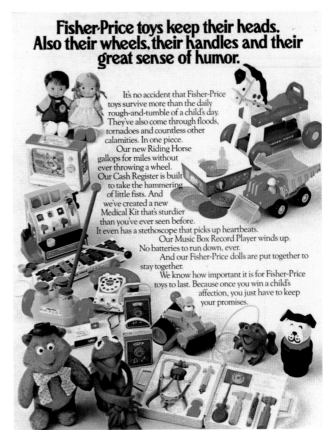

It's no accident that Fisher-Price toys survive more than the daily rough-and-tumble of a child's day. They've also come through floods, tornadoes and countless other calamities. In one piece.

Our new Riding Horse gallops for miles without ever throwing a wheel.

Our Cash Register is built to take the hammering of little fists. And we've created a new Medical Kit that's sturdier than you've ever seen before. It even has a stethoscope that picks up heartbeats.

Our Music Box Record Player winds up. No batteries to run down, ever.

And our Fisher-Price dolls are put together to stay together.

We know how important it is for Fisher-Price toys to last. Because once you win a child's affection, you just have to keep your promises.

Fisher-Price Toys, 1977

Fisher-Price has three funny Muppets for you. Kermit, Fozzie and Rowlf.

We're very proud of our new friends. Not just because they're stars of "The Muppet Show," but because they're very entertaining fellows all on their own.

Kermit, the fascinating frog, has a soft green body. And long, long arms and legs with Velcro patches at the tips. So he can be posed in hundreds of funny ways.

Fozzie's comical grin and chubby plush body invites lots of squeezes. And he comes nattily dressed in fedora and bowtie.

Then there's Rowlf, a fuzzy-wuzzy Muppet hand-puppet who's always ready for a giggly heart-to-heart talk.

And, of course, all three Muppets are made with famous Fisher-Price quality. They're completely machine-washable and dryer-safe.

So they'll last through years of the most affectionate hugging and tugging.

In fact, we think they're just the kind of toys that best friends are made of.

MUPPET Character © Henson Associates, Inc. 1966, 1976, 1977.
©1977 Fisher-Price Toys, East Aurora, New York 14052. Division of the Quaker Oats Company.

Fisher-Price Toys, 1977

Why Fisher-Price trucks are the best trucks you can put in the hands of a preschool child.

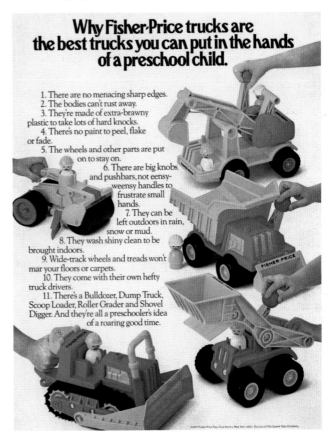

1. There are no menacing sharp edges.
2. The bodies can't rust away.
3. They're made of extra-brawny plastic to take lots of hard knocks.
4. There's no paint to peel, flake or fade.
5. The wheels and other parts are put on to stay on.
6. There are big knobs and pushbars, not eensy-weensy handles to frustrate small hands.
7. They can be left outdoors in rain, snow or mud.
8. They wash shiny clean to be brought indoors.
9. Wide-track wheels and treads won't mar your floors or carpets.
10. They come with their own hefty truck drivers.
11. There's a Bulldozer, Dump Truck, Scoop Loader, Roller Grader and Shovel Digger. And they're all a preschooler's idea of a roaring good time.

©1977 Fisher-Price Toys, East Aurora, New York 14052. Division of The Quaker Oats Company.

Fisher-Price Toys, 1977

Nobody knows how to talk to kids like See'n Say talking toys.

Mattel See 'n Say Talking Toys, 1979

Once in a childhood there's a doll that's your very best friend. That's why Fisher-Price created My Friend Mandy.

She's a little-girl doll. Not too babyish. Not too grown-up. Her body is soft enough to hug, yet you can stand her up or sit her down, and turn her dimply smile in your direction.

My Friend Mandy has thick shiny hair to wash, brush or curl. And she comes dressed as you see her here, complete with stretchy pink tights.

My Friend Mandy brings along her own nightgown, too, because she always sleeps over.

You can buy her the other well-made outfits on this page. Or if you're handy with a needle, Fisher-Price includes a clothes pattern with each purchase.

All we ask is that you meet My Friend Mandy face to face. Because to see her is to love her.

Look for My Friend Mandy in the doll department of your favorite store.

Fisher-Price Mandy Dolls, 1977

Mattel Hug 'N Talk Dolls, 1978 ◄ *Fisher-Price My Baby Beth Dolls, 1978*

Because a baby doll can be her first armful of love, Fisher-Price created My Baby Beth.

When a small child holds a baby doll of its own, something remarkable happens. A proud and protective feeling, an inkling of what it's like to be responsible for someone smaller than you.

My Baby Beth, with her trusting and appealing face, brings out that feeling beautifully. She has a soft, huggable body, that feels like you're holding a real baby. And our unique design lets you sit her up as well as most infants her age.

You can also wash her face and hands and comb her wispy baby hair. Because she's likely to get lots of jammy kisses and fervent hugs.

My Baby Beth comes with a knitted sweater, cap and booties. And if you or your child like to sew, there's also a simple pattern to make her a baby sleeper.

Naturally, My Baby Beth is made the Fisher-Price way, to survive the awkward affection and little mistakes of a beginning parent. Because we know this baby is going to be loved very hard.

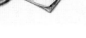

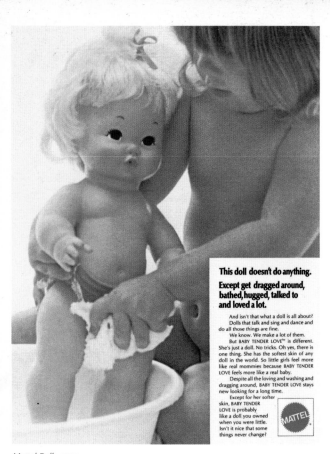

This doll doesn't do anything.

Except dragged around, bathed, hugged, talked to and loved a lot.

And isn't that what a doll is all about?
Dolls that talk and sing and dance and
do all those things are fine.

We know. We make a lot of them.
But BABY TENDER LOVE™ is different.
She's just a doll. No tricks. Oh yes, there is
one thing. She has the softest skin of any
doll in the world. So little girls feel more
like real mommies because BABY TENDER
LOVE feels more like a real baby.

Despite all the loving and washing and
dragging around, BABY TENDER LOVE stays
new looking for a long time.

Except for her softer
skin, BABY TENDER
LOVE is probably
like a doll you owned
when you were little.
Isn't it nice that some
things never change?

MATTEL

Mattel Dolls, 1970

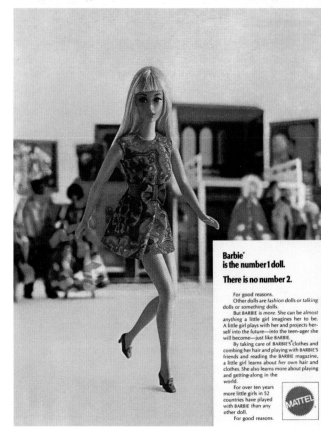

Barbie® is the number 1 doll.

There is no number 2.

For good reasons.
Other dolls are fashion dolls or talking
dolls or something dolls.

But BARBIE is more. She can be almost
anything a little girl imagines her to be.
A little girl plays with her and projects her-
self into the future—into the teen-ager she
will become—just like BARBIE.

By taking care of BARBIE's clothes and
combing her hair and playing with BARBIE's
friends and reading the BARBIE magazine,
a little girl learns about her own hair and
clothes. She also learns more about playing
and getting along in the
world.

For over ten years
more little girls in 52
countries have played
with BARBIE than any
other doll.

For good reasons.

MATTEL

Barbie Dolls, 1970

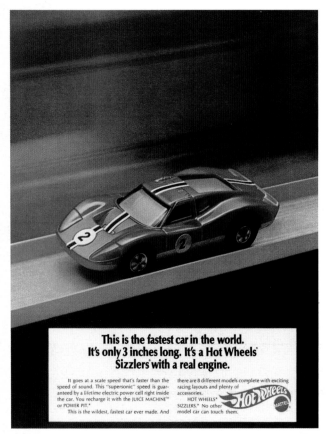

This is the fastest car in the world.
It's only 3 inches long. It's a Hot Wheels®
Sizzlers® with a real engine.

It goes at a scale speed that's faster than the
speed of sound. This "supersonic" speed is guar-
anteed by a lifetime electric power cell right inside
the car. You recharge it with the JUICE MACHINE™
or POWER PIT.™

This is the wildest, fastest car ever made. And

there are 8 different models complete with exciting
racing layouts and plenty of
accessories.

HOT WHEELS®
SIZZLERS.® No other
model car can touch them.

Hot Wheels **MATTEL**

Hot Wheels Toy Cars, 1970

Now, your little ones can play with these wonderful, whacky Dr. Seuss characters.

All these good friends of Dr. Seuss
come to life in a whimsical laugh-a-minute
line of toys.

It's as if these beloved characters
jumped right out of the pages of the books
and into your house to play with your
children.

They talk and sing and say the happiest
things. Until now your children have only
been able to read about Dr. Seuss char-
acters. Now they can play with them, too.

During this intro-
ductory period only,
when you buy any
Dr. Seuss toy, you get
a giant Cat-In-The-Hat
poster free. (16" by 42".)

Dr. Seuss Toys, 1970

▶ Playmobil Toys, 1978

More Major League players wear Rawlings gloves than any other kind. Players like Brooks Robinson, Johnny Bench and Billy Williams. A few want minor customizing. But all wear, basically, the same Rawlings gloves you can buy in the store.

Rawlings gloves are available at sporting goods stores and departments everywhere, at prices that fit every budget.

Johnny Bench, Brooks Robinson and Billy Williams are members of Rawlings Pro Advisory Staff. Rawlings Sporting Goods Company • Division of A-T-O Inc. • 2300 Delmar Blvd. • St. Louis, Mo. 63166

Rawlings

"THE MARK OF A PRO"

Rawlings Gloves, 1971

Every good cook has to start somewhere.

For her, there's no thrill quite like when she bakes that first Betty Crocker chocolate cake in her Easy-Bake Oven.

More than all the fun she'll have, Easy-Bake is a great way for her to create love in warm little bites.

Easy-Bake has built-in safety features, is U. L. approved and bakes with two ordinary light bulbs. And comes with real Betty Crocker mixes.

Easy-Bake. Because she'll love it.

 Easy-Bake® Oven
from **Kenner**

© General Mills Fun Group, Inc.

Easy-Bake Oven, 1973

NeRF Toys

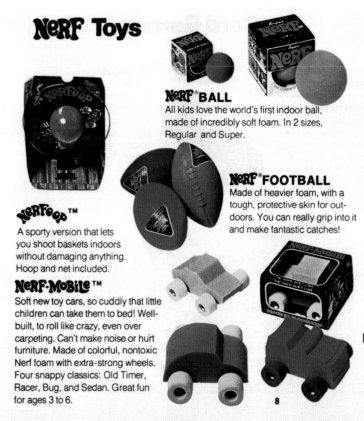

NeRF® BALL
All kids love the world's first indoor ball, made of incredibly soft foam. In 2 sizes, Regular and Super.

NeRFooP™
A sporty version that lets you shoot baskets indoors without damaging anything. Hoop and net included.

NeRF-MoBiLe™
Soft new toy cars, so cuddly that little children can take them to bed! Well-built, to roll like crazy, even over carpeting. Can't make noise or hurt furniture. Made of colorful, nontoxic Nerf foam with extra-strong wheels. Four snappy classics: Old Timer, Racer, Bug, and Sedan. Great fun for ages 3 to 6.

NeRF® FOOTBALL
Made of heavier foam, with a tough, protective skin for outdoors. You can really grip into it and make fantastic catches!

MONOPOLY® (Standard)
Kids and grown-ups love to buy, sell, swap real estate, build houses and hotels, collect rents, and merrily bankrupt each other in the world's most popular board game. Ages 8 to adult, 2 to 8 players.

MONOPOLY® (Better Edition)
Contains heavier board, extra equipment, plus special molded Banker's Tray which holds the money, houses, hotels and title cards neatly and conveniently. Ages 8 to adult, 2 to 10 players.

8

Chatham Blankets, 1976 ◄ *Nerf Toys and Monopoly Game, 1973* ► *Greenland Studios Dolls, 1972*

Superman Products, 1979

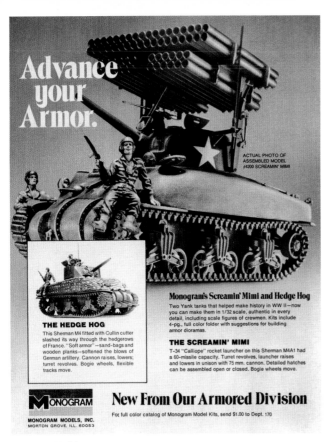

Advance your Armor.

ACTUAL PHOTO OF ASSEMBLED MODEL #4200 SCREAMIN' MIMI

THE HEDGE HOG

This Sherman M4 fitted with Cullin cutter slashed its way through the hedgerows of France. "Soft armor"—sand-bags and wooden planks—softened the blows of German artillery. Cannon raises, lowers; turret revolves. Bogie wheels, flexible tracks move.

Monogram's Screamin' Mimi and Hedge Hog

Two Yank tanks that helped make history in WW II—now you can make them in 1/32 scale, authentic in every detail, including scale figures of crewmen. Kits include 4-pg., full color folder with suggestions for building armor dioramas.

THE SCREAMIN' MIMI

T-34 "Calliope" rocket launcher on this Sherman M4A1 had a 60-missile capacity. Turret revolves, launcher raises and lowers in unison with 75 mm. cannon. Detailed hatches can be assembled open or closed. Bogie wheels move.

MONOGRAM

MONOGRAM MODELS, INC.
MORTON GROVE, ILL. 60053

New From Our Armored Division

For full color catalog of Monogram Model Kits, send $1.00 to Dept. 170

Monogram Models, 1975

TYCO

America's Largest Manufacturer of Electric Trains

Tyco Electric Trains, 1972

An Amazing Buy for Only $1.98

GIANT 4ft. INFLATABLE GIRAFFE TOSS SET

Great for Fun on the beach, bazaars, etc.
- 7 Piece Set • 4 Plastic Rings
- 2 Inflatable Balls • Safe Vinyl Construction

Lovable Gerald Giraffe plays ball as well as a rousing game of ring toss! 4 plastic rings and 2 inflatable balls are included, making 'Gerry' eligible for the "Athlete of the Year" award! 2 giant feelers rise skyward to catch the rings; attached to his ample middle there's a basketball hoop. Lets everyone test his skill! Realistic jungle coloring is a cover-up for an otherwise gentle nature. Toss him about, he'll bounce back for more.

The most wonderful thing about this game is that your child (and husband too!) will go back to play with it, time after time and never tire of it!

OFFER WILL NOT BE REPEATED THIS SEASON

Supply is limited this time of year and we do not intend to offer this again until just before Christmas. To avoid disappointment and to have fun this summer, order yours right now—order 2 and we pay the postage!

36

Palm Co. Inflatables, 1971

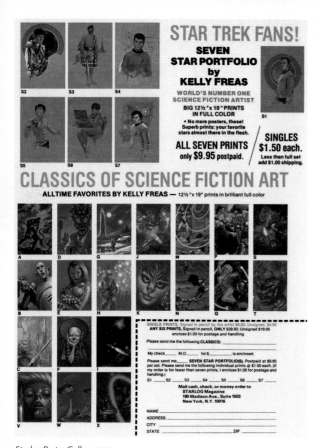
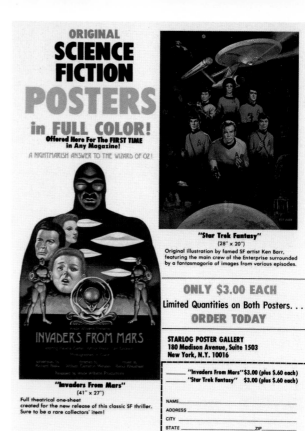
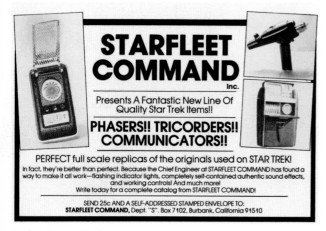
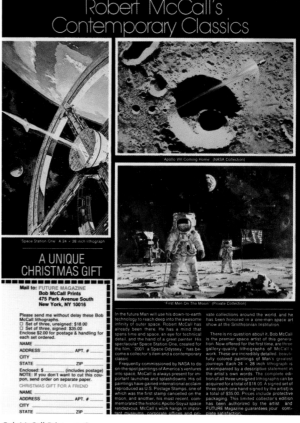

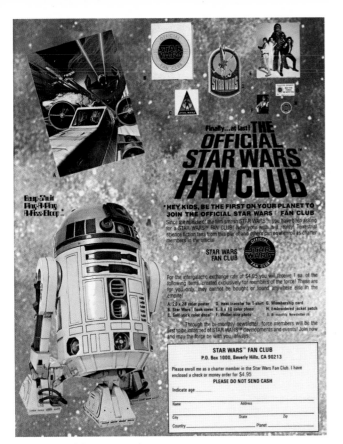

Star Wars Fan Club, 1978

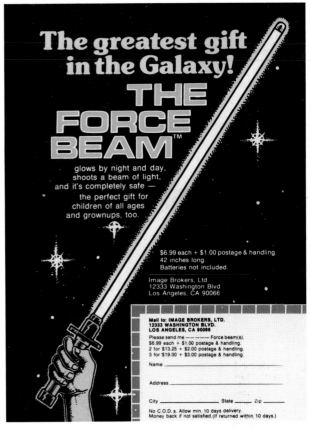
The Force Beam, 1978

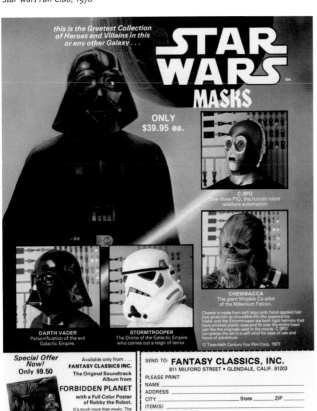
Star Wars Fan Club, 1978

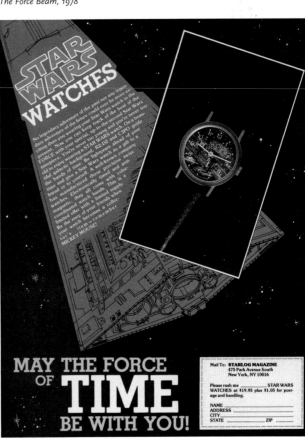
Star Wars Fan Club, 1978

 Gran Toros Ferrari

Magnifico!

A hot-blooded miniature of Italy's legendary racer – HOT WHEELS GRAN TOROS Ferrari. With every detail of Chris Amon's hand-crafted car cut down to 1/43 scale. From scoops to spoiler. Take the traditional pepper-red body. Sleek.

Smooth. And unquestionably *bellissimo*. Notice the 60 degree fuel injected V-12 engine. It'll power the little beauty through the straight at an effortless 440 scale MPH. Unmistakably Italian. HOT WHEELS GRAN TOROS Ferrari. Wherever it runs, it'll get the champions.

"HOT WHEELS" is a U.S. registered trademark of Mattel, Inc. ©1970 Mattel, Inc.

GENERAL

Curb weight	125.5 gms.
Weight distribution, front/rear	63.9/61.6 gms.
Wheelbase, in.	2.10 in.
Track, front/rear	1.51/1.53 in.
Overall length	3.67 in.
Width	1.85 in.
Height	1.26 in.
Ground clearance	.12 in.
Overhang, front/rear	.94 in.

CHASSIS AND BODY

Layout	front engine, rear drive
Body/frame	metal
Wheels	simulated mag type
Tires	Supersport G. P.'s
Suspension	spring/bar
Bearings	low friction Celcon

ACCELERATION & COASTING

Hot Wheels Toy Cars, 1970

winner of the 1970 Indy 500 says:

Boys, which are faster— the new Johnny Lightning 500's or the Sizzlers?

The new Johnny Lightning® 500's running on their tracks are <u>twice as fast</u> as the Sizzlers on their tracks or any tracks. That's a fact.

CHALLENGE A KID WHO HAS A SIZZLER—AND WIN!!!

Three reasons why you want the *new Johnny Lightning 500's*:

1
The new Johnny Lightning 500's are faster than any other cars. In fact, they are the fastest in the world.

2
The Johnny Lightning 500's don't need any tricks or gimmicks. No batteries. No motors. No recharging. No headaches.

3
With Johnny Lightning it's your skill that matters. You make them go...control the speed...test your nerves. The new 500's are solid ...easy to set up and take apart.

Get the fabulous Johnny Lightning cars and three fantastic new 500 sets—Indy, Le Mans, Cyclone.

 ©1970 Topper Corp., Elizabeth, N. J.

BOYS' LIFE • NOVEMBER 1970

19

Johnny Lightning, 1970

From *EMPIRE.*
The #1 maker of ride-ons, dependable, sturdy and beautiful

Hot Cycle®

For all children

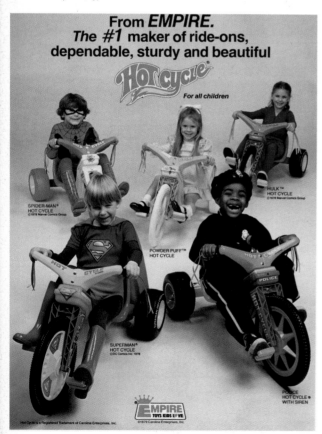

SPIDER-MAN® HOT CYCLE ©1978 Marvel Comics Group

HULK™ HOT CYCLE ©1978 Marvel Comics Group

POWDER PUFF™ HOT CYCLE

SUPERMAN® HOT CYCLE ©DC Comics Inc. 1978

POLICE HOT CYCLE® WITH SIREN

Hot Cycle is a Registered Trademark of Carolina Enterprises, Inc. ©1979 Carolina Enterprises, Inc.

Hot Cycles, 1979

EASY RIDERS
BY ROADMASTER AMF

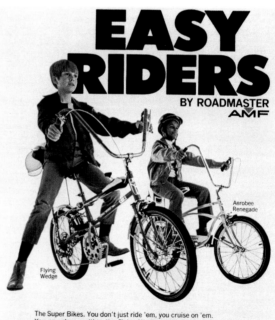

Aerobee Renegade

Flying Wedge

The Super Bikes. You don't just ride 'em, you cruise on 'em.

You can choose either the Flying Wedge with a 5-speed Stick Shift or the Aerobee Renegade with dependable coaster brake . . . or any one of 41 other AMF Roadmaster models. For the name of your nearest dealer, call free 800-243-6000. AMF Incorporated, Wheel Goods Division, Olney, Illinois 62450.

The Flying Wedge features a 5-speed stick shift control and Derailleur gear.

Even the chain guard on the Renegade says action!

Roadmaster Easy Rider Bikes, 1970

▶ *Star Wars Fan Club, 1978*

STAR WARS

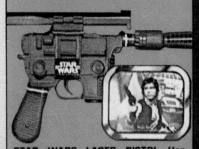
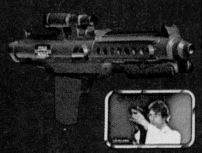

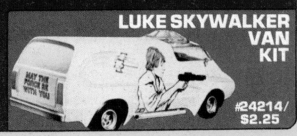

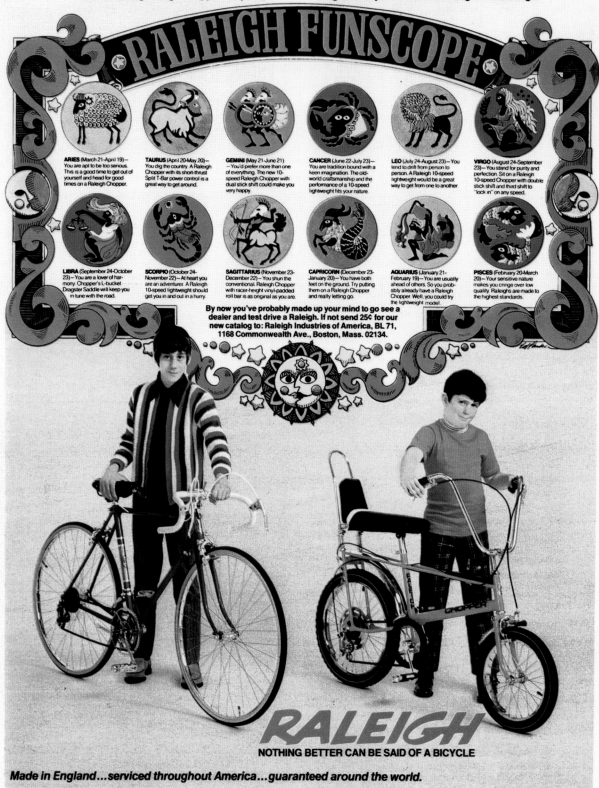

Raleigh Bikes, 1971

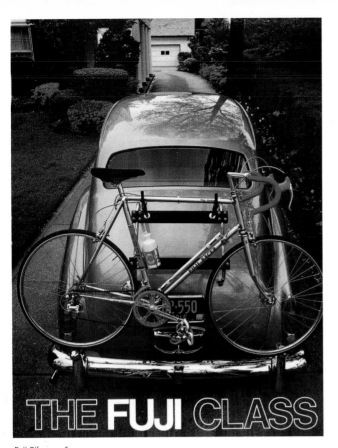

THE **FUJI** CLASS

Fuji Bikes, 1976

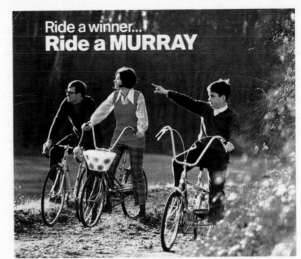

Ride a winner...
Ride a MURRAY

10 Speeds — 5 speeds — 3 speeds; Murray has them all. Ride in the Bike Hike, races or just for fun. You can choose a Murray bike for whatever you need. See the new Grand Tour racer or Leisure Tour Lightweights, mini-weights, Hi-Rise Eliminators and middle weights. Ride a winner, ride a Murray.

THE MURRAY OHIO MFG. CO., Nashville, Tenn. 37204

New Murray Mark Four
Top achievement. Eliminator styling, lightweight performance. 5 speed, 3 speed and coaster brake models. Finished in new super bright hi-flam colors.

New Murray 27″ Lightweights
The model to pick for serious cycling or for leisure riding. 27″ wheels for finer performance. Gum tires withstand high temperatures. Center pull caliper brakes insure even tension. 10 or 5 speed gearing. Racing or touring models.

Murray Eliminator Mark II
A real supercharged hi-riser! Exclusive twin bar frame with raked front end. "Pretzel" handlebars. Deluxe console with stick shift on multi-speed models. Racy three-dimensional chain guard.

Murray Bikes, 1971

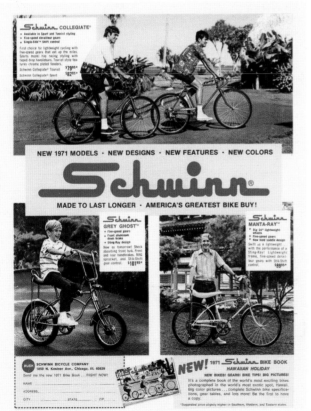

NEW 1971 MODELS · NEW DESIGNS · NEW FEATURES · NEW COLORS

Schwinn®

MADE TO LAST LONGER · AMERICA'S GREATEST BIKE BUY!

Schwinn Bikes, 1971

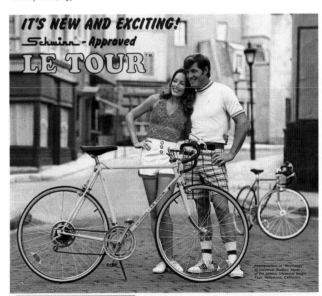

IT'S NEW AND EXCITING!
Schwinn - Approved
LE TOUR ™

... Just 31 lbs., and only $147.95*

If you are a cycling enthusiast, a glance at the specifications of the new Schwinn-Approved Le Tour is enough to make you envious (no matter what you are riding) . . . but if you are just getting into cycling — the new Schwinn-Approved Le Tour is your best buy! Built to Schwinn's exacting standards with the same precision craftsmanship that has made Schwinn the quality name the world over . . . Schwinn engineering offers the American bicyclist a whole new standard of excellence at a price that dares comparison . . . just $147.95* at your nearby Schwinn Factory Authorized Cyclery, assembled and ready-to-ride.

Send 25¢ for the complete Schwinn Catalog

Schwinn
BICYCLE COMPANY
1842 North Kostner Avenue ● Chicago, Illinois 60639

Suggested price, subject to change without notice.

Schwinn Bikes, 1974

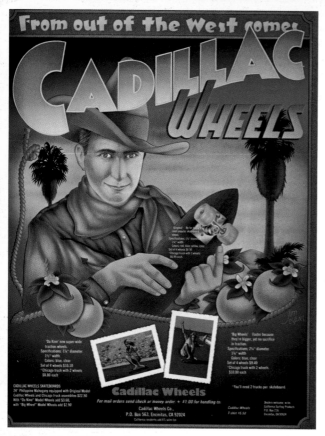

Cadillac Skateboard Wheels, 1974

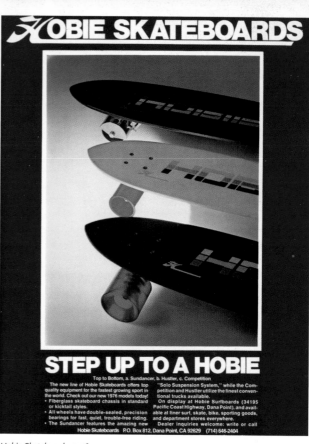

Hobie Skateboards, 1976

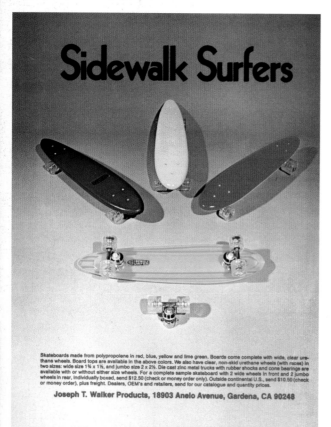

Joseph T. Walker Skateboards, 1976

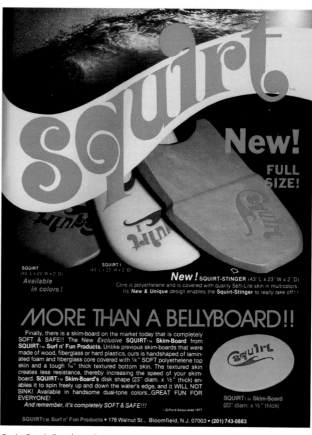

Squirt Boogie Boards, 1978 ▶ *Val Surf Boardshop, 1978*

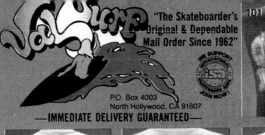

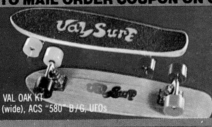

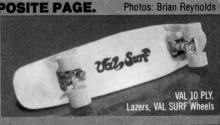

The Masses Are Revolting!

NATIONAL LAMPOON

A Twenty First Century Communications Publication

. . . wouldn't you agree? All across the nation, the Forces of Formica and the Demagogues of Doublethink are determined to overthrow your sanity and your lunch.

Why not insulate yourself from this rather off-putting generation with a protective barricade of *National Lampoons?* Each month, you can hole up in your trendy chateau, put your feet up on an accommodating serf and quietly giggle at the entire mess with the help of our remarkable publication. Every issue of the *National Lampoon* slugs it out with a particular aspect of this annoying century, everything from politics to puberty. Designed to foil the Fascists and clot those bleeding hearts, the *National Lampoon* gives you a little perspective on these chicken-in-a-basket-case times.

Sound like fun? Well, you're wrong, it will be.

Just send Louise the Computer the very interesting coupon on this page along with $5.95 of your boring old money and we'll replace them with a full year of brand new chuckles 'n' boffs. Coming issues include Bad Taste, Paranoia, Show Biz, Politics and The Future!

Just $5.95 (the price of a single tie clip!) brings you monthly protection from those maddening maniacs determined to drive you out of your mind and into a straightjacket.

Wild!

Eaton goes wild for animals and birds.
And so will you. Uninhibited. Free.
Nature Lore...a refreshing new collection
of Letterquettes, Notes, Fold & Seal
and Cubes. It's a natural from Eaton.
From $1.00 to $3.00.

Eaton Paper Division of *textron*
Pittsfield, Massachusetts 01201

Spangled Christmas Ball Kit

These sparkling, elegant Christmas balls look so exquisite you just can't believe how quick and economical they are to make. This is one Christmas preparation project the children can join in with happy results. Just pin spangles, sequins and beads on the preshaped white foam balls. Add the gold filigree ornaments, large jewel-like colored beads and cord for hanging on your tree or in a window. The balls will become a treasured Christmas tradition. You may order sets of three exactly as shown, or three of any one shape (only in the color for that shape as pictured). Balls shown are ¾ actual size. These Christmas ball kits would make perfect Christmas presents, whether you completed them yourself, or gave the kits as gifts to people who love do-it-yourself projects.

Home Projects Kits, 1971

TUT HOLOGRAM

The WHITE LIGHT HOLOGRAM is a unique three dimensional optical phenomenon created by advanced LASER technology. Each hologram comes alive magically with movement—so real you want to reach out and touch it! HOLOGRAPHY is the only process which allows you to view King Tut as though it were the original art piece. A most unique conversation piece! LIMITED QUANTITIES. PRODUCED BY **White Light Works, Inc.** Woodland Hills, CA. 213-703-8880.

24KT GOLD Electroplate

BUCKLE OR **PENDANT**

ONLY **$19.95**

Tut Hologram Jewelry, 1978

By Dorothy Lambert Brightbill

CROSS-STITCH A CHILD'S PRAYER

A new kind of casual cross-stitch makes this child's prayer easy, fast to do. The stitches slant and tilt engagingly, completely in tune with the whimsical mother animals and their babies. Design is stamped on 100 percent creamy white linen (cut size, 17 x 20"); brightly colored embroidery floss and instructions are included in kit #CPS-152; $2. (Frame, plywood backing, and hook are not included in kit.)

Creative Stitchery, 1970

AUTHENTIC COLLECTORS ITEMS FROM STAR TREK

Star Trek Collectors Items, 1976

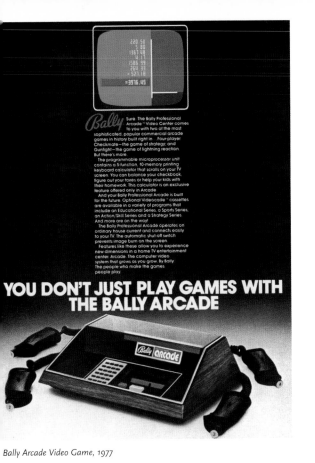
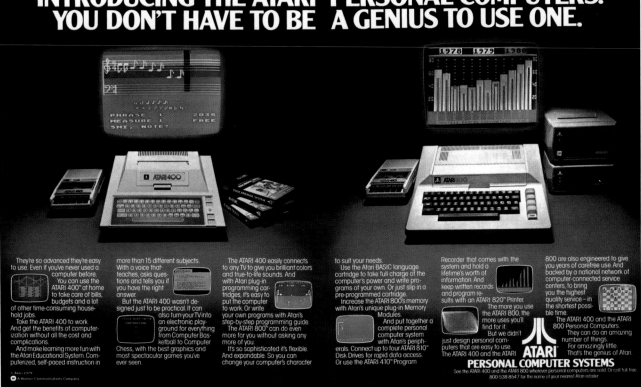

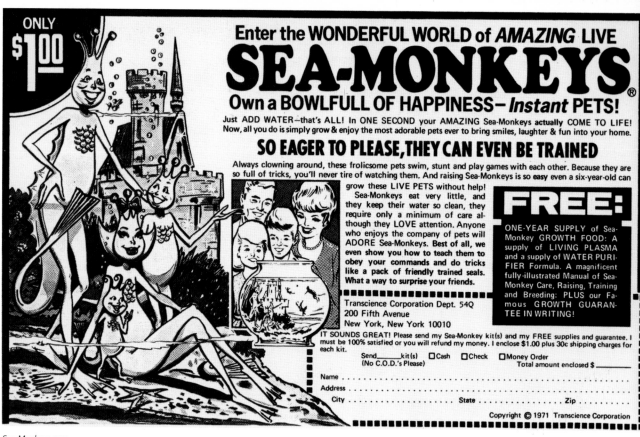

Sea-Monkeys, 1972

Norman Rockwell Needlepoint Kit, 1974

Reese Palley Collectibles, 1978

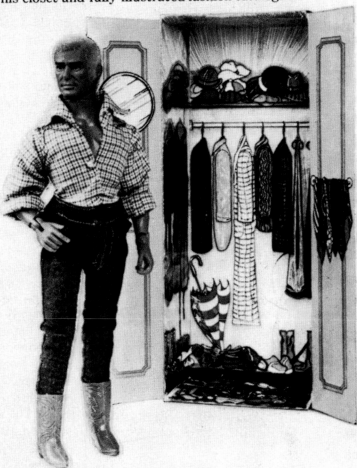
Gay Bob Doll, 1978

The Country's Latest Craze
A BOXFULL OF SMILES

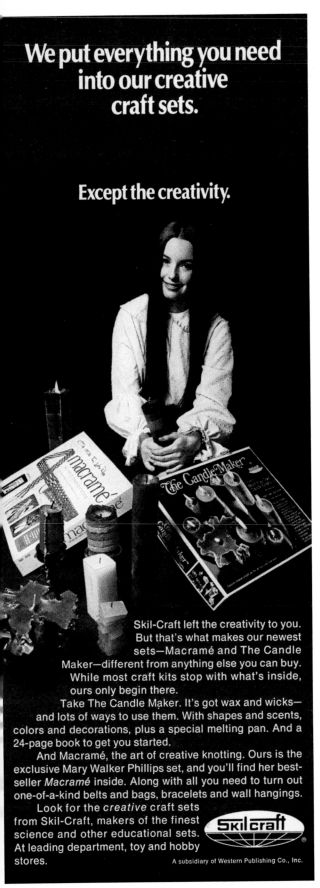

We put everything you need into our creative craft sets.

Except the creativity.

Skil-Craft left the creativity to you. But that's what makes our newest sets—Macramé and The Candle Maker—different from anything else you can buy. While most craft kits stop with what's inside, ours only begin there.

Take The Candle Maker. It's got wax and wicks—and lots of ways to use them. With shapes and scents, colors and decorations, plus a special melting pan. And a 24-page book to get you started.

And Macramé, the art of creative knotting. Ours is the exclusive Mary Walker Phillips set, and you'll find her best-seller *Macramé* inside. Along with all you need to turn out one-of-a-kind belts and bags, bracelets and wall hangings.

Look for the *creative* craft sets from Skil-Craft, makers of the finest science and other educational sets. At leading department, toy and hobby stores.

Skil-craft®

A subsidiary of Western Publishing Co., Inc.

An *Exclusive* Collector's Piece in a Limited Edition
Inspired by the Academy Award Nominee Movie "Love Story"
MAGNIFICENT IMPORTED
"LOVE STORY"
HAND-PAINTED MUSIC BOX

Plays the Hauntingly Beautiful "Love Story" Theme Song While Exquisite Figurine Lovers Revolve in Gentle Embrace Atop Finely Crafted Music Box

From the heartwarming movie that brings back a sentimental era, comes a classic music box. And when you gaze at the lovers and listen to the hauntingly beautiful theme song, you'll remember and relive every emotion packed scene of this moving story. As the lovers revolve, they literally seem to come to life in rollicking snow games, high-spirited adventure and warm tender love.

The figurines are artistically crafted in softly colored finely-glazed ceramic with a lovely lustrous finish. So beautiful in fact, that it's sure to become a treasured collector's piece, and when you see it in person, and only then, will you fully appreciate its lovely and exquisite charm.

OFFER WILL NOT BE REPEATED THIS SEASON

We believe this lovely music box is an exceptional value for only $4.98. Supply is limited and to avoid disappointment, we urge you to order yours right now. Each hand-painted, lustrous finish music box is 7" high x 4" wide. We of course, send you this on a full money back guarantee if you're not completely delighted with the beauty it brings into your home. So hurry —order now as this offer will not be repeated this season in this magazine.

---------- MAIL 10 DAY NO-RISK COUPON TODAY! ----------
PALM CO., Dept. 5465, 4500 N.W. 135th St., Miami, Fla. 33054

Please send the following on 10-day money back guarantee if not delighted. Enclosed is check or m.o. for $_____

_____ #10729 Love Story Music Boxes @ $4.98 (add 65¢ postage)

☐ Send C.O.D. I enclose $1 goodwill deposit per Music Box and will pay postman balance plus all postage charges.

☐ Check here for #10238 "Raindrops Keep Falling on My Head" Music Box (not shown) @ $4.98 (Add 65¢ postage)

☐ SAVE $1.30. Order any 2 Music Boxes for only $9.96 and we pay post. Make wonderful gifts!

Name_____

Address_____

City_____

State_____Zip_____
[Canadian orders, add $1.50 extra.]

Love Story Music Box, 1971

Camouflage Smoking Gear, 1977

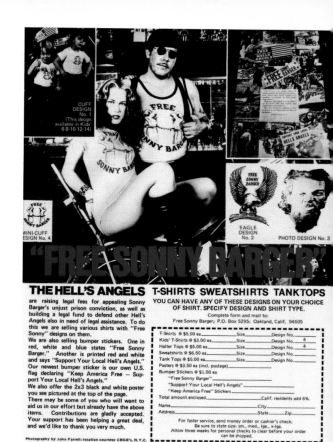

Hell's Angels Apparel, 1977

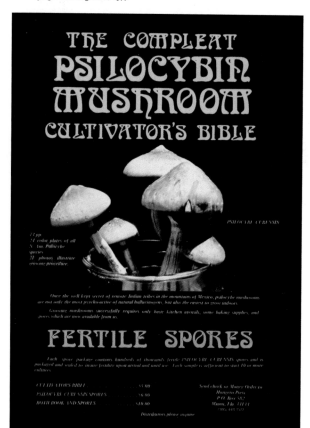

Psilocybin Mushroom Cultivator's Bible, 1977

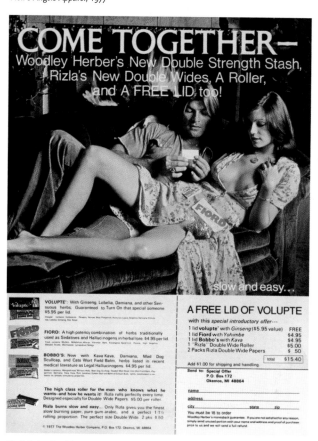

Mail-Order Smoking Gear, 1977

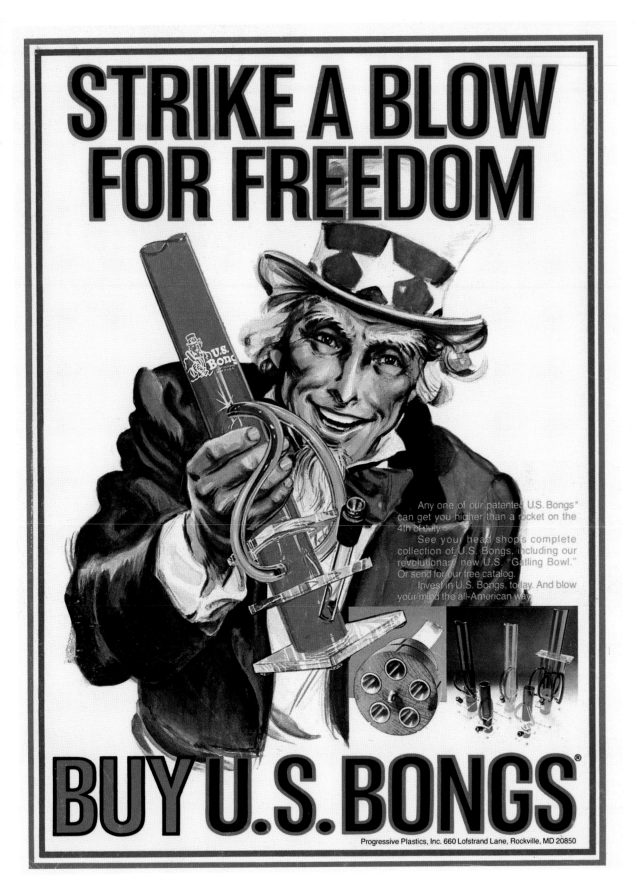

U.S. Bongs, 1977

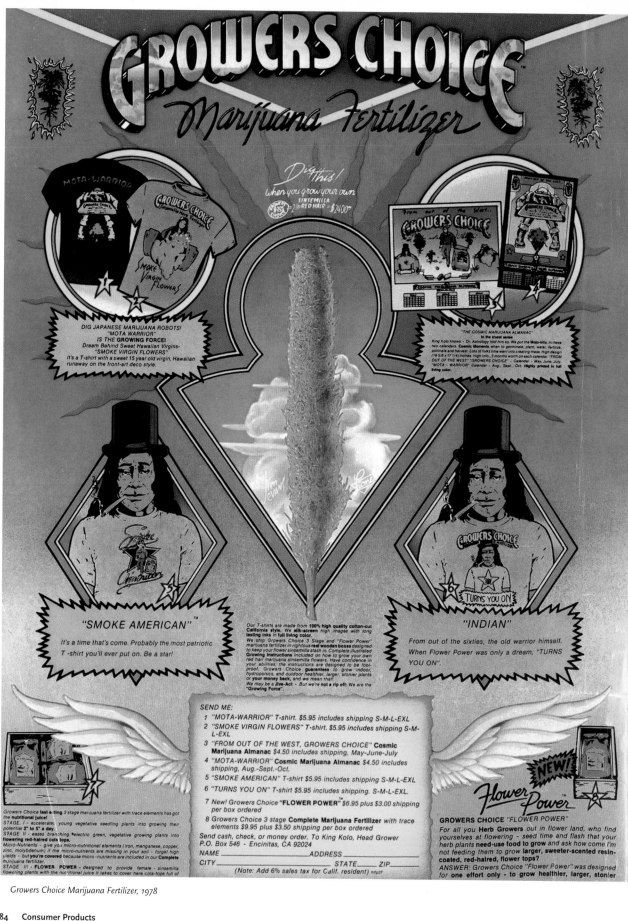

Growers Choice Marijuana Fertilizer, 1978

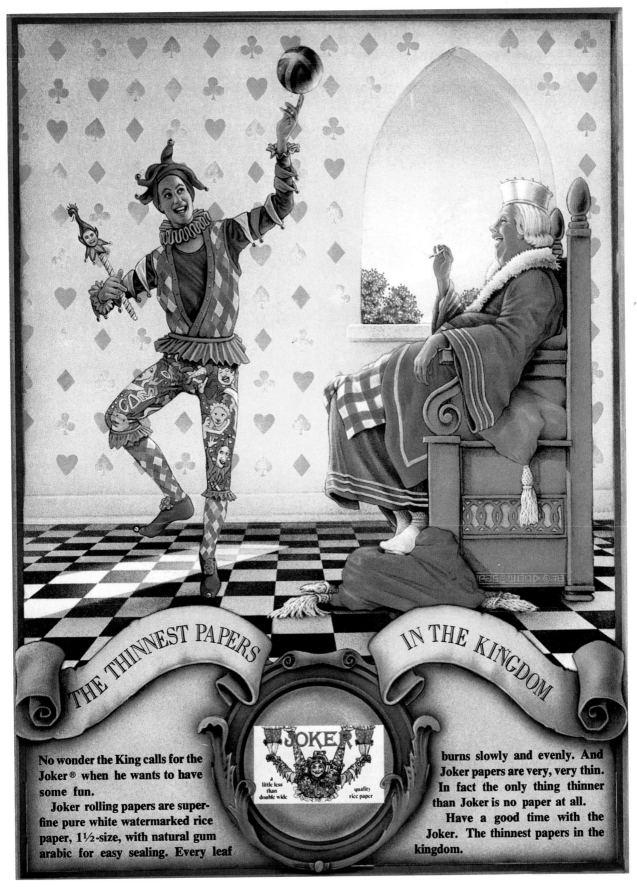

THE THINNEST PAPERS IN THE KINGDOM

No wonder the King calls for the Joker® when he wants to have some fun.

Joker rolling papers are super-fine pure white watermarked rice paper, 1½-size, with natural gum arabic for easy sealing. Every leaf burns slowly and evenly. And Joker papers are very, very thin. In fact the only thing thinner than Joker is no paper at all.

Have a good time with the Joker. The thinnest papers in the kingdom.

Joker Rolling Papers, 1978

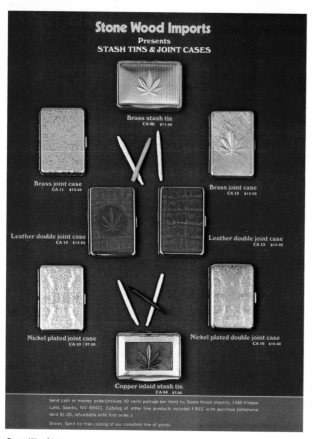

Stone Wood Imports, 1978

Honest Heat Melting Point Tester, 1978

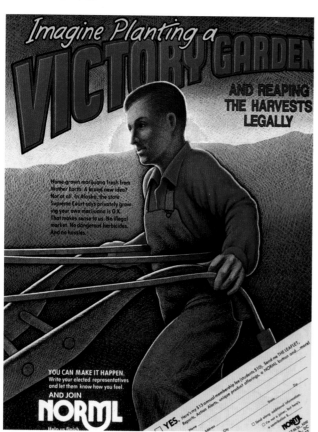

National Organization for the Reform of Marajuana Laws, 1979

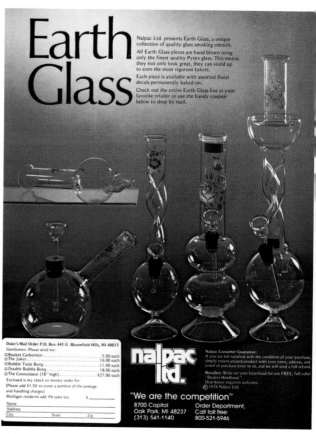

Nalpac Bongs, 1978

PRECIOUS MEMORY

This handsome commemorative coin is minted from one ounce of .999 fine silver. Sure to be an increasingly valuable heirloom and numismatic treat in the high years to come! Also available in bronze and pewter, in pendant or keyring style. Send $30 for silver or $10 for bronze or pewter to: **Fantasy World, P.O. Box 14331, Las Vegas, Nevada, 89114.**

Fantasy World Commemorative Coin, 1976

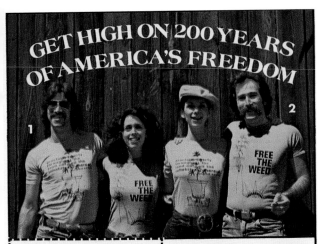

GET HIGH ON 200 YEARS OF AMERICA'S FREEDOM

Please send me ____ Shirts at **$5.50** ea. ($4.85 + .65 handling)
Name _____
Address _____
City _____
State _____ Zip _____
Style #1 **"planter"** beige
 ☐S ☐M ☐L ☐XL
Style #2 **"statue"** sky blue
 ☐S ☐M ☐L ☐XL

Don't miss the Bicentennial RUSH! Get in on this one-time liberated T-shirt offering and celebrate with this totally original conceptual marijuana design of The Statue of Liberty and the Liberty Bell. Finest quality T-shirts in 100% cotton, made in the U.S.A. Allow 2-4 weeks delivery.

Enclose check or money order, (no cash please) Payable to: CRYSTAL MAGICK PROMOTIONS, INC., P.O. Box 5061, Smithtown, New York 11787

Crystal Magick Promotions, 1976

For those who live in hope....

THE COMPLEAT

PSILOCYBIN MUSHROOM CULTIVATOR'S BIBLE

COMPRISING

82 pp. COMPLETE INTEGRATED RAP ON ALL PHASES OF SUCCESSFULL PSILOCYBIN MUSHROOM HUNTING AND CULTIVATION. COVERS ALL PROCEDURES FOR HIGH YIELD INDOOR CULTURES.

16 PICTURES

OF THE N. AMERICAN PSILOCYBE SPECIES & COMPREHENSIVE GUIDE FOR IDENTIFICATION AND GEO-GRAPHIC DISTIBUTION.

PSILOCBE CUBENSIS

Spore Sample Included

$6.00 CHECK OR M.O. TO

HONGERO PRESS P.O. Box 582 Miami Fla

Psilocybin Mushroom Cultivator's Bible, 1976

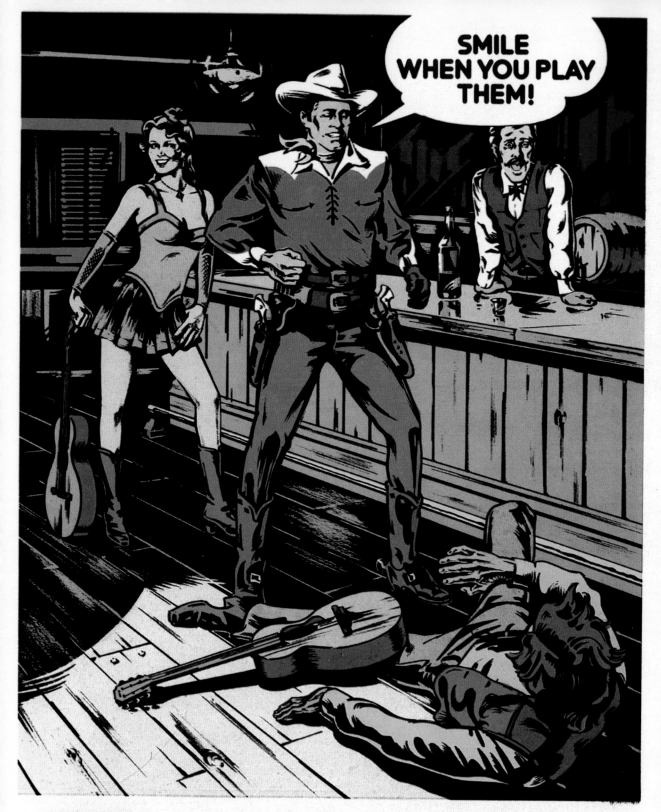

Load up a set of good old bronze alloy Cumberlands on your six or twelve stringer. If you hanker for a softer sound, try a set of Silk 'n Steel Cumberlands. Then start strummin. And smilin. And shuckin. And jivin.

Fender ® Strings and Accessories, CBS Musical Instruments, CBS Inc., Battle Creek, Michigan

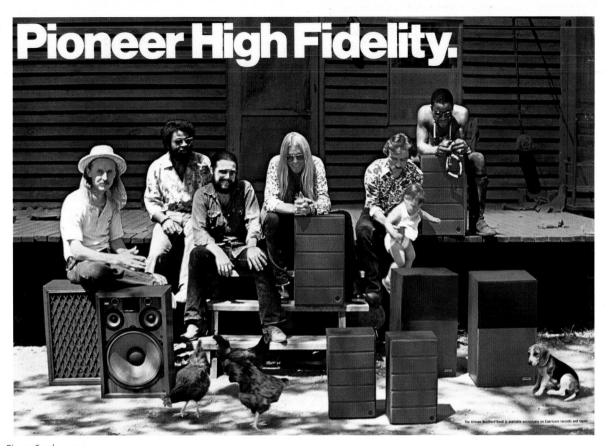

Pioneer Speakers, 1974

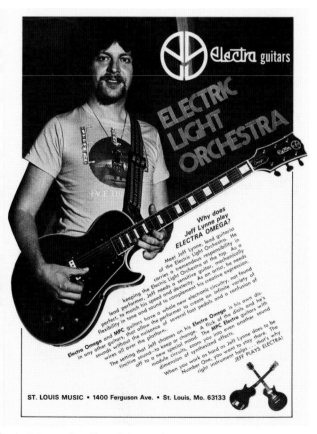

Fender Guitars, 1976 ◄ *Electra Guitars, 1976*

Voice Box Talking Guitar, 1976

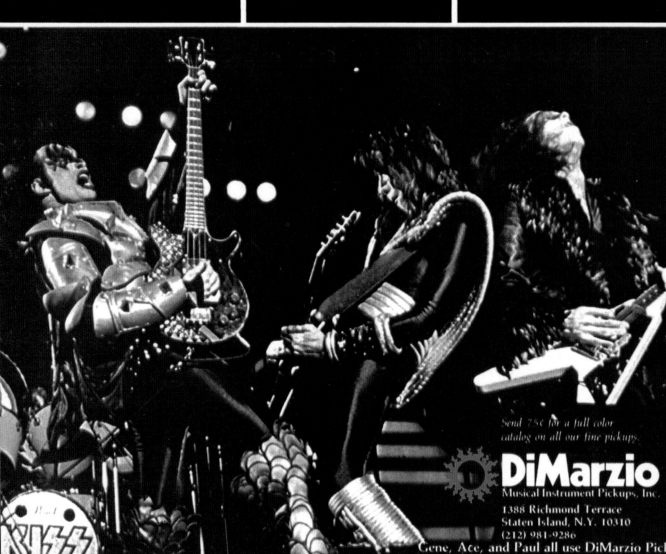

"I am *precisely* three inches high," said the Caterpillar, "though I frequently become much higher."

"With that magic mushroom?" Alice asked eagerly.

"With music!" retorted the Caterpillar, conjuring visions of Fender® guitars and matching amplifiers. "I play inhumanly hot licks on my Stratocaster® and back myself with everything else."

"But *I* have only *two* arms," sighed Alice. "If I am to reach new heights on a Strat, I shall need your backing on electric bass."

"On a *Fender!*" smiled the Caterpillar. "Or two or three. I should much rather get *my* hands on what TV concert bassmen play."

"And of course," Alice sang out . . . "9 out of 10 pick a Fender bass!"*

For a full-color poster of this ad, send $1 to: Fender, Box 3410, Dept. 175, Fullerton, CA 92634.

*Source: National Marketing Research of California, 1974.

CBS Musical Instruments
A Division of CBS Inc.

DiMarzio Musical Instrument Pickups, 1979 ◄　*Fender Guitars, 1975*

WHY PUNCH IS MORE IMPORTANT THAN POWER IN A CB.

When it comes to power all CBs have pretty much the same. No more than five watts. That's the law. The law, however, says nothing about punch.

Punch is what you do with that five watts to make sure your voice covers the distance and still comes through loud and clear. Punch is what sets Cobras apart from the other CBs.

With a Cobra your voice punches through ignition and background noises. Punches through interference. Punches through other transmissions.

So your voice gets to where it's going the same way it started out. Loud and clear.

And because Cobras have distortion-free reception, you hear what's coming back the same way you sent it out. Loud and clear.

And if loud and clear is what you're starting to associate with a Cobra, then our message has punched through.

Cobra

Punches through loud and clear.

Cobra Communications Product Group Dynascan Corp.
6460 W. Cortland St., Chicago, Illinois 60635

For information on our complete line write for brochure #CB-2.

Cobra CB, 1976

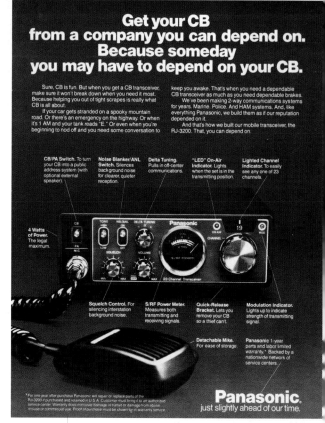
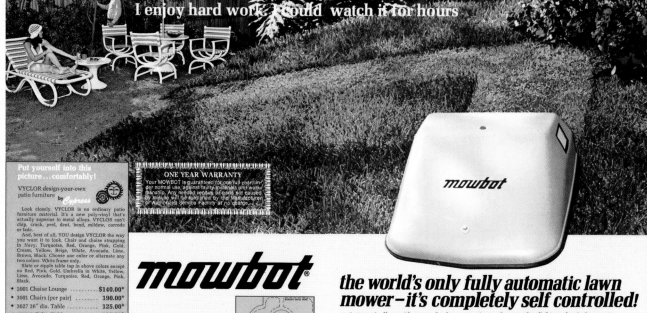

I enjoy hard work. I could watch it for hours

mowbot

the world's only fully automatic lawn mower—it's completely self controlled!

● **Automatically avoids trees, shrubs — stops instantly upon the slightest physical contact**
● **Battery powered — no trailing cords, no noisy, hot, polluting engines**

MOWBOT is completely self-propelled and self-controlled. It will mow your lawn without any human control. Here's how. Start anywhere on your lawn. Turn the key and MOWBOT silently moves off in a straight line leaving a smooth, even swath. When it reaches the control-wire border you've installed, sensors automatically guide MOWBOT back into your lawn. Each time MOWBOT reaches the border, it turns itself back into your lawn.

MOWBOT will continue this random cutting for up to 3½ hours per charge—enough time to mow about 10,000 sq. ft. It will even negotiate elevations of 30° to 45°. A built-in low voltage regulator maintains enough battery reserve power to permit you to "walk" MOWBOT back for recharging. A detachable power control leash is provided for this purpose. The leash is also handy for controlling MOWBOT for close-in trimming.

A pair of 3-blade cutting discs slice, then thoroughly mulch clippings. Blades also "swing-away" to virtually eliminate dangerous ejection of stones, branches and other objects.

Specifications — Cutting Width . . . **23"** / Cutting Height Adjustment . . . **½"-3"** / Operating Speed . . . **120' per min.** / Max. Recharge Interval . . . **8 hours** (avg. cost of 2½ -5¢) / Avg. Effective Battery Life . . . **3 seasons** / Includes: auto-type 12V battery; recharger; detachable power leash; approx. 350' control wire.

$675.00
DELIVERED ANYWHERE IN CONTINENTAL U.S.

Put yourself into this picture...comfortably!

VYCLOR *design-your-own patio furniture* by *Cypress*

Look closely. VYCLOR is no ordinary patio furniture material. It's a new poly-vinyl that's actually superior to metal alloys. VYCLOR can't chip, crack, peel, dent, bend, mildew, corrode or fade.

And, best of all, YOU design VYCLOR the way you want it to look. Chair and chaise strapping in Navy, Turquoise, Red, Orange, Pink, Gold, Cream, Yellow, Beige, White, Avocado, Lime, Brown, Black. Choose one color or alternate any two colors. White frame only.

Slate or ripple table top in above colors except no Red, Pink, Gold, Umbrella in White, Yellow, Lime, Avocado, Turquoise, Red, Orange, Pink, Black.

- 2001 Chaise Lounge **$140.00**
- 3001 Chairs (per pair) **190.00**
- 3627 36" dia. Table **125.00**
- 4227 42" dia. Table **130.00**
- 628C Umbrella **75.00**
- 2416 End Table **55.00**

*Plus applicable shipping/handling
SAVE $50 to $60 off of single-unit delivered prices. See order card for details!

Playboy Club credit Keyholders may choose to purchase MOWBOT or CYPRESS lawn furniture in convenient installments. See accompanying order card.

Installation & Random Cutting

MOWBOT is designed to work **without assistance** within a control area—your lawn. Create this area by slicing a shallow, 2" slit all around your lawn. Lay MOWBOT control wire into the slit and replace sod. Don't forget to surround permanent obstacles like trees, shrubs, flower beds.

The border control transmitter, when plugged into any electric outlet, automatically converts the current to a harmless, silent signal. Upon sensing this signal, MOWBOT automatically turns back into your lawn at a random angle.

The result is a random-cut lawn free of unsightly cut marks and tire impressions. Horticulturists agree that random cutting produces healthier grass.

ONE YEAR WARRANTY
Your MOWBOT is guaranteed for one full year, under normal use, against faulty materials and workmanship. Any needed repairs or parts not caused by misuse will be furnished by the Manufacturer or Authorized Service Facility at no charge.

Mowbot Automatic Lawnmower, 1975

► *Superscope Recorder, 1977*

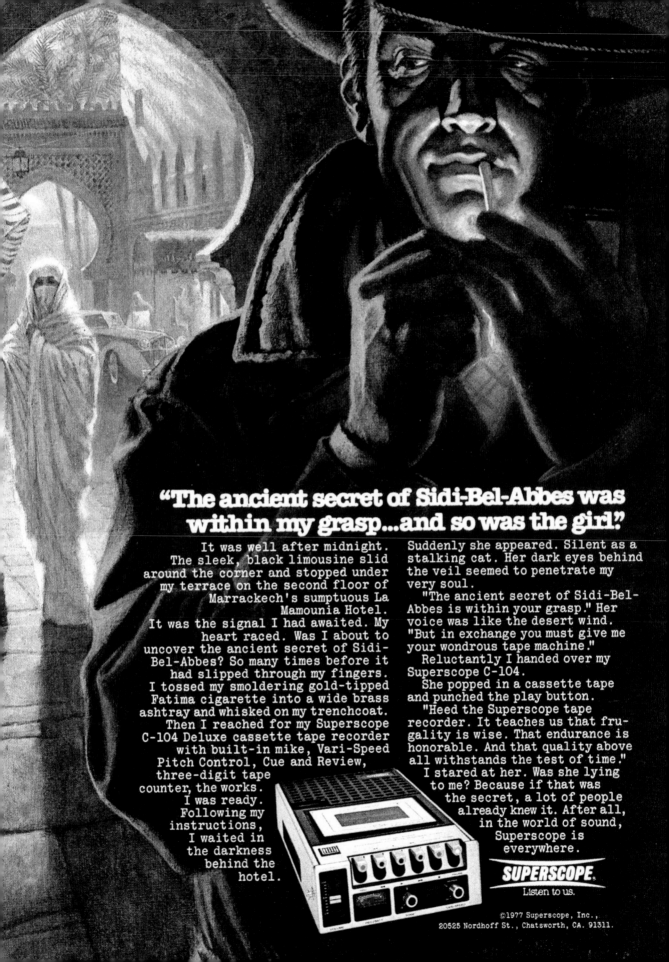

"The ancient secret of Sidi-Bel-Abbes was within my grasp...and so was the girl."

It was well after midnight. The sleek, black limousine slid around the corner and stopped under my terrace on the second floor of Marrackech's sumptuous La Mamounia Hotel.

It was the signal I had awaited. My heart raced. Was I about to uncover the ancient secret of Sidi-Bel-Abbes? So many times before it had slipped through my fingers. I tossed my smoldering gold-tipped Fatima cigarette into a wide brass ashtray and whisked on my trenchcoat.

Then I reached for my Superscope C-104 Deluxe cassette tape recorder with built-in mike, Vari-Speed Pitch Control, Cue and Review, three-digit tape counter, the works.

I was ready. Following my instructions, I waited in the darkness behind the hotel.

Suddenly she appeared. Silent as a stalking cat. Her dark eyes behind the veil seemed to penetrate my very soul.

"The ancient secret of Sidi-Bel-Abbes is within your grasp." Her voice was like the desert wind. "But in exchange you must give me your wondrous tape machine."

Reluctantly I handed over my Superscope C-104.

She popped in a cassette tape and punched the play button.

"Heed the Superscope tape recorder. It teaches us that frugality is wise. That endurance is honorable. And that quality above all withstands the test of time."

I stared at her. Was she lying to me? Because if that was the secret, a lot of people already knew it. After all, in the world of sound, Superscope is everywhere.

SUPERSCOPE.

Listen to us.

©1977 Superscope, Inc.,
20525 Nordhoff St., Chatsworth, CA. 91311.

There are paper bullets and hunting bullets and there's a big difference.

And Winchester-Western makes both...very carefully. We doubt that it's possible to engineer a hunting bullet more accurate than ours. Or one that performs as precisely with the proper amount of mushrooming and expansion. For example, your Silvertip® or Power-Point® performs as well as our factory bullets — because they're the same bullets.

A match bullet is constructed differently and is based on different ballistic engineering principles. Our Accuracy Match Bullets in .22, .25, 6mm, 6.5mm and 30 caliber offer bench, silhouette, varmint and target shooters the utmost in performance and accuracy.

To bring out the best in your shooting, buy the best performing bullet for the job; any of 61 rifle or handgun bullets designed by Winchester-Western ballistic engineers.

To get the latest information on more than 600 shotshell, rifle and handgun reloads, send for your free copy of our Ball Powder Loading Data Book. Write Winchester-Western, 275 Winchester Avenue, New Haven, CT 06504. Attention Data Book.

WINCHESTER Western
we don't want you to miss a thing.

Winchester Bullets, 1977

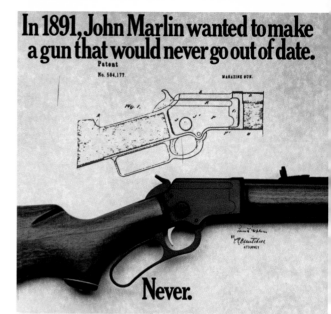

In 1891, John Marlin wanted to make a gun that would never go out of date.

Never.

Eighty-six years ago, John Marlin got this great idea for a rifle. A gun so basic, so perfectly down to earth, it couldn't help but stick around for awhile. And stick around it has.

You see, we're still making America's finest lever action .22, the Marlin 39, with the same high standards of quality we put into the first .22 lever action.

And then some. Like a genuine American black walnut stock with sling swivels. An action with six critical parts machined from solid steel forgings, then heat treated for added strength and durability. Simple, one-step take-down. Solid top receiver with side ejection. And a new mounting bar that accommodates rings for ¾", ⅞" or 1" tube scopes, for total optical flexibility.

Of course, when it comes to accuracy, the 39 is almost legendary. One big reason is its tapered barrel with Micro-Groove® rifling.

And to make sighting quick and easy, the 39 comes with an adjustable folding semi-buckhorn rear sight, and ramp front sight with Wide-Scan™ hood.

And today you can get this famous gun in two different versions. The Golden 39A rifle and the Golden 39M straight-grip carbine. Both about $134.95.

See the entire Marlin line, along with popular-priced Glenfield rifles, at your nearest gun dealer. Also, ask for our new, free catalog. Or write Marlin Firearms Co., North Haven, CT. 06473.

Marlin Made now as they were then.

Marlin Rifles, 1977

In celebration of our country's 200th birthday, the NRA has teamed up two well known names in the knife field, Schrade Cutlery and Aurum Etchings, to bring you...

The National Rifle Association
Bicentennial-Second Amendment Knife

This collector's edition is deep etched on both sides and blackened for contrast. They are made of 440C stainless steel. The knives are shipped in a wooden presentation box fitted with velvet . . . and are numbered from 1 to 1775 and begin again at 1977. It features solid brass hilt and blade guard . . . Laminated wood handle.

Join Our Celebration
Use the order blank below.

Bicentennial-Second Amendment Knife

Mail to – National Rifle Association, Knife Collection, 1600 Rhode Island Ave., N.W., Washington, D.C. 20036
(please allow 4 weeks for delivery)

Gentlemen: Blade length 6 1/2" Overall length 11" Ship to: Name _____

Please send me _____ Regular Issue Knife at $100.00 total $ _____

Grand total $ _____ Address _____

CHARGE MY □ BANKAMERICARD CARD EXP. _____ City _____

CHARGE MY □ MASTER CHARGE (AND INTERBANK NO.) CARD EXP. _____ State _____

Please sign _____ Zip _____ TAR676

NRA Bicentennial-Second Amendment Knife, 1976

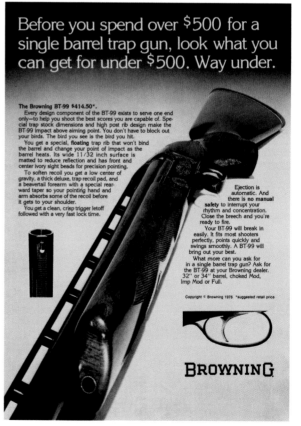

Before you spend over $500 for a single barrel trap gun, look what you can get for under $500. Way under.

The Browning BT-99 $414.50*.
Every design component of the BT-99 exists to serve one end only—to help you shoot the best scores you are capable of. Special trap stock dimensions and high post rib design make the BT-99 impact above aiming point. You don't have to block out your birds. The bird you see is the bird you hit.

You get a special, floating trap rib that won't bind the barrel and change your point of impact as the barrel heats. Its wide 11/32 inch surface is matted to reduce reflection and has front and center ivory sight beads for precision pointing.

To soften recoil you get a low center of gravity, a thick deluxe, trap recoil pad, and a beavertail forearm with a special rearward taper so your pointing hand and arm absorbs some of the recoil before it gets to your shoulder.

You get a clean, crisp trigger letoff followed with a very fast lock time.

Ejection is automatic. And there is no manual safety to interrupt your rhythm and concentration. Close the breech and you're ready to fire.

Your BT-99 will break in easily. It fits most shooters perfectly, points quickly and swings smoothly. A BT-99 will bring out your best.

What more can you ask for in a single barrel trap gun? Ask for the BT-99 at your Browning dealer. 32" or 34" barrel, choked Mod, Imp Mod or Full.

Copyright © Browning 1976 *suggested retail price

BROWNING

Browning Trap Gun, 1976

One jig saw cut circles around the rest.

The method of testing was scrupulously fair.

A nationally recognized product research organization, The Robert W. Hunt Company, conducted the entire project. They took comparable Craftsman, Black & Decker, Skil, and Rockwell jig saws priced under $20 and proceeded to cut up hundreds of board feet of pine, masonite, oak, even galvanized metal.

At the completion of the tests, one thing was clear. We quote:

"Our test data indicates that the Rockwell jig saws have cutting speeds 12% to 120% faster than the other saws tested, depending on the material being cut." (R. W. Hunt Co., Chicago, Illinois.)

In other words, our jig saw cut circles around the rest.

For a free copy of the results of the tests conducted by the Robert W. Hunt Company, write: John Trebel, Power Tool Division, Rockwell International, 400 North Lexington Avenue, Pittsburg, Pa. 15208.

For the Rockwell dealer nearest you call anytime, toll free 800 243-5000 (Connecticut 1-800-922-8568—Excluding Hawaii and Alaska)

Rockwell International

Rockwell International Jig Saws, 1973

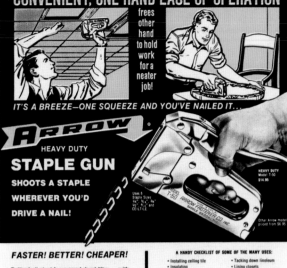

CONVENIENT, ONE HAND EASE OF OPERATION

frees other hand to hold work for a neater job!

IT'S A BREEZE—ONE SQUEEZE AND YOU'VE NAILED IT...

ARROW

HEAVY DUTY

STAPLE GUN

SHOOTS A STAPLE WHEREVER YOU'D DRIVE A NAIL!

HEAVY DUTY Model T-50 $14.95

Uses 6 Staple Sizes ¼", ⁵⁄₁₆", ⅜", ⁷⁄₁₆" and ½" CEILTILE

Other Arrow models priced from $6.95

FASTER! BETTER! CHEAPER!

Built of all-steel for rugged durability... with a patented jam-proof mechanism for smooth, trouble-free performance... the one-hand operated Arrow T-50 Staple Gun provides the versatility, power and convenience you need to perform 1,001 fastening jobs—Faster, better, cheaper than hammer and nails!

A HANDY CHECKLIST OF SOME OF THE MANY USES:

- Installing ceiling tile
- Insulating
- Weatherstripping
- Re-upholstering furniture
- Wire fencing
- Tacking carpet pads
- Repairing screens
- Electrical wiring
- Attaching window shades to dowels
- Tacking down linoleum
- Lining closets
- Installing wallboard and plywood paneling
- Covering valances
- Boat fiberglass insulation
- Kitchen shelf trimming
- Fastening decorations
- Securing burlap wrappings around tree trunks

LIMITED TIME ARROW SPECIALS FEATURED AT YOUR LOCAL DEALER FOR HARDWARE WEEK

No. T-50FS SPECIAL | JT-21C SPECIAL | T-55FS SPECIAL

Available at Hardware, Lumber, Building Material, Stationery, Variety Stores and other Retail Outlets.

ARROW FASTENER COMPANY, INC./SADDLE BROOK, N. J. 07663/In Canada: Quebec Province

THE STANDARD OF EXCELLENCE BY WHICH ALL OTHERS ARE JUDGED

Arrow Staple Gun, 1974

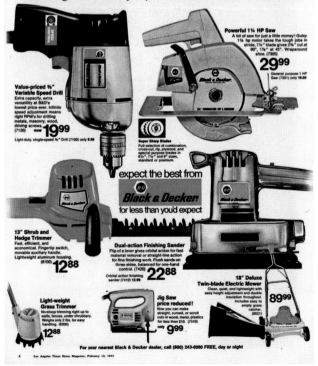

Give yourself a present...

on Washington's Birthday...a power tool from **Black & Decker**

Powerful 1¼ HP Saw
A lot of saw for just a little money! Gutsy 1¼ hp motor takes the tough jobs in stride. 7¼" blade gives 2¾" cut at 90°, 1⅞" at 45°. Wraparound shoe. (7305)
29⁹⁹
General purpose 1 HP Saw (7301) only 19.99

Value-priced ⅜"
Variable Speed Drill
Extra capacity, extra versatility at B&D's lowest price ever. Infinite speed adjustment means right RPMs for drilling metals, masonry, wood, driving screws. (7120) now **19⁹⁹**
Light-duty, single-speed ⅜" Drill (7100) only 9.99

Super Sharp Blades
Full selection of combination, cross-cut, rip, plywood, and special purpose blades in 9½", 7¼" and 8" sizes, standard or premium.

expect the best from
Black & Decker
for less than you'd expect

13" Shrub and Hedge Trimmer
Fast, efficient, and economical. Fingertip switch, movable auxiliary handle. Lightweight aluminum housing. (8100) **12⁸⁸**

Dual-action Finishing Sander
Flip of a lever gives orbital action for fast material removal or straight-line action for fine finishing work. Flush sands on three sides, balanced for one-hand control. (7420)
Orbital action finishing sander (7416) 12.99 **22⁸⁸**

18" Deluxe Twin-blade Electric Mower
Clean, quiet, and lightweight with easy height adjustment and double insulation throughout. Includes easy to empty grass catcher. (8021) **89⁹⁹**

Light-weight Grass Trimmer
No-stoop trimming right up to walls, fences, under shrubbery. Weighs only 2 lbs. for easy handling. (8200) **12⁸⁸**

Jig Saw price reduced!
Now you can make straight, curved, or scroll cuts in wood, metal, plastics for less than $10. (7510) only **9⁹⁹**

For your nearest Black & Decker dealer, call (800) 243-6000 FREE, day or night

Los Angeles Times Home Magazine, February 13, 1972

Black & Decker Tools, 1972

With the Poulan 76, you'll have a lot easier time with your trees than George had with his.

Introducing the new Poulan 76, our Bicentennial Special Limited Edition.

You'll never see another saw that looks like it. Or another super lightweight that cuts like it. Because it's got every feature you need to make cutting a breeze. Like enough power to handle a 4-inch log in less than 6 seconds. An all-position carburetor to keep you cutting at any angle. A 10-inch sprocket nose cutting bar for less wear. A super quiet multi-chambered muffler.

And if that's not enough, it's available at participating Poulan dealers with a carrying case *absolutely free* for a limited time only.

See the model 76 at your Poulan dealer today. But hurry. A deal this good on a saw this good can't last forever.

Poulan model 76.
$129.95* with free carrying case.

Beaird-Poulan Division, Emerson Electric Co., Shreveport, Louisiana. See the Yellow Pages under "Saws" for your nearest Poulan dealer. • Offer good at participating dealers for a limited time only. Manufacturer's Suggested Retail Price.

Poulan Chain Saw, 1976

▶ *Coleman Camping Trailers, 1978*

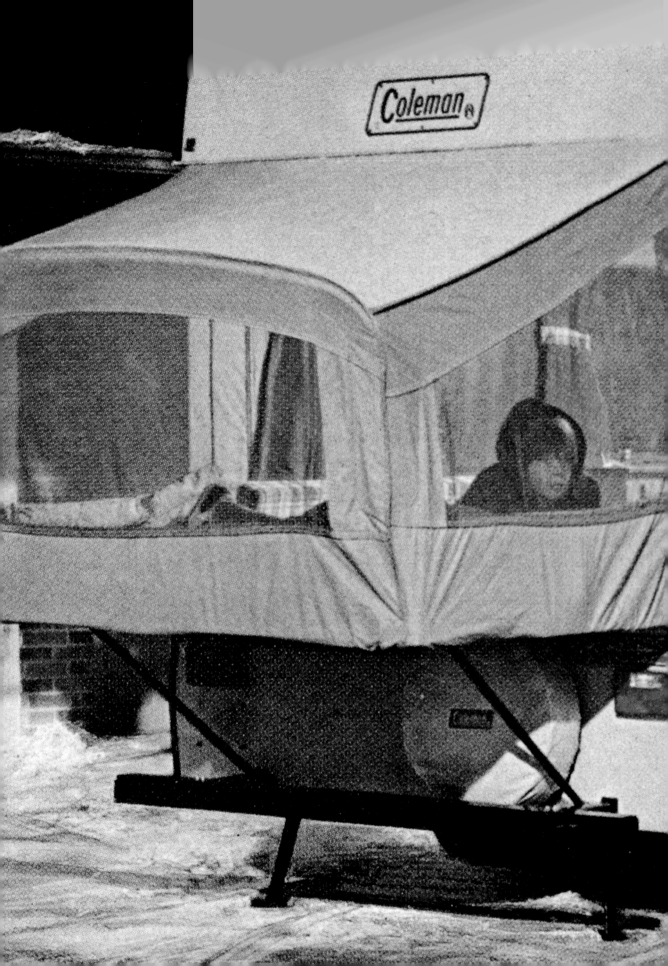

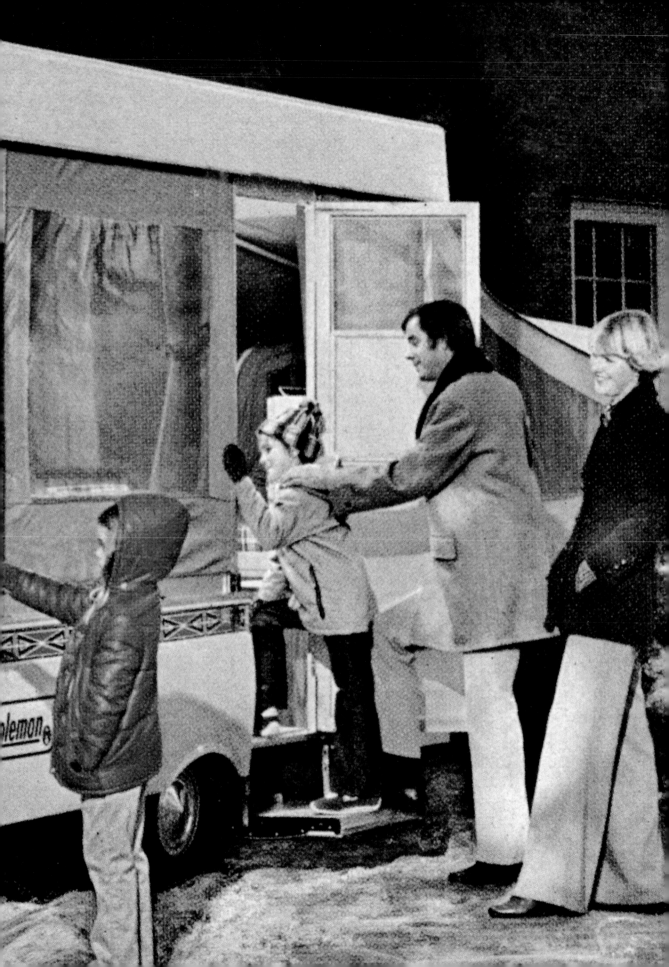

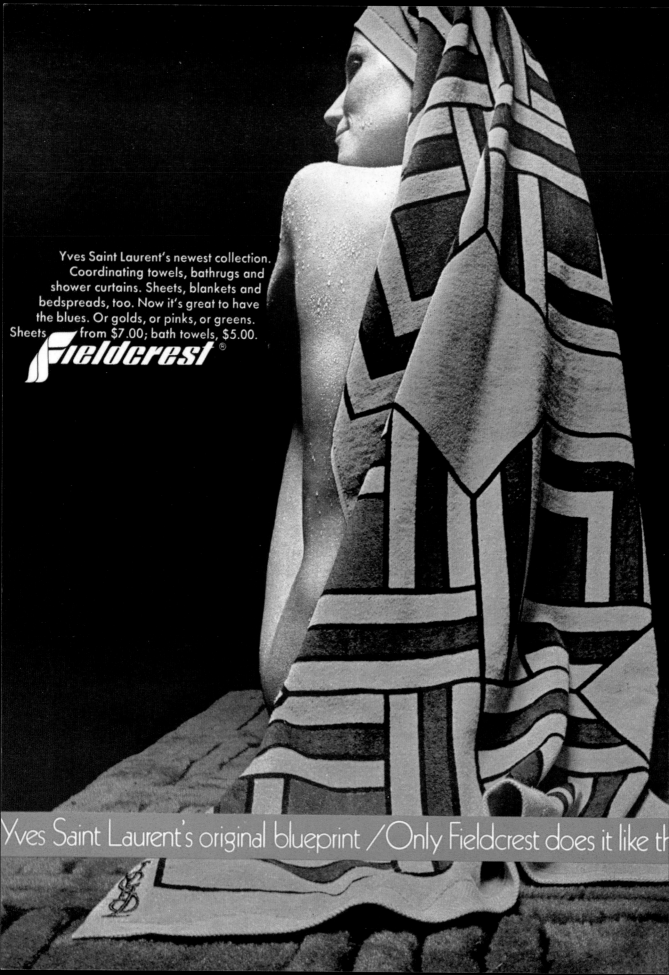

Sears Department Stores, 1978

Collect Luxor. The famous 100% cotton towel from Martex.

Martex Towels, 1979

It's more than one third of his little life.
Let him spend it dreaming in Wamsutta with Mickey and his Friends.
(By the way, these No-Iron sheets and pillowcases are child's play to care for.)

Other sleep-over companions: Bozo the Clown, Sleeping Beauty, Raggedy Ann & Andy, Peter Pan and Snow White. In Sheets, Pillowcases and Towels.
WAMSUTTA MILLS (DIVISION OF M. LOWENSTEIN & SONS, INC.) 111 WEST 40th STREET, NEW YORK, N.Y. 10018 WALT DISNEY CHARACTERS, © WALT DISNEY PRODUCTIONS

Fieldcrest Towels, 1972 ◀ Wamsutta Sheets, 1970

How to build your dream room.
You could begin by commissioning Anita Wagenvoord to design sheets especially for you. Or you could simply buy the sheets she has already designed especially for us—Gingham Park. In NeverNever Iron Percale of 50% KODEL® polyester and 50% combed cotton. With matching towels. At fine stores. Burlington Domestics, a Division of Burlington Industries, New York, N.Y. 10019. KODEL® An Eastman Fiber.
Burlington House

Burlington House, 1972

Color.
Deep, intense color.
Colors a bed
never saw before.
Colors by Springmaid.

Liberate your bedroom with Springmaid's new Bed Lib Collection.

You've seen colors like this only in your imagination.

A new dyeing technique creates new brilliance, and Springmaid creates new interest with new color combinations in topsheets and pillowcases, all with the elegant custom detail of a French cuff never before found in ready-to-wear bed fashions. You can put together any of the lively combinations shown above—and more. Add the excitement of Water Flowers and Chevron prints and make it a total look with coordinating coverlets, dust ruffles and bath towels.

For all its elegance, this collection gives you every convenience. These sheets and pillowcases never need ironing, thanks to a Wondercale blend of 50% Kodel® polyester, 50% combed cotton. They wash cleaner more easily and retain their color-brilliance because they're the first with Scotchgard® brand sheet and pillowcase protector.

Come enjoy the fun, the fashion and the freedom from care. It's all yours with the new Bed Lib Collection by Springmaid.

For the store nearest you, call free of charge: (800) 631-1972.
In New Jersey: (800) 962-2803.
Springs Mills, Inc., 104 West 40th Street, New York, N.Y. 10018

Springmaid Sheets, 1972

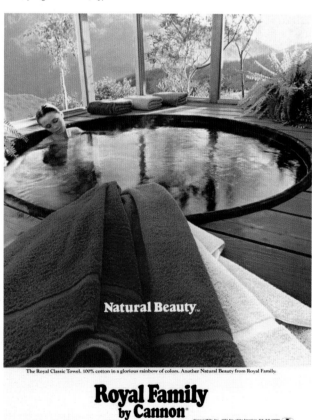

Natural Beauty™

The Royal Classic Towel. 100% cotton in a glorious rainbow of colors. Another Natural Beauty from Royal Family.

Royal Family
by Cannon®

Cannon Mills, Inc., 1271 Ave. of the Americas, N.Y. N.Y. 10020

Cannon Towels, 1979

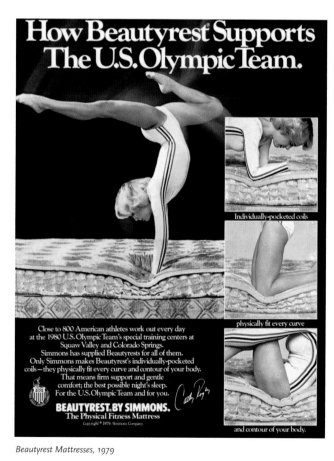

How Beautyrest Supports
The U.S. Olympic Team.

Individually-pocketed coils

physically fit every curve

Close to 800 American athletes work out every day at the 1980 U.S. Olympic Team's special training centers at Squaw Valley and Colorado Springs. Simmons has supplied Beautyrests for all of them. Only Simmons makes Beautyrest's individually-pocketed coils—they physically fit every curve and contour of your body. That means firm support and gentle comfort; the best possible night's sleep. For the U.S. Olympic Team and for you.

BEAUTYREST. BY SIMMONS.
The Physical Fitness Mattress

Copyright © 1979 Simmons Company.

and contour of your body.

Beautyrest Mattresses, 1979

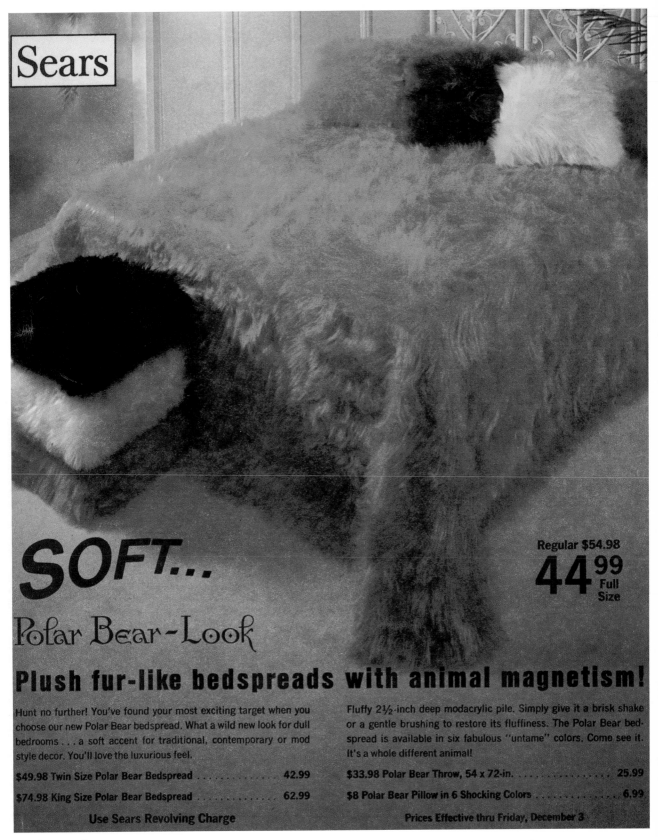

Sears

Regular $54.98
44.99 Full Size

SOFT...

Polar Bear-Look

Plush fur-like bedspreads with animal magnetism!

Hunt no further! You've found your most exciting target when you choose our new Polar Bear bedspread. What a wild new look for dull bedrooms . . . a soft accent for traditional, contemporary or mod style decor. You'll love the luxurious feel.

Fluffy 2½-inch deep modacrylic pile. Simply give it a brisk shake or a gentle brushing to restore its fluffiness. The Polar Bear bedspread is available in six fabulous "untame" colors. Come see it. It's a whole different animal!

$49.98 Twin Size Polar Bear Bedspread 42.99

$74.98 King Size Polar Bear Bedspread 62.99

$33.98 Polar Bear Throw, 54 x 72-in. 25.99

$8 Polar Bear Pillow in 6 Shocking Colors 6.99

Use Sears Revolving Charge

Prices Effective thru Friday, December 3

Sears Department Stores, 1971

301

Crest Toothpaste, 1971

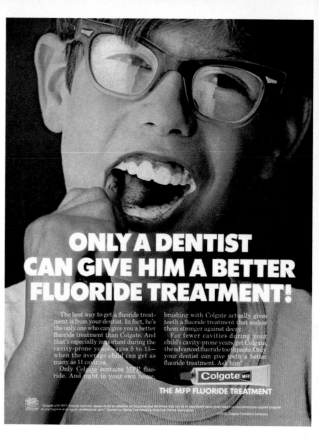

Colgate Toothpaste, 1972

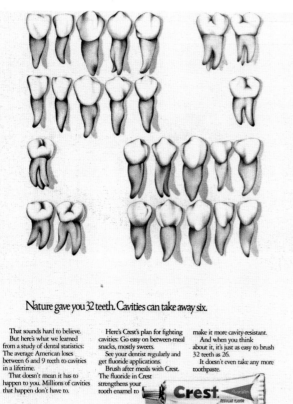

Crest Toothpaste, 1972

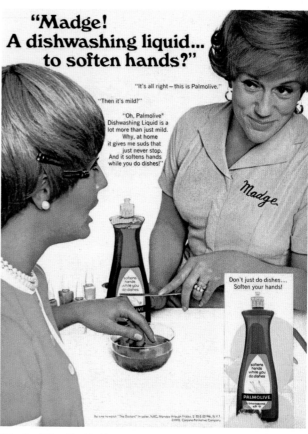

Palmolive Dishwashing Liquid, 1971　　　▶ *Monster Vitamins, 1975*

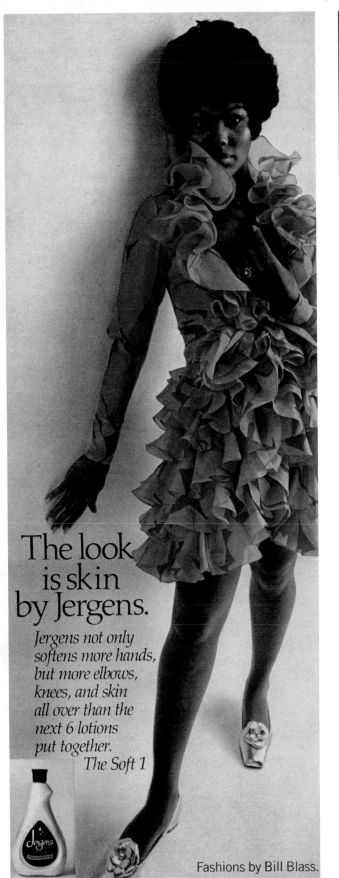

The look is skin by Jergens.

Jergens not only softens more hands, but more elbows, knees, and skin all over than the next 6 lotions put together.
The Soft 1

Fashions by Bill Blass.

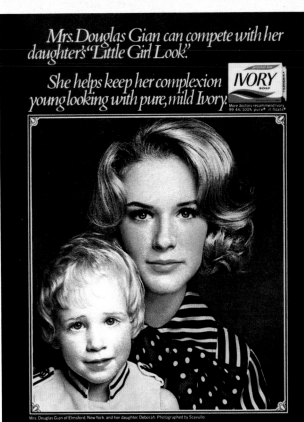

Ivory Soap, 1970

Great Skin Day Care Moisturizer. Cleanser. Freshener. Night Care Cream. Hand Cream.

Ultra Brite Toothpaste, 1975 ◄◄ *Alpha Keri Bath Oil, 1977* ◄ *Jergens Lotion, 1970* *Fabergé Great Skin Lotion, 1976*

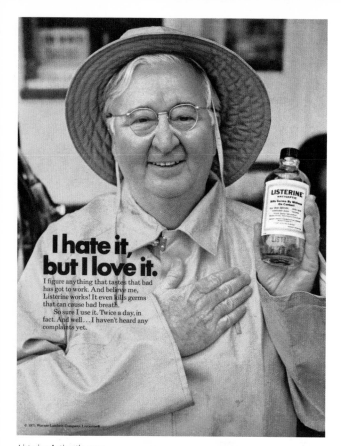

I hate it, but I love it.

I figure anything that tastes that bad has got to work. And believe me, Listerine works! It even kills germs that can cause bad breath.

So sure I use it. Twice a day, in fact. And well...I haven't heard any complaints yet.

Listerine Antiseptic, 1971

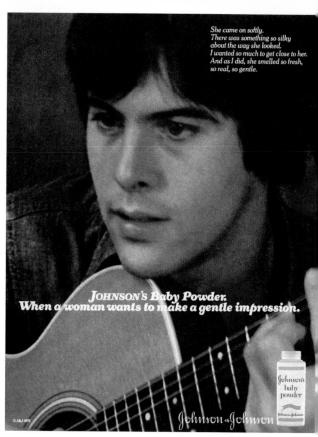

She came on softly. There was something so silky about the way she looked. I wanted so much to get close to her. And as I did, she smelled so fresh, so real, so gentle.

JOHNSON'S Baby Powder.
When a woman wants to make a gentle impression.

Johnson & Johnson

Johnson's Baby Powder, 1974

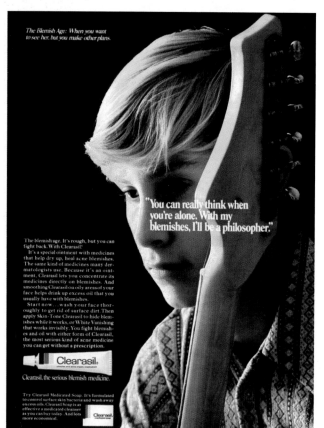

The Blemish Age: When you want to see her, but you make other plans.

"You can really think when you're alone. With my blemishes, I'll be a philosopher."

The blemish age. It's rough, but you can fight back. With Clearasil.

It's a special ointment with medicines that help dry up, heal acne blemishes. The same kind of medicines many dermatologists use. Because it's an ointment, Clearasil lets you concentrate its medicines directly on blemishes. And smoothing Clearasil on oily areas of your face helps drink up excess oil that you usually have with blemishes.

Start now...wash your face thoroughly to get rid of surface dirt. Then apply Skin-Tone Clearasil to hide blemishes while it works, or White Vanishing that works invisibly. You fight blemishes and oil with either form of Clearasil, the most serious kind of acne medicine you can get without a prescription.

Clearasil, the serious blemish medicine.

Try Clearasil Medicated Soap. It's formulated to control surface skin bacteria and wash away excess oils. Clearasil Soap is as effective a medicated cleanser as you can buy today. And lots more economical.

Clearasil Blemish Medicine, 1971

Oh no!

The OH NO's—aggravating, frustrating acne blemishes that crop up at the worst possible times. Fight 'em with Clearasil. It contains the same ingredients many dermatologists use. Apply Clearasil all over your face. Double on stubborn OH NO's. And be smart. Help fight today's OH NO's, help prevent tomorrow's, by using Clearasil every day. It's the most serious kind of blemish medicine you can get without a prescription.

Clearasil. Oh yes.

Fight the OH NO's two ways:
(1) Skin-Tone Clearasil hides while it fights.
(2) White Vanishing Clearasil Cream Medication fights invisibly.

Clearasil Blemish Medicine, 1970

308 Consumer Products

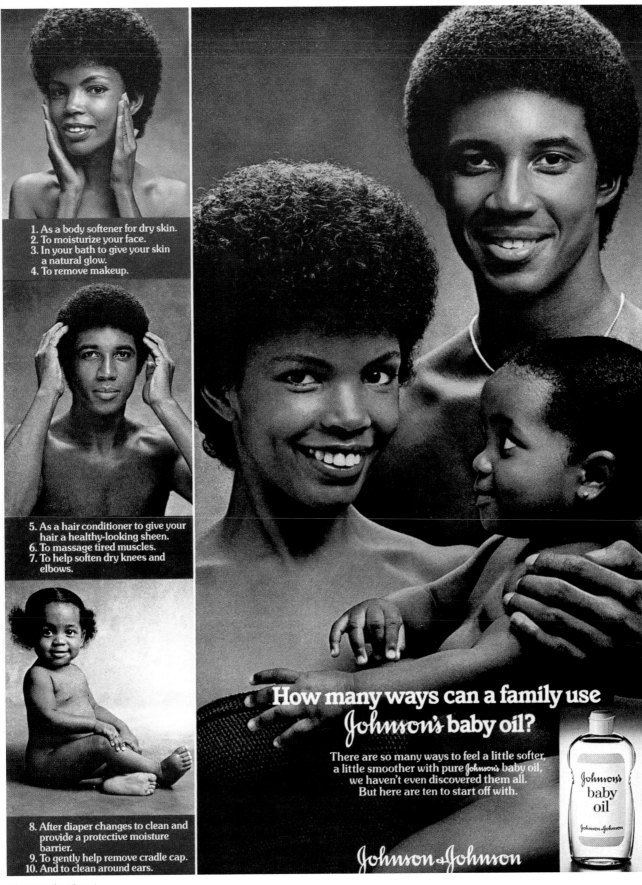

1. As a body softener for dry skin.
2. To moisturize your face.
3. In your bath to give your skin a natural glow.
4. To remove makeup.

5. As a hair conditioner to give your hair a healthy-looking sheen.
6. To massage tired muscles.
7. To help soften dry knees and elbows.

8. After diaper changes to clean and provide a protective moisture barrier.
9. To gently help remove cradle cap.
10. And to clean around ears.

How many ways can a family use Johnson's baby oil?

There are so many ways to feel a little softer, a little smoother with pure *Johnson's* baby oil, we haven't even discovered them all. But here are ten to start off with.

Johnson's baby oil

Johnson & Johnson

Johnson's Baby Oil, 1976

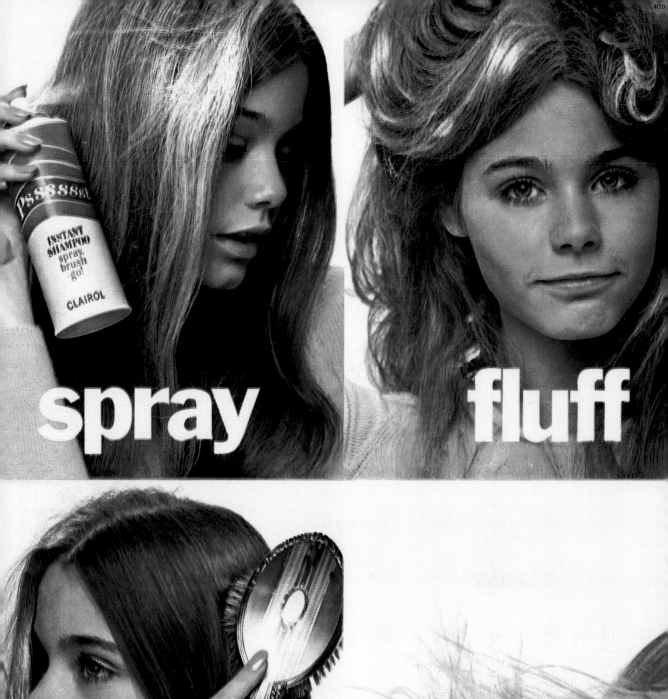

spray

fluff

brush

go!

Pursettes Tampons, 1974

K'West Aloe Products, 1977

Psssssst Instant Shampoo, 1973 ◀ *Cruex Jock Itch Powder, 1977*

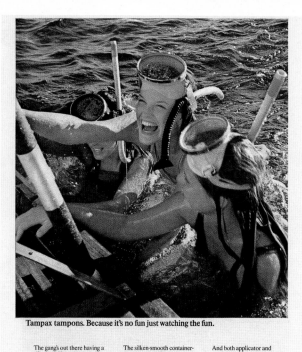

Tampax tampons. Because it's no fun just watching the fun.

The gang's out there having a terrific time. How about you? Can't go swimming because it's the wrong time of the month? Wrong! A doctor developed Tampax tampons for girls like you. They come in three absorbency-sizes: Regular, Super, Junior. And they're worn internally.

The silken-smooth container-applicator makes them easy and comfortable to insert. And their gentle three-way expansion gives you dependable protection. They're easy to remove because the withdrawal cord is safety-stitched.

And both applicator and tampon are completely flushable. There are so many reasons for trying Tampax tampons. But the best still is: no one likes being left out of the fun.

Right from the start...
TAMPAX

Tampax Tampons, 1971

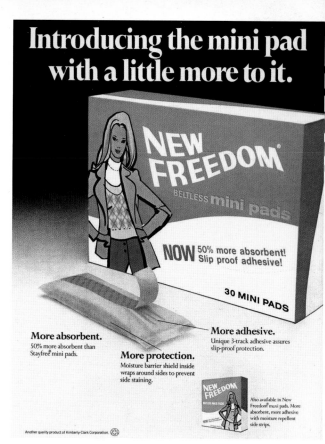

Introducing the mini pad with a little more to it.

NOW 50% more absorbent! Slip proof adhesive!

30 MINI PADS

More absorbent.
50% more absorbent than Stayfree® mini pads.

More protection.
Moisture barrier shield inside wraps around sides to prevent side staining.

More adhesive.
Unique 3-track adhesive assures slip-proof protection.

Also available in New Freedom® maxi pads. More absorbent, more adhesive with moisture repellent side strips.

Another quality product of Kimberly-Clark Corporation.

New Freedom Sanitary Pads, 1975

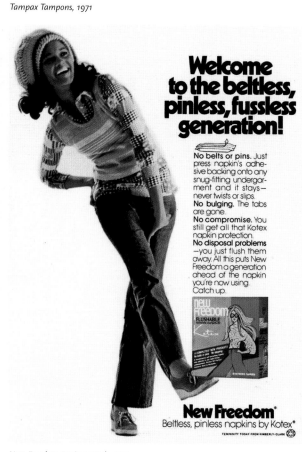

Welcome to the beltless, pinless, fussless generation!

No belts or pins. Just press napkin's adhesive backing onto any snug-fitting undergarment and it stays— never twists or slips.
No bulging. The tabs are gone.
No compromise. You still get all that Kotex napkin protection.
No disposal problems —you just flush them away. All this puts New Freedom a generation ahead of the napkin you're now using. Catch up.

New Freedom®
Beltless, pinless napkins by Kotex®

FEMININITY TODAY FROM KIMBERLY-CLARK

New Freedom Sanitary Pads, 1973

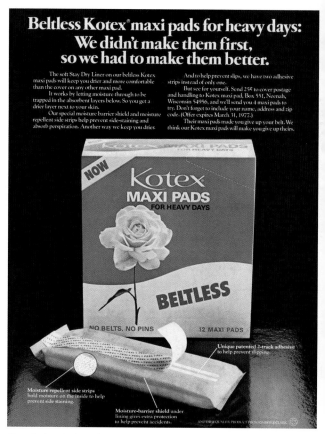

Beltless Kotex® maxi pads for heavy days: We didn't make them first, so we had to make them better.

The soft Stay Dry Liner on our beltless Kotex maxi pads will keep you drier and more comfortable than the cover on any other maxi pad.

It works by letting moisture through to be trapped in the absorbent layers below. So you get a drier layer next to your skin.

Our special moisture barrier shield and moisture repellent side strips help prevent side-staining and absorb perspiration. Another way we keep you drier.

And to help prevent slips, we have two adhesive strips instead of only one.

But see for yourself. Send 25¢ to cover postage and handling to Kotex maxi pad, Box 551, Neenah, Wisconsin 54956, and we'll send you 4 maxi pads to try. Don't forget to include your name, address and zip code. (Offer expires March 31, 1977.)

Their maxi pads made you give up your belt. We think our Kotex maxi pads will make you give up theirs.

Kotex MAXI PADS FOR HEAVY DAYS
NOW
BELTLESS
NO BELTS, NO PINS 12 MAXI PADS

Unique patented 2-track adhesive to help prevent slipping.

Moisture repellent side strips hold moisture on the inside to help prevent side staining.

Moisture-barrier shield under lining gives extra protection to help prevent accidents.

ANOTHER QUALITY PRODUCT FROM KIMBERLY-CLARK

Kotex Sanitary Pads, 1976 ▶ *Kotex Sanitary Pads, 1970*

Dear Mother Nature:

Drop dead!

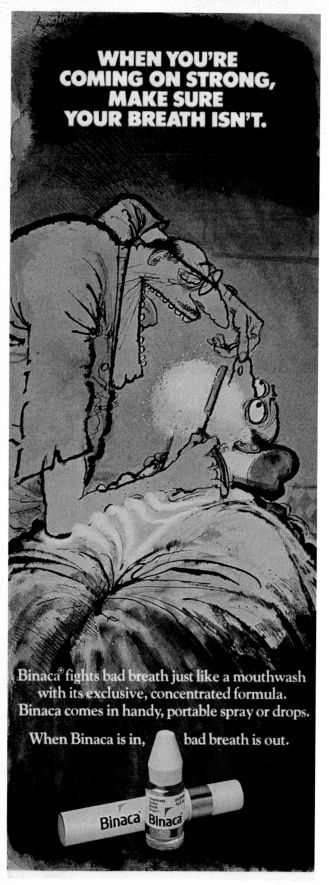

WHEN YOU'RE COMING ON STRONG, MAKE SURE YOUR BREATH ISN'T.

Binaca® fights bad breath just like a mouthwash with its exclusive, concentrated formula.
Binaca comes in handy, portable spray or drops.

When Binaca is in, bad breath is out.

Binaca Breath Freshener, 1971

ANNOUNCING INNER RINSE® THE UNIQUE DOUCHING SYSTEM.

Only a system can be so convenient, cost so little, and work so well.

Now there's a vaginal cleansing system that helps solve all three problems of douching. It isn't awkward like old-fashioned douching bags. It doesn't cost a tiny fortune every time you use it, like those new disposables. Because it's re-usable. And it won't upset your natural pH balance. Because it's non-acid.

Remember, INNER RINSE isn't just a douche, it's a douching system, a unique you-shaped Cleansing Unit, plus a gentle yet effective Cleansing Concentrate. Together, the Unit and the Concentrate work deep inside to help remove the source of odors, giving you the freshness and confidence you want.

Cleansing Unit.

Simply use cap to measure Concentrate.

Pour Concentrate into Unit, then fill Unit with water.

Attach nozzle to Unit.

After use, nozzle stores inside Unit. Out of sight.

SPECIALLY-DESIGNED CLEANSING UNIT
Reusable • Compact, pliable, easy to use and store • No bag to hang, nothing to get into the tub for • Two to three times more cleansing than disposables. Yet costs much less per use.

Liquid Concentrate.

SPECIALLY-FORMULATED CLEANSING CONCENTRATE
Comes with system. Refills available. • Non-acid. Won't upset your natural pH balance • Concentrated for truly effective cleansing • Good, clean scent. Not medicinal, perfumey or lingering.

inner rinse.

Special Introductory Offer.
$1.00 MAIL-IN REFUND WITH PROOF-OF-PURCHASE.
See specially-marked Inner Rinse System packages at your store for details.

Inner Rinse Douche, 1975

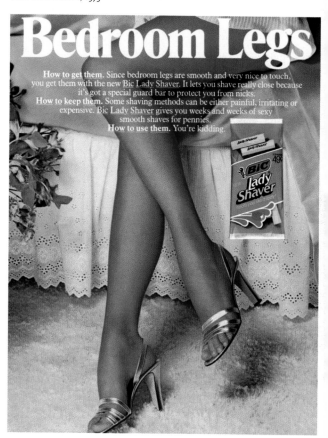

Bedroom Legs

How to get them. Since bedroom legs are smooth and very nice to touch, you get them with the new Bic Lady Shaver. It lets you shave really close because it's got a special guard bar to protect you from nicks.
How to keep them. Some shaving methods can be either painful, irritating or expensive. Bic Lady Shaver gives you weeks and weeks of sexy smooth shaves for pennies.
How to use them. You're kidding.

BIC Lady Shaver 49¢

Lady Shaver Disposable Razors, 1979 ▶ *FDS Feminine Hygiene Deodorant, 1970*

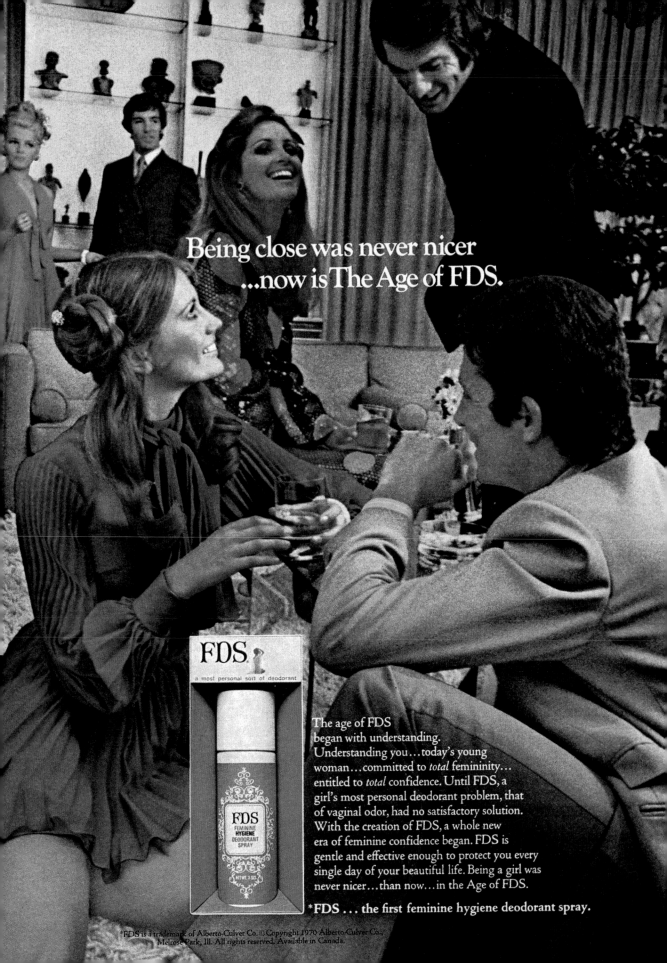

Being close was never nicer
...now is The Age of FDS.

FDS. 🂠
a most personal sort of deodorant

FDS
FEMININE
HYGIENE
DEODORANT
SPRAY

NET WT. 3 OZ.

The age of FDS
began with understanding.
Understanding you...today's young
woman...committed to *total* femininity...
entitled to *total* confidence. Until FDS, a
girl's most personal deodorant problem, that
of vaginal odor, had no satisfactory solution.
With the creation of FDS, a whole new
era of feminine confidence began. FDS is
gentle and effective enough to protect you every
single day of your beautiful life. Being a girl was
never nicer...than now...in the Age of FDS.

***FDS ... the first feminine hygiene deodorant spray.**

THE PLOP PLOP FIZZ FIZZ IS FAST FAST

Alka-Seltzer.® For upset stomach with headache the plop plop fizz fizz is fast fast.
Read the label, use only as directed. ෴ Miles Laboratories, Inc. 1977

Bounty Paper Towels, 1978

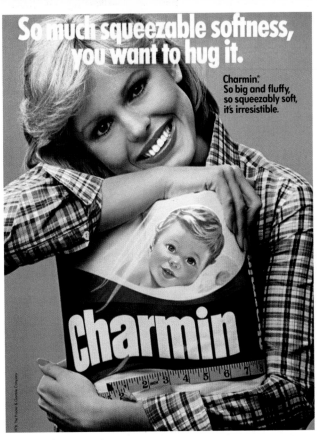

Charmin Toilet Paper, 1978

Alka-Seltzer Heartburn Medicine, 1977 ◄ Precise Plant Food, 1975

S & H Green Stamps, 1978

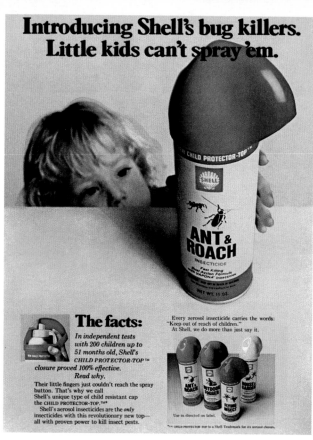

Introducing Shell's bug killers. Little kids can't spray 'em.

The facts:

In independent tests with 200 children up to 51 months old, Shell's CHILD PROTECTOR-TOP™ closure proved 100% effective. Read why.

Their little fingers just couldn't reach the spray button. That's why we call Shell's unique type of child resistant cap the CHILD PROTECTOR-TOP.™

Shell's aerosol insecticides are the *only* insecticides with this revolutionary new top— all with proven power to kill insect pests.

Every aerosol insecticide carries the words: "Keep out of reach of children." At Shell, we do more than just say it.

Use as directed on label.

Shell Insecticides, 1974

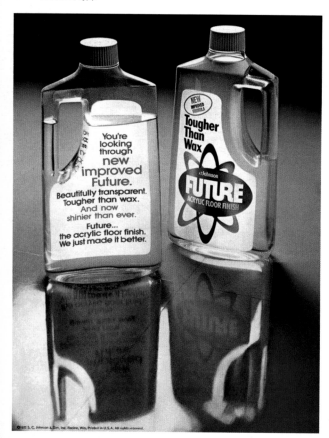

Future Floor Finish, 1973

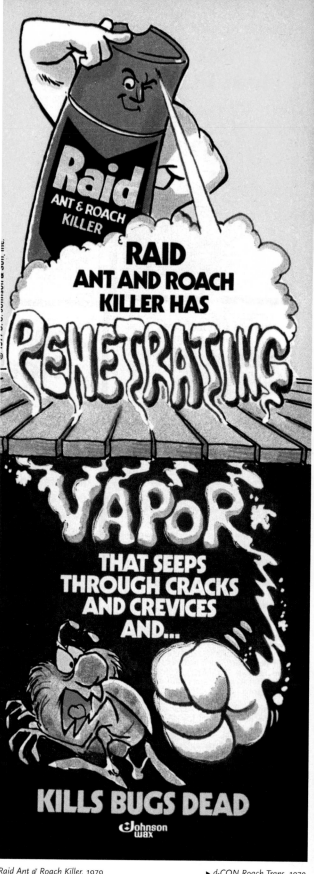

Raid Ant & Roach Killer, 1979

▶ *d-CON Roach Traps, 1979*

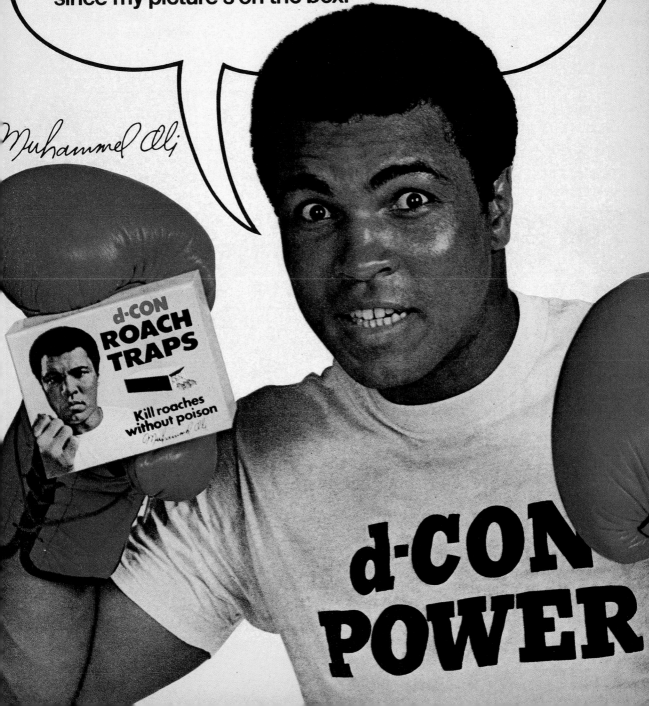

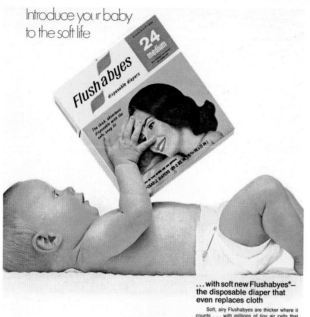

Introduce your baby to the soft life

Flushabyes
disposable diapers

... with soft new Flushabyes®—
the disposable diaper that
even replaces cloth

Soft, airy Flushabyes are thicker where it counts . . . with millions of tiny air cells that breathe as baby moves. And they're even more absorbent than cloth, because they're filled with soft, pure natural fibers. So they draw moisture from the skin . . . fast.

Flushabyes come in three sizes to give every baby a safe, snug fit. And there is no plastic back. You use Flushabyes just like cloth diapers . . . with baby's regular rubber pants.

With Flushabyes, baby gets a brand-new diaper every change. So you never have to worry about soaps or detergents or bleaches causing diaper rash. And they cost so little.

Try soft new Flushabyes. At home or away, a soft new life for your baby.

*Facelle Company, a Division of International Paper Company. ©1969, Facelle Company

Flush-a-byes Disposable Diapers, 1970

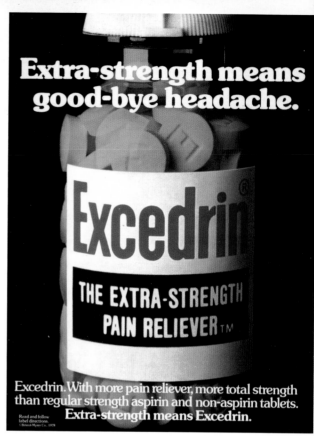

Extra-strength means good-bye headache.

Excedrin®

THE EXTRA-STRENGTH PAIN RELIEVER™

Excedrin. With more pain reliever, more total strength than regular strength aspirin and non-aspirin tablets. **Extra-strength means Excedrin.**

Read and follow
label directions.
©Bristol-Myers Co. 1978

Excedrin Pain Reliever, 1978

Wet Ones®
MOIST TOWELETTES
for Baby

Extra large, for
extra thorough
clean-ups.
Soft cloth, for
baby's delicate skin.

Moist from
first to last,
so the last
cleans as
thoroughly
as the first.

Just one 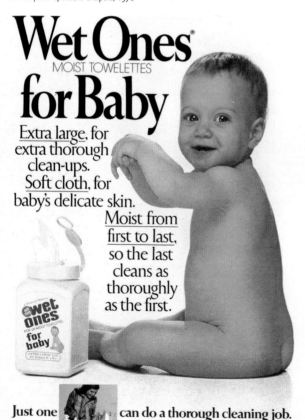 can do a thorough cleaning job.

Wet Ones Towelettes, 1978

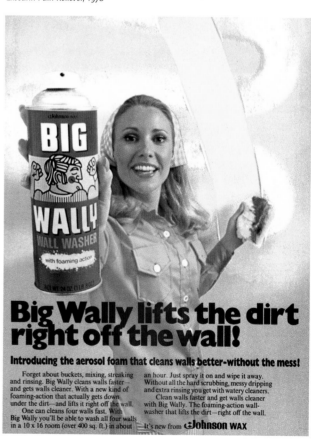

Big Wally lifts the dirt right off the wall!

Introducing the aerosol foam that cleans walls better-without the mess!

Forget about buckets, mixing, streaking and rinsing. Big Wally cleans walls faster—and gets walls cleaner. With a new kind of foaming-action that actually gets down under the dirt—and lifts it right off the wall.

One can cleans four walls fast. With Big Wally you'll be able to wash all four walls in a 10 x 16 room (over 400 sq. ft.) in about

an hour. Just spray it on and wipe it away. Without all the hard scrubbing, messy dripping and extra rinsing you get with watery cleaners.

Clean walls faster and get walls cleaner with Big Wally. The foaming-action wall-washer that lifts the dirt—right off the wall.

It's new from **Johnson WAX**

Big Wally Wall Cleaner, 1972

▶ *Johnson's Baby Oil, 1971*

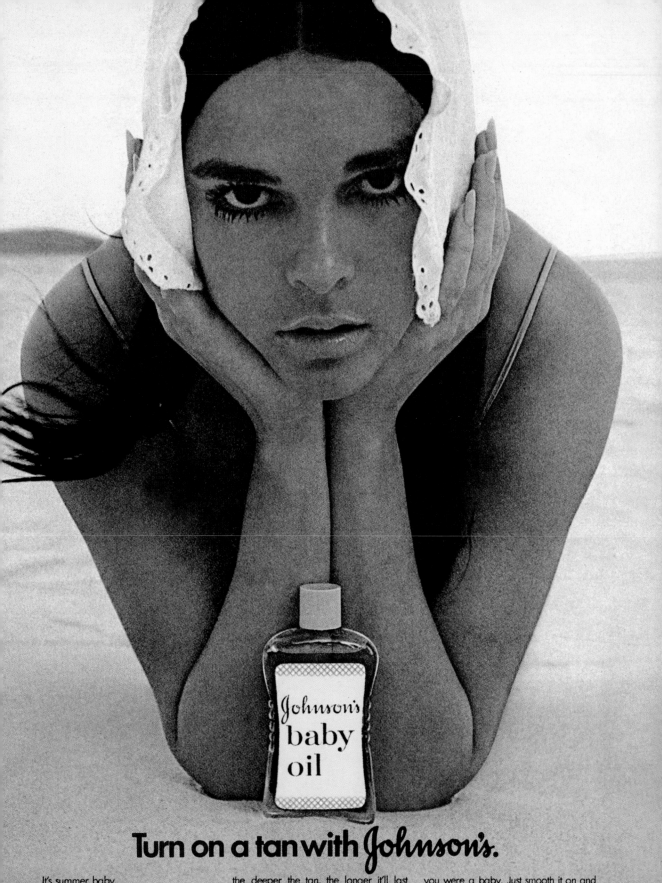

Turn on a tan with *Johnson's.*

It's summer baby.

The pale, romantic heroine is out. The tan, romantic heroine is in. Be one, a bronze and beautiful one, by turning on a tan with *Johnson's* Baby Oil. It makes those long summer rays tan deep. And the deeper the tan, the longer it'll last after summer is gone. What's more, after sun bathing, bathing yourself in baby oil keeps your skin moist and supple.

It's the same pure oil your mother used to keep your skin soft and smooth when you were a baby. Just smooth it on and let the sun do its thing. But don't overdo it. (Remember, baby oil has no sunscreens, so you should take a little less sun than with cover-up lotions and creams.) Turn on a tan, baby. And you'll turn on your hero.

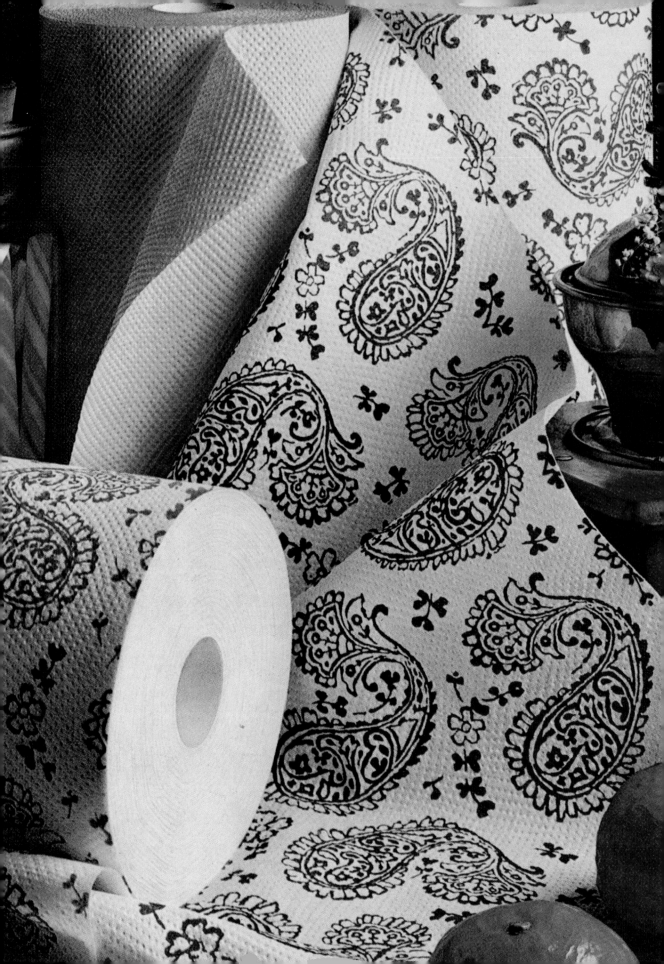

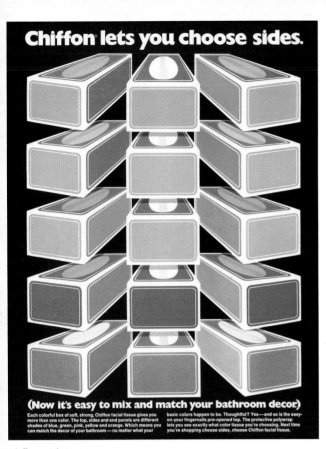

Chiffon Facial Tissue, 1971

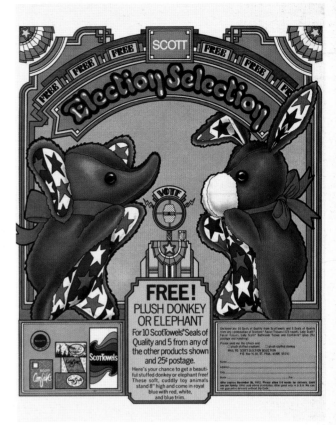

Scott Paper Towels, 1972

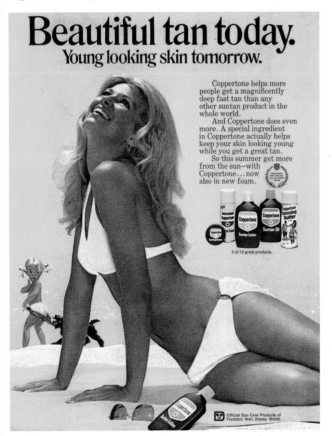

Kleenex Paper Towels, 1971 ◄ *Coppertone Suntan Products, 1972*

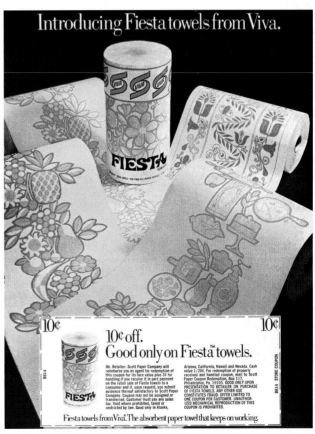

Fiesta Paper Towels, 1972

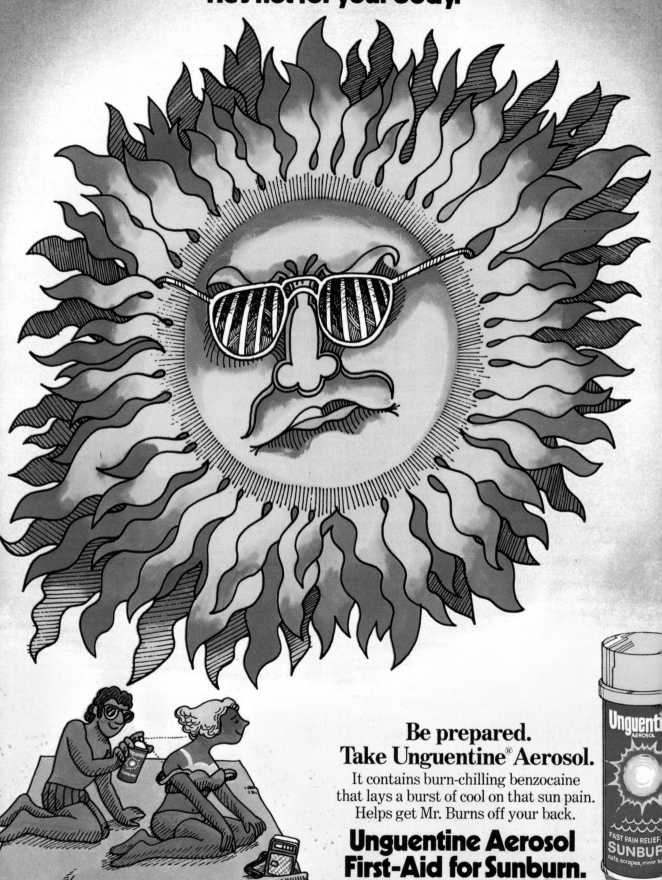

Now! Look great as nature intended

with MALE BAG Face Colour
FROM ENGLAND

Completely undetectable, there's nothing like it for men. Male Bag Face Colour creates a week-end-in-the-country look all year round. It smoothes on transparently and is non-streaking and waterproof, yet washes off when you want.

Not a bronzer. Male Bag Face Colour creates believable, healthy colour. It comes in three individualized shades to let you select the one that naturally blends with your own colouring.

Male Bag also offers a unique total face kit, the first of its kind for men. All part of a complete face care line. Available only by mail.

Get and keep a healthy look for face (and body!) all year round. **ORDER TODAY.**

MONEY BACK GUARANTEE
If you are not completely satisfied, return unused portion within 30 days for a full refund.

☐ **YES!** Please send me the MALE BAG Face Colour (4 oz.) tube at $10.00 each. I've enclosed $_____ for _____ Face Colour(s) plus 50¢ postage and handling.

☐ **YES!** Please send me the Male Bag Kit, containing: Face Colour (1.34 oz.), Skin Conditioner (8 oz.), Hide-It stick, Lip Toner stick and Lash/Moustache Tint, all for $19.50. I've enclosed $_____ for _____ Kits(s) plus $1.50 postage and handling. CT residents, add 7% sales tax to all sales.

☐ Please send me your brochure on the Male Man concept.

IMPORTANT: My complexion is ☐ Fair ☐ Medium ☐ Dark
Please print:
Name _____
Address _____
City _____ State _____ Zip _____

For charge orders, call TOLL FREE 24 hours a day—7 days a week
800-621-5199
(In Illinois, call 800-972-5858)

MAIL TO:
MALE MAN Ltd.
PO BOX 4209 GREENWICH, CT 06830

ES-01

Male Bag Cosmetics, 1979

I discovered the natural way to look at the world in my SOFLENS Contact Lenses.

Backpacking with my friends is a lot more fun since I switched to Bausch & Lomb SOFLENS (polymacon) Contact Lenses. And they all tell me I look more attractive now than I did in glasses.

My eye doctor suggested Bausch & Lomb SOFLENS Contact Lenses. And they were comfortable right away, because they're so soft and pliable. It only takes me a few minutes a day to take care of them. I don't worry about losing them either, because they rarely pop out.

If you're an active person who needs vision correction and you want to look attractive in a natural way, you should find out about Bausch & Lomb SOFLENS Contact Lenses, too.

BAUSCH & LOMB SOFLENS (polymacon) Contact Lenses

Bausch & Lomb Soflens Contact Lenses, 1978

PROTECT EYES FROM GLARE

ENJOY REAL EYE COMFORT

Now you can enjoy comfortable vision in strong sunlight while playing tennis, sailing, golfing, motoring, or reading on the beach. Adjustable dark green plastic shield slips on your specs in a jiffy. Wear the Sport Visor on regular or sun glasses.

SPORT VISOR $1.98 + 20¢ Mailing Each
ALLOW 3-4 WEEKS FOR DELIVERY

Anthony Enterprises, 585 Market, Dept. HG-572, San Francisco, Ca. 94105
Name _____
Address _____
City & State _____ Zip _____

How Many	ITEM	Price Ea.	Total
	SPORT VISOR	$1.98	
			Total

NO STAMPS OR COD's, PLEASE
California residents add 5% Sales Tax

Unguentine Sunburn Spray, 1974 ◄ *Sports Visor, 1972*

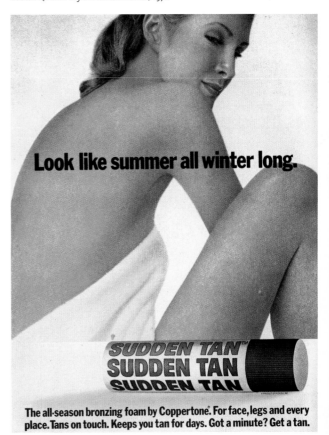

Look like summer all winter long.

The all-season bronzing foam by Coppertone. For face, legs and every place. Tans on touch. Keeps you tan for days. Got a minute? Get a tan.

Sudden Tan Bronzing Foam, 1973 ► *Solarcaine Sunburn Relief Products, 1974*

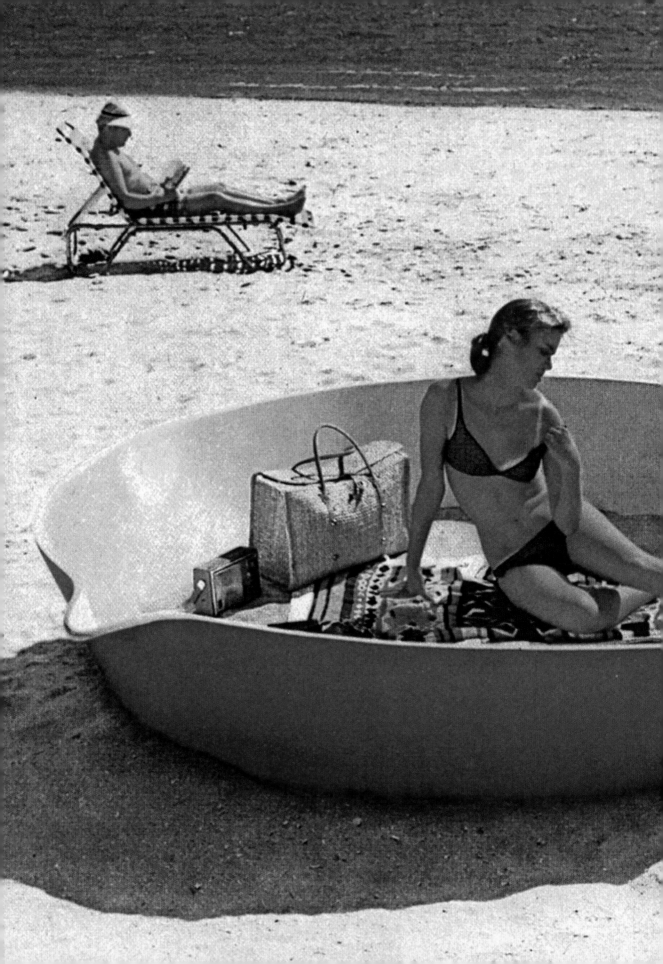

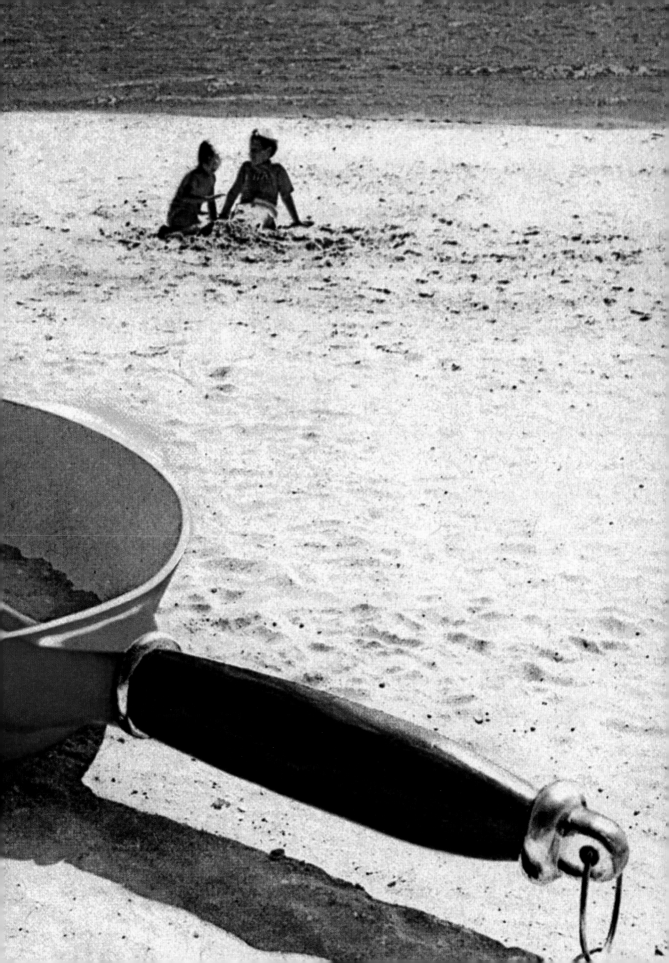

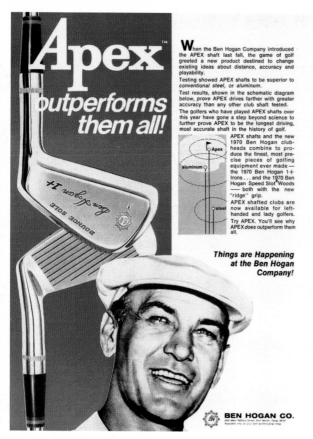

Apex
outperforms them all!

When the Ben Hogan Company introduced the APEX shaft last fall, the game of golf greeted a new product destined to change existing ideas about distance, accuracy and playability.

Testing showed APEX shafts to be superior to *conventional steel*, or *aluminum*.

Test results, shown in the schematic diagram below, *prove* APEX drives farther with greater accuracy than any other club shaft tested.

The golfers who have played APEX shafts over this year have gone a step beyond science to further prove APEX to be the longest driving, most accurate shaft in the history of golf.

APEX shafts and the new 1970 Ben Hogan club-heads combine to produce the finest, most precise pieces of golfing equipment ever made — the 1970 Ben Hogan 1+ Irons . . . and the 1970 Ben Hogan Speed Slot Woods — both with the new "ridge" grip.

APEX shafted clubs are now available for left-handed and lady golfers.

Try APEX. You'll see why APEX *does* outperform them all.

Things are Happening at the Ben Hogan Company!

BEN HOGAN CO.

Ben Hogan Golf Clubs, 1970

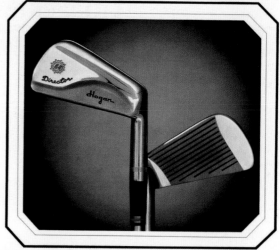

FROM · BEN · HOGAN

The Director... *a professionally designed, superbly balanced instrument.*

My new DIRECTOR™ irons are the finest precision instruments I have yet developed. They incorporate the latest engineering techniques, the finest and most suitable materials, and all the years of playing and manufacturing experience that I have amassed.

DIRECTOR irons feel good in your hands. They respond with a solid impact when you strike the ball. They truly help you *direct* the ball toward the hole.

You will experience a new level of golfing enjoyment when you try them.

Ben Hogan

Ben Hogan

Ben Hogan Golf Clubs, 1973

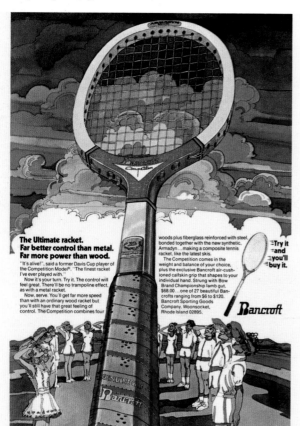

The Ultimate racket.
Far better control than metal.
Far more power than wood.

"It's alive!", said a former Davis Cup player of the Competition Model®. "The finest racket I've ever played with."

Now it's your turn. Try it. The control will feel great. There'll be no trampoline effect, as with a metal racket.

Now, serve. You'll get far more speed than with an ordinary wood racket but you'll still have that great feeling of control. The Competition combines four woods plus fiberglass reinforced with steel, bonded together with the new synthetic, Armadyn... making a composite tennis racket, like the latest skis.

The Competition comes in the weight and balance of your choice, plus the exclusive Bancroft air-cushioned calfskin grip that shapes to your individual hand. Strung with Bow Brand Championship lamb gut, $68.00... one of 27 beautiful Bancrofts ranging from $6 to $120. Bancroft Sporting Goods Company, Woonsocket, Rhode Island 02895.

Try it and you'll buy it.

Bancroft

Bancroft Tennis Raquets, 1973

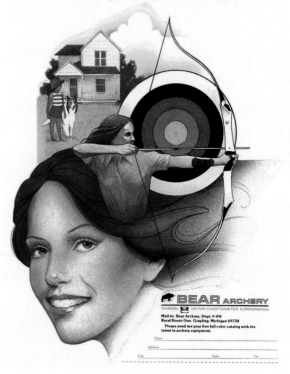

"There is no sight more beautiful than the graceful figure of a woman as she draws the bowstring to her cheek and confidently faces her target."

BEAR ARCHERY
DIVISION VICTOR COMPTOMETER CORPORATION

Mail to: Bear Archery, Dept. P-SW
Rural Route One, Grayling, Michigan 49738
Please send me your free full color catalog with the latest in archery equipment.

Name
Address
City State Zip

Bear Archery, 1977 ▶ *U.S. Postal Service, 1975*

Stamp Collecting. It lets you see what makes America, America.

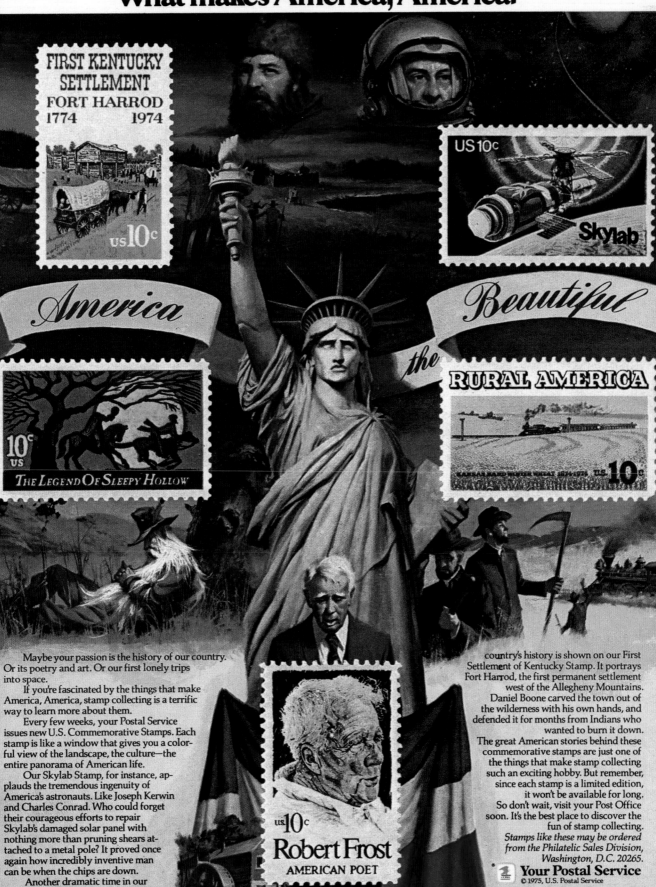

FIRST KENTUCKY SETTLEMENT FORT HARROD 1774 1974 — US 10c

US 10c Skylab

10c US — THE LEGEND OF SLEEPY HOLLOW

RURAL AMERICA — KANSAS HARD WINTER WHEAT 1874-1974 US 10c

America the Beautiful

US 10c Robert Frost — AMERICAN POET

Maybe your passion is the history of our country. Or its poetry and art. Or our first lonely trips into space.

If you're fascinated by the things that make America, America, stamp collecting is a terrific way to learn more about them.

Every few weeks, your Postal Service issues new U.S. Commemorative Stamps. Each stamp is like a window that gives you a colorful view of the landscape, the culture—the entire panorama of American life.

Our Skylab Stamp, for instance, applauds the tremendous ingenuity of America's astronauts. Like Joseph Kerwin and Charles Conrad. Who could forget their courageous efforts to repair Skylab's damaged solar panel with nothing more than pruning shears attached to a metal pole? It proved once again how incredibly inventive man can be when the chips are down.

Another dramatic time in our country's history is shown on our First Settlement of Kentucky Stamp. It portrays Fort Harrod, the first permanent settlement west of the Allegheny Mountains. Daniel Boone carved the town out of the wilderness with his own hands, and defended it for months from Indians who wanted to burn it down.

The great American stories behind these commemorative stamps are just one of the things that make stamp collecting such an exciting hobby. But remember, since each stamp is a limited edition, it won't be available for long. So don't wait, visit your Post Office soon. It's the best place to discover the fun of stamp collecting.

Stamps like these may be ordered from the Philatelic Sales Division, Washington, D.C. 20265.

Your Postal Service
© 1975, U.S. Postal Service

NOW...WORLD'S FIRST LOW-COST IMPORTED FLAME GUN

Melts Ice Fast!...Burns Up Snow!

A fine buy at regular price—a give-away value at special super-sale price! You save $12! Never slip again—avoid dangerous falls—costly law suits! This quality jet-rod Flame Gun clears stairs, walks, driveways of even heaviest snow, thickest ice in seconds, frees "snowed in" cars. No heart-taxing shoveling—no bending. Easy, clean, one-hand operation from comfortable standing position. No cumbersome cords, no expensive batteries, no costly fuel!

SAFE...SIMPLE...COSTS MERE PENNIES PER USE!

In summer, kills weeds fast, sterilizes ground, gets rid of insect nests, keeps flagstone and cement walks clear, trims borders! Less than 2 pints of kerosene gives 30 minutes continuous use. Completely safe; weighs under 5 lbs; full instructions included. Order today—you will soon be paying $12 more! Next season, do your weeding without bending.

ONLY $17.98 plus $1.00 for postage and handling.

Prompt Shipment. **HOBI,** Dept. IP-20
Satisfaction Guaranteed. 7 Delaware Drive, Lake Success, N.Y. 11040

39

Purex keeps your pool in better shape no matter what shape your pool is in.

Purex heaters, pumps, filters and underwater lights. **Guardex** quality chemicals, automatic chlorinators and test kits. Just ask your favorite pool builder, dealer or serviceman. Purex Corporation, Ltd., Pool Products Division

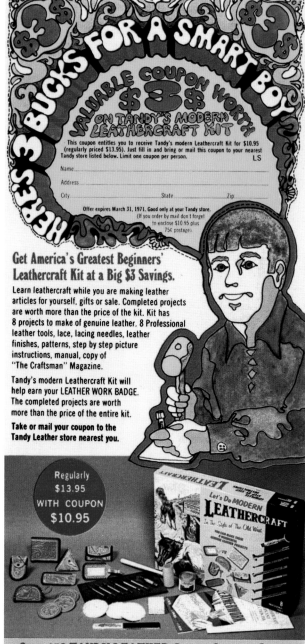

Purex Pool Supplies, 1973

Tandy's Leathercraft Kit, 1970

▶ *Kohler Enclosure Habitat, 1979*

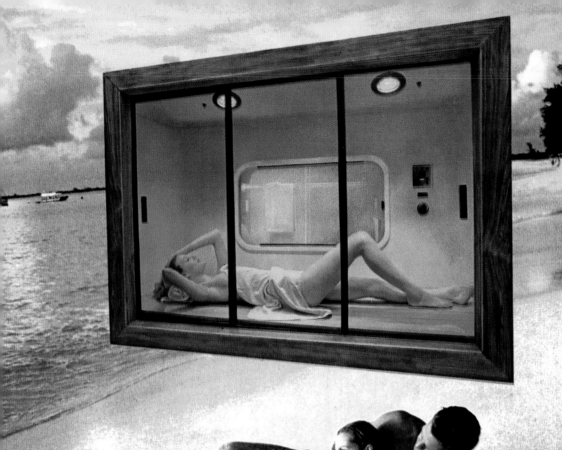

you can't live in a perfect climate. But that doesn't mean you can't own one.

Habitat,™ by Kohler.

Habitat is a remarkable addition to the series of Kohler environmental enclosures. It's designed to let you experience the soothing elements of warm Sun, refreshing Rain, and cleansing Steam, a delightful option. All within a single unit.

Habitat also gives you two conditioning elements, Ambience and Warm Breeze, to enhance the atmosphere. And warm the enclosure.

This is how it works. Select any element to begin your *Habitat* experience. When you're ready for a change, select another element . . . or let *Habitat* sequence automatically every 20 minutes. You can also add conditioning elements as you wish. Add Warm Breeze to Sun, and you have a desert afternoon, buffed by light wind. Ambience and Rain create a bright summer shower.

The combinations seem endless. And so do the pleasures.

For all its uniqueness, *Habitat* is water and energy efficient. A one-hour sequence costs just about 25¢.

Habitat's suggested list price is about $5000, plus freight, installation, and options.

Learn more about *Habitat*. In the U.S. or Canada, look for your Kohler dealer in the Yellow Pages. Or send 50¢ to Kohler Co., Box AA, Kohler. WI 53044.

Habitat, by Kohler. A climate you can own.

THE BOLD LOOK OF **KOHLER**

You're going to spend a lot of nice days and nights...and dollars.

RELAX
YOU'VE GOT MASTER CHARGE

Perfect for hotels, motels, restaurants, gas stations or just about any emergency along the way. Master Charge ... good in more places across the country than any other card. And it lets you stretch out your payments, if you like.

master charge.
THE INTERBANK CARD.

Look for the Master Charge sign or the Interbank symbol

Master Charge Card, 1973

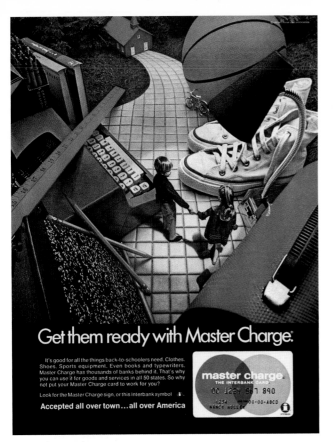

Master Charge Card, 1970

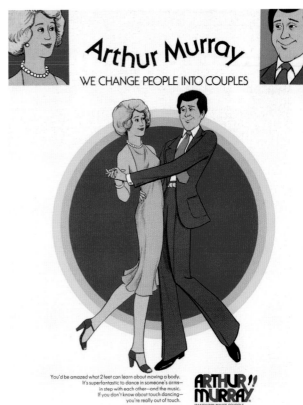

Arthur Murray Dance School, 1975

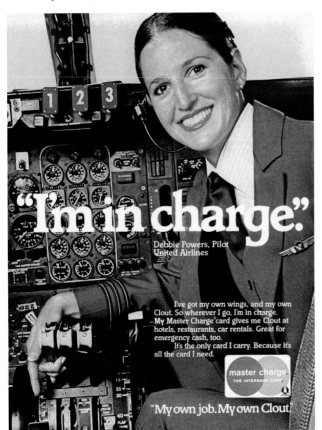

Master Charge Card, 1979

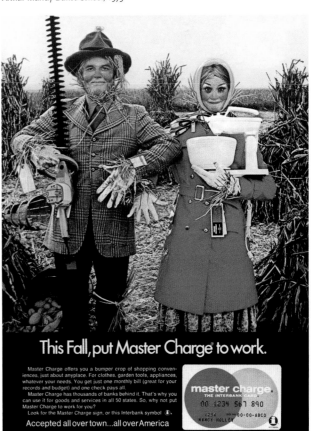

Master Charge Card, 1970

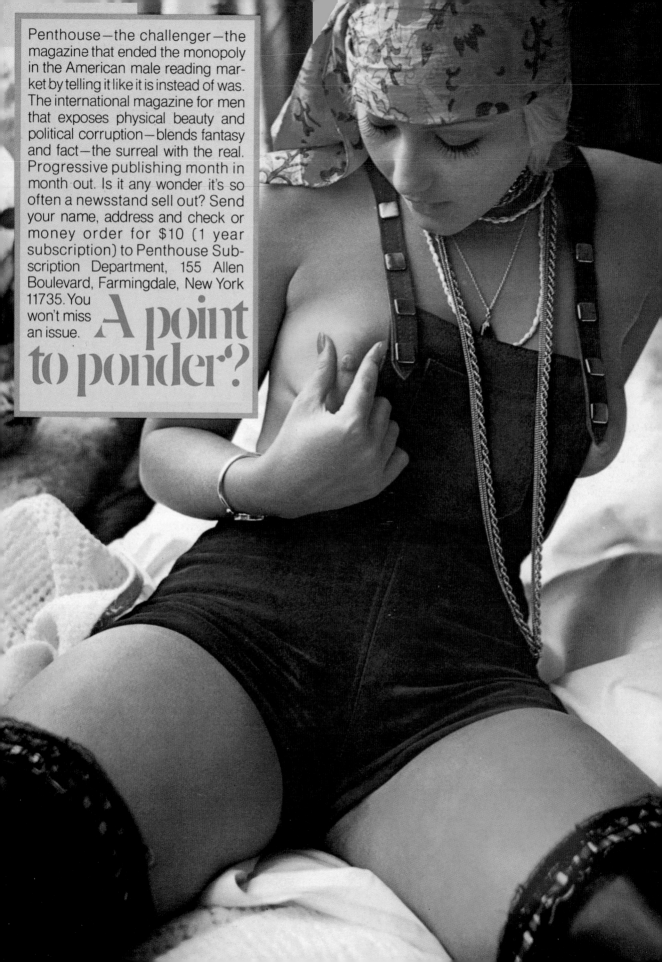

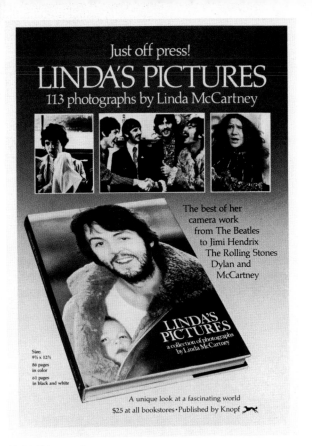

Just off press!

LINDA'S PICTURES
113 photographs by Linda McCartney

The best of her
camera work
from The Beatles
to Jimi Hendrix
The Rolling Stones
Dylan and
McCartney

Size:
9½ x 12½
86 pages
in color
61 pages
in black and white

A unique look at a fascinating world
$25 at all bookstores • Published by Knopf

Linda's Pictures, 1976

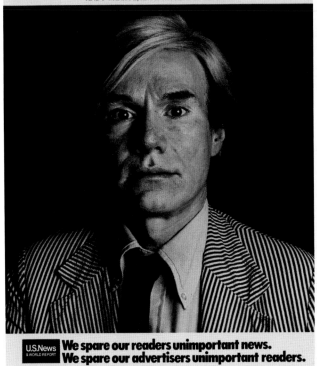

"No gossip."

ANDY WARHOL, ARTIST. A READER SINCE 1968.

U.S.News & WORLD REPORT We spare our readers unimportant news.
We spare our advertisers unimportant readers.

U.S. News & World Report Magazine, 1977

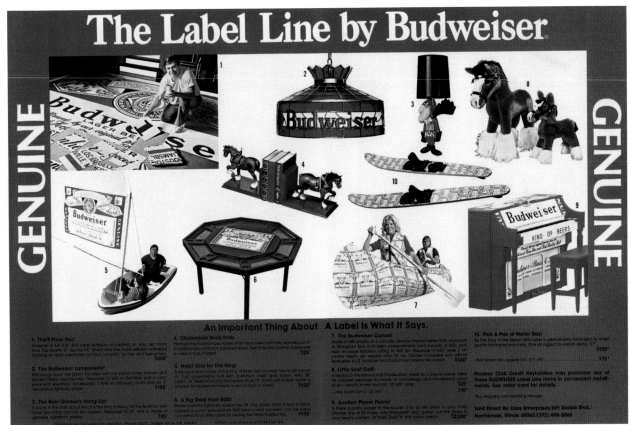

The Label Line by Budweiser

GENUINE **GENUINE**

An Important Thing About A Label Is What It Says.

Penthouse Magazine, 1974 ◀ Budweiser Products, 1973

THE RUMORS ARE TRUE:

Larry Flynt Has Cleaned Up His Act.

Oh, he's still publishing *Hustler*, "the magazine nobody quotes." And it's as unquotable as ever.

But starting this month, Larry Flynt is also publishing a new type of magazine.

Not just new for Larry. New for American publishing.

A magazine created by some of the best talent that ever worked at *Playboy*, *Rolling Stone*, *Esquire* and over a dozen other top magazines.

A magazine that breaks rules to bring literary and graphic excellence together with breathtakingly erotic photography.

A magazine featuring such writers as Norman Mailer, Wilfrid Sheed, or whomever else you'd like to read.

A magazine about the world we live in *now*.

A magazine called *Chic*. On newsstands everywhere.

CHIC

A LARRY FLYNT PUBLICATION

Chic Magazine, 1976

The Hot Tub Experience

Blissfully yours for $995

It's a simple pleasure — as old as the ages. Healthy for mind, body, and soul.

By yourself, or with others.

Hot tubbing has become an institution along our California coast. Now, thanks to the modest cost and practicality of our new do-it-yourself package, anyone can enjoy the benefits. Just one weekend will transform your own deck or garden into a sensuous new environment.

We'll deliver a complete hot tub spa package anywhere in the U.S. for only $995, plus freight.

Comes to your door pre-cut, pre-plumbed, complete. Includes solid redwood tub, pump, filter, heater, hydro-massage booster jets, and accessories. All you need is household tools and a friend — it's that simple!

We offer several tub sizes, with delivery and set-up available in central California.

California Cooperage
REDWOOD HOT TUBS
Railroad Square — Box E,
San Luis Obispo, CA 93406
Phone (805) 544-9300

Call or write today for our free color brochure, or enclose $1 and we'll send the photo-story book, **California Hot Tubbing**, (Uniplan Publishing, reg. $2.95).

CALIFORNIA COOPERAGE
REDWOOD HOT TUBS
Railroad Square — Box E,
San Luis Obispo, CA 93406

☐ Enclosed is $1. Rush me the "California Hot Tubbing" book and your literature, via First Class Mail.
☐ Just send me your free literature, via Third Class Mail.

Name _____
Address _____
City _____
State _____ Zip _____
 713

California Cooperage Hot Tubs, 1977

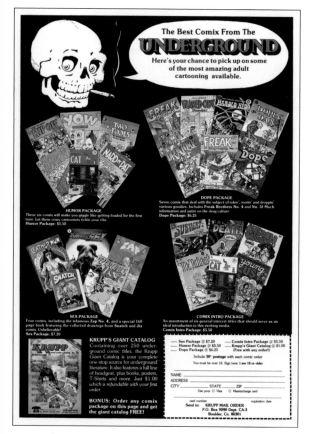

Krupp Mail Order Comics, 1978

What other newsweekly puts in so many great shots?

Graphics is just one of the ways in which The Third Newsweekly is different from the others.

How a magazine *looks* and *feels* has a lot to do with the enjoyment people get out of it... the mood it puts them in... the way they respond to it.

Sports Illustrated is ahead of the game from the start because sports themselves are so graphic... full of split-

second action... moments of drama and high emotion... breath-catching dangers... scenes of idyllic beauty and tranquility.

We go out and capture the best of these great shots and then bring them to our readers in lavish color. The result? No other newsweekly can match The Third for visual impact, pace, and sheer beauty.

A graphic environment like this makes a beautiful setting for selling. And when you're proud of what you're selling — whether it's goods or services or ideas — that matters. A lot.

Put SI on your next schedule. We'll do all we can to make you look good.

Sports Illustrated
The Third Newsweekly.

Sports Illustrated Magazine, 1974

Theodore Audel & Co. Books, 1974

Bell & Howell Schools, 1974

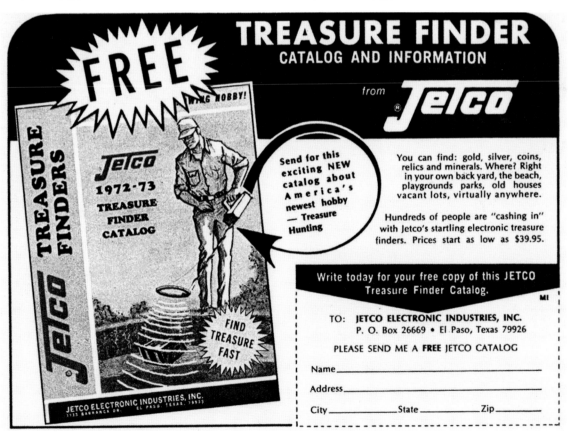
Jetco Treasure Finders, 1974

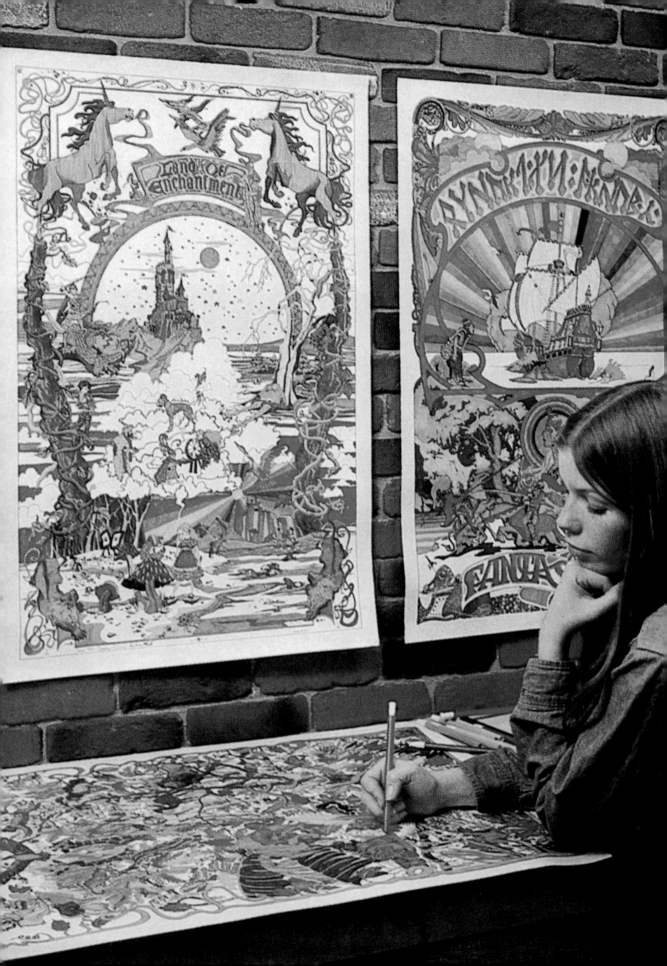

Caption: *Occult Arts Society, 1974*

Caption: *The Living Bible, 1971*

Caption: *Apartment Life Posters, 1975 ◄ Whole Earth Catalog, 1970*

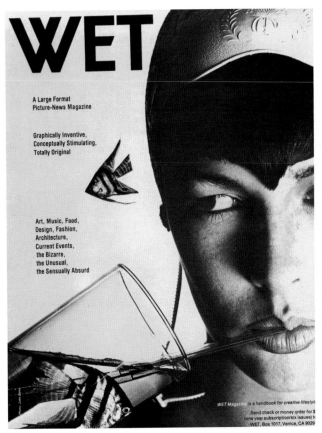

Caption: *WET Magazine, 1979*

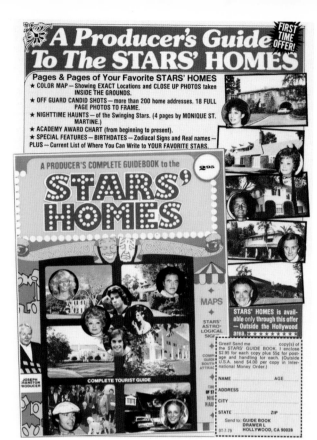

The Jesus Crusade, 1972

Stars' Homes Guidebook, 1979

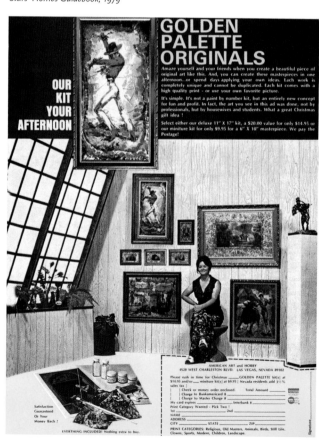

Fine Art Prints, 1973

Golden Palette Painting Kits, 1973

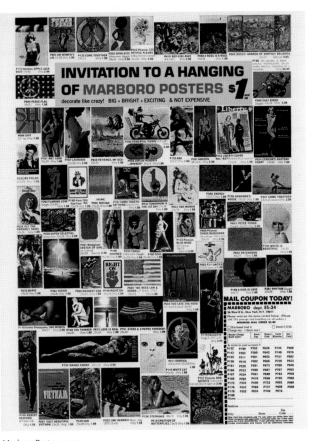

Marboro Posters, 1971

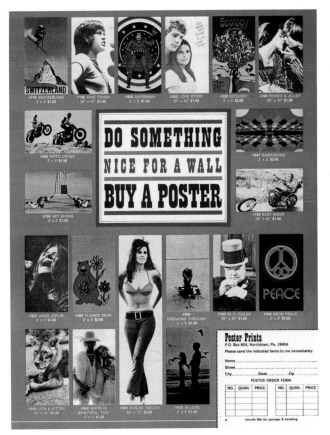

Poster Prints, 1971

PETER MAX©

For two decades, the everwidening popularity enjoyed by this modern master has secured his standing among the most important and influential contemporary artists.

This serigraph, in a limited edition of 175 was hand printed by master craftsmen under the supervision of Peter Max. Each of the serigraphs has been numbered and hand-signed by the artist. Your museum-mounted print will be delivered ready to hang in a beautiful polished aluminum frame.

As this is a limited edition, we suggest you order your serigraph promptly. Upon inspection, if you do not agree that this fine-art serigraph is a valuable addition to your collection, you may return the print within 15 days (undamaged) for a full refund. Send the coupon or phone us anytime. Call collect (212) 249-8121 and give credit card information. If you prefer your print unframed, deduct $60.

Royal Gardens, 22" x 26", serigraph

Randall Schwartz and Associates/27 East 67 Street/New York City/New York 10021

Name_____

Address_____

City_____ State_____ Zip_____

Signature_____

_____Royal Gardens at $475 each_____

Credit Card No._____

Master Charge ○ Visa ○

Expiration Date_____

Peter Max Posters, 1979

▶ *Poker Playing Dogs Posters, 1973*

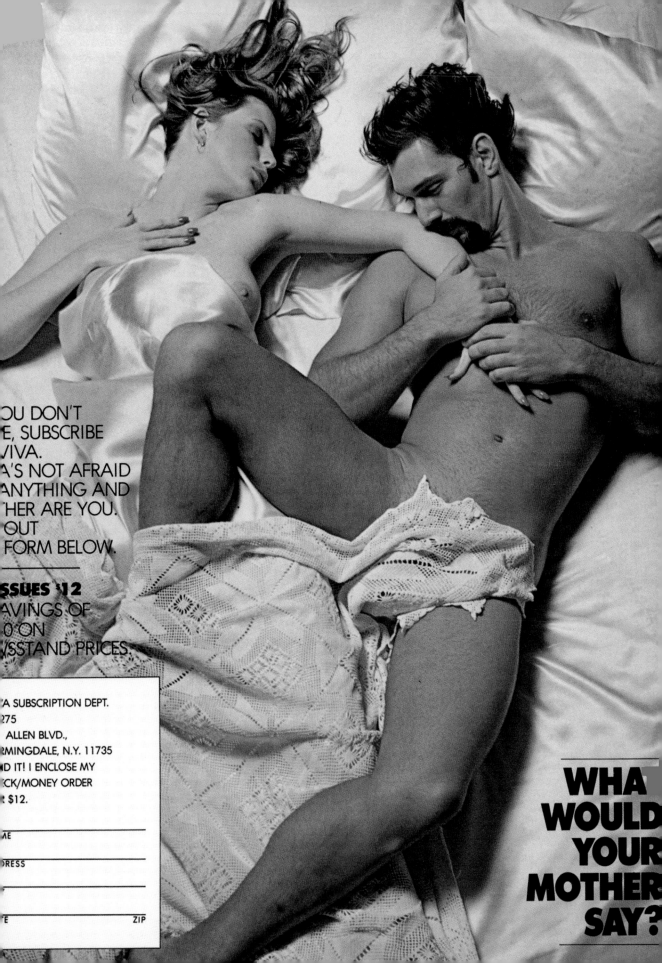

OU DON'T
E, SUBSCRIBE
VIVA.
A'S NOT AFRAID
ANYTHING AND
HER ARE YOU.
OUT
FORM BELOW.

SSUES '12
AVINGS OF
0 ON
SSTAND PRICES.

WHA
WOULD
YOUR
MOTHER
SAY?

New Conceptrol Shields.
A prophylactic created to make you feel
like you're not wearing anything.

Conceptrol **Shields**

Conceptrol Shields Condoms, 1974

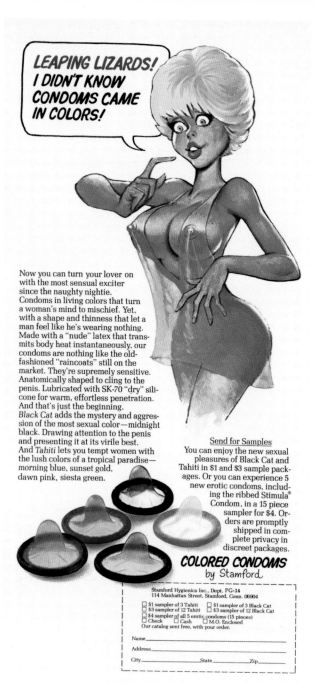

> **LEAPING LIZARDS! I DIDN'T KNOW CONDOMS CAME IN COLORS!**

Now you can turn your lover on with the most sensual exciter since the naughty nightie. Condoms in living colors that turn a woman's mind to mischief. Yet, with a shape and thinness that let a man feel like he's wearing nothing. Made with a "nude" latex that transmits body heat instantaneously, our condoms are nothing like the old-fashioned "raincoats" still on the market. They're supremely sensitive. Anatomically shaped to cling to the penis. Lubricated with SK-70 "dry" silicone for warm, effortless penetration. And that's just the beginning. *Black Cat* adds the mystery and aggression of the most sexual color—midnight black. Drawing attention to the penis and presenting it at its virile best. And *Tahiti* lets you tempt women with the lush colors of a tropical paradise—morning blue, sunset gold, dawn pink, siesta green.

Send for Samples
You can enjoy the new sexual pleasures of Black Cat and Tahiti in $1 and $3 sample packages. Or you can experience 5 new erotic condoms, including the ribbed Stimula® Condom, in a 15 piece sampler for $4. Orders are promptly shipped in complete privacy in discreet packages.

COLORED CONDOMS
by Stamford

Stamford Hygienics Inc., Dept. PG-14
114 Manhattan Street, Stamford, Conn. 06904

☐ $1 sampler of 3 Tahiti ☐ $1 sampler of 3 Black Cat
☐ $3 sampler of 12 Tahiti ☐ $3 sampler of 12 Black Cat
☐ $4 sampler of all 5 erotic condoms (15 pieces)
☐ Check ☐ Cash ☐ M.O. Enclosed
Our catalog sent free, with your order.

Name _____
Address _____
City _____ State _____ Zip _____

Viva Magazine, 1975 ◄ Colored Condoms, 1975

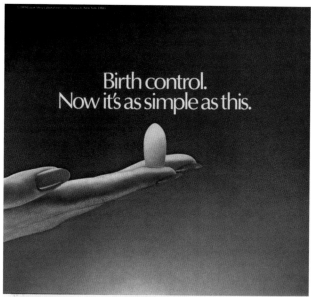

Birth control.
Now it's as simple as this.

Birth control, simplified.

Encare Birth Control, 1979

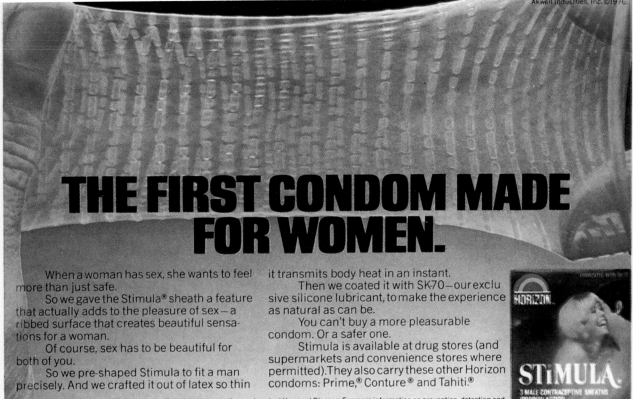

THE FIRST CONDOM MADE FOR WOMEN.

When a woman has sex, she wants to feel more than just safe.

So we gave the Stimula® sheath a feature that actually adds to the pleasure of sex—a ribbed surface that creates beautiful sensations for a woman.

Of course, sex has to be beautiful for both of you.

So we pre-shaped Stimula to fit a man precisely. And we crafted it out of latex so thin it transmits body heat in an instant.

Then we coated it with SK-70—our exclusive silicone lubricant, to make the experience as natural as can be.

You can't buy a more pleasurable condom. Or a safer one.

Stimula is available at drug stores (and supermarkets and convenience stores where permitted). They also carry these other Horizon condoms: Prime,® Conture® and Tahiti.®

Horizon Means VD Protection. The sheath is still the best known safeguard against Venereal Disease. For more information on prevention, detection and treatment of VD, write: Akwell Industries, Inc., Dothan, Ala. 36301. America's largest manufacturer of male contraceptives. Also available in Canada.

Stimula Condom, 1976

Introduced in May, 1976

e.p.t.®
In-home
early **p**regnancy **t**est.

The only early pregnancy test thousands of American women have used for the past 2½ years accurately, safely, privately, in their own homes.

As your doctor will tell you, health precautions for proper fetal development are critical during the first 60 days. So don't guess at pregnancy. E.P.T. is the only in-home early pregnancy test proven accurate by thousands of American women in over two and one-half years of successful use.

e.p.t. accuracy has been clinically confirmed by doctors
The high accuracy rate of E.P.T. has been clinically confirmed by doctors. And when performed as directed, E.P.T. is fully as accurate as similar hospital and laboratory tests ordered by obstetricians. No other in-home pregnancy test is more accurate than E.P.T.

e.p.t. is safe, fast, inexpensive
A simple test of morning urine gives you the answer in two hours. Think of it—an accurate, easy pregnancy test you can take at home. No waiting for appointments, no suspense, no maddening delays. And E.P.T. costs less than your doctor usually charges for a visit and a laboratory fee.

e.p.t. detects one of the early signs of conception
E.P.T. is the same type of pregnancy test used in millions of lab tests and in thousands of hospitals in the U.S. As early as nine days after you've missed an expected period, E.P.T. can tell you if you're pregnant. That's when E.P.T. can detect HCG.

the pregnancy hormone, in your urine. If E.P.T. says you're not pregnant, your period should begin soon. If a week goes by and it hasn't begun, you should take a second E.P.T. If, once again, E.P.T. indicates that you are not pregnant, consult your physician.
Remember: E.P.T. comes to you with fine credentials from Warner/Chilcott, many of whose products you know and trust. E.P.T. is the only early pregnancy test that has been in use—accurately, safely—by thousands of American women in their own homes for over two and one-half years.

e.p.t. the original in-home early pregnancy test women have used for two and one-half years.

1. Put three drops of urine in test tube.

2. Add contents of plastic vial. Shake 10 seconds, place tube in holder (seen under, bonded for two hours).

3. If, after two hours, a dark brown donut shaped ring is visible, your test is positive. If no ring appears, your test is negative.

E.P.T. Home Pregnancy Test, 1979

Now. A safe, simple way to prevent pregnancy.

It's Semicid, a safe, easy-to-use vaginal contraceptive suppository with an active ingredient proven effective by millions of women.

If you're dissatisfied with your present birth control method, you should know about Semicid, a real alternative in contraception from Whitehall Laboratories, one of the world's leading pharmaceutical companies.

Semicid is safe and effective. It contains the maximum allowable level of nonoxynol-9, an ingredient which safely kills sperm in seconds. It's the spermicide doctors recommend most and has been used effectively by millions of women for over 10 years. Now this tested, proven ingredient is available in Semicid.

Semicid is safe, too. Unlike the pill, it has no hormonal side effects. And unlike the IUD, it can't damage uterine walls. Furthermore, Semicid does not effervesce the way the other vaginal suppository does. Semicid is non-irritating to most women. There's also no unpleasant odor or taste. Neither you nor your partner will notice Semicid is there at all.

Semicid is neat and convenient. Slim, only an inch long, Semicid is so simple and easy to use. There's no applicator, so there's nothing to fill, clean, or remove. Semicid is not messy like foams, creams and jellies. And it's not awkward like the diaphragm. It lets love-making happen naturally, spontaneously.

Within minutes after you insert it, Semicid dissolves and spreads a protective covering over the cervical opening and adjoining vaginal walls.

Semicid comes in a small, discreet dispenser containing 10 suppositories. You can purchase it without a prescription. For more information about this remarkable contraceptive, ask your doctor. Use only as directed.

Semicid.

Discreet carrying case

Semicid Contraceptive, 1979

345

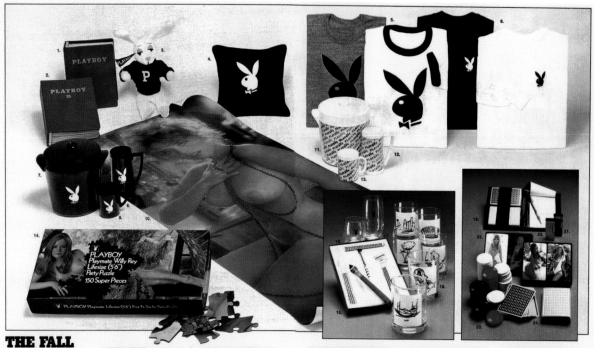

Playboy Products, 1974

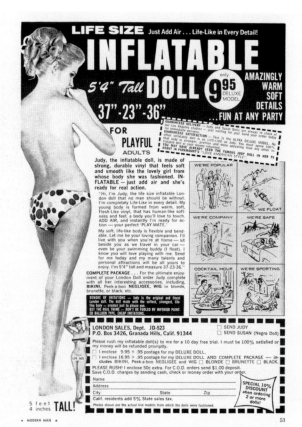

Inflatable Sex Doll, 1970

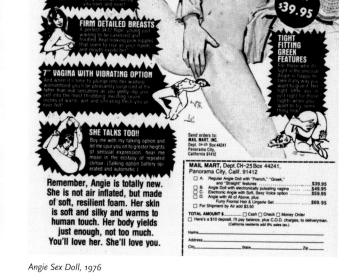

Angie Sex Doll, 1976

Don't wait to be MUGGED, MOLESTED or RAPED

NEW

. . . to realize the value of "PARALYZER"—the civilian version of the highly publicized tear gas law enforcement device, successfully used and approved by foreign and domestic police departments. SELF DEFENSE for women, cabbies, postmen, etc. Only 4" x ¾". Fast and easy to use. Fires up to 50 streams of CS tear gas to 8 feet away. The "PARALYZER" has been editorialized on NBC and CBS Television, and major newspapers as a precision protective instrument that will stop a 300 lb. man for up to 20 minutes, even persons under the influence of alchohol or narcotics with no permanent injury. Simply point in general direction of attacker. 5 year shelf life. Twice as effective as competitive sprays, used by U.S. and foreign governments.

**The "PARALYZER" NOW AVAILABLE TO PUBLIC.
$4.95 EACH** plus 65¢ each shipping. N.Y. State residents, add applicable sales tax.

NCI **NCI SECURITY PRODUCTS CORP.**
32 South Central Avenue, Dept. AS-1,
P.O. Box 8, Spring Valley, NY 10977

DEALER INQUIRIES INVITED
(Satisfaction Guaranteed or Money Back)

(SIZE 4" x ¾")

Paralyzer, 1979

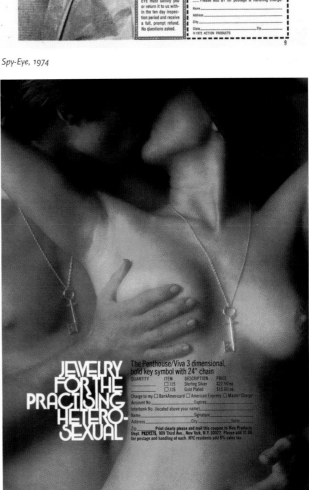

Spy-Eye, 1974

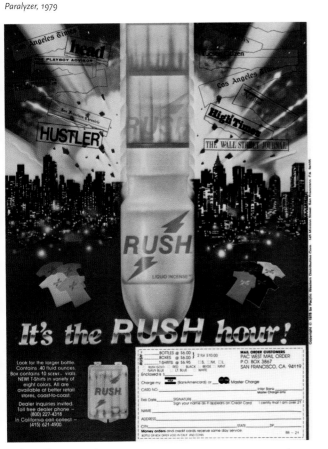

Rush Liquid Incense, 1978

Penthouse/Viva Jewelry, 1975

347

And the winner is...

Take This Sock and Stuff It

With the relaxing of obscenity laws in 1970, men's magazines solicited a more mainstream audience by upgrading to glossy pages, all the better to display their newly liberated spreads. Advertisers followed suit with slicker campaigns for sex-related products. What sexually enlightened American male could resist this snug accessory to house his "banana and two plums" ... especially when it was being sold by such a tasty tart?

Steck dir den Strumpf sonstwohin

Mit der Lockerung der Sittengesetze 1970 versuchten die Männermagazine, durch Einführung von Hochglanzpapier den Zugang zu einem breiteren Mainstreampublikum zu finden, auf dem sich natürlich ihre gerade erst sexuell befreiten Aktmodelle umso besser abbilden ließen. Die Werbekunden folgten ihrem Beispiel mit schnieken Werbekampagnen für Erotikartikel. Welcher aufgeklärte amerikanische Mann konnte so einem molligen Accessoire widerstehen, in dem er seine „Banane und zwei Pflaumen" verstauen konnte ... besonders, wenn es von so einem leckeren Früchtchen angeboten wurde?

Balance-lui ta purée!

Avec le relâchement des lois sur l'obscénité en 1970, les magazines de charme cherchèrent à élargir leur lectorat en passant au papier glacé où leurs images nouvellement libérées étaient mieux mises en valeur. Les annonceurs leur emboîtèrent le pas avec des campagnes plus osées pour des produits liés à la sexualité. Quel mâle américain sexuellement dans le coup pouvait résister à cet accessoire douillet pour y mettre à l'abri « sa banane et ses deux prunes » ... surtout quand la marchande de fruits était si alléchante?

El relleno lo pones tú

Al relajarse las leyes que regulaban la pornografía en 1970, las revistas para hombres decidieron dirigirse a un público más general mediante páginas satinadas en las que mostraban los nuevos temas emergidos tras la liberación. Los anunciantes hicieron lo propio y optaron por crear campañas ingeniosas, mas insustanciales, para vender cualquier producto relacionado con el sexo. ¿Qué norteamericano progresista y liberado sexualmente podía resistirse a comprar este ceñido accesorio para albergar su «plátano y dos ciruelas»... especialmente cuando lo anunciaba una jovencita tan sugerente?

このソックスに突っ込んじまえ

1970年の猥褻法の緩和にともない、より幅広い読者を獲得しようともくろんだ男性誌各誌は、光沢感のある高級紙を採用するようになった。それは、より過な写真を掲載する自由を得た彼らにとって渡りに船の出来事だった。広告主も、うさんくさいセックス関連商品とともに、そうした動向に追従した。セックス進歩的なアメリカ男なら、彼の"バナナと2個のプラム"を心地よくつつんでくれるこんなアクセサリーを見逃せないはず…。それも、こんなおいしそうな女売ってくれるんだったらね？

Sock it to him!

The versatile Banana Warmer.
One size fits all.
Give it to the man who has every-
thing and no place to put it. It
holds and protects anything
from a banana and two
plums to the family jewels.
He can use it as a pipe
and tobacco pouch
or he can use his
imagination!

Swank Magazine Banana Warmer, 1975

349

He runs it down the flagpole and up the establishment.

"PUTNEY SWOPE"

The Truth and Soul Movie

A Film by Robert Downey. A Cinema V Presentation.

SEE IT WHEN IT COMES TO A THEATRE NEAR YOU

Putney Swope, 1970

NORMAN MAILER, in *Armies of the Night*, calls Jerry Rubin "the most militant, unpredictable, creative — therefore dangerous — hippie-oriented leader available on the New Left."

DO IT!
Jerry Rubin
Introduction by ELDRIDGE CLEAVER

In **DO IT!**, Jerry Rubin has written the most important political statement made by a white revolutionary in America today. It is *The Communist Manifesto* of our era and as a handbook for American revolutionaries must be compared to Che Guevara's *Guerrilla Warfare*.

DO IT! is a Declaration of War between the generations — calling on kids to raise a new society upon the ashes of the old.

DO IT! is a prose poem singing the inside saga of the movement; it is a frenzied emotional symphony for a new social disorder; a comic book for seven-year-olds; a tribute to insanity.

Eldridge Cleaver has written an introduction to it and Quentin Fiore has designed the book with more than 100 pictures, cartoons and mind-zaps.

● Cloth: $5.95
Paper: $2.45
Simon and Schuster

Do It!, 1970

The Most Devastating Detective Story Of This Century.

REDFORD/HOFFMAN
"ALL THE PRESIDENT'S MEN"

ROBERT REDFORD/DUSTIN HOFFMAN ALL THE PRESIDENT'S MEN
Starring JACK WARDEN Special appearance by MARTIN BALSAM HAL HOLBROOK and JASON ROBARDS as Ben Bradlee
Screenplay by WILLIAM GOLDMAN • Based on the book by CARL BERNSTEIN and BOB WOODWARD • Music by DAVID SHIRE
Produced by WALTER COBLENZ • Directed by ALAN J. PAKULA
A Wildwood Enterprises Production • A Robert Redford-Alan J. Pakula Film
A WARNER COMMUNICATIONS COMPANY

NOW PLAYING EVERYWHERE

Saturday Night Fever, 1977 ◄ All the President's Men, 1976

Premieres Christmas at selected theatres around the country.

CLINT EASTWOOD is Dirty Harry in Magnum Force

A MALPASO COMPANY FILM Also Starring HAL HOLBROOK Co-Starring MITCHELL RYAN · DAVID SOUL · FELTON PERRY · ROBERT URICH Music LALO SCHIFRIN Story by JOHN MILIUS Screenplay by JOHN MILIUS and MICHAEL CIMINO Produced by ROBERT DALEY Directed by TED POST · PANAVISION® · TECHNICOLOR® Celebrating Warner Bros. 50th Anniversary A Warner Communications Company

Magnum Force, 1973 *► Woodstock, 1970*

woodstock ● the movie
with a little help from our friends.)

starring joan baez • joe cocker • country joe & the fish • crosby, stills, nash & young • arlo guthrie • richie havens • jimi hendrix
santana • john sebastian • sha-na-na • sly & the family stone • ten years after • the who • and 400,000 other beautiful people.

film by michael wadleigh • produced by bob maurice

a wadleigh-maurice, ltd. production • technicolor® from warner bros

soundtrack album on cotillion records and tapes

see it soon at a theatre near you

Give our regards to Broadway and tell them we're on our way! (Rocky)

Lou Adler Presents
The Michael White Production
Starring
Tim Curry

THE ROCKY HORROR SHOW

DIRECTED BY
Jim Sharman

BOOK, MUSIC & LYRICS BY
Richard O'Brien

NEW YORK GRAND PREMIERE SUNDAY EVENING, MARCH 9 • SEATS NOW!
FRIDAY EVENING, MARCH 7 (Sold Out) 20TH CENTURY FOX PREVIEW—A SALUTE TO "ROCKY"
PUBLIC PREVIEW SATURDAY EVENING, MARCH 8 at 8 PM (Seats Available) $7.50, $6.5
REGULAR PRICES: Tues., Wed., Thurs. & Sun.—Orch. $11; Mezz. $8, 7, 6. Fri., Sat. & Opening Night—Orch. $13; Mezz. $10, 9, 8.
Please enclose stamped self-addressed envelope with check or money order and list alternate dates. AMERICAN EXPRESS ACCEPTED.
REGULAR PERFORMANCE SCHEDULE: Tues., Wed. & Thurs. at 8 PM; 2 Perfs. Fri. & Sat. at 7:30 & 10:30 PM; Mat. Sun. at 3 PM.

THE BELASCO 44th St. East of B'way/JU 6-7950

JONES IS BACK AND THE DEVIL'S GOT HIM

THE DEVIL AND MR. JONES

X-RATED · COLOR
WORLD PREMIERE NOW · The BYRON · NEW YORK CITY
· COMING SOON TO A THEATRE NEAR YOU.

The Rocky Horror Show, 1975 ◄ *The Devil and Mr. Jones, 1975*

They Shoot Horses, Don't They?, 1970

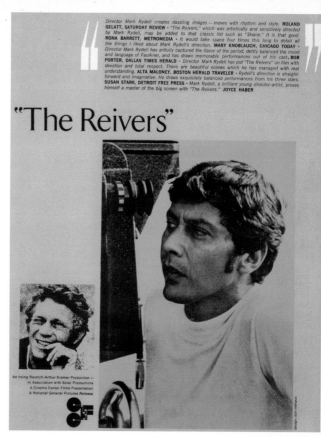

"The Reivers"

The Reivers, 1970

The Secret of Santa Vittoria, 1970

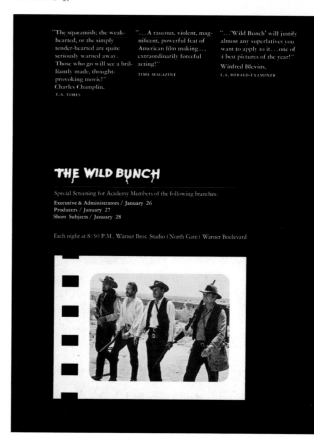

THE WILD BUNCH

The Wild Bunch, 1970 ▶ Midnight Cowboy, 1970

"Justin Hoffman gives one of the screen's more incredible and powerful performances." — FORT WORTH STAR-TELEGRAM

MIDNIGHT COWBOY" A JEROME HELLMAN-JOHN SCHLESINGER PRODUCTION

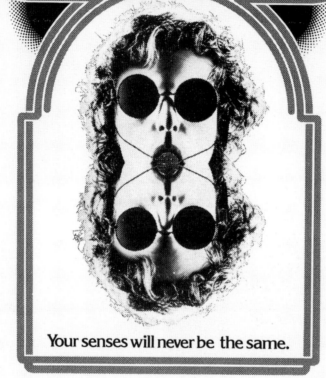

Tommy the Movie

Ann-Margret is The Mother

Roger Daltrey is Tommy

Eric Clapton is The Preacher

Keith Moon is Uncle Ernie

Jack Nicholson is The Doctor

Peter Townshend is Himself

Oliver Reed is The Lover

Elton John is The Pinball Wizard

John Entwistle is Himself

Paul Nicholas is Cousin Kevin

Robert Powell is Captain Walker

Tina Turner is The Acid Queen

Your senses will never be the same.

Columbia Pictures And Robert Stigwood Present A Film By Ken Russell

Tommy

By The Who Based On The Rock Opera By Pete Townshend

Starring
Ann-Margret Oliver Reed Roger Daltrey And Featuring **Elton John**
As Tommy As The Pinball Wizard

Guest Artists
**Eric Clapton John Entwistle Keith Moon Paul Nicholas
Jack Nicholson Robert Powell Pete Townshend
Tina Turner** And **The Who**

Associate Producer **Harry Benn** Musical Director **Pete Townshend** Screenplay By **Ken Russell**
Executive Producers **Beryl Vertue** And **Christopher Stamp** Produced By **Robert Stigwood** And **Ken Russell**
Directed By **Ken Russell** Original Soundtrack Album on Polydor Records polydor and Tapes
© 1975 The Robert Stigwood Organisation Limited

PG PARENTAL GUIDANCE SUGGESTED

EXCLUSIVE NORTHERN CALIFORNIA SHOWINGS!

STARTS FRIDAY APRIL 25th

IN SAN FRANCISCO — **NORTHPOINT THEATRE**, Bay Street And Powell, 989-6060
Oakland—**CENTURY 22**, 562-9990 San Jose—**CENTURY 21**, 246-3629 Sacramento—**CENTURY 22**, 922-6551

Tommy, 1975

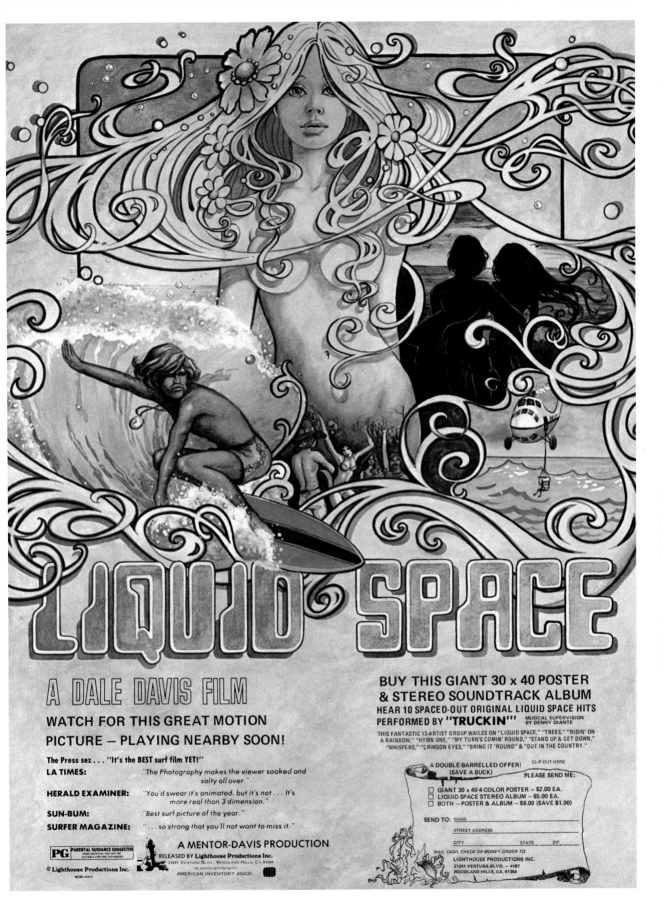

Liquid Space, 1974

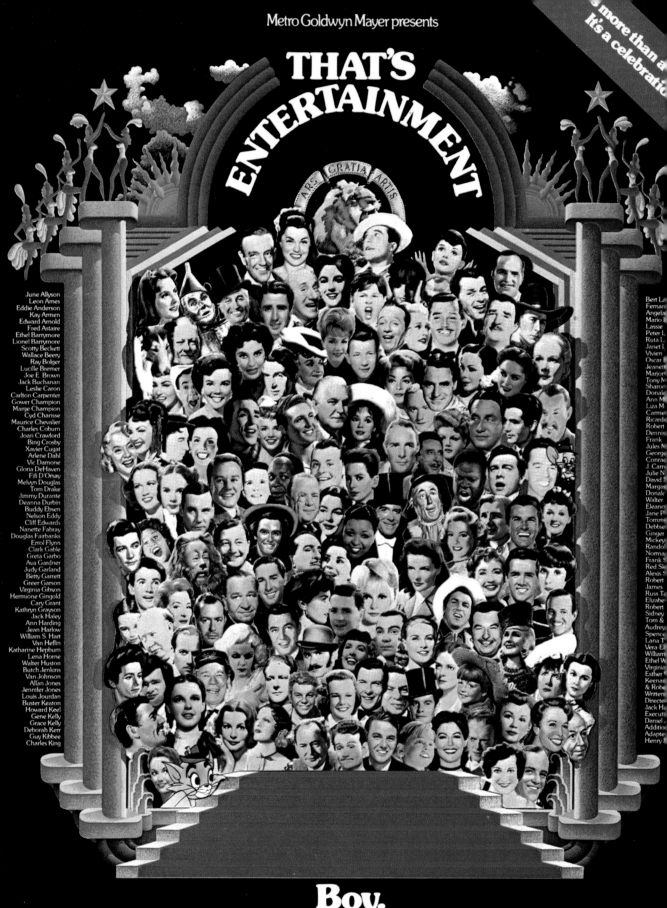

Metro Goldwyn Mayer presents

THAT'S ENTERTAINMENT

A.R.S. GRATIA ARTIS

It's more than a...
It's a celebration

June Allyson
Leon Ames
Eddie Anderson
Kay Armen
Edward Arnold
Fred Astaire
Ethel Barrymore
Lionel Barrymore
Scotty Beckett
Wallace Beery
Ray Bolger
Lucille Bremer
Joe E. Brown
Jack Buchanan
Leslie Caron
Carlton Carpenter
Gower Champion
Marge Champion
Cyd Charisse
Maurice Chevalier
Charles Coburn
Joan Crawford
Bing Crosby
Xavier Cugat
Arlene Dahl
Vic Damone
Gloria DeHaven
Fifi D'Orsay
Melvyn Douglas
Tom Drake
Jimmy Durante
Deanna Durbin
Buddy Ebsen
Nelson Eddy
Cliff Edwards
Nanette Fabray
Douglas Fairbanks
Errol Flynn
Clark Gable
Greta Garbo
Ava Gardner
Judy Garland
Betty Garrett
Greer Garson
Virginia Gibson
Cary Grant
Kathryn Grayson
Jack Haley
Ann Harding
Jean Harlow
William S. Hart
Van Heflin
Katharine Hepburn
Lena Horne
Walter Huston
Butch Jenkins
Van Johnson
Allan Jones
Jennifer Jones
Louis Jourdan
Buster Keaton
Howard Keel
Gene Kelly
Grace Kelly
Deborah Kerr
Guy Kibbee
Charles King

Bert La
Fernan
Angela
Mario L
Lassie
Peter L
Ruta L
Janet L
Vivien
Oscar L
Jeanett
Marjor
Tony M
Sharon
Donald
Ann M
Liza M
Carmen
Ricardo
Robert
Dennis
Frank
Jules M
George
Conrad
J. Carro
Julie N
David N
Margar
Donald
Walter
Eleanor
Jane P
Tommie
Debbie
Ginger
Mickey
Randol
Norma
Frank S
Red Ske
Alexis S
Robert
James
Russ Ta
Elizabe
Robert
Sidney
Tom &
Audrey
Spencer
Lana T
Vera-El
William
Ethel W
Virginia
Esther
Keenan
& Robe
Written
Directe
Jack Ha
Execut
Daniel
Additio
Adapte
Henry

Boy.
Do we need it now.

TED KRAMER IS ABOUT TO LEARN
WHAT 10 MILLION WOMEN ALREADY KNOW.

He's got a wife he wants to get back, and a kid he won't ever let go.

His boy is teaching him how to make French toast, the girl in the office wants to sleep over, and he has to juggle his job and the PTA.

For Ted Kramer, life is going to be full of surprises.

Columbia Pictures presents a Stanley Jaffe production

Dustin Hoffman
in
"Kramer vs. Kramer"
Meryl Streep Jane Alexander

Director of Photography Nestor Almendros Based upon the novel by Avery Corman Produced by Stanley R. Jaffe
Written for the screen and directed by Robert Benton

PG PARENTAL GUIDANCE SUGGESTED

© 1979 COLUMBIA PICTURES INDUSTRIES. INC

Columbia Pictures

Opens December 19th at selected theatres.

Kramer vs. Kramer, 1979

"THRILLING BOTH AS TO FACT AND IN THE FILM'S
RECOUNTING OF IT! THE RAW TRUTH BOGGLES
THE MIND AND OUT PACES THE IMAGINATION!
Al Pacino provides one of the outstanding
performances of the year!" — Judith Crist

A PARAMOUNT RELEASE
DINO DE LAURENTIIS
presents

AL PACINO in
"SERPICO"

Produced by MARTIN BREGMAN Directed by SIDNEY LUMET
Screenplay by WALDO SALT AND NORMAN WEXLER Based on the book by PETER MAAS
Music by MIKIS THEODORAKIS Color by TECHNICOLOR® A Paramount Release
Original Soundtrack Album on Paramount Records and Tapes

R RESTRICTED

NOW PLAYING BARONET and FORUM THEATRES, NEW YORK, OPENS
DEC. 18 VILLAGE, PANTAGES, and VAN NUYS DRIVE-IN, LOS ANGELES
AND COMING SOON TO A THEATRE IN YOUR CITY

Serpico, 1974

The original sound track music from the Warner Bros. film starring Barbra Streisand and Kris Kristofferson. The movie will be released to theatres nationwide at Christmas. The album is available now on Columbia Records and Tapes.

Now a paperback from Warner Books

Album produced by: Barbra Streisand and Phil Ramone.

Available at

That's Entertainment, 1974 *A Star Is Born, 1976*

IT'S "A SMASH"! (—New York Times) IT'S "HIL-
ARIOUS" (—Gannett Newspapers) IT'S ★★★ HIGH-
EST RATING (—New York Daily News) IT'S "ONE OF THE
GREAT AMERICAN MOVIES"! (—New York Magazine)
IT'S "MAGNIFICENT"! (—Saturday Review) IT'S "AN
ORGY FOR MOVIE LOVERS"! (—New Yorker Magazine)
IT'S "A WINNER"! (—Metromedia TV) IT'S "A BLOCK-
BUSTER"! (—After Dark Playboy) IT'S "BRILLIANTLY
ORIGINAL"! (—Family Circle) IT'S THE DAMN-
DEST THING YOU EVER SAW!

R RESTRICTED Original soundtrack available on ABC Records and GRT Tapes.

EXCLUSIVE NORTHERN CALIFORNIA ENGAGEMENT

P NORTHPOINT
POWELL & BAY—989 6060 NOW SHOWING

MATINEES DAILY — Shows Daily At: 2:00, 4:45, 7:30 And 10:00 P.M.
ADJACENT FREE PARKING AFTER 6PM & ALL DAY SUN. AND HOLIDAYS.

Nashville, 1975

Finding the one you love... is finding yourself.

HEROES

A TURMAN-FOSTER COMPANY PRODUCTION
"HEROES"
Co-starring HARRISON FORD · Written by JAMES CARABATSOS · Music by JACK NITZSCHE
and RICHARD HAZARD · Directed by JEREMY PAUL KAGAN · Produced by DAVID FOSTER
and LAWRENCE TURMAN · A UNIVERSAL PICTURE · TECHNICOLOR®

Opens at Movie Theatres Everywhere November 4th.

Heroes, 1977

Moment by Moment, 1978

Grease, 1978

 ▶ *The Cheap Detective, 1978*

He knows every cheap trick,
cheap joke, cheap shot,
and cheap dame
in the book.

PETER FALK

EILEEN BRENNAN

STOCKARD CHANNING

DOM DeLUISE

JOHN HOUSEMAN

FERNANDO LAMAS

PAUL WILLIAMS

ANN-MARGRET

SID CAESAR

JAMES COCO

LOUISE FLETCHER

MADELINE KAHN

MARSHA MASON

NICOL WILLIAMSON

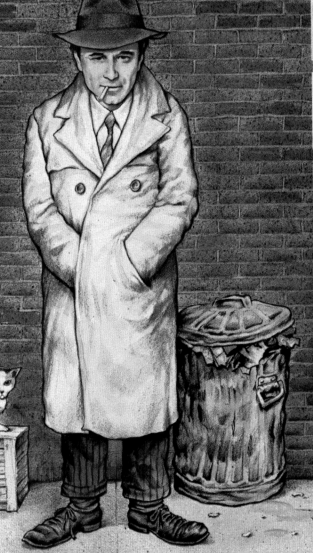

NEIL SIMON'S
THE CHEAP DETECTIVE

A COLUMBIA/EMI Presentation
A RAY STARK PRODUCTION OF NEIL SIMON'S "THE CHEAP DETECTIVE" A ROBERT MOORE Film starring PETER FALK
co-starring ANN-MARGRET · EILEEN BRENNAN · SID CAESAR · STOCKARD CHANNING · JAMES COCO · DOM DeLUISE · LOUISE FLETCHER
JOHN HOUSEMAN · MADELINE KAHN · FERNANDO LAMAS · MARSHA MASON · PHIL SILVERS · ABE VIGODA · PAUL WILLIAMS · NICOL WILLIAMSON
Music by PATRICK WILLIAMS · Director of Photography JOHN A. ALONZO, A.S.C. · Written by NEIL SIMON
Produced by RAY STARK · Directed by ROBERT MOORE · from RASTAR

PG PARENTAL GUIDANCE SUGGESTED
SOME MATERIAL MAY NOT BE SUITABLE FOR CHILDREN

Columbia
Pictures

STARTS JUNE 23rd AT SELECTED THEATRES NEAR YOU!

The Boy Friend, 1971

Funny Lady, 1975

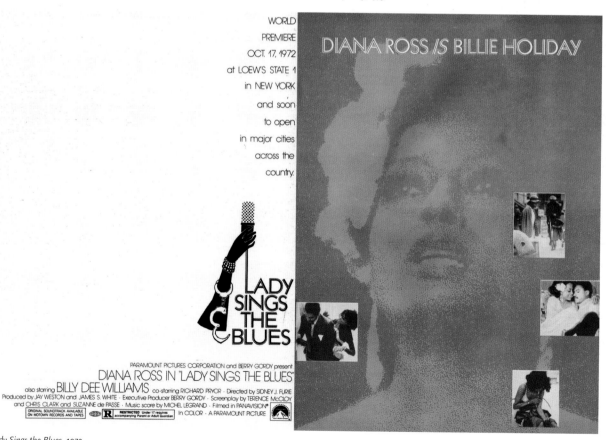

Lady Sings the Blues, 1972

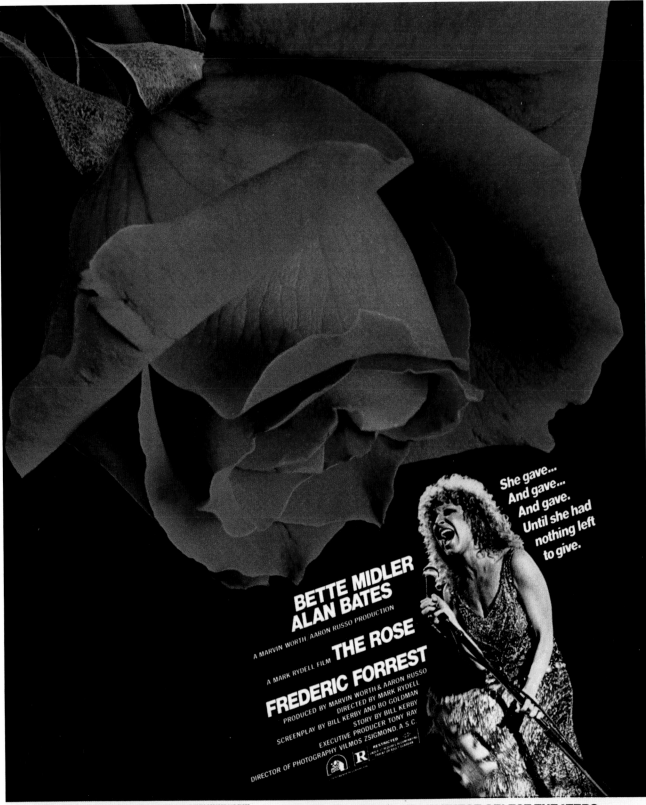

She gave...
And gave...
And gave.
Until she had
nothing left
to give.

BETTE MIDLER
ALAN BATES

A MARVIN WORTH, AARON RUSSO PRODUCTION

A MARK RYDELL FILM **THE ROSE**

FREDERIC FORREST

PRODUCED BY MARVIN WORTH & AARON RUSSO
DIRECTED BY MARK RYDELL
SCREENPLAY BY BILL KERBY AND BO GOLDMAN
STORY BY BILL KERBY
EXECUTIVE PRODUCER TONY RAY
DIRECTOR OF PHOTOGRAPHY VILMOS ZSIGMOND, A.S.C.

OPENS NOVEMBER 8TH IN THESE SELECT THEATERS

AVCO CENTER CINEMA
WESTWOOD 475-0711
WILSHIRE BLVD. 1 BLOCK E. OF WESTWOOD

EGYPTIAN, HOLLYWOOD
467-6167
6712 HOLLYWOOD BLVD

NEWPORT CINEMA
NEWPORT BEACH 714/644 0760

The Rose, 1979

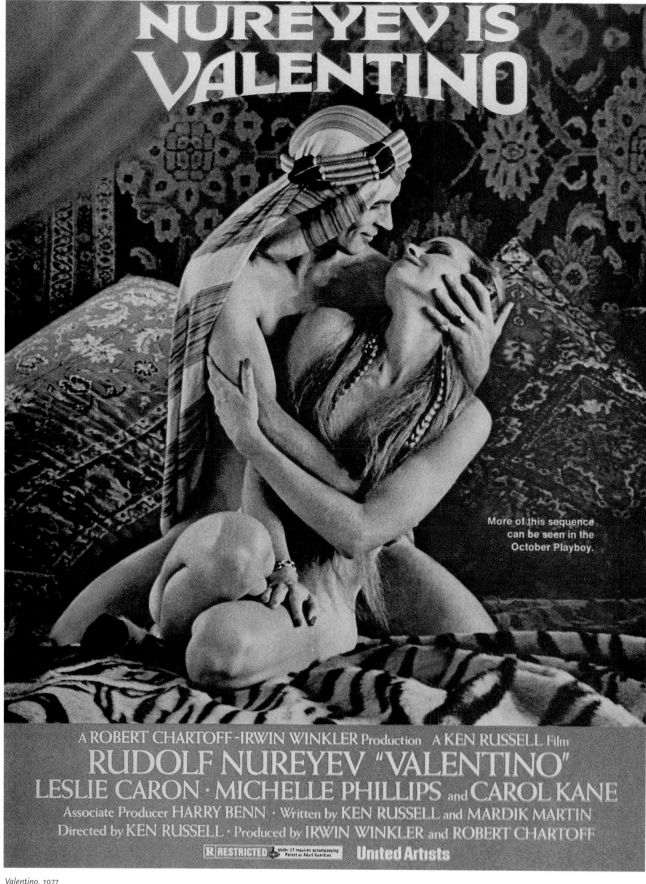

Valentino, 1977

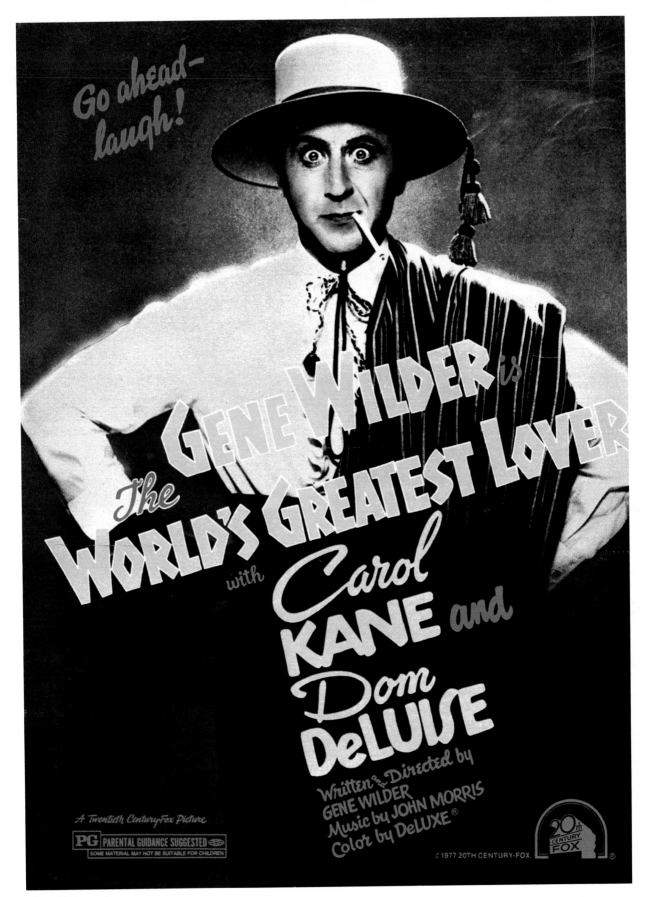

The World's Greatest Lover, 1977

367

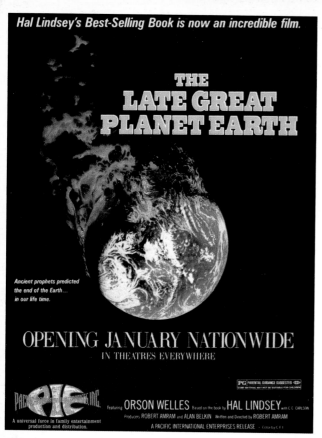

The Late Great Planet Earth, 1978

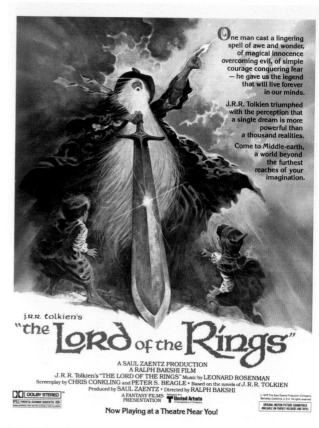

The Lord of the Rings, 1979

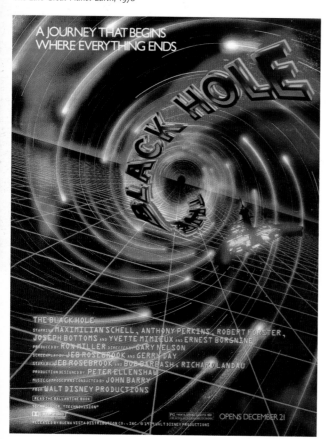

The Black Hole, 1979

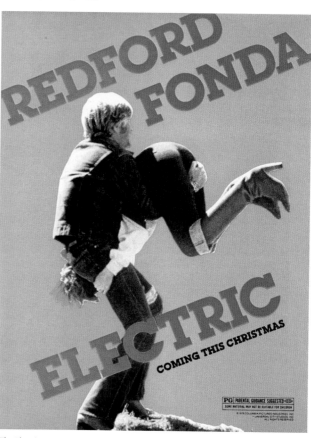

The Electric Horseman, 1979

▶ *Apocalypse Now, 1979*

Apocalypse Now

MARLON BRANDO ROBERT DUVALL MARTIN SHEEN in APOCALYPSE NOW
FREDERIC FORREST ALBERT HALL SAM BOTTOMS LARRY FISHBURNE and DENNIS HOPPER

Produced and Directed by FRANCIS COPPOLA

Written by JOHN MILIUS and FRANCIS COPPOLA

Co-Produced by FRED ROOS, GRAY FREDERICKSON and TOM STERNBERG

Director of Photography VITTORIO STORARO Production Designer DEAN TAVOULARIS Editor RICHARD MARKS

Sound Design by WALTER MURCH Music by CARMINE COPPOLA and FRANCIS COPPOLA

WORLD PREMIERE AUGUST 15th AT THE CINERAMA DOME THEATRE
Reserved tickets now on sale at box office or by mail.

"We can do anything we want. We're college students!"

NATIONAL LAMPOON's

ANIMAL HOUSE

A comedy from Universal Pictures that will escape sometime this summer.

Starring: John Belushi, Tim Matheson, John Vernon, Verna Bloom, Thomas Hulce,
and Donald Sutherland as "Jennings"

Plus a cast of 4,623 other very funny people.

Produced by Matty Simmons and Ivan Reitman
Directed by John Landis
Written by Harold Ramis, Doug Kenney, and Chris Miller

National Lampoon's Animal House, 1978

The Front, 1976

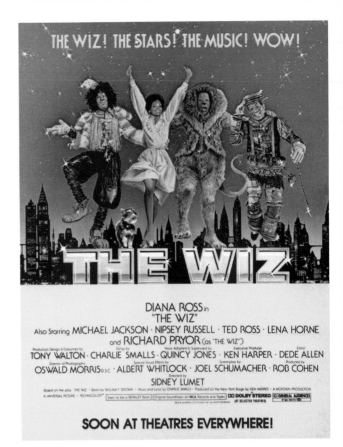

The Wiz, 1978

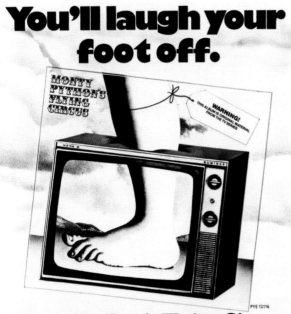

Monty Python's Flying Circus, 1975

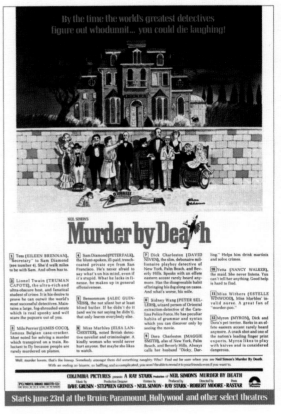

Murder by Death, 1976

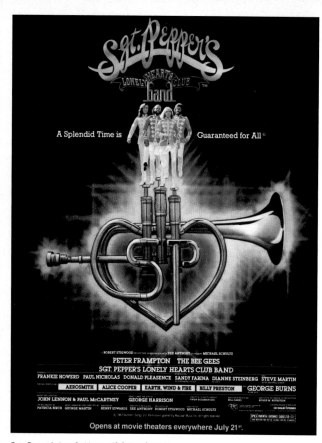

Sgt. Pepper's Lonely Hearts Club Band, 1978

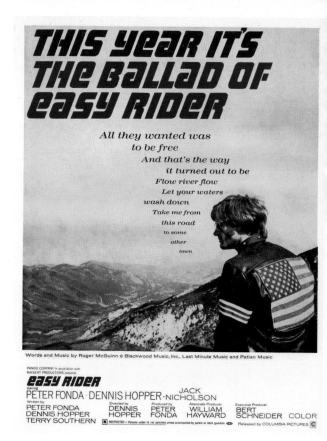

Easy Rider, 1970

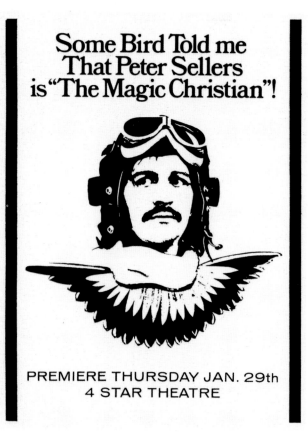

The Magic Christian, 1970

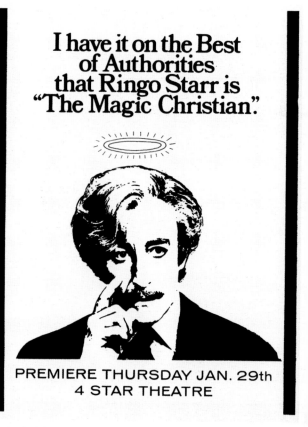

The Magic Christian, 1970 ▶ *Revenge of the Pink Panther, 1978*

PETER SELLERS in BLAKE EDWARDS'

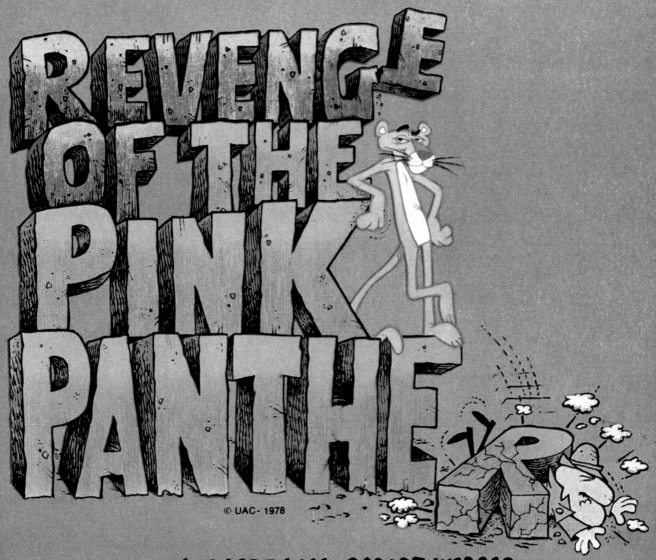

REVENGE OF THE PINK PANTHER

© UAC- 1978

Starring **HERBERT LOM** · **ROBERT WEBBER**

with **DYAN CANNON**

Music **HENRY MANCINI** — Executive Producer **TONY ADAMS**

Screen Play by **FRANK WALDMAN** · **RON CLARK** · **BLAKE EDWARDS**

Animation **DePATIE · FRELENG**

Story by **BLAKE EDWARDS** — Produced and Directed by **BLAKE EDWARDS**

 United Artists
A Transamerica Company

STAR TREK
THE MOTION PICTURE ™

THE HUMAN ADVENTURE IS JUST BEGINNING.

Paramount Pictures Presents A GENE RODDENBERRY Production A ROBERT WISE Film STAR TREK —THE MOTION PICTURE Starring WILLIAM SHATNER LEONARD NIMOY DeFOREST KELLE
Co-Starring JAMES DOOHAN GEORGE TAKEI MAJEL BARRETT WALTER KOENIG NICHELLE NICHOLS Presenting PERSIS KHAMBATTA and Starring STEPHEN COLLINS as Decker Music by JERRY G
Screenplay by HAROLD LIVINGSTON Story by ALAN DEAN FOSTER Produced by GENE RODDENBERRY Directed by ROBERT WISE A Paramount Picture

From deep space...

Invasion of the Body Snatchers

The seed is planted...terror grows.

A Robert H. Solo Production of A Philip Kaufman Film
"Invasion of the Body Snatchers"
Donald Sutherland · Brooke Adams · Leonard Nimoy
Jeff Goldblum · Veronica Cartwright · Screenplay by W. D. Richter,
Based on the novel "The Body Snatchers" by Jack Finney · Produced by Robert H. Solo
DOLBY STEREO ™ Directed by Philip Kaufman **United Artists** A Transamerica Company **PG** PARENTAL GUIDANCE SUGGESTED
SOME MATERIAL MAY NOT BE SUITABLE FOR CHILDREN

Star Trek: The Motion Picture, 1979 ◄ *Invasion of the Body Snatchers, 1979*

CLOSE ENCOUNTER
OF THE FIRST KIND
Sighting of a UFO

CLOSE ENCOUNTER
OF THE SECOND KIND
Physical evidence

CLOSE ENCOUNTER
OF THE THIRD KIND
Contact

WE ARE NOT ALONE

CLOSE ENCOUNTERS
OF THE THIRD KIND

A COLUMBIA/EMI Presentation CLOSE ENCOUNTERS OF THE THIRD KIND
A PHILLIPS Production A STEVEN SPIELBERG Film Starring RICHARD DREYFUSS with FRANCOIS TRUFFAUT as Lacombe
Music by JOHN WILLIAMS Visual Effects by DOUGLAS TRUMBULL Director of Photography VILMOS ZSIGMOND, A.S.C.
Produced by JULIA PHILLIPS and MICHAEL PHILLIPS Written and Directed by STEVEN SPIELBERG
Read the Dell Book Panavision®

COMING TO SELECTED THEATRES

Close Encounters of the Third Kind, 1977

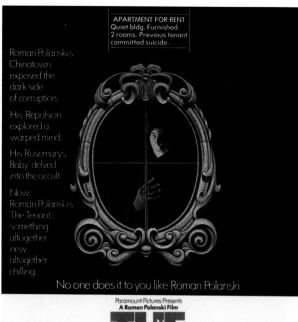

APARTMENT FOR RENT
Quiet bldg. Furnished.
2 rooms. Previous tenant
committed suicide.

Roman Polanski's
Chinatown
exposed the
dark side
of corruption.

His 'Repulsion'
explored a
warped mind.

His 'Rosemary's
Baby' delved
into the occult.

Now,
Roman Polanski's
The Tenant...
something
altogether
new,
altogether
chilling.

No one does it to you like Roman Polanski

Paramount Pictures Presents
A Roman Polanski Film

THE TENANT

Starring Isabelle Adjani Melvyn Douglas Jo Van Fleet and Shelley Winters as the Concierge
Music by Philippe Sarde Produced by Andrew Braunsberg Screenplay by Gerard Brach and Roman Polanski
Directed by Roman Polanski Director of Photography Sven Nykvist Paperback published by Bantam Books In Color
A Paramount Picture

STARTS FRIDAY, JUNE 25th

The Tenant, 1976

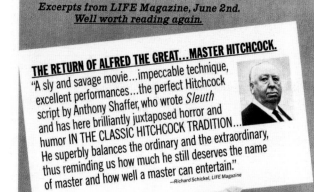

Excerpts from LIFE Magazine, June 2nd.
Well worth reading again.

THE RETURN OF ALFRED THE GREAT...MASTER HITCHCOCK.

"A sly and savage movie...impeccable technique,
excellent performances...the perfect Hitchcock
script by Anthony Shaffer, who wrote *Sleuth*
and has here brilliantly juxtaposed horror and
humor IN THE CLASSIC HITCHCOCK TRADITION...
He superbly balances the ordinary and the extraordinary,
thus reminding us how much he still deserves the name
of master and how well a master can entertain."
—Richard Schickel, LIFE Magazine

HITCHCOCK'S
FRENZY

From the Master of Shock
A Shocking Masterpiece!

ALFRED HITCHCOCK'S "FRENZY"
starring JON FINCH · ALEC McCOWEN · BARRY FOSTER
co-starring BILLIE WHITELAW · ANNA MASSEY
BARBARA LEIGH-HUNT · BERNARD CRIBBINS · VIVIEN MERCHANT
Screenplay by ANTHONY SHAFFER Directed by ALFRED HITCHCOCK
A UNIVERSAL RELEASE · TECHNICOLOR®

SEE IT NOW AT A THEATRE OR DRIVE-IN NEAR YOU.

Frenzy, 1972

WIN A PART IN "HAPPY DAYS"
PLUS A TRIP FOR TWO TO HOLLYWOOD, AND $5,000 IN CASH.

There's More: In Hollywood, the Grand Prize winner gets to lunch with members of the cast of Paramount Television's hit show, "Happy Days", hotel accommodations for 2 for one week, a tour of Paramount Studios, and limousine service to the studio. While you're packing, throw in a bottle of the 1-ounce BLUE JEANS cologne. It'll make you feel soft and breezy and carefree.

To Enter: Follow the official rules on the entry blank below. Other prizes include

2ND PRIZE: 10 winners will get a Sunbeam Beauty Trio (1000 Watt Blower Dryer, Mist-stick Curler Styler & Electric Manicure Set).

3RD PRIZE: 50 winners will get a Kodak Hawkeye Pocket Instamatic Camera.

4TH PRIZE: 300 winners will get a Rock 'n Roll record album from the 50's.

5TH PRIZE: 8000 winners will get a BLUE JEANS cologne iron-on jean patch.

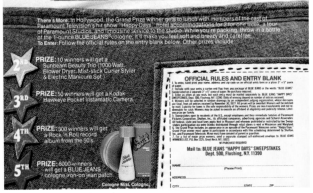

Happy Days, 1977

BREAKFAST WITH CAGNEY!

On February 13 Jimmy Cagney begins his first television interview in 30 years with David Hartman on Good Morning America!

Jimmy Cagney has a lifetime of stories. And he's kept them all to himself. Until now.

Starting Tuesday, February 13, David Hartman will welcome one of the greatest entertainers of this century to Good Morning America for a series of candid, intimate conversations. And if there are any memories that Mr. Cagney forgets, David's other special guests can help him out— **Pat O'Brien, George Raft,**

Ralph Bellamy, and **Jack Lemmon,** all former Cagney co-stars. You'll also meet **John Travolta** who, surprisingly enough, has his own Cagney stories.

All this plus up-to-the-minute ABC News and the regular features with the Good Morning America family.

So, please welcome Mr. Cagney for breakfast. You might even serve grapefruit. It'll make him feel right at home.

GOOD MORNING AMERICA
ⓐⓑⓒ ABC Television Network
Consult local listings for exact time and channel.

Good Morning America, 1979

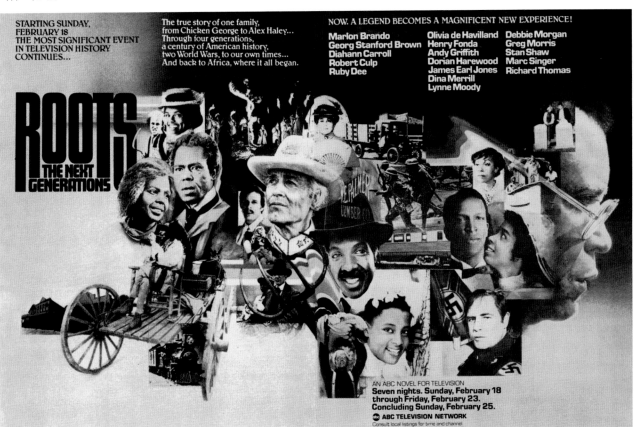

STARTING SUNDAY, FEBRUARY 18
THE MOST SIGNIFICANT EVENT IN TELEVISION HISTORY CONTINUES...

The true story of one family, from Chicken George to Alex Haley... Through four generations, a century of American history, two World Wars, to our own times... And back to Africa, where it all began.

NOW. A LEGEND BECOMES A MAGNIFICENT NEW EXPERIENCE!

Marlon Brando
Georg Stanford Brown
Diahann Carroll
Robert Culp
Ruby Dee

Olivia de Havilland
Henry Fonda
Andy Griffith
Dorian Harewood
James Earl Jones
Dina Merrill
Lynne Moody

Debbie Morgan
Greg Morris
Stan Shaw
Marc Singer
Richard Thomas

ROOTS
THE NEXT GENERATIONS

AN ABC NOVEL FOR TELEVISION
Seven nights. Sunday, February 18 through Friday, February 23. Concluding Sunday, February 25.
ⓐⓑⓒ TELEVISION NETWORK
Consult local listings for time and channel

Roots: The Next Generations, 1979

Andy Warhol's

A Film by
Paul Morrissey
in

RATED

NO ONE UNDER 17 ADMITTED

ANDY WARHOL'S "FRANKENSTEIN" • A Film by PAUL MORRISSEY • Starring Joe Dallesandro
Monique Van Vooren • Udo Kier • Introducing Arno Juerging • Dalila Di Lazzaro • Srdjan Zelenovic
A CARLO PONTI – BRAUNSBERG – RASSAM PRODUCTION 🎬 COLOR • A BRYANSTON PICTURES RELEASE

Andy Warhol's Frankenstein, 1974

► *Silent Movie, 1976*

Disco, 1979

Thank God It's Friday, 1978

Adam & Yves, 1972

▶ *Swept Away..., 1975*

"Swept Away..."

A film by Lina Wertmuller

Clay Theatre

Fillmore, 1972 ◄ More American Graffiti, 1979

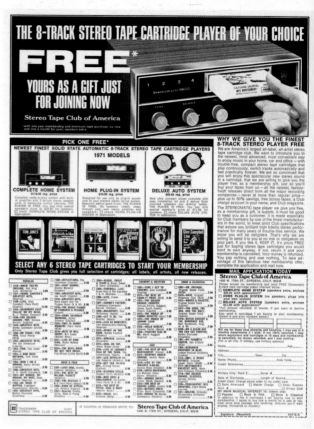

RCA Record Club, 1971

8-Track Stereo Tape Club of America, 1971

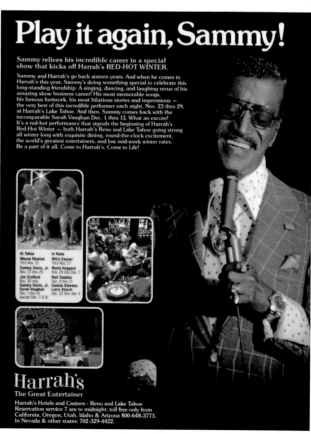

Proudly They Came, To Honor America, 1971

Harrah's Hotels and Casinos, 1977

▶ The Godfather: Part II Soundtrack, 1975

PARAMOUNT PICTURES PRESENTS

The Godfather PART II

Michael's family album

Original motion picture soundtrack recording.

abc Records

KSAN Radio Station, 1976 ◄ *KSAN Radio Station, 1975*

GRAND FUNK

We're An American Band

Produced by Todd Rundgren
On Capitol Records & Tapes

Grand Funk, We're an American Band, 1973

▶ The Edgar Winter Group, They Only Come Out at Night, 1973

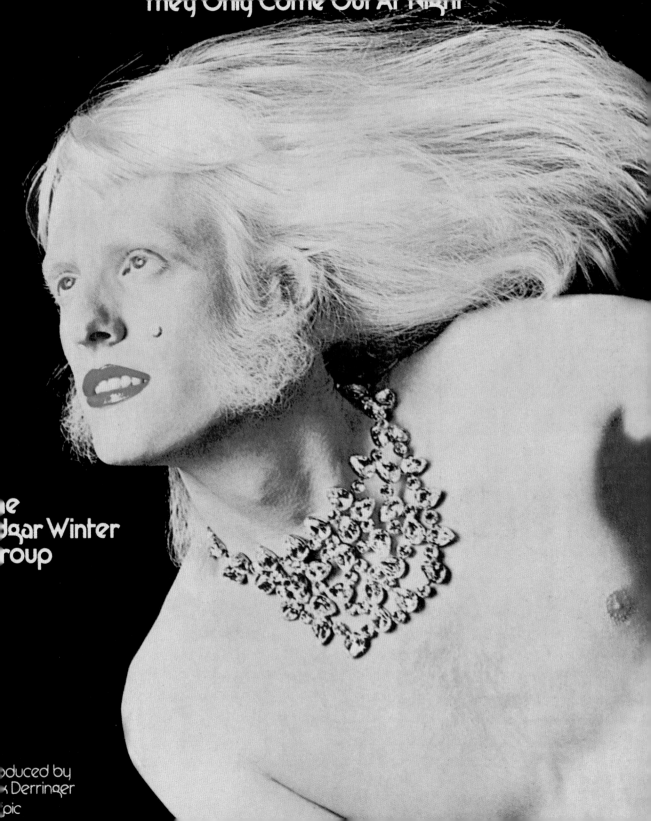

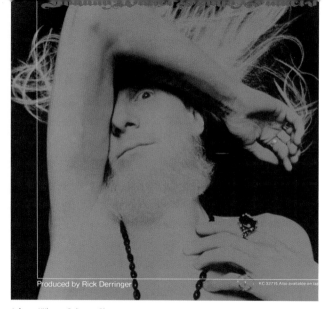

Johnny Winter, Saints & Sinners, 1974

Millennium Records, 1978

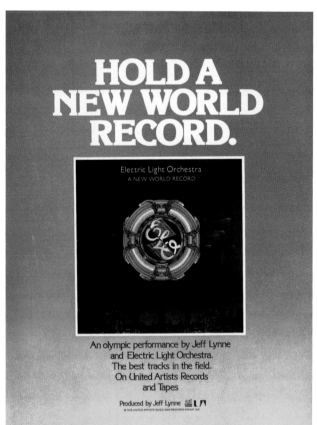

Electric Light Orchestra, A New World Record, 1977

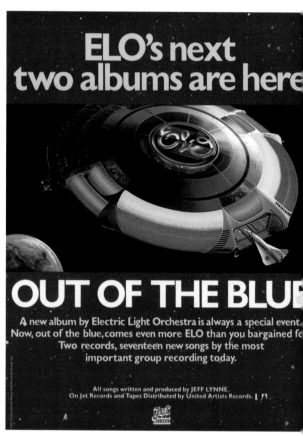

Electric Light Orchestra, Out of the Blue, 1977

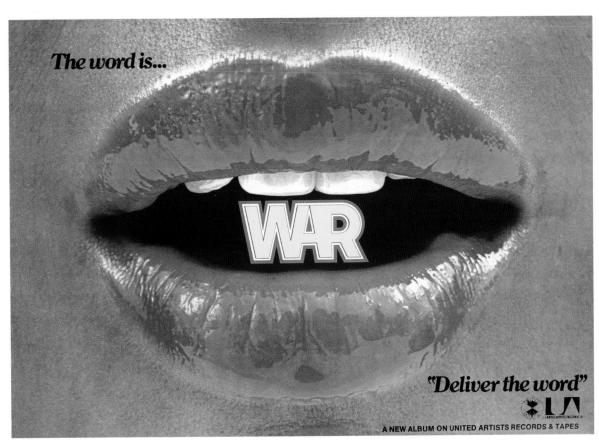

War, Deliver the Word, 1973

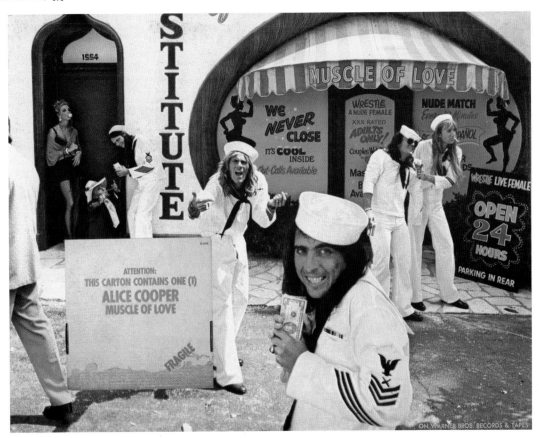

Alice Cooper, Muscle of Love, 1974

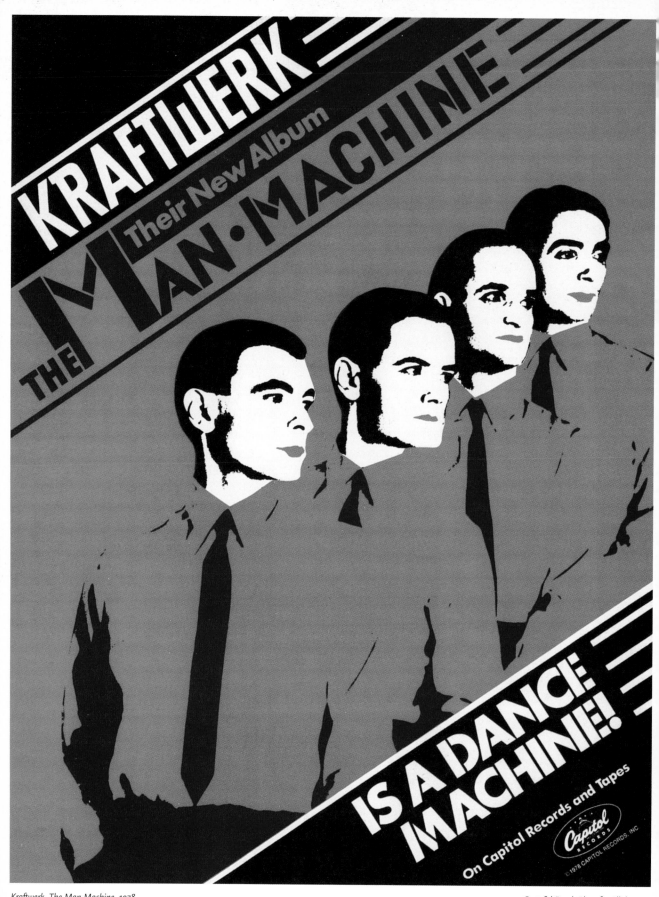

Kraftwerk, The Man-Machine, 1978

United Artists Records
and Grateful Dead Records
proudly present
"Blues For Allah."
A brilliant musical achievement
from the legendary
Grateful Dead.

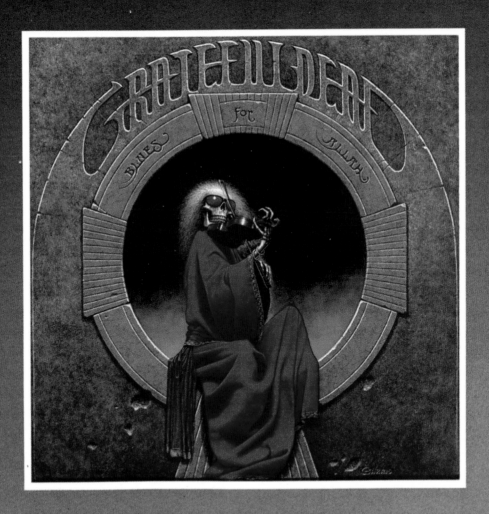

On Grateful Dead Records
Distributed by United Artists Records

Ringo Starr, Ringo, 1973

Paul McCartney & Wings, Band on the Run, 1973

John Lennon, Mind Games, 1973

American Flyer, 1979

▶ *John Lennon, Walls and Bridges, 1974*

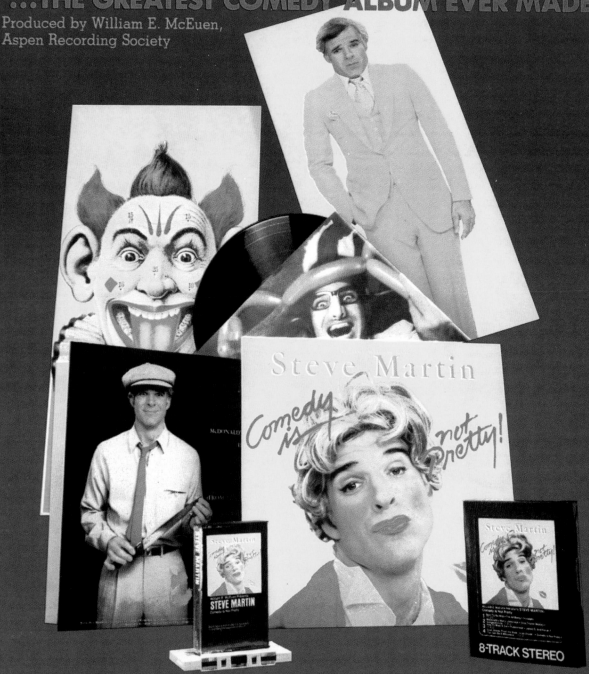

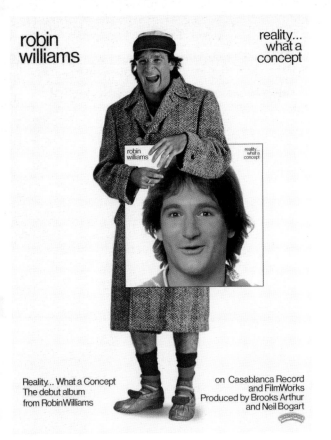

Robin Williams, Reality...What a Concept, 1979

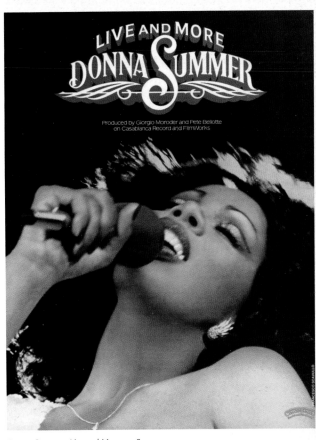

Donna Summer, Live and More, 1978

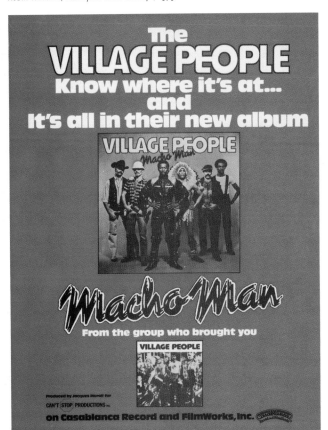

Steve Martin, Comedy is not Pretty, 1979 ◄ *The Village People, Macho Man, 1978*

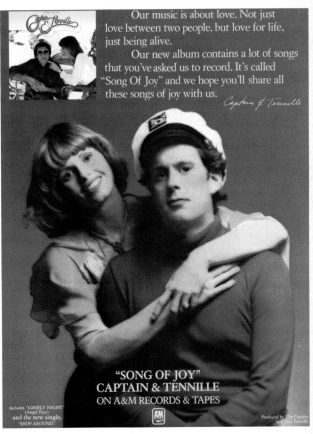

Captain & Tennille, Song of Joy, 1976

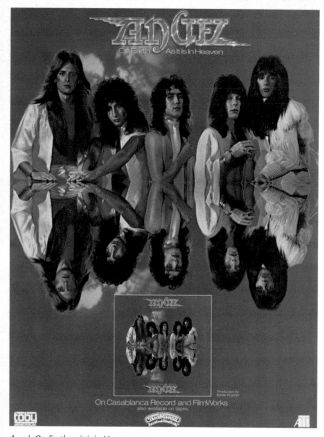

Angel, On Earth as it is in Heaven, 1977

The Doors, Absolutely Live, 1970

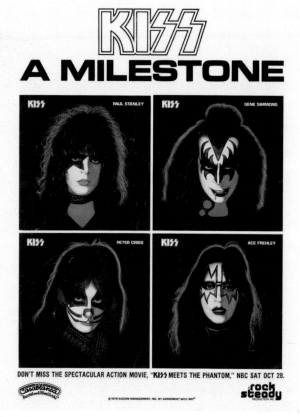

Kiss, 1978

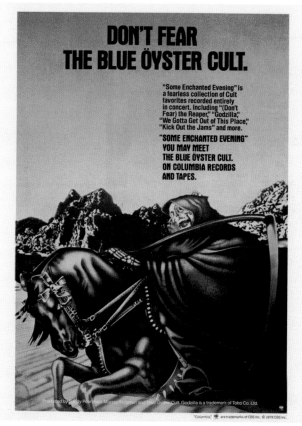

The Blue Oyster Cult, Some Enchanted Evening, 1978 ▶ The Village People, Cruisin', 1978

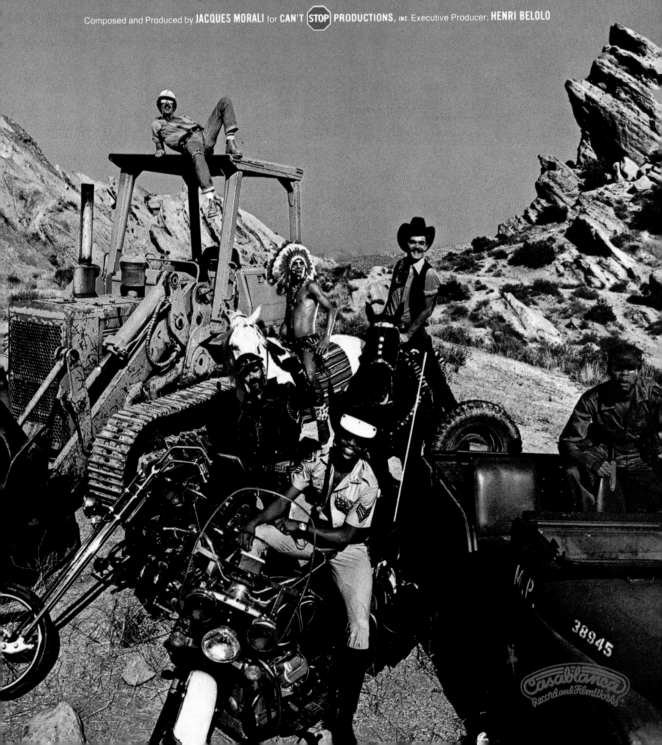

If You Think "Macho Man" Is Hot, Wait Till You Start

Cruisin'

The Hot New LP From The Dynamic

VILLAGE PEOPLE

on Casablanca Record and FilmWorks

Composed and Produced by **JACQUES MORALI** for **CAN'T STOP PRODUCTIONS,** INC. Executive Producer: **HENRI BELOLO**

How Can You Refuse?
When **Cher** Says...
Take Me Home

Includes the hit single
"TAKE ME HOME"
Produced by Bob Esty

Cher's Debut Album "TAKE ME HOME" On Casablanca Record and FilmWorks
Produced By Bob Esty
And Additional Songs Produced By Ron Dante
Executive Producer: Charles Koppelman For The Entertainment Company

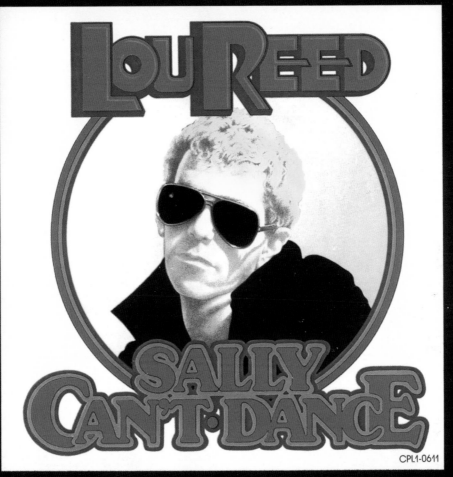

earotic.

**His new album.
The way rock was <u>meant</u> to roll.**

CPL1-0611

Produced by Steve Katz and Lou Reed

RCA Records and Tapes

FIVE OF THE WORLD'S FAVORITE PEOPLE.

The Jacksons.
A new name, a new record label and
a new album with some of the best
music they have ever made. It's called
"The Jacksons" and it includes
their great single,"Enjoy Yourself."

"The Jacksons." Michael,
Marlon, Tito, Jackie and Randy.
Five of your favorite people
making your favorite music.

Produced by
Kenneth Gamble and Leon Huff.
Music provided by MFSB.
A production of
Philadelphia International Records.

On Epic Records and Tapes.

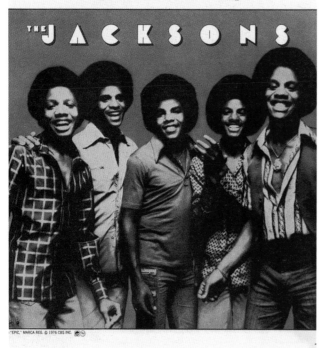

The Jacksons, 1976

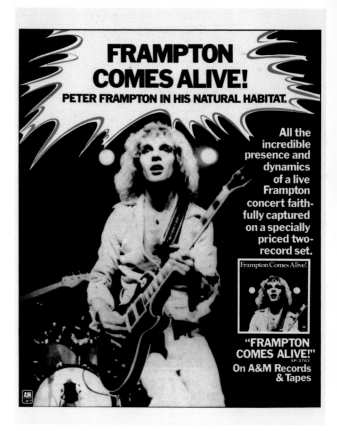

Peter Frampton, Frampton Comes Alive!, 1976

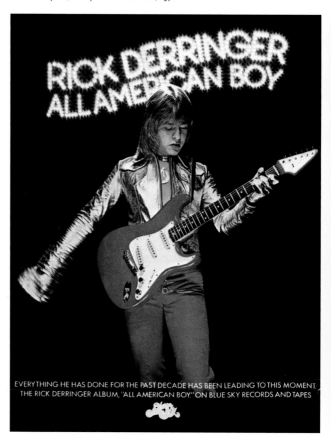

Rick Derringer, All American Boy, 1974 ▶ *Bob Marley & The Wailers, 1976*

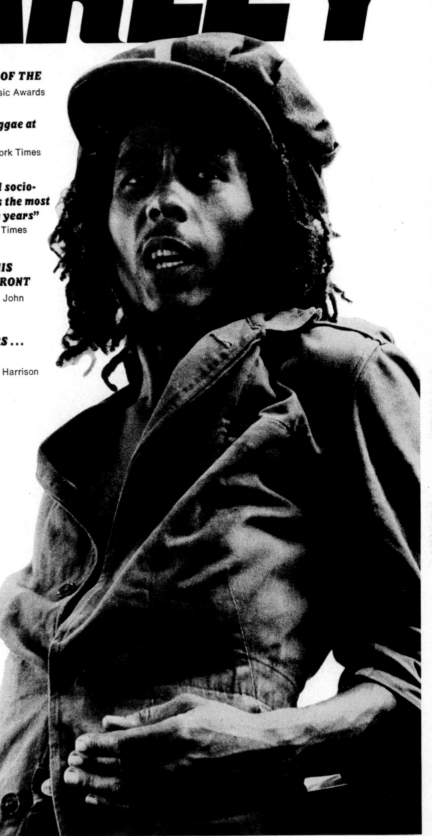

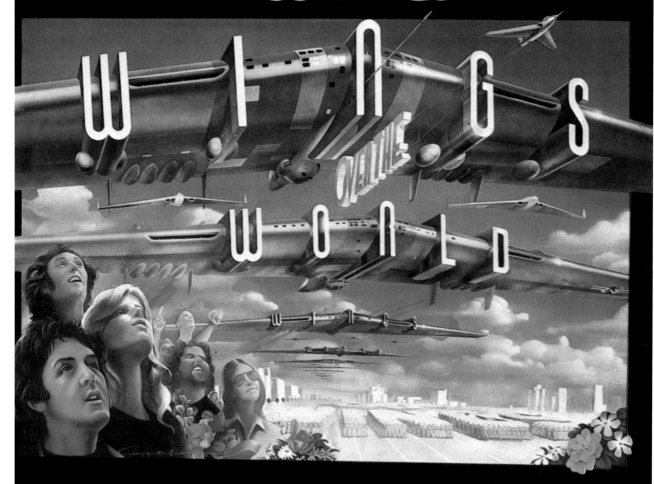

SEE
PAUL McCARTNEY
& WINGS

CBS-TV, FRIDAY, MARCH 16, 11:30 PM
(CST 10:30 PM)
90 MINUTES OF INTIMATE FILM, UNFORGETTABLE McCARTNEY MUSIC.

Paul McCartney & Wings, 1979

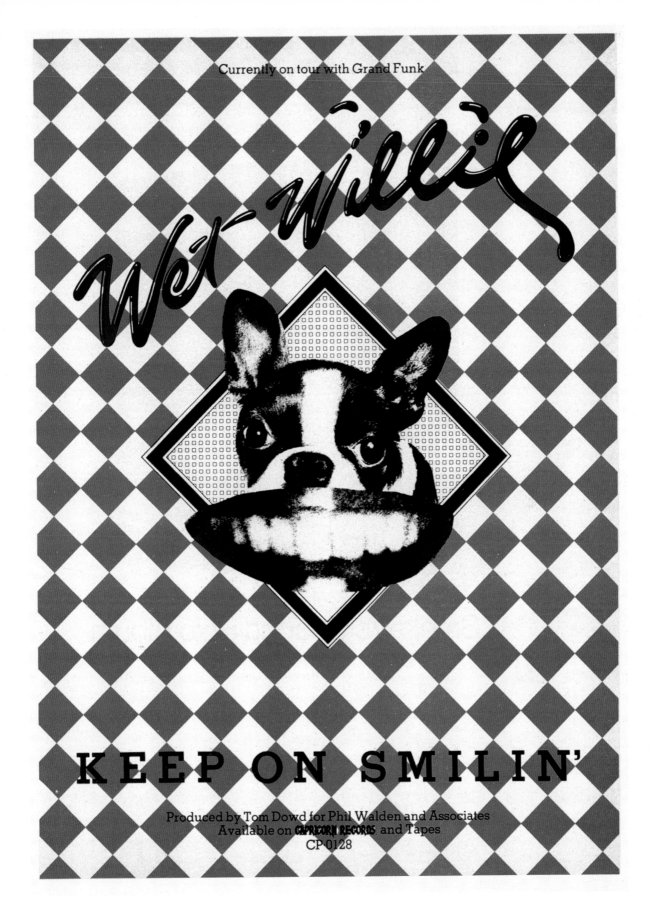

Currently on tour with Grand Funk

Wet Willie

KEEP ON SMILIN'

Produced by Tom Dowd for Phil Walden and Associates
Available on CAPRICORN RECORDS, and Tapes
CP-0128

Wet Willie, Keep On Smilin', 1974

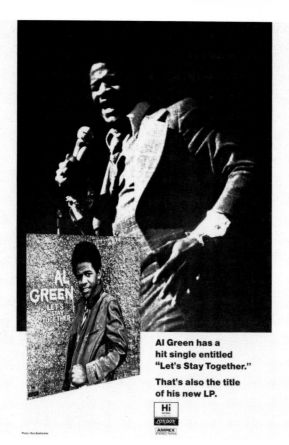

Al Green, Let's Stay Together, 1972

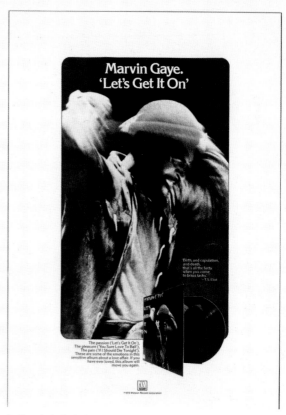

Marvin Gaye, Let's Get It On, 1974

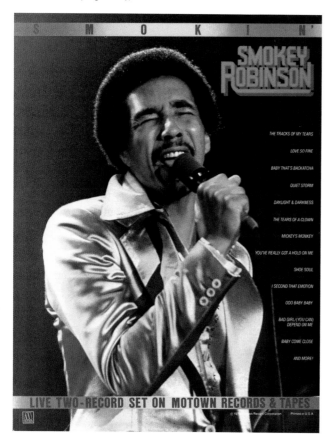

Smokey Robinson, Smokin', 1979

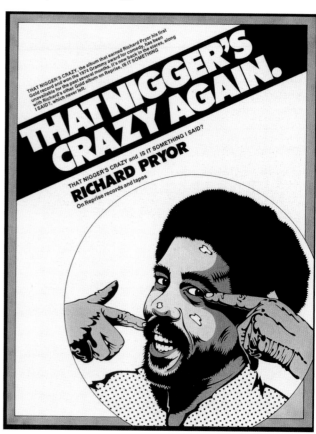

Richard Pryor, That Nigger's Crazy Again, 1976

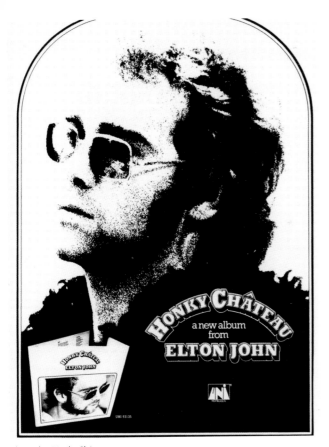

Elton John, Honky Château, 1972

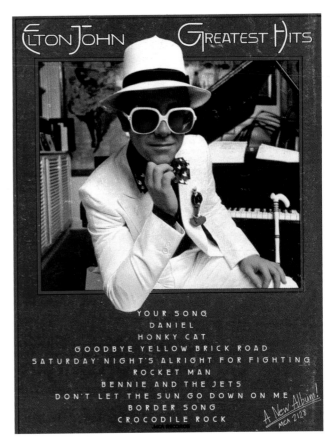

Elton John, Greatest Hits, 1974

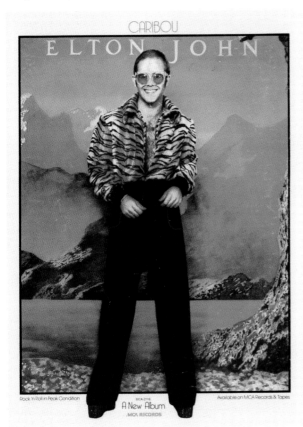

Elton John, Caribou, 1974

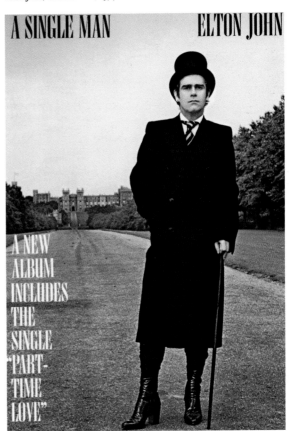

Elton John, A Single Man, 1978

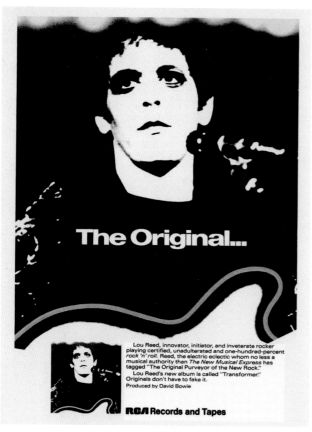

Lou Reed, Transformer, 1973

Bruce Springsteen, Born to Run, 1975

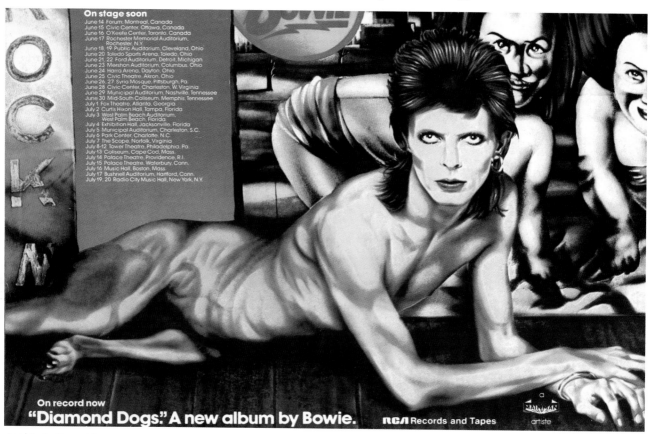

David Bowie, Diamond Dogs, 1974

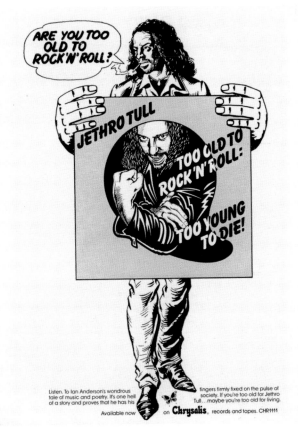

Jethro Tull, Too Old to Rock 'n' Roll: Too Young to Die!, 1976

Patti Smith, Horses, 1976

Pink Floyd, A Nice Pair, 1974

David Bowie, Changes, 1974

Linda Ronstadt, Silk Purse, 1970

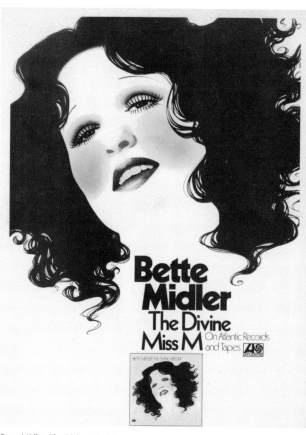

Bette Midler, The Divine Miss M, 1973

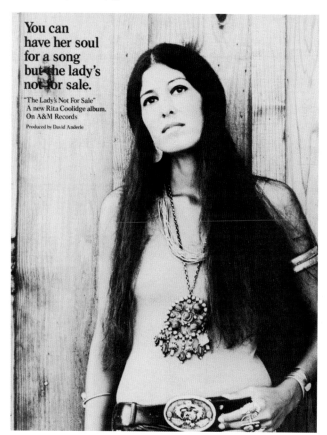

Rita Coolidge, The Lady's Not For Sale, 1973

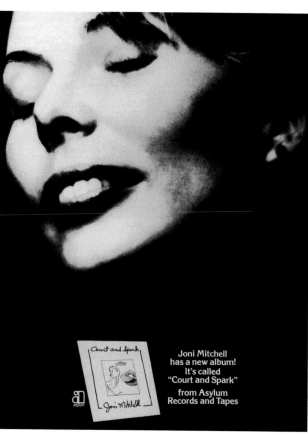

Joni Mitchell, Court and Spark, 1974

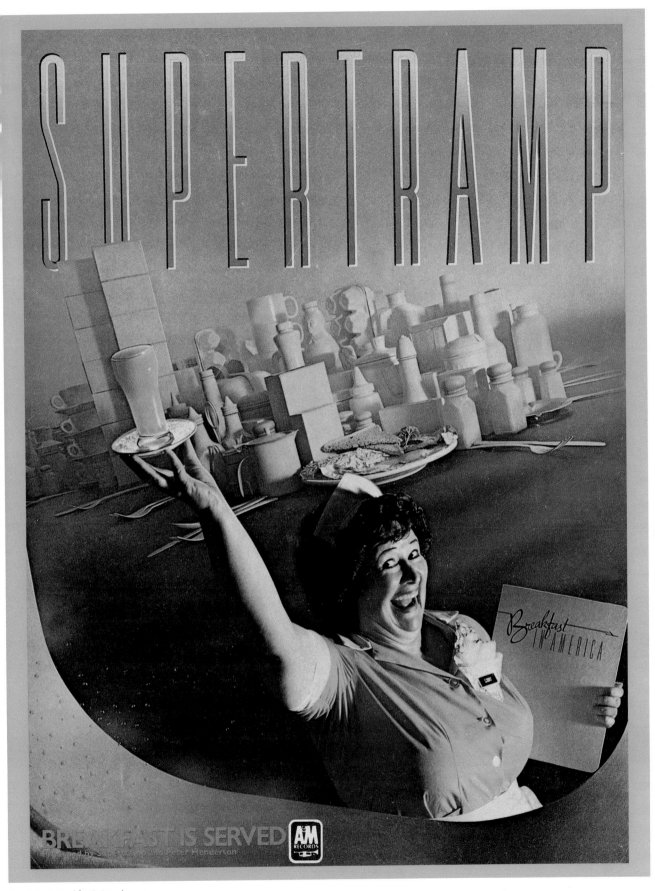

Supertramp, Breakfast is Served, 1979

ZAPPA / BEEFHEART
MOTHERS
BONGO FURY
LIVE IN CONCERT AT ARMADILLO WORLD HEADQUARTERS
AUSTIN, TEXAS
May 20th & 21st, 1975

Cheryl Ladd, Cheryl Ladd, 1978

Carly's new album is available now at record stores everywhere

Carly Simon, Hotcakes, 1974

Bongo Fury, 1975 ◄ *Billy Joel, 52nd Street, 1979*

The Mothers of Invention, The Grand Wazoo, 1973

Neil Young, On the Beach, 1974

▶ Cat Stevens, Foreigner, 1973

TELLY

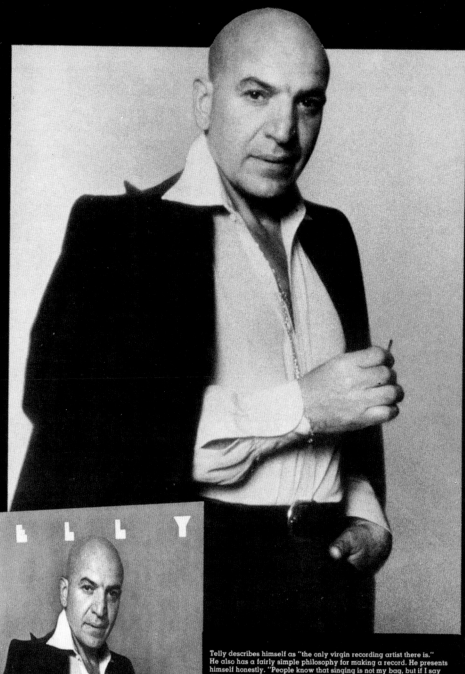

Telly describes himself as "the only virgin recording artist there is."
He also has a fairly simple philosophy for making a record. He presents
himself honestly. "People know that singing is not my bag, but if I say
'Hey, this is how Telly feels about this or that song,' I can't make mistakes.
I can only make mistakes by pretending to be a great singer."
First, you'll ask, what is an actor doing making a record? Well,
when you hear Telly's dramatic interpretation of "You're A Lady," "You've
Lost That Lovin' Feelin'," and "Rubber Bands and Bits of String," you'll
stop asking those silly questions and fall in love. Telly answers this
question by modestly stating, "I was asked to make a record."

PRODUCED BY SNUFF GARRETT

MCA-436
MCA RECORDS

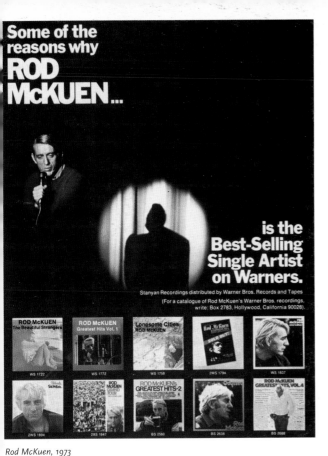

Rod McKuen, 1973

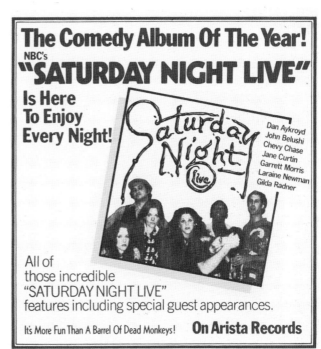

Saturday Night Live, 1976

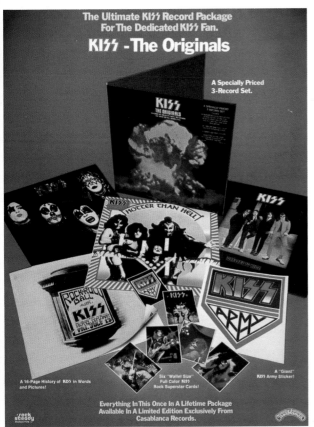

Telly Savalas, Telly, 1974 ◄ *Kiss, 1975*

You might think it's funny, but before Woody Allen became one of America's foremost comic film makers, he was one of America's foremost stand-up comedians.

On this album you can see where his movies come from. You can see where laughs come from. If you listen closely, you can see where babies come from.

It's the best on record from a young man who once said, "I don't believe in a life after death, but I'm bringing along a change of underwear."

Woody Allen
The Nightclub Years--1964-1968
"It's the SLEEPER album of the year."
On United Artists Records & Tapes

Woody Allen, The Night Club Years, 1974

And the winner is...

Disco Duds

When *Playgirl* magazine was launched in 1973, it positioned itself as a *Playboy* for women. Filled with hunky men baring it all, the magazine attempted to extend the lifestyle and brand by initiating a nightclub modeled after, you guessed it, Hugh Hefner's Playboy Clubs. With its unsophisticated gaggle of models – donning matching stone-washed denim disco wear and exuding anything but "entertainment" or "excitement" – this ad hinted that maybe *Playgirl* readers were better off boogying elsewhere.

Discokrampf

1973 erschien die Zeitschrift *Playgirl* auf dem Markt, die sich als *Playboy* für Frauen positionierte und jede Menge muskulöser Männer brachte, die alle Hüllen fallen ließen. Das Magazin versuchte, Lebensstil und Marke durch Gründung eines Nachtclubs zu stärken, dessen Vorbild, Sie haben es erraten, Hugh Hefners Playboy Clubs waren. Mit seinem biederen Fotomodellgrüppchen, das komplett in zusammenpassender Stonewashed Jeans-Discokleidung eingekleidet ist und weder „Entertainment" noch „Aufregung" vermittelt, scheint diese Werbung anzudeuten, dass die *Playgirl*–Leserinnen woanders besser aufgehoben sind, wenn sie sich amüsieren wollen.

Étalons disco

Lors de son lancement en 1973, *Playgirl* se présenta comme une version pour femmes de *Playboy*. Rempli de beaux mâles qui n'avaient rien à cacher, le magazine tenta de promouvoir un mode de vie et une marque en inaugurant un night-club inspiré, naturellement, des clubs Playboy d'Hugh Heffner. Avec sa brochette de mannequins peu folichons portant des tenues disco assorties en jean délavé et n'ayant pas franchement l'air de s'éclater, cette pub semblait plutôt dire aux lectrices de *Playgirl* que pour guincher, elles feraient mieux d'aller voir ailleurs.

¿Fiebre del sábado noche?

Desde el mismo día de su lanzamiento, en 1973, la revista *Playgirl* se presentó como un *Playboy* para mujeres. Repleta de desnudos integrales de hombres bien torneados, pretendía trasladar su estilo de vida y su marca a un club de noche moldeado según los parámetros de –lo ha adivinado...– los Clubs Playboy de Hugh Hefner. Pero, ante la pandilla de modelos ordinarias vestidas con vaqueros lavados a la piedra y camisetas a conjunto que vendía cualquier cosa menos «entretenimiento» y «emoción», es probable que las lectoras del *Playgirl* pensaran que era mejor ir a mover el esqueleto a cualquier otro sitio.

ディスコのダメ男

1973 年に創刊された『プレイガール』誌は、女性のための『プレイボーイ』を標榜していた。たくましい裸の男たちを満載した同誌は、知名度と、誌上で提唱するライフスタイルを広めようと、ナイトクラブをオープンさせた。そのモデルになったのは、お察しの通り、ヒュー・ヘフナーの「プレイボーイクラブ」である。野暮ったいモデルの一団——お揃いのストーンウォッシュ・デニムのディスコウェアを身につけたその雰囲気は、"エンターテイメント"や"エキサイトメント"からほど遠い——を起用したこの広告は、『プレイガール』の読者なら、もっといい遊び場を見つけられますよ、と教えてくれている。

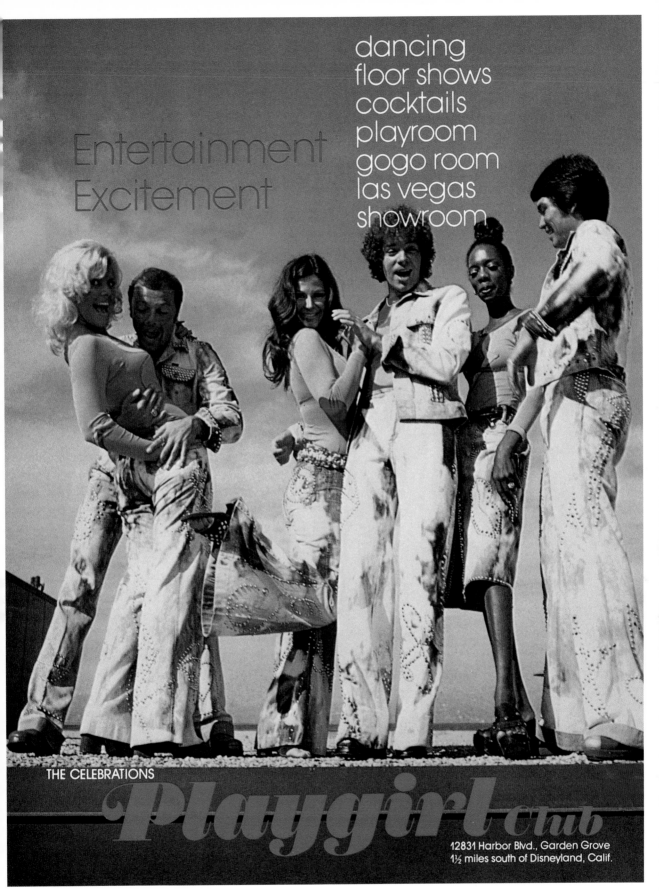

dancing
floor shows
cocktails
playroom
gogo room
las vegas
showroom

Entertainment
Excitement

THE CELEBRATIONS

Playgirl club

12831 Harbor Blvd., Garden Grove
1½ miles south of Disneyland, Calif.

Playgirl Club, 1974

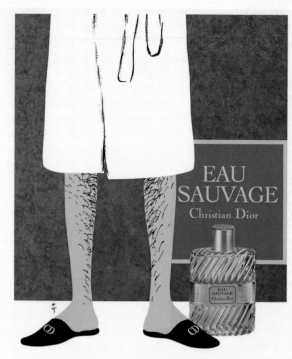

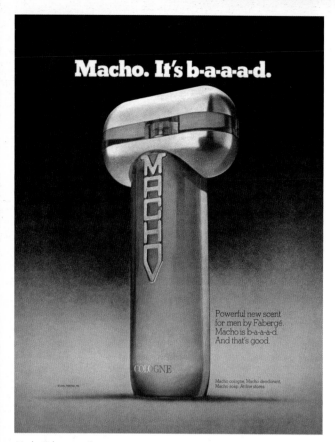

Macho Cologne, 1976

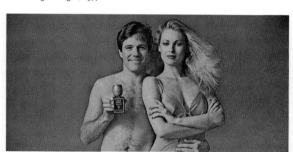

Eau Sauvage Cologne, 1977

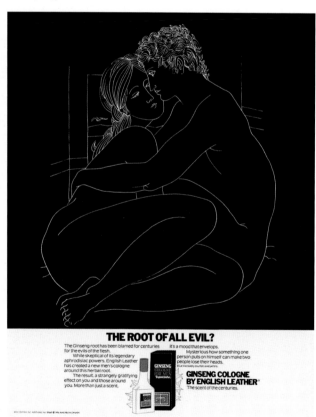

Paris Underflair Underwear, 1973 ◄ *Ginseng Cologne, 1976*

English Leather Cologne, 1979 ► *Jovan Sex Appeal After Shave, 1978*

Now that you have acquired the "power" my son, you must swear to me by the sacred sword of Jovan, that you will use the power only for good... never for evil.

What babies his face can baby your legs.

When you shave your legs, your razor takes off more than hair. It scrapes away some natural oils and moisture, leaving your delicate skin feeling dry and irritated. Why not do for your legs what he does for his face? Use Rise® Baby Face™ Shave Cream.

It <u>contains 14% baby oil</u>—so it actually <u>conditions</u> your skin as you shave. Even leaves a little layer of moisturizers behind to help soothe and soften and protect your skin—really takes care of your legs. And what could be nicer than that?

Rise BABY FACE—to shave your legs baby-soft, baby-smooth.

The kind of guy who uses it doesn't need it.

Pub Cologne.

After Shave, After Shave Balm, Deodorant Spray, too.

Baby Face Shave Cream, 1974 ◄ *Pub Cologne, 1971*

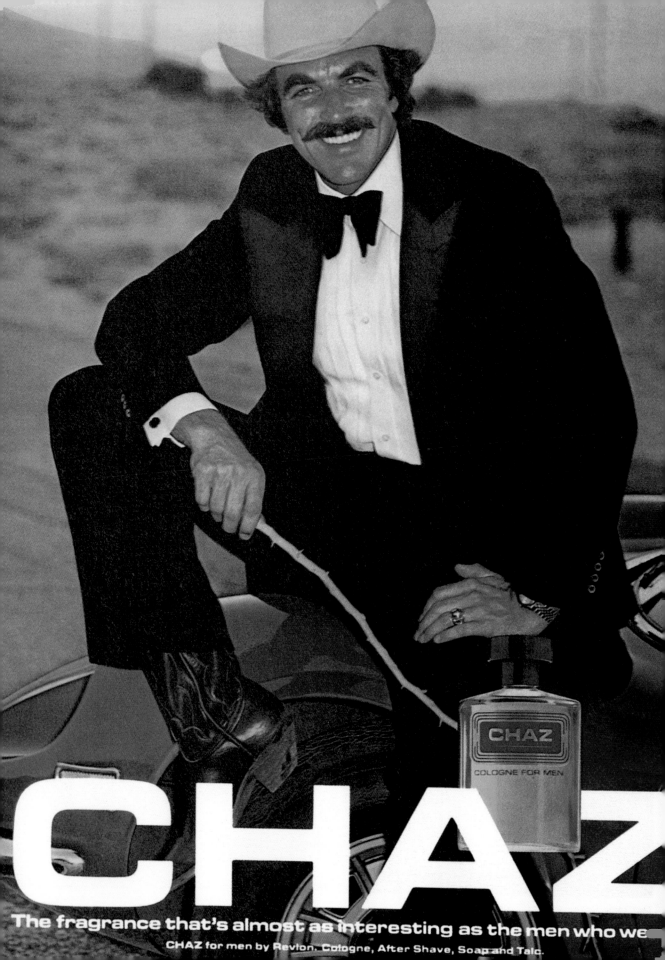

CHAZ

The fragrance that's almost as interesting as the men who we

CHAZ for men by Revlon. Cologne, After Shave, Soap and Talc.

CHAZ
COLOGNE FOR MEN

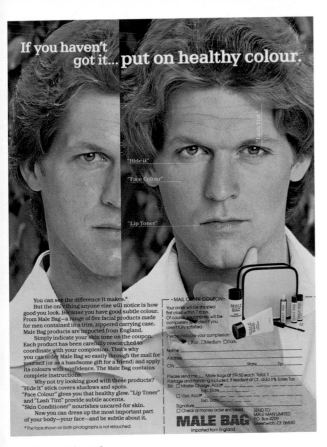

Male Bag Cosmetics, 1978

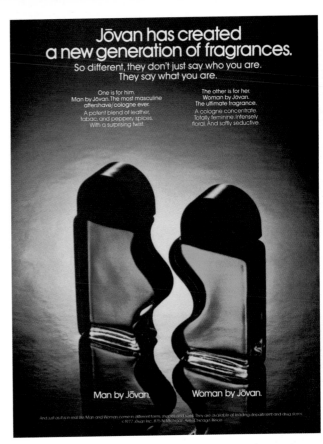

Jovan Cologne, 1978

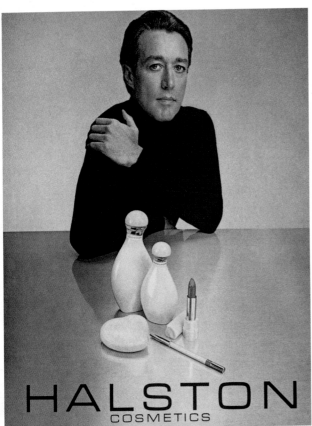

Chaz Cologne, 1979 ◄ Halston Cologne, 1979

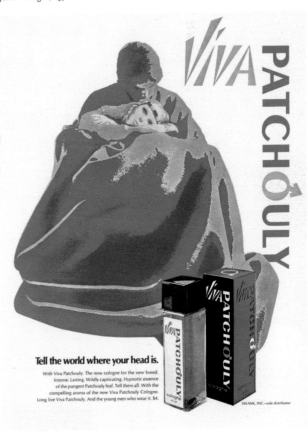

Viva Patchouly Cologne, 1971

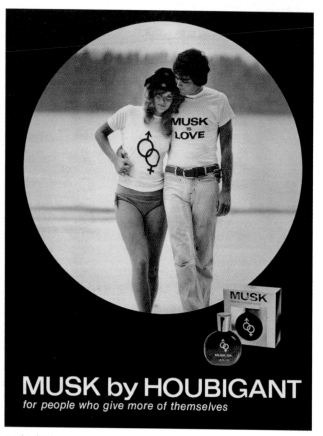

MUSK by HOUBIGANT
for people who give more of themselves

MUSK

Musk Oil Cologne, 1974

"I would like to create a cologne that will last as long as there are men and women."
PIERRE FRANÇOIS PASCAL, GUERLAIN 1860

Guerlain Cologne, 1974

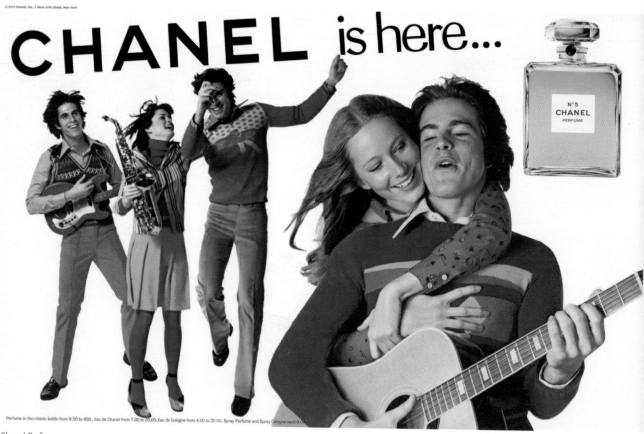

© 1972 Chanel, Inc., 1 West 57th Street, New York

CHANEL is here...

N°5
CHANEL
PERFUME

Perfume in the classic bottle from 8.50 to 400., Eau de Chanel from 7.00 to 20.00, Eau de Cologne from 4.00 to 20.00, Spray Perfume and Spray Cologne each 6.00

Chanel Perfume, 1973

▶ *Brylcreem Men's Hair Product, 1974*

BRYLCREEM SAYS DON'T MEASURE YOUR SEX APPEAL BY THE LENGTH OF YOUR HAIR.

← **NOT SEXY** **SEXY** →

A. Sideburns too long and too wide. End result: not too terrific. We said goodbye to sideburns and let his hair grow 1½ inches all over. Then gave it a layered cut.

Also recommended: frequent shampooing with Brylcreem Once A Day Shampoo to condition the hair while washing away excess oil, dirt and loose dandruff.

B. This guy was fighting natural curl with a cut that was too closely cropped on sides and back. We let it grow for two months and shaped it.

Because curly hair is porous and tends to dry out quickly, we used a dab of Brylcreem to condition while helping to keep the hair neat and manageable all day.

C. Too much hair, too little face. We took off 5 inches. Gave him a scissor cut, parted on the side to add more width and fullness to the top.

When hair goes through this change from very long to short, it needs about a week to lay right. Help it along with Brylcreem Power Hold, a specially formulated control hair spray that provides real holding power all day.

D. This guy's hair was all wrong for the shape of his face. Too long in back and too much of one length.

We cut off 2½ inches in front, 3 inches in back. We layered it on top for more body and gave him a geometric cut along the edges for the New Short look.

Brylcreem believes that sexy is as sexy does. And when your hair really does something for you, then you've got sex appeal.

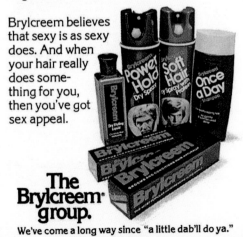

The Brylcreem group.
We've come a long way since "a little dab'll do ya."

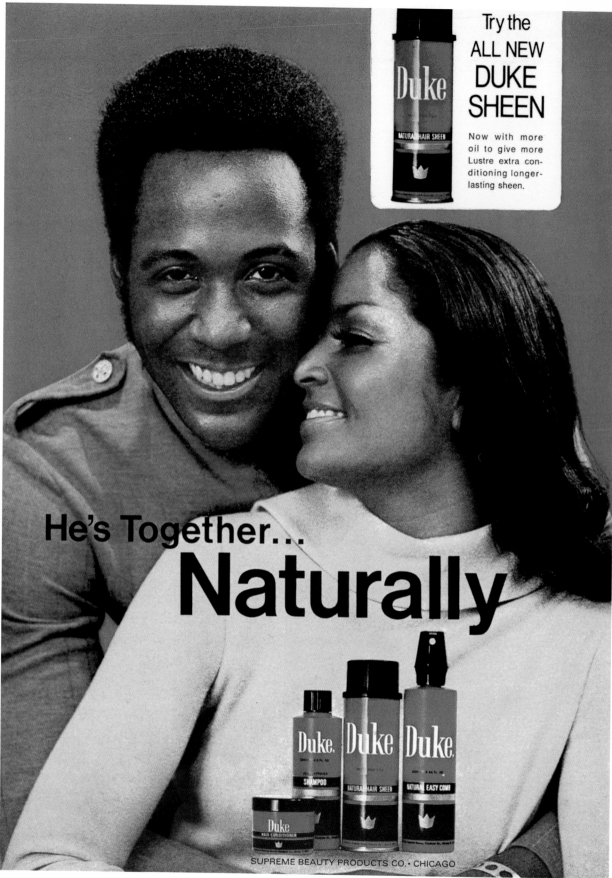

Try the
**ALL NEW
DUKE
SHEEN**

Now with more oil to give more Lustre extra conditioning longer-lasting sheen.

He's Together...
Naturally

SUPREME BEAUTY PRODUCTS CO. · CHICAGO

Duke Hair Products, 1971

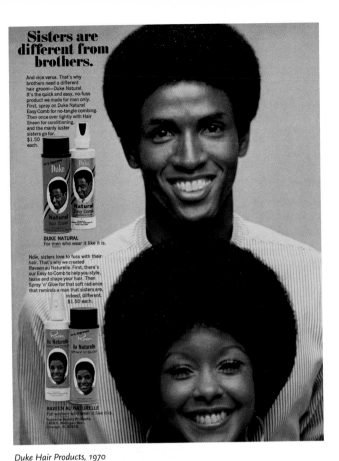
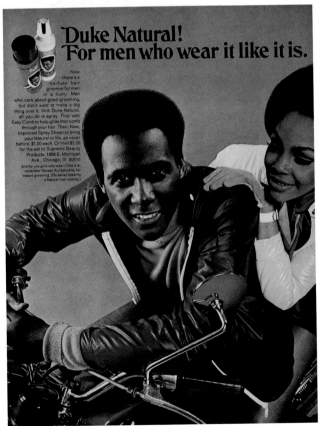
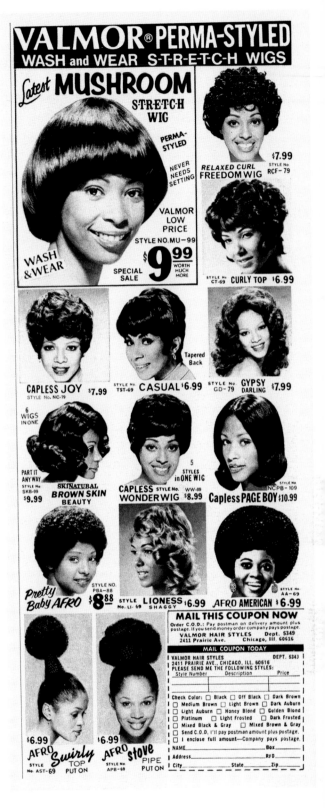
431

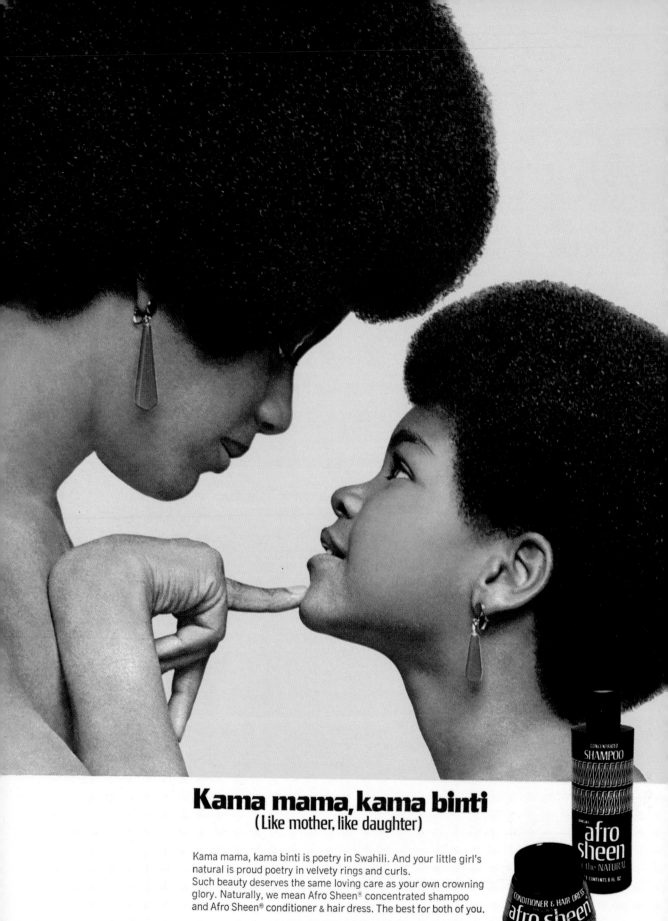

Kama mama, kama binti
(Like mother, like daughter)

Kama mama, kama binti is poetry in Swahili. And your little girl's
natural is proud poetry in velvety rings and curls.
Such beauty deserves the same loving care as your own crowning
glory. Naturally, we mean Afro Sheen® concentrated shampoo
and Afro Sheen® conditioner & hair dress. The best for both of you.

wantu wazuri use afro sheen®

JOHNSON PRODUCTS CO., INC., CHICAGO, ILLINOIS 60620

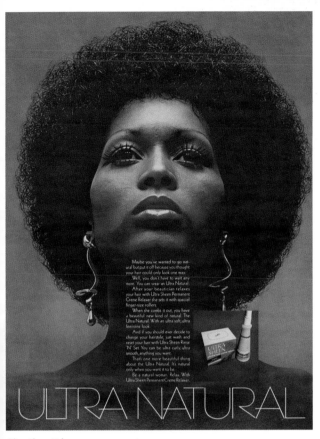

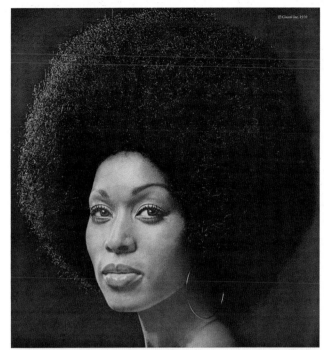

ULTRA NATURAL

Ultra Sheen Relaxer, 1970

Who can say "no" to a gorgeous brunette?

Clairol Loving Care Hair Color, 1970

"I have a terrific new way to wash my hair. It's a shampoo with vitamins, minerals, protein and herbs."

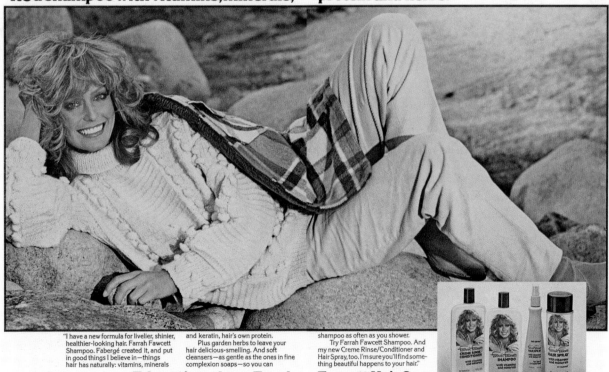

"I have a new formula for livelier, shinier, healthier-looking hair. Farrah Fawcett Shampoo. Fabergé created it, and put in good things I believe in—things hair has naturally: vitamins, minerals and keratin, hair's own protein.

Plus garden herbs to leave your hair delicious-smelling. And soft cleansers—as gentle as the ones in fine complexion soaps—so you can

Fabergé introduces Farrah

shampoo as often as you shower.

Try Farrah Fawcett Shampoo. And my new Creme Rinse/Conditioner and Hair Spray, too. I'm sure you'll find something beautiful happens to your hair."

Fawcett Hair Care
Something beautiful happens to your hair.

Afro Sheen Hair Products, 1971 ◄ Farrah Fawcett Hair Care, 1978

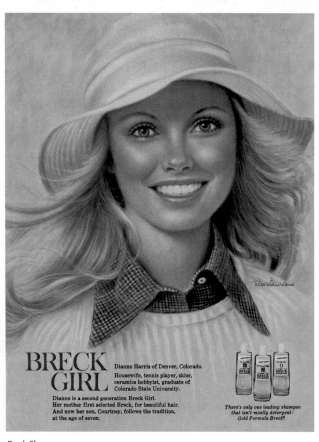

BRECK GIRL

Dianne Harris of Denver, Colorado.

Housewife, tennis player, skier, ceramics hobbyist, graduate of Colorado State University.

Dianne is a second generation Breck Girl. Her mother first selected Breck, for beautiful hair. And now her son, Courtney, follows the tradition, at the age of seven.

There's only one leading shampoo that isn't mostly detergent: Gold Formula Breck.

Breck Shampoo, 1974

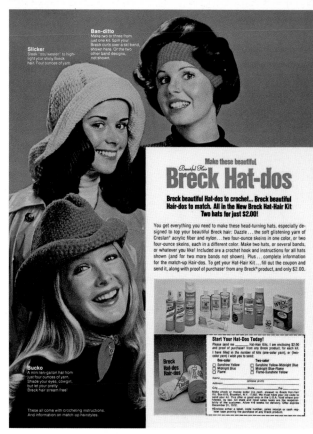

Slicker
Sleek "bou'wester" to highlight your shiny Breck hair. Four ounces of yarn.

Ban-ditto
Make two or three from just one kit. Spill your Breck curls over a ski band, shown here. Or the two other band designs, not shown.

Bucko
A mini ten-gallon hat from just four ounces of yarn. Shade your eyes, cowgirl, but let your pretty Breck hair stream free!

These all come with crocheting instructions. And information on match-up hairstyles.

Make these beautiful
Breck Hat-dos

Breck beautiful Hat-dos to crochet... Breck beautiful Hair-dos to match. All in the New Breck Hat-Hair Kit. Two hats for just $2.00!

You get everything you need to make these head-turning hats, especially designed to top your beautiful Breck hair: Dazzle... the soft glistening yarn of Creslan® acrylic fiber and nylon... two four-ounce skeins in one color, or two four-ounce skeins, each in a different color. Make two hats, or several bands, or whatever you like! Included are a crochet hook and instructions for all hats shown (and for two more bands not shown). Plus... complete information for the match-up Hair-dos. To get your Hat-Hair Kit... fill out the coupon and send it, along with proof of purchase* from any Breck® product, and only $2.00.

Start Your Hat-Dos Today!

Breck Hat-dos Kit, 1972

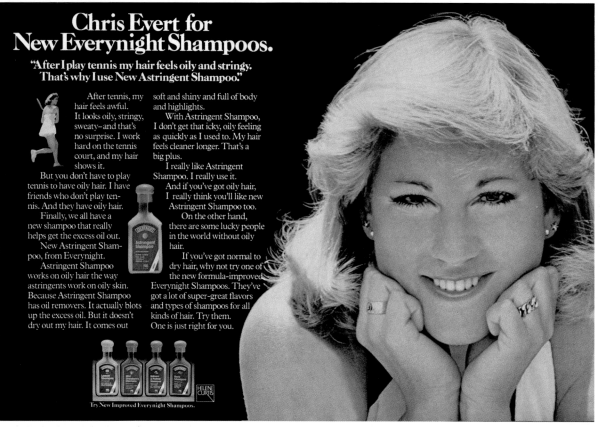

Chris Evert for
New Everynight Shampoos.

"After I play tennis my hair feels oily and stringy. That's why I use New Astringent Shampoo."

After tennis, my hair feels awful. It looks oily, stringy, sweaty–and that's no surprise. I work hard on the tennis court, and my hair shows it.

But you don't have to play tennis to have oily hair. I have friends who don't play tennis. And they have oily hair.

Finally, we all have a new shampoo that really helps get the excess oil out.

New Astringent Shampoo, from Everynight.

Astringent Shampoo works on oily hair the way astringents work on oily skin. Because Astringent Shampoo has oil removers. It actually blots up the excess oil. But it doesn't dry out my hair. It comes out soft and shiny and full of body and highlights.

With Astringent Shampoo, I don't get that icky, oily feeling as quickly as I used to. My hair feels cleaner longer. That's a big plus.

I really like Astringent Shampoo. I really use it.

And if you've got oily hair, I really think you'll like new Astringent Shampoo too.

On the other hand, there are some lucky people in the world without oily hair.

If you've got normal to dry hair, why not try one of the new formula-improved Everynight Shampoos. They've got a lot of super-great flavors and types of shampoos for all kinds of hair. Try them. One is just right for you.

Try New Improved Everynight Shampoos.

HELENE CURTIS

Everynight Shampoos, 1976

▶ Clairol Herbal Essence Creme Rinse, 1973

Now there's a velvet *creme rinse* to follow the beautiful Clairol® herbal essence shampoo experience. It makes your hair so fresh and tame and luscious, you'll think you're handling flower petals.

Introducing Clairol® herbal essence Creme Rinse.

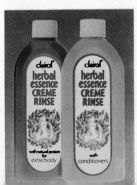

Inside Clairol's beautiful new creme rinse is the breathtakingly fresh essence of mysterious green herbs and enchanted flowers. Like Melissa. Mountain Gentian. Juniper. And birch leaves. The same beautiful combination of earthy pleasures that makes the famous Clairol herbal essence shampoo such a beautiful experience.

Besides the wildly fresh way new Clairol herbal essence creme rinse makes your hair smell, it also gives your hair the velvety soft texture of the inside of a rose petal. And helps it to comb like silk right down to the ends. Treat your hair to the newest pleasure from the garden of earthly delights. The beautiful new Clairol herbal essence creme rinse.

©1972 Clairol, Inc.

Psssssst Instant Shampoo, 1972

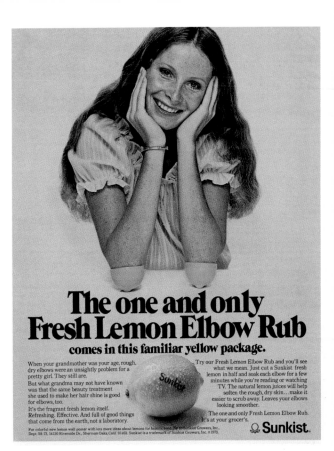

Sunkist Lemons, 1973

"Gee, Your Hair Smells Terrific" Shampoo, 1975 ◄ Adorn Hair Spray, 1971

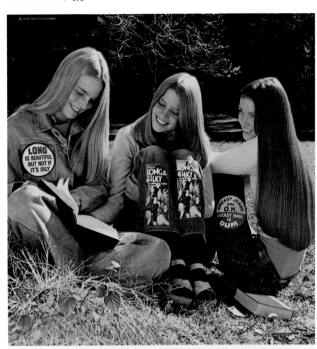

Long & Silky Conditioner, 1974

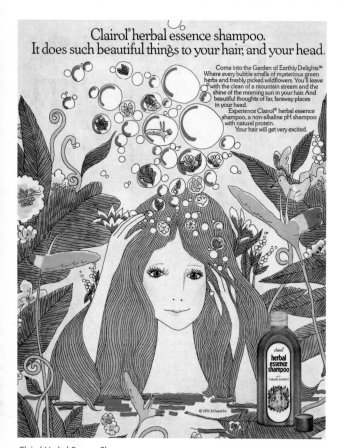

Clairol Herbal Essence Shampoo, 1975

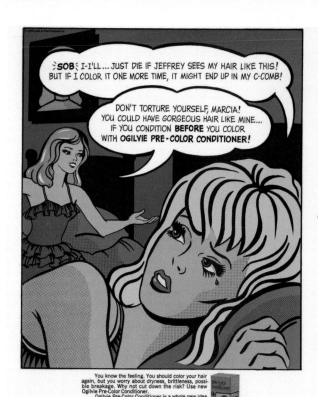

Ogilvie Pre-Color Conditioner, 1973

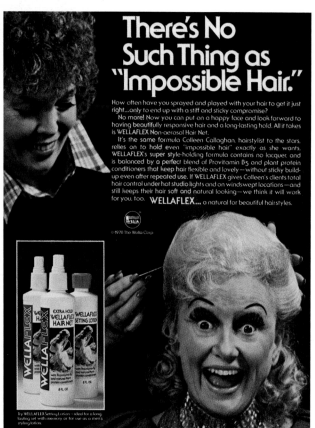

Wellaflex Hair Products, 1978

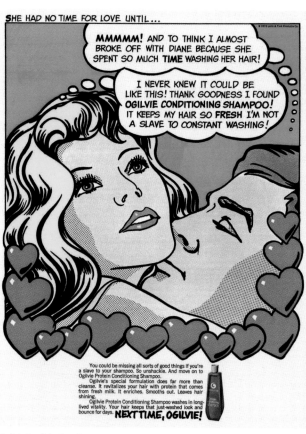

Ogilvie Conditioning Shampoo, 1973

▶ *Breck Shampoo, 1974*

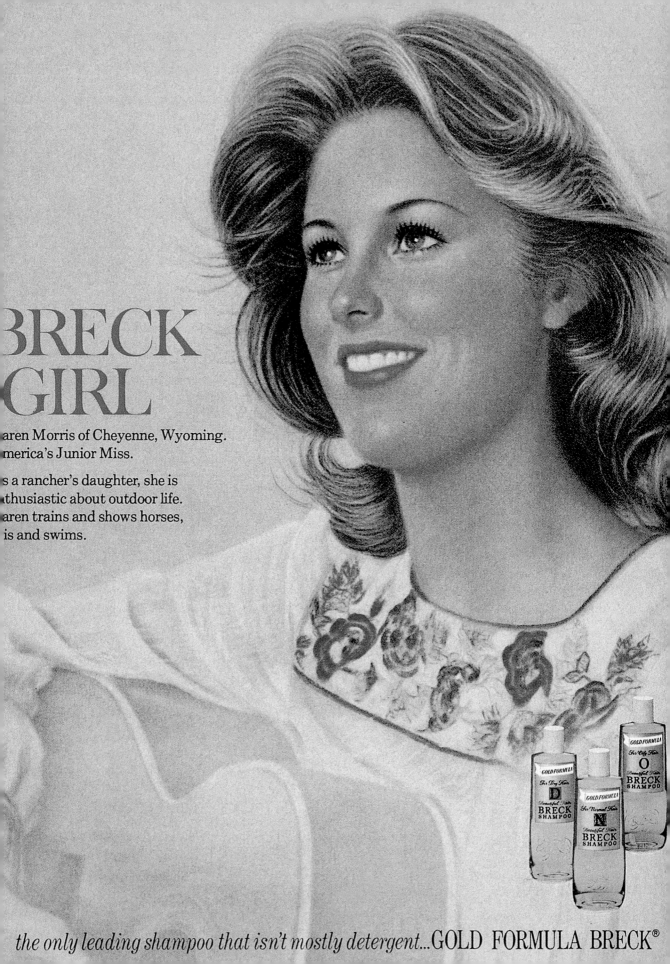

nail gloss
ultra Dior
TWILIGHT VIOLET
074

nail gloss
ultra Dior
SETTING SUN
073

nail gloss
ultra Dior
POLARIS PINK
075

nail gloss
ultra Dior
EVENING GREEN
079

Christian
Dior

Resilience challenges the frail nail.

Give your nails a fighting chance. With new Resilience. The incredibly long-wearing, flexible nail enamel that stands up to chips, to cracks and splits. Coty fortifies Resilience with a unique Polyester Resin that has never before been used in a nail enamel. Blazes it with high glossers. And dazzles it with 14 high fashion colors, plus clear "Sparkling Glass." Then puts it in a very sensible spill-proof bottle. Wear new Resilience. And be a knock-out.

New Resilience by Coty

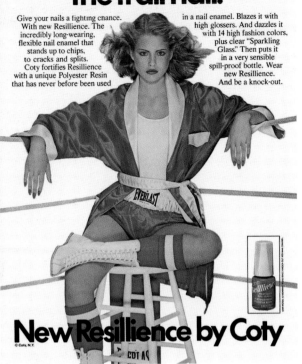

Coty Nail Enamel, 1979

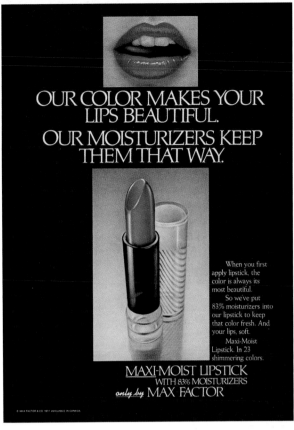

OUR COLOR MAKES YOUR LIPS BEAUTIFUL.
OUR MOISTURIZERS KEEP THEM THAT WAY.

When you first apply lipstick, the color is always its most beautiful. So we've put 83% moisturizers into our lipstick to keep that color fresh. And your lips, soft. Maxi-Moist Lipstick. In 23 shimmering colors.

MAXI-MOIST LIPSTICK
WITH 83% MOISTURIZERS
only by MAX FACTOR

Max Factor Lipstick, 1977

THERE'S MORE TO BEING RICH THAN MEETS THE EYE.

Jewels by Fred Joaillier Beverly Hills.

At Redken, beautiful promises are based in scientific fact. So when we say our new colors for lips and nails are rich, we mean rich.

pH Plus™ Conditioning Lipstick gives you more than a pretty mouth. Loaded with hard-working emollients, protein and vitamins, it pampers and protects your lips. Its long-lasting color glides on as effortlessly as sheer chiffon. Without caking. Without drying out.

pH Plus Conditioning Nail Colour leaves more than a jewel-bright finish. It's packed with polymers that act like another, stronger nail layer to help your nails resist breaking and softening in water. pH Plus Nail Colour is quick-drying, too.

We even put thought into the bottle. The application is pre-measured. The bottle is spill-proof.

And our six new colors are elegant. For lips: Privileged Beige, Million $ Mauve, Foxy Beige, Red Sable, Iced Champagne and Caviar Brown. With six new Nail Colours that coordinate beautifully.

We feel that scientific products like ours can best be recommended by a licensed cosmetologist. You'll find pH Plus Lipstick and Nail Colour in the hands of professionals. Look for it in select beauty salons that use and sell Redken products. If you don't already know such a salon, check your Yellow Pages Telephone Directory. Then, go after Redken's new Richer-Than-Rich Colors. You'll be that much richer for it!

pH PLUS RICHER-THAN-RICH COLORS

REDKEN® AT KNOWLEDGEABLE HAIRSTYLING SALONS

Christian Dior Nail Enamel, 1973 ◄ *Redken Cosmetics, 1977*

"Color me soft."

Cover Girl creates 'LIP SOFTENERS'

Don't just color your lips. Soften them, too.
Cover Girl's special 'lip softening' formula makes taking care of your lips a super, soft job. Glides on nice and easy. Soft and creamy. Color is drenched with lip smoothing conditioners that moisturize and protect, too. Go ahead. Treat your lips to some super softness. (You've got 22 sumptuous shades to do it in!)

COVER GIRL 'LIP SOFTENERS' LIPSTICKS THAT <u>SOFTEN</u> LIPS AS THEY COLOR

Cover Girl Lipsticks, 1977

441

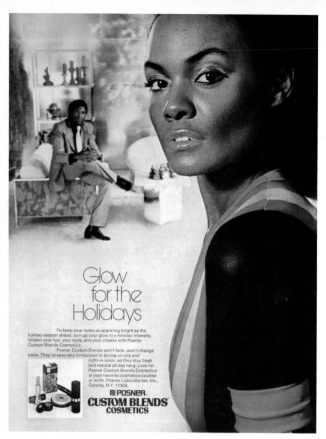

Glow
for the
Holidays

To keep your looks as sparkling bright as the holiday season ahead, turn up your glow to a holiday intensity. Glisten your lips, your eyes, and your cheeks with Posner Custom Blends Cosmetics.

Posner Custom Blends won't fade, won't change color. They're specially formulated to be low-in-oils and right-in-color, so they stay fresh and natural all day long. Look for Posner Custom Blends Cosmetics at your favorite cosmetics counter or write: Posner Laboratories, Inc., Corona, N.Y. 11368.

POSNER
CUSTOM BLENDS
COSMETICS

Posner Custom Blends Cosmetics, 1974

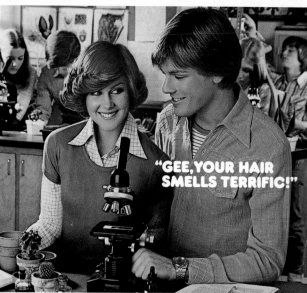

"GEE, YOUR HAIR SMELLS TERRIFIC!"

"Gee, Your Hair Smells Terrific" is the shampoo made to leave hair smelling terrific. With a soft, young breezy-fresh fragrance. Like meadows of wildflowers in spring. But that's not all "Gee" makes hair feel super-clean, too. Leaves it soft, silky and very shiny. Because isn't that why you wash your hair in the first place? "Gee, Your Hair Smells Terrific" Shampoo and same-fragrance Conditioner. Try them both and see: they're terrific!

FRAGRANCE SHAMPOO & FRAGRANCE CONDITIONER.
Available in normal/dry and oily hair formulas.

"Gee, Your Hair Smells Terrific" Shampoo, 1979

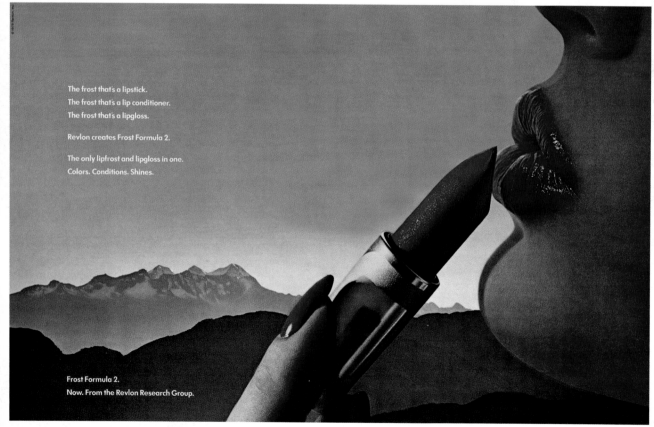

The frost that's a lipstick.
The frost that's a lip conditioner.
The frost that's a lipgloss.

Revlon creates Frost Formula 2.

The only lipfrost and lipgloss in one.
Colors. Conditions. Shines.

Frost Formula 2.
Now. From the Revlon Research Group.

Revlon Lipstick, 1978

▶ *Royal Shield Hair Products, 1972*

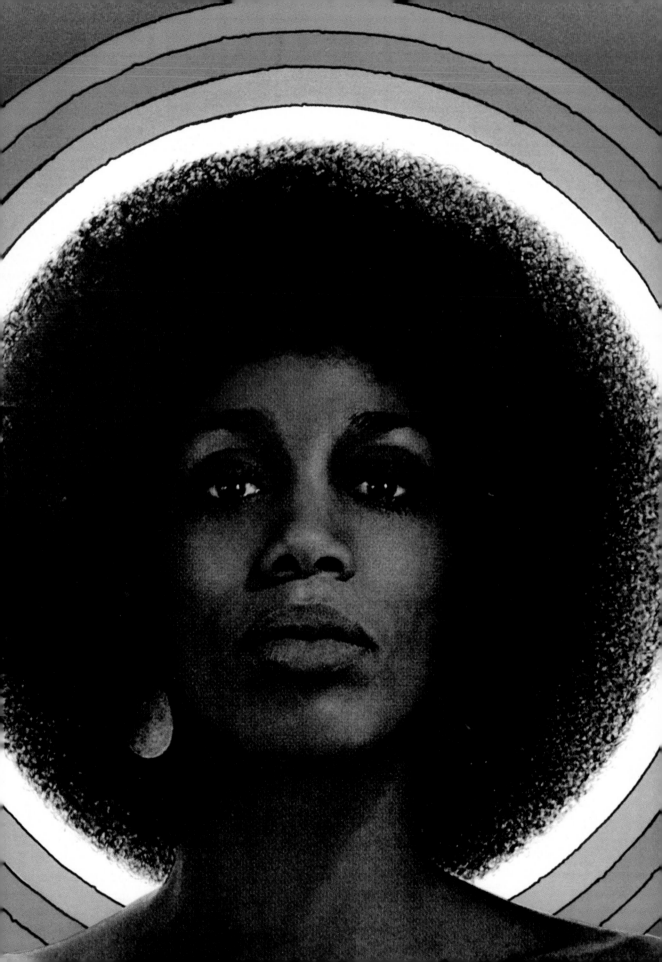

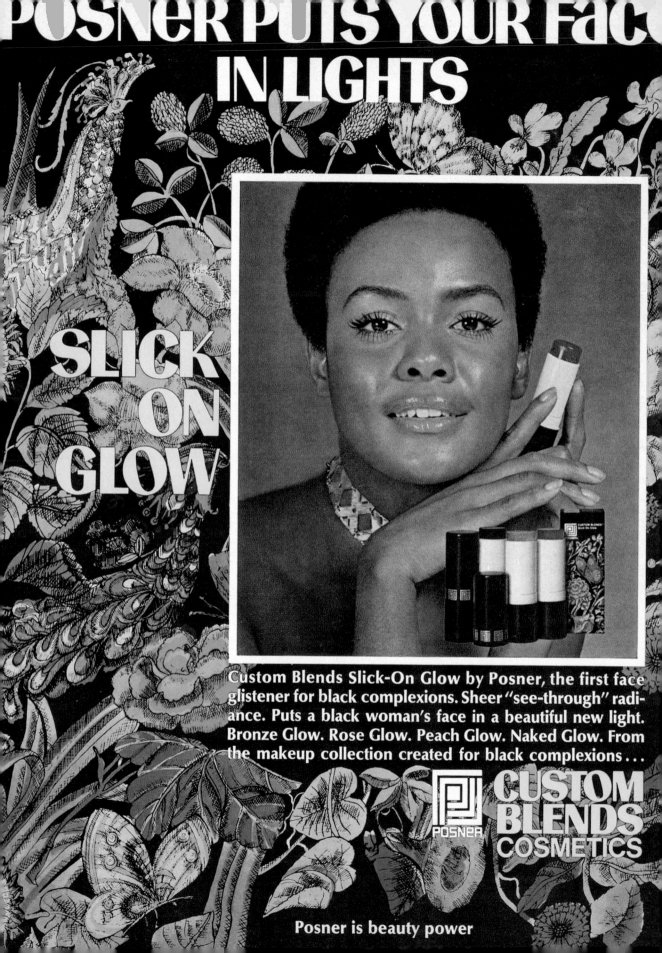

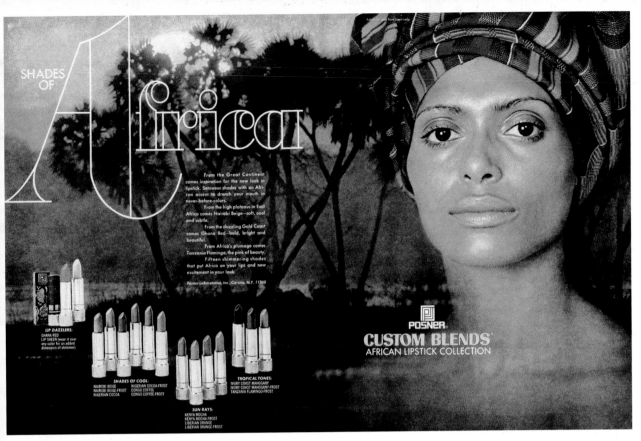

SHADES OF *Africa*

From the Great Continent comes inspiration for the new look in lipstick. Sensuous shades with an African accent to drench your mouth in never-before-colors.

From the high plateaus in East Africa comes Nairobi Beige—soft, cool and subtle.

From the dazzling Gold Coast comes Ghana Red—bold, bright and beautiful.

From Africa's plumage comes Tanzania Flamingo, the pink of beauty.

Fifteen shimmering shades that put Africa on your lips and new excitement in your look.

Posner Laboratories, Inc.: Corona, N.Y. 11368

LIP DAZZLERS:
GHANA RED
LIP SHEEN (wear it over any color for an added dimension of shimmer)

SHADES OF COOL:
NAIROBI BEIGE
NAIROBI BEIGE-FROST
NIGERIAN COCOA
NIGERIAN COCOA-FROST
CONGO COFFEE
CONGO COFFEE-FROST

SUN RAYS:
KENYA MOCHA
KENYA MOCHA-FROST
LIBERIAN ORANGE
LIBERIAN ORANGE-FROST

TROPICAL TONES:
IVORY COAST MAHOGANY
IVORY COAST MAHOGANY-FROST
TANZANIA FLAMINGO-FROST

POSNER
CUSTOM BLENDS
AFRICAN LIPSTICK COLLECTION

Posner Custom Blends Cosmetics, 1971

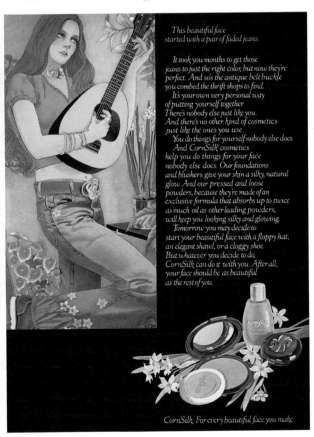

This beautiful face started with a pair of faded jeans.

It took you months to get those jeans to just the right color, but now they're perfect. And so's the antique belt buckle you combed the thrift shops to find.

It's your own very personal way of putting yourself together. There's nobody else just like you. And there's no other kind of cosmetics just like the ones you use.

You do things for yourself nobody else does. And CornSilk cosmetics help you do things for your face nobody else does. Our foundations and blushers give your skin a silky, natural glow. And our pressed and loose powders, because they're made of an exclusive formula that absorbs up to twice as much oil as other leading powders, will keep you looking silky and glowing.

Tomorrow you may decide to start your beautiful face with a floppy hat, an elegant shawl, or a cloggy shoe. But whatever you decide to do, CornSilk can do it with you. After all, your face should be as beautiful as the rest of you.

CornSilk. For every beautiful face you make.

Posner Custom Blends Cosmetics, 1972 ◄ *CornSilk Cosmetics, 1974*

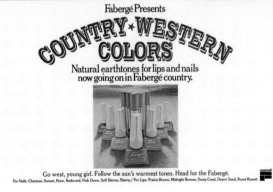

Fabergé Presents
COUNTRY · WESTERN COLORS
Natural earthtones for lips and nails now going on in Fabergé country.

Go west, young girl. Follow the sun's warmest tones. Head for the Fabergé.

For Nails: Chestnut, Sunset, Fawn, Redwood, Pink Dawn, Soft Sienna, Sherry. / For Lips: Prairie Brown, Midnight Bronze, Dusty Coral, Desert Sand, Burnt Russet.

Fabergé Cosmetics, 1974

THIS IS LOVE IN 1972

Love's A Little Cover is a sheer, smooth makeup that covers so well, you'll look fresh and soft even in daylight.

Love's A Little Cover* evens out your skin tone.
Love's A Little Cover covers even minor skin imperfections.
Love's A Little Cover comes in ten subtle shades from light to deep.
It makes you look so fresh and soft,
you won't have to worry about the harsh light of day.

Love Cosmetics by Menley & James.

Love Cosmetics, 1972

AZIZA DEMONSTRATES
HOW TO HAVE A MORE MEMORABLE MOUTH.

If you're still using the same meek lipcolor, do something nice for your lips. Aziza has a lip gloss that not only gives your mouth great shine and definition, but also gives it incredible color. And that's what makes a mouth almost impossible to forget.

The secret of Natural Lustre Lip Gloss is our unique way of combining beautiful creme color with shiny, frosted color.

When you sweep it on, you'll see both sheer, lustrous color and a subtle, tinted highlight just where light touches your lips.

For the most unforgettable results, apply Natural Lustre this way:
1. Use tip of sponge applicator to draw a neat outline of color on lower lip.

2. Fill in with broad side of wand. Repeat on upper lip. Of course, Natural Lustre has lots of pretty shine. And since our gloss can't separate on your lips,

the memorable look will also last longer.

The warm shade our model, Brooke Shields, is wearing is Tawny Pink with Pink Lustre. And there are 11 more super fashion shades to choose from.

Natural Lustre Lip Gloss. It's the only lip gloss with luscious creme color and color highlight to give you a truly memorable mouth.

Natural Lustre Lip Gloss.

Aziza by Prince Matchabelli

Aziza Lip Gloss, 1979

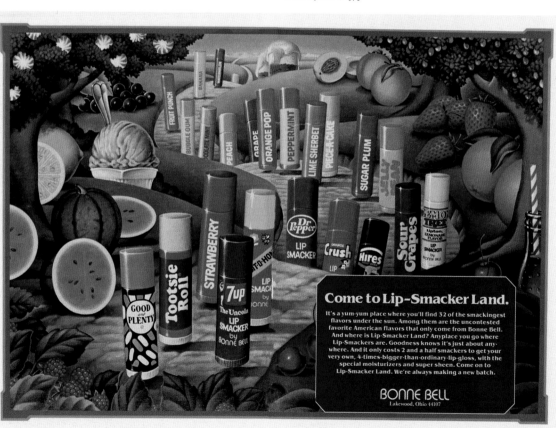

Come to Lip-Smacker Land.

It's a yum-yum place where you'll find 32 of the smackingest flavors under the sun. Among them are the uncontested favorite American flavors that only come from Bonne Bell. And where is Lip-Smacker Land? Anyplace you go where Lip-Smackers are. Goodness knows it's just about anywhere. And it only costs 2 and a half smackers to get your very own, 4-times-bigger-than-ordinary-lip-gloss, with the special moisturizers and super sheen. Come on to Lip-Smacker Land. We're always making a new batch.

BONNE BELL
Lakewood, Ohio 44107

Bonne Bell Lip-Smacker, 1979

▶ *Clinique Cosmetics, 1977*

The Clinique Computer will see you now.

It will be a revelation. In a quick 30-second consultation, you will learn <u>your skin type</u>, you will learn how to have <u>better and better looking skin</u>. Developed by a group of <u>leading dermatologists</u>, the fast, informative <u>Clinique Computer Analysis</u> is available at no charge at any Clinique Counter.

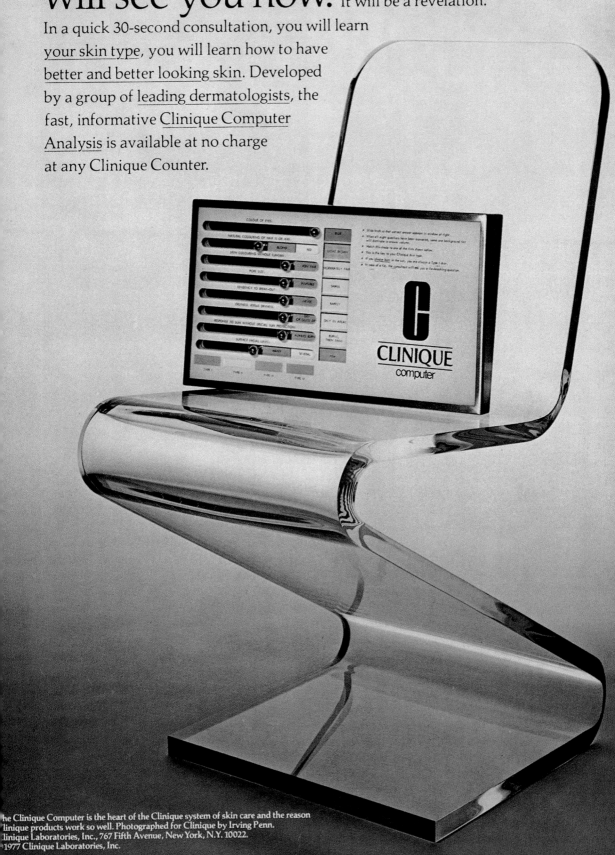

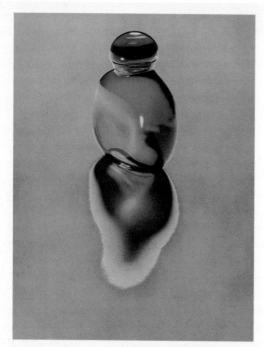

HALSTON

Z-14 FOR MEN
Sparkling, warm, sexy.

1-12 FOR MEN
Clean, crisp, fresh.

Halston Cosmetics, 1978

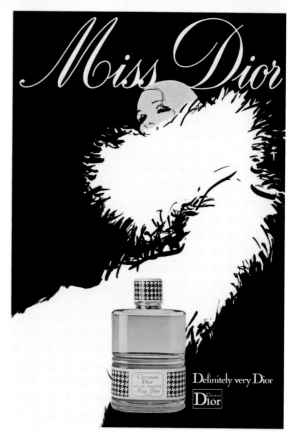

Miss Dior Perfume, 1971

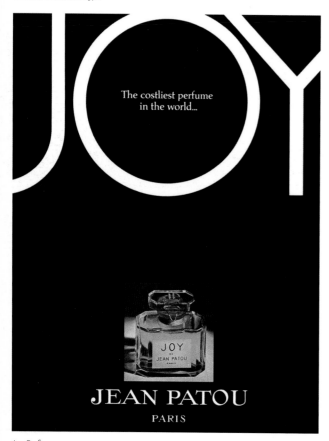

Joy Perfume, 1975

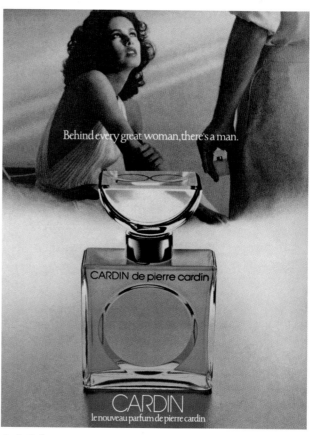

Cardin Perfume, 1971

▶ *Born Blonde Hair Color, 1970*

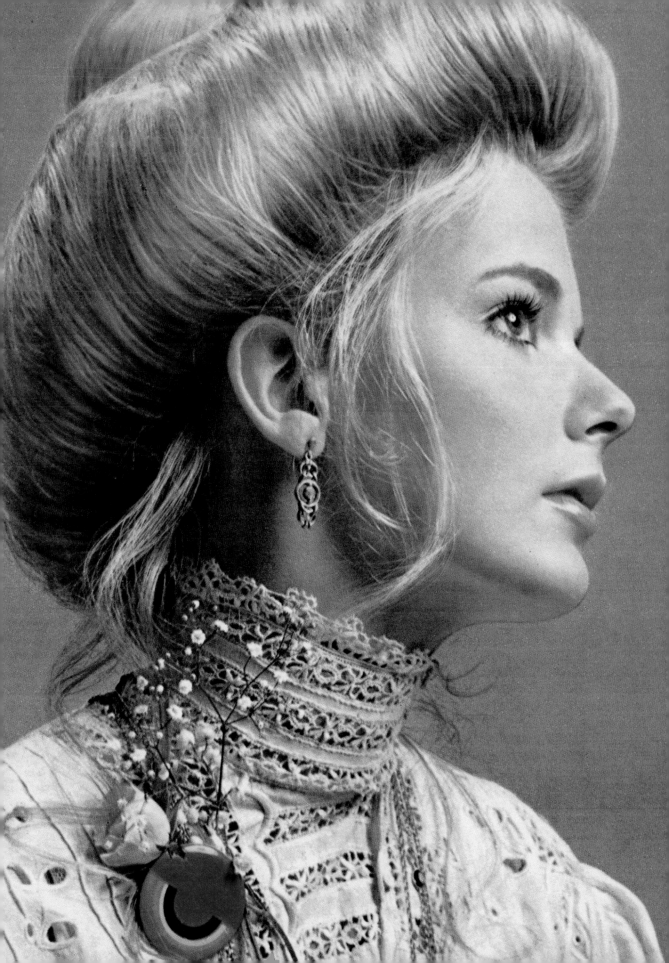

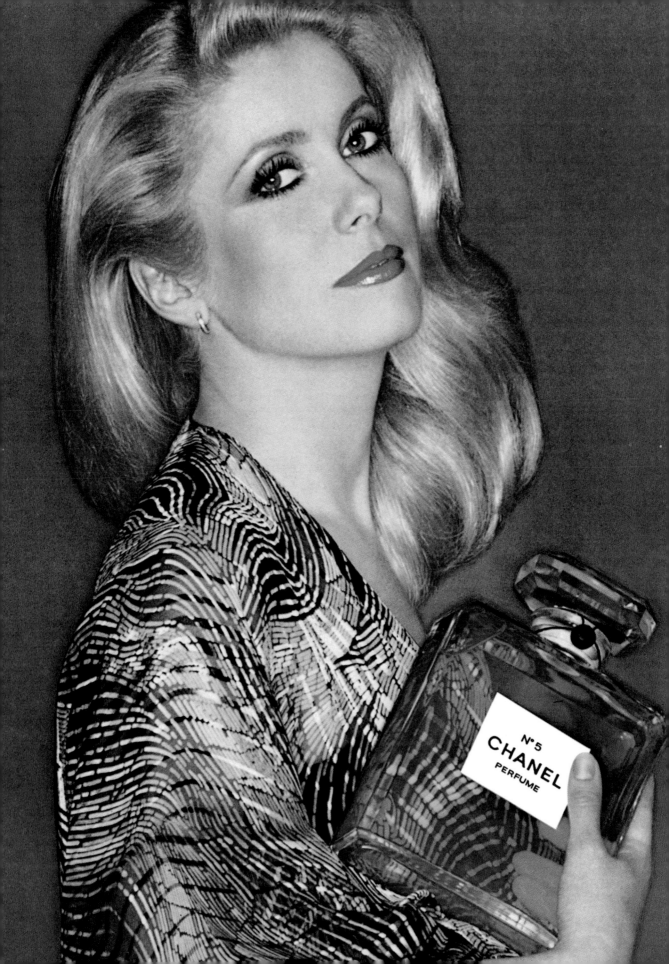

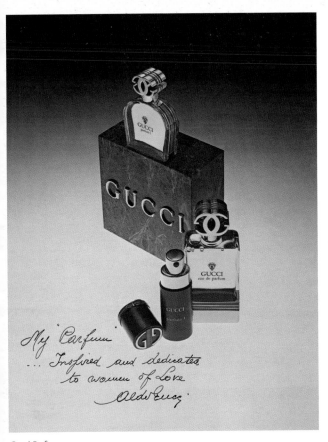

Gucci Perfume, 1975

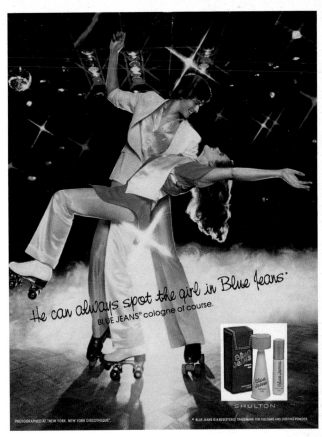

Blue Jeans Cologne, 1978

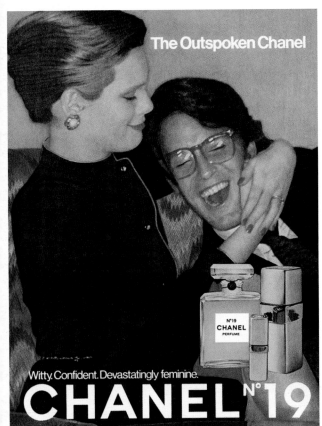

Chanel No. 5 Perfume, 1977 ◄ Chanel No. 19 Perfume, 1977

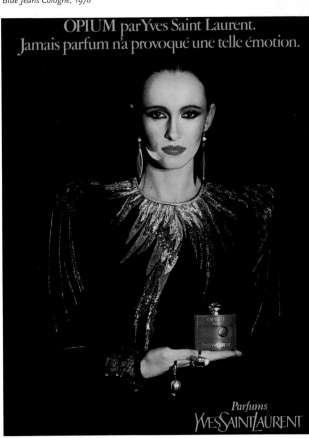

Opium Perfume, 1979

Smitty did it.

Smitty's the spirited, sexy new feeling in fragrance. Smitty gives you a feeling that's electric, exciting. And only Smitty does it.

Smitty by Coty

© Coty, N.Y.
Available in Canada.

Smitty Cologne, 1972

MARK EDEN IS THE WORLD'S MOST SUCCESSFUL BUSTLINE DEVELOPER

"I increased my Bustline from 35" to a full 39" in just 8 weeks with the Mark Eden Developer"

says Anita Paul:

"This year with fashion demanding a really good bustline I decided to try the Mark Eden method. After just 8 weeks on the program, I have achieved truly fantastic results. My bustline lifted and became much more shapely and increased in size from 35" to a full, firm 39". You can imagine how pleased I am — I am really delighted with and proud of my new figure!"

WHAT IS THE MARK EDEN METHOD? The Mark Eden Method is a tremendously exciting concept of bustline development. It is not a cream, not an artificial stimulator. It is an exerciser that employs special techniques, safely and effectively—the degree of effectiveness turning upon factors which vary among individuals—with thousands of women throughout America reporting remarkable success in enlarging, shaping and firming their bustlines to their loveliest proportions.

THE MARK EDEN EXCLUSIVE MONEY BACK GUARANTEE: The four women shown here are just a few of the many, many women who are reporting gains of from 3 to 5 inches on their bustlines—and while we do not state that every woman will receive results, thousands upon thousands of women are reporting that the Mark Eden Developer has given them the kind of bustline development they have always dreamed of ...And if the Mark Eden Developer does not produce for you the results which have delighted so many of our customers, this guarantee is your protection: If after using the Mark Eden Bustline Developer and Course for only two weeks, you do not see a significant difference in your bustline development, simply return the Developer and course to Mark Eden and your money will be promptly refunded.

THE PRICE IS ONLY $9.95 COMPLETE! You receive the fabulous Mark Eden Developer ...You receive a complete course of instructions, fully illustrated by photographs, which shows and tells you exactly how to use this remarkable developer for your maximum results ...and you receive the Mark Eden MONEY BACK GUARANTEE.

Anita Paul today— a full 39"

NOW READ WHAT OTHER WOMEN HAVE TO SAY ABOUT THE MARK EDEN DEVELOPER:

Mrs. Myralin Collins, Grand Prairie, Texas: "I can hardly believe my own results. I have increased my bust from a 34B to a 36D in just 30 days with the Mark Eden Developer."

Mrs. Douglas Tidwell, Franklin, Tenn.: "I never dreamed that after four children I would ever regain my bustline, but after just six weeks I have gone from a 32A to a 36C."

Mrs. Sharon Ford, Prospect Harbor, Me.: "I must admit I was a bit skeptical at first, but after eight weeks of use I increased my bustline from 35 inches to 37½ inches. Now after nine months of use I measure a firm 40 inches."

HUNDREDS OF THOUSANDS OF WOMEN DESIRING FULLER, SHAPELIER BUSTLINES HAVE USED THE MARK EDEN DEVELOPER...HERE ARE JUST A FEW OF THE THOUSANDS WHO ARE REPORTING AMAZING RESULTS:

Mark Eden P.O. Box 7843, Dept. LH-11 San Francisco, CA 94120

Mark Eden Bustline Developer, 1971

FIRMS UP PROBLEM AREAS LIKE HIPS, THIGHS AND ABDOMEN

Now for Both Men and Women — The Fabulous New

"MASSAGE" BAND

2,000 Vibrations per Minute — 26 Double Action Pulsating Pads

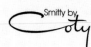

GET BACK IN SHAPE...LOOK AND FEEL YEARS YOUNGER — AND SOLD ON A MONEY-BACK GUARANTEE!

Amazing electronic breakthrough fights flab — abdomen and ...

waistline, hips, even upper arms

JUST LIKE HAVING YOUR OWN PERSONAL HEALTH CLUB

New *Tingler* "Massage" Band has got to be the fastest, easiest, most agreeable way of getting back into shape ever. An amazing electronic breakthrough that's proven safe and effective by thousands. All you do is attach belt around virtually any part of the body you want to tone and tighten ... then relax. Marvelous for flabby abdomen, "spread out" waistline, even those *resistant-to-exercise* problem areas like upper arms and thighs! You couldn't get more effective treatment at expensive spas or health clubs.

DELIGHTFUL "TINGLING" MASSAGE-LIKE SENSATION!

Instantly, you begin to feel a soothing warmth, an invigorating "tingling" sensation. You just know something wonderful is happening. And it is! 26 double-action *oh-so* comfortable pads are vibrating — "massaging" soft, saggy muscles 2,000 times each and every minute. You can actually *feel* muscles tighten, begin to firm like they were when you were young. And because local blood circulation is improved, you feel so much better. You look younger, peppier, too!

MIRROR MUST SHOW RESULTS

You must look in the mirror and be delighted with what you see ... you must be convinced that *The Tingler* "massage" band has helped you ... or your money will be refunded without question. For a figure that looks and feels younger, order now! One size fits all — men and women. Packs flat for traveling. Plugs in anywhere.

GREENLAND STUDIOS
4339 Greenland Building, Miami, Florida 33054

MAIL 10-DAY NO-RISK COUPON TODAY

GREENLAND STUDIOS
4339 Greenland Building, Miami, Fla. 33054

You May Charge Your Order

Greenland Studios Massage Band, 1973

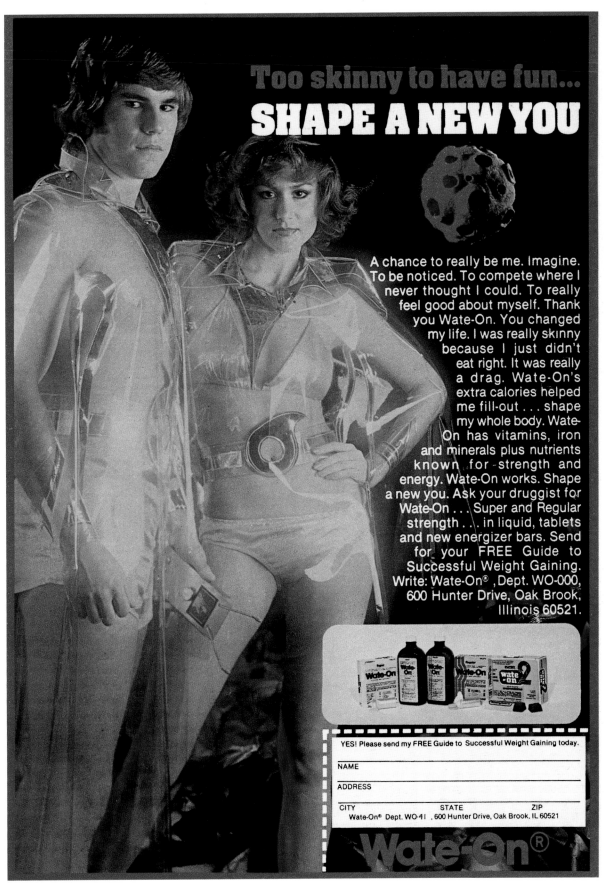

Wate-On Weight Gain Products, 1978

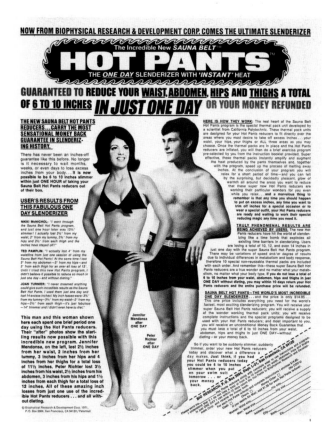

Hot Pants Slenderizer, 1971

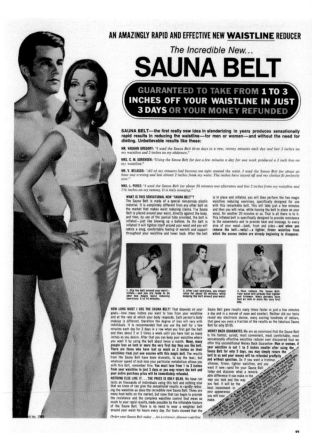

Sauna Belt Waistline Reducer, 1970

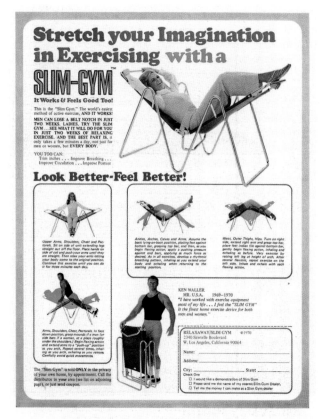

Slim-Gym Exerciser, 1970

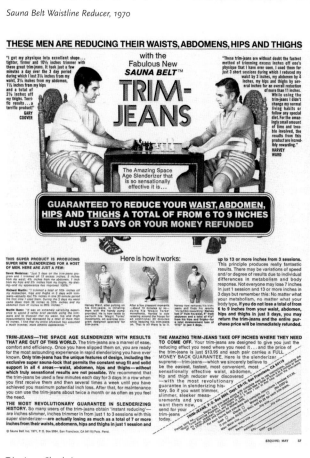

Trim-Jeans Slenderizer, 1971

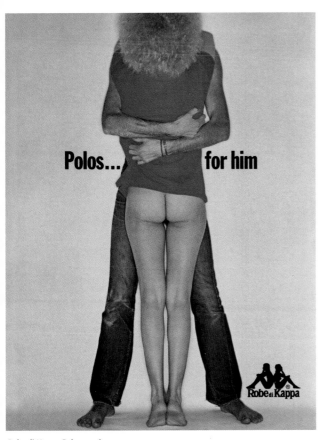

Robe di Kappa Polos, 1976

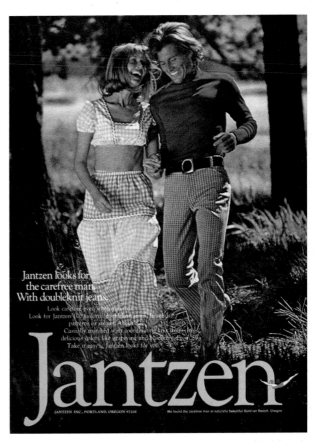

Jantzen Sportswear, 1972

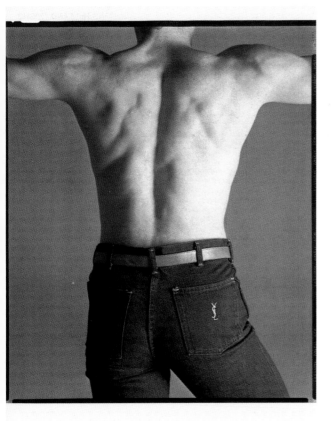

YSL Jeans, 1977

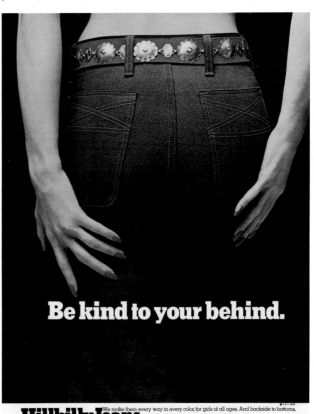

Hillbilly Jeans, 1973

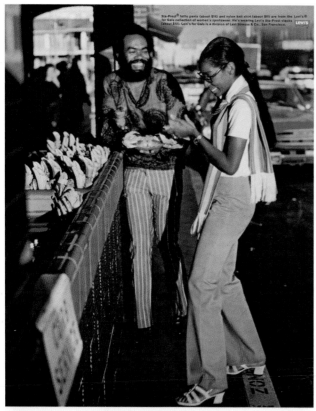

Have you ever had a <u>bad</u> time in Levi's?

Levi's, 1970

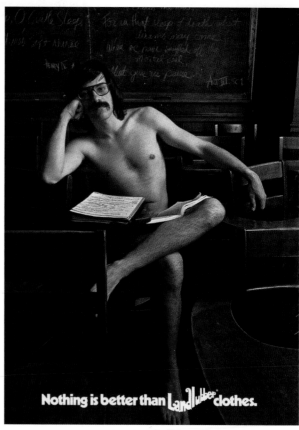

Nothing is better than Landlubber clothes.

Landlubber Clothes, 1971

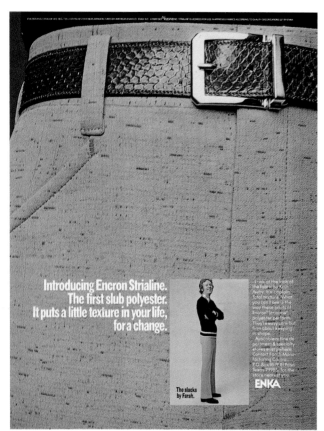

Introducing Encron Strialine.
The first slub polyester.
It puts a little texture in your life,
for a change.

The slacks
by Farah.

ENKA

Enka, 1974

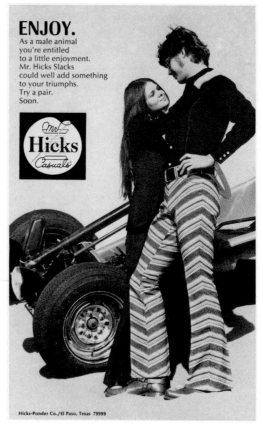

ENJOY.
As a male animal
you're entitled
to a little enjoyment.
Mr. Hicks Slacks
could well add something
to your triumphs.
Try a pair.
Soon.

Hicks Casuals

Hicks-Ponder Co./El Paso, Texas 79999

Mr. Hicks Casuals, 1971 ▶ *Padrino Fashions, 1974*

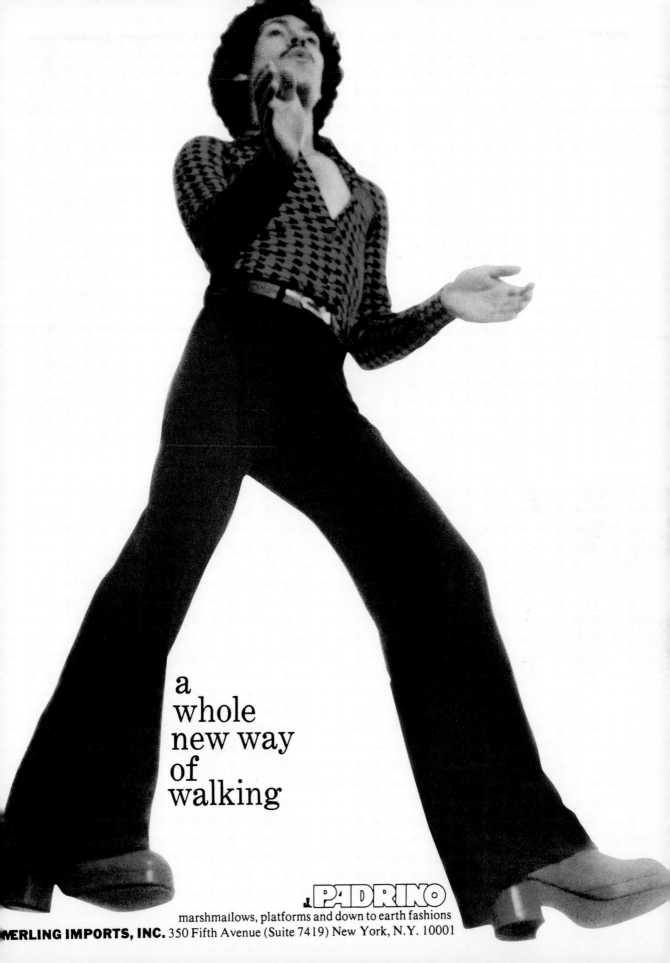

a
whole
new way
of
walking

PADRINO

marshmallows, platforms and down to earth fashions

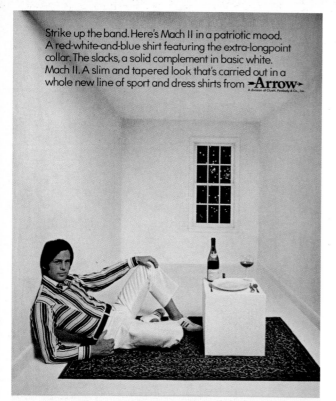

Strike up the band. Here's Mach II in a patriotic mood. A red-white-and-blue shirt featuring the extra-longpoint collar. The slacks, a solid complement in basic white. Mach II. A slim and tapered look that's carried out in a whole new line of sport and dress shirts from **Arrow**

A division of Cluett, Peabody & Co., Inc.

A right-angular state of mind. Mach II.

Arrow Shirts, 1970

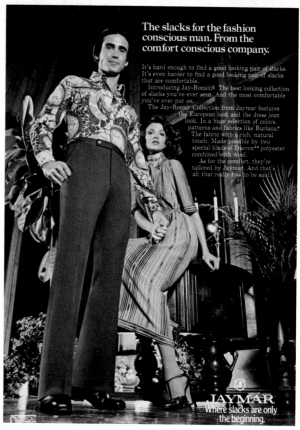

The slacks for the fashion conscious man. From the comfort conscious company.

It's hard enough to find a good looking pair of slacks. It's even harder to find a good looking pair of slacks that are comfortable.

Introducing Jay-Bonair.® The best looking collection of slacks you've ever seen. And the most comfortable you've ever put on.

The Jay-Bonair Collection from Jaymar features the European look and the dress jean look. In a huge selection of colors, patterns and fabrics like Burlana.® The fabric with a rich, natural touch. Made possible by two special kinds of Dacron** polyester combined with wool.

As for the comfort, they're tailored by Jaymar. And that's all that really has to be said.

JAYMAR
Where slacks are only the beginning.

Jaymar Slacks, 1976

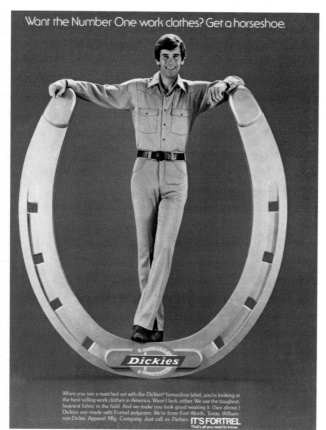

Want the Number One work clothes? Get a horseshoe.

When you see a matched set with the Dickies® horseshoe label, you're looking at the best selling work clothes in America. Wasn't luck, either. We use the toughest, heaviest fabric in the field. And we make you look good wearing it. (See above.) Dickies are made with Fortrel polyester. We're from Fort Worth, Texas. Williamson-Dickie Apparel Mfg. Company. Just call us Dickies. **IT'S FORTREL** That's all you need to know.

Dickies Work Clothes, 1979

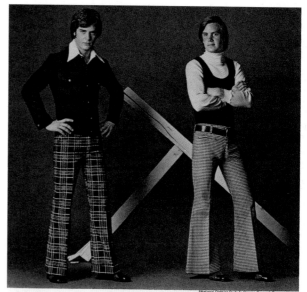

You'll thank Cheap Jeans™ for making it with Cotton Corduroy,
at a time like this.

*National Clothing Study by Opinion Research Bureau

Before, during and after games, 83% of American men want comfort first in clothing.* Cotton is comfortable because it breathes. That's why Cheap Jeans™, (a division of U.S. Industries), makes top scoring numbers of 100% cotton corduroy by J. P. Stevens. The sporty plaids and patterns keep your interest. The rugged long wear keeps your spirits high. This fall, the name of the game is cotton. Plaid or houndstooth check trouser jean, in navy or brown; 26 to 38. Left, $15.50; right, $14.50. Battle jacket, 36 to 44, $14.00. At fine stores.

1370 AVE. OF THE AMERICAS, NEW YORK, N.Y. 10019 • LOS ANGELES • RALEIGH • DALLAS • WASHINGTON **COTTON INCORPORATED**

Cotton Incorporated, 1973

▶ *Levi's, 1971*

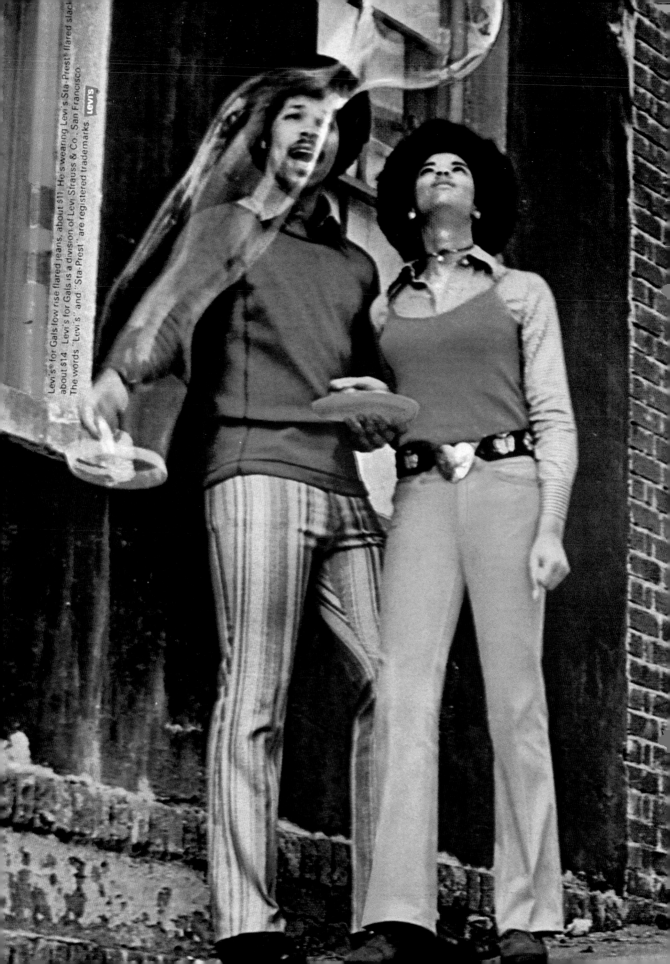

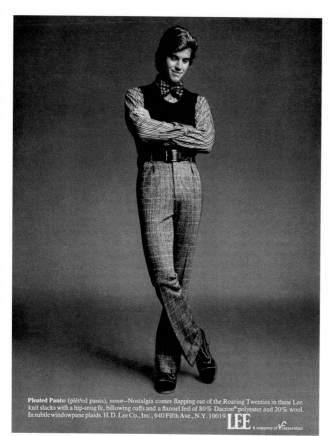

Lee Slacks, 1972

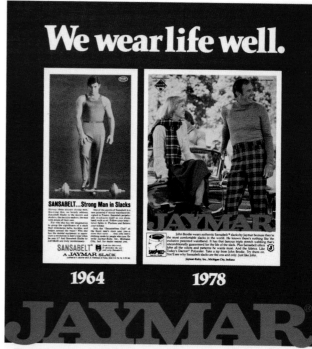

Jaymar Sportswear, 1978

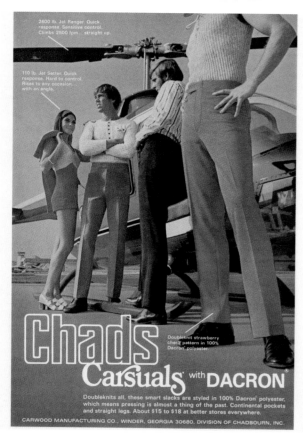

Chads Slacks, 1971

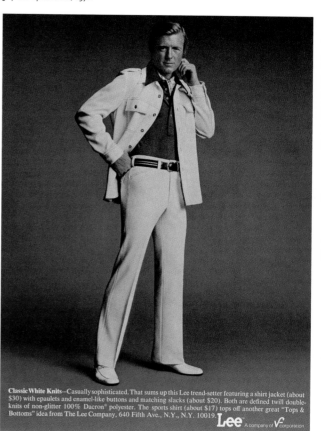

Lee Knits, 1975

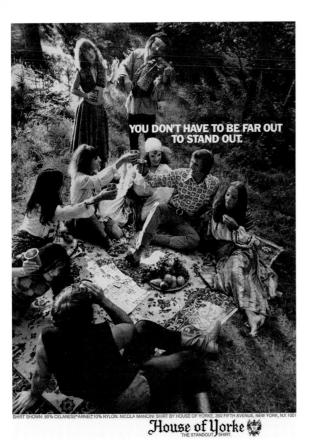

House of Yorke Shirts, 1971

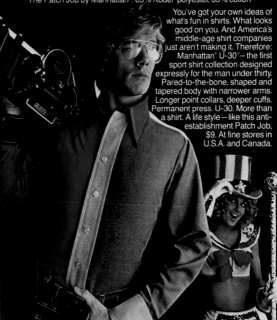

Manhattan Shirts, 1971

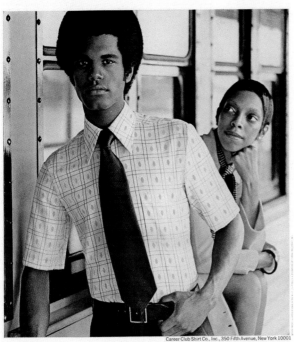

Career Club Shirts, 1972

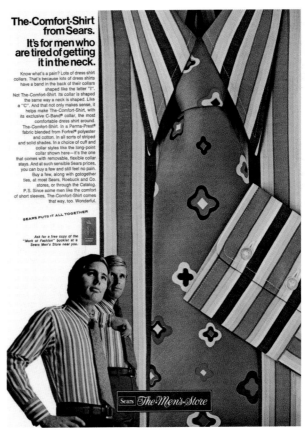

Sears Department Stores, 1971

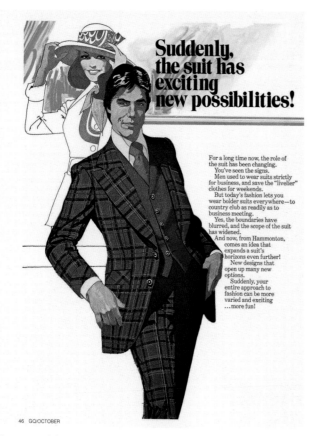

Suddenly, the suit has exciting new possibilities!

For a long time now, the role of the suit has been changing.

You've seen the signs.

Men used to wear suits strictly for business, and save the "livelier" clothes for weekends.

But today's fashion lets you wear bolder suits everywhere—to country club as readily as to business meeting.

Yes, the boundaries have blurred, and the scope of the suit has widened.

And now, from Hammonton, comes an idea that expands a suit's horizons even further!

New designs that open up many new options.

Suddenly, your entire approach to fashion can be more varied and exciting ...more fun!

46 GQ/OCTOBER

Hammonton Suits, 1975

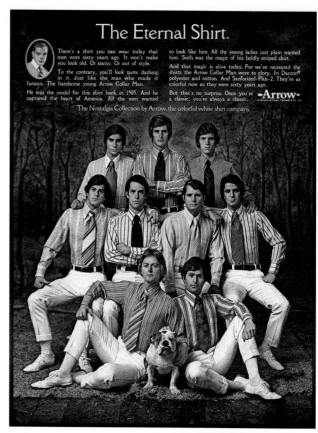

The Eternal Shirt.

There's a shirt you can wear today that men wore sixty years ago. It won't make you look old. Or corny. Or out of style.

To the contrary, you'll look quite dashing in it. Just like the man who made it famous. The handsome young Arrow Collar Man.

He was the model for this shirt back in 1905. And he captured the heart of America. All the men wanted to look like him. All the young ladies just plain wanted him. Such was the magic of his boldly striped shirt.

And that magic is alive today. For we've recreated the shirts the Arrow Collar Man wore to glory. In Dacron® polyester and cotton. And Sanforized-Plus-2. They're as colorful now as they were sixty years ago.

But that's no surprise. Once you're a classic, you're always a classic.

Arrow A division of Cluett, Peabody & Co. Inc.

The Nostalgia Collection by Arrow, the colorful white shirt company.

Arrow Shirts, 1971

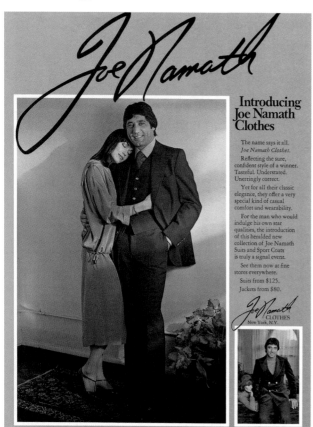

Joe Namath

Introducing Joe Namath Clothes

The name says it all. *Joe Namath Clothes.*

Reflecting the sure, confident style of a winner. Tasteful. Understated. Unerringly correct.

Yet for all their classic elegance, they offer a very special kind of casual comfort and wearability.

For the man who would indulge his own star qualities, the introduction of this heralded new collection of Joe Namath Suits and Sport Coats is truly a signal event.

See them now at fine stores everywhere.

Suits from $125.
Jackets from $80.

Joe Namath CLOTHES
New York, N.Y.

Joe Namath Clothes, 1977

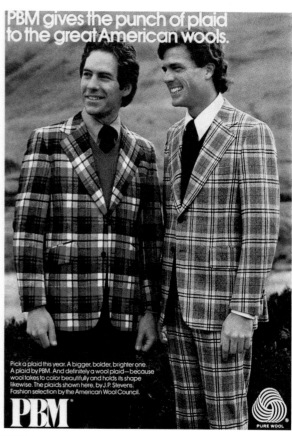

PBM gives the punch of plaid to the great American wools.

Pick a plaid this year. A bigger, bolder, brighter one. A plaid by PBM. And definitely a wool plaid—because wool takes to color beautifully and holds its shape likewise. The plaids shown here, by J.P. Stevens. Fashion selection by the American Wool Council.

PBM

PURE WOOL

PBM Wools, 1973

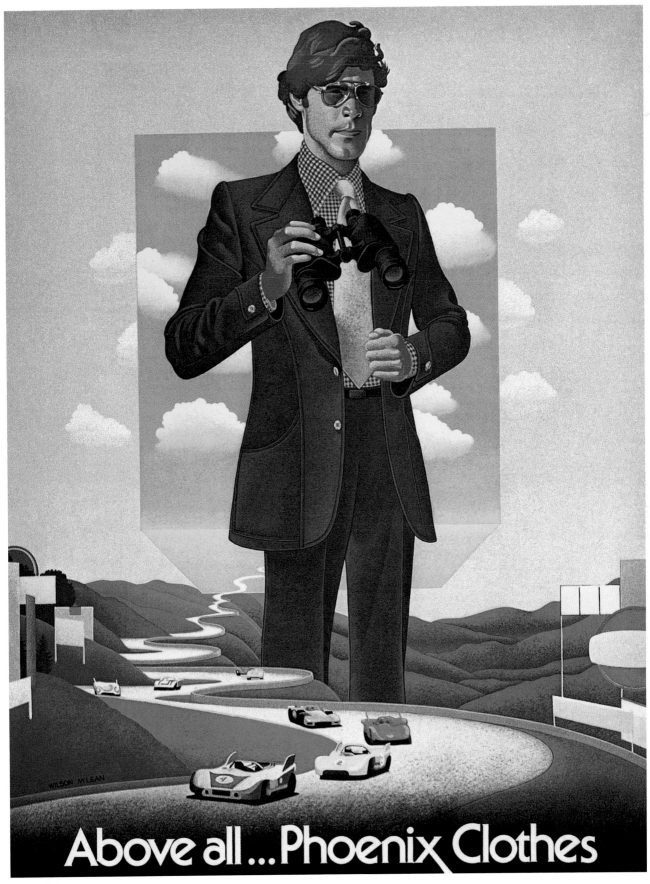

Above all ... Phoenix Clothes

Phoenix Clothes, 1974

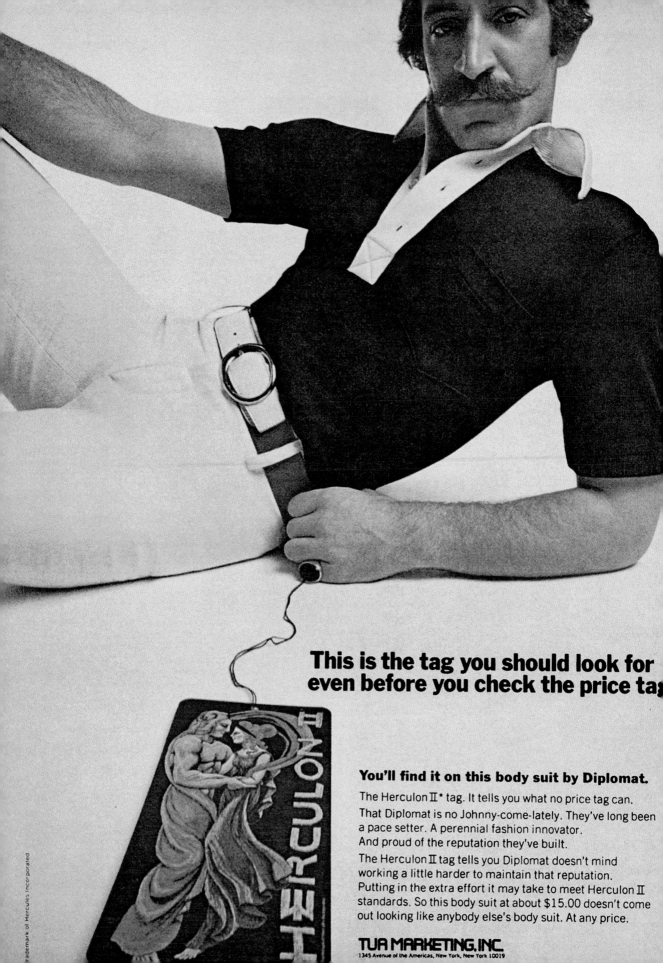

This is the tag you should look for even before you check the price tag

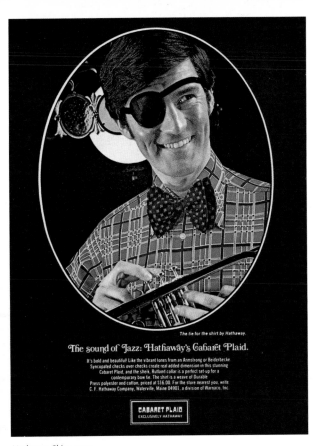

Hathaway Shirts, 1973

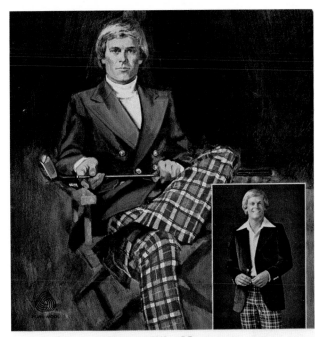

Johnny Miller Menswear, 1976

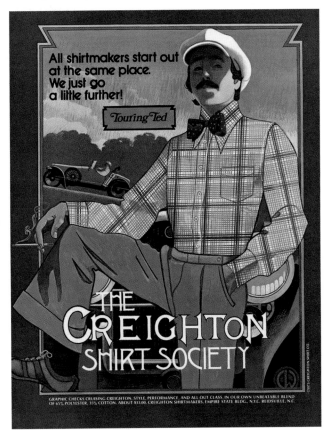

Herculon II, 1973 ◀ *Creighton Shirts, 1974*

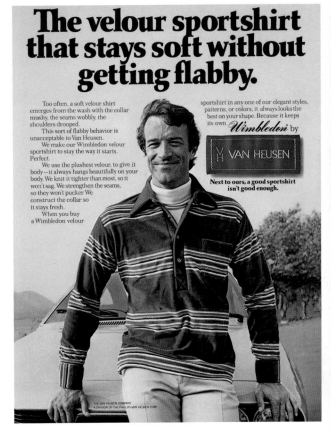

Van Heusen Sportshirts, 1977

Here's Johnny!

...great mixer that he is, with his sport duo that blends polyester for easy care, finespun wool for a soft touch and linen for a crisp, summer look. For complete coordination, add the Johnny Carson shirts and ties especially designed for the duo. See it all at fine stores throughout the United States and Canada.

Johnny Carson Apparel, Inc.

For name of nearest dealer, write to 2020 Elmwood Ave., Buffalo, N.Y. 14216 Canadian residents, write to 637 Lakeshore Blvd. W., Toronto 20, Ontario

Johnny's Sport Duo is 61% polyester, 28% wool worsted and 11% linen.

photographed by Howell Conant at Tres Vidas, Acapulco, Mexico

Johnny Carson Apparel, 1974

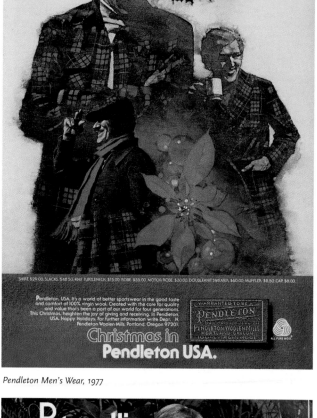

SHIRT, $29.00. SLACKS, $48.50. KNIT TURTLENECK, $15.00. ROBE, $55.00. MOTOR ROBE, $30.00. DOUBLEKNIT SWEATER, $60.00. MUFFLER, $8.50. CAP $8.00.

Pendleton, USA. It's a world of better sportswear in the good taste and comfort of 100% virgin wool. Created with the care for quality and value that's been a part of our world for four generations. This Christmas, heighten the joy of giving and receiving. In Pendleton, USA. Happy Holidays. For further information write Dept. N. Pendleton Woolen Mills, Portland, Oregon 97201.

WARRANTED TO BE A PENDLETON
PENDLETON WOOLEN MILLS
PORTLAND OREGON
100% VIRGIN WOOL
ALL PURE WOOL

Christmas in Pendleton USA.

Pendleton Men's Wear, 1977

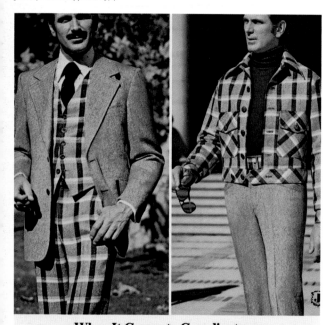

When It Comes to Coordinates...
THE NAME OF THE GAME IS THE NAME!

This Fall, Jaymar re-affirms its continuation of a seemingly lost art—providing your favorite men's and department store with a New World of Coordinated Sportcoats, Jackets and Slacks tailored to Old World quality.

Coordinates of every popular color, cut and pattern, designed to look lavish yet made to wear and wear and wear!

This season's featured Coordinate is a daring Donegal tweed that doubles itself in

one sure shot. It's a five-piece favorite of 100% wool. Other Jaymar Coordinates come in textured, spun and double-knit polyesters. And all the slacks feature Ban-Rol* to prevent waistband roll-over.

So if you're looking for a "look", if you care about quality, consider this: when it comes to Coordinates, the name of the game is the name! Consider Jaymar. Jaymar-Ruby, Inc., Michigan City, Indiana 46360.

JAYMAR® COORDINATES WITH BAN-ROL*
Made by people who care...for people who care®

*Reg. T.M. Ban-Rol Co.

©Jaymar-Ruby, Inc. 1974

Jaymar Coordinates, 1974

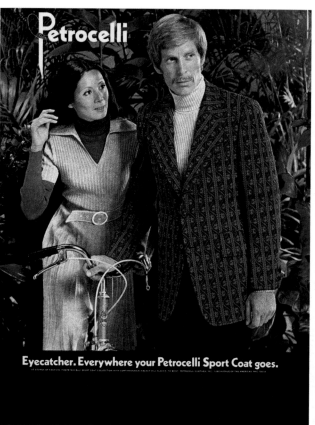

Petrocelli

Eyecatcher. Everywhere your Petrocelli Sport Coat goes.

Petrocelli Sport Coats, 1972

► *Johnny Carson Apparel, 1974*

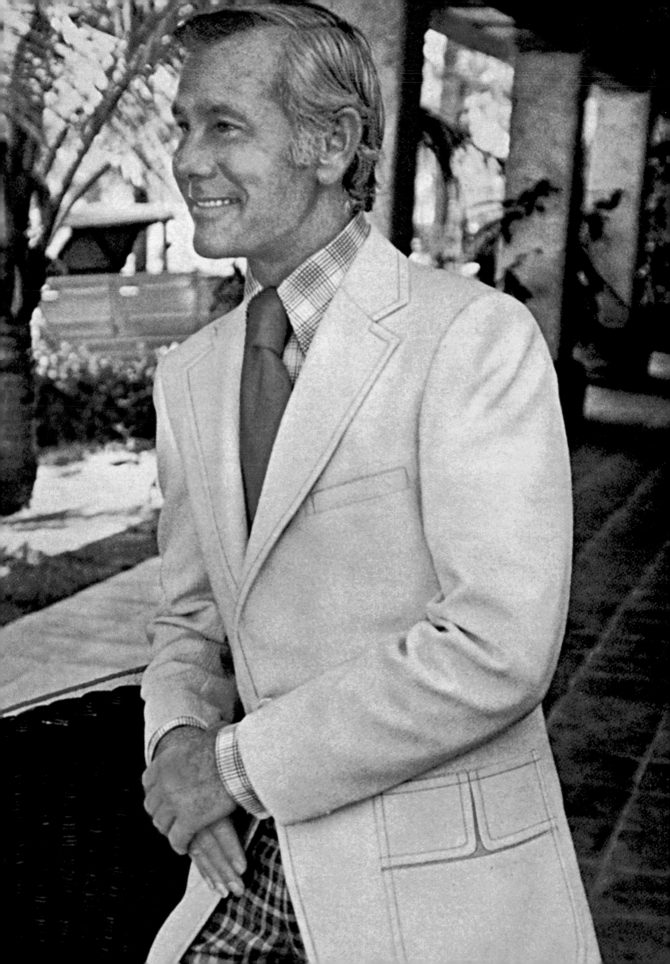

Encron Strialine Polyester, 1976

Geoffrey Beene Men's Wear, 1974

Enkalure Nylon, 1975

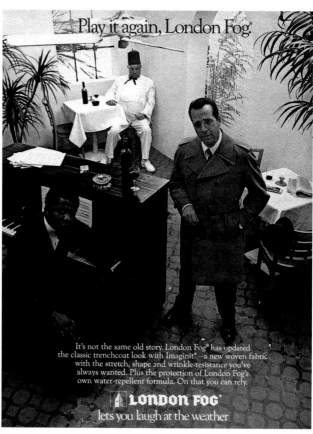

London Fog Trench Coats, 1972 ▶ *Rainfair Trench Coats, 1975*

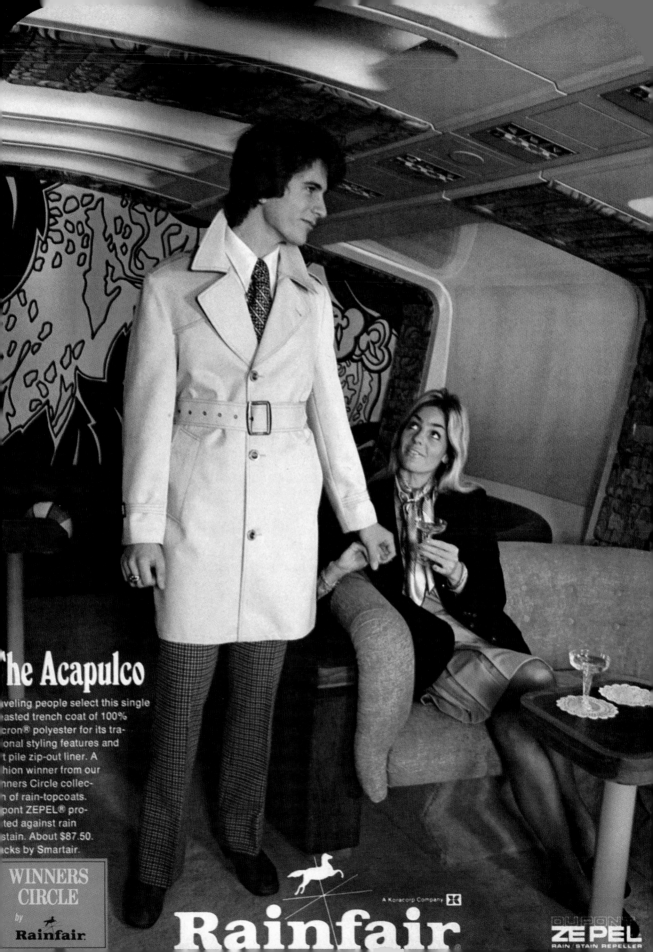

The Acapulco

...aveling people select this single
...asted trench coat of 100%
...cron® polyester for its tra-
...onal styling features and
... pile zip-out liner. A
...hion winner from our
...nners Circle collec-
...n of rain-topcoats.
...pont ZEPEL® pro-
...ted against rain
...stain. About $87.50.
...cks by Smartair.

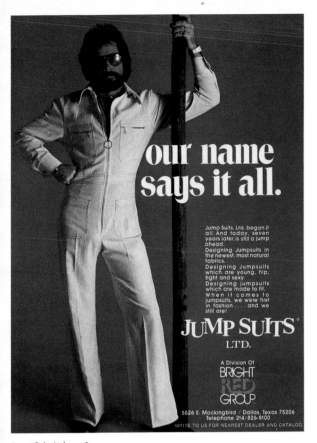

Jump Suits Ltd., 1976

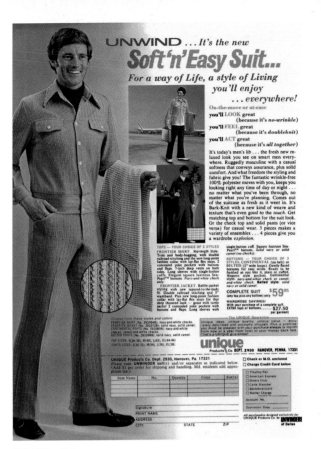

Soft 'n' Easy Suit, 1974

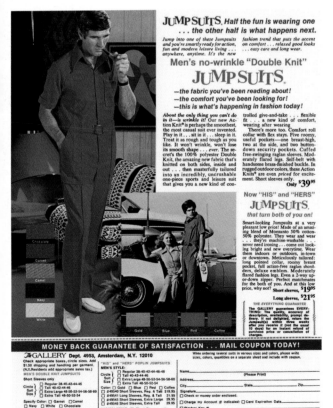

Jump Suits Ltd., 1972 ◄ *Jump Suits Ltd., 1972*

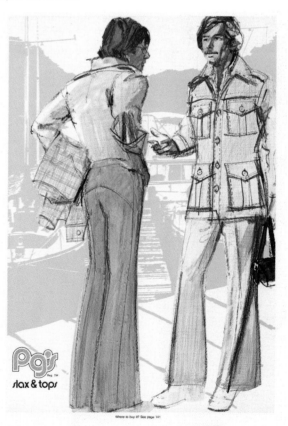

Pg's Sportswear, 1975

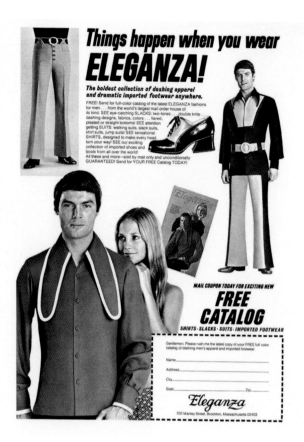

Eleganza Men's Wear, 1972

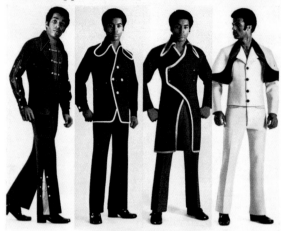

Eleganza Men's Wear, 1972

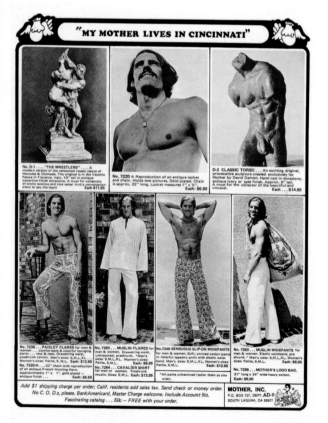

Mother, Inc. Mail Order, 1972

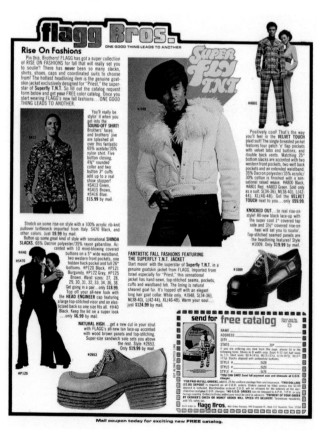

Flagg Bros. Men's Fashions, 1973 ▶ *Flagg Bros. Men's Fashions, 1974*

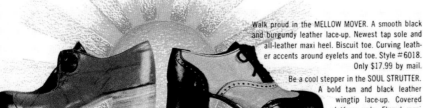
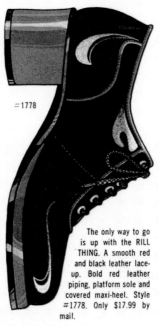
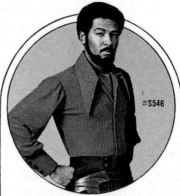
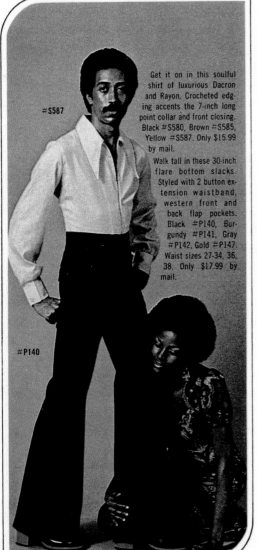

Jantzen Sportswear, 1973

Jantzen Sportswear, 1974

Modern Art

Jantzen sets
the new direction
for swimwear in these
soft, stylish knits.
An action brief of
DuPont ANTRON® nylon
and LYCRA® spandex,
a shirt of ANTRON.
They're pure "Body Art"™—
from just one of the
collections that makes
Jantzen #1 in swimwear.

Jantzen Swimwear, 1976

▶ *Sir Jac Jackets, 1971*

THE SATURDAY MORNING JACKET

Action-Back Poplin Tee·Jacs with Ze Pel®

Happy, nostalgic Saturday. Lots of people grow used to our Tee Jacs. Some grow out of them, and need new ones. At your favorite store or write Stahl Urban Co., Empire State Bldg., New York, N.Y. 10001

®ZE PEL IS DUPONT'S REGISTERED TRADEMARK FOR ITS RAIN AND STAIN REPELLER

sir jac

100 years of making it...right

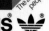

Pua Hawaii Surf Line, 1978

Adidas Warm Ups, 1977

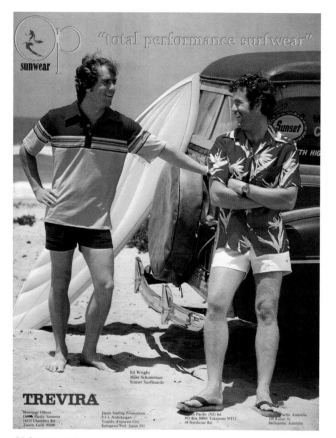

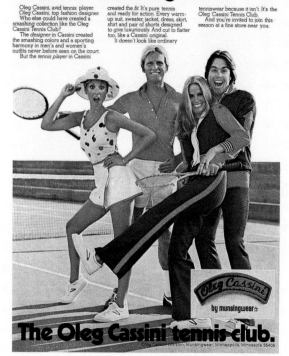

OP Sunwear, 1978

Oleg Cassini Tennis Wear, 1974

Neets n Grubs™ from Sears.

As comfortable when they're new as most jeans are when they're old.

We went to a lot of trouble to make our new jeans feel old.

To begin with, they're made from a fabric blended especially for us. Part Trevira® polyester, part Avril® rayon and part Lycra® spandex. They're Perma-Prest® jeans. Stretchable jeans. And as comfortable as your bleach-worn grubby jeans.

Only they're neats. Flares with belt loops and plain fronts. In stripes, plaids and solids. In Trim Regular or Trim n' Tight. And only in The Jeans Joint at most Sears, Roebuck and Co. stores, or through the Catalog.

Now you know why we call them Neets n Grubs. And why they're probably the most comfortable jeans you've ever worn. Right from the beginning.

SUPPLIER FOR THE U.S. OLYMPIC TEAM

THE NEW JEANS JOINT IN

Sears *The Men's Store* KING'S ROAD

Sears Department Store, 1971

Wool. It's got life.

PURE WOOL

ALL MAN, PART PURITAN®

In durable Aquaknit® machine wash-and-dry sweaters of pure wool. Wool. It's got life. And Aquaknits have the longest life of all. That's why they're the best selling, full-fashioned sweaters of their kind. Wear Peerdale, the classic favorite of demanding men everywhere. When the look is all man, the sportswear is all Puritan.

PURITAN® THE WARNACO GROUP Altona, Penna. 15603

Puritan's machine washable and dryable lambswool and shetland yarns are spun by Woonsocket Spinning Company, Division of Amicale Yarn, Inc.

Puritan Sweaters, 1971

Underflair!

A few bare inches of smooth, supple, shape-showing maleness in soft Egyptian cotton. In colors that dare. In stores that care.

Le French Brief by *Eminence* PARIS

Eminence International Inc., 12 West 18th Street, N.Y., N.Y. 10011.

Eminence Briefs, 1978

Return to Paradise

with the underwear more comfortable than nothing at all! Adam Briefs' exciting new "Jean Look" print gives you the feel and fit of your favorite pair of jeans. The next time you change underwear, experience Paradise with the casual comfort of Adam's exciting "Jean Look" briefs.

Adam Briefs™
P.O. Box 4090
Beverly Hills, California 90213

where to buy it? See page 189

Adam Briefs, 1976

477

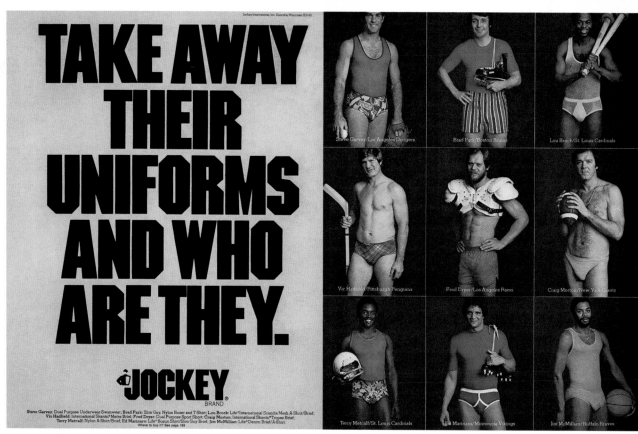

Jockey Underwear, 1976

Maybe you should wear two jock straps.

Most men buy their athletic supporter mainly for swimming. They also use it for jogging, tennis, golf, softball and a lot more. But even though most men buy a jock mainly for swimming, not very many men buy a real swimming jock. That's why Bike thinks you ought to wear two jock straps. For swimming, our #58 Nylon Swimmer. It's a sleek racer design made to dry in a flash (which avoids chafing), with a narrow elastic waistband that won't show above your swim suit. For jogging, tennis, golf, softball and a lot more, our famous Pro 10 Supporter. It's the deluxe jock that we designed for deluxe jocks like pro football and tennis players. It's also a fast-drying, long lasting supporter with no rolling or bunching of the leg straps and waistband after washing. Look for the Bike display in your sporting goods or department store.

BIKE®

The Kendall Company, Sports Division, Wellesley Hills, Mass.

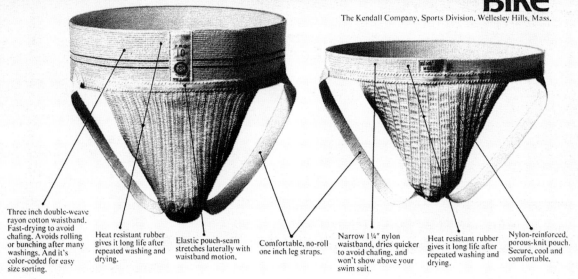

Three inch double-weave rayon cotton waistband. Fast-drying to avoid chafing. Avoids rolling or bunching after many washings. And it's color-coded for easy size sorting.

Heat resistant rubber gives it long life after repeated washing and drying.

Elastic pouch-seam stretches laterally with waistband motion.

Comfortable, no-roll one inch leg straps.

Narrow 1¼" nylon waistband, dries quicker to avoid chafing, and won't show above your swim suit.

Heat resistant rubber gives it long life after repeated washing and drying.

Nylon-reinforced, porous-knit pouch. Secure, cool and comfortable.

Bike Jock Straps, 1973

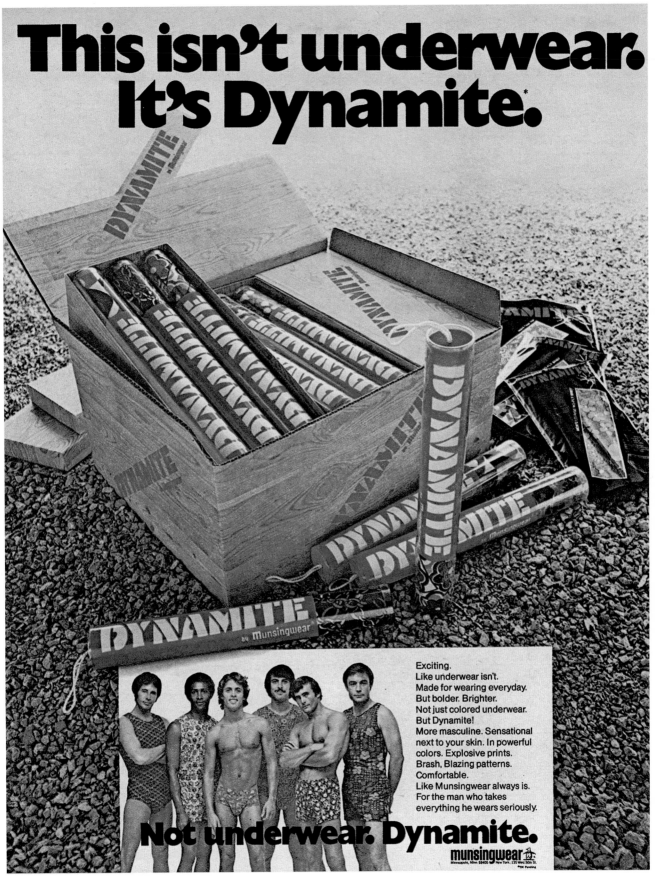

This isn't underwear. It's Dynamite.*

Exciting.
Like underwear isn't.
Made for wearing everyday.
But bolder. Brighter.
Not just colored underwear.
But Dynamite!
More masculine. Sensational
next to your skin. In powerful
colors. Explosive prints.
Brash, Blazing patterns.
Comfortable.
Like Munsingwear always is.
For the man who takes
everything he wears seriously.

Not underwear. Dynamite.

munsingwear

Dynamite Underwear, 1973

▶ *Adam Briefs, 1976*

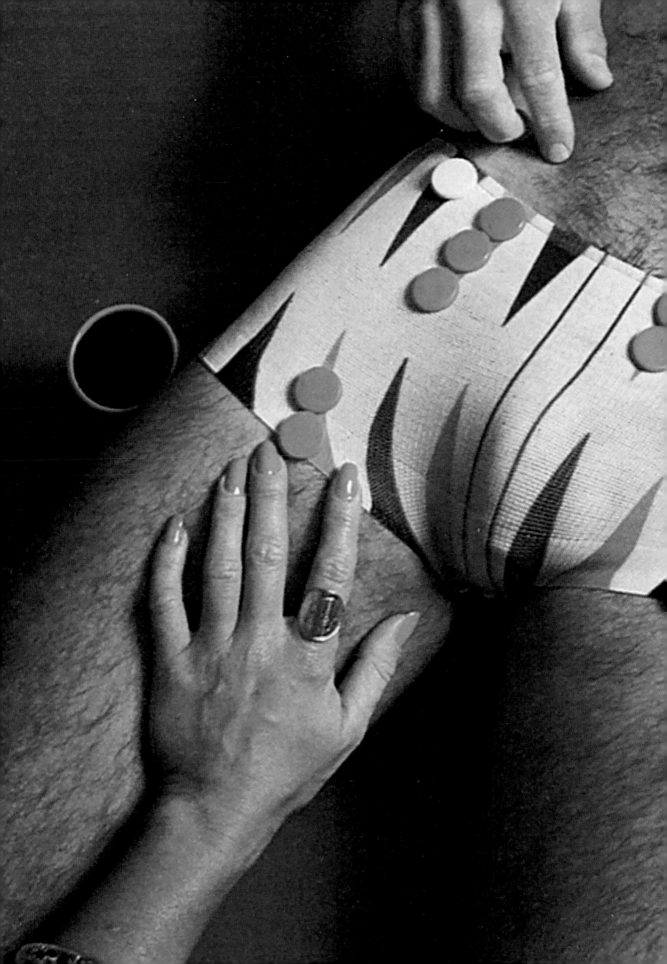

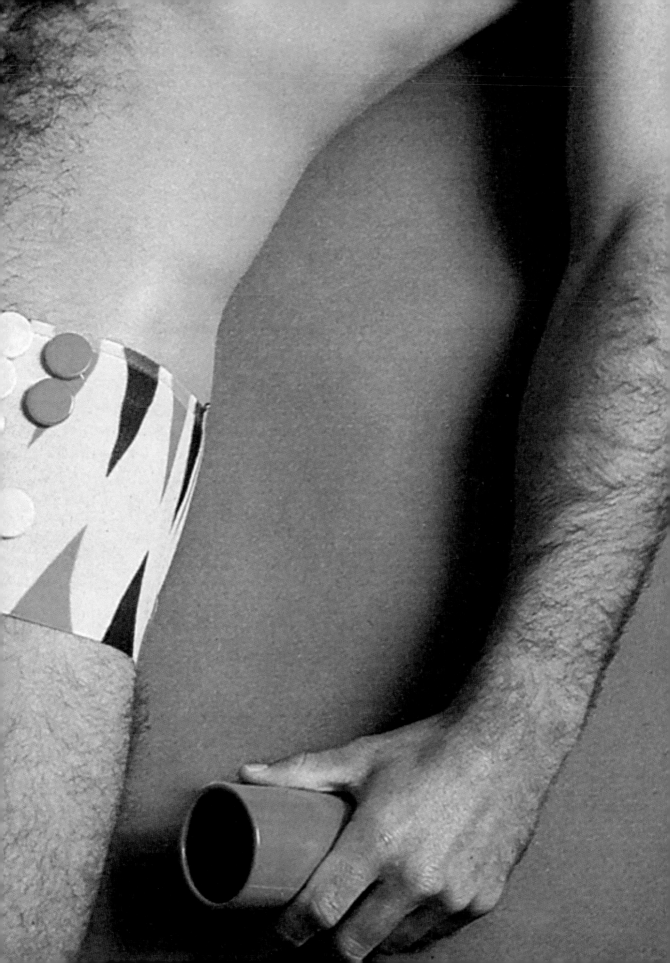

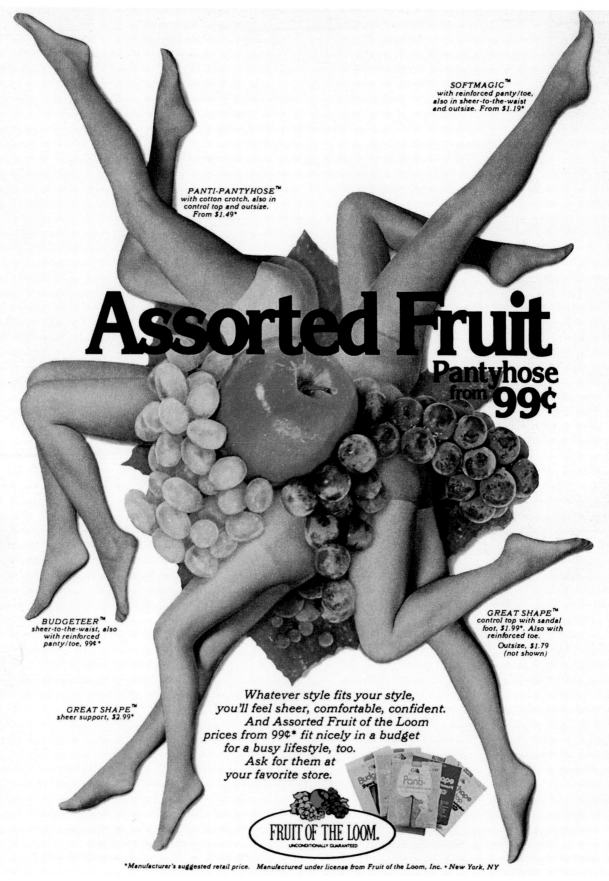

SOFTMAGIC™
with reinforced panty/toe,
also in sheer-to-the-waist
and outsize. From $1.19*

PANTI-PANTYHOSE™
with cotton crotch, also in
control top and outsize.
From $1.49*

Assorted Fruit
Pantyhose from 99¢

BUDGETEER™
sheer-to-the-waist, also
with reinforced
panty/toe, 99¢*

GREAT SHAPE™
control top with sandal
foot, $1.99*. Also with
reinforced toe.
Outsize, $1.79
(not shown)

GREAT SHAPE™
sheer support, $2.99*

Whatever style fits your style,
you'll feel sheer, comfortable, confident.
And Assorted Fruit of the Loom
prices from 99¢* fit nicely in a budget
for a busy lifestyle, too.
Ask for them at
your favorite store.

FRUIT OF THE LOOM.
UNCONDITIONALLY GUARANTEED

*Manufacturer's suggested retail price. Manufactured under license from Fruit of the Loom, Inc. • New York, NY

Fruit of the Loom Panty Hose, 1978

▶ *Interwoven Socks, 1972*

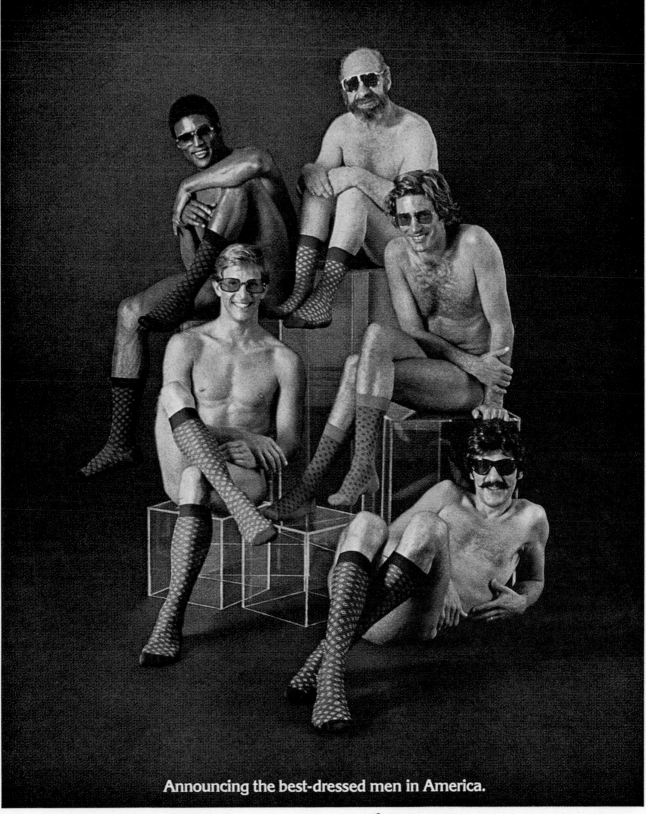

Announcing the best-dressed men in America.

You're looking at a revolution.
The most influential men in America are breaking out of their socks—out of their old, blah, boring, one-color, no-style socks.

At Interwoven/Esquire Socks, we saw it coming all the way. That's why we make the great fashion socks that are making it happen.

In lots of great colors and lengths. All in the first

Ban-Lon® pattern socks ever made. They feel softer and fit better than any sock you've ever worn.

That's why we dress the best-dressed men in America. Or anywhere.

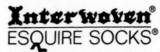 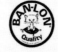

Interwoven®
ESQUIRE SOCKS®

BAN-LON® Quality

Peter Max paints panty hose for Burlington-Cameo.

they come in three proportioned-to-fit sizes, $8.00 each. body stockings, too. one size only, in 2 peter max original designs (not shown). cost $10.00 each. buy the panty hose or body stockings and you get a coupon for a peter max poster. (it's a copy of this page blown up to poster size 24"x36".) send us the coupon you'll find in the package and one dollar to cover handling and postage. we'll send you the poster. who knows, your room might even look as good as your legs.

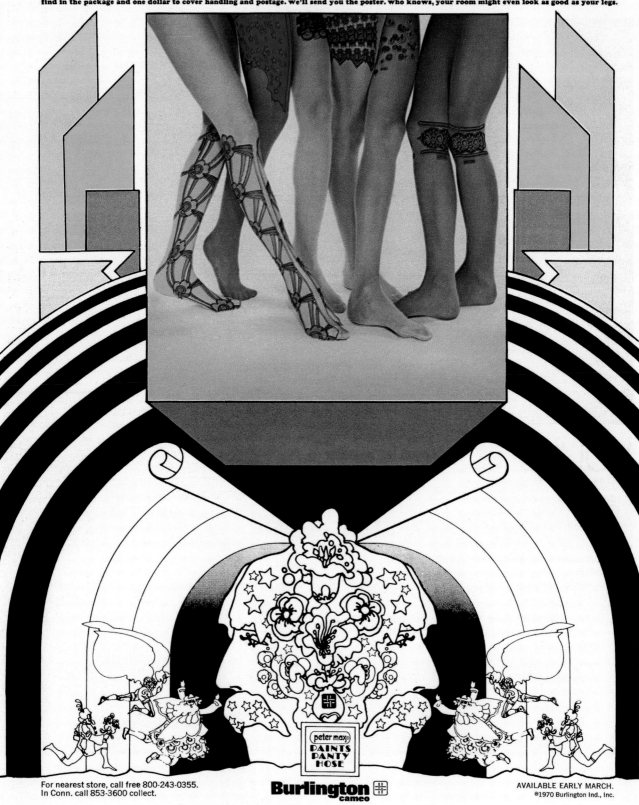

For nearest store, call free 800-243-0355.
In Conn. call 853-3600 collect.

Burlington cameo

AVAILABLE EARLY MARCH.
®1970 Burlington Ind., Inc.

Burlington Panty Hose, 1972

Big Mama,

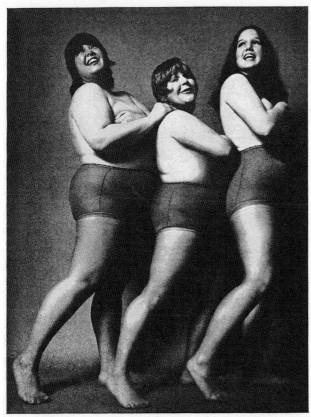

you're beautiful.
(You're even guaranteed for 30-days-wear-or-a-new-pair.)

Beautifully fitting and sheer, from top to toe, be you Large or Extra Large* Big Mama pantyhose—thanks to your new Captiva® nylon yarn's super stretch, strength and wearability.

Beautifully long-wearing, as evidenced by your guarantee of 30 days wear or a new pair, no matter what.

Beautifully practical with your exclusive reusable panty.

Beautifully comfortable, with not a single lump, bump, bulge, seam, or wrinkle to be seen or felt.

Beautifully beautiful in your fifteen luscious sheer shades.

And beautifully economical*, at Ardens Shops, Gemco, Memco, Wonderworld and other fine chain, drug and variety stores everywhere. Or, write: Sheffield Hosiery Mills, 1190 N.W. 159th Drive, Miami, Florida 33169. A division of Sheffield Industries, Inc.

Captiva® nylon. They last.

®TRADE MARK ALLIED CHEMICAL CORPORATION | Allied Chemical |

*Large: 5'-5'9'', 165-230 lbs. Extra Large: 5'-5'9'', 230-260 lbs. Sunlight, beige-tone, tantone, taupetone, cinnamon, twilite, coffee, navy, off-white, off-black, white in all styles. Plus plum, red onion, rust and grey in Large Big Mama only. Large, Extra Large Big Mama pantyhose, $2.49; also in sheer stretch Lycra® Spandex support pantyhose, $3.49: suggested retail prices.

R

Captiva Panty Hose, 1972

Fancy up your legs with these smart new fashion knee highs from Beverly Jane. Choose from a dazzling array of styles and colors, cuffed and uncuffed. Then, pull up your socks. And step out in style. Hanes-Mills, P.O. Box 2105, High Point, North Carolina 27261.

Beverly Jane Hanes
Red Label®

FANCY FOOTWORK.

Hanes Socks, 1977

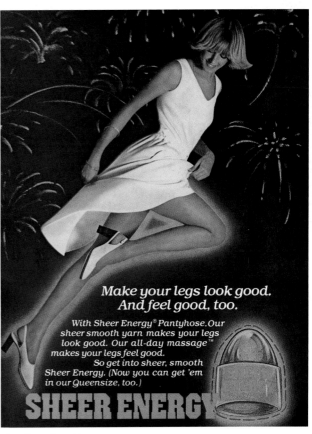

Make your legs look good. And feel good, too.

With Sheer Energy® Pantyhose. Our sheer smooth yarn makes your legs look good. Our all-day massage™ makes your legs feel good.

So get into sheer, smooth Sheer Energy. (Now you can get 'em in our Queensize, too.)

SHEER ENERGY

Sheer Energy Panty Hose, 1977

485

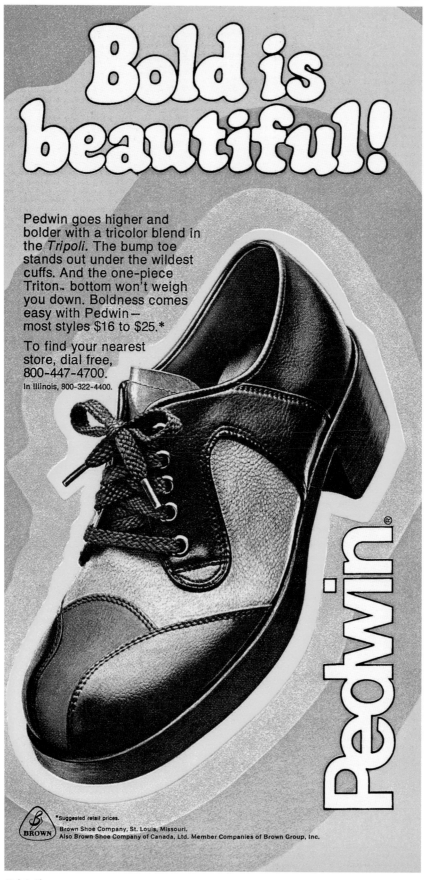

Bold is beautiful!

Pedwin goes higher and bolder with a tricolor blend in the *Tripoli.* The bump toe stands out under the wildest cuffs. And the one-piece Triton™ bottom won't weigh you down. Boldness comes easy with Pedwin— most styles $16 to $25.*

To find your nearest store, dial free, 800-447-4700.

In Illinois, 800-322-4400.

Pedwin®

*Suggested retail prices.
Brown Shoe Company, St. Louis, Missouri.
Also Brown Shoe Company of Canada, Ltd. Member Companies of Brown Group, Inc.

Pedwin Shoes, 1974

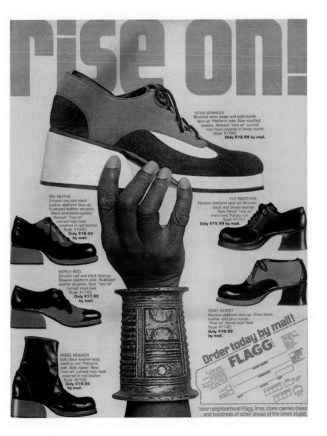

Flagg Bros. Shoes, 1972

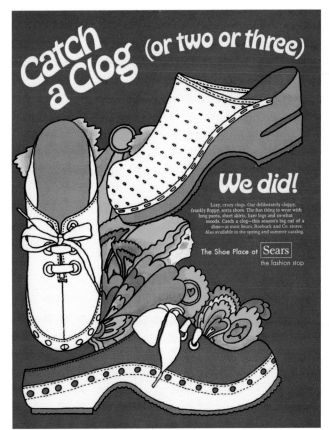

Sears Department Store, 1970

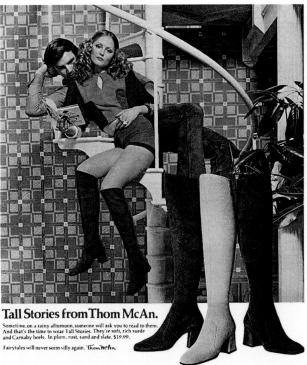

Thom McAn Shoes, 1971

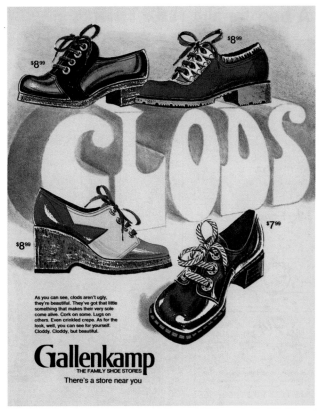

Gallenkamp Shoes, 1972

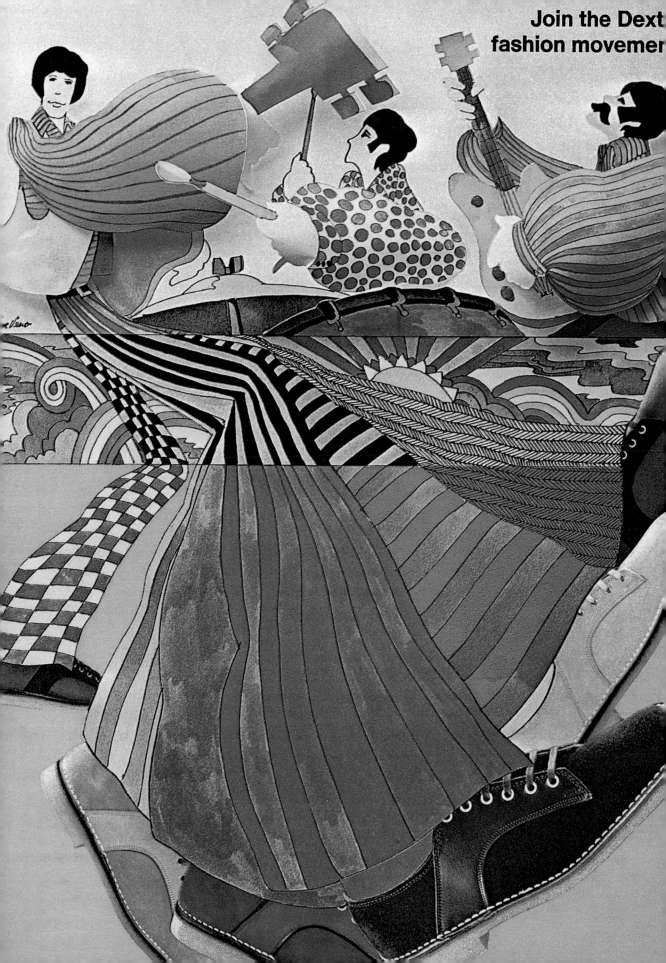

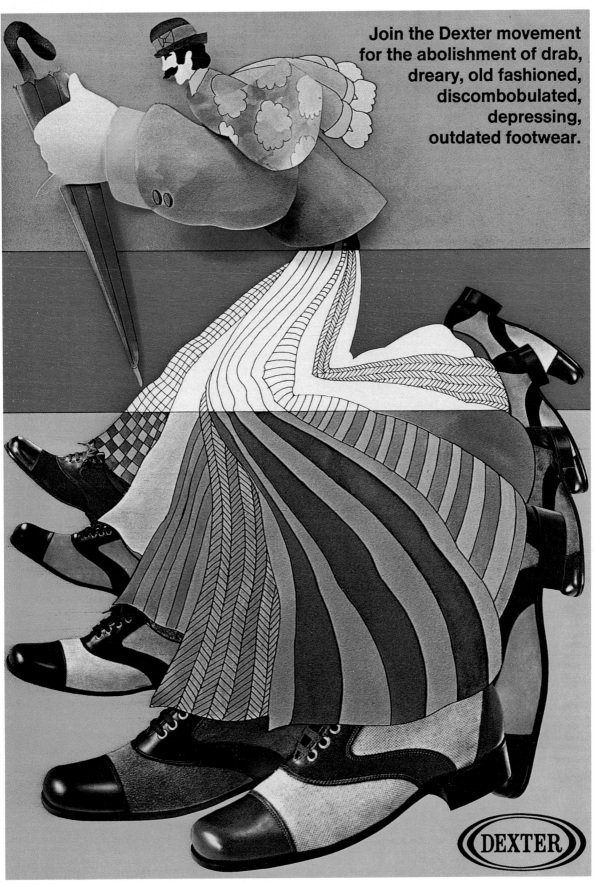

Join the Dexter movement for the abolishment of drab, dreary, old fashioned, discombobulated, depressing, outdated footwear.

DEXTER

Dexter Shoes, 1971 ◄ *Dexter Shoes, 1971*

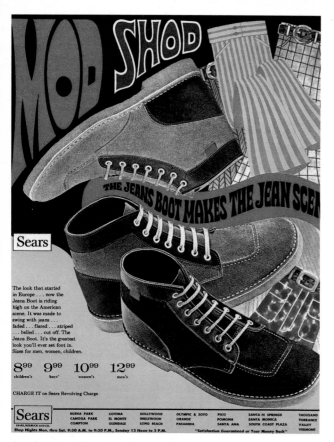

THE JEANS BOOT MAKES THE JEAN SCEN

Sears

The look that started
in Europe . . . now the
Jeans Boot is riding
high on the American
scene. It was made to
swing with jeans . . .
faded . . . flared
. . . belled . . . cut off. The
Jeans Boot. It's the greatest
look you'll ever set foot in.
Sizes for men, women, children.

8⁹⁹ 9⁹⁹ 10⁹⁹ 12⁹⁹
children's boys' women's men's

CHARGE IT on Sears Revolving Charge

Sears
SEARS, ROEBUCK AND CO.
Shop Nights Mon. thru Sat. 9:30 A.M. to 9:30 P.M., Sunday 12 Noon to 5 P.M.

BUENA PARK	COVINA	HOLLYWOOD	OLYMPIC & SOTO	PICO	SANTA FE SPRINGS	THOUSAND
CANOGA PARK	EL MONTE	INGLEWOOD	ORANGE	POMONA	SANTA MONICA	TORRANCE
COMPTON	GLENDALE	LONG BEACH	PASADENA	SANTA ANA	SOUTH COAST PLAZA	VALLEY
						VERMONT

"Satisfaction Guaranteed or Your Money Back"

Sears Department Store, 1971

Announcing the Sunshine Shoes.

The world can always use more sunshine. And we've done our part
with these new Hush Puppies. We start with pigskin suede. One of the softest,
most comfortable leathers in the world. Then we add the colors of sunsets and dawns and trees and lakes.
And we shape it all into the brightest, bounciest, sunniest shoes
that ever walked down the street. Try a pair.
They make life a little brighter. From about $15.

They're more than shoes. They're Hush Puppies®

Products of
WOLVERINE
WORLD WIDE ©1972 Wolverine World Wide, Inc., Rockford, Michigan 49351, makers of Hush Puppies® shoes and boots.

Hush Puppies Shoes, 1972

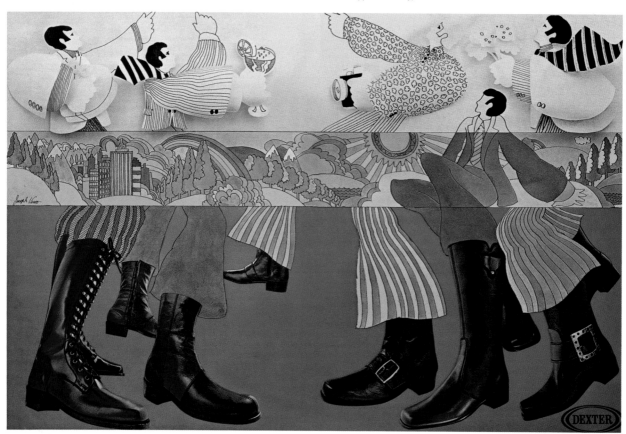

Dexter Shoes, 1971

▶ *DingoBoots, 1977*

490 Fashion & Beauty

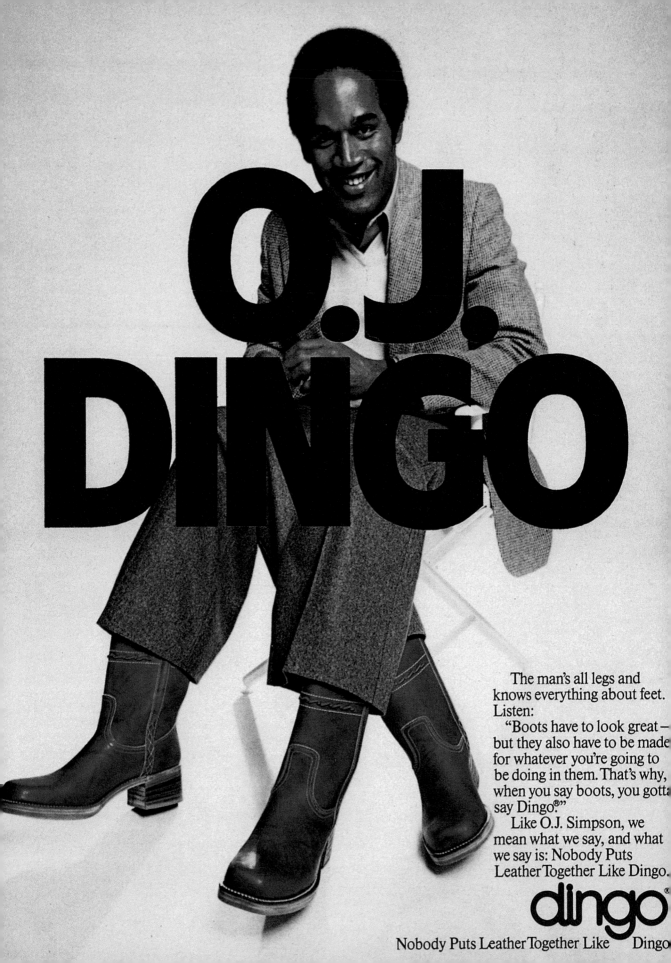

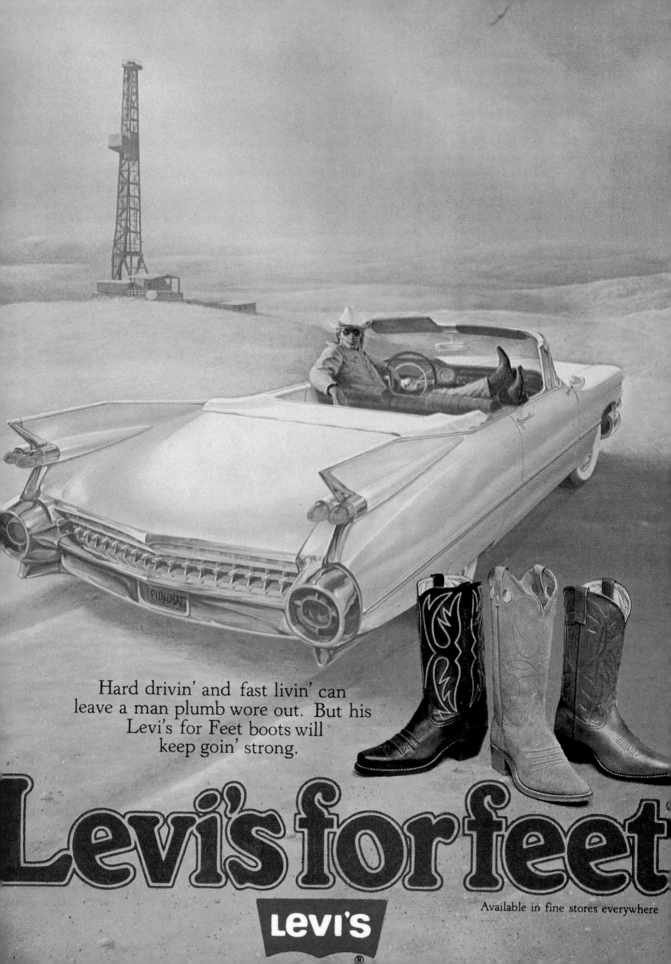

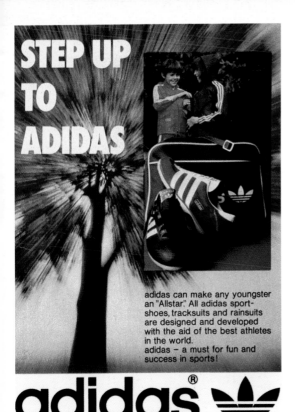

Adidas Athletic Shoes, 1975

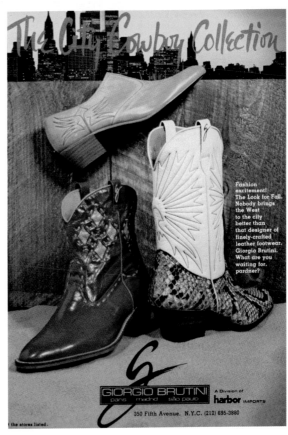

Giorgio Brutini Boots, 1979

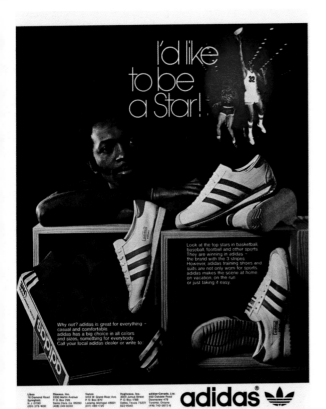

Levi's Boots, 1979 ◄ Adidas Athletic Shoes, 1973

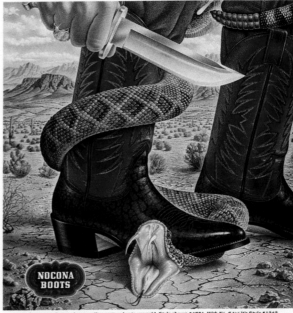

Nocona Boots, 1979

You'll get a boot out of this.
$5.88 a pair.

Where can you possibly find hook and eyelet lace-up boots, with side zippers, stretch shiny vinyl uppers, 1½ inch man-made heel, man-made soles, 16 inches high for $5.88 a pair?

At Wards. If you're ready for a boot, we're ready

for you. In brown, black and white.

Open a Wards "Charg-All" account. It makes shopping simpler in our stores and catalogs.

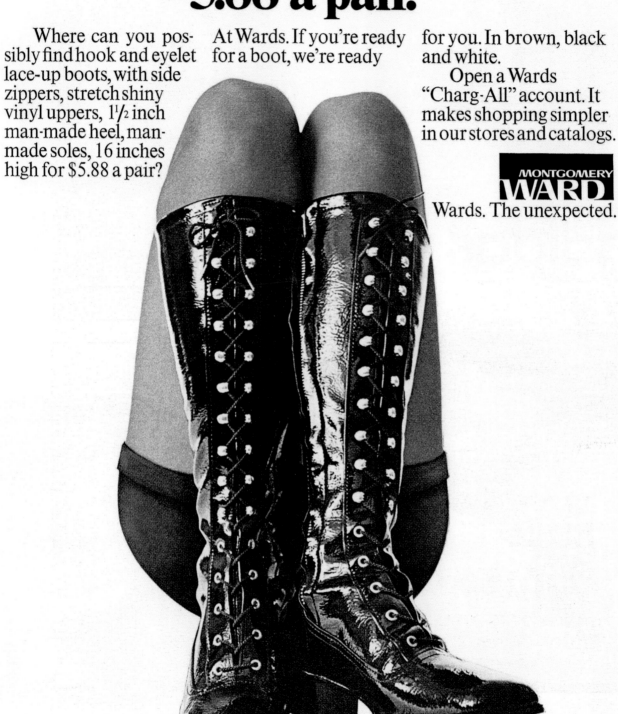

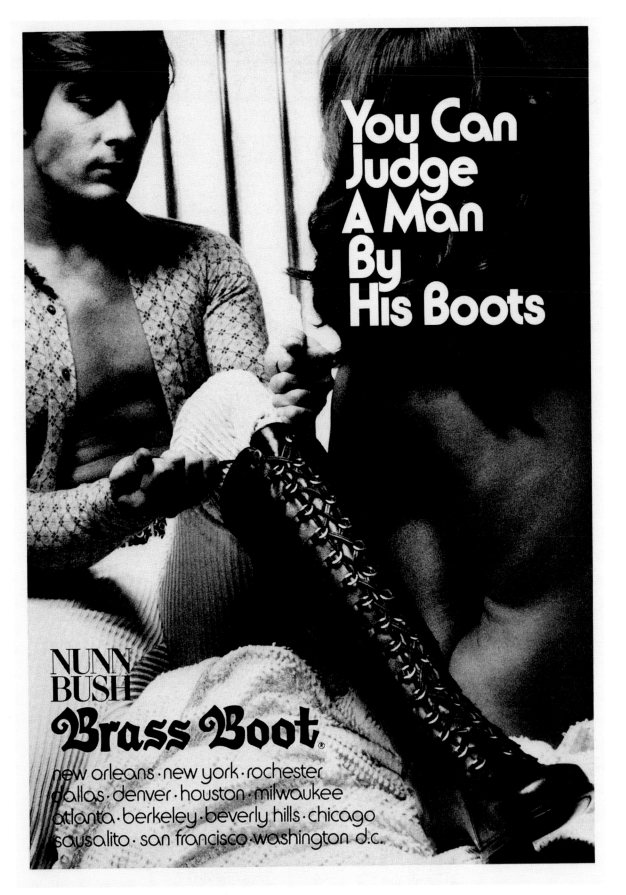

You Can Judge A Man By His Boots

NUNN BUSH
Brass Boot.
new orleans · new york · rochester
dallas · denver · houston · milwaukee
atlanta · berkeley · beverly hills · chicago
sausalito · san francisco · washington d.c.

Montgomery Ward Department Store, 1971, ◄ Nunn Bush Boots, 1971

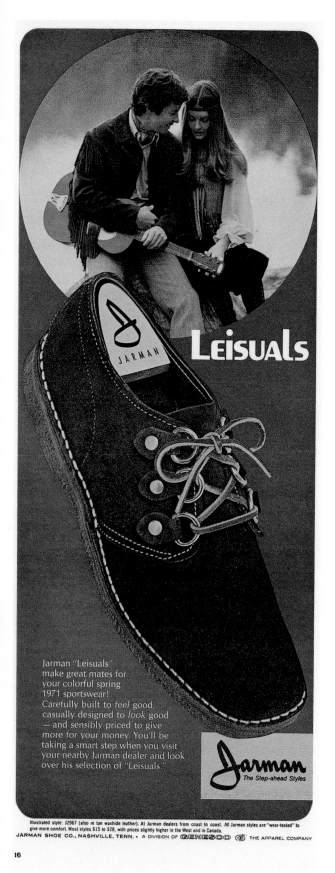

Leisuals

Jarman "Leisuals" make great mates for your colorful spring 1971 sportswear! Carefully built to *feel* good, casually designed to *look* good — and sensibly priced to give more for your money. You'll be taking a smart step when you visit your nearby Jarman dealer and look over his selection of "Leisuals."

Jarman
The Step-ahead Styles

Illustrated style: J2967 (also in tan waxhide leather). At Jarman dealers from coast to coast. All Jarman styles are "wear-tested" to give more comfort. Most styles $15 to $28, with prices slightly higher in the West and in Canada.
JARMAN SHOE CO., NASHVILLE, TENN. • A DIVISION OF **GENESCO** THE APPAREL COMPANY

16

Jarman Shoes, 1971

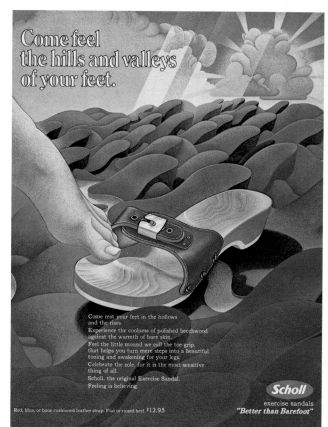

Come feel the hills and valleys of your feet.

Come rest your feet in the hollows and the rises.
Experience the coolness of polished beechwood against the warmth of bare skin.
Feel the little mound we call the toe-grip, that helps you turn mere steps into a beautiful toning and awakening for your legs.
Celebrate the sole, for it is the most sensitive thing of all.
Scholl, the original Exercise Sandal.
Feeling is believing.

Red, blue, or bone cushioned leather strap. Flat or raised heel. $12.95

Scholl
exercise sandals
"Better than Barefoot"

Dr. Scholl's Sandals, 1974

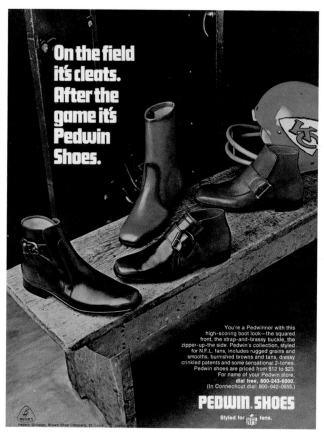

On the field it's cleats. After the game it's Pedwin Shoes.

You're a Pedwinner with this high-scoring boot look—the squared front, the strap-and-brassy buckle, the zipper-up-the-side. Pedwin's collection, styled for N.F.L. fans, includes rugged grains and smooths, burnished browns and tans, dressy crinkled patents and some sensational 2-tones. Pedwin shoes are priced from $12 to $23. For name of your Pedwin store, dial free, 800-243-6000. (In Connecticut dial: 800-942-0655.)

PEDWIN SHOES
Styled for NFL fans.

Pedwin Division, Brown Shoe Company, St. Louis.

Pedwin Shoes, 1972

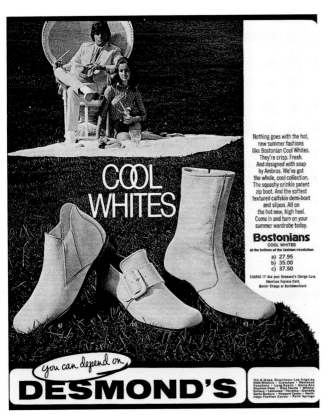

COOL WHITES

Nothing goes with the hot, new summer fashions like Bostonian Cool Whites. They're crisp. Fresh. And designed with snap by Ambros. We've got the whole, cool collection. The squashy crinkle patent zip boot. And the softest textured calfskin demi-boot and slipon. All on the hot new, high heel. Come in and turn on your summer wardrobe today.

Bostonians
COOL WHITES
at the bottom of the fashion revolution
a) 27.95
b) 35.00
c) 37.50

CHARGE IT! Use your Desmond's Charge Card, American Express Card, Master Charge or BankAmericard

you can depend on
DESMOND'S

7th & Hope, Downtown Los Angeles · 5560 Wilshire · Crenshaw · Westwood · Pasadena · Long Beach · Santa Ana · Sherman Oaks · West Covina · Whittier · Ventura · Lakewood · Torrance · Glendale · Santa Barbara · Newport Center · Northridge Fashion Center · Palm Springs

Desmond's Department Store, 1972

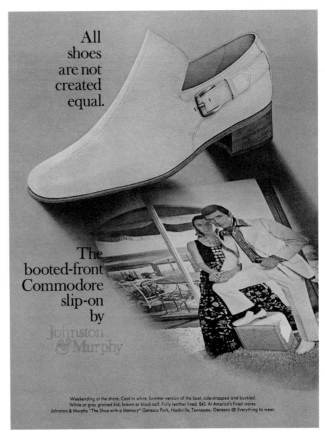

All shoes are not created equal.

The booted-front Commodore slip-on by
Johnston & Murphy

Weekending at the shore. Cool in white. Summer version of the boot, side-strapped and buckled. White or grey grained kid; brown or black calf. Fully leather lined. $45. At America's finest stores. Johnston & Murphy "The Shoe with a Memory" Genesco Park, Nashville, Tennessee. Genesco ⊕ Everything to wear.

Johnston & Murphy Shoes, 1971

THE NEWEST COLOR SENSATION IN MEN'S AND WOMEN'S CASUAL FOOTWEAR

Crayons by PADRINO

COLORFUL, LIGHTWEIGHT CRAYONS™ IN CANVAS, MESH AND NUBUCK LEATHER UPPERS COORDINATED WITH TRANSLUCENT, FLEXIBLE, COLORFUL SIGNATURE CRAYONS™ SOLES.

AT SMERLING IMPORTS, INC., 350 FIFTH AVENUE, NEW YORK, N.Y. 10001
Los Angeles, California Mart, Rm. A442, Los Angeles, Ca. 90015 · Smerling Imports Canada, Ltd., 251 Barkley Dr., Toronto, Ontario M4A-2N7 Canada

Padrino Footwear, 1977

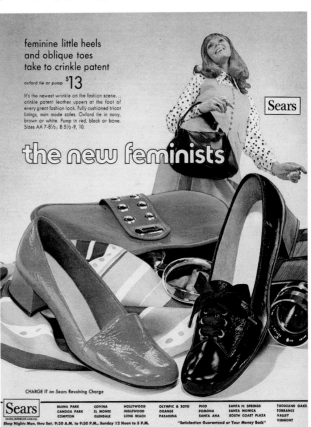

feminine little heels and oblique toes take to crinkle patent

oxford tie or pump $13

It's the newest wrinkle on the fashion scene... crinkle patent leather uppers at the foot of every great fashion look. Fully cushioned tricot linings, man made soles. Oxford tie in navy, brown or white. Pump in red, black or bone. Sizes AA 7-8½; B 5½-9, 10.

Sears

the new feminists

CHARGE IT on Sears Revolving Charge

Sears
SEARS, ROEBUCK AND CO.
Shop Nights Mon. thru Sat. 9:30 A.M. to 9:30 P.M., Sunday 12 Noon to 5 P.M.

BUENA PARK	COVINA	HOLLYWOOD	OLYMPIC & SOTO	PICO	SANTA FE SPRINGS	THOUSAND OAKS
CANOGA PARK	EL MONTE	INGLEWOOD	ORANGE	POMONA	SANTA MONICA	TORRANCE
COMPTON	GLENDALE	LONG BEACH	PASADENA	SANTA ANA	SOUTH COAST PLAZA	VALLEY · VERMONT

"Satisfaction Guaranteed or Your Money Back"

Sears Department Store, 1971

If it's now we have it— at savings!

QualiCraft
shapes the uncovered cover-up. Wraps of straps making the merry match for shortpants. White crinkle, studded in brass and wrapping up knee-hi, 8.99. Waxy brown leather, thigh-circling, at 6.99. Funshiner newness, and they're priced nice!

6⁹⁹ & 8⁹⁹

Leeds

Now Your BankAmericard Welcome Here

Buy them at your nearby Leed's—96 stores in California • Mail Orders: Leed's, 731 S. Broadway, Los Angeles 90014
Mail orders, add 60¢ per pair postage plus sales tax. (Sorry—No C. O. D.'s)

Leeds Stores, 1971

▶ *Weyenberg Massagic Footwear, 1972*

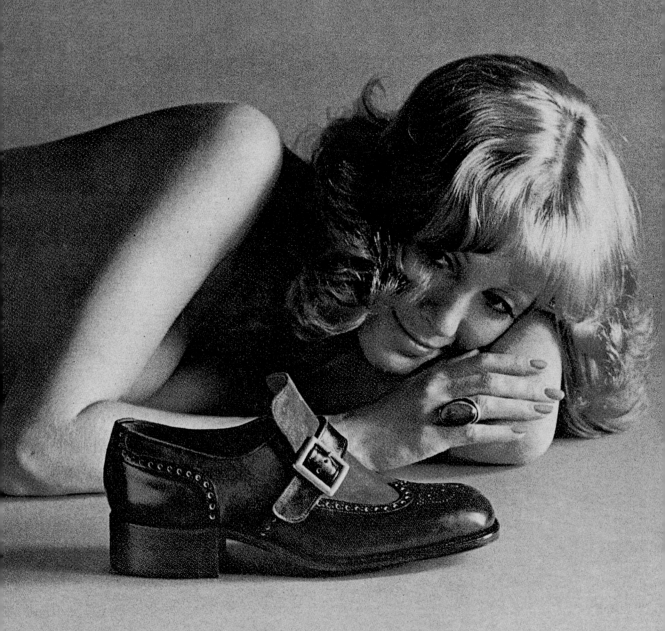

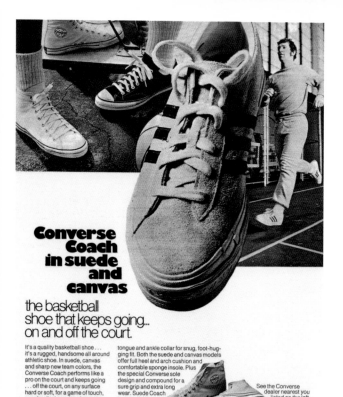

Converse Coach in suede and canvas

the basketball shoe that keeps going... on and off the court.

It's a quality basketball shoe... it's a rugged, handsome all around athletic shoe. In suede, canvas and sharp new team colors, the Converse Coach performs like a pro on the court and keeps going ... off the court, on any surface hard or soft, for a game of touch, mowing the lawn, jogging, you name it. The new suede Coach is in cool, supple, napped glove leather for beautiful, long-lasting comfort, and it boasts a padded

tongue and ankle collar for snug, foot-hugging fit. Both the suede and canvas models offer full heel and arch cushion and comfortable sponge insole. Plus the special Converse sole design and compound for a sure grip and extra long wear. Suede Coach in natural, blue, gold and black Oxford. Canvas Coach in black and white Hi-Top and Oxford. More sports heroes from Converse.

See the Converse dealer nearest you — listed on the left.

★ **converse**

Converse Athletic Shoes, 1971

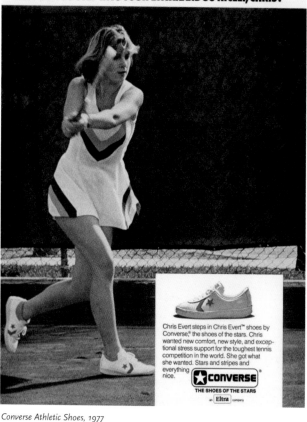
"I can play better than you. 'Cause I practice every day. I wear P.F Flyers. And my dad is Hank Aaron."

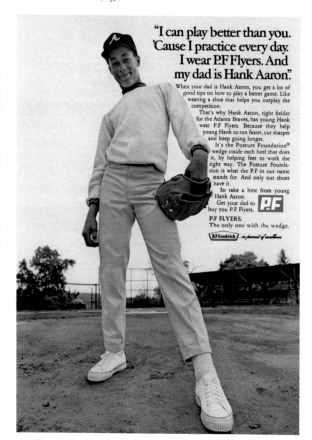

When your dad is Hank Aaron, you get a lot of good tips on how to play a better game. Like wearing a shoe that helps you outplay the competition.

That's why Hank Aaron, right fielder for the Atlanta Braves, has young Hank wear P.F Flyers. Because they help young Hank to run faster, cut sharper and keep going longer.

It's the Posture Foundation® wedge inside each heel that does it, by helping feet to work the right way. The Posture Foundation is what the P.F in our name stands for. And only our shoes have it.

So take a hint from young Hank Aaron.

Get your dad to buy you P.F Flyers. **P.F**

P.F. FLYERS.
The only one with the wedge.

B.F.Goodrich *...a partner of excellence*

P.F. Flyers Athletic Shoes, 1971

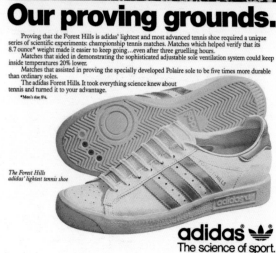

Our proving grounds.

Proving that the Forest Hills is adidas' lightest and most advanced tennis shoe required a unique series of scientific experiments: championship tennis matches. Matches which helped verify that its 8.7 ounce* weight made it easier to keep going...even after three gruelling hours.

Matches that aided in demonstrating the sophisticated adjustable sole ventilation system could keep inside temperatures 20% lower.

Matches that assisted in proving the specially developed Polaire sole to be five times more durable than ordinary soles.

The adidas Forest Hills. It took everything science knew about tennis and turned it to your advantage.

*Men's size 8½.

The Forest Hills adidas' lightest tennis shoe

adidas ✦
The science of sport.

Adidas Athletic Shoes, 1979

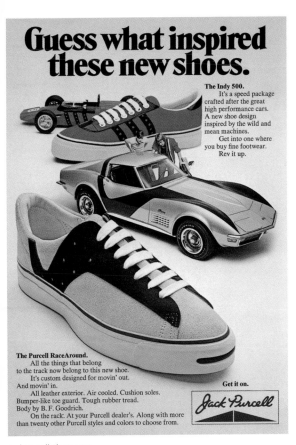

Guess what inspired these new shoes.

The Indy 500.
It's a speed package crafted after the great high performance cars. A new shoe design inspired by the wild and mean machines.
Get into one where you buy fine footwear. Rev it up.

The Purcell RaceAround.
All the things that belong to the track now belong to this new shoe.
It's custom designed for movin' out.
And movin' in.
All leather exterior. Air cooled. Cushion soles. Bumper-like toe guard. Tough rubber tread. Body by B. F. Goodrich.
On the rack. At your Purcell dealer's. Along with more than twenty other Purcell styles and colors to choose from.

Get it on.

Jack Purcell

Jack Purcell Shoes, 1972

The best double coverage on the court. Wigwam Socks and Converse All Stars.®

Wigwam Socks and Converse All Stars. They work together for fit, feel, support, and comfort. From one end of the court to the other.

Wigwam Socks come high or low, in different styles and colors to match your All Stars.

Converse All Stars, high-cut or low, in smooth leather, suede or canvas, in your team colors. To match your Wigwams.

Put your best feet forward this season. Put them in Wigwam Socks and Converse All Stars.

Wigwam Socks and Converse All Stars.

Converse Athletic Shoes/Wigwam Socks, 1974

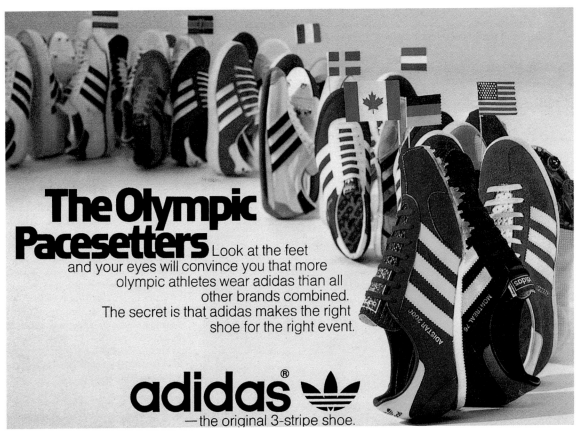

The Olympic Pacesetters

Look at the feet and your eyes will convince you that more olympic athletes wear adidas than all other brands combined. The secret is that adidas makes the right shoe for the right event.

adidas®
—the original 3-stripe shoe.

Adidas Athletic Shoes, 1976

501

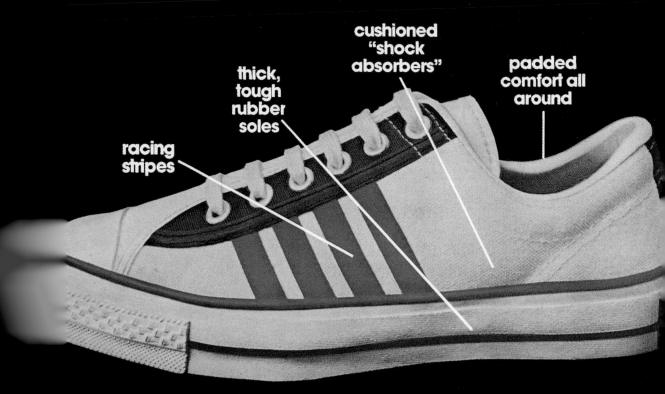

The Winner. Built by Converse.® Just for Sears.

cushioned "shock absorbers"

padded comfort all around

thick, tough rubber soles

racing stripes

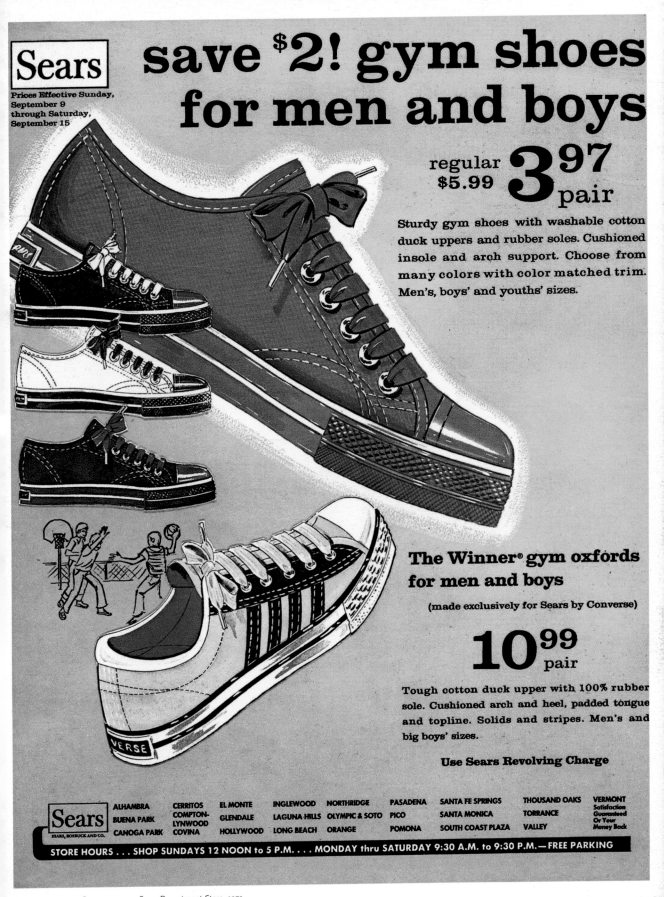

save $2! gym shoes for men and boys

regular
$5.99
3⁹⁷ pair

Sturdy gym shoes with washable cotton
duck uppers and rubber soles. Cushioned
insole and arch support. Choose from
many colors with color matched trim.
Men's, boys' and youths' sizes.

The Winner® gym oxfords for men and boys

(made exclusively for Sears by Converse)

10⁹⁹ pair

Tough cotton duck upper with 100% rubber
sole. Cushioned arch and heel, padded tongue
and topline. Solids and stripes. Men's and
big boys' sizes.

Use Sears Revolving Charge

Sears Department Store, 1974 ◄ *Sears Department Store, 1973*

503

I don't make shoes for your feet. I make shoes for your body.

When the body is in a healthy erect posture, you should be able to draw a straight line between the ear, wrist, and ankle. The Earth Shoe® helps you attain this posture.

Shoe is actually lower than the toe.

This helps guide your body into a straighter, more upright posture. A posture that takes weight and pressure off your lower back and the metatarsal area of your foot. This should help reduce fatigue, and make walking and standing easier and more comfortable.

This straighter posture is similar to that attained in the Lotus position in Yoga.

The sole of my shoe is molded in the form of a healthy footprint in sand.

Lowering the heel is not enough.

The entire sole of my shoe is molded in a very special way. With each step you take, your weight is shifted from your heel to the outside of your foot, to the ball of your foot, and to your big toe.

This gentle rolling motion allows you to walk and stand for hours longer without tiring. You should feel a whole new energy in my shoes.

My shoe is completely different from any shoe you've ever worn. It's a shoe for your entire body.

It was designed by studying the body. How it stands. How it walks. And what it needs. I call my shoe The Earth Shoe.®

It's more natural to walk with your heels lower than your toes.

That might sound strange at first. But look at your footprints when you walk barefoot in sand. You will see that the heel is much deeper than the toe. This is the natural way your body wants to walk.

My shoes work with your body.

The heel of The Earth

To get an idea of how The Earth Shoe works, stand barefoot with your toes up on a book. Feel what begins to happen to your body.

The toe of my shoe is wide. So your toes can spread out naturally and comfortably. Instead of being cramped and squashed.

The arch of The Earth Shoe is much more than just a support. It helps your arch exercise. When you try my shoes you will feel the difference immediately.

It took me 10 years to perfect The Earth Shoe. And I did it with several doctors, in my native Denmark, who not only worked with me, but actually wore the shoes to test each delicate adjustment.

You may feel strange at first.

When you first put The Earth Shoe on, you may feel a little odd. This is because you will be using neglected muscles you're not used to using.

Wearing my shoe is a special way of exercising your body while you walk. You should wear them moderately at first, until you get used to this new way of walking.

Where to buy them.

My shoes are sold at stores that only sell The Earth Shoe. In every case, these stores were opened by people who wore my shoes, and believed in them so much, they decided to sell them themselves.

To really appreciate my shoes you must try them.

I have received thousands of letters from wearers who were pleased beyond their expectations. Come try them. You will see, perhaps for the first time in your life, what it is like to stand straighter, to walk more gracefully, naturally and comfortably.

earth shoe

As with all successful ideas and inventions, there are imitators.

Although we may look like The Earth Shoe,® none reproduce the careful design and years of testing that are built into every pair. The Earth Shoe is patented. It can not be copied without being changed. To be sure you're getting the real thing, look on the sole for The Earth Shoe trademark, and U.S. patent number, 3305947.

The Earth Shoe® is a registered Trademark of Kalso Systemet Inc., 251 Park Avenue So., New York, N.Y. 10010. ©1974 Kalso Systemet Inc.

Anne Kalso

The Earth Shoe® comes in styles for men and women, from open sandals to high boots. From $23.50 to $42.50. Prices slightly higher in the West.

For The Earth Shoe® store near you please see facing page.

Earth Shoe, 1974

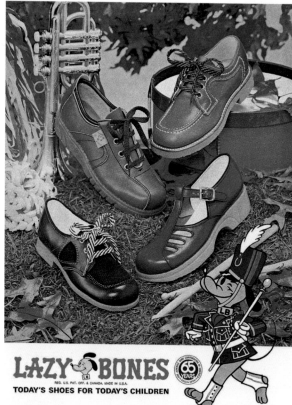

LAZY BONES

REG. U.S. PAT. OFF. & CANADA. MADE IN U.S.A.

TODAY'S SHOES FOR TODAY'S CHILDREN

65 YEARS

FOR **FREE** COLORING BOOK WRITE: THE LAZY-BONES SHOEMAKERS, DEPT. M-8 7912 BONHOMME AVE. • ST. LOUIS, MO. 63105

Lazy Bones Children's Shoes, 1978

Everything you need to know about

comfortable shoes.

Everyone who owns a pair of Roots can skip this. The rest of the world, please note.

Roots is a comfortable, casual shoe — different from the shoes you grew up in, and different from other casual shoes, too.

There's nothing else quite like them. Here's the story.

How Roots are different from ordinary shoes.

The Roots sole is a single, seamless piece. Inside, it is sculptured to fit your foot.

It cradles your heel and supports your arch. Unlike ordinary shoes, you stand in Roots, not on them.

The Roots toe is not pointed like the toes of ordinary shoes. It is broad and rounded like feet so your toes have room to wiggle and air can circulate to keep your feet cool.

The bottom of the sole is molded in a "rocker" shape so that it fits the natural heel-to-toe motion of walking.

The heel is only about the height of the heel on a tennis shoe and the "rocker" sole curves up toward the tip of the toe. If you wonder whether or not all this makes any sense put one of your ordinary shoes on a table and look at it for a minute. Notice that the heels have worn away and the sole has assumed a comfortable curve. Whether you wear size 3½ or 13, high heel or regular heel, the more you wear an ordinary shoe, the more it assumes the shape of Roots.

Your shoes are trying to tell you something

How Roots are different from other casual shoes.

There are other casual shoes that look like Roots at first glance.

Some have sculptured soles. Others are styled to look as though they do.

But none of them has the obvious love of good leather and fine boot-making you'll find in a pair of Roots.

The difference in Roots is due, in large part, to the men pictured here. John Kowalewski and his sons are custom-bootmakers. They built the first pairs of Roots with the same care and enthusiasm they

The men who make Roots

poured into the expensive shoes they had made for exclusive boutiques.

Today they run the Roots factory in Toronto where every pair of Roots is made.

They pick the leather, set the standards, supervise the whole operation.

They are of the old school.

So, in Roots you have more than a shoe made for the way you were born to walk. You also have a beautifully made pair of shoes, visibly nicer (and a little more expensive) than the rest.

Why Roots cost more.

Even the Kowalewski's can't make a beautiful shoe from inferior stuff.

So, Roots are made of the best of everything in the best way the old school knows how to make them. The soles are made of a special gum rubber for the right combination of flex and durability.

The "uppers" are made from the best top-grain Canadian leather. This leather is drum-dyed, a costly process which permeates the hide with rich, natural color and doesn't clog the pores that let leather breathe.

No two drum-dyed hides match perfectly so each pair of Roots is cut from the same piece of leather. The heel has a built-in support called a "counter." It helps the shoe keep its shape and helps position your

foot in the shoe. Expensive leather shoes have this feature. Most casual shoes don't.

Roots leather is sewn with nylon thread. It's expensive, but doesn't deteriorate the way cotton thread does.

And so it goes.

From first to last, Roots are made the best possible way.

These differences ought to make a difference to everyone spending more than $25 for a pair of shoes.

The trouble with Roots.

The trouble is, they're so damned comfortable. Believe it or not, people worry about that. They worry that after wearing Roots they'll hate their old shoes.

They worry that after getting used to Roots they won't be able to wear ordinary shoes. Some people just like to worry.

But there simply isn't anything to worry about. Walking in Roots is very much like walking in bare feet and you've been doing that on and off for most of your life.

Roots do take some getting used to because they ask you to use muscles in your legs and back that have been under-used wearing ordinary shoes. And of course, they don't look like ordinary shoes

From Canada with love

either, which bothers some people.

But, if you're secure enough to deal with a few characters who want to know why you're wearing those "funny-looking shoes" you're going to love the comfort of Roots.

Sold only at Roots stores.

You'll find genuine Roots only at Roots stores in the cities listed here. And you'll find these stores as comfortable an experience as Roots themselves.

They don't look like ordinary shoe stores. And the sales people don't act like ordinary shoe sales people.

You'll find them wearing what they're selling and servicing what they sell.

As a result Roots customers keep coming back for more. The record right now is 10 pairs bought in less than a year, by a man who is definitely old enough to know better.

Evidently it's easier than we guessed to go bananas over Roots.

Roots.

"Be kind to feet. They outnumber people two to one."

Sold only at Roots stores in: Albuquerque, Amsterdam (Neth.), Ann Arbor, Atlanta, Austin, Berkeley, Birmingham (Ala.), Birmingham (Mich.), Boulder, Calgary, Cambridge, Chicago, Columbus, Costa Mesa, Dallas, Denver, East Lansing, Edmonton, Eugene, Evanston, Fort Lauderdale, Halifax, Hartford, Houston, Kansas City (Mo.), La Jolla, Las Vegas, London (Ont.), Los Angeles, Madison, Malibu, Miami, Milwaukee, Minneapolis, Montreal, Munich (Ger.), New York, Ottawa, Palo Alto, Philadelphia, Pittsburgh, Portland, San Francisco, Scottsdale, Seattle, Toronto, Tucson, Vancouver, Victoria, White Plains.

Roots are made in 15 styles for men and women.
For more about them send 25¢ for "The Book of Roots" to Roots Natural Footwear, 1203 Caledonia Rd., Toronto M6A 2X3, Canada. ©1975. Don Michael Co.

Roots Footwear, 1975

▸ *Sears Department Store, 1971*

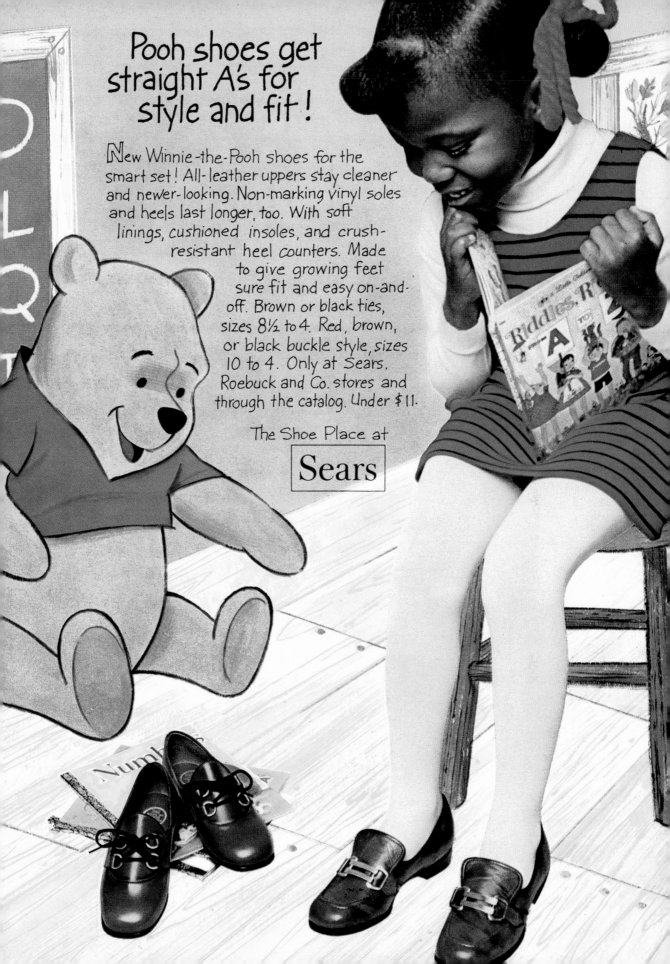

SALE! don't pay $30.00

the *famous* heidi dress

NOW ONLY $12.99
SAVE NOW!

OUR EXCLUSIVE! The famous "Heidi" Dress is now yours for a fraction of what you'd expect to pay for it in a store! And you'll look absolutely smashing in this nostalgic little piece of dynamite! We've gone all out to capture the rustic flavor and charm of a tiny Alpine village for you! With a lovely edelweiss flower print... authentic white shadow stripe bodice insert and puff sleeves, delicately edged with real lace... plus a lavishly-full and feminine gathered skirt! No Swiss miss ever looked more enchanting! Dress zips in back, Avril® cotton-rayon fabric is machine washable. In a stunning blue print.

Junior Sizes: 5, 7, 9, 11, 13, 15, 17
Misses: 6, 8, 10, 12, 14, 16, 18
Half Sizes: 14½, 16½, 18½, 20½, 22½
Women's: 34, 36, 38, 40, 42

OUR GUARANTEE You must be completely delighted with this beautiful "Heidi" Dress or you may return it for a full refund of the purchase price, no questions asked! Now, that's a guarantee in writing!

Lana Lobell
Hanover, Penna. 17331

Heidi Dress, 1976

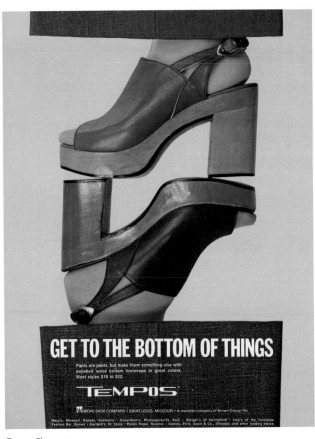

GET TO THE BOTTOM OF THINGS

Pants are pants, but make them something else with polished wood bottom footwraps in great colors. Most styles $18 to $22.

TEMPOS

WOHL SHOE COMPANY • SAINT LOUIS, MISSOURI • A member company of Brown Group, Inc.

Macy's, Missouri, Kansas, California • Donaldson's, Minneapolis/St. Paul • Steiger's of Springfield • Ivey's of the Carolinas Fashion Bar, Denver • Garland's, St. Louis • Palais Royal, Houston • Carson, Pirie, Scott & Co., Chicago; and other leading stores.

Tempos Shoes, 1973

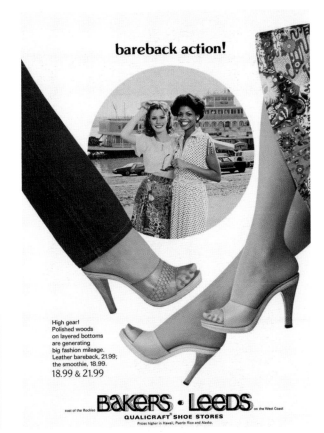

bareback action!

High gear! Polished woods on layered bottoms are generating big fashion mileage. Leather bareback, 21.99; the smoothie, 18.99.
18.99 & 21.99

east of the Rockies **BAKERS · LEEDS** on the West Coast
QUALICRAFT® SHOE STORES
Prices higher in Hawaii, Puerto Rico and Alaska.

Bakers/Leeds Shoe Stores, 1979

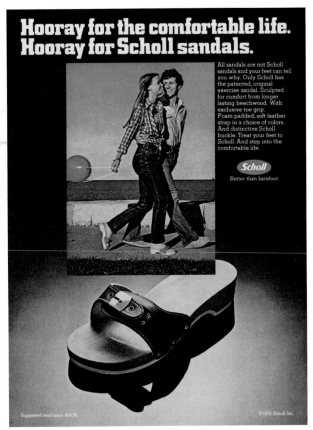

Hooray for the comfortable life.
Hooray for Scholl sandals.

All sandals are not Scholl sandals and your feet can tell you why. Only Scholl has the patented, original exercise sandal. Sculpted for comfort from longer lasting beechwood. With exclusive toe grip. Foam-padded, soft leather strap in a choice of colors. And distinctive Scholl buckle. Treat your feet to Scholl. And step into the comfortable life.

Scholl
Better than barefoot.

Suggested retail price: $14.95

© 1975 Scholl, Inc.

Dr. Scholl's Sandals, 1974

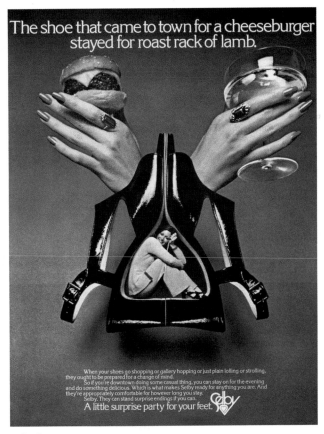

The shoe that came to town for a cheeseburger stayed for roast rack of lamb.

When your shoes go shopping or gallery hopping or just plain lolling or strolling, they ought to be prepared for a change of mind. So if you're downtown doing some casual thing, you can stay on for the evening and do something delicious. Which is what makes Selby ready for anything you are. And they're appropriately comfortable for however long you stay. Selby. They can stand surprise endings if you can.
A little surprise party for your feet.

Selby

Selby Shoes, 1973

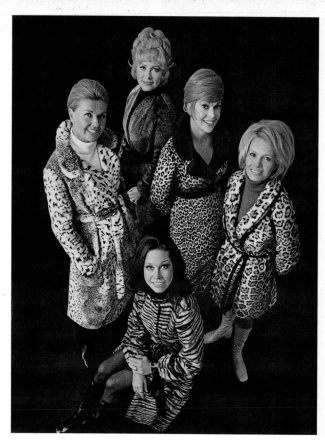

Five women who can easily afford any fur coat in the world tell why they're proudly wearing fakes.

DORIS DAY: *"Killing an animal to make a coat is a sin. It wasn't meant to be, and we have no right to do it.*
"At one time, before I was aware of the situation, I did buy fur coats. Today when I look at them hanging in the closet I could cry.
"It's so wrong for a man to think that the biggest thing he can do for his wife is buy her a fur coat at Christmas. It's the most evil thing he can do. Buy her a fake fur. They're so beautiful, so lovely, so warm, so pretty to look at.
"A woman gains status when she refuses to see anything killed to be put on her back. Then she's truly beautiful..."

AMANDA BLAKE: *"The wearing of any kind of skins—even the kind that are supposedly raised for fur, like mink or sable—is something that I just don't believe in. Killing animals for vanity I think is a shame.*
"I feel very guilty about having worn fur coats. As for the women who know about our vanishing wildlife and continue to buy fur coats—I wonder how they'd like to be skinned?
"I have noticed that the reaction to real fur coats is becoming nausea on the observer's part. If a woman wants to wear something that looks like an animal, fake fur is the only way to go.
"People are putting the whole real fur thing down and I thank God...thank God."

JAYNE MEADOWS: *"I don't see how you can wear a fur coat without feeling, literally, like a murderer. It is, I believe, against God's law. Against His whole plan for the universe.*
"I feel very sad for women who continue to purchase real fur coats. They are lacking in a woman's most important requisites, heart and sensitivity.
"Bravo for the women who are wearing fake fur. It's the only way to go. It's warmer and everything else. And you are happy with it because you don't feel guilty in it. You don't feel like a murderer."

ANGIE DICKINSON: *"Although I don't feel I have the right to tell other people what to do, my respect for an animal's right to live doesn't let me approve of the killing of animals for coats.*
"If a woman can help an animal or a child, that's the most important thing."

MARY TYLER MOORE: *"The killing of an animal for the sake of the appearance of luxury doesn't achieve anything. I have seen so many coats so much more attractive than fur—some fake fur, some fabric. It's in the design, not necessarily the fabric.*
"I am aware that there are specific ecological problems, but for me all animals have a right to humane treatment.

"Someday, soon I hope, the killing of an animal for fur will hold for us the same revulsion we feel, say, when we hear those horrible stories about parts of the world where they open the top of a live monkey's skull and pour hot lead in because it's supposed to improve the flavor of the meat."

E. F. Timme & Son is one of the world's leading suppliers of plush and flat fabrics for home, industry and transportation.

Although Timme-Tation fake fur represents only a small part of our output and income, it is the subject of virtually all our advertising.

For two reasons:

1. We believe that the slaughter of wildlife in the name of fashion is cruel and, eventually, suicidal. We want to do something about it. As we gain acceptance for fake fur through advertising, the demand for the real thing goes down. So fewer animals die.

And that's the big thing.

2. As more and more people start turning to fake fur, we want them to know that E. F. Timme & Son makes the best fake fur money can buy. 45 different kinds. With heavy emphasis, we don't mind adding, on the Endangered Species.

Incidentally, we only make the fabric. It's the many fine manufacturers and designers who buy from us who make the coats. Miss Day's "Lynx," Miss Blake's "Hair Seal," Miss Meadows' "Leopard," Miss Dickinson's "Jaguar," Miss Moore's "Tiger" were designed and executed by Lupu in Timme-Tation Lynx, Silver Frost, Congo, Jagra and Bengal.

TIMME-TATION FAKE FUR
E.F. TIMME & SON, INC.
200 MADISON AVENUE, NEW YORK CITY
CLEAN BY FUR COAT METHOD ONLY

Fur coats shouldn't be made of fur.

These ladies have received no payment for their appearance in this ad. At their request a contribution has been made by the E. F. Timme Co. to Cleveland Amory's Fund For Animals. These ladies are all on the national board of that organization. For information on how you can join, write Fund For Animals, Inc., Box 444, Wall Street Station, N.Y.C.

Timme-Tation Fake Furs, 1971

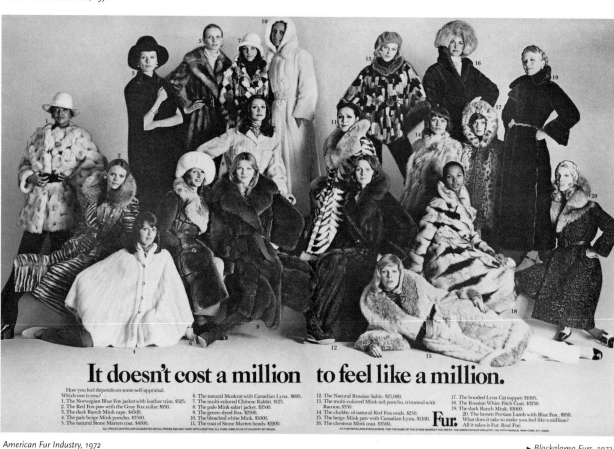

It doesn't cost a million to feel like a million.

How you feel depends on some self-appraisal. Which one is you?
1. The Norwegian Blue Fox jacket with leather trim. $525.
2. The Red Fox paw with the Gray Fox collar. $950.
3. The dark Ranch Mink cape. $450.
4. The pale beige Mink poncho. $3500.
5. The natural Stone Marten coat. $4000.
6. The natural Muskrat with Canadian Lynx. $695.
7. The multi-colored Chinese Rabbit. $125.
8. The pale Mink safari jacket. $3500.
9. The green-dyed Fox. $2500.
10. The bleached white Mink. $5000.
11. The coat of Stone Marten heads. $2200.
12. The Natural Russian Sable. $25,000.
13. The multi-colored Mink tail poncho, trimmed with Racoon. $350.
14. The chubby of natural Red Fox ovals. $250.
15. The beige Mink paw with Canadian Lynx. $1100.
16. The chestnut Mink coat. $3500.
17. The hooded Lynx Cat topper. $1095.
18. The Russian White Fitch Coat. $3250.
19. The dark Ranch Mink. $3000.
20. The brown Persian Lamb with Blue Fox. $950. What does it take to make you feel like a million? All it takes is Fur. Real Fur.

Fur.

ALL PRICES QUOTED ARE SUGGESTED RETAIL PRICES AND MAY VARY WITH LOCATION. ALL FURS LABELED AS TO COUNTRY OF ORIGIN.
AT FINE RETAILERS EVERYWHERE. FOR THE NAME OF THE STORE NEAREST YOU WRITE: THE AMERICAN FUR INDUSTRY, 342 FIFTH AVENUE, NEW YORK, N.Y. 10001

American Fur Industry, 1972

▶ *Blackglama Furs, 1973*

What becomes a Legend most?

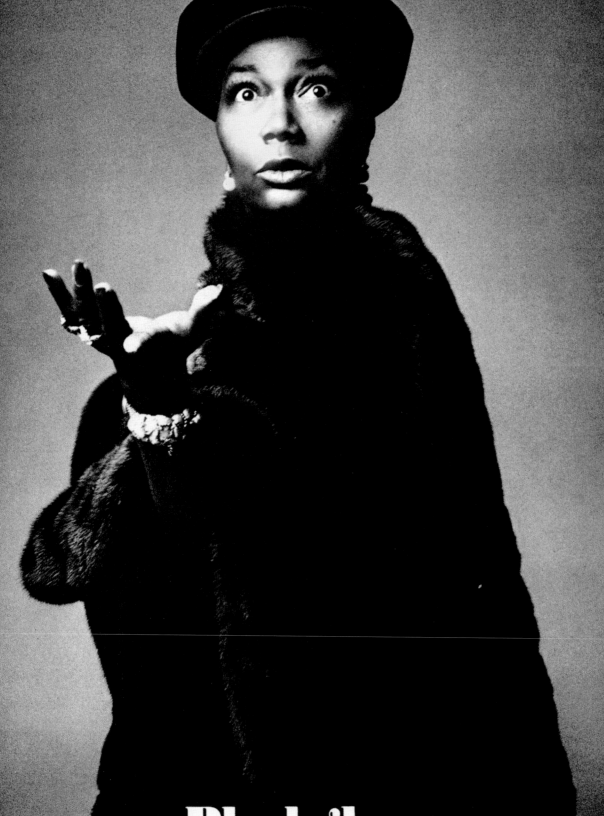

Blackglama

Courreges Boutiques, 1978

Montgomery Ward Department Store, 1971

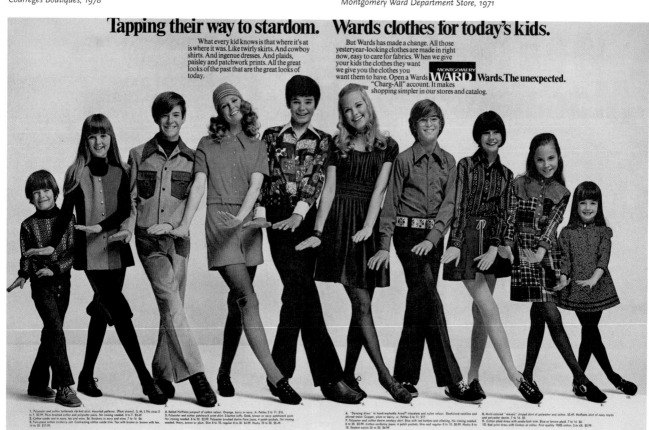

Montgomery Ward Department Store, 1971

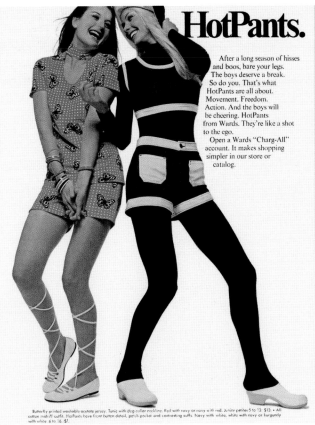

HotPants.

After a long season of hisses and boos, bare your legs. The boys deserve a break. So do you. That's what HotPants are all about. Movement. Freedom. Action. And the boys will be cheering. HotPants from Wards. They're like a shot to the ego.

Open a Wards "Charg-All" account. It makes shopping simpler in our store or catalog.

Butterfly printed washable acetate jersey. Tunic with dog collar neckline. Red with navy or navy with red. Junior petites 5 to 13. $13. • All cotton midriff outfit. HotPants have front button detail, patch pocket and contrasting cuffs. Navy with white, white with navy or burgundy with white. 6 to 16. $7.

Wards. The unexpected.

Miniature cable pattern in Dacron® polyester and cotton knit. Button front cardigan top, pull-on HotPants. Machine washable. Berry, brown or navy. 8 to 16. $12. • All nylon midriff. Elasticized puffy sleeves, shirred with elastic at neck, sleeves and midriff. Black, white, orangy-red, yellow or navy. S,M,L. $6. • Double knit Acrilan® acrylic HotPants. Elastic waistband. White, red, brown or black. 6 to 16. $4.

MONTGOMERY WARD

Montgomery Ward Department Store, 1971

HANG TEN

Hang Ten shoes to get together with your Hang Ten sportswear. Sold wherever you find Hang Ten junior clothing. For stores in U.S. write: 1010 Sycamore Avenue, So. Pasadena, Ca. 91030. In Canada write: Hang Ten Pret-A-Porter, 9500 Meilleur St., Montreal, Q., Canada H2N-287.

Hang Ten Sportswear, 1979

This is Aileen. Bold. Brave. Sure. Ahead. It's all top deck for the nicest nautical separates. A striped cardigan blazer and pantskirt in 100% textured cotton double knit. Both in sizes 5-15. Together with a 100% cotton knit mock turtleneck. Sizes S,M,L. Blazer, as shown only, about $17.* Mock turtleneck and pantskirt in coordinated solid colorings. Mock turtleneck about $6.* Pantskirt about $7.* All of Aileen is at the nearest and nicest specialty shops and department stores. Aileen, Inc., 1407 Broadway, New York 10018.

aileen

Aileen Women's Wear, 1970

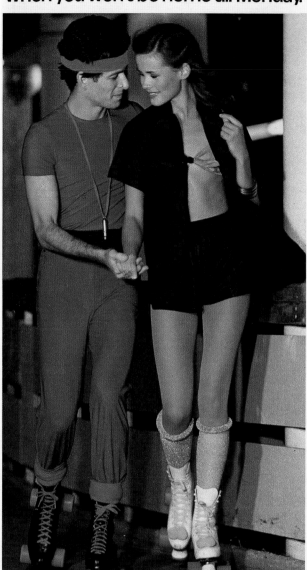

Lee Denim, 1978

Sasson Women's Wear, 1979

Happy Legs Women's Wear, 1979

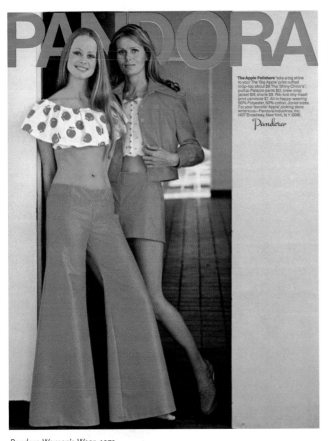

Pandora Women's Wear, 1973

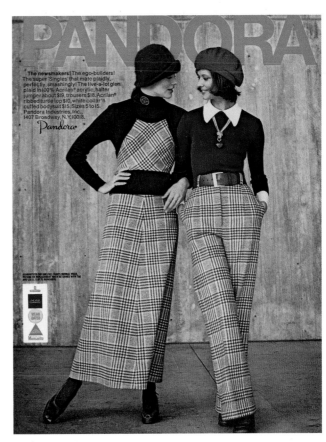

Pandora Women's Wear, 1972

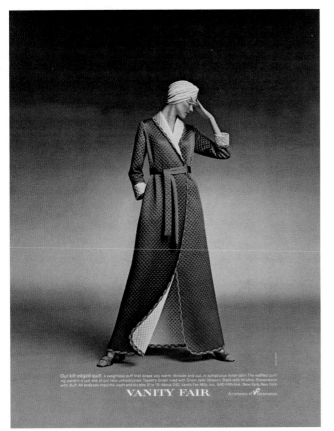

Vanity Fair Robes, 1973

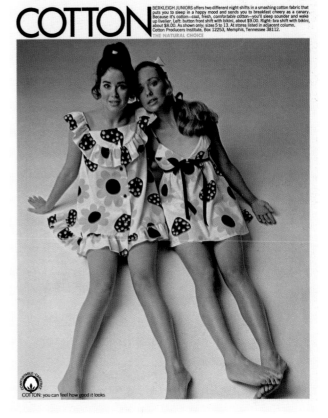

Cotton Producers Institute, 1970

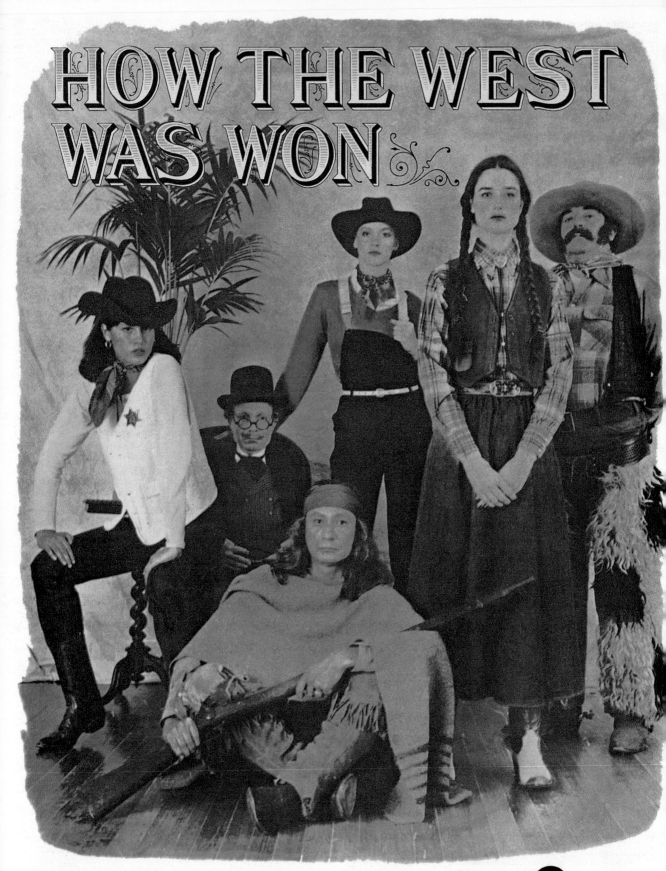

HOW THE WEST WAS WON

Out of the West comes a look that is changing the way America dresses. It's bright, bold, sassy and sweet. And, the Gap's got it. Straight leg denims, bright knits, earth tone vests in burlap or suede, and the new look in overalls. Discover the fashion look of the West at The Gap. You'll be glad you did.

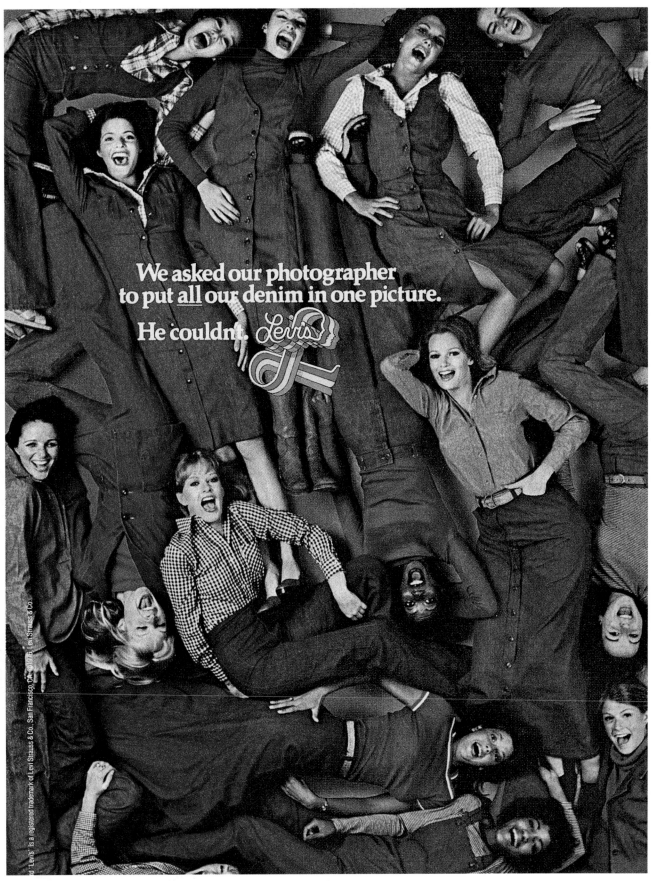

We asked our photographer
to put all our denim in one picture.
He couldnt. Levi's

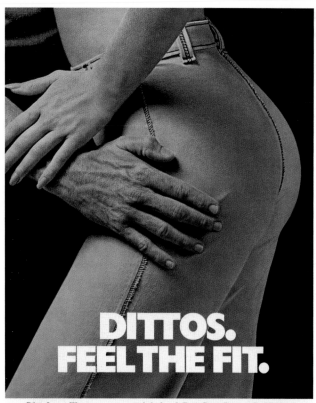

Ditto Jeans, 1975

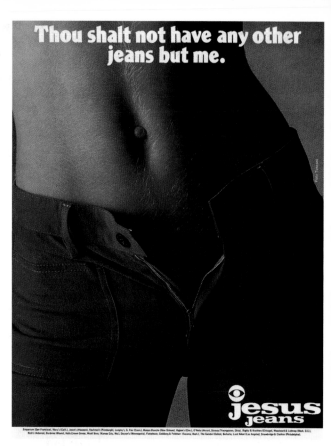

Jesus Jeans, 1976

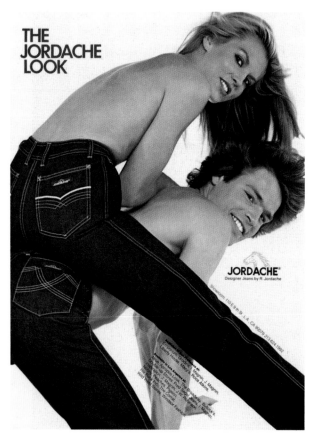

Jordache Jeans, 1979

Happy Legs Women's Wear, 1973

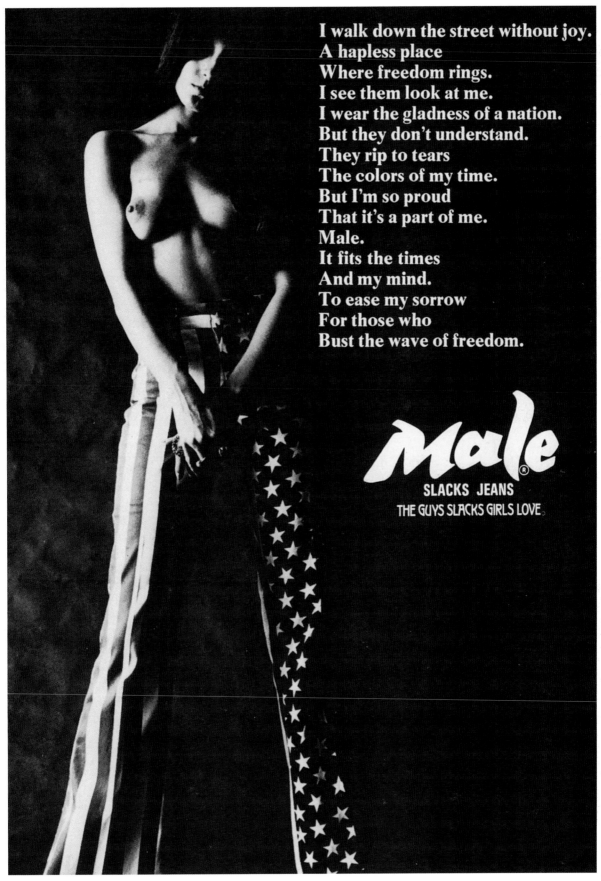

I walk down the street without joy.
A hapless place
Where freedom rings.
I see them look at me.
I wear the gladness of a nation.
But they don't understand.
They rip to tears
The colors of my time.
But I'm so proud
That it's a part of me.
Male.
It fits the times
And my mind.
To ease my sorrow
For those who
Bust the wave of freedom.

Male

SLACKS JEANS
THE GUYS SLACKS GIRLS LOVE.

Male Slacks, 1971

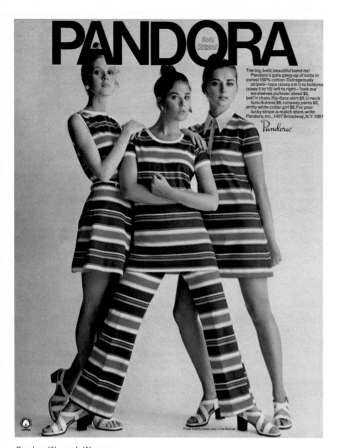

Pandora Women's Wear, 1970

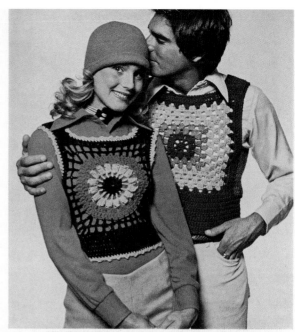

Coats & Clark Wool, 1972

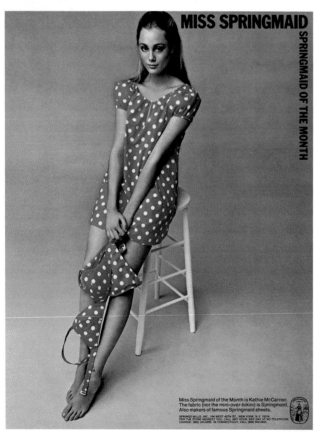

Springmaid Fabric, 1970

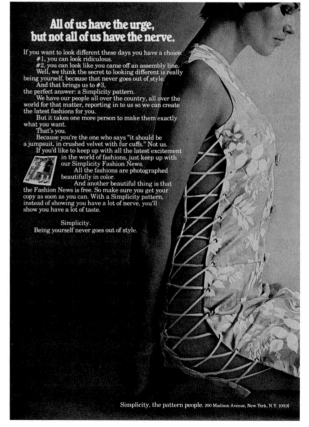

Simplicity Patterns, 1970

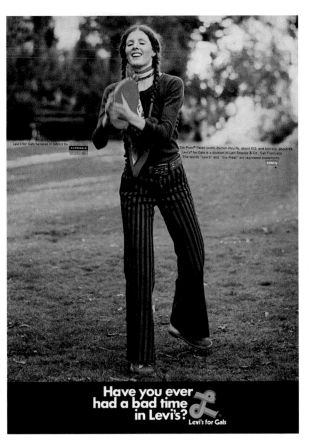

Levi's, 1971

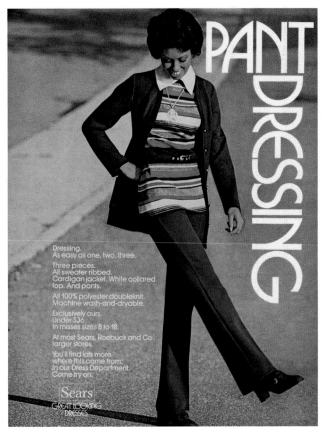

Sears Department Store, 1973

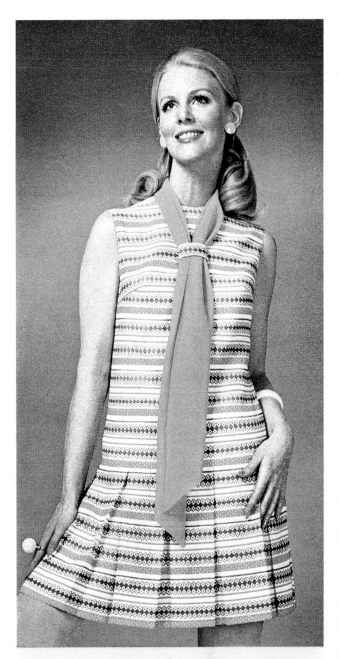

for the girl who knows . . .

A breeze of sheer voile, striped and scarfed and swished with pleats. 65% **DACRON** polyester-35% cotton. Green/purple (shown), gold/ black, red/blue. Sizes 10 to 18. About $30. **R & K Originals,** 1400 Broadway, New York, N. Y. 10018, a Division of Jonathan Logan.

✱DU PONT REGISTERED TRADEMARK. SLIGHTLY HIGHER IN THE WEST.

R & K Originals Dresses, 1970

519

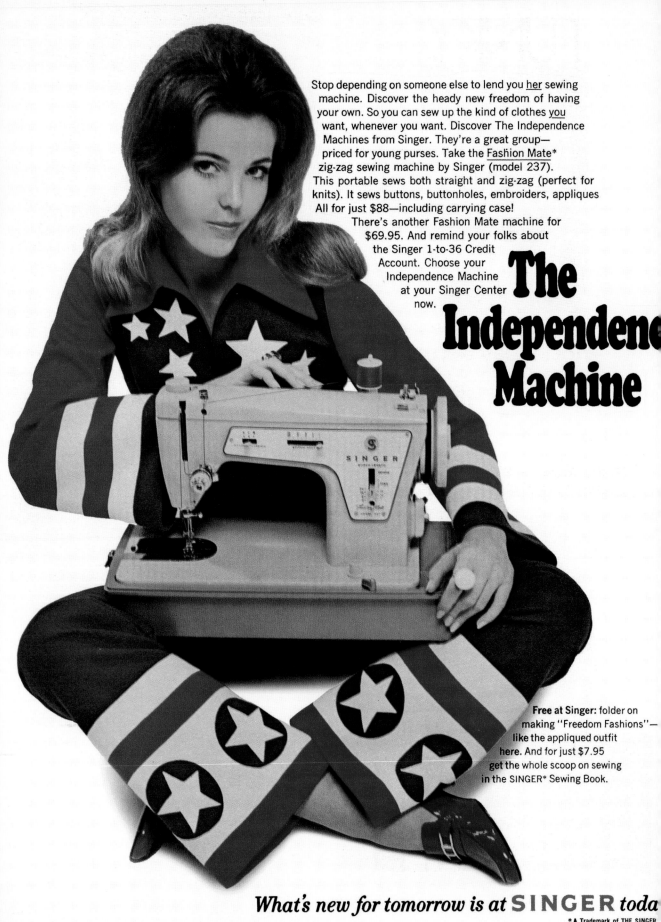

Stop depending on someone else to lend you <u>her</u> sewing machine. Discover the heady new freedom of having your own. So you can sew up the kind of clothes <u>you</u> want, whenever you want. Discover The Independence Machines from Singer. They're a great group— priced for young purses. Take the <u>Fashion Mate</u>* zig-zag sewing machine by Singer (model 237). This portable sews both straight and zig-zag (perfect for knits). It sews buttons, buttonholes, embroiders, appliques All for just $88—including carrying case! There's another Fashion Mate machine for $69.95. And remind your folks about the Singer 1-to-36 Credit Account. Choose your Independence Machine at your Singer Center now.

The Independence Machine

Free at Singer: folder on making "Freedom Fashions"— like the appliqued outfit here. And for just $7.95 get the whole scoop on sewing in the SINGER* Sewing Book.

What's new for tomorrow is at SINGER *toda*

* A Trademark of THE SINGER

FUNKY.

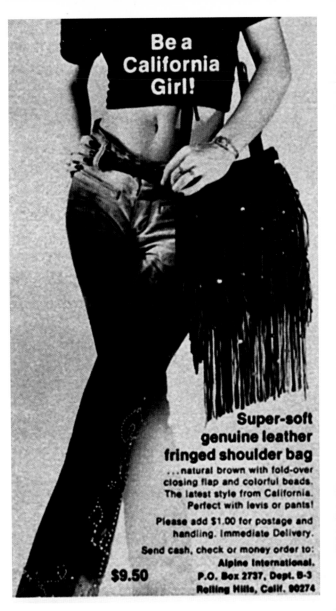

Funky Fashions, 1976

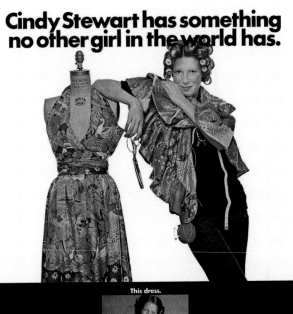

Singer Sewing Machines, 1970 ◄ *Coats & Clark Fabrics, 1973*

Alpine International Shoulder Bag, 1974

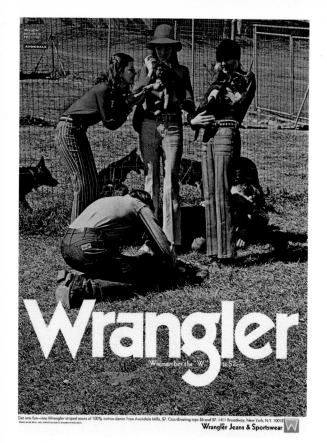

Wrangler Jeans, 1971

See what a little Hubba Hubba does for you.

Hubba Hubba Apparel, 1972

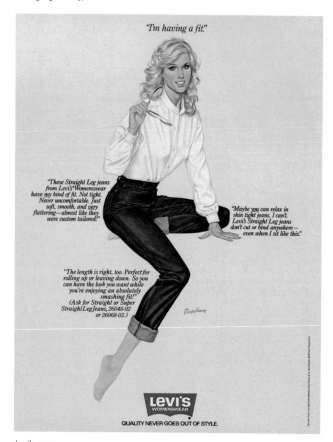

"I'm having a fit."

"These Straight Leg jeans from Levi's Womenswear have my kind of fit. Not tight. Never uncomfortable. Just soft, smooth, and very flattering—almost like they were custom tailored!"

"Maybe you can relax in skin tight jeans. I can't. Levi's Straight Leg jeans don't cut or bind anywhere— even when I sit like this."

"The length is right, too. Perfect for rolling up or leaving down. So you can have the look you want while you're enjoying an absolutely smashing fit!" (Ask for Straight or Super Straight Leg Jeans, 26048-02 or 26068-02.)

LEVI'S WOMENSWEAR

QUALITY NEVER GOES OUT OF STYLE.

Levi's, 1979

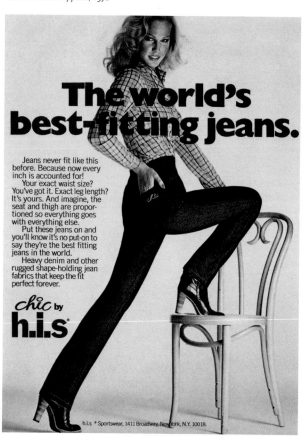

The world's best-fitting jeans.

Jeans never fit like this before. Because now every inch is accounted for!

Your exact waist size? You've got it. Exact leg length? It's yours. And imagine, the seat and thigh are proportioned so everything goes with everything else.

Put these jeans on and you'll know it's no put-on to say they're the best fitting jeans in the world.

Heavy denim and other rugged shape-holding jean fabrics that keep the fit perfect forever.

chic by h.i.s

h.i.s ® Sportswear, 1411 Broadway, New York, N.Y. 10018.

Chic Jeans, 1978

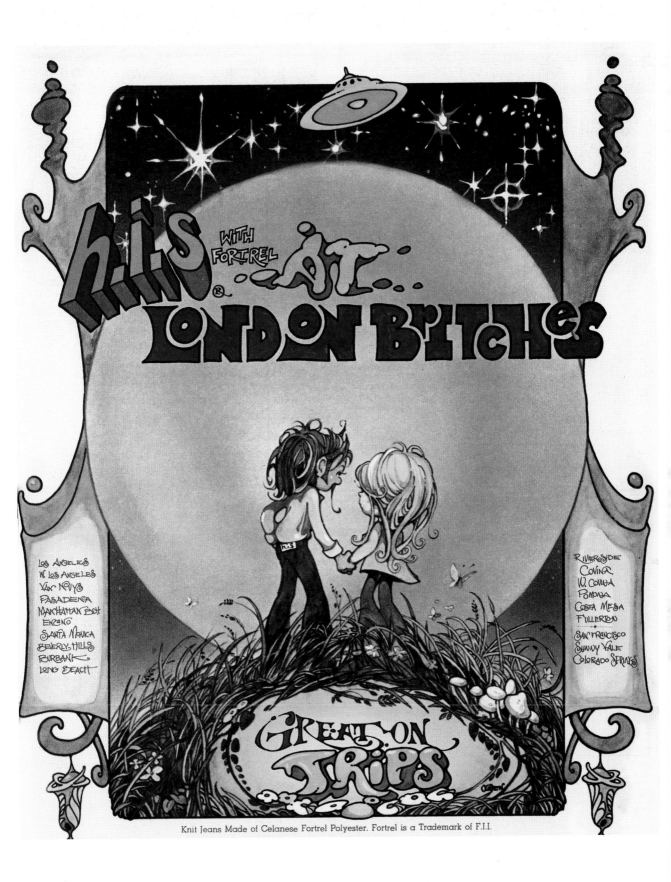

London Britches Stores, 1970

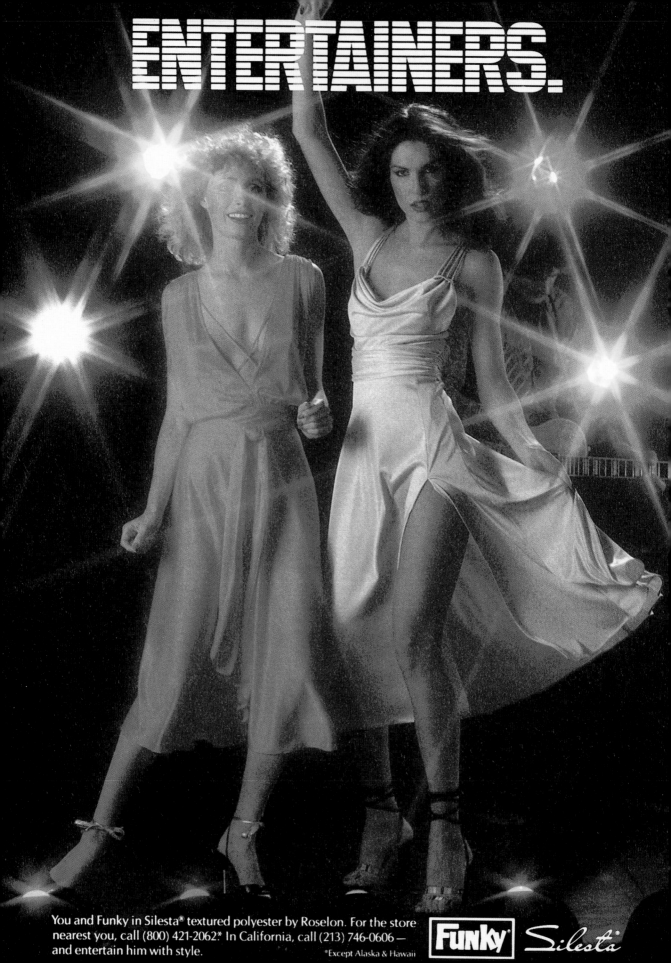

ENTERTAINERS.

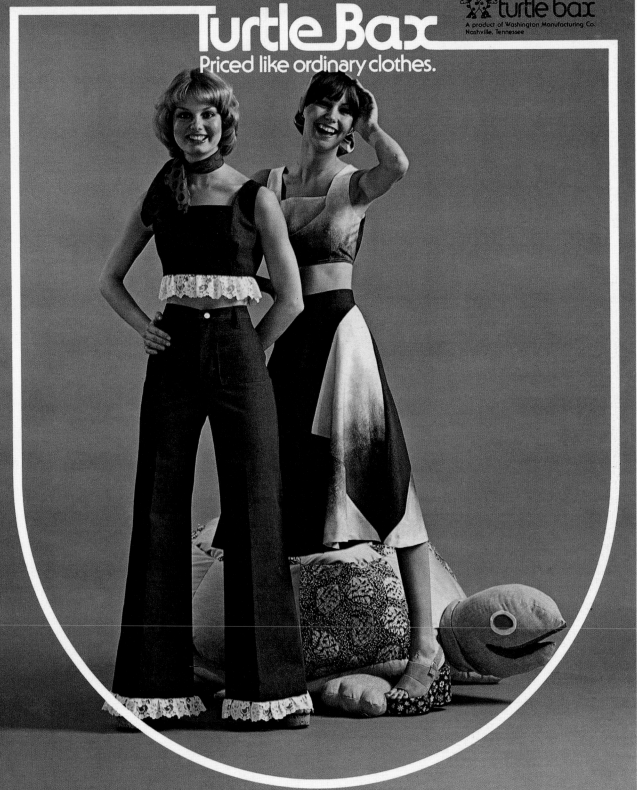

Funky Fashions, 1978 ◄ *Turtle Bax Clothing, 1975*

Are you the right kind of woman for it?

Can you brew bathtub gin?

Can you light his fire swiveling to a calypso beat while slugging champagne from a bottle and wearing nothing but one Edwardian rose behind your ear?

Find something to talk about when the TV set goes on the blink?

Do you *have* to have your carrot juiced every morning?

Own at least one pair of strategically cut-out bikini panties?

Have you a perceptive eye, a mind like a calculator, a bent for men who dig bikini panties, a passion for Fibber McGee, a cool head for business and an obsession for snakeskin backgammon boards?

Will you say "Yes" to a summer at sea even though you get seasick taking a bath?

Promise to love, honor and seduce him with caviar, rum swizzles and suckling pig on your anniversary that *he* forgot?

Be first on the block with an ocelot?

Do a striptease without giggling?

See a psychiatrist if he does?

Did you say you knew the male silkworm moth (*Bombyx mori*) can detect the female's scent from 6.8 miles upwind?

You did?

Congratulations.

You get the idea.

Why not get in touch with the Mistress Collection: call toll-free 800-421-2062.*

Tell the operator you're ready for Funky's new Alfresco Group in sensual nylon jersey. She'll tell you where to go.

In California call: 213-749-1481.
*Except Alaska & Hawaii

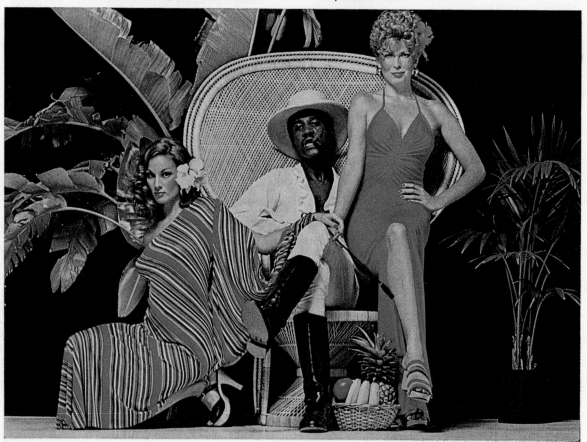

The Mistress Collection by Funky.

Funky. Executive Offices: 1053 South Main Street, Los Angeles, California 90015

Funky Fashions, 1974

▶ *Christian Dior Swimwear, 1977*

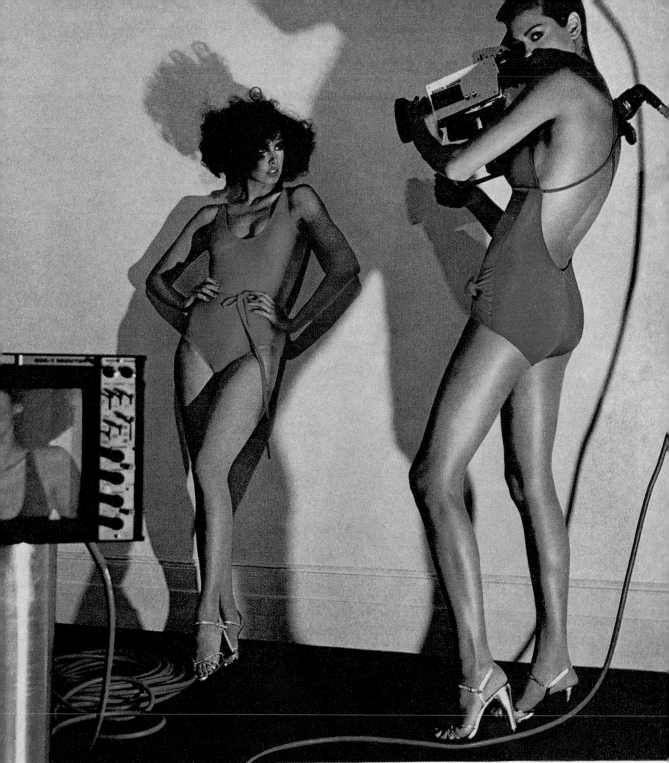

VON WANGENHEIM

Electrifying is Your Dior.

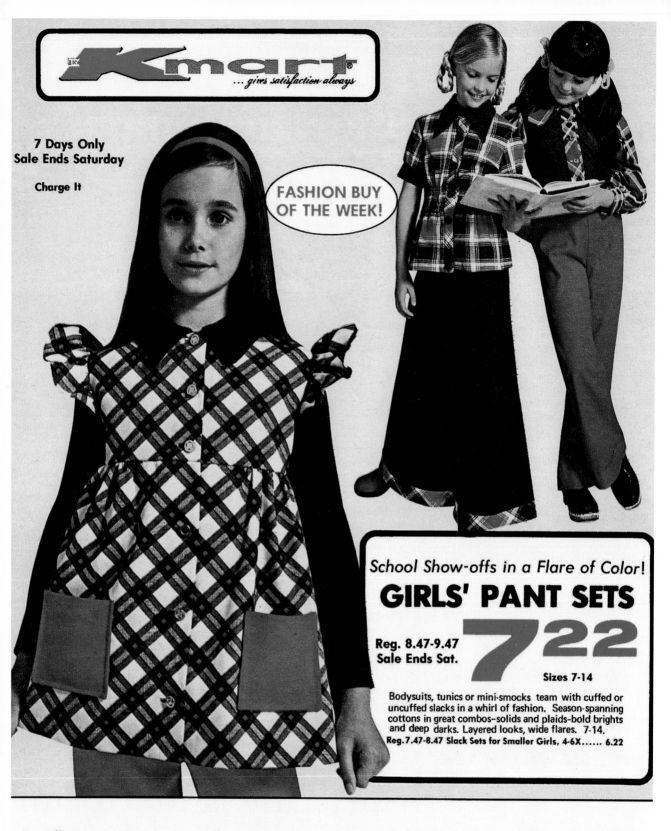

Kmart Stores, 1973

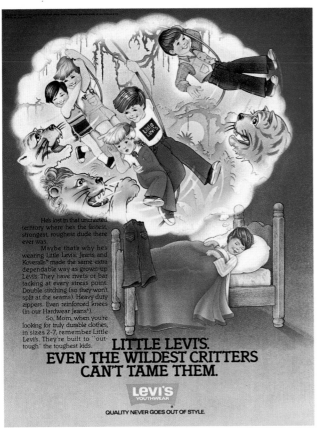

Levi's, 1978

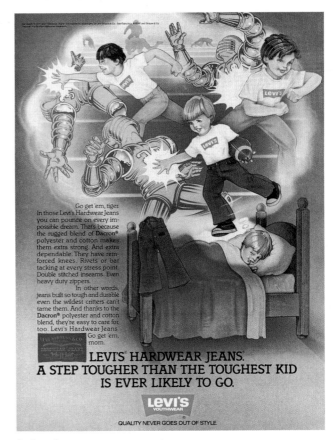

Levi's, 1978

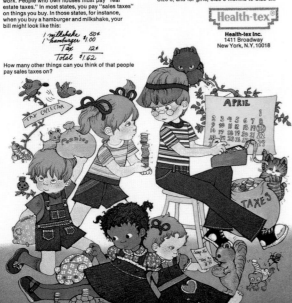

Health-tex Children's Wear, 1978

Health-tex Children's Wear, 1975

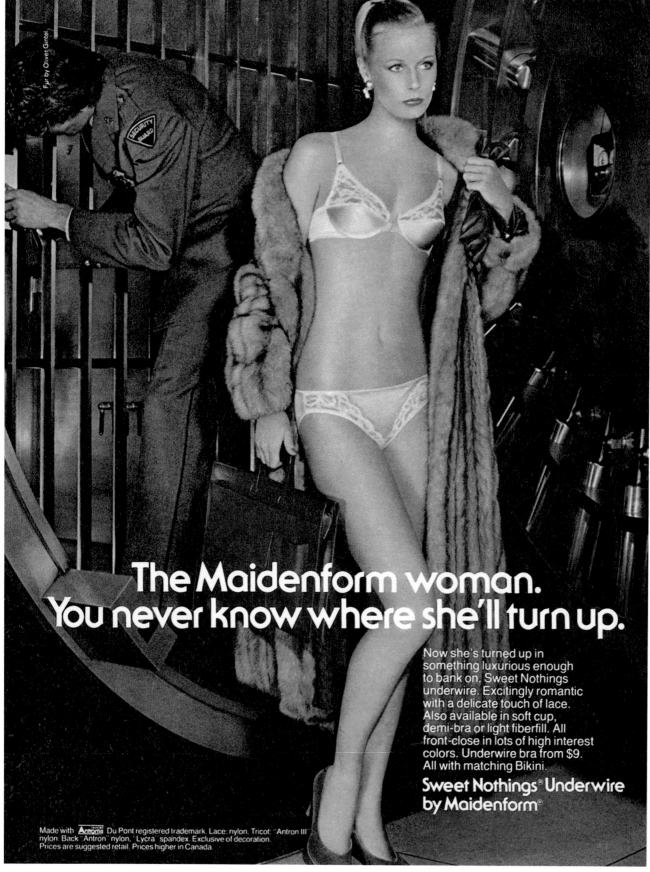

Maidenform Lingerie, 1979

Flattening vs. Flattering

Actual unretouched photos using same model.

Sears Pretty Natural® Shaper.
It's built like you are.

One-sided girdle vs. Two-sided Shaper.

Sears Pretty Natural Shaper is constructed in two halves. So it conforms to your body. Firms you up. Rounds you out. And looks beautifully natural under clothes.

If flat is not your look, get into a Pretty Natural Shaper (or a Pretty Natural Shaper Plus for a little more control in the tummy). It'll make you look as womanly as you are. Only better.

THE FASHION PLACE

Sears

Available in most larger Sears retail stores and the catalog. © Sears, Roebuck and Co. 1978

Sears Department Store, 1978

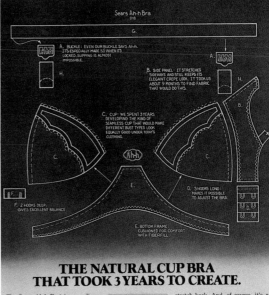

Sears Ah-h Bra

A. BUCKLE: EVEN OUR BUCKLE SAYS Ah-h. IT'S ESPECIALLY MADE SO WHEN IT'S LOCKED, SLIPPING IS ALMOST IMPOSSIBLE.

B. SIDE PANEL: IT STRETCHES SIDEWAYS AND STILL KEEPS ITS ELEGANT CREPE LOOK. IT TOOK US ABOUT 9 MONTHS TO FIND FABRIC THAT WOULD DO THIS.

C. CUP: WE SPENT 3 YEARS DEVELOPING THE KIND OF SEAMLESS CUP THAT WOULD MAKE DIFFERENT BUST TYPES LOOK EQUALLY GOOD UNDER TODAY'S CLOTHING.

D. 3 HOOKS LONG: MAKES IT POSSIBLE TO ADJUST THE BRA.

E. BOTTOM FRAME: CUSHIONED FOR COMFORT WITH FIBERFILL

F. 2 HOOKS DEEP: GIVES EXCELLENT BALANCE

THE NATURAL CUP BRA
THAT TOOK 3 YEARS TO CREATE.

The Sears Ah-h Bra® is no ordinary natural cup bra. So it follows that it wasn't created in an ordinary way.

You see, before we at Sears sat down to design the natural cup Ah-h Bra, we sat down with the experts who were going to wear it. Women (over 2,000) just like you. We got to know their opinions. And their feelings. And then the work began. And when it was finished, we had the bra women wanted. The natural cup Ah-h Bra.

A bra with our exclusive one piece shoulder straps. A bra with completely seamless crepe polyester cups. A bra with crepe stretch sides and

stretch back. And, of course, it's a Perma-Prest® bra.

The natural cup Ah-h Bra is available in B, C and D cups. (Ah-h Bra also comes in underwire and contour cup.) At most Sears larger stores. And in the catalog.

Come into Sears and see the natural cup Ah-h Bra. When you put it on, you'll see that the three years it took to create were worth it.

THE FASHION PLACE

Sears

At most Sears larger stores and in the catalog. © Sears, Roebuck and Co. 1977. ® Registered trade-mark of Sears, Roebuck and Co.

Sears Department Store, 1977

How to have a great-looking fanny:

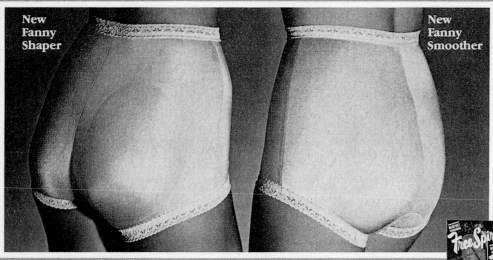

New Fanny Shaper

New Fanny Smoother

New Free Spirit® gives you the fanny you weren't born with.
The Fanny Shaper lifts and rounds. The Fanny Smoother slims and trims, without flattening. Now in satin knit and lace–chic and shiny. Both in white and beige with cotton crotch.

Playtex® will refund $2 if you buy before Oct. 31, 1979. **Free Spirit $2 Refund**

Details on store coupon. Fiber content: polyester/DuPont®Lycra Spandex.®

Free Spirit Shaper, 1979

Frederick's of Hollywood, 1975

Frederick's of Hollywood, 1978

Frederick's of Hollywood, 1974

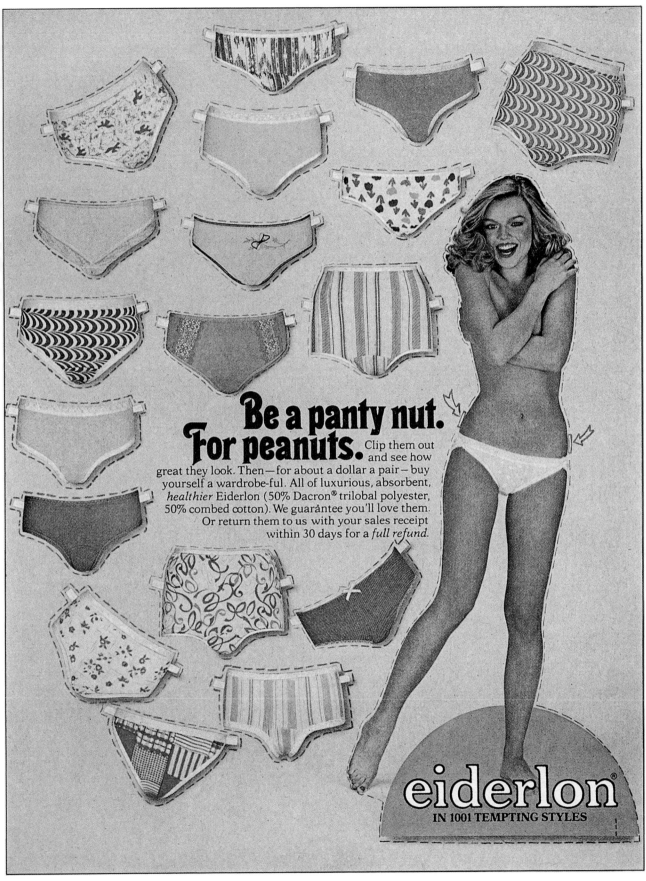

Be a panty nut. For peanuts. Clip them out and see how great they look. Then—for about a dollar a pair—buy yourself a wardrobe-ful. All of luxurious, absorbent, *healthier* Eiderlon (50% Dacron® trilobal polyester, 50% combed cotton). We guarantee you'll love them. Or return them to us with your sales receipt within 30 days for a *full refund*.

eiderlon®
IN 1001 TEMPTING STYLES

Eiderlon Panties, 1978

Freedom Foot ™

the SYMBOL of KUNTA KINTE'S FOOT

ACTUAL SIZE

Be one of the thousands already wearing the symbol of Kunta Kinte's foot.

Hand crafted in cast metal, thoroughly encased in 24 ct. gold plate, with an 18 inch gold plated chain included.

FREEDOM
8242 Moberly Lane, Dallas, Tx. 75227
CALL TOLL FREE 800-527-7060

Please rush ☐ at $9.95 each (Texas residents
Qty.
add 5% Sales Tax) TOTAL $_____
☐ Check ☐ Bank Amer. ☐ Money Order ☐ Master Charge

Credit Card No. _____

Master Charge Inter Bk. No. _____ Exp. Date _____

NAME (PLEASE PRINT) _____

ADDRESS _____

CITY _____ STATE _____ ZIP _____

Freedom Foot Necklace, 1977

THE PUKA

$23*

THE PUKA SHELL CHOKER—
FROM HAWAII'S BIG SURF
BEACHES. MOTHER NATURE'S
FINEST MATCHED, WHITE
SHELLS INDIVIDUALLY
HANDCRAFTED WITH
STERLING SILVER CLASP.

THE GIFT OF SIMPLIC-
ITY FOR THE NATURAL
MAN AT A REASONABLE
PRICE. AVAILABLE IN
3 SHELL SIZES. DIRECT
FROM HAWAII AND
FULLY GUARANTEED.

Photo by IMAGE

The Puka Necklace, 1975

TOKEN of LOVE
from the
CITY of NEW YORK

A 14kt gold token to symbolize your feelings
for the City or the one you love.

This token is a replica of the New York City Transit Authority subway token. Its size and weight are
approximately the same; and is an authorized, licensed product of the New York City Transit Authority.

All pendants have 18" Sterling Silver or
Gold Filled chains.

	Present size token	15¢ size token
14kt.	150.00_____	75.00_____
14kt/w Diamond	175.00_____	100.00_____
Sterling Silver	20.00_____	15.00_____
Gold Filled	20.00_____	15.00_____
Total $_____	(N.J. Residents add 5% sales tax.)	

☐ Check ☐ Money Order Postage Prepaid

Master Charge Account #_____ Exp. Date____

BankAmericard/Visa Account #_____ Exp. Date____

Subway Fashions, Inc.
17 Main St., Flanders, N.J. 07836

Name_____
Address_____
City_____ State____ Zip____
Signature_____

SUBWAY FASHIONS INC.

© N.Y.C.T.A. 1979

Subway Fashions, 1977

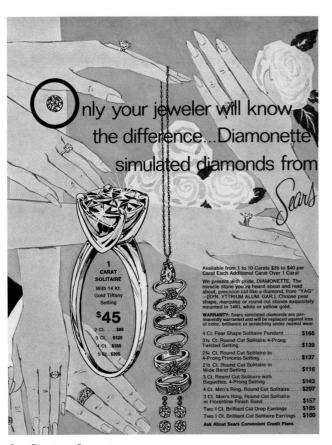

Sears Department Store, 1971

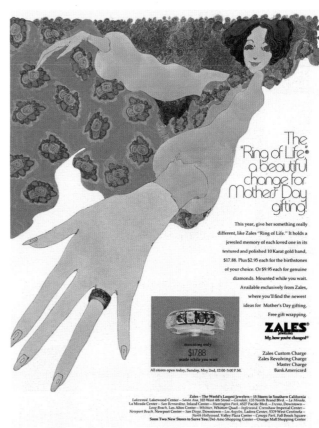

Zales Jewelers, 1971

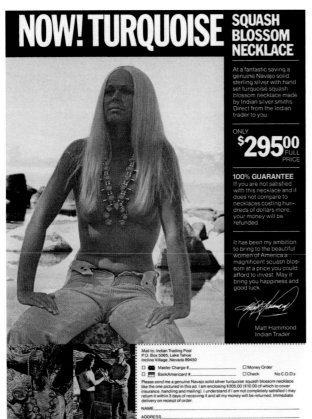

Indian Trading Post, 1974

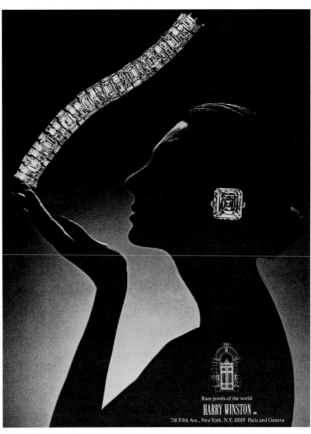

Harry Winston Jewelers, 1975

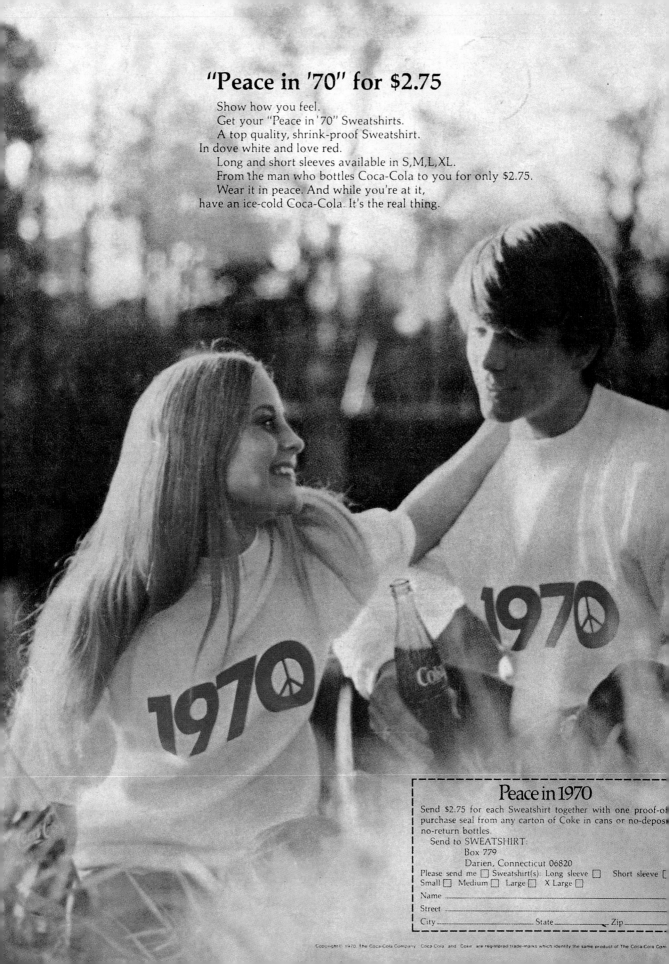

"Peace in '70" for $2.75

Show how you feel.
Get your "Peace in '70" Sweatshirts.
A top quality, shrink-proof Sweatshirt.
In dove white and love red.
Long and short sleeves available in S,M,L,XL.
From the man who bottles Coca-Cola to you for only $2.75.
Wear it in peace. And while you're at it,
have an ice-cold Coca-Cola. It's the real thing.

Peace in 1970

Send $2.75 for each Sweatshirt together with one proof-of-
purchase seal from any carton of Coke in cans or no-deposit
no-return bottles.
Send to SWEATSHIRT:
Box 779
Darien, Connecticut 06820

Please send me ☐ Sweatshirt(s): Long sleeve ☐ Short sleeve ☐
Small ☐ Medium ☐ Large ☐ X Large ☐

Name _____

Street _____

City _____ State _____ Zip _____

Daytons Fabrics, 1973

J.C. Penney Department Store, 1978

Peace In '70 Sweatshirt, 1970 ◄ *Lonely Ladies T-Shirts, 1974*

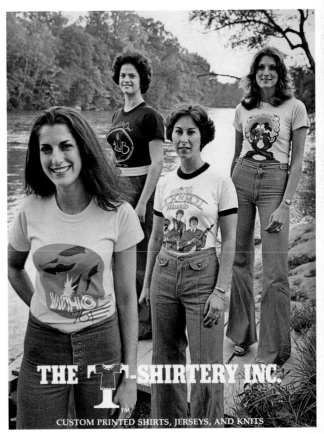

The T-Shirtery, 1976

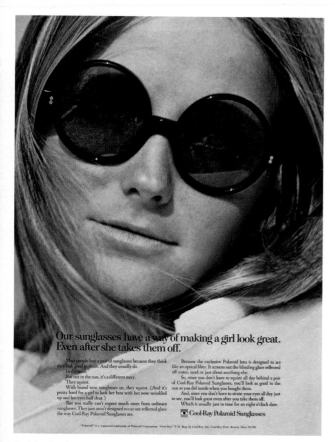

Cool-Ray Sunglasses, 1970

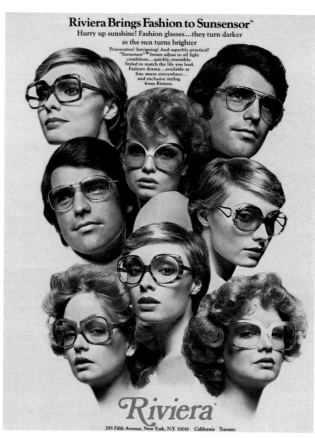

Riviera Eyewear, 1974

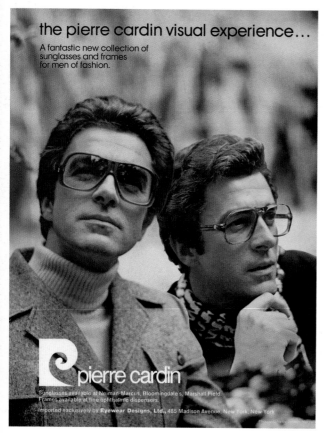

Pierre Cardin Eyewear, 1976

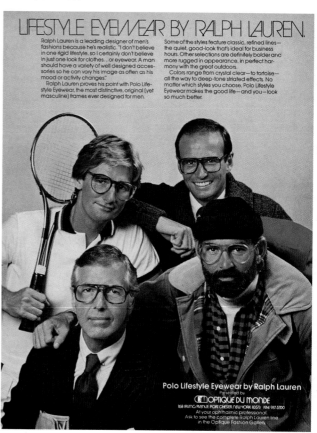

Polo Lifestyle Eyewear, 1977

▶ *Christian Dior Sunglasses, 1977*

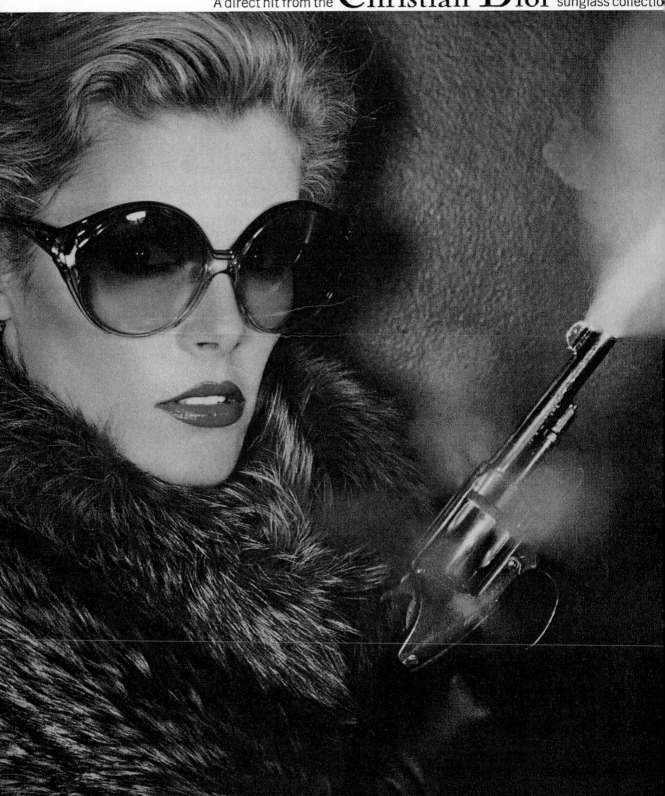

And the winner is...

A Scent of Man

Did the gay man of the "Me Generation" really need his own cologne? Apparently so. The sexual revolution had arrived, so why not exploit the purchasing power of the new openly homosexual man with one of the sillier products of the seventies? One can only wonder what combination of highly charged elixirs would send a potential mate's pheromones racing, while effectively combating come-ons from women. While the product may have relied on some rather creative chemistry, this lackluster ad fails to score.

Ein Hauch von Mann

Brauchten die schwulen Männer der „Me-Generation" dieses Duftwasser wirklich? Offensichtlich. Die sexuelle Revolution hatte ihren Einzug gehalten, warum sollte man dann nicht die Kaufkraft der nun offen homosexuellen Männer mit einem der albernsten Produkte der Siebziger ausbeuten? Man fragt sich, welche Kombination hoch potenter Elixiere die Phäromone eines potenziellen Partners zur Raserei bringen und gleichzeitig sämtliche Annäherungsversuche von Frauen wirkungsvoll ins Feld schlagen würde. Dieses Produkt mag eine relativ kreative chemische Zusammensetzung gehabt haben, aber bei der langweiligen Anzeige vergeht einem einfach alles.

La fleur du mâle

L'homosexuel de la génération « moi, moi et moi » avait-il vraiment besoin de sa propre eau de Cologne? Il faut le croire. La révolution sexuelle étant passée par là, pourquoi ne pas tenter d'exploiter l'homme gay récemment sorti du placard avec un des produits les plus débiles des années 70? On peut se demander quelle combinaison de fragrances hautement chargées allaient stimuler les phéromones d'un partenaire potentiel tout en repoussant efficacement les avances des dames? Le produit reposait peut-être sur une composition chimique plutôt créative, mais cette pub terne, elle, manquait singulièrement de sex-appeal.

Esencia masculina

¿De verdad necesitaban los homosexuales de la «generación del yo» su propia colonia? Aparentemente, sí. La revolución sexual había llegado, así que ¿por qué no explotar el poder adquisitivo de los nuevos hombres abiertamente homosexuales ofreciéndoles uno de los productos más estúpidos de los años setenta? Mejor no imaginar qué combinación de elixires es capaz de disparar un subidón de feromonas en los posibles amantes masculinos al tiempo que mantiene a raya a las posibles interesadas... Por mucha creatividad química que exhibiera el producto, lo cierto es que este anuncio mediocre no lograba su cometido.

男の香り

「ミージェネレーション」のゲイ男性たちは、本当に彼らのためのコロンが必要なのだろうか？ そうらしい。性革命の到来とともに新しく登場した、ゲイであることを隠さない男たちの購買力を、70年代を代表するくだらない商品に使ってもらってなにが悪い？ しかし、いったいいかなる霊薬を組み合わせたら、見込みがありそうな男のフェロモンをたぎらせる一方で、女たちの誘惑はうまくしりぞけるような香りになるのだろうか。商品そのものは、創造的な化学のたまものかもしれないが、このパッとしない広告では、相手をものにできるはずもない。

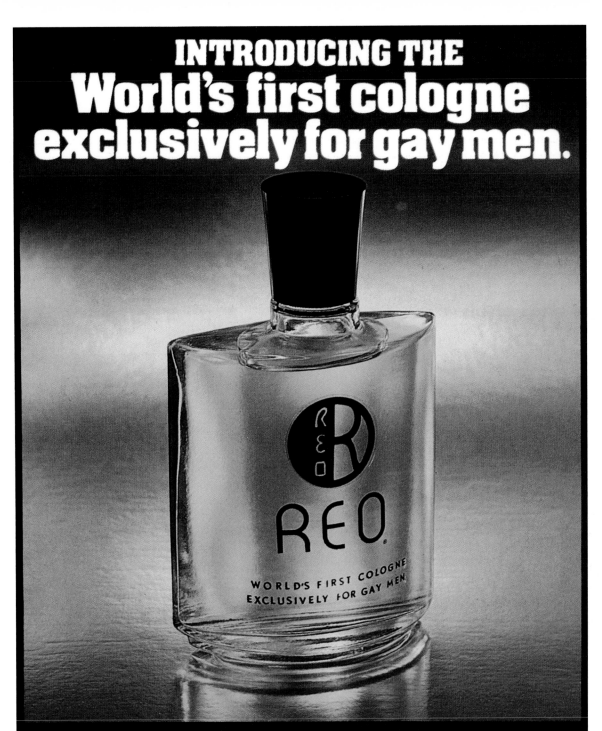

INTRODUCING THE
World's first cologne exclusively for gay men.

REO

WORLD'S FIRST COLOGNE
EXCLUSIVELY FOR GAY MEN

...our Christmas gift to you. With every purchase we'll include the custom designed Reo Pendant with your order. (Expires Dec. 31)

24 Kt..Plate

REO Cologne, 1978

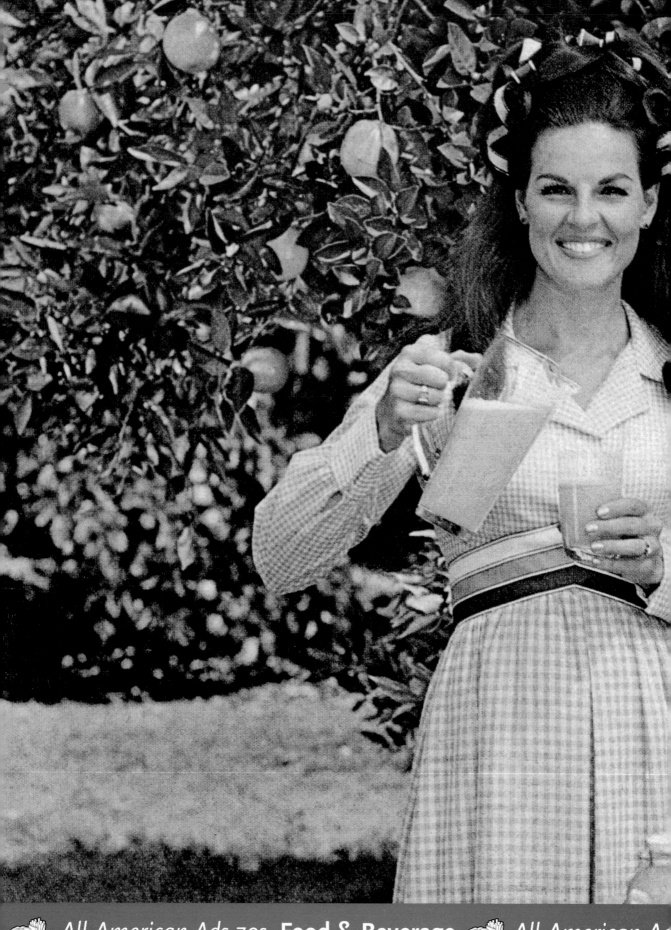

 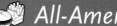

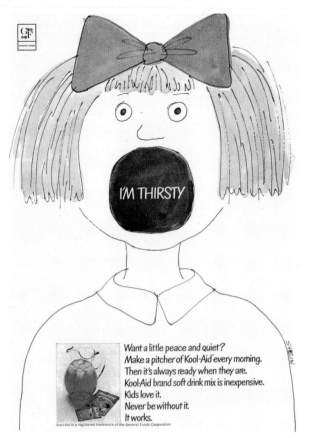

Want a little peace and quiet?
Make a pitcher of Kool-Aid every morning.
Then it's always ready when they are.
Kool-Aid brand soft drink mix is inexpensive.
Kids love it.
Never be without it.
It works.

Kool-Aid is a registered trademark of the General Foods Corporation.

Kool-Aid Soft Drink Mix, 1971

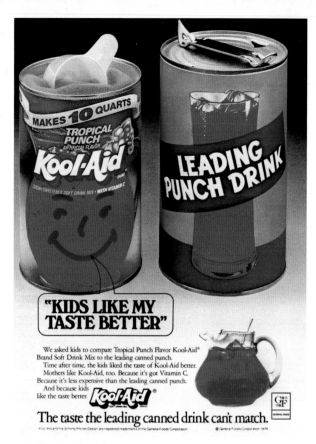

MAKES **10** QUARTS
TROPICAL PUNCH
Kool-Aid

LEADING PUNCH DRINK

"KIDS LIKE MY TASTE BETTER"

We asked kids to compare Tropical Punch Flavor Kool-Aid®
Brand Soft Drink Mix to the leading canned punch.
Time after time, the kids liked the taste of Kool-Aid better.
Mothers like Kool-Aid, too. Because it's got Vitamin C.
Because it's less expensive than the leading canned punch.
And because kids
like the taste better. **Kool-Aid** ®

The taste the leading canned drink can't match.

Kool-Aid and the Smiling Pitcher Design are registered trademarks of the General Foods Corporation. © General Foods Corporation 1978

Kool-Aid Soft Drink Mix, 1978

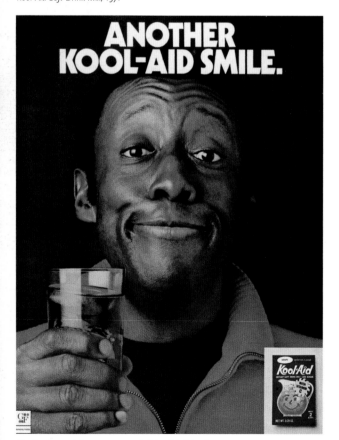

ANOTHER KOOL-AID SMILE.

Florida Orange Juice, 1970 ◄ *Kool-Aid Soft Drink Mix, 1973*

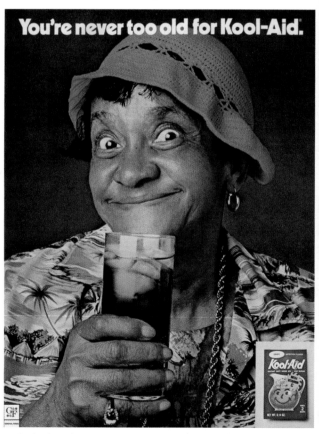

You're never too old for Kool-Aid.

Kool-Aid Soft Drink Mix, 1974 ► *Gatorade Thirst Quencher, 1978*

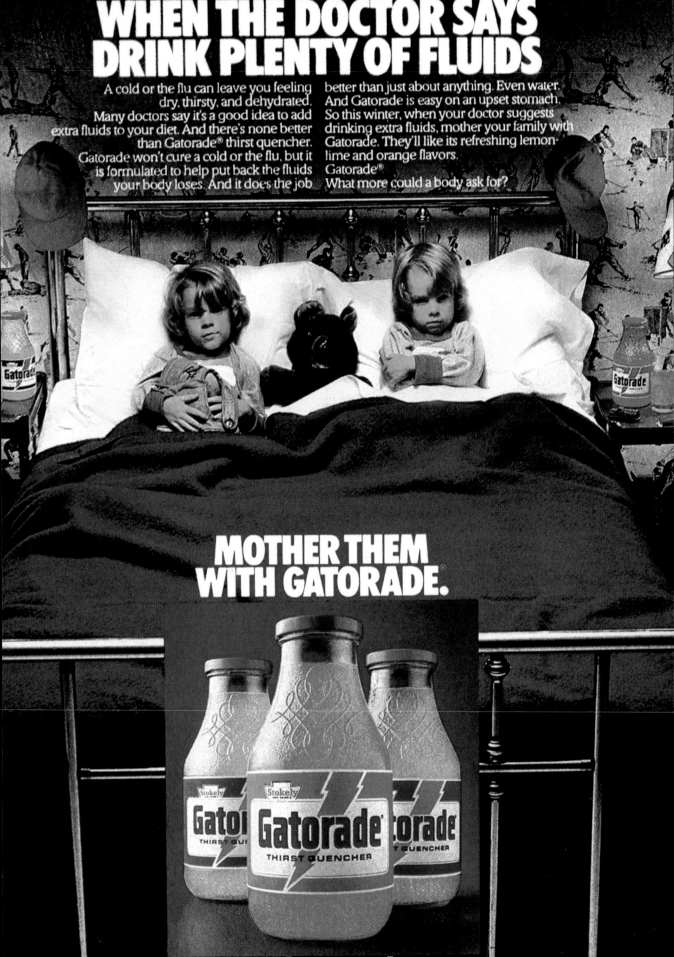

On their 56th morning in outer space, three men will drink Tang.

And then check Skylab's solar array wings one last time and set the instruments on their module towards home.

This will come true. In less than 3 years, man will actually learn to live for extended periods of time in the first manned space station.

And Tang will be on board. The same instant breakfast drink that's on your kitchen table. Orange-flavored Tang with more vitamin C than orange juice. Nutritious Tang.

H.K. WIMMER

Natural Tasting TANG

For breakfast tomorrow.

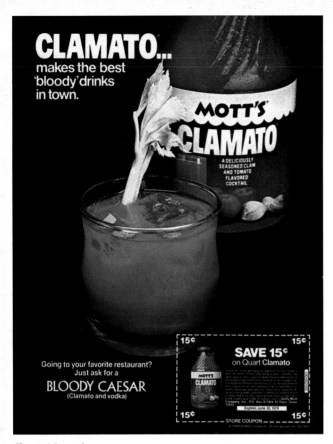

Clamato Juice, 1978

THE RELIEF PITCHER

It's the middle of a hot seventh inning and Grandpa is tiring on the mound—time to bring in the summer's newest relief pitcher... iced Red Zinger herb tea. The natural way to cool off a hot afternoon thirst, iced Red Zinger tea is a welcome change of pace from carbonated soft drinks.

Add a little time and a little honey, then sit back and enjoy the clean delicious taste of iced herb tea. Try mixing some Red Zinger tea with fruit juice and create your own summer punch. At a nickel a glass, iced Red Zinger is the summer relief pitcher.... the one that belongs on the bench.

CELESTIAL SEASONINGS

AN HERBAL RENEWAL PROJECT

Celestial Seasonings Herbal Tea, 1977

Wake up some ice with Awake.

You wouldn't believe ice could taste so good.

Fill an old-fashioned glass with 4 teaspoons of Birds Eye® Awake,® 3 jiggers of water, and crushed ice. Stir and get loaded with Vitamin C.

Awake is soft-frozen. You can use a spoonful or two and put the rest right back in your freezer. Ready for the next time you feel like giving yourself a lift.

Awake isn't only for breakfast.

Tang Orange Beverage, 1971 ◄ *Awake Energy Drink, 1970*

FREE! 4 PUNCHY BOOK COVERS FROM HAWAIIAN PUNCH®

WITH 3 PROOFS OF PURCHASE PLUS 25¢ FOR POSTAGE & HANDLING

Send 'em back to school with 4 free book covers

Each gloss coated, water resistant Punchy book cover comes with a different illustration on the front, and an assortment of educational tables and historical information on the back.

For each free set of 4 book covers you order, just fill out the coupon and mail it...along with 3 "Punchy" pictures cut out from any three labels of 46 oz. Hawaiian Punch) plus 25¢ for postage and handling.

Mail coupon to:
Hawaiian Punch Book Cover Offer
P.O. Box 800C, Braintree, Mass. 02184

Send me _____ sets of Punchy Book Covers.

Name

Address

City State Zip

Offer expires March 30, 1974. Offer void where prohibited. Allow 4 weeks for delivery. Valid only in U.S.A.

Hawaiian Punch—The True Fruit Punch
Delicious Hawaiian Punch has 7 natural fruit juices... not less than 10% natural fruit juices and all the Vitamin C of fresh squeezed orange juice.

Hawaiian Punch, 1973

General Foods® International Coffees Introduces:

New Irish Mocha Mint.

"Lucky us."

"If you love the flavors of chocolate and mint as much as I do, you're in luck. New Irish Mocha Mint is coffee with a rich, chocolatey flavor and an elegant touch of mint. Delicious. Soothing. Of course, I love the other flavors, too. Orange Cappuccino with an enticing aroma of orange, chocolatey flavored Suisse Mocha, cinnamony Cafe Vienna, and smooth Café Francais. But for chocolate and mint lovers, new Irish Mocha Mint is a special treat. Lucky us!"

—Carol Lawrence

International Coffee, 1978

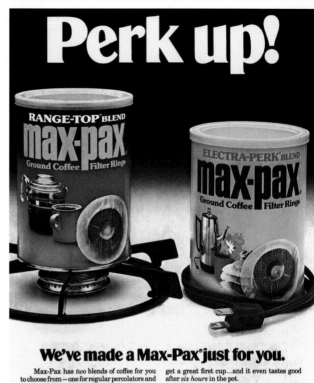

Perk up!

We've made a Max-Pax® just for you.

Max-Pax has *two* blends of coffee for you to choose from—one for regular percolators and one for electric percolators.

And Max-Pax is the only coffee that comes in a filter to trap grounds and sediment, things that can turn coffee bitter.

So no matter which blend you perk up, you get a great first cup...and it even tastes good after *six hours* in the pot.

Get yourself some Max-Pax, Range-Top® blend or Electra-Perk® blend.

If Max-Pax tastes good even after six hours, imagine how delicious it tastes just perked.

Max-Pax Coffee, 1975

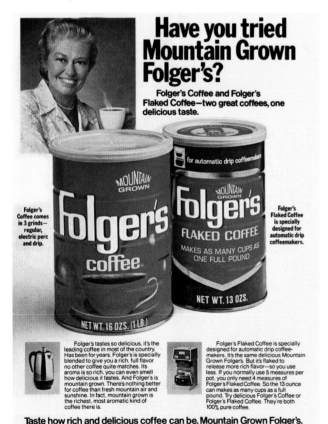

Have you tried Mountain Grown Folger's?

Folger's Coffee and Folger's Flaked Coffee—two great coffees, one delicious taste.

Folger's Coffee comes in 3 grinds—regular, electric perc and drip.

Folger's Flaked Coffee is specially designed for automatic drip coffeemakers.

Folger's tastes so delicious, it's the leading coffee in most of the country. Has been for years. Folger's is specially blended to give you a rich, full flavor no other coffee quite matches. Its aroma is so rich, you can even smell how delicious it tastes. And Folger's is mountain grown. There's nothing better for coffee than fresh mountain air and sunshine. In fact, mountain grown is the richest, most aromatic kind of coffee there is.

Folger's Flaked Coffee is specially designed for automatic drip coffeemakers. It's the same delicious Mountain Grown Folger's. But it's flaked to release more rich flavor—so you use less. If you normally use 5 measures per pot, you only need 4 measures of Folger's Flaked Coffee. So the 13 ounce can makes as many cups as a full pound. Try delicious Folger's Coffee or Folger's Flaked Coffee. They're both 100% pure coffee.

Taste how rich and delicious coffee can be. Mountain Grown Folger's.

Folger's Coffee, 1978

GROUND ROAST COFFEE

We've got the combination.

It wasn't easy making a coffee that looks and smells like ground roast and tastes fresh-perked. But we did it. Taster's Choice® 100% freeze-dried coffee. And for you decaffeinated drinkers, Taster's Choice Decaffeinated with the green label, 97% caffein-free.

Nice combination.

We look, smell and taste like ground roast.

Taster's Choice Coffee, 1974

The quiet strength
of the earth . . .

brought to your teacup by our unique herb tea blends.

available in health and natural food stores, and most grocery stores
in the bay area.

Celestial Seasonings Herbal Tea, 1975

▶ *Sanka Instant Coffee, 1972*

What makes Hi-C®the sensible drink?
The fresh fruit it's made from?
The fact that it's naturally sweetened?
Or is it all that vitamin C?
It's all this. And more. Hi-C is loved by the <u>whole</u> family.
No wonder Hi-C is the sensible drink…
it makes sense for everyone.

The Sensible drink

Hi-C Grape Drink, 1970

Wow! I could've had a V-8

Taking a break? V-8 Cocktail Vegetable Juice
is a healthful blend of 8 vegetables that
tastes terrific and is naturally low in calories.
Only 35 calories a 6-ounce serving.
**Remember, the time
to think of having "V-8" is before
you've had something else.**

V-8 Vegetable Juice, 1978

Coca-Cola, 1977

Coca-Cola, 1978 ▶ *Perrier Sparkling Water, 1977*

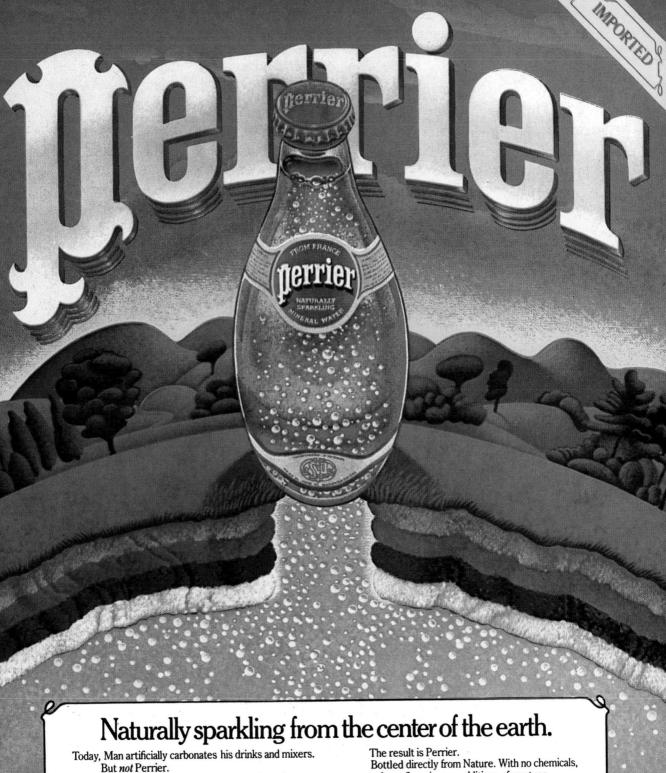

Naturally sparkling from the center of the earth.

Today, Man artificially carbonates his drinks and mixers.

But *not* Perrier.

The miracle of Perrier is *natural carbonation:*

Lighter, more refreshing and more delicate than any made by Man.

That "miracle" takes place deep below the surface of the earth in Southern France near Vergeze.

There, delicate gasses — trapped over 140 million years ago in the volcanic eruptions of the Cretaceous Era — are released and rise through porous limestone and cracked marls to add natural life and sparkle to the icy waters of a single spring: *Source Perrier.*

The result is Perrier.

Bottled directly from Nature. With no chemicals, preservatives, flavorings or additives of any type.

And no calories.

100% natural Perrier.

Pure refreshment served chilled with a slice of fresh lemon or a wedge of lime. So versatile it adds "the sparkle of champagne" to fine wines. And, with imported spirits, is the mixer *par excellence.*

Imported Perrier.

It is the product of Nature and the love of France. Enjoy it in good health.

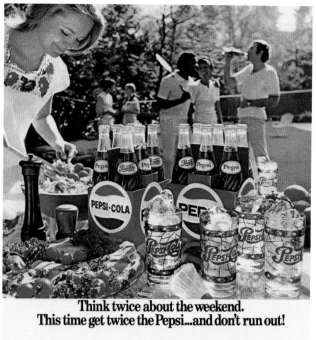

Think twice about the weekend.
This time get twice the Pepsi...and don't run out!

Will there ever be Pepsi-Cola enough for big weekends? Only if you buy enough. So we're reminding you to think twice... get twice as many cartons as you usually do. Look for the "Think Twice" display in your store and load up with the best value of all: Pepsi flavor and Pepsi quality.

Special Offer
6 Tiffany glasses for only $2.95

Serve Pepsi in style with these beautiful 12-oz. glasses embossed with a Tiffany design. Heavyweight... machine-washable. Yours for only $2.95 prepaid.
Mail to: "Think Twice"
Tiffany Glass Offer
P.O. Box 69-1901
Minneapolis, Minnesota 55469
Please rush me_____ sets of 6 Tiffany glasses.
I enclose $2.95 for each set. (Add state and local taxes where applicable.)

Name _____
Address _____
City _____ State _____ Zip _____

Pepsi-Cola, 1971

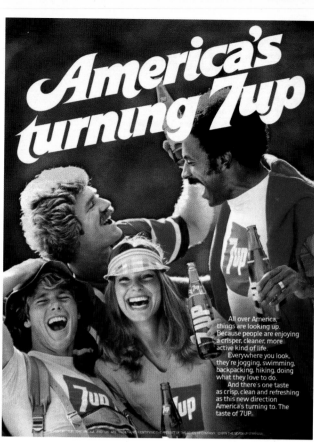

America's turning 7up

All over America, things are looking up. Because people are enjoying a crisper, cleaner, more active kind of life.
Everywhere you look, they're jogging, swimming, backpacking, hiking, doing what they love to do.
And there's one taste as crisp, clean and refreshing as this new direction America's turning to. The taste of 7UP.

Seven Up, 1979

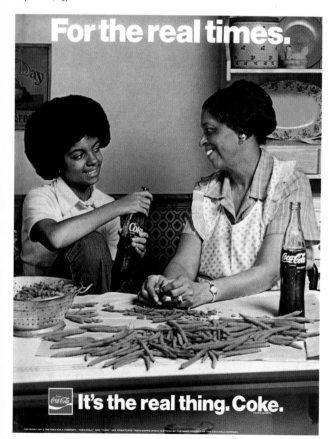

For the real times.

It's the real thing. Coke.

Coca-Cola, 1974

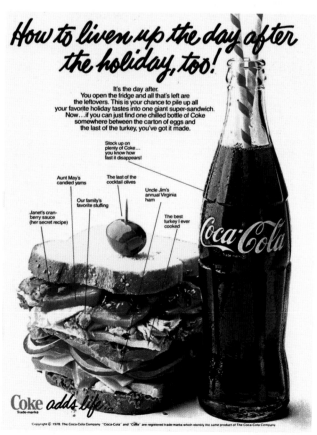

How to liven up the day after the holiday, too!

It's the day after. You open the fridge and all that's left are the leftovers. This is your chance to pile up all your favorite holiday tastes into one giant super-sandwich. Now...if you can just find one chilled bottle of Coke somewhere between the carton of eggs and the last of the turkey, you've got it made.

Stock up on plenty of Coke... you know how fast it disappears!

Aunt May's candied yams
The last of the cocktail olives
Uncle Jim's annual Virginia ham
Our family's favorite stuffing
Janet's cranberry sauce (her secret recipe)
The best turkey I ever cooked

Coke *adds life...*

Coca-Cola, 1978

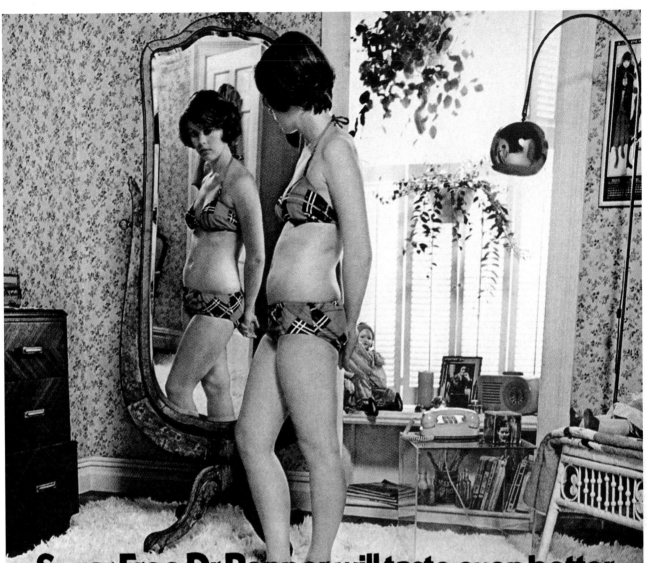

Sugar Free Dr Pepper will taste even better after you try on last year's bathing suit.

Some people drink Sugar Free Dr Pepper just because they like it. But a lot more people drink it because it tastes great and there are only two calories per serving.

And no matter how much you drink, it doesn't leave an unpleasant aftertaste.

So when you get up the courage to try on last year's bikini, have a nice cold Sugar Free Dr Pepper handy.

Put on the suit, peek in the mirror and quickly take a sip. Then look in the mirror again and take another sip.

Notice how Sugar Free Dr Pepper tastes better and better every time you look in the mirror?

Just keep sipping, watch what you eat and pretty soon you'll start looking better and better too.

Sugar Free Dr Pepper. You can drink a lot of it.

Sugar Free Dr Pepper, 1973

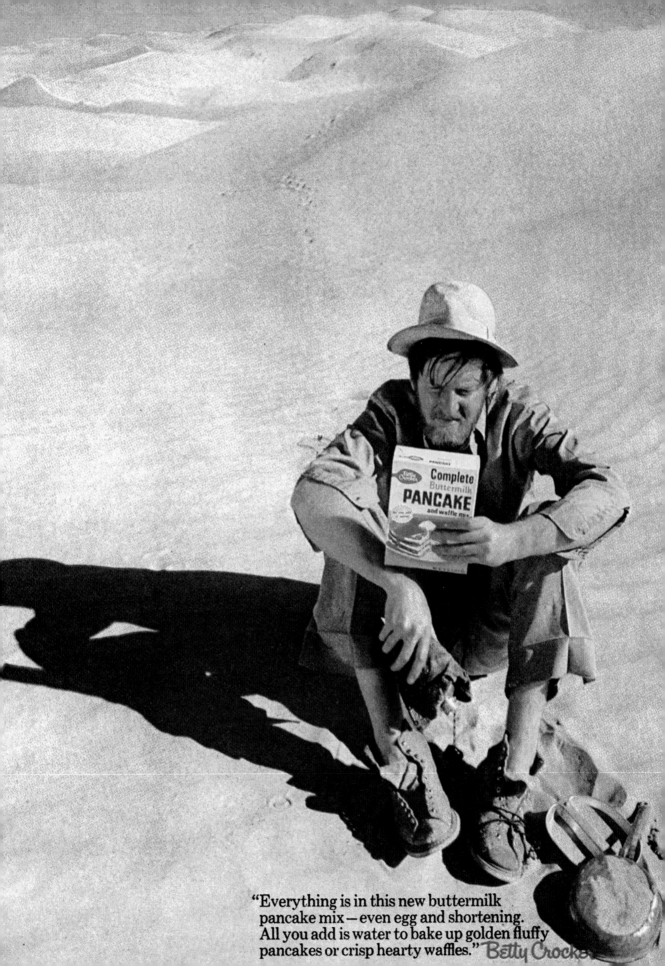

"Everything is in this new buttermilk
pancake mix — even egg and shortening.
All you add is water to bake up golden fluffy
pancakes or crisp hearty waffles." *Betty Crocker*

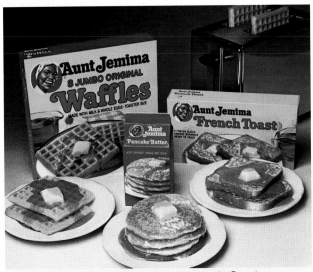

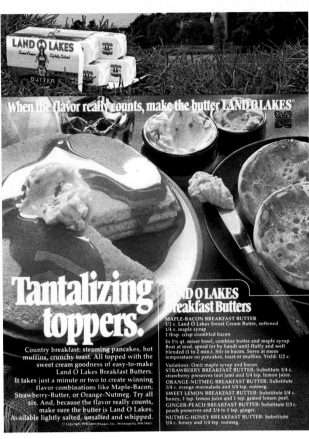

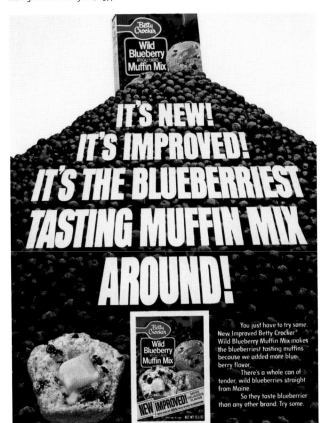

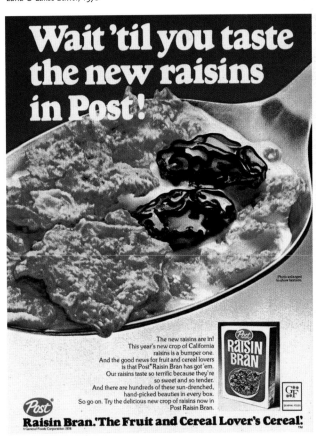

Aunt Jemima Breakfasts, 1977

Land O Lakes Butter, 1978

Betty Crocker Pancake Mix, 1970 ◄ *Betty Crocker Muffin Mix, 1978*

Post Raisin Bran Cereal, 1978

Quaker announces a 100% vitamin & iron cereal for kids

King Vitaman Cereal, 1970

Fortified with 8 essential vitamins!

Kellogg's Corn Flakes Cereal, 1972

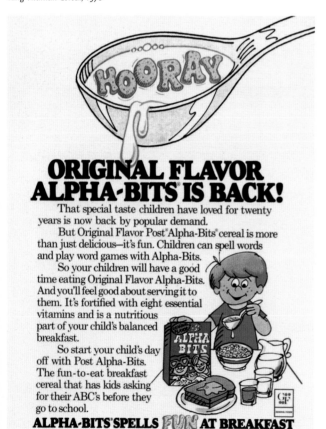

ORIGINAL FLAVOR ALPHA-BITS IS BACK!

Alpha-Bits Cereal, 1978

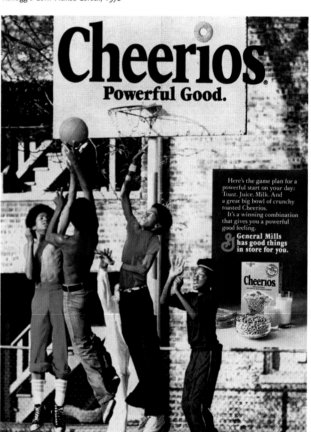

Cheerios
Powerful Good.

Cheerios Cereal, 1976

Kellogg's Product 19 Cereal, 1971

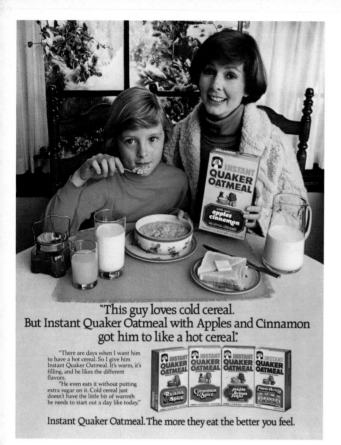

"This guy loves cold cereal.
But Instant Quaker Oatmeal with Apples and Cinnamon
got him to like a hot cereal."

"There are days when I want him to have a hot cereal. So I give him Instant Quaker Oatmeal. It's warm, it's filling, and he likes the different flavors."

"He even eats it without putting extra sugar on it. Cold cereal just doesn't have the little bit of warmth he needs to start out a day like today."

Instant Quaker Oatmeal. The more they eat the better you feel.

Instant Quaker Oatmeal, 1977

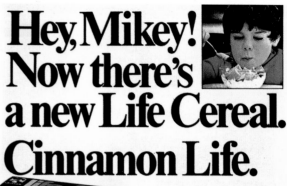

Hey, Mikey! Now there's a new Life Cereal. Cinnamon Life.

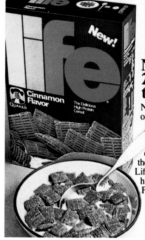

Now there are 2 kinds of Life Cereals to please all kinds of kids.

New Cinnamon Life starts with that crunchy, oatsy flavor kids like Mikey love. And on top of that is a great new cinnamon taste. Mikeys everywhere will love the cinnamon. Mothers everywhere will love the protein. Cinnamon Life is the new delicious high-protein cereal. From Quaker.

Life Cereal, 1978

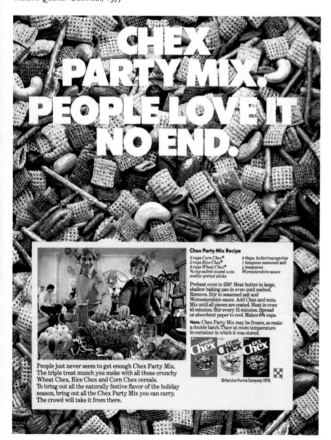

CHEX PARTY MIX. PEOPLE LOVE IT NO END.

Chex Party Mix Recipe

2 cups Corn Chex®
2 cups Rice Chex®
2 cups Wheat Chex®
¾ cup salted mixed nuts and/or pretzel sticks
6 tbsps. butter/margarine
1 teaspoon seasoned salt
4 teaspoons Worcestershire sauce

Preheat oven to 250°. Heat butter in large, shallow baking pan in oven until melted. Remove. Stir in seasoned salt and Worcestershire sauce. Add Chex and nuts. Mix until all pieces are coated. Heat in oven 45 minutes. Stir every 15 minutes. Spread on absorbent paper to cool. Makes 6¾ cups.

Note: Chex Party Mix may be frozen, so make a double batch. Thaw at room temperature in container in which it was stored.

People just never seem to get enough Chex Party Mix. The triple treat munch you make with all those crunchy Wheat Chex, Rice Chex and Corn Chex cereals. To bring out all the naturally festive flavor of the holiday season, bring out all the Chex Party Mix you can carry. The crowd will take it from there.

©Ralston Purina Company 1978.

Chex Cereal, 1978

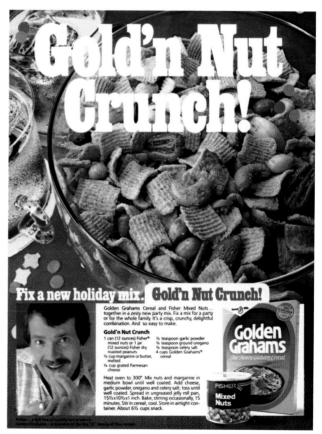

Gold'n Nut Crunch!

Fix a new holiday mix. Gold'n Nut Crunch!

Golden Grahams Cereal and Fisher Mixed Nuts... together in a zesty new party mix. Fix a mix for a party or for the whole family. It's a crisp, crunchy, delightful combination. And so easy to make.

Gold'n Nut Crunch

1 can (12 ounces) Fisher® mixed nuts or 1 jar (12 ounces) Fisher dry roasted peanuts
¼ cup margarine or butter, melted
¼ cup grated Parmesan cheese
¼ teaspoon garlic powder
¼ teaspoon ground oregano
¼ teaspoon celery salt
4 cups Golden Grahams® cereal

Heat oven to 300°. Mix nuts and margarine in medium bowl until well coated. Add cheese, garlic powder, oregano and celery salt; toss until well coated. Spread in ungreased jelly roll pan, 15½x10½x1 inch. Bake, stirring occasionally, 15 minutes. Stir in cereal; cool. Store in airtight container. About 6½ cups snack.

Golden Grahams Cereal, 1978

▶ *Carnation Instant Breakfast, 1970*

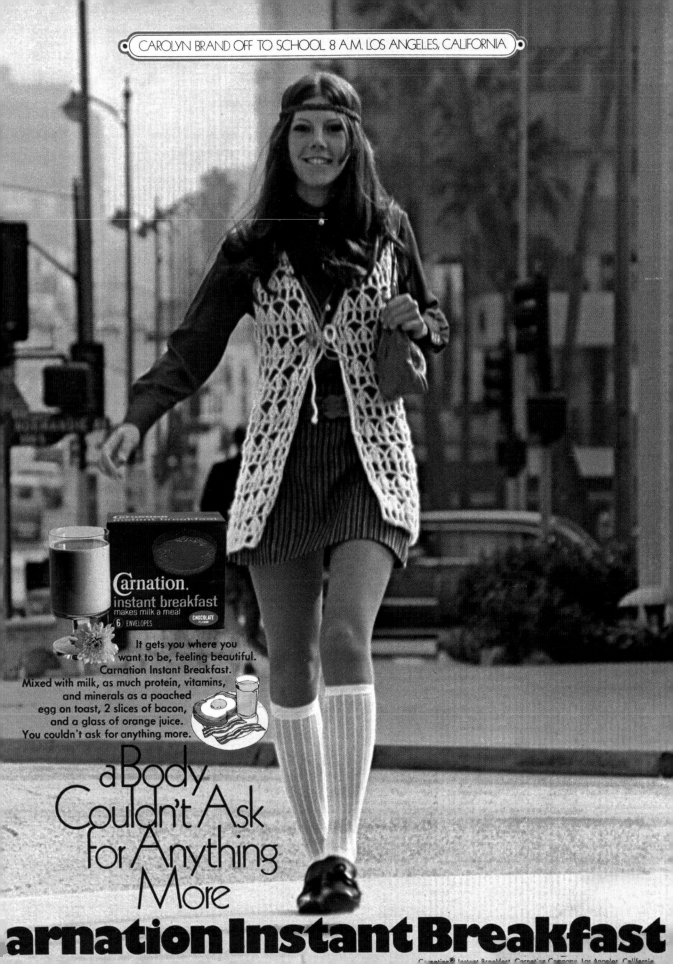

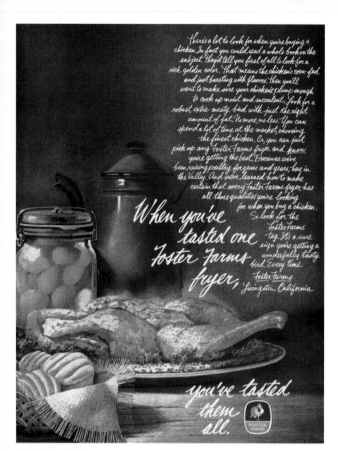

Foster Farms Chicken, 1970

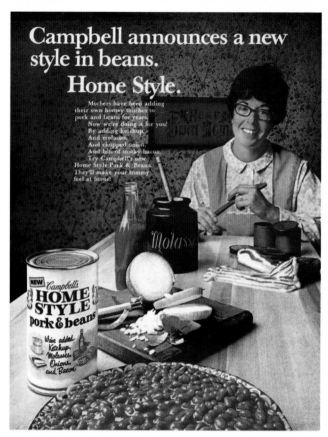

Campbell's Pork & Beans, 1970

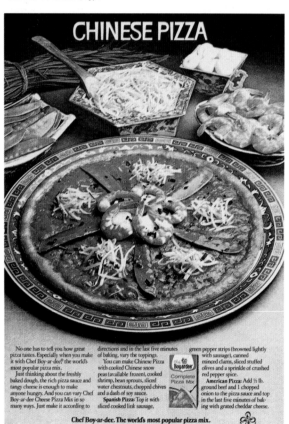

Chef Boy-ar-dee Pizza Mix, 1973

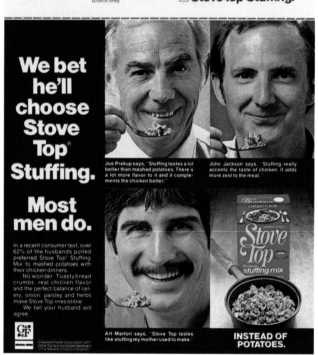

Stove Top Stuffing Mix, 1978

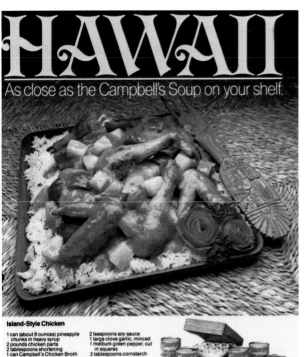

HAWAII

As close as the Campbell's Soup on your shelf.

Island-Style Chicken

1 can (about 8 ounces) pineapple chunks in heavy syrup	2 teaspoons soy sauce
2 pounds chicken parts	1 large clove garlic, minced
2 tablespoons shortening	1 medium green pepper, cut in squares
1 can Campbell's Chicken Broth	3 tablespoons cornstarch
¼ cup vinegar	¼ cup water
2 tablespoons brown sugar	

Drain pineapple chunks, reserving syrup. In skillet, brown chicken in shortening; pour off fat. Add reserved syrup, broth, vinegar, sugar, soy, and garlic. Cover; cook over low heat 40 minutes. Add green pepper and pineapple chunks; cook 5 minutes more or until done. Stir occasionally. Combine cornstarch and water; gradually stir into sauce. Cook, stirring until thickened. Serve with cooked parsleyed rice. Makes 4 servings.

Cookbook offer: There's a world of good cooking waiting for you in Campbell's "Cooking with Soup" cookbook. Over 600 recipes fill this beautiful 200-page, hard-covered book. Just send $1.50 and two Campbell's Soup labels with your name, address, and zip code to: COOKBOOK, Box 1981C, Maple Plain, Minn. 55348. Offer good only in U.S.A. Allow 6 weeks for delivery.

A world of good cooking brought home with Campbell's.

Campbell's Soup, 1978

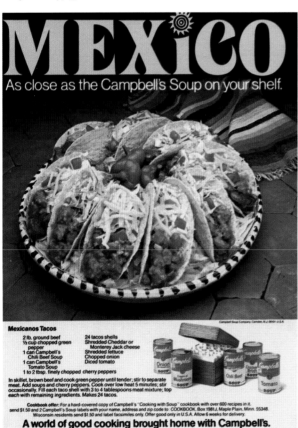

MEXiCO

As close as the Campbell's Soup on your shelf.

Mexicanos Tacos

2 lb. ground beef	24 tacos shells
½ cup chopped green pepper	Shredded Cheddar or Monterey Jack cheese
1 can Campbell's Chili Beef Soup	Shredded lettuce
1 can Campbell's Tomato Soup	Chopped onion
1 to 2 tbsp. finely chopped cherry peppers	Diced tomato

In skillet, brown beef and cook green pepper until tender; stir to separate meat. Add soups and cherry peppers. Cook over low heat 5 minutes; stir occasionally. Fill each taco shell with 3 to 4 tablespoons meal mixture; top each with remaining ingredients. Makes 24 tacos.

Cookbook offer: For a hard-covered copy of Campbell's "Cooking with Soup" cookbook with over 600 recipes in it, send $1.50 and 2 Campbell's Soup labels with your name, address and zip code to: COOKBOOK, Box 1981J, Maple Plain, Minn. 55348. Wisconsin residents send $1.50 and label facsimiles only. Offer good only in U.S.A. Allow 6 weeks for delivery.

A world of good cooking brought home with Campbell's.

Campbell's Soup, 1978

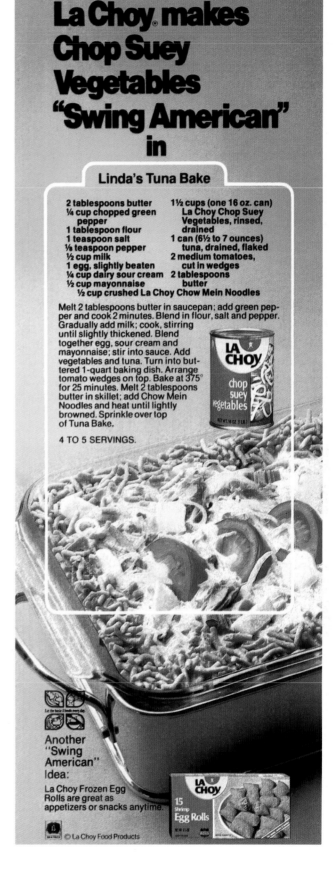

La Choy makes Chop Suey Vegetables "Swing American" in

Linda's Tuna Bake

2 tablespoons butter	1½ cups (one 16 oz. can) La Choy Chop Suey Vegetables, rinsed, drained
¼ cup chopped green pepper	
1 tablespoon flour	1 can (6½ to 7 ounces) tuna, drained, flaked
1 teaspoon salt	
⅛ teaspoon pepper	2 medium tomatoes, cut in wedges
½ cup milk	
1 egg, slightly beaten	2 tablespoons butter
¼ cup dairy sour cream	
½ cup mayonnaise	
½ cup crushed La Choy Chow Mein Noodles	

Melt 2 tablespoons butter in saucepan; add green pepper and cook 2 minutes. Blend in flour, salt and pepper. Gradually add milk; cook, stirring until slightly thickened. Blend together egg, sour cream and mayonnaise; stir into sauce. Add vegetables and tuna. Turn into buttered 1-quart baking dish. Arrange tomato wedges on top. Bake at 375° for 25 minutes. Melt 2 tablespoons butter in skillet; add Chow Mein Noodles and heat until lightly browned. Sprinkle over top of Tuna Bake.

4 TO 5 SERVINGS.

Another "Swing American" Idea:

La Choy Frozen Egg Rolls are great as appetizers or snacks anytime.

© La Choy Food Products

La Choy Chop Suey Vegetables, 1978

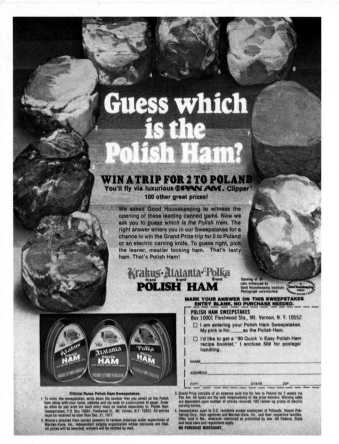

Polish Ham, 1977

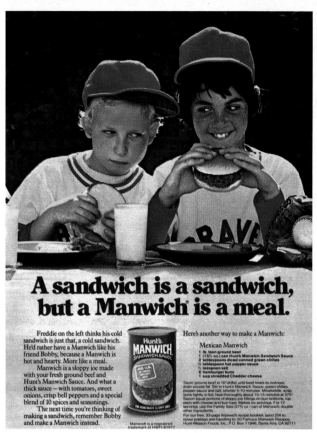

Manwich Sandwich Sauce, 1978

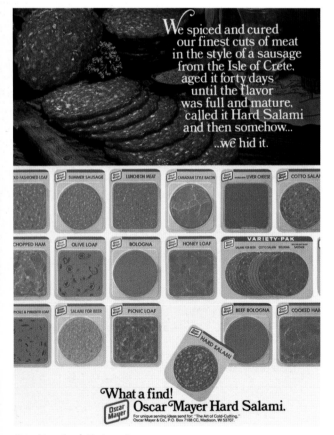

Oscar Mayer Lunch Meats, 1978

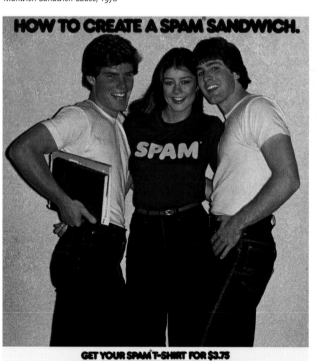

Spam Canned Meat, 1979

▶ Ortega Products, 1971

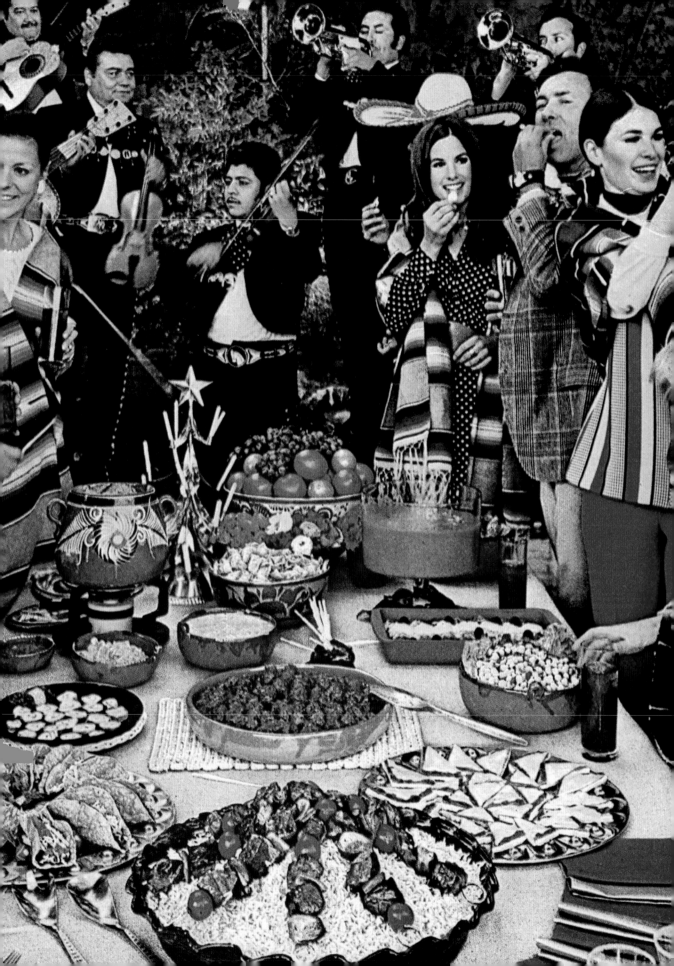

A pinch of this and a pinch of that. Just the right amount of herbs and spices. That's what makes a great spaghetti sauce. So we put a packet full of pinches inside Kraft Tangy Italian Style Dinner. The good kind you cook up fresh.

Kraft Spaghetti Dinner, 1973

Cook once. Eat twice. <u>That's</u> Italian!

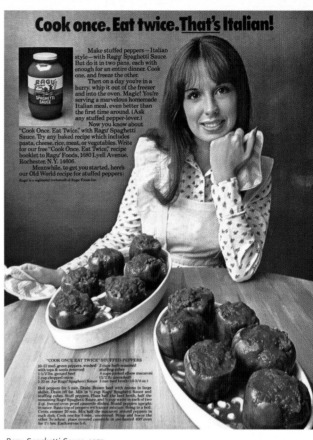

Make stuffed peppers—Italian style—with Ragú Spaghetti Sauce. But do it in two pans, each with enough for an entire dinner. Cook one, and freeze the other.

Then on a day you're in a hurry, whip it out of the freezer and into the oven. Magic! You're serving a marvelous homemade Italian meal, even better than the first time around. (Ask any stuffed pepper-lover.)

Now you know about "Cook Once. Eat Twice." with Ragú Spaghetti Sauce. Try any baked recipe which includes pasta, cheese, rice, meat, or vegetables. Write for our free "Cook Once. Eat Twice." recipe booklet to Ragú Foods, 1680 Lyell Avenue, Rochester, N.Y. 14606.

Meanwhile, to get you started, here's our Old World recipe for stuffed peppers:

Ragú is a registered trademark of Ragú Foods Inc.

"COOK ONCE EAT TWICE" STUFFED PEPPERS

10-12 med. green peppers, washed with tops & seeds removed	2 cups herb seasoned stuffing cubes
1-1/2 lbs. ground beef	4 cups cooked elbow macaroni
1 cup chopped onion	(1/2 lb. uncooked)
3 33 oz. jar Ragú Spaghetti Sauce	1 can beef broth (10-3/4 oz.)

Boil peppers for 5 min. Drain. Brown beef with onions in large skillet. Drain off fat. Mix in ½ cup Ragú Spaghetti Sauce and stuffing cubes. Stuff peppers. Place half the beef broth, half the remaining Ragú Spaghetti Sauce, and ½ cup water in each of two 2 qt. freezer-oven proof casserole dishes. Stand peppers upright in sauce. Baste top of peppers with sauce mixture, filling to a boil. Cover, simmer 20 min. Mix half the macaroni around peppers in each dish. Cook one for 5 min., uncovered. Wrap and freeze the other. To reheat, place covered casserole in pre-heated 400° oven for 1½ hrs. Each serves 5-6.

Ragu Spaghetti Sauce, 1973

Today your husband left on a business trip. You've finally got a chance to start reading that new novel. And somehow, tonight, you don't feel like eating those leftovers.

It's a good day for Stouffer's.

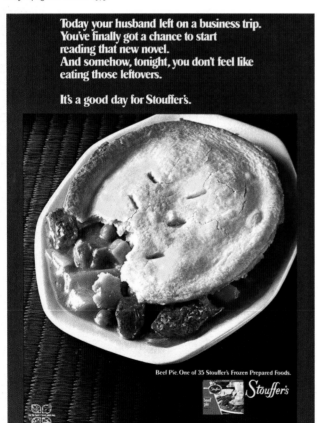

Beef Pie. One of 35 Stouffer's Frozen Prepared Foods.

Stouffer's

Stouffer's Frozen Food, 1973

Top row: Veal Parmigiana, Beefsteak with Mushroom Sauce; Bottom row: Cheese and Tomato Pie, Lasagna.

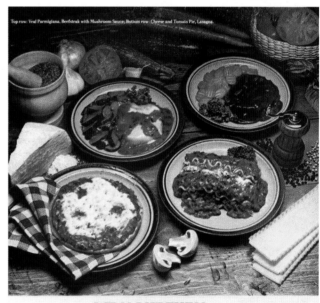

WE MAKE THEM LIKE YOU'D MAKE THEM.

We use the same good ingredients in Weight Watchers® Frozen Meals you would.

Farm-grown tomatoes, mozzarella and romano cheese in our Italian Pies.

Out-of-the-ordinary vegetables like zucchini with sauce in our Veal Parmigiana.

Chopped beefsteak and crinkle cut carrots in our Beefsteak with Mushroom Sauce Meal.

Ground veal and ricotta cheese in our Lasagna.

It's a naturally simple idea: Nothing tastes better than the real thing. With our good ingredi-ents, our special sauces and just the right spices, we don't put in empty calories and fillers. In fact, we're so proud of our 24 Weight Watchers Frozen Meals, we print the nutritional informa-tion right up front on our package. So reach for our pink packages in your grocer's freezer. You'll always come up with a lot of good eating.

Weight Watchers Frozen Meals, 1978

▶ *Chicken of the Sea Tuna, 1971*

Do you believe in mermaids? A lot of people do.

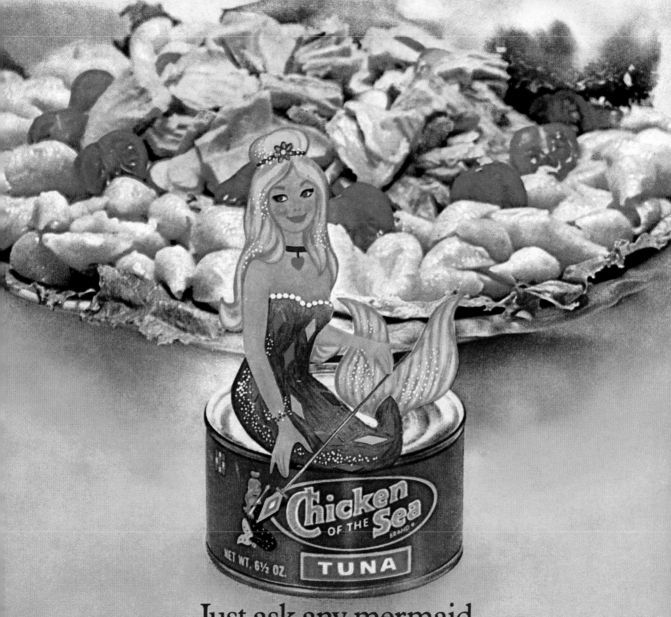

Just ask any mermaid
you happen to see
What's the best tuna?
"It's Chicken of the Sea."

Look for Chicken of the Sea Frozen Shrimp, too!

Hungry Jack® Flaky Biscuits are
BIG TASTIN' BISCUITS

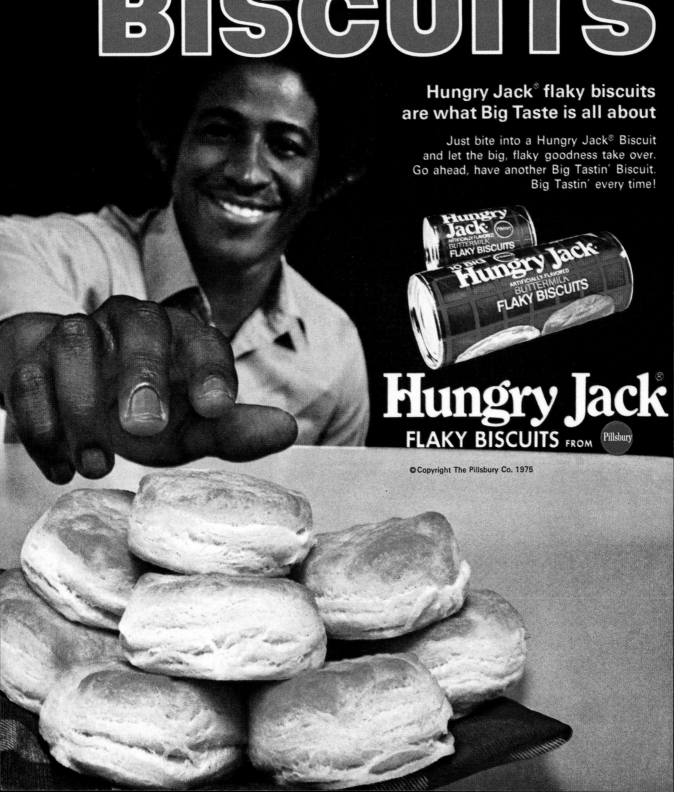

Hungry Jack® flaky biscuits are what Big Taste is all about

Just bite into a Hungry Jack® Biscuit and let the big, flaky goodness take over. Go ahead, have another Big Tastin' Biscuit. Big Tastin' every time!

Hungry Jack®
FLAKY BISCUITS FROM Pillsbury

For people who can't leave well enough alone, look what you can do with a Banquet Fried Chicken Dinner.

Fried chicken dinner. Banquet makes it good and Banquet makes it fast and if you want it fancier, Banquet can help out there too with this easy, delicious recipe:

Take one Banquet Fried Chicken Dinner from your freezer. Sprinkle chicken with paprika, thyme, grated Parmesan. Heat for 25 minutes leaving foil sealed. Then combine peas with fresh sauteed mushrooms and onions. Add butter and parsley to potatoes. Remove foil, heat additional 10 minutes, then serve with fresh fruit. Banquet. Great food, plain or fancy.

Banquet Foods Corporation, St. Louis, Missouri 63101

Banquet Frozen Dinners, 1973

Fish for compliments.

Sunkist Lemons, 1973

How to have ground beef 3 times a week and love it.
Campbell's Soup puts welcome new variety in the daily grind.

SOUPERBURGER
1 pound ground beef
¼ cup chopped onion
1 tablespoon shortening
1 can (10¾ ounces) Campbell's Vegetable Soup
2 tablespoons ketchup
1 teaspoon prepared mustard
Dash pepper
6 buns, split and toasted

In skillet, brown beef and onion in shortening; stir to separate meat. Add remaining ingredients except buns. Cook 5 minutes; stir now and then. Serve on buns. Garnish with onion and tomato slices. Makes 6 sandwiches.

UPSIDE DOWN PIE
1 pound ground beef
½ cup chopped celery
½ cup chopped onion
½ cup chopped green pepper
1 tablespoon shortening
1 teaspoon salt
1 can (10¾ ounces) Campbell's Tomato Soup
1½ cups prepared biscuit mix
½ cup milk
3 slices (3 ounces) process cheese, cut in half diagonally

In oven-proof skillet (10 to 11 inches), brown beef and cook celery, onion, and green pepper in shortening until tender. Stir in salt, soup. Combine biscuit mix and milk; roll or pat dough into a circle slightly smaller than skillet. Spread meat mixture evenly in skillet; top with biscuit dough. Bake at 450°F. for 15 minutes. Turn upside down on platter. Top with cheese. Cut into wedges and serve. 6 servings.

BURGER BEAN CUPS
1 can Campbell's Cream of Mushroom Soup
1 pound ground beef
¼ cup fine dry bread crumbs
¼ cup finely chopped onion
1 egg, slightly beaten
½ teaspoon salt
1 package (9 ounces) frozen cut green beans, cooked and drained
¼ teaspoon dried dill leaves

Thoroughly mix ¼ cup soup, beef, bread crumbs, onion, egg, salt, and pepper. Divide into 4 mounds on waxed paper. Flatten each into 5-inch circle. Turn up edge of meat to form a half-inch rim; remove from paper. Place in shallow baking dish. Combine remaining soup, beans and dill. Spoon into burger cups. Bake at 350°F. 30 minutes. 4 servings.

M'm! M'm! Good and easy!

Don't miss Campbell's TV Special, "Debbie Reynolds and The Sound of Children," on NBC, Thurs. Nov. 6th, at 7:30 p.m. EST.

Hungry Jack Biscuits, 1975 ◄ *Campbell's Soup, 1970*

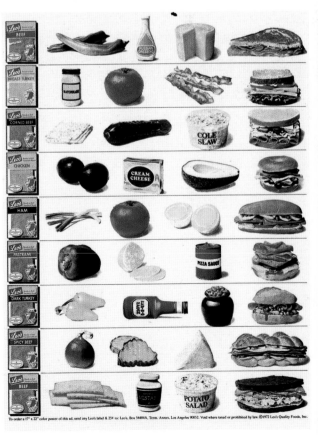

Leo's Meats, 1972

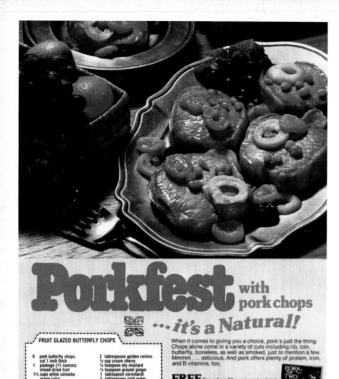

Porkfest with pork chops
...it's a Natural!

FRUIT GLAZED BUTTERFLY CHOPS

6 pork butterfly chops, cut 1 inch thick	2 tablespoons golden raisins
1 package (11 ounces) mixed dried fruit	¼ cup cream sherry
	½ teaspoon dry mustard
1½ cups white catawba grape juice	½ teaspoon ground ginger
	1 tablespoon cornstarch
	2 tablespoons cold water

In medium saucepan, combine dried fruit, grape juice, raisins, sherry, mustard, and ginger. Bring to boiling. Cover; reduce heat and simmer till fruit is plump and tender, about 25 to 30 minutes. Meanwhile, place butterfly chops on rack in broiler pan. Broil at moderate temperature 3 to 4 inches from heat till done, about 25 minutes, turning once. In small bowl, combine cornstarch and cold water. Stir into fruit mixture. Cook, stirring constantly, over moderate heat till mixture is thickened and bubbly. Cook 1 minute longer. Serve fruit sauce with chops. Makes 6 servings.

When it comes to giving you a choice, pork's just the thing. Chops alone come in a variety of cuts including rib, loin, butterfly, boneless, as well as smoked, just to mention a few. Mmmm ... delicious. And pork offers plenty of protein, iron, and B vitamins, too.

FREE For a free 32-page recipe book "Pork for Two" (it has recipes for more than two, too), send a self-addressed, stamped, business envelope to: National Pork Producers Council, P.O. Box 10351, Des Moines, Iowa 50306. You'll discover pork's a natural for breakfast, brunch and lunch time, dinner time, snack time, any time. Offer good in U.S.A. only

National Pork Producers Council, 1978

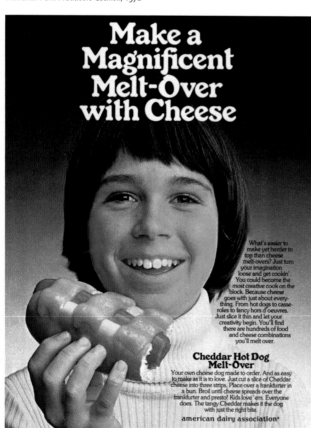

Make a Magnificent Melt-Over with Cheese

What's easier to make yet harder to top than cheese melt-overs? Just turn your imagination loose and get cookin'. You could become the most creative cook on the block. Because cheese goes with just about everything. From hot dogs to casseroles to fancy hors d'oeuvres. Just slice it thin and let your creativity begin. You'll find there are hundreds of food and cheese combinations you'll melt over.

Cheddar Hot Dog Melt-Over

Your own cheese dog made to order. And as easy to make as it is to love. Just cut a slice of Cheddar cheese into three strips. Place over a frankfurter in a bun. Broil until cheese spreads over the frankfurter and presto! Kids love 'em. Everyone does. The tangy Cheddar makes it the dog with just the right bite.

american dairy association®

American Dairy Association, 1978

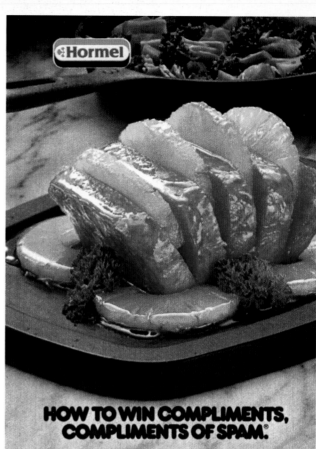

⊕ **Hormel**

HOW TO WIN COMPLIMENTS, COMPLIMENTS OF SPAM.

It's easy to win compliments when you start with SPAM® Luncheon Meat. Because SPAM can be the start of a whole world of good things. Put it in a casserole. Add it to a salad. Make it into a midnight snack. Dice it up with eggs. Or fry it up by itself.

Our special blend of pork shoulder and Hormel ham can really make a meal. And it's the perfect ingredient for your food budget.

PINEAPPLE SPAM LOAF

1 can (12-oz.) SPAM® Luncheon Meat
1 can (8-oz.) pineapple slices
¼ cup brown sugar
¼ tsp. dry mustard

Cut four slices almost, but not quite, all the way through SPAM loaf. Cut pineapple slices in half and place one halved slice in each of the slits in the SPAM. Place loaf in small pie pan or shallow casserole; arrange remaining pineapple around SPAM. Combine brown sugar and dry mustard mixture with two tbsp. pineapple juice; spoon over SPAM. Bake in pre-heated 350° oven for 25-30 minutes, basting occasionally. Makes four servings.

Eat the basic 4 foods every day.

A LOT OF MEALS. BUT NOT A LOT OF MONEY.

Spam Canned Meat, 1978

▶ *McDonald's, 1979*

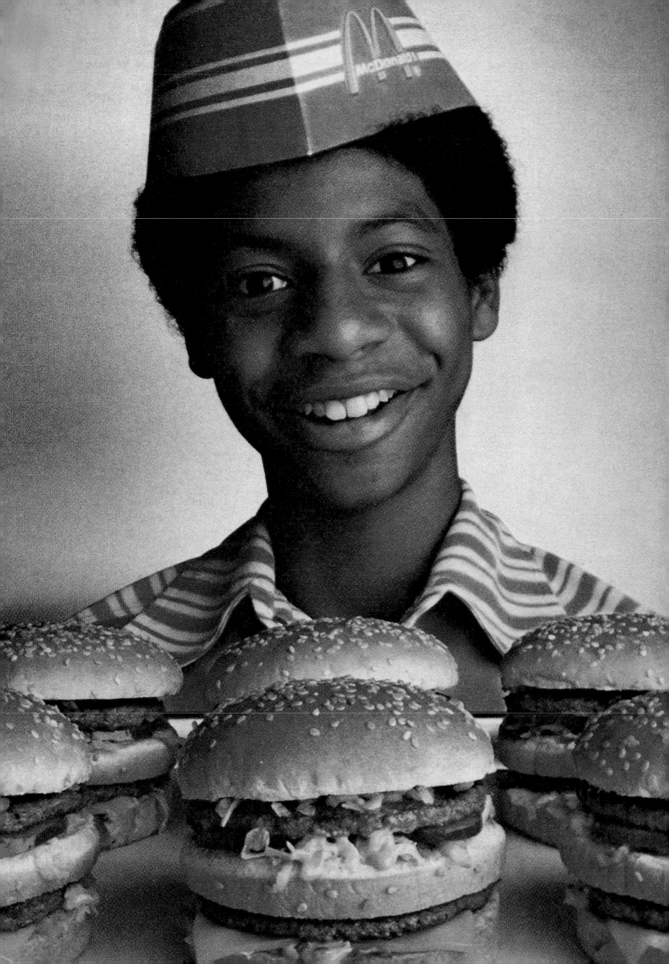

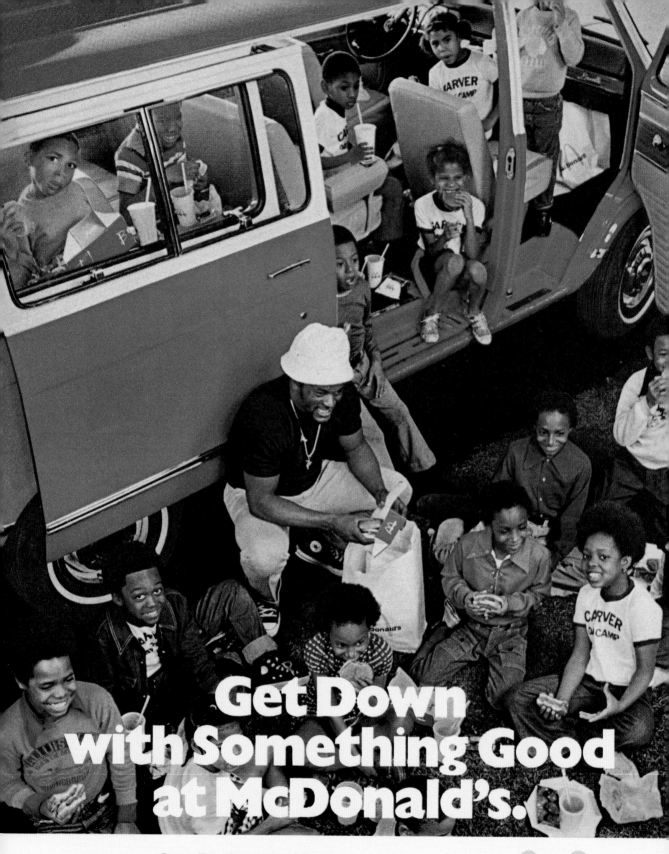

Get Down with Something Good at McDonald's.

Carver Day Camp Gettin' Down.
 Field trips are always a lot of fun.
Especially if you stop by McDonald's on your way home.
Because when it comes to good eatin',
McDonald's is one place that will satisfy everybody.
On the real side, kids can really dig
gettin' down at McDonald's.

McDonald's

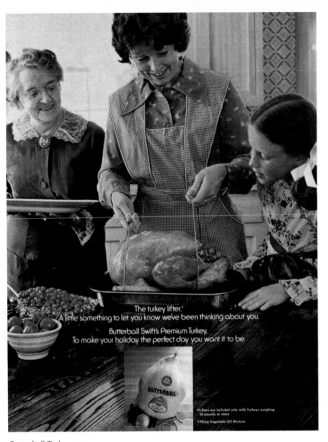

Butterball Turkey, 1973

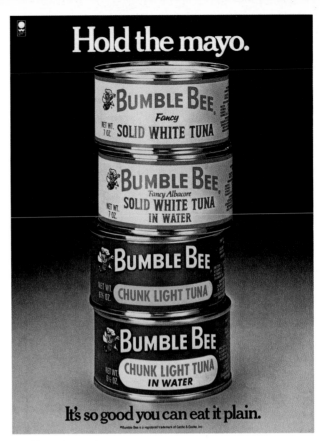

Bumble Bee Tuna, 1978

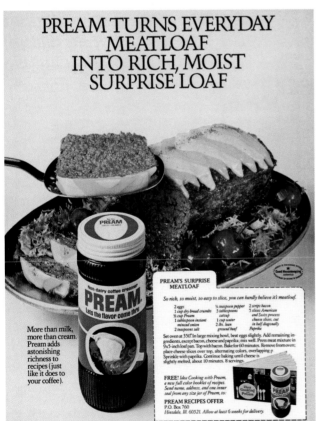

McDonald's, 1973 ◄ *Pream Non-dairy Creamer, 1971*

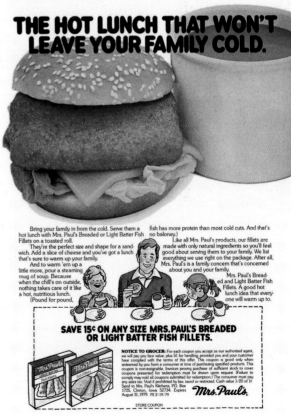

Mrs. Paul's Fish Fillets, 1979

SQUEEZ CHART

Kraft Squeeze - A - Snak Cheese Spread, 1973

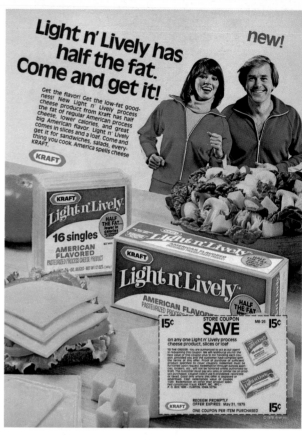

Light n' Lively Cheese Product, 1978

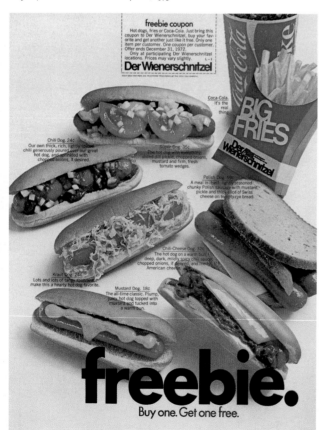

Der Wienerschnitzel, 1972

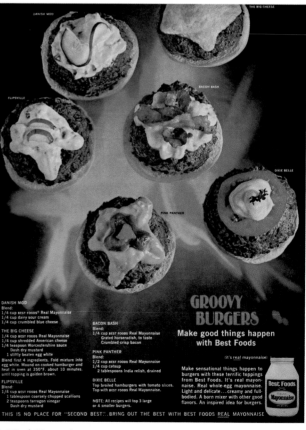

Best Foods Mayonnaise, 1970

▶ *Burger King, 1977*

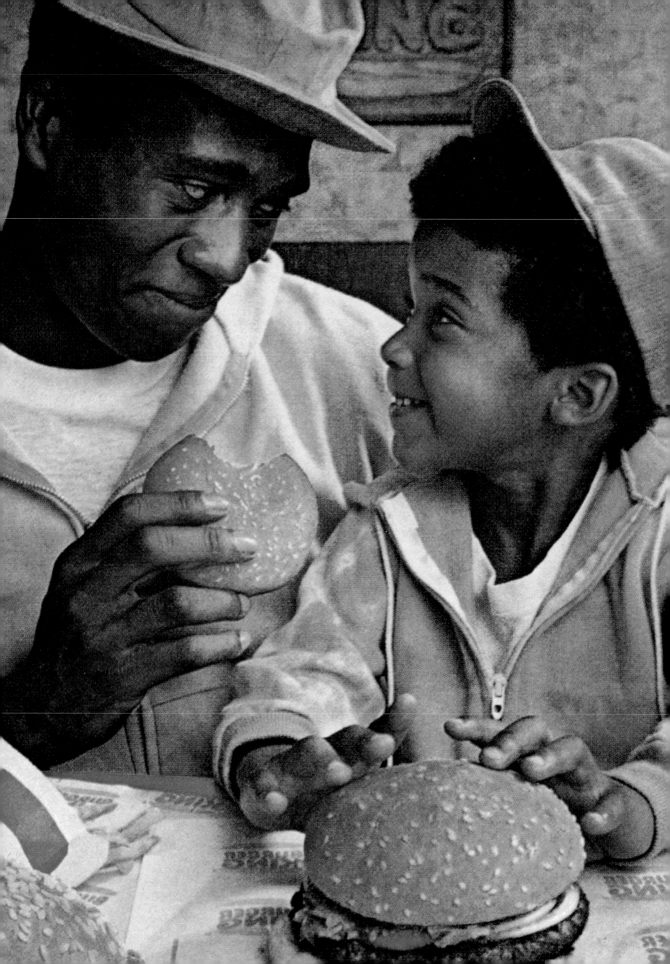

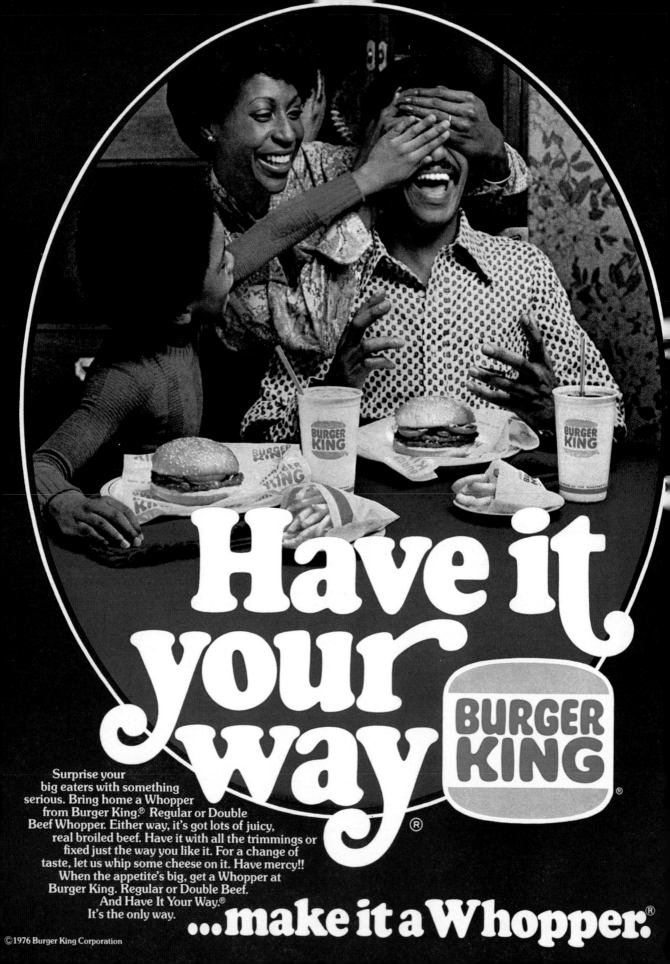

Have it your way

BURGER KING

...make it a Whopper.

Surprise your big eaters with something serious. Bring home a Whopper from Burger King.® Regular or Double Beef Whopper. Either way, it's got lots of juicy, real broiled beef. Have it with all the trimmings or fixed just the way you like it. For a change of taste, let us whip some cheese on it. Have mercy!! When the appetite's big, get a Whopper at Burger King. Regular or Double Beef. And Have It Your Way.® It's the only way.

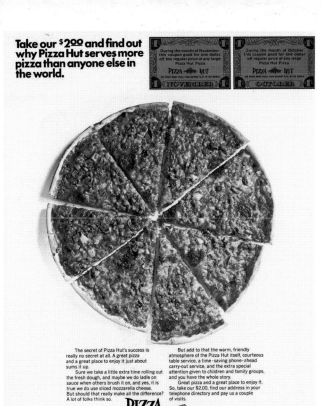

Take our $2.00 and find out why Pizza Hut serves more pizza than anyone else in the world.

The secret of Pizza Hut's success is really no secret at all. A great pizza and a great place to enjoy it just about sums it up.

Sure we take a little extra time rolling out the fresh dough, and maybe we do ladle on sauce when others brush it on, and yes, it is true we do use sliced mozzarella cheese. But should that really make all the difference? A lot of folks think so.

But add to that the warm, friendly atmosphere of the Pizza Hut itself, courteous table service, a time-saving phone-ahead carry-out service, and the extra special attention given to children and family groups, and you have the whole story.

Great pizza and a great place to enjoy it. So, take our $2.00, find our address in your telephone directory and pay us a couple of visits.

PIZZA HUT
we serve the family circle

Pizza Hut, 1970

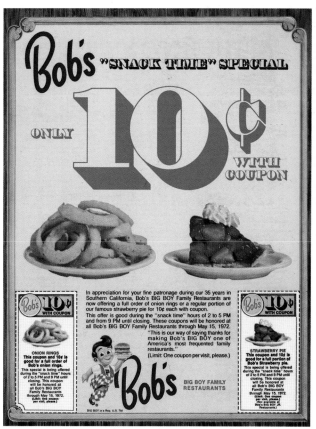

International House of Pancakes, 1971

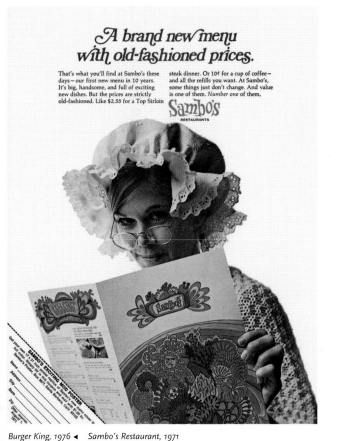

A brand new menu with old-fashioned prices.

That's what you'll find at Sambo's these days—our first new menu in 10 years. It's big, handsome, and full of exciting new dishes. But the prices are strictly old-fashioned. Like $2.55 for a Top Sirloin steak dinner. Or 10¢ for a cup of coffee—and all the refills you want. At Sambo's, some things just don't change. And value is one of them. *Number one* of them.

Sambo's
RESTAURANTS

Burger King, 1976 ◄ *Sambo's Restaurant, 1971*

Bob's Big Boy Family Restaurants, 1972

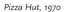

Almond Blossom Ham

Simple and simply delicious with Hormel Cure|81®Ham and Blue Diamond® Almonds.

APRICOT ALMOND GLAZE

1 can (8 oz.) pineapple tidbits in unsweetened juice	12 cloves
	10 allspice
1 can (17 oz.) apricot halves in heavy syrup	2 cinnamon sticks
	½ cup Blue Diamond®
1 tsp. lemon juice	Blanched Slivered
1 Tbsp. cornstarch	Almonds, toasted

While your dependable Cure / 81® ham bakes, drain pineapple and reserve juice. Combine juice with apricots and syrup in blender and whirl until pureed. In medium saucepan, thoroughly blend puree, lemon juice and cornstarch. Drop spices in saucepan. Bring to a boil over medium heat, stirring constantly until thickened. Remove from heat, strain out spices. Brush hot onto ham during last half hour of baking. Cut pineapple tidbits in half and arrange with almonds as shown. Reheat remaining glaze, add almonds and serve as a sauce.

✻Hormel✻

Hormel Ham/Blue Diamond Almonds, 1978

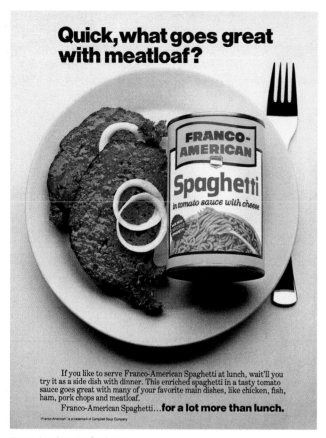

Quick, what goes great with meatloaf?

If you like to serve Franco-American Spaghetti at lunch, wait'll you try it as a side dish with dinner. This enriched spaghetti in a tasty tomato sauce goes great with many of your favorite main dishes, like chicken, fish, ham, pork chops and meatloaf.

Franco-American Spaghetti...**for a lot more than lunch.**

"Franco-American" is a trademark of Campbell Soup Company

Franco-American Spaghetti, 1978

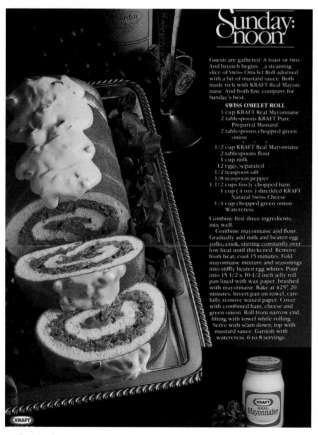

Sunday: noon

Guests are gathered. A toast or two. And brunch begins...a steaming slice of Swiss Omelet Roll adorned with a bit of mustard sauce. Both made rich with KRAFT Real Mayonnaise. And both fine company for Sunday's best.

SWISS OMELET ROLL

1 cup KRAFT Real Mayonnaise
2 tablespoons KRAFT Pure Prepared Mustard
2 tablespoons chopped green onion
* * *
1/2 cup KRAFT Real Mayonnaise
2 tablespoons flour
1 cup milk
12 eggs, separated
1/2 teaspoon salt
1/8 teaspoon pepper
1-1/2 cups finely chopped ham
1 cup (4 ozs.) shredded KRAFT Natural Swiss Cheese
1/4 cup chopped green onion
Watercress

Combine first three ingredients; mix well.
Combine mayonnaise and flour. Gradually add milk and beaten egg yolks; cook, stirring constantly over low heat until thickened. Remove from heat; cool 15 minutes. Fold mayonnaise mixture and seasonings into stiffly beaten egg whites. Pour into 15-1/2 x 10-1/2-inch jelly roll pan lined with wax paper; brushed with mayonnaise. Bake at 425°, 20 minutes. Invert pan on towel; carefully remove waxed paper. Cover with combined ham, cheese and green onion. Roll from narrow end, lifting with towel while rolling. Serve with seam down; top with mustard sauce. Garnish with watercress. 6 to 8 servings.

Kraft Mayonnaise, 1979

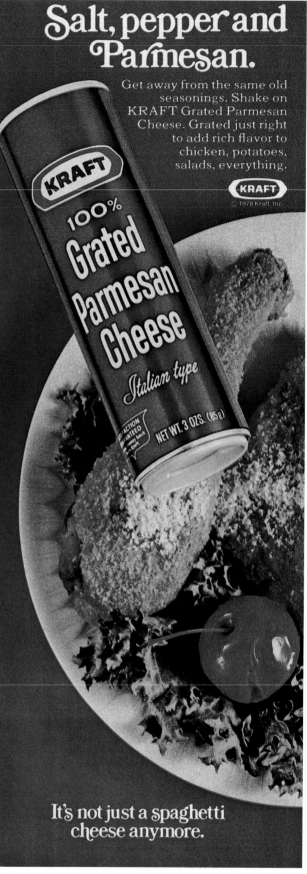

Salt, pepper and Parmesan.

Get away from the same old seasonings. Shake on KRAFT Grated Parmesan Cheese. Grated just right to add rich flavor to chicken, potatoes, salads, everything.

© 1978 Kraft, Inc.

It's not just a spaghetti cheese anymore.

Kraft Parmesan Cheese, 1978

SPRINKLE JELL-O® INSTEAD OF

BRAND GELATIN

Instead of fruit sauce on ice cream or you-know-what on strawberries or "jimmies" on cup cakes. Sprinkle Jell-O Brand Gelatin right out of the box. It tastes fruity and sweet at the same time.

Sprinkle Jell-O in 15 fruity flavors. Sprinkle Orange Jell-O on strawberries or Strawberry Jell-O on ice cream or Lime Jell-O on cup cakes. Then keep what's left in your covered sugar bowl or baby food jar.

Tomorrow. Be different and have fu Sprinkle Jell-O Gelatin out of the box on the things you already like. And you may find you can even like them better. Sprinkle. Sprinkle. Sprinkle.

If you love ice cream, now you have something else to love.

There isn't a man, woman, or kid in these United States of America who hasn't loved at least one double-dip chocolate ice cream cone right down to the last bite.

Now you can introduce your tongue to a new love. Cool 'n Creamy pudding. From Birds Eye.

Cool 'n Creamy comes frozen. You'll find it in the frozen food section of the supermarket, near the ice cream and the frozen cheesecake.

Because we could freeze it, Cool 'n Creamy is rich and smooth like pudding, and cold and creamy like ice cream.

Cool 'n Creamy stores right in your refrigerator. It's there. Waiting for you. Like ice cream. Another great choice when the kids say, "What's for dessert, Mom?"

Today, the Cool 'n Creamy cone. Tomorrow, the Cool 'n Creamy scoop.

Someday, the old ball park will ring with glory, "Peanuts? Popcorn? Ice cream? Cool 'n Creamy? How many, mister?"

Cool 'n Creamy. The best thing since ice cream.

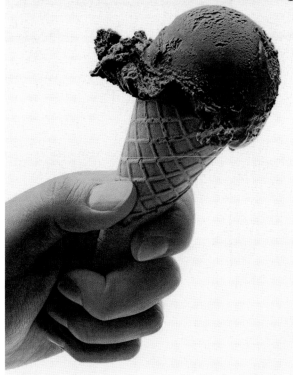

Cool 'n Creamy Pudding, 1971

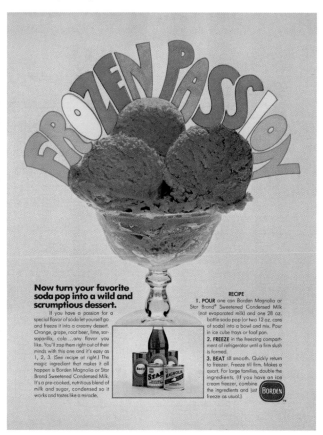

FROZEN PASSION

Now turn your favorite soda pop into a wild and scrumptious dessert.

If you have a passion for a special flavor of soda let yourself go and freeze it into a creamy dessert. Orange, grape, root beer, lime, sarsaparilla, cola...any flavor you like. You'll zap them right out of their minds with this one and it's easy as 1, 2, 3. (See recipe at right.) The magic ingredient that makes it all happen is Borden Magnolia or Star Brand Condensed Milk. It's a pre-cooked, nutritious blend of milk and sugar, condensed so it works and tastes like a miracle.

RECIPE

1. **POUR** one can Borden Magnolia or Star Brand® Sweetened Condensed Milk (not evaporated milk) and one 28 oz. bottle soda pop (or two 12 oz. cans of soda) into a bowl and mix. Pour in ice cube trays or loaf pan.

2. **FREEZE** in the freezing compartment of refrigerator until a firm slush is formed.

3. **BEAT** till smooth. Quickly return to freezer. Freeze till firm. Makes a quart. For large families, double the ingredients. (If you have an ice cream freezer, combine the ingredients and just freeze as usual.)

Jell-O Gelatin, 1971 ◄ *Borden, 1971*

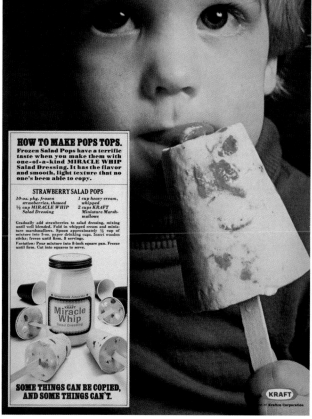

HOW TO MAKE POPS TOPS.

Frozen Salad Pops have a terrific taste when you make them with one-of-a-kind MIRACLE WHIP Salad Dressing. It has the flavor and smooth, light texture that no one's been able to copy.

STRAWBERRY SALAD POPS

10-oz. pkg. frozen strawberries, thawed
½ cup MIRACLE WHIP Salad Dressing
1 cup heavy cream, whipped
2 cups KRAFT Miniature Marshmallows

Gradually add strawberries to salad dressing, mixing until well blended. Fold in whipped cream and miniature marshmallows. Spoon approximately ½ cup of mixture into 5-oz. paper drinking cups. Insert wooden sticks; freeze until firm. 8 servings.
Variation: Pour mixture into 8-inch square pan. Freeze until firm. Cut into squares to serve.

SOME THINGS CAN BE COPIED, AND SOME THINGS CAN'T.

Kraft Miracle Whip, 1976

581

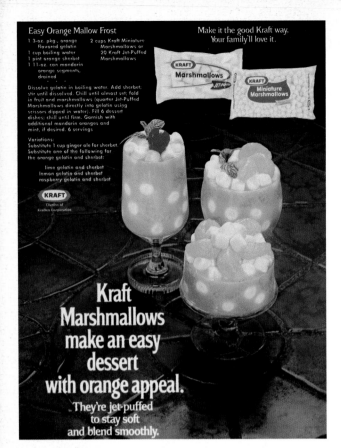

Easy Orange Mallow Frost

1 3-oz. pkg., orange	2 cups Kraft Miniature
flavored gelatin	Marshmallows or
1 cup boiling water	20 Kraft Jet-Puffed
1 pint orange sherbet	Marshmallows
1 11-oz. can mandarin	
orange segments,	
drained	

Dissolve gelatin in boiling water. Add sherbet;
stir until dissolved. Chill until almost set; fold
in fruit and marshmallows (quarter Jet-Puffed
Marshmallows directly into gelatin using
scissors dipped in water). Fill 6 dessert
dishes; chill until firm. Garnish with
additional mandarin oranges and
mint, if desired. 6 servings

Variations:
Substitute 1 cup ginger ale for sherbet.
Substitute one of the following for
the orange gelatin and sherbet:

 lime gelatin and sherbet
 lemon gelatin and sherbet
 raspberry gelatin and sherbet

KRAFT
Division of
Kraftco Corporation

Make it the good Kraft way.
Your family'll love it.

Kraft Marshmallows make an easy dessert with orange appeal.

They're jet-puffed
to stay soft
and blend smoothly.

Kraft Marshmallows, 1974

The "notice anything different about me tonight dear?" Pudding.

Jell-O Pudding Boston Cream Pie

One 5-oz. package (6-serving size) Jell-O® Vanilla
 or Banana Cream Pudding & Pie Filling
2-1/3 cups milk
1 square Bakers® Unsweetened Chocolate
1 tablespoon butter
1/2 cup prepared Dream Whip® Whipped
 Topping*
1 baked, cooled 8- or 9-inch yellow cake layer
*Or use 1/4 cup heavy cream, whipped.

Combine pudding mix and milk in saucepan. Cook
and stir over medium heat until mixture comes to a
full boil. Remove from heat. Combine 1 cup of the
hot pudding with chocolate and butter, stirring
until melted. Cover surface of each pudding with
wax paper; chill. Beat plain
pudding just until smooth;
blend in prepared topping.
Split cake layer in half to
make 2 layers. Place 1 layer
on serving plate; spread with
plain pudding mixture. Top
with the other cake layer.
Beat chocolate pudding mix-
ture until smooth. Spread
over top of cake. Chill 1 hour.

Jell-O, Bakers and Dream Whip
are trademarks of General Foods Corp.

JELL-O
PUDDING & PIE FILLING

Jell-O Gelatin, 1970

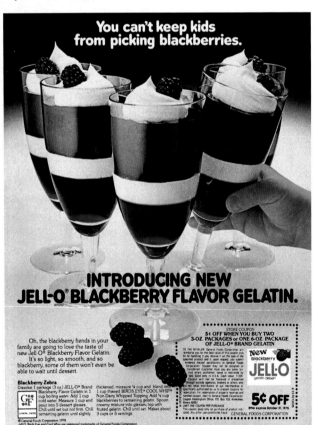

You can't keep kids from picking blackberries.

INTRODUCING NEW JELL-O® BLACKBERRY FLAVOR GELATIN.

Oh, the blackberry fiends in your
family are going to love the taste of
new Jell-O® Blackberry Flavor Gelatin.
It's so light, so smooth, and so
blackberry, some of them won't even be
able to wait until dessert.

Blackberry Zebra
Dissolve 1 package (3 oz.) JELL-O® Brand
Blackberry Flavor Gelatin in 1
cup boiling water. Add 1 cup
cold water. Measure 1 cup and
pour into 5 dessert glasses.
Chill until set but not firm. Chill
remaining gelatin until slightly

thickened; measure ¾ cup and blend into
1 cup thawed BIRDS EYE® COOL WHIP
Non-Dairy Whipped Topping. Add ½ cup
blackberries to remaining gelatin. Spoon
creamy mixture into glasses; top with
fruited gelatin. Chill until set. Makes about
3 cups or 5 servings

© General Foods Corporation 1976
Jell-O, Birds Eye and Cool Whip are registered trademarks of General Foods Corporation

Jell-O Gelatin, 1978

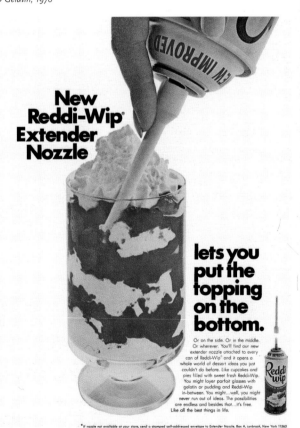

New Reddi-Wip® Extender Nozzle

lets you put the topping on the bottom.

Or on the side. Or in the middle.
Or wherever. You'll find our new
extender nozzle attached to every
can of Reddi-Wip® and it opens a
whole world of dessert ideas you just
couldn't do before. Like cupcakes and
pies filled with sweet fresh Reddi-Wip.
You might layer parfait glasses with
gelatin or pudding and Reddi-Wip
in-between. You might...well, you might
never run out of ideas. The possibilities
are endless and besides that...it's free.
Like all the best things in life.

*If nozzle not available at your store, send a stamped self-addressed envelope to Extender Nozzle, Box A, Lynbrook, New York 11563

Reddi-Wip Topping, 1970 ▶ *Kraft Miracle Whip/Marshmallows, 1973*

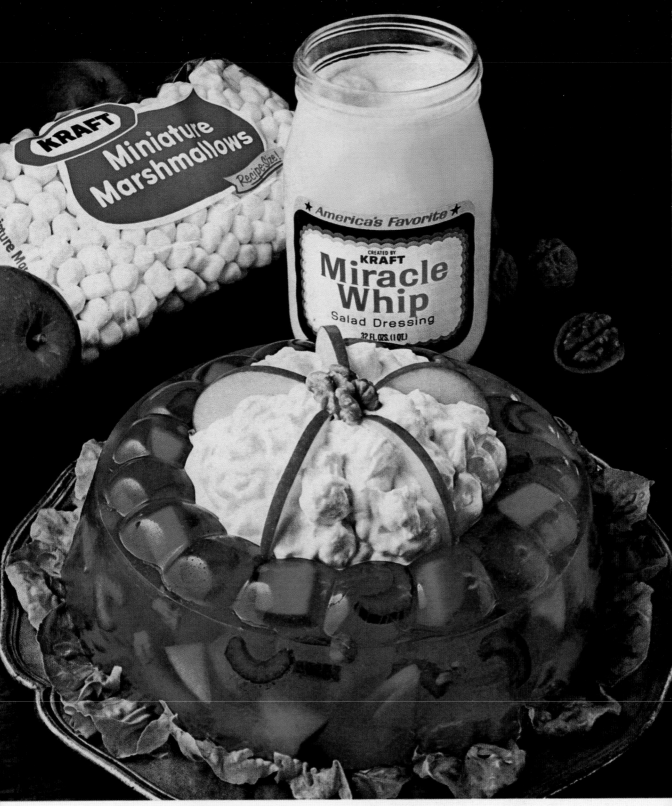

It takes two to top the Waldorf.

Nothing tops it better than these two from Kraft . . . Miracle Whip Salad Dressing and Kraft Miniature Marshmallows. A great combination! The lively fresh flavor of Miracle Whip and smooth blending Miniature Marshmallows add a special taste and texture, to make any molded waldorf a very special salad.

Waldorf Crown Salad

2 3oz. pkgs. strawberry flavored gelatin
2 c. boiling water
1½ c. cold water
1 c. cubed apples
½ c. thinly sliced celery
¼ c. chopped walnuts

Dissolve gelatin in boiling water; stir in cold water. Chill until thickened; fold in remaining ingredients. Pour into 5-cup ring mold. Chill until firm. Unmold, surround with lettuce. Fill center with Regal Dressing; garnish with fresh apple slices and a walnut half, if desired.

Regal Dressing

1½ c. Kraft Miniature Marshmallows
1 c. dairy sour cream
½ c. Miracle Whip Salad Dressing

Combine ingredients; mix well. 6 to 8 servings.

Division of Kraftco Corporation

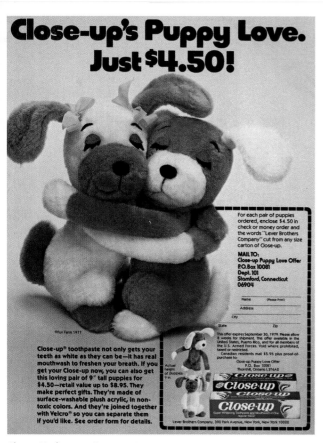
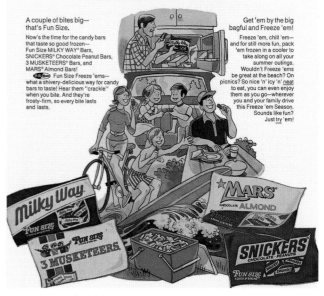
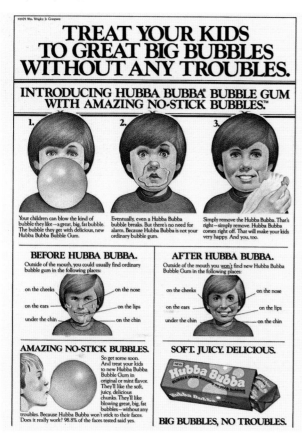
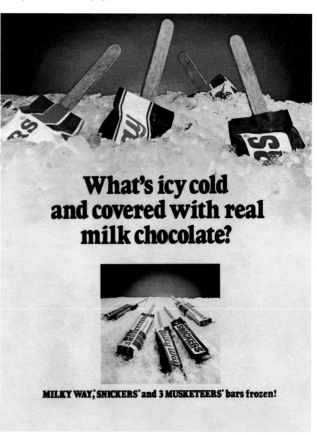

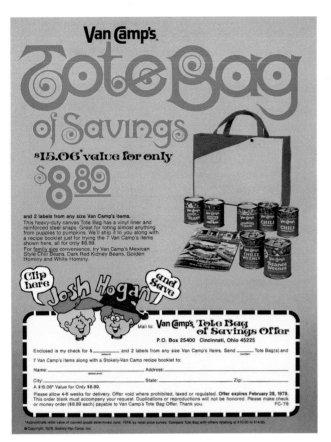

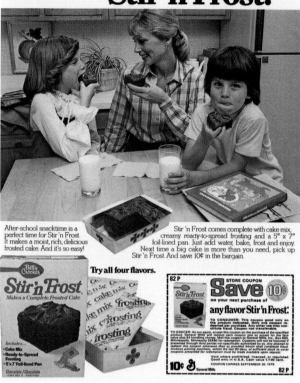
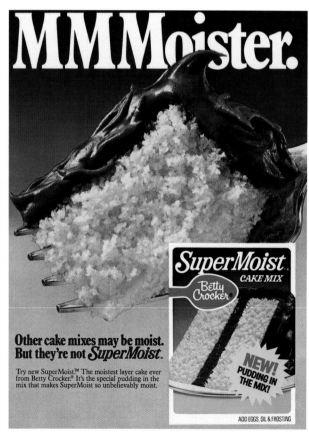
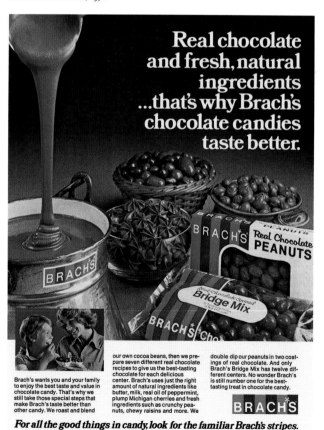

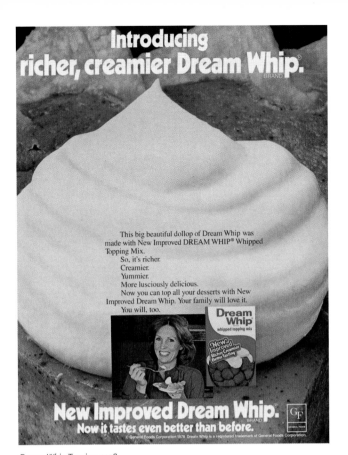

Dream Whip Topping, 1978

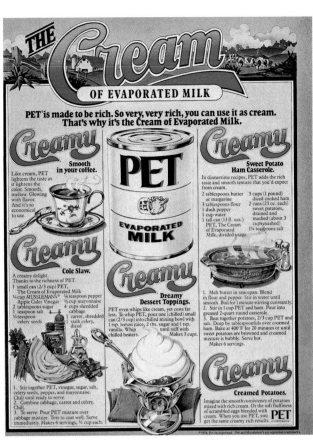

Pet Evaporated Milk, 1978

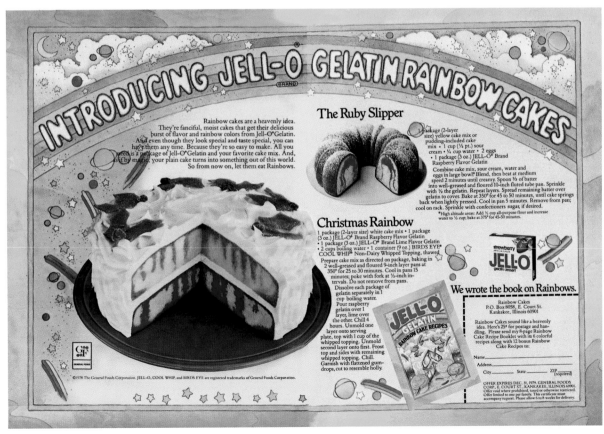

Jell-O Gelatin, 1978

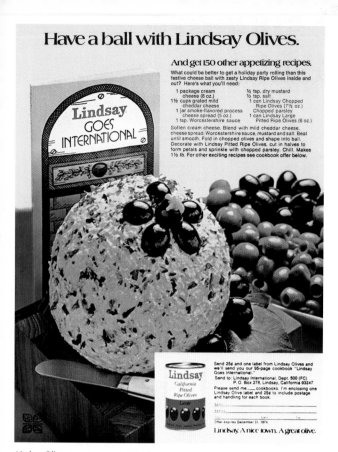

Have a ball with Lindsay Olives.

And get 150 other appetizing recipes.

What could be better to get a holiday party rolling than this festive cheese ball with zesty Lindsay Ripe Olives inside and out? Here's what you'll need:

1 package cream cheese (8 oz.)
1½ cups grated mild cheddar cheese
1 jar smoke-flavored process cheese spread (5 oz.)
1 tsp. Worcestershire sauce
½ tsp. dry mustard
½ tsp. salt
1 can Lindsay Chopped Ripe Olives (7½ oz.)
Chopped parsley
1 can Lindsay Large Pitted Ripe Olives (6 oz.)

Soften cream cheese. Blend with mild cheddar cheese, cheese spread. Worcestershire sauce, mustard and salt. Beat until smooth. Fold in chopped olives and shape into ball. Decorate with Lindsay Pitted Ripe Olives, cut in halves to form petals and sprinkle with chopped parsley. Chill. Makes 1½ lb. For other exciting recipes see cookbook offer below.

Lindsay GOES INTERNATIONAL

Send 25¢ and one label from Lindsay Olives and we'll send you our 95-page cookbook "Lindsay Goes International."
Send to: Lindsay International, Dept. 500 (FC) P. O. Box 278, Lindsay, California 93247
Please send me ____ cookbooks. I'm enclosing one Lindsay Olive label and 25¢ to include postage and handling for each book.

Offer expires December 31, 1974

Lindsay. A nice town. A great olive.

Lindsay Olives, 1973

Squeez·A·Picnic

Sharp. Pimento. Hickory Smoke. Bacon. Jalapeño Pepper. Garlic. Swiss-American. In between the baseball game and the barbecue, squeeze in some good picnic snacking with Squeez-A-Snak process cheese spread from Kraft. It never needs refrigeration, so you can take it along for on-the-spot snacks in 7 flavors. Crackers, anyone?

Squeez, squeez, everybody Squeez-A-Snak.

Squeez-A-Snak Cheese Spread, 1974

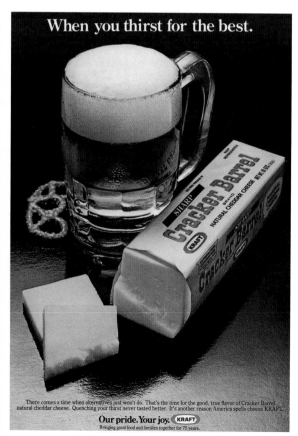

When you thirst for the best.

There comes a time when alternatives just won't do. That's the time for the good, true flavor of Cracker Barrel natural cheddar cheese. Quenching your thirst never tasted better. It's another reason America spells cheese KRAFT.

Our pride. Your joy. KRAFT
Bringing good food and families together for 75 years.

Cracker Barrel Cheese, 1978

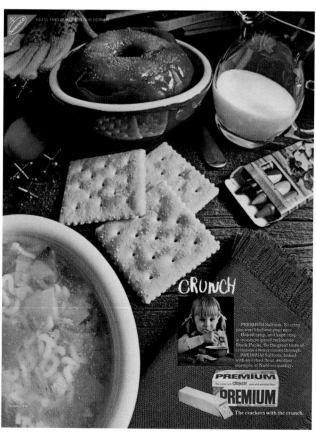

Premium Crackers, 1970

▶ *Bell Potato Chips, 1972*

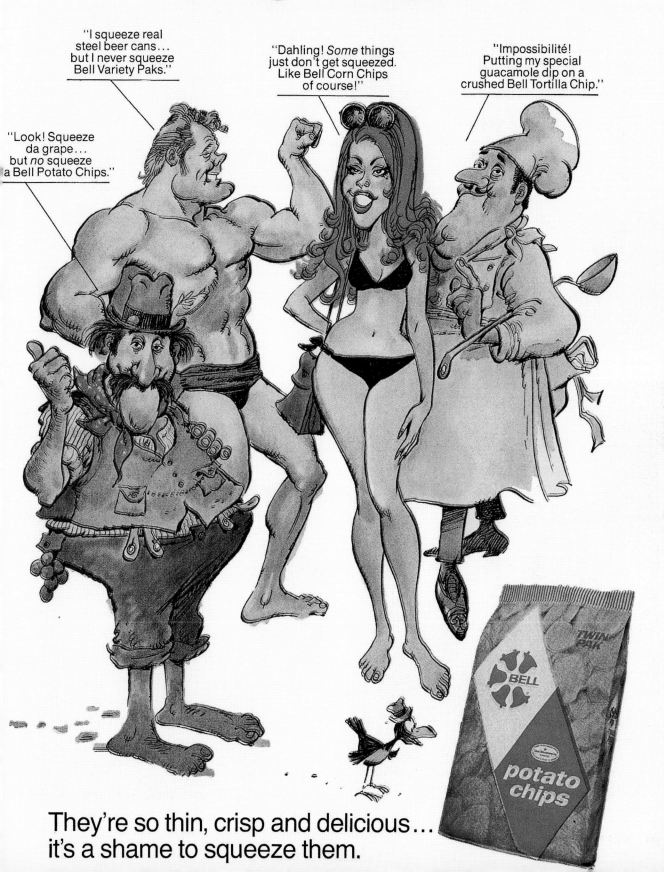

When you're in hot water at lunchtime, it's time for the Instant Lunch.

Getting a good hot meal when you've got an hour for lunch is easy.

But getting one when you're in a hurry is just about impossible. Unless you've got the Instant Lunch from Maruchan.

The Instant Lunch starts cooking right after you pour hot water into the cup. Wait three minutes and it's ready—a rich broth accented with just the right seasonings and thick with tasty noodles. Each Chicken, Beef, and Pork flavored Instant Lunch also contains vegetables and egg.

The Instant Lunch from Maruchan. When you've only got an instant for lunch.

Maruchan. Makers of Won Ton Soup, Ramen Supreme Noodles and the Instant Lunch.

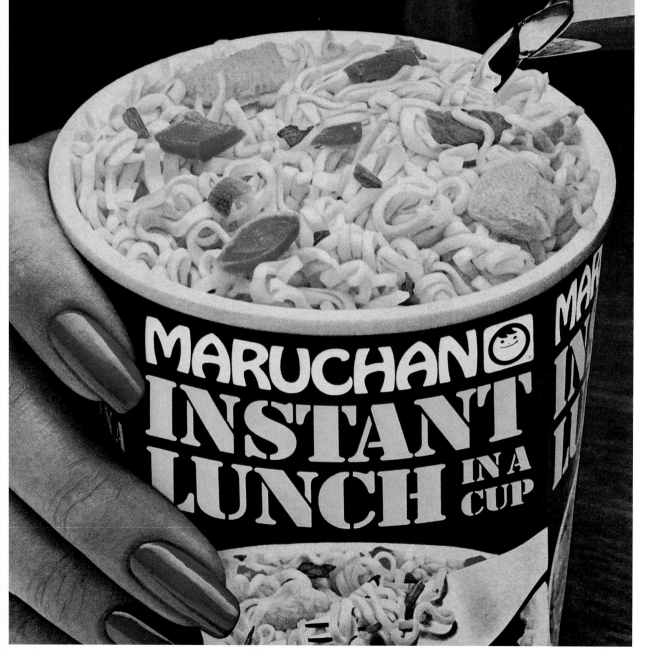

Maruchan Instant Lunch In A Cup, 1978

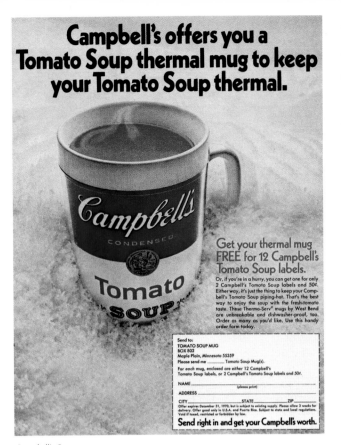

Campbell's Soup, 1970

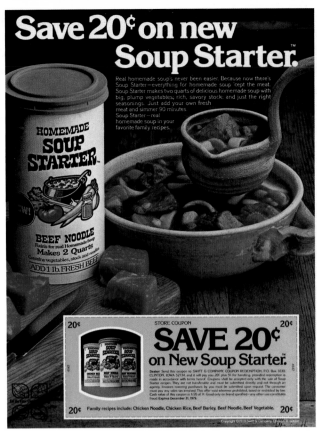

Soup Starter, 1978

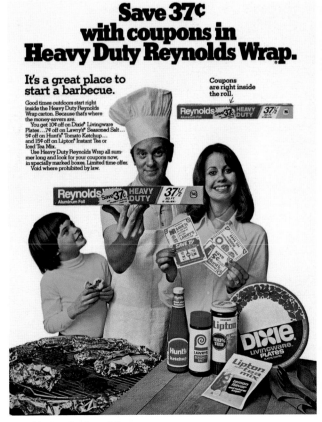

Campbell's Chunky Soup, 1971

Reynolds Wrap Aluminum Foil, 1975

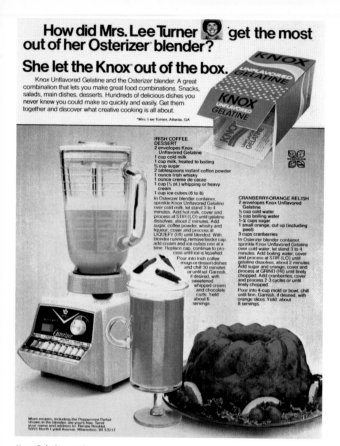

How did Mrs. Lee Turner 👤 get the most out of her Osterizer blender?
She let the Knox out of the box.

Knox Unflavored Gelatine and the Osterizer blender. A great combination that lets you make great food combinations. Snacks, salads, main dishes, desserts. Hundreds of delicious dishes you never knew you could make so quickly and easily. Get them together and discover what creative cooking is all about.

*Mrs. Lee Turner, Atlanta, GA

IRISH COFFEE DESSERT
2 envelopes Knox Unflavored Gelatine
1 cup cold milk
1 cup milk, heated to boiling
⅔ cup sugar
2 tablespoons instant coffee powder
1 ounce Irish whisky
1 ounce creme de cacao
1 cup (½ pt.) whipping or heavy cream
1 cup ice cubes (6 to 8)

In Osterizer blender container, sprinkle Knox Unflavored Gelatine over cold milk; let stand 3 to 4 minutes. Add hot milk, cover and process at STIR (LO) until gelatine dissolves, about 2 minutes. Add sugar, coffee powder, whisky and liqueur; cover and process at LIQUEFY (HI) until blended. With blender running, remove feeder cap, add cream and ice cubes one at a time. Replace cap, continue to process until ice is liquefied.
Pour into Irish coffee mugs or dessert dishes and chill 30 minutes or until set. Garnish, if desired, with sweetened whipped cream and chocolate curls. Yield: about 6 servings.

CRANBERRY-ORANGE RELISH
2 envelopes Knox Unflavored Gelatine
½ cup cold water
½ cup boiling water
1-¼ cups sugar
1 small orange, cut up (including peel)
3 cups cranberries

In Osterizer blender container, sprinkle Knox Unflavored Gelatine over cold water; let stand 3 to 4 minutes. Add boiling water; cover and process at STIR (LO) until gelatine dissolves, about 2 minutes. Add sugar and orange; cover and process at GRIND (HI) until finely chopped. Add cranberries; cover and process 2-3 cycles or until finely chopped.
Pour into 4-cup mold or bowl, chill until firm. Garnish, if desired, with orange slices. Yield: about 8 servings.

More recipes, including the Peppermint Parfait shown in the blender, are yours free. Send your name and address to: Recipe Booklet, 5055 North Lydell Avenue, Milwaukee, WI 53217.

Knox Gelatine, 1978

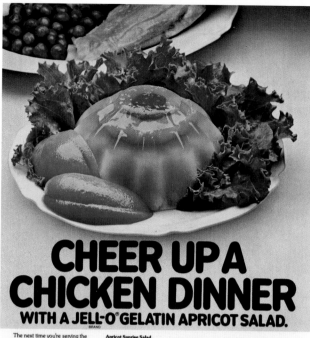

CHEER UP A CHICKEN DINNER
WITH A JELL-O® GELATIN APRICOT SALAD.

The next time you're serving the usual, serve an unusually delicious Jell-O® Gelatin and California Apricot salad. Then sit back and bask in the compliments. Your family will love the bright, fresh color and flavor of Jell-O® Gelatin and apricot salads. And you'll love how easy they are to make.

For a new free 36-page recipe booklet, write: California Apricot Advisory Board, 1295 Blvd. Way, Walnut Creek, California 94595.

Apricot Sunrise Salad
6 to 8 maraschino cherries · 1 can (17 oz.) apricot halves, drained · 1 package (3 oz.) JELL-O® Brand Apricot Flavor Gelatin · ¾ cup boiling water · 1½ cups crushed ice

Place cherry in each of 6-8 individual molds or custard cups; top each with apricot half, cut side down. Combine gelatin and boiling water in electric blender. Cover; blend at low speed until gelatin dissolves, about 1 minute. Add crushed ice; blend at high speed until ice melts, about 30 seconds. Pour into molds; chill until firm. Unmold; serve with remaining apricot halves and greens, if desired. Makes 6-8 servings.

Jell-O is a registered trademark of General Foods Corp. © General Foods Corporation 1978

A Jell-O® Gelatin and California Apricot salad makes supper super.

Jell-O Gelatin, 1978

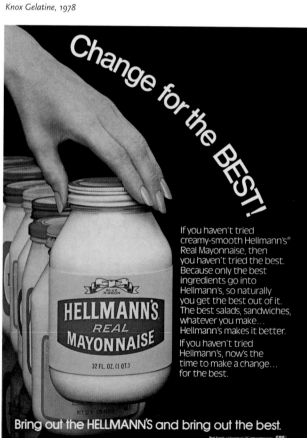

Change for the BEST!

If you haven't tried creamy-smooth Hellmann's® Real Mayonnaise, then you haven't tried the best. Because only the best ingredients go into Hellmann's, so naturally you get the best out of it. The best salads, sandwiches, whatever you make… Hellmann's makes it better.

If you haven't tried Hellmann's, now's the time to make a change… for the best.

HELLMANN'S REAL MAYONNAISE
32 FL. OZ. (1 QT.)

NET 32 FL. OZ. (1 QT.)

Bring out the HELLMANN'S and bring out the best.

Best Foods, a division of CPC International Inc.

Hellmann's Mayonnaise, 1978

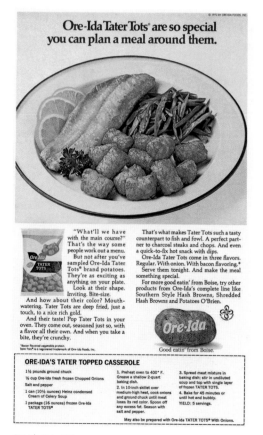

© 1973 BY ORE-IDA FOODS, INC.

Ore-Ida Tater Tots® are so special you can plan a meal around them.

"What'll we have with the main course?" That's the way some people work out a menu. But not after you've sampled Ore-Ida Tater Tots® brand potatoes. They're as exciting as anything on your plate. Look at their shape. Inviting. Bite-size.
And how about their color? Mouth-watering. Tater Tots are deep fried, just a touch, to a nice rich gold.
And their taste! Pop Tater Tots in your oven. They come out, seasoned just so, with a flavor all their own. And when you take a bite, they're crunchy.

That's what makes Tater Tots such a tasty counterpart to fish and fowl. A perfect partner to charcoal steaks and chops. And even a quick-to-fix hot snack with dips.
Ore-Ida Tater Tots come in three flavors. Regular. With onion. With bacon flavoring.* Serve them tonight. And make the meal something special.
For more good eatin' from Boise, try other products from Ore-Ida's complete line like Southern Style Hash Browns, Shredded Hash Browns and Potatoes O'Brien.

*Bacon flavored vegetable protein.
Tater Tots® is a registered trademark of Ore-Ida Foods, Inc.

Ore-Ida Good eatin' from Boise.

ORE-IDA'S TATER TOPPED CASSEROLE
1½ pounds ground chuck
½ cup Ore-Ida fresh frozen Chopped Onions
Salt and pepper
1 can (10½ ounces) Heinz condensed Cream of Celery Soup
1 package (16 ounces) frozen Ore-Ida TATER TOTS®

1. Preheat oven to 400° F. Grease a shallow 2-quart baking dish.
2. In 10-inch skillet over medium-high heat, cook onions and ground chuck until meat loses its red color. Spoon off any excess fat. Season with salt and pepper.
3. Spread meat mixture in baking dish; stir in undiluted soup and top with single layer of frozen TATER TOTS.
4. Bake for 45 minutes or until hot and bubbly. YIELD: 5 servings.

May also be prepared with Ore-Ida TATER TOTS® With Onions.

Ore-Ida Tater Tots, 1973

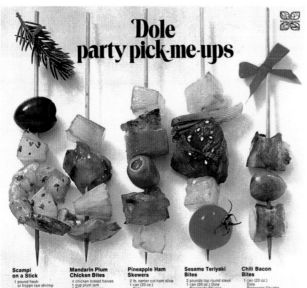

Dole party pick-me-ups

Scampi on a Stick
1 pound fresh or frozen raw shrimp
1 can (20 oz.) Dole Pineapple Chunks
24 large pitted ripe olives
½ cup butter, melted
1 Tbsp. chopped parsley
½ tsp. garlic salt

Shell shrimp leaving tails on. Drain pineapple reserving ¼ cup syrup. Assemble skewers as shown. Combine butter, reserved syrup, parsley and garlic salt; brush over skewers. Broil. Use remaining marinade as dunk.

Mandarin Plum Chicken Bites
4 chicken breast halves
1 cup plum jam
3 Tbsp. soy sauce
1 Tbsp. dry sherry
½ tsp. garlic powder
½ tsp. ground ginger
1 can (20 oz.) Dole Pineapple Chunks
2 large green bell peppers

Bone and skin chicken breasts; cut into 24 chunks. Combine plum jam, soy sauce, sherry, garlic powder and ginger. Marinate chicken over night. Drain pineapple; cut bell pepper into 24 chunks. Assemble skewers as shown. Brush with marinade. Broil.

Pineapple Ham Skewers
2 lb. center cut ham slice
1 can (20 oz.) Dole Pineapple Chunks
2 tsp. Hot English style mustard
2 Tbsp. butter, melted
24 stuffed green olives

Cut ham into 48 cubes. Drain pineapple reserving ¼ cup syrup. Combine syrup, mustard and butter. Assemble skewers as shown. Brush with mustard mixture. Broil.

Sesame Teriyaki Bites
2 pounds top round steak
1 can (20 oz.) Dole Pineapple Chunks
½ cup teriyaki sauce
1 Tbsp. honey
½ tsp. ground ginger
12 green onions, 2" lengths
24 cherry tomatoes

Cut steak into 24 cubes. Drain pineapple reserving ¼ cup syrup. Combine syrup, teriyaki sauce, honey and ginger. Marinate steak in mixture over night. Assemble skewers as shown. Brush with marinade. Broil. Sprinkle with sesame seeds; add tomato before serving.

Chili Bacon Bites
1 can (20 oz.) Dole Pineapple Chunks
24 slices bacon
24 large stuffed green olives
1 cup chili sauce

Drain pineapple reserving ¼ cup syrup. Cut bacon slices in halves; wrap each half slice of bacon around a chunk of pineapple. Assemble skewers as shown. Blend chili sauce and reserved syrup; brush over skewers. Broil. Use remaining chili sauce as dunk.

Each recipe makes 24 servings.
All skewers broil 3 inches from heat for 6 minutes, or until done, turning once.

They'll say "you shouldn't have," but they'll be awfully glad you did. Serve all five, or choose a few and save the rest for next time. They're easy to prepare ahead — then they cook in just 6 minutes! For more ideas, order Dole's beautiful hardcover Cookbook. For the simplest to most elaborate meal. 78 pages of recipes. 28 color photographs. A $4.95 value for only $1.95 and one Dole Blue Label. Send to: Dole Cookbook, Box 6333, Chicago, Ill. 60677. Offer good only in U.S. Void where restricted, taxed or prohibited.

Dole Pineapple Chunks, 1973

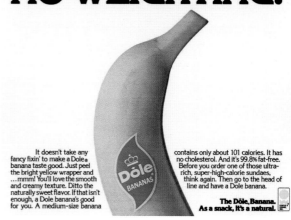

NO WEIGHTING.

It doesn't take any fancy fixin' to make a Dole banana taste good. Just peel the bright yellow wrapper and …mmm! You'll love the smooth and creamy texture. Ditto the naturally sweet flavor. If that isn't enough, a Dole banana's good for you. A medium-size banana contains only about 101 calories. It has no cholesterol. And it's 99.8% fat-free. Before you order one of those ultra-rich, super-high-calorie sundaes, think again. Then go to the head of line and have a Dole banana.

The Dole Banana. As a snack, it's a natural.

Dole Bananas, 1978

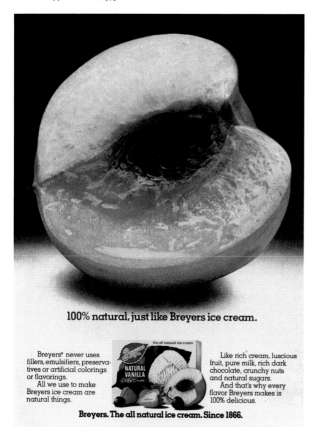

100% natural, just like Breyers ice cream.

Breyers® never uses fillers, emulsifiers, preservatives or artificial colorings or flavorings.

All we use to make Breyers ice cream are natural things.

Like rich cream, luscious fruit, pure milk, rich dark chocolate, crunchy nuts and natural sugars.

And that's why every flavor Breyers makes is 100% delicious.

Breyers. The all natural ice cream. Since 1866.

Breyers Ice Cream, 1978

Real fruit juice. Not heavy syrup.
That's what makes Libby's Juice Pack Peaches taste peachier.

Libby's knows a peach should taste peachy, not syrupy. That's why Libby's Juice Pack Peaches are bathed in a fresh stream of lightly sweetened real fruit juices, instead of heavy syrup.

Ah, Libby's delicious Juice Pack Fruits; Peaches, Pears and Fruit Cocktail in real fruit juices.

Libby's borrowed the idea from nature, for a fresher fruit taste.

Libby's Fruit, 1979

Pro football teams are stuck on Chiquita® Bananas.

Collect all 26 NFL emblems.

Every single team in the National Football League now serves Chiquita Bananas as an official Training Table food.

We felt the least we can do is return the honor. So we put an NFL team emblem on every bunch of Chiquita Bananas.

Now every time you buy a bunch, you get a team. Just peel them right off the peel. And collect them.

The faster you eat, the faster your collection grows.

And if you start eating now, by Super Bowl Day you may own the entire collection. Good luck.

Chiquita is a registered trademark of United Fruit Company.

Chiquita Bananas, 1970

WISH·BONE.
FOR PEOPLE WHO REALLY LIKE SALADS.

People who love the natural goodness of fresh, crisp salad vegetables want only Wish-Bone.
Because Wish-Bone dressings are perfectly balanced and blended to make
every flavor taste as bright and lively as nature's good greens themselves.
Wish-Bone. For people who really like salads.

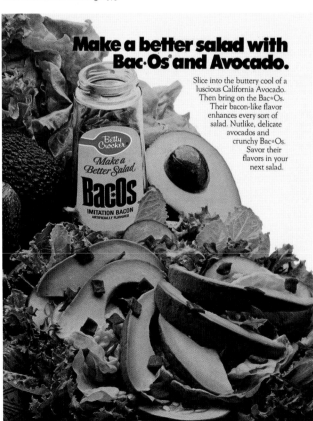

Wish-Bone Italian Dressing, 1973

Cream of the crop.

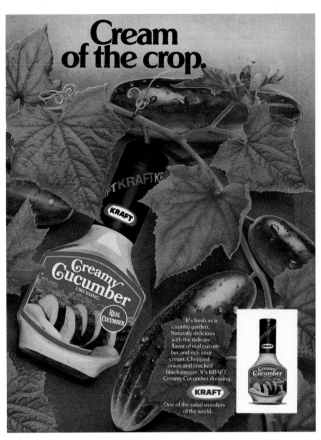

It's fresh as a country garden. Naturally delicious with the delicate flavor of real cucumber and rich sour cream. Chopped onion and cracked black pepper. It's KRAFT Creamy Cucumber dressing.

KRAFT

One of the salad wonders of the world.

Kraft Cucumber Dressing, 1978

Make a better salad with Bac·Os® and Avocado.

Slice into the buttery cool of a luscious California Avocado. Then bring on the Bac*Os. Their bacon-like flavor enhances every sort of salad. Nutlike, delicate avocados and crunchy Bac*Os. Savor their flavors in your next salad.

Bac-Os Imitation Bacon, 1978

A ONE-OF-A-KIND TASTE
From Two Great Salad Makers

With Hidden Valley Ranch® Original Buttermilk Salad Dressings and Best Foods® Real Mayonnaise, you can create a dressing that's deliciously different.
Just mix Hidden Valley Ranch with milk or buttermilk and, of course, Best Foods. Best Foods smooth, rich consistency makes your dressing creamy-good.
And because you make it up fresh, this unique dressing gives you flavor you just can't get from a bottle.
So for livelier-tasting salads, try Hidden Valley Ranch and Best Foods.

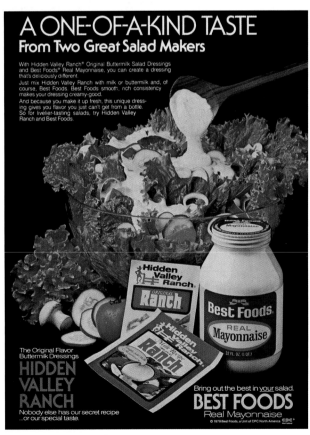

The Original Flavor Buttermilk Dressings

HIDDEN VALLEY RANCH
Nobody else has our secret recipe
...or our special taste.

Bring out the best in **your** salad.

BEST FOODS
Real Mayonnaise

Hidden Valley Ranch Dressing, 1979

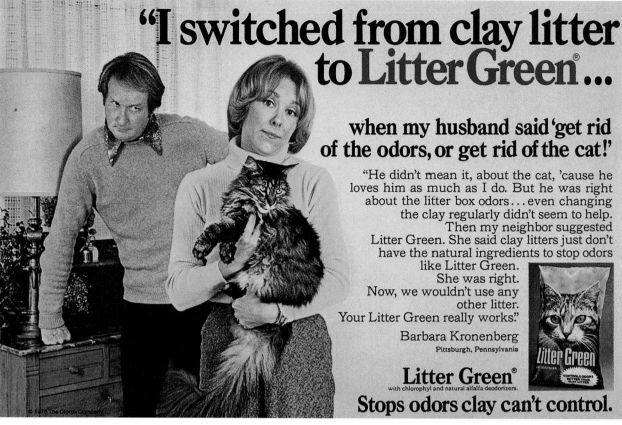

"I switched from clay litter to Litter Green®...

when my husband said 'get rid of the odors, or get rid of the cat!'

"He didn't mean it, about the cat, 'cause he loves him as much as I do. But he was right about the litter box odors...even changing the clay regularly didn't seem to help. Then my neighbor suggested Litter Green. She said clay litters just don't have the natural ingredients to stop odors like Litter Green. She was right. Now, we wouldn't use any other litter. Your Litter Green really works."

Barbara Kronenberg
Pittsburgh, Pennsylvania

Litter Green®
with chlorophyl and natural alfalfa deodorizers.

Stops odors clay can't control.

Litter Green Cat Litter, 1977

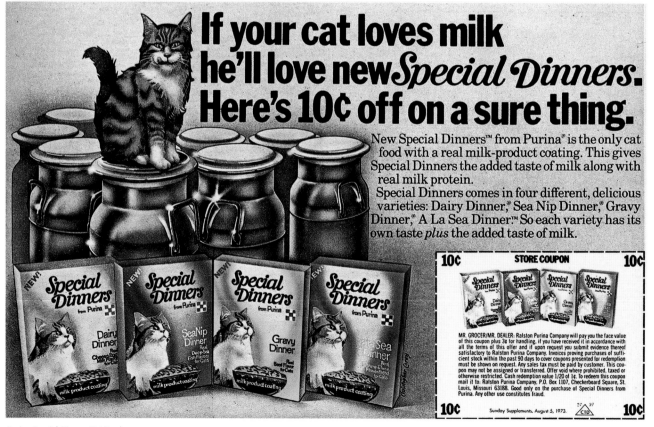

If your cat loves milk he'll love new *Special Dinners*. Here's 10¢ off on a sure thing.

New Special Dinners™ from Purina® is the only cat food with a real milk-product coating. This gives Special Dinners the added taste of milk along with real milk protein.

Special Dinners comes in four different, delicious varieties: Dairy Dinner,® Sea Nip Dinner,® Gravy Dinner,® A La Sea Dinner.™ So each variety has its own taste *plus* the added taste of milk.

Purina Special Dinners Cat Food, 1973

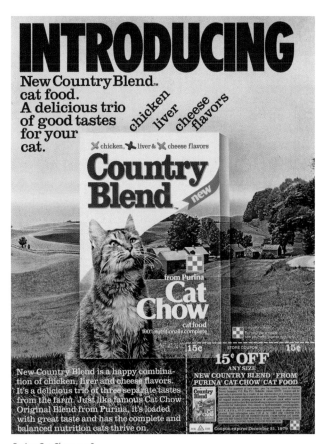

Purina Cat Chow, 1978

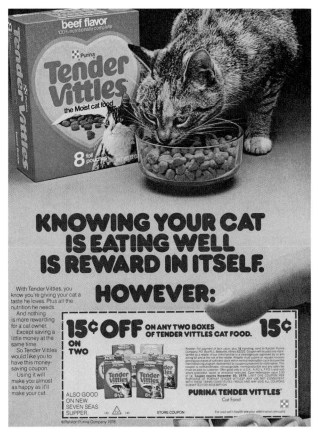

Purina Tender Vittles Cat Food, 1978

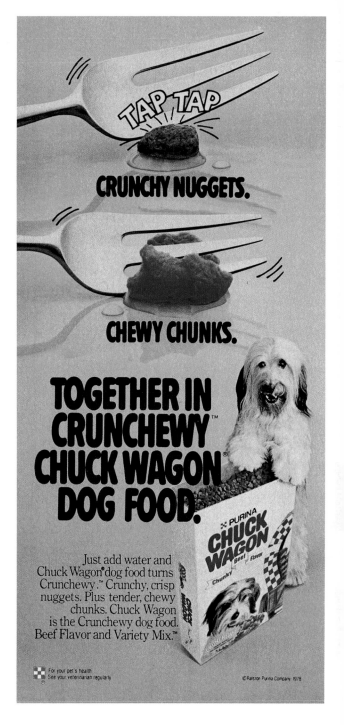

Purina Chuck Wagon Dog Food, 1978

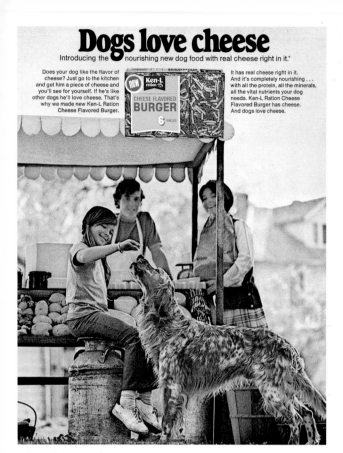

Dogs love cheese

Introducing the nourishing new dog food with real cheese right in it."

Does your dog like the flavor of cheese? Just go to the kitchen and get him a piece of cheese and you'll see for yourself. If he's like other dogs he'll love cheese. That's why we made new Ken-L Ration Cheese Flavored Burger.

It has real cheese right in it. And it's completely nourishing . . . with all the protein, all the minerals, all the vital nutrients your dog needs. Ken-L Ration Cheese Flavored Burger has cheese. And dogs love cheese.

Ken-L Ration Dog Food, 1971

Veterinarians prefer Ken-L Ration over all other canned dog foods.

In a nationwide survey, veterinarians preferred Ken-L Ration over any other canned dog food— and by 6 to 1 over the other leading canned food.

The survey shows that most vets prefer a completely balanced meat and grain diet like Ken-L Ration...for the carbohydrates, vitamins, minerals, and fiber that meat alone doesn't have.

When it comes to your dog's diet, listen to what the vets say—give your dog Ken-L Ration.

Ken-L Ration Dog Food, 1978

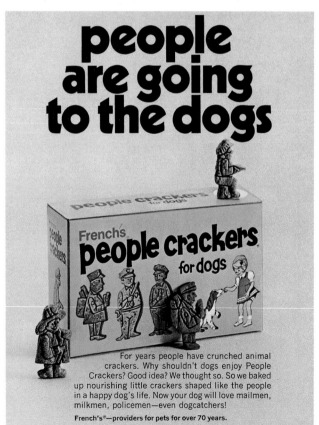

people are going to the dogs

French's people crackers for dogs

For years people have crunched animal crackers. Why shouldn't dogs enjoy People Crackers? Good idea? We thought so. So we baked up nourishing little crackers shaped like the people in a happy dog's life. Now your dog will love mailmen, milkmen, policemen—even dogcatchers!

French's®—providers for pets for over 70 years.

French's People Crackers for Dogs, 1972

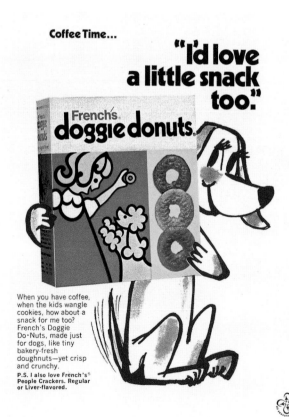

Coffee Time...

"I'd love a little snack too."

French's doggie donuts.

When you have coffee, when the kids wangle cookies, how about a snack for me too? French's Doggie Do·Nuts, made just for dogs, like tiny bakery-fresh doughnuts—yet crisp and crunchy.

P.S. I also love French's® People Crackers. Regular or Liver-flavored.

French's Doggie Donuts, 1973

America's #1 Burger. Now even better.

"It's m-m-meatier!"

New, improved Ken-L Ration® Burger. Meatier. And tastier.

Ken-L Ration Dog Food, 1978

And the winner is...

Hold the Kartoffelsalat

Ah, those Americans. Always screwing around with the world's cuisine. But what the heck, *everyone* liked to experiment a little in the seventies. What homemaker wouldn't be tempted to throw caution to the wind with Chef Boy-ar-dee's suggestion to load up a perfectly fine instant pizza with knockwurst and sauerkraut? Keeping the family happy may have still been a priority in many households, but we think someone in the test kitchen was working overtime on this idea.

Danke, keinen Kartoffelsalat

Ach, diese Amerikaner! Immer müssen sie die Kochkünste der Welt durch den Fleischwolf drehen. Aber was soll's, in den Siebzigern waren wir doch *alle* experimentierfreudig. Welche Hausfrau würde nicht liebend gern alle Vorbehalte in den Wind schlagen und sich von Chef Boy-ar-dees Vorschlag verführen lassen, eine unschuldige Instant-Pizza mit Knackwurst und Sauerkraut zu belegen? In vielen Haushalten mag das Glück der Familie nach wie vor Vorrang gehabt haben, aber hier haben wir den Eindruck, als wäre die Fantasie mit jemandem in der Versuchsküche durchgegangen.

Chaud devant, pizza teutonne!

Ah, ces Américains! Toujours en train de saboter la cuisine internationale. Cela dit, dans les années 70, *tout le monde* aimait tenter de nouvelles expériences. Quelle bonne mère de famille pouvait résister à la suggestion du chef Boy-ar-dee de rajouter à une déjà succulente pizza précuite un peu de choucroute et de saucisses? Satisfaire la famille avec de bons petits plats nourrissants était sans doute encore une priorité dans de nombreux foyers mais les cuistots du laboratoire de Boy-ar-dee avaient vraisemblablement abusé des heures sup.

¡Mi reino por una Kartoffelsalat!

¡Ay, los americanos, siempre jugando con la gastronomía mundial...! Pero ¡qué diablos!, *todo el mundo* experimentaba un poco en los años setenta. ¿Qué ama de casa no se sentiría tentada de lanzar el sentido común por la borda y cocinar la sugerencia de Chef Boy-ar-dee de decorar una suculenta pizza instantánea con chucrut y salchichas alemanas? Es posible que mantener a la familia feliz siguiera siendo una prioridad en muchos hogares, pero se diría que en esta cocina a alguien se le fue un poco la olla...

ジャーマンポテトは抜きにして

まったくアメリカ人ときたら。世界中の食をいじくり回して。ま、でもしょうがないか。70年代は実験の時代だから。そのままで十分おいしそうなインスタント・ピザに、スパイシー・ソーセージとザウアークラウトをどっさりのせるというシェフボイアーディの提案には、どんな主婦だって冒険心をくすぐられてしまうだろう。まだこの時代、家族を満足させることが、多くの人にとって最優先事項だったとはいえ、社内キッチンでこのアイデアを考え出した人物は、きっと残業つづきだったに違いない。

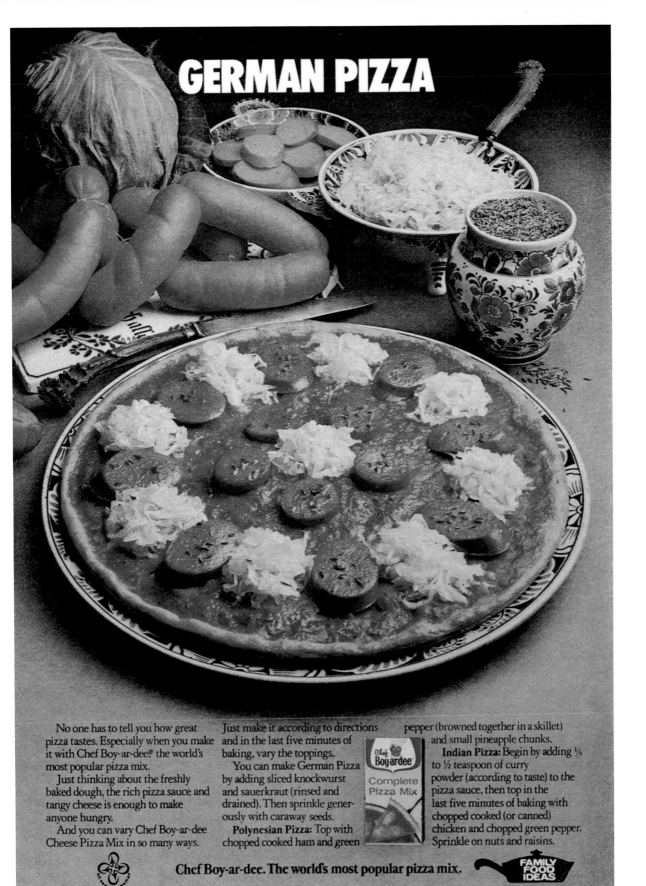

GERMAN PIZZA

No one has to tell you how great pizza tastes. Especially when you make it with Chef Boy-ar-dee® the world's most popular pizza mix.

Just thinking about the freshly baked dough, the rich pizza sauce and tangy cheese is enough to make anyone hungry.

And you can vary Chef Boy-ar-dee Cheese Pizza Mix in so many ways.

Just make it according to directions and in the last five minutes of baking, vary the toppings.

You can make German Pizza by adding sliced knockwurst and sauerkraut (rinsed and drained). Then sprinkle generously with caraway seeds.

Polynesian Pizza: Top with chopped cooked ham and green pepper (browned together in a skillet) and small pineapple chunks.

Indian Pizza: Begin by adding ¼ to ½ teaspoon of curry powder (according to taste) to the pizza sauce, then top in the last five minutes of baking with chopped cooked (or canned) chicken and chopped green pepper. Sprinkle on nuts and raisins.

Chef Boy-ar-dee. The world's most popular pizza mix.

Chef Boy-ar-dee Pizza Mix, 1973

American Seating, 1973

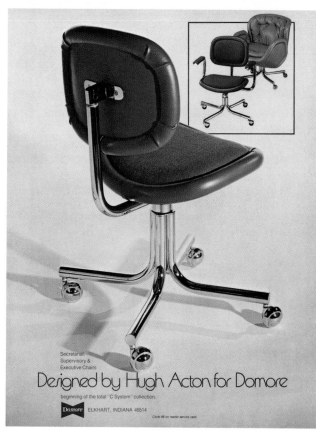

Domore Furniture, 1973

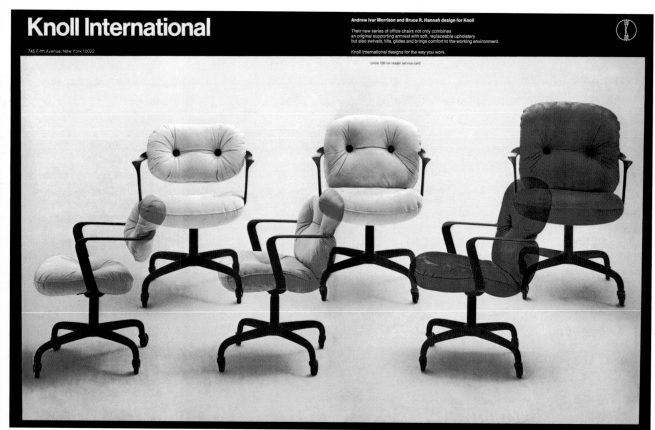

Flexsteel Mystery Chairs, 1972 ◄ Knoll International, 1973 ► *Stroheim & Romann Fabrics, 1972*

LA-Z-BOY

Relaxes All Kinds Of Dads!

for FATHER'S DAY

Because you love Dad, you want him to have the very best. matter what kind of Dad he is — sportsman — TV bu checker enthusiast or what, he will be pleased and happy in La-Z-Boy reclining chair because it will give him the kin comfort he has always wanted! And that includes real lay-b stretch-out comfort.

Best news yet, Mom, **La-Z-Boy reclining chairs are availabl long-wearing, stain-resistant Herculon® Olefin Fibers, which** on sale now for Father's Day. No matter what the decor of room — your La-Z-Boy dealer has the style for you.

Happy Father's Day, Dad!

On Sale Now At La-Z-Boy Dealers Everywh

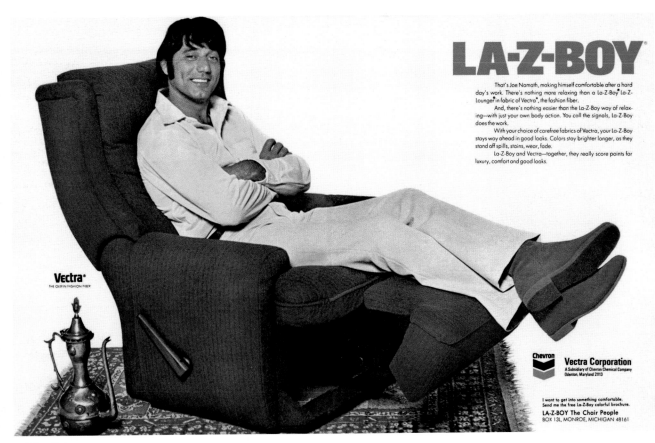

LA-Z-BOY®

That's Joe Namath, making himself comfortable after a hard day's work. There's nothing more relaxing than a La-Z-Boy® La-Z-Lounger® in fabric of Vectra®, the fashion fiber.

And, there's nothing easier than the La-Z-Boy way of relaxing—with just your own body action. You call the signals, La-Z-Boy does the work.

With your choice of carefree fabrics of Vectra, your La-Z-Boy stays way ahead in good looks. Colors stay brighter longer, as they stand off spills, stains, wear, fade.

La-Z-Boy and Vectra—together, they really score points for luxury, comfort and good looks.

Vectra®
THE OLEFIN FASHION FIBER

Chevron Vectra Corporation
A Subsidiary of Chevron Chemical Company
Odenton, Maryland 21113

I want to get into something comfortable.
Send me the free La-Z-Boy colorful brochure.
LA-Z-BOY The Chair People
BOX 13L, MONROE, MICHIGAN 48161

La-Z-Boy Chairs, 1973

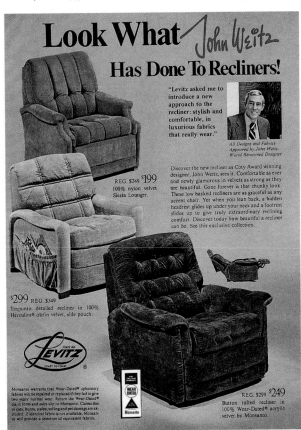

Look What *John Weitz* Has Done To Recliners!

"Levitz asked me to introduce a new approach to the recliner: stylish and comfortable, in luxurious fabrics that really wear."

All Designs and Fabrics Approved by John Weitz, World Renowned Designer

REG. $249 $199
100% nylon velvet Siesta Lounger.

Discover the new recliner as Coty Award winning designer, John Weitz, sees it. Comfortable as ever and newly glamorous in velvets as strong as they are beautiful. Gone forever is that chunky look. These low backed recliners are as graceful as any accent chair. Yet when you lean back, a hidden headrest glides up under your neck and a footrest slides up to give truly extraordinary reclining comfort. Discover today how beautiful a recliner can be. See this exclusive collection.

$299 REG. $349
Trapunto detailed recliner in 100% Herculon® olefin velvet, side pouch.

Levitz SINCE 1910 COAST TO COAST®

REG. $299 $249
Button tufted recliner in 100% Wear-Dated® acrylic velvet by Monsanto.

Monsanto warrants that Wear-Dated® upholstery fabrics will be repaired or replaced if they fail to give two years' normal wear. Return the Wear-Dated® claim form and sales slip to Monsanto. Claims due to cuts, burns, stains, soiling and pet damage are excluded. If identical fabric is not available, Monsanto will provide a selection of equivalent fabrics.

La-Z-Boy Chairs, 1972 ◄ *Levitz Furniture, 1978*

Give the gift that keeps on giving...

LA-Z-BOY® LA-Z-ROCKER®

Isn't it about time you gave mom the comfort she's always wanted? The La-Z-Boy La-Z-Rocker is a chair she can really enjoy. She'll love its stylish good looks designed to enhance any decor. But the La-Z-Rocker is more than just another pretty chair. It's the only swivel rocker that gently flexes its back for even greater comfort. So see the beautiful styles, choose from hundreds of fabrics and give mom the comfort she deserves!

DUPONT ZEPEL SOIL/STAIN REPELLER

Send 50c for color folder and furniture care booklet

LA-Z-BOY® CHAIR CO., "The Chair People"®, Dept. EB-76, Monroe, Mich. 48161

La-Z-Boy Chairs, 1976

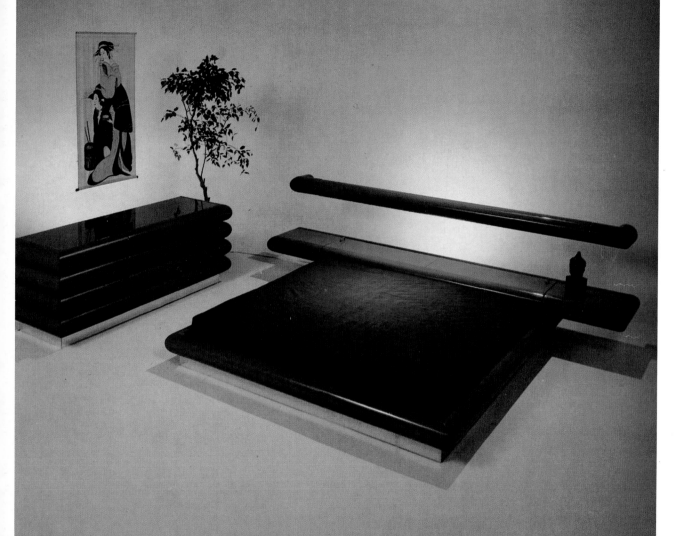

Testing Bed & Testing Bureau designed By J. Wade Beam.

CASA BELLA

Casa Bella Furnishings, 1979

▶ *Pace Furniture, 1979*

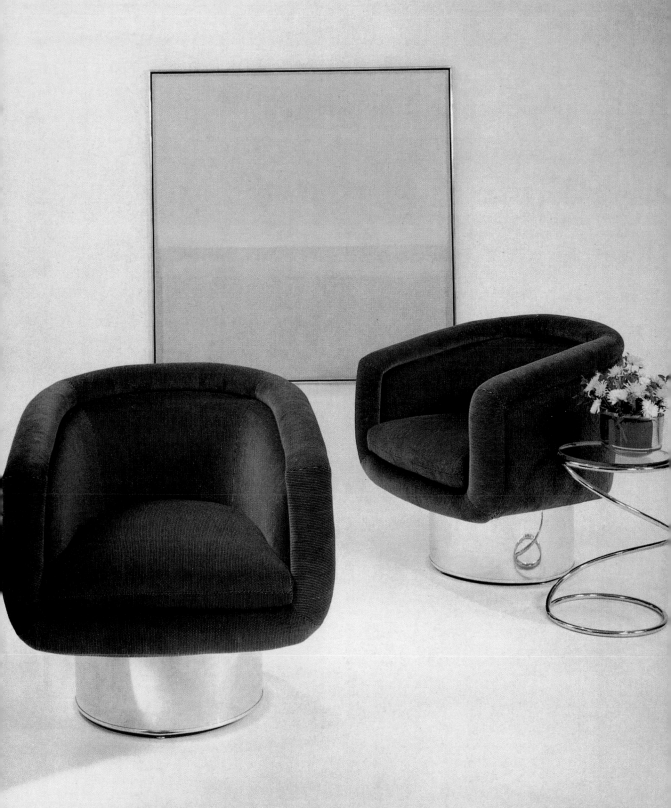

310 LOUNGE CHAIR / DESIGN LEON ROSEN

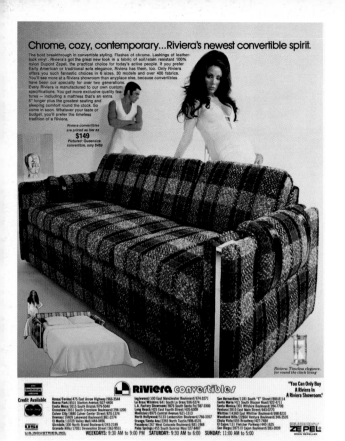

Riviera Convertibles, 1974

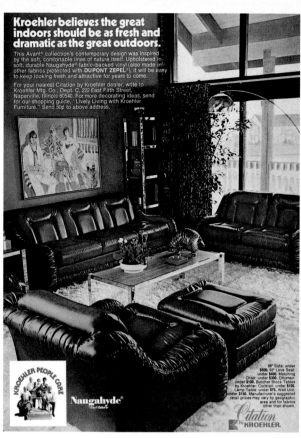

Kroehler Furniture, 1974

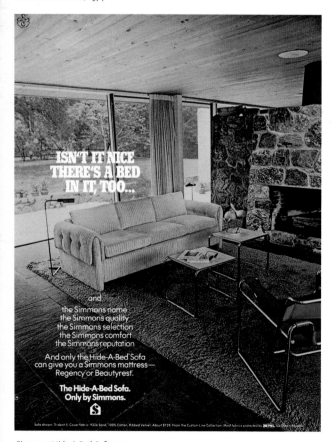

Simmons Hide-A-Bed Sofa, 1973

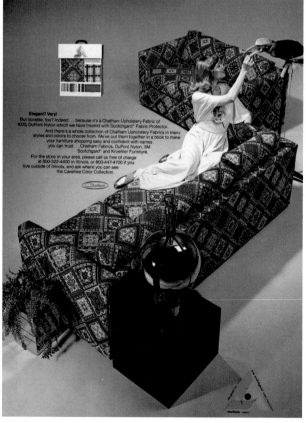

Chatham Furniture, 1976 ▶ *Selig Furniture, 1974*

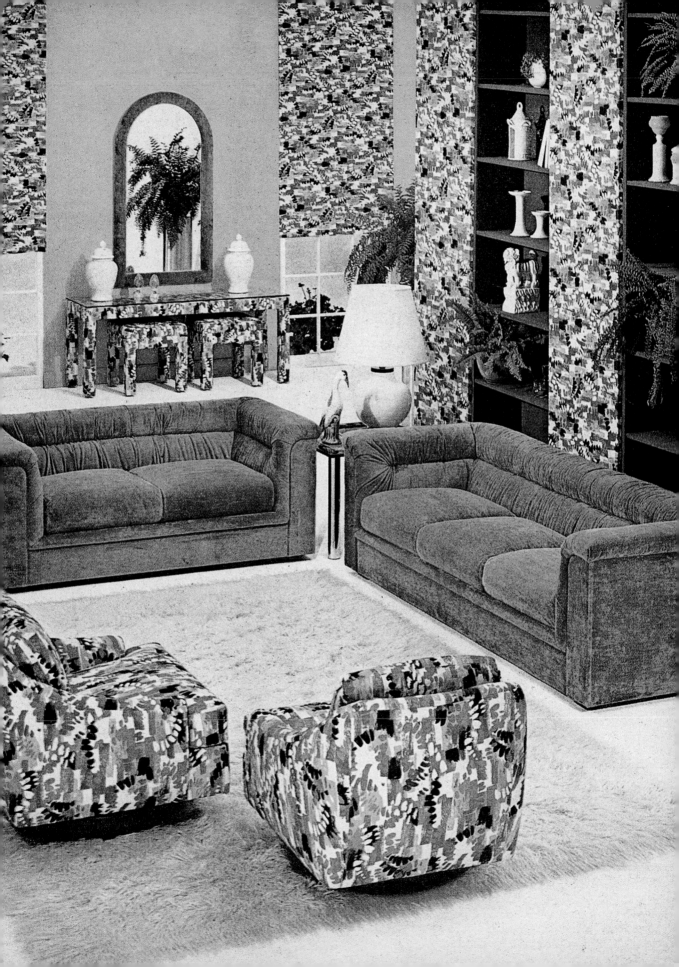

when it's contemporary

ARGOS © ORIGINAL EDWARD FIELDS DESIGN

when it's traditional ...

SHIRAZ © ORIGINAL EDWARD FIELDS DESIGN

MARK OF THE WORLD'S BEST

PURE WOOL PILE

NO LIMIT TO / CARPET DESIGN AT / EDWARD FIELDS

NEW YORK 232 EAST 59TH ST / LOS ANGELES 8950 BEVERLY BLVD
BOSTON 420 BOYLSTON STREET / CHICAGO MERCHANDISE MART

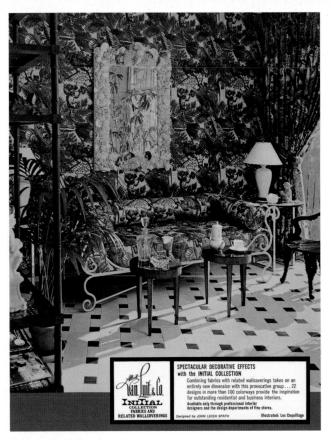

Van Luit & Co. Wallcoverings, 1972

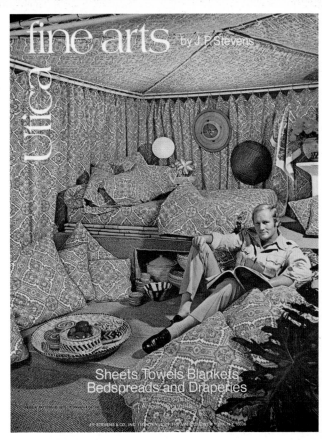

Utica Fabrics, 1975

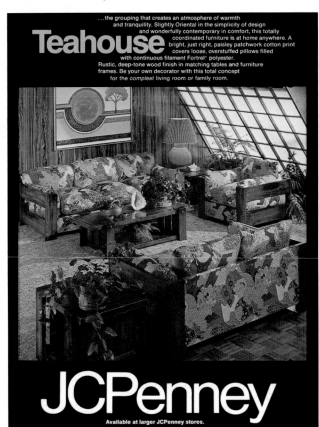

Edward Fields Rugs, 1972 ◄ *J.C. Penney Department Store, 1979*

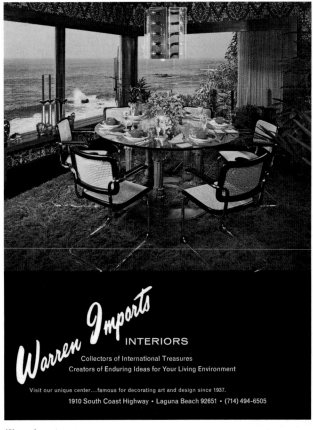

Warren Imports, 1972

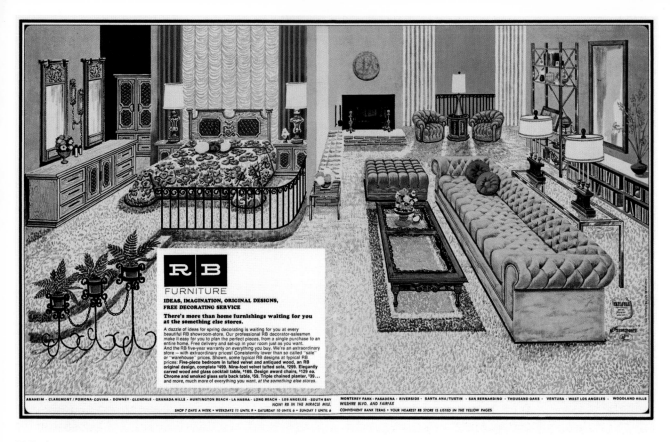

RB Furniture, 1970

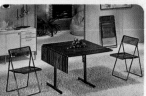

Chromcraft Furniture, 1973

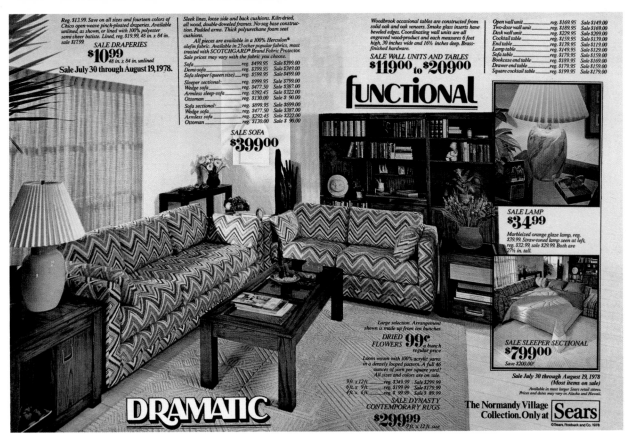

Sears Department Store, 1978

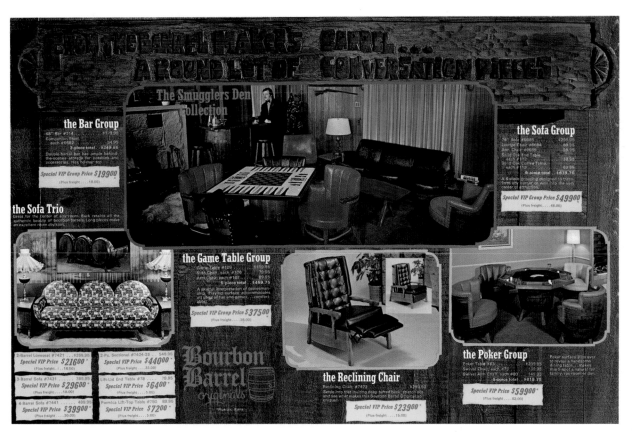

Bourbon Barrel Furniture, 1972

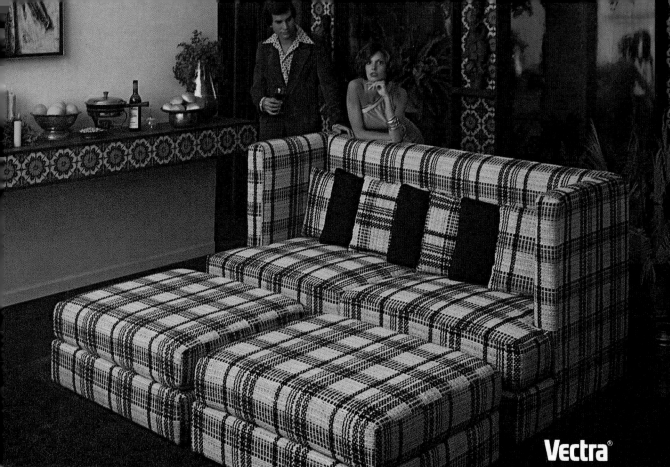

Vectra®

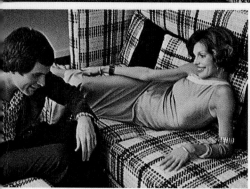

Kroehler believes your furniture should be as generous and interesting as you are.

There's a welcome quality—a mood—to this Citation by Kroehler sofa that fits perfectly with the way you feel about people. It's a comfortable, sheltered nook for a very private conversation. And it loves to have a party!

Hotline: For your nearest Citation by Kroehler dealer, call 800-447-4700 toll free. (In Illinois: 800-322-4400.) For more decorating ideas, send for our 26-page full-color shopping guide: "Lively Living with Kroehler Furniture." Send 50¢ to: Kroehler Mfg. Co., Dept. I, 222 E. Fifth Street, Naperville, IL 60540.

79" Shelter Sofa (height of back: 39") with 2 Ottomans (each 38" long) in 100% Vectra® Olefin fibers: all 3 pieces under $900. Also available as a Sleep-or-Lounge with luxurious queen-size (60 x 72") mattress. Sleep-or-Lounge with 2 Ottomans: under $1000. Manufacturer's suggested retail prices may vary by geographic area, and for fabrics other than shown. Upholstered pieces also available in other fashion fabrics protected with DuPont Zepel® stain repellent.

Citation by **KROEHLER**.

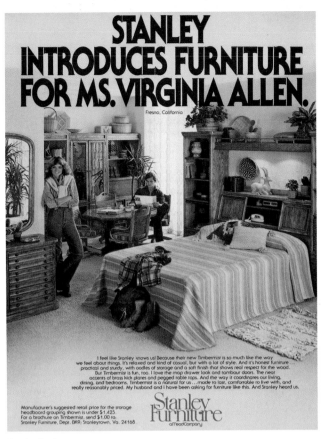

STANLEY INTRODUCES FURNITURE FOR MS. VIRGINIA ALLEN.

Fresno, California

I feel like Stanley knows us! Because their new Timbermist is so much like the way we feel about things. It's relaxed and kind of casual, but with a lot of style. And it's honest furniture... practical and sturdy, with oodles of storage and a soft finish that shows real respect for the wood. But Timbermist is fun, too. I love the map drawer look and tambour doors. The neat accents of brass kick plates and pegged table tops. And the way it coordinates our living, dining, and bedrooms. Timbermist is a natural for us...made to last, comfortable to live with, and really reasonably priced. My husband and I have been asking for furniture like this. And Stanley heard us.

Manufacturer's suggested retail price for the storage
headboard grouping shown is under $1,425.
For a brochure on Timbermist, send $1.00 to.
Stanley Furniture, Dept. BK9; Stanleytown, Va. 24168.

Stanley Furniture a Mead Company

Stanley Furniture, 1979

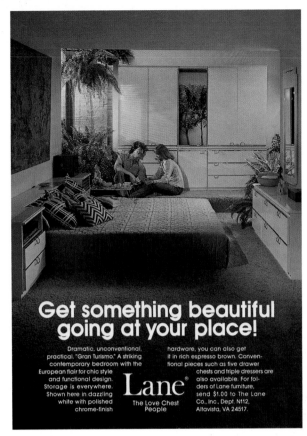

Get something beautiful going at your place!

Dramatic, unconventional, practical. "Gran Turismo." A striking contemporary bedroom with the European flair for chic style and functional design. Storage is everywhere. Shown here in dazzling white with polished chrome-finish

hardware, you can also get it in rich espresso brown. Conventional pieces such as five drawer chests and triple dressers are also available. For folders of Lane furniture, send $1.00 to The Lane Co., Inc., Dept. N112, Altavista, VA 24517.

Lane®
The Love Chest People

Lane Furniture, 1979

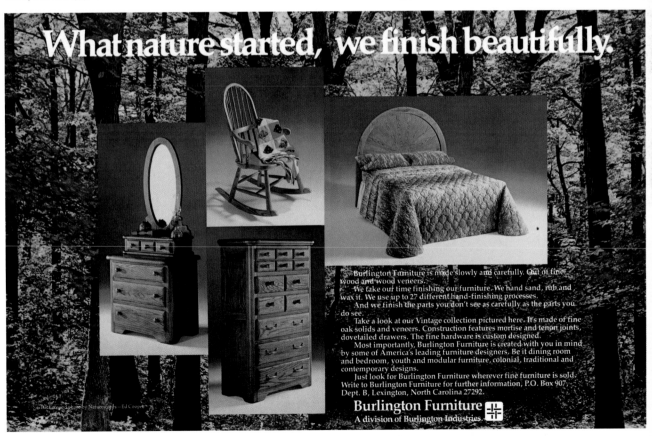

What nature started, we finish beautifully.

Burlington Furniture is made slowly and carefully. Out of fine wood and wood veneers.

We take our time finishing our furniture. We hand sand, rub and wax it. We use up to 27 different hand-finishing processes.

And we finish the parts you don't see as carefully as the parts you do see.

Take a look at our Vintage collection pictured here. It's made of fine oak solids and veneers. Construction features mortise and tenon joints, dovetailed drawers. The fine hardware is custom designed.

Most importantly, Burlington Furniture is created with you in mind by some of America's leading furniture designers. Be it dining room and bedroom, youth and modular furniture, colonial, traditional and contemporary designs.

Just look for Burlington Furniture wherever fine furniture is sold. Write to Burlington Furniture for further information, P.O. Box 907, Dept. B, Lexington, North Carolina 27292.

Burlington Furniture
A division of Burlington Industries.

Kroehler Furniture, 1975 ◄ *Burlington Furniture, 1979*

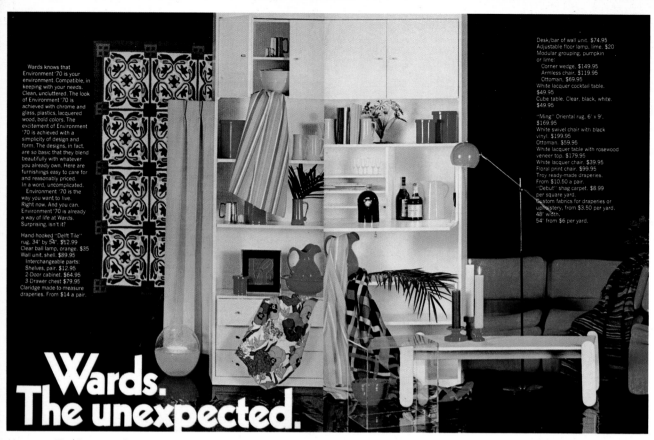

Wards knows that Environment '70 is your environment. Compatible, in keeping with your needs. Clean, uncluttered. The look of Environment '70 is achieved with chrome and glass, plastics, lacquered wood, bold colors. The excitement of Environment '70 is achieved with a simplicity of design and form. The designs, in fact, are so basic that they blend beautifully with whatever you already own. Here are furnishings easy to care for and reasonably priced. In a word, uncomplicated. Environment '70 is the way you want to live. Right now. And you can. Environment '70 is already a way of life at Wards. Surprising, isn't it?

Hand-hooked "Delft Tile" rug, 34" by 54". $12.99
Clear ball lamp, orange. $35
Wall unit, shell. $89.95
Interchangeable parts:
Shelves, pair. $12.95
2-Door cabinet. $64.95
3-Drawer chest $79.95
Claridge made-to-measure draperies. From $14 a pair.

Desk/bar of wall unit. $74.95
Adjustable floor lamp, lime. $20
Modular grouping, pumpkin or lime:
Corner wedge. $149.95
Armless chair. $119.95
Ottoman. $69.95
White lacquer cocktail table. $49.95
Cube table. Clear, black, white. $49.95

"Ming" Oriental rug, 6' x 9'. $169.95
White swivel chair with black vinyl. $199.95
Ottoman. $59.95
White lacquer table with rosewood veneer top. $179.95
White lacquer chair. $39.95
Floral print chair. $99.95
Troy ready-made draperies. From $10.50 a pair.
"Debut" shag carpet. $8.99 per square yard.
Custom fabrics for draperies or upholstery, from $3.50 per yard, 48" width.
54" from $6 per yard.

Wards.
The unexpected.

Montgomery Ward Department Store, 1970

This year Simmons offers more models than Chevrolet, Ford, Plymouth, Chrysler and Pontiac put together.

Hide-A-Bed®sofas by Simmons. Over 390 models.
With style, luxury, elegance, and a bed.
When Simmons can give you the sofa you want,
isn't it nice there's a bed in it, too?

For decorating booklet, "Hide-A-Bed Sofas for the Way We Live Now," send name, address and 25¢ to Simmons, 2 Park Avenue, N.Y.C. 10016.

First Lane, Front to Back		Second Lane, Front to Back		Third Lane, Front to Back		Fourth Lane, Front to Back		Fifth Lane, Front to Back	
Talisi-4 (White)	from $530	Cambridge-5	from $630	Norman-2	from $490	Biscayne-4 (Olive)	from $340	Grenada-4	about $390
Cortina-4	from $430	Commropo-5	from $530	LaSalle-4	about $495	Medison-4	about $425	Andreas-5	about $595
Pizzo-5	from $532	Straus-5	from $1120	Clairemore-1	about $399	Carter-3	about $399	Squire-4	about $440
Palencia-4	from $520	Crescent-4	about $495	Stockbridge-2	about $330	Warwick-4	about $530	Mayfair-5	about $525
Oznovecy	from $940	Sanford-4	from $560	Thomas-3	about $385	Porter-5	about $385	Lexington-3	about $385
		Farmount	from $610	Infanty-4 (White)	about $895	Kingston-3	about $399	Rogue-1	about $900
		Providence-4	about $350	Libra-4	from $800	Bonfinate-3	about $710	Sutton-4	about $491
				Lawrence-2	about $320	Monocery-4	about $375	Clundy-3	about $450
				Knowiles-4	about $450	Olympia-5	from $625		
						Dexapo-3	about $440		

SIMMONS
SECOND CENTURY

Simmons Hide-A-Bed Sofa, 1971

▶ *Montgomery Ward Department Store, 1970*

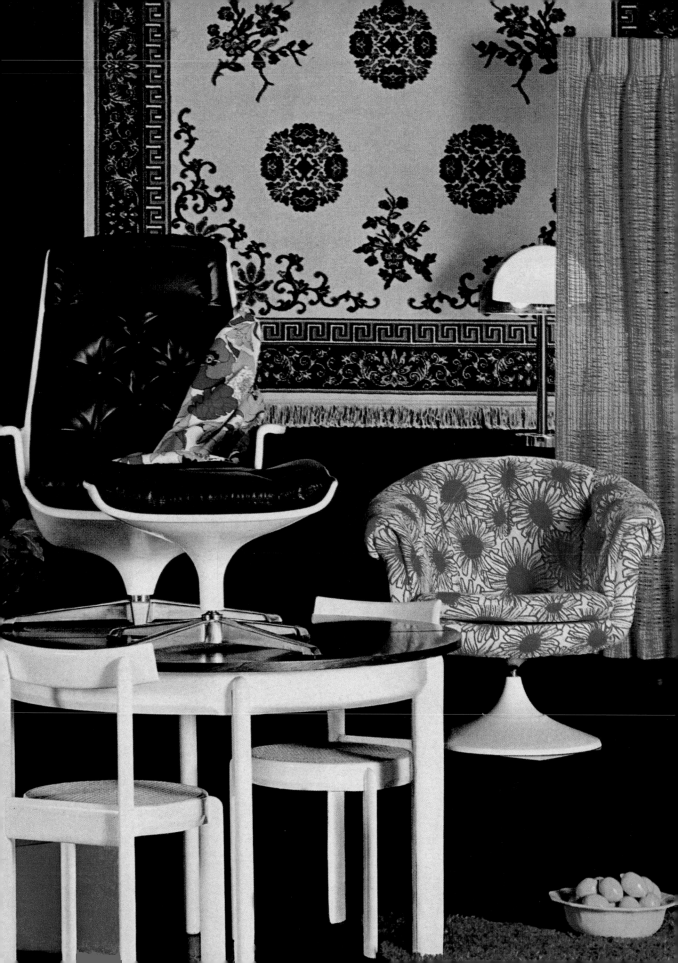

Feel clean all over

It's a grand feeling when everything's clean.
Rugs, walls, table tops, everything. And one of your
best helpers is gas heat. There's no heat cleaner
than gas. No heat more comfortable or dependable.
And do you know how thrifty gas heat is? Check into it—
with your gas company or heating contractor.

Gas heat gives you a better deal.

FORGET WHAT MAMA LIKED.

First, Marquise was a little on the defiant side. Now it's a contemporary classic. Very subtle and sophisticated. Very clean and crisp. Architectural in its simplicity and reality. And totally unpretentious. It's on display today in most unstuffy furniture stores.

Chromcraft Furniture, 1974

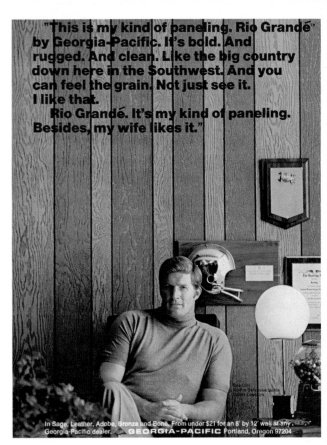

"This is my kind of paneling. Rio Grande™ by Georgia-Pacific. It's bold. And rugged. And clean. Like the big country down here in the Southwest. And you can feel the grain. Not just see it. I like that.

Rio Grandé. It's my kind of paneling. Besides, my wife likes it."

In Sage, Leather, Adobe, Bronze and Bone. From under $21 for an 8' by 12' wall at any Georgia-Pacific dealer. **GEORGIA-PACIFIC** Portland, Oregon 97204

Georgia-Pacific Paneling, 1970

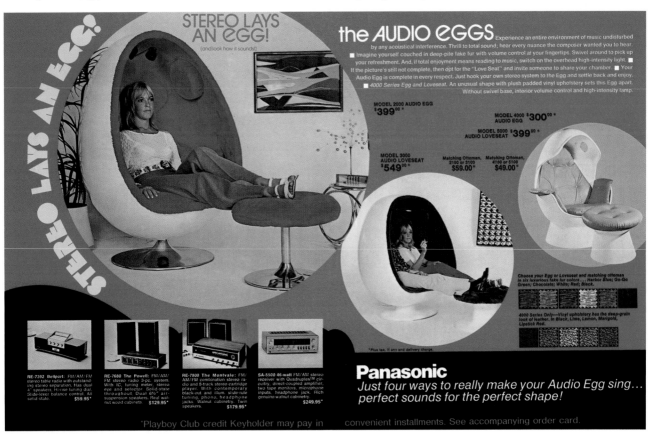

American Gas Association, 1971 ◄ Panasonic Audio Egg, 1972

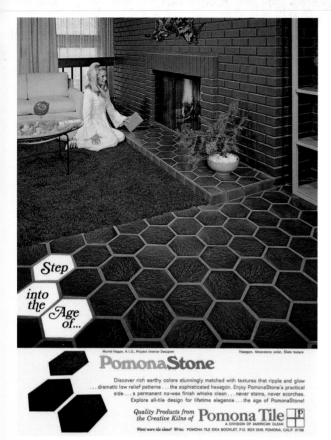

Step into the Age of...

PomonaStone

Muriel Hagan, A.I.D., Project Interior Designer

Hexagon, Moonstone color, Slate texture

Discover rich earthy colors stunningly matched with textures that ripple and glow ...dramatic low relief patterns...the sophisticated hexagon. Enjoy PomonaStone's practical side...a permanent no-wax finish whisks clean...never stains, never scorches. Explore all-tile design for lifetime elegance...the age of PomonaStone!

Quality Products from the Creative Kilns of **Pomona Tile** [P]
A DIVISION OF AMERICAN OLEAN

Want more tile ideas? Write: POMONA TILE IDEA BOOKLET, P.O. BOX 2248, POMONA, CALIF. 91766

Pomona Tile, 1972

UP OFF YOUR KNEES, GIRLS. SHINYL VINYL, THE NO-WAX FLOOR IS HERE.

It has a built-in polished surface that takes the place of wax. Throw away your wax! Give up stripping down! Now there's Shinyl Vinyl from Congoleum in over 200 exciting floors, all with a beautiful No-Wax shine. To last the life of the floor. A finish that can't be greasy-grimed to death, or heeled-and-toed away. Even kids can't hurt it—

it's *that* tough. And so is the sound-proofing cushion of foamed vinyl underneath. It "gives-in" under pressure from above. Then bounces back—to look brand new. Undented. Undaunted. A thing of beauty forever. Untouched by human knees. For a free 20 page decorator book write Congoleum, Box MC40, Kearny, New Jersey 07032.

Cushionflor® Spring® Pacemaker® Peerless®

Congoleum

Congoleum Floors, 1970

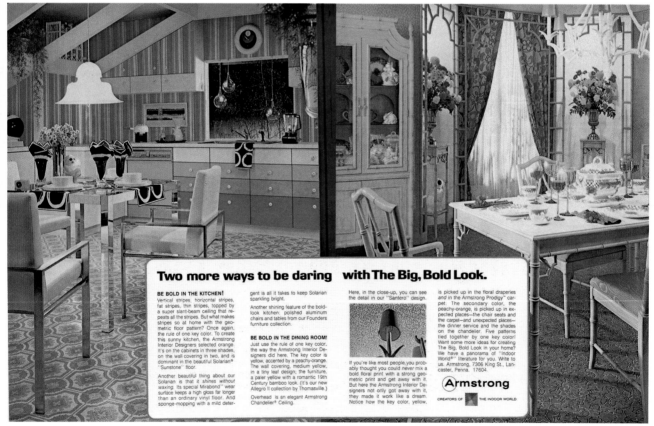

Two more ways to be daring with The Big, Bold Look.

BE BOLD IN THE KITCHEN!
Vertical stripes, horizontal stripes, fat stripes, thin stripes, topped by a super slant-beam ceiling that repeats all the stripes. But what makes stripes so at home with the geometric floor pattern? Once again, the rule of one key color. To create this sunny kitchen, the Armstrong Interior Designers selected orange. It's on the cabinets in three shades, on the wall covering in two, and is dominant in the beautiful Solarian® "Sunstone" floor.

Another beautiful thing about our Solarian is that it shines without waxing. Its special Mirabond™ wear surface keeps a high gloss far longer than an ordinary vinyl floor. And sponge-mopping with a mild deter-

gent is all it takes to keep Solarian sparkling bright.

Another shining feature of the bold-look kitchen: polished aluminum chairs and tables from our Founders furniture collection.

BE BOLD IN THE DINING ROOM!
Just use the rule of one key color, the way the Armstrong Interior Designers did here. The key color is yellow, accented by a peachy-orange. The wall covering, medium yellow, in a tiny leaf design; the furniture, a paler yellow with a romantic 19th Century bamboo look. (It's our new Allegro II collection by Thomasville.)

Overhead is an elegant Armstrong Chandelier® Ceiling.

Here, in the close-up, you can see the detail in our "Santero" design.

If you're like most people, you probably thought you could never mix a bold floral print with a strong geometric print and get away with it. But here the Armstrong Interior Designers not only got away with it, they made it work like a dream. Notice how the key color, yellow,

is picked up in the floral draperies and in the Armstrong Prodigy™ carpet. The secondary color, the peachy-orange, is picked up in expected places—the chair seats and the carpet—and unexpected places—the dinner service and the shades on the chandelier. Five patterns tied together by one key color! Want some more ideas for creating The Big, Bold Look in your home? We have a panorama of "Indoor World®" literature for you. Write to us. Armstrong, 7306 King St., Lancaster, Penna. 17604.

Armstrong

CREATORS OF ■ THE INDOOR WORLD

Armstrong Floors, 1973

▶ *Congoleum Floors, 1971*

MIX.MATCH.BUT FORGET THE WAX.

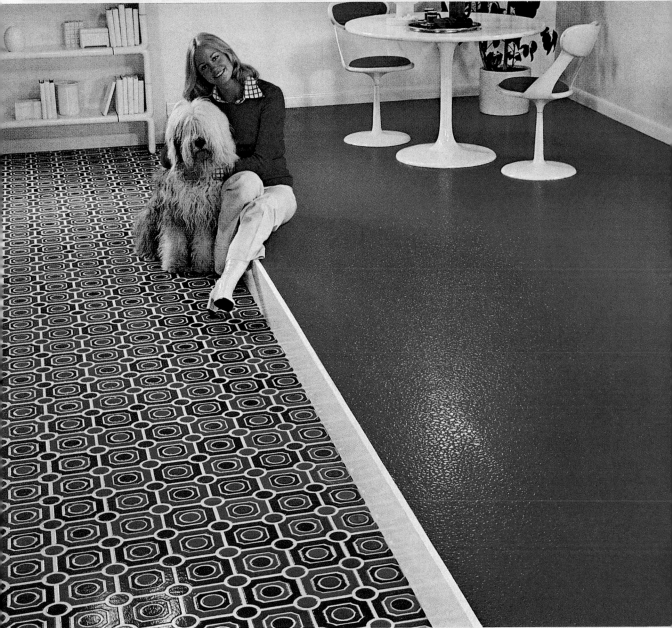

Shinyl Vinyl no-wax floors.

It's the end of the one-way floor. (And the end of waxing day.) It's the "Now Floor" in no-wax Shinyl® Vinyl. Start with a mod motif—like the red, white, and blue above. Add a solid color mate for accent. Or dabble in splashy blue-greens, red-oranges, candy pinks, grassy greens, and lemon—or black, bronze, and tawny.

Then it's relaxing—no waxing. The built-in Shinyl Vinyl surface needs no waxing. Sponge mopping does it. And because it's cushioned beneath, Shinyl Vinyl rebounds from heavy traffic, like new.

Pick your Shinyl Vinyl from over 200 patterns and colors at your Congoleum dealer. As easy to get to as the yellow pages.

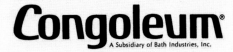

Congoleum®
A Subsidiary of Bath Industries, Inc.

Congoleum ®

The most no-wax cushioned floors in your color.
Like 22 in Blue.

And this blue is all new. It's just one of the Prestige collection, based on authenticated designs from the many lands that have made up the heritage of America.

These inspired designs feature the convenience of all our no-wax, Shinyl Vinyl® floors, and the comfort of cushioning. A no-wax, Shinyl Vinyl floor stays fresher looking longer, usually with just sponge mopping. In time, a reduction in gloss will occur in areas of heavier use. We recommend Congoleum Vinyl Dressing to provide a higher shine, if preferred.

See this great new collection and choose your floor in your color. Find us in the Yellow Pages under "Flooring".

Pattern #45001 shown.

Congoleum Floors, 1975

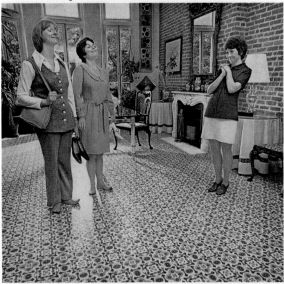

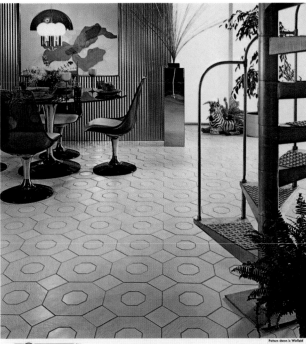

Viking Carpet, 1972

GAF Floor Products, 1973

Thomasville Furniture, 1979

National Floor Products, 1972

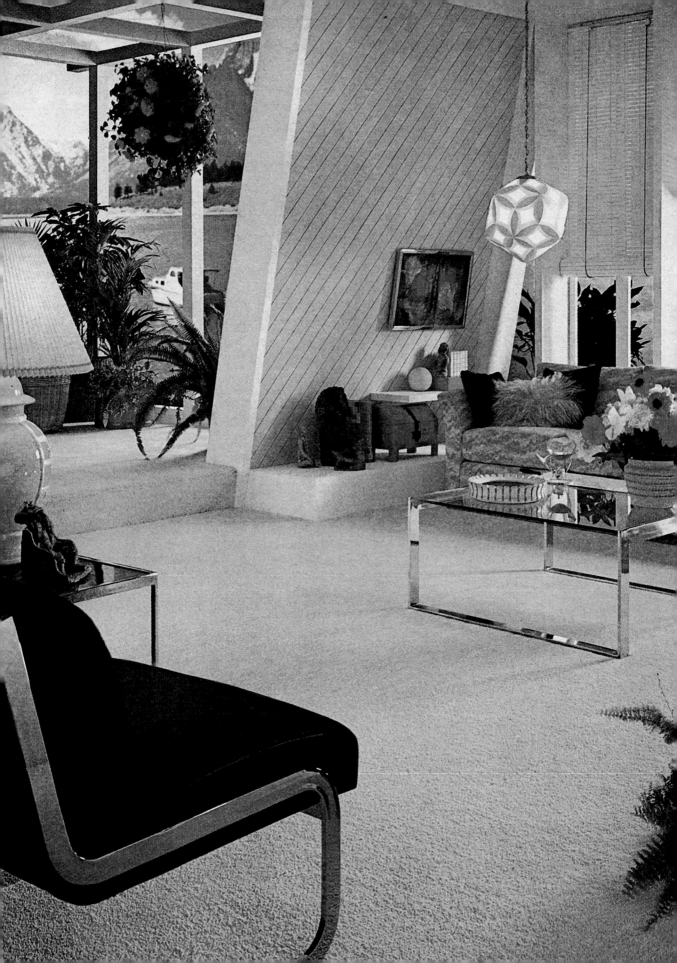

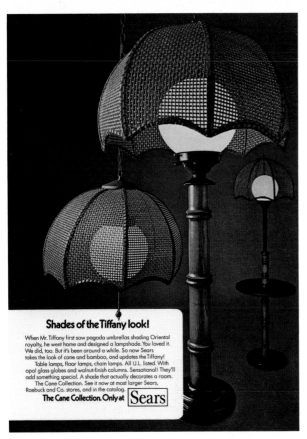

Sears Department Store, 1972

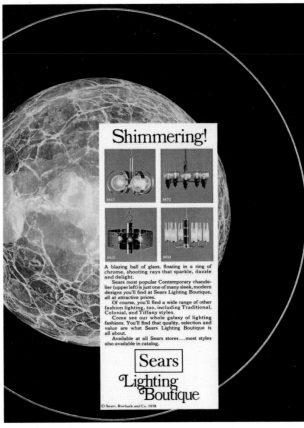

Sears Department Store, 1978

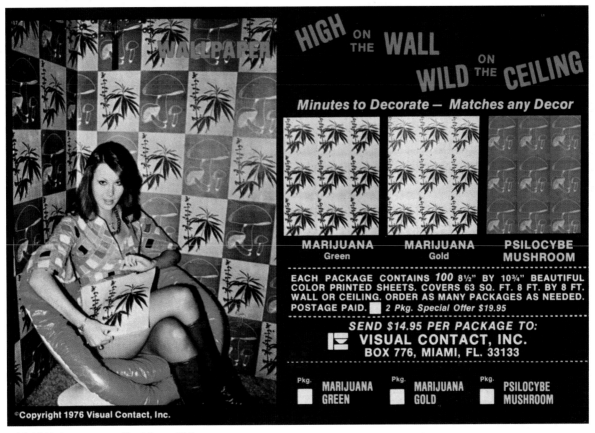

Philadelphia Carpets, 1974 ◄ *Visual Contact Wallpaper, 1977*

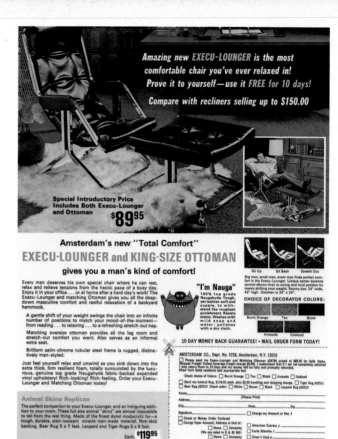

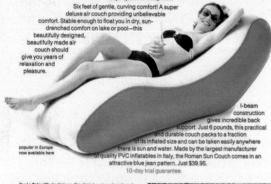

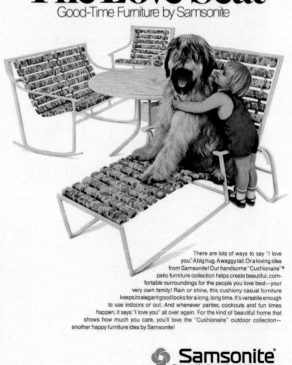

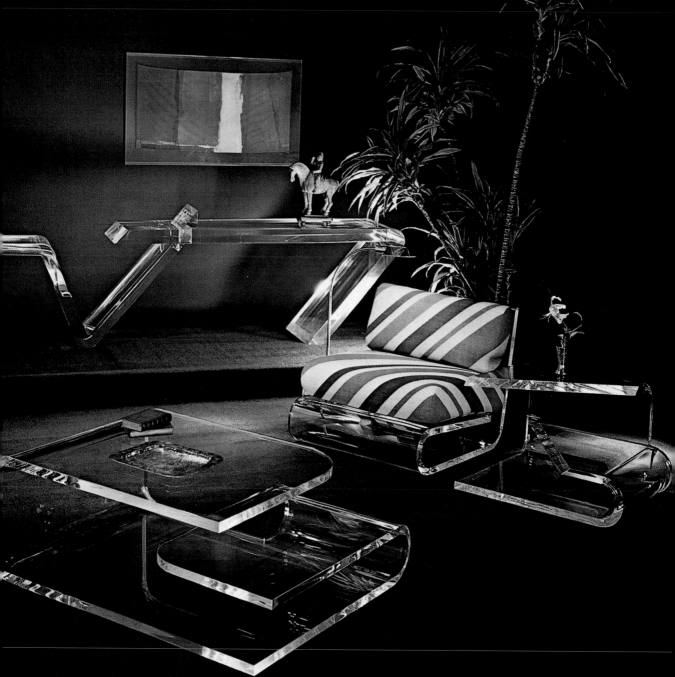

SIGNATURES IN ACRIVUE

⑤ THE SWEDLOW GROUP

You Loved 'em Before. You'll Love 'em Again!

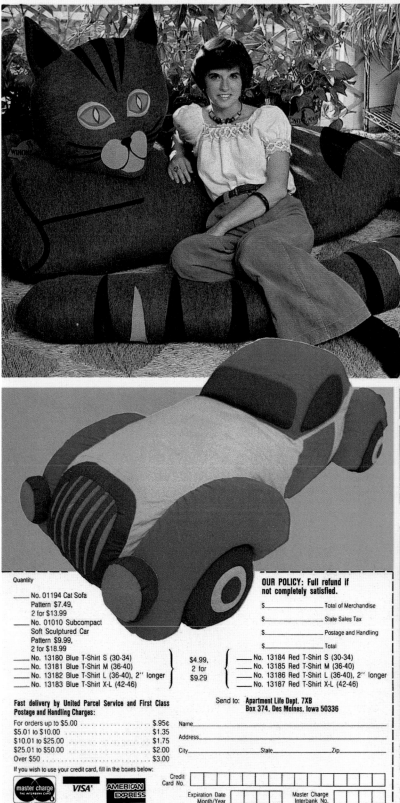

One more shot at these oldies but goodies from Apartment Life

Give your lifestyle sensational treatment with these exclusive and economical designs from Apartment Life. Our fabulous furniture designs give you and your guests something pretty to look at, comfy to sit in, and lots to talk about! And our colorific T-shirt is guaranteed to fit you and your lifestyle to a T!

Cat Sofa Pattern The pet your landlord can't complain about and guests will adore. Seat as many as you can on this center of conversation. Package includes full-size patterns, materials list (sofa requires approximately 5½ yards of cotton or cotton/polyester fabric and about 20 pounds of polyester stuffing), and instructions. Make one for yourself and another for a friend!

Soft Sculpture Car Pattern A child's delight that adults will love lounging in. Package includes full-size patterns, materials list (car requires approximately 8 yards of 60-inch wide fabric and about 30 pounds of polyester stuffing) and directions. Finished car measures 57″ x 28″ and moves easily from youngster's room to living center for extra (and extra unique) adult seating.

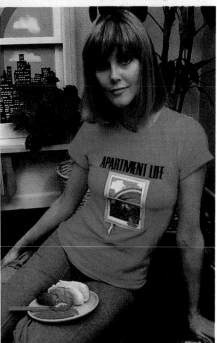

Apartment Life T-Shirt Finally, the T-shirt that makes a statement—beautifully—about your chosen lifestyle. Apartment Life's rainbow insignia imprinted on quality 100% cotton crew-necked shirt. Available in red (shown) or blue, and sizes to fit all. (Sizes are given in after-washing measurements to allow for slight shrinkage.)

Warner Wallcoverings, 1973 ◀ *Apartment Life Furniture, 1978*

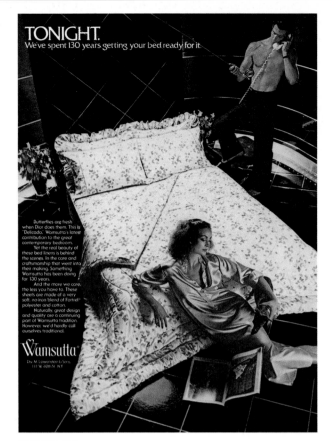

Mix it, match it, any way you turn it, UpDate turns you on.

Your bedrooms never came so alive! Just see what Bob Van Allen's new UpDate collection can do for them! It's crafted by *Kenneth Home Fashions* into cozy comforters, wild bedspreads, gay dust ruffles, exciting draperies! Matching pillows and piece goods from Riverdale—treated with "Scotchgard" Brand Fabric Protector. Use all the same pattern, or mix them up.

There are four to choose from, and four colors: seafoam, earth, cadet blue, cranberry. All in a perfect blend of 50% Fortrel polyester, 50% cotton—machine washable. UpDate...what a wonderful way to sleep! What a wonderful way to decorate too—only from *Kenneth Home Fashions*. And so outstanding in fashion and value, they're a Celanese House selection.

a Celanese house selection

Fortrel® is a trademark of Fiber Industries, Inc., a subsidiary of Celanese Corporation.

Selected patterns and colors available at fine stores everywhere.

Celanese House, 1977

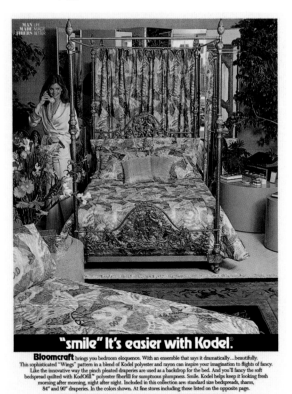

TONIGHT.
We've spent 130 years getting your bed ready for it.

Butterflies are fresh when Dior does them. This is "Delicado." Wamsutta's latest contribution to the great contemporary bedroom.

Yet the real beauty of these bed linens is behind the scenes. In the care and craftsmanship that went into their making. Something Wamsutta has been doing for 130 years.

And the more we care, the less you have to. These sheets are made of a very soft, no-iron blend of Fortrel® polyester and cotton.

Naturally, great design and quality are a continuing part of Wamsutta tradition. However, we'd hardly call ourselves traditional.

Wamsutta®
Div. M. Lowenstein & Sons.
111 W. 40th St. N.Y.

Wamsutta, 1977

Bloomcraft brings you bedroom eloquence. With an ensemble that says it dramatically...beautifully. This sophisticated "Wings" pattern in a blend of Kodel polyester and rayon can inspire your imagination to flights of fancy. Like the innovative way the pinch pleated draperies are used as a backdrop for the bed. And you'll fancy the soft bedspread quilted with KodOfill® polyester fiberfill for sumptuous plumpness. Smile. Kodel helps keep it looking fresh morning after morning, night after night. Included in this collection are: standard size bedspreads, shams, 84" and 90" draperies. In the colors shown. At fine stores including those listed on the opposite page.

"smile" It's easier with Kodel.

Bedroom ensemble by Bloomcraft. Kodel® polyester by Eastman.

EASTMAN CHEMICAL PRODUCTS, INC., a subsidiary of Eastman Kodak Company, 1133 AVENUE OF THE AMERICAS, NEW YORK, N.Y. 10036. KODEL is Eastman's trademark for its polyester fiber. Eastman does not make fabrics or consumer textile products and therefore makes no warranties with respect to such products.

1980

Bloomcraft, 1979

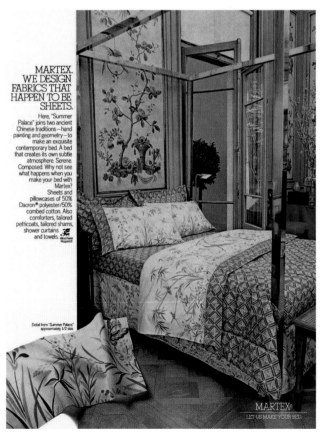

MARTEX. WE DESIGN FABRICS THAT HAPPEN TO BE SHEETS.

Here, "Summer Palace" joins two ancient Chinese traditions—hand painting and geometry—to make an exquisite contemporary bed. A bed that creates its own subtle atmosphere. Serene. Composed. Why not see what happens when you make your bed with Martex?

Sheets and pillowcases of 50% Dacron® polyester/50% combed cotton. Also comforters, tailored petticoats, tailored shams, shower curtains and towels.

Detail from "Summer Palace," approximately 1/2 size.

MARTEX®
LET US MAKE YOUR BED.

Martex Sheets, 1979

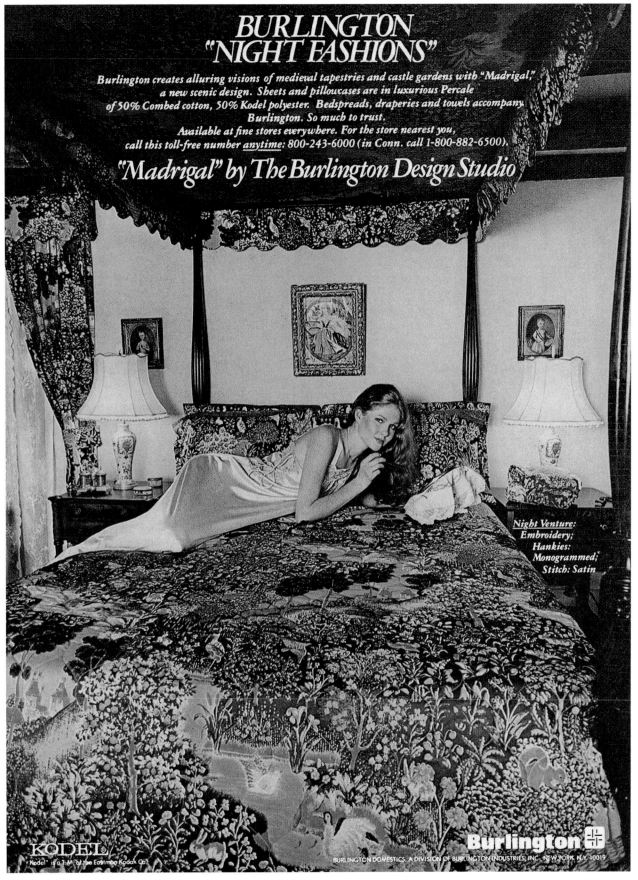

BURLINGTON
"NIGHT FASHIONS"

Burlington creates alluring visions of medieval tapestries and castle gardens with "Madrigal,"
a new scenic design. Sheets and pillowcases are in luxurious Percale
of 50% Combed cotton, 50% Kodel polyester. Bedspreads, draperies and towels accompany.
Burlington. So much to trust.
Available at fine stores everywhere. For the store nearest you,
call this toll-free number anytime: 800-243-6000 (in Conn. call 1-800-882-6500).

"Madrigal" by The Burlington Design Studio

Night Venture:
Embroidery;
Hankies:
Monogrammed;
Stitch: Satin

KODEL
Kodel is a T.M. of the Eastman Kodak Co.

BURLINGTON DOMESTICS, A DIVISION OF BURLINGTON INDUSTRIES, INC. NEW YORK, N.Y. 10019

Burlington

Burlington Fabrics, 1977

▶ *Sears Department Store, 1973*

633

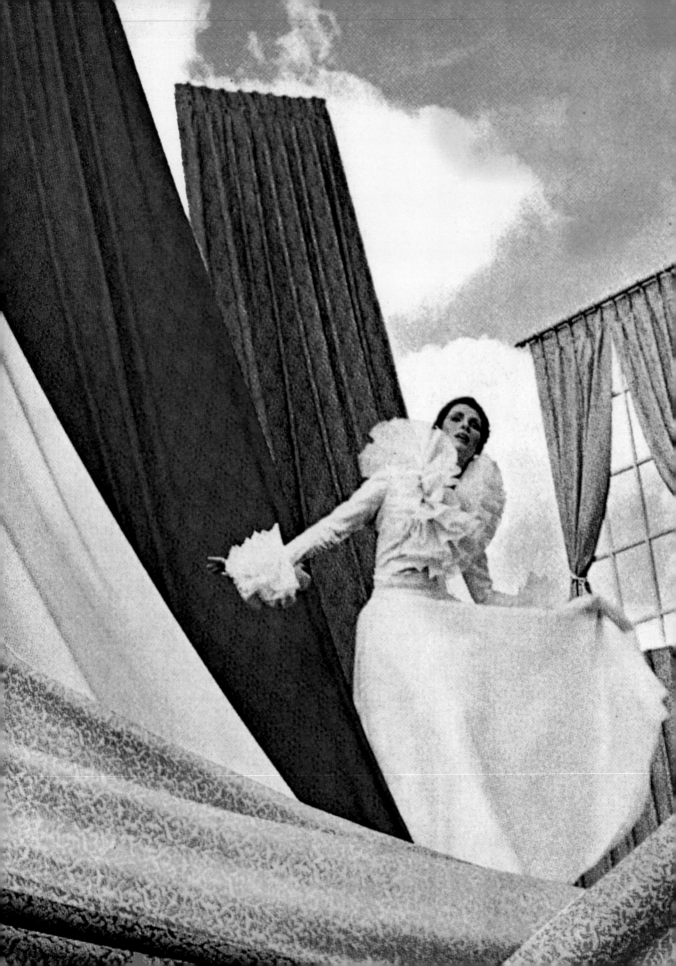

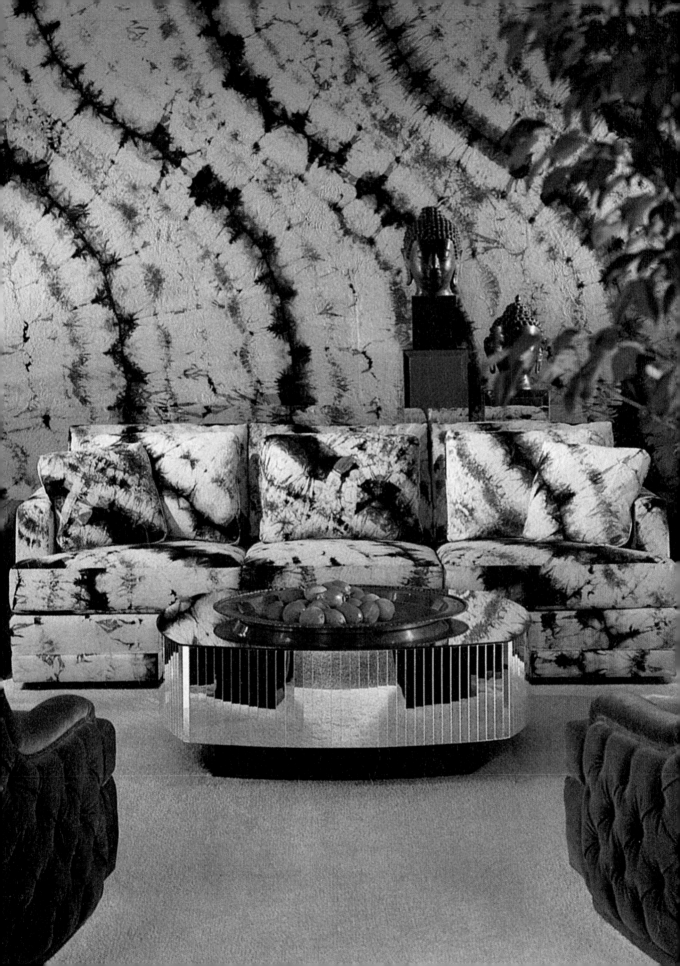

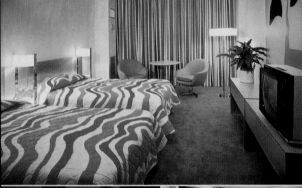
Wool Bureau, 1974

Simmons Furniture, 1974

Boussac of France Inc.
Fabrics
979 Third Avenue · New York 10022 · 212·4210534
Showrooms in – Los Angeles, Miami, Seattle, Dallas,
Boston, San Francisco, Minneapolis, Chicago, Houston, Paris, London.

Richard Giglio

Boussac of France Fabrics, 1974

Bob Crane & Associates Realtor, 1979

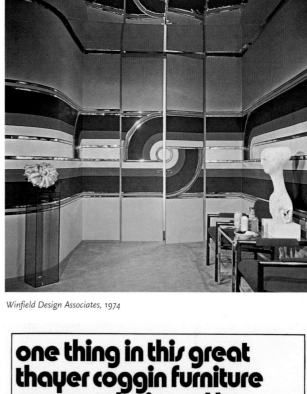
Winfield Design Associates, 1974

Modern Master Tapestries, 1972 ◄ *Lady Pepperell Sheets, 1978*

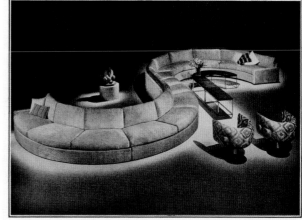
Allied Chemical Technology, 1971 ► *Roman Shades by Ray, 1972*

From Me To You 32321 Open House Collection

Good Glory 32344 Open House Collection

Poor Pitiful Plaid 36258 Open House Collection/The Days Of Wine And Roses 36259 Open House Collection

Wall-Tex®
your home becomes you.

What a special feeling it is when someone walks into your home and says: "Yes, this is really you." Wall-Tex® can help achieve that look. Wall-Tex. The fabric-backed wallcovering. So beautiful, so personal. So practical, too. Washable, stain resistant, a terrific crack hider, easy to put up, stripping right when you want a change and still offering so much for your money. Wall-Tex. Look through our more than 800 patterns wherever wallcoverings are sold. You'll find yourself. Your s' Your essence. And then . . . your home really becomes you!

Wall-Tex is a brand name and only Borden makes

BORDEN COLUMBUS COATED FABRICS
Division of Borden Chemical, Borden Inc.
Columbus, Ohio 43216

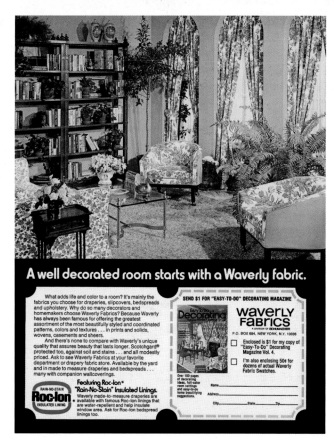

A well decorated room starts with a Waverly fabric.

What adds life and color to a room? It's mainly the fabrics you choose for draperies, slipcovers, bedspreads and upholstery. Why do so many decorators and homemakers choose Waverly Fabrics? Because Waverly has always been famous for offering the greatest assortment of the most beautifully styled and coordinated patterns, colors and textures . . . in prints and solids, wovens, casements and sheers.

And there's none to compare with Waverly's unique quality that assures beauty that lasts longer. Scotchgard® protected too, against soil and stains . . . and all modestly priced. Ask to see Waverly Fabrics at your favorite department or drapery fabric store. Available by the yard and in made to measure draperies and bedspreads . . . many with companion wallcoverings.

Featuring Roc-lon® "Rain-No-Stain" Insulated Linings.
Waverly made-to-measure draperies are available with famous Roc-lon linings that are water-repellent and help insulate window area. Ask for Roc-lon bedspread linings too.

SEND $1 FOR "EASY-TO-DO" DECORATING MAGAZINE

waverly FABRICS
A DIVISION OF SCHUMACHER
P.O. BOX 684, NEW YORK, N.Y. 10036

☐ Enclosed is $1 for my copy of "Easy-To-Do" Decorating Magazine Vol. 4.

☐ I'm also enclosing 50¢ for dozens of actual Waverly Fabric Swatches.

Over 100 pages of decorating ideas, full-color room settings and easy-to-do home beautifying suggestions.

Name _____
Address _____
City _____ State _____ Zip _____

Waverly Fabrics, 1973

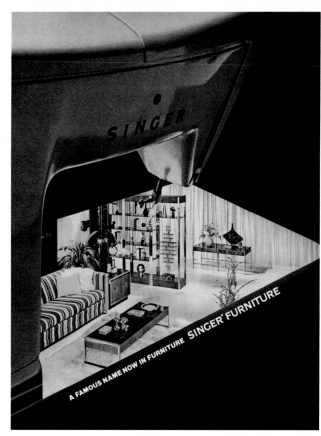

A FAMOUS NAME NOW IN FURNITURE SINGER® FURNITURE

Singer Furniture, 1972

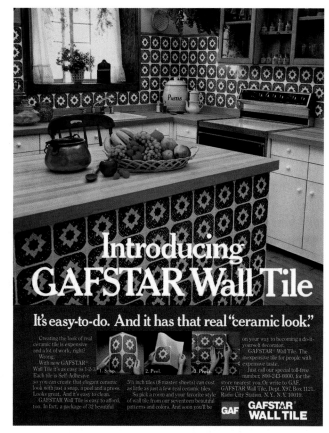

Introducing GAFSTAR Wall Tile

It's easy-to-do. And it has that real "ceramic look."

Creating the look of real ceramic tile is expensive and a lot of work, right? Wrong.

With new GAFSTAR® Wall Tile it's as easy as 1-2-3. Each tile is Self-Adhesive so you can create that elegant ceramic look with just a snap, a peel and a press. Looks great. And it's easy to clean.

GAFSTAR Wall Tile is easy to afford, too. In fact, a package of 32 beautiful

1. Snap. 2. Peel. 3. Press.

5½ inch tiles (8 master sheets) can cost as little as just a few real ceramic tiles.

So pick a room and your favorite style of wall tile from our seventeen beautiful patterns and colors. And soon you'll be

on your way to becoming a do-it-yourself decorator.

GAFSTAR Wall Tile. The inexpensive tile for people with expensive taste.

Just call our special toll-free number: 800-243-6000, for the store nearest you. Or write to GAF, GAFSTAR Wall Tile, Dept. X97, Box 1121, Radio City Station, N.Y., N.Y. 10019.

GAF GAFSTAR WALL TILE

Eljer Plumbingware, 1972 ◄◄ *Wall-Tex, 1974* ◄ *Gafstar Wall Tile, 1978*

Shaw-Walker has a new kind of desk

This new desk offers a choice of more than 100 standard drawer variations

Clerical Desk

Executive Desk and Credenza

Secretarial Desk

Newer looking. Easier working. More drawers. More knee-room. And all in the same amount of floor space as before. That's what makes Shaw-Walker's Skytronic™ a new *kind* of desk.

Because the Skytronic gives you so much more, each desk can actually be "programmed" to simplify nearly every kind of office work. Example: Even the standard 60 x 30-inch desk—the one used for most clerical jobs—can now have as few as two or as many

as *seventeen* work-organizing Clutter-Proof® Drawers.

See Skytronic at your local Shaw-Walker branch or dealer. Or phone for the colorful brochure *Electronic-Age Desks*. You'll agree, that by any standard of comparison, you get *more* for your dollar in Skytronic.

 SHAW-WALKER
52 Division Street Muskegon, Michigan 49443

Shaw-Walker Office Furniture, 1970

647

And the winner is...

Natural Disaster

Produced by the prestigious furniture manufacturer, Thonet, known for their elegant bentwood chairs, this confusing design mélange could hardly be called classic. While the ad copy emphasized the honesty of pine and simplicity of form, this lounge group revealed that natural was in and style was out. Lapsing into the prevalent "back to nature" aesthetic of the time, these pieces seemed destined for a college dormitory rather than a pedestal at MOMA.

Naturkatastrophe

Dieses verwirrende Designgemenge, hergestellt von dem renomierten Möbelhaus Thonet, das für seine eleganten Stühle aus gebogenem Holz bekannt ist, kann man wohl kaum als klassisch bezeichnen. Während der Text der Anzeige das ehrliche Kiefernholz und die einfache Form preist, beweist diese Sitzgruppe doch nur eines: Natürlichkeit war in und Stil war out. Diese Einrichtungsgegenstände folgen der damals vorherrschenden Ästhetik des „Zurück zur Natur"; sie sehen aus, als würden sie eher im Studentenwohnheim als auf einem Podest im Museum für Gestaltung landen.

Catastrophe naturelle

Produit par Thonet, le prestigieux fabriquant de meubles célèbre pour ses sièges en bois courbé, ce mélange déconcertant de styles n'avait rien de classique. Si le texte de la pub insistait sur l'authenticité du sapin et la simplicité de la forme, cet ensemble de salon indiquait clairement que le naturel était « in » et l'élégance « out ». Sombrant dans l'esthétique du « retour à la nature » qui prédominait à l'époque, ces meubles semblaient plus à leur place dans un dortoir universitaire plutôt que derrière une vitrine d'un musée du design.

Desastre natural

Elaborado por el prestigioso fabricante de mobiliario Thonet, célebre por sus elegantes sillones de madera alabeada, este diseño confuso distaba mucho de convertirse en un clásico. Pese a que el texto del anuncio realzaba la calidad del pino y la simplicidad de formas, el juego de sillón y sofá mostraba mucha naturalidad pero pocas ideas de diseño. Estas piezas, que intentaron adherirse a la estética del «retorno a la naturaleza» en boga en la época, parecían más destinadas a la habitación de un internado que a uno de los pedestales del MOMA.

自然災害

エレガントな曲げ木の椅子で知られる一流家具メーカー、トーネットがプロデュースしたこのよくわからないデザインの寄せ集めは、どうやったって傑作とは呼べない。広告コピーはパイン材の暖かみとシンプルなフォルムを強調しているが、このラウンジチェアのセットが浮き彫りにしているのは、ナチュラルこそインで、スタイルはアウトだという考え方だ。当時、広く蔓延していた「自然に帰れ」的美意識に陥ってしまったこれらの椅子の行き着く先は、MOMAの台座の上ではなく、どこかの学生寮だったはず。

The Pine Line. A lounge group with nothing between you and the honesty of its natural wood. Elemental. Adaptable. And most comfortable. The random width pine planks enclose plump urethane cubes. Chair, two and three seaters in your choice of fabrics. Complementary tables also available. See it at the Thonet Center of Design. New York. Chicago. Los Angeles. Dallas. Or write Thonet Industries Inc., 491 East Princess Street, York, Pa. 17405. Telephone (717) 845-6666.

THONET
CENTER OF DESIGN

Thonet Furniture, 1973

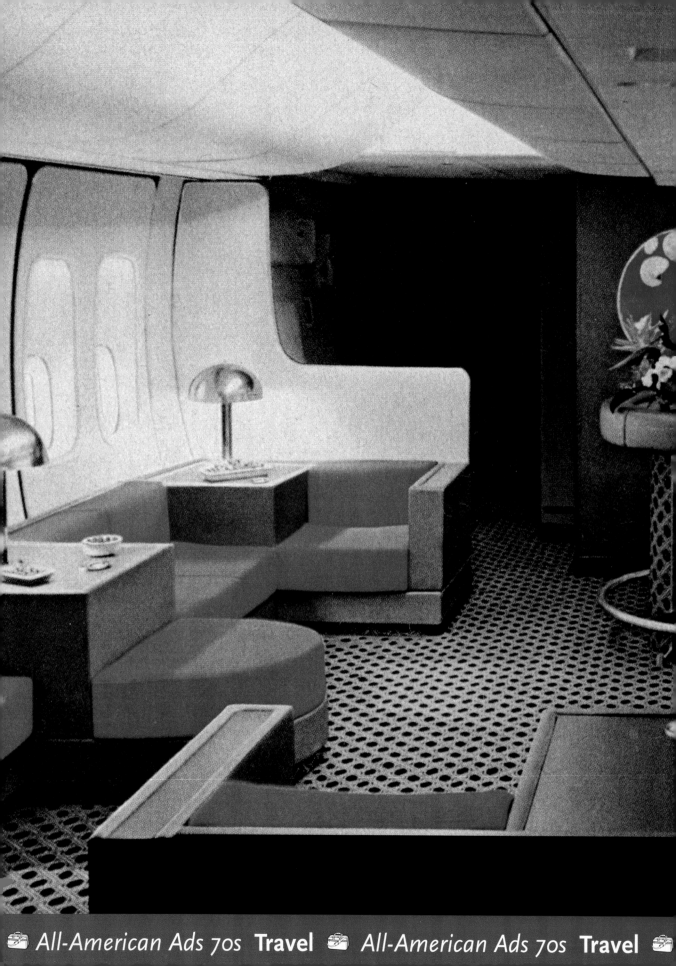

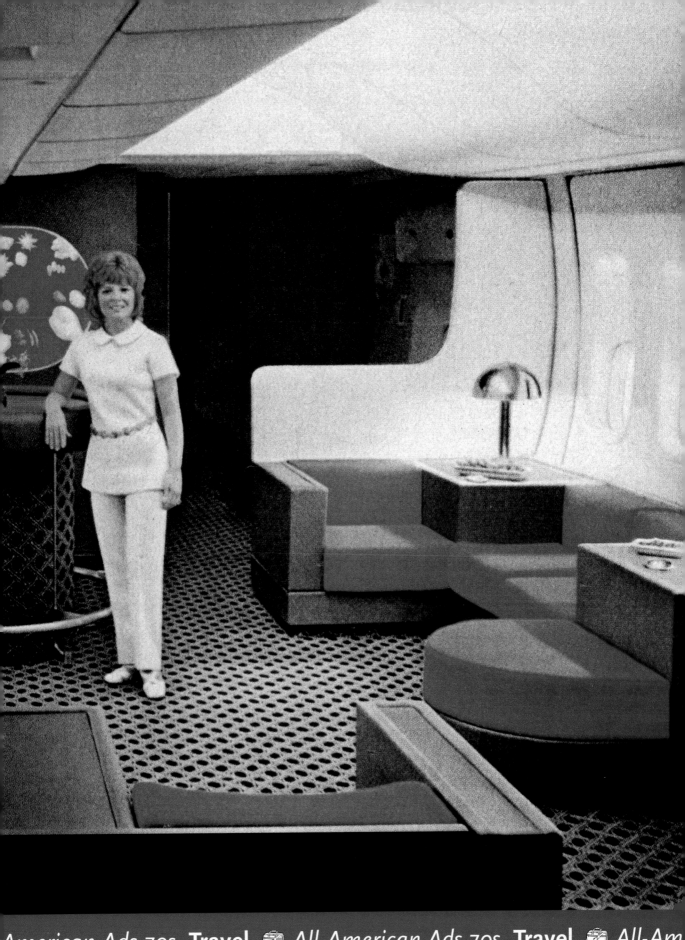

Picking an airline for its food is like picking a restaurant for its flying ability.

We don't know of a single restaurant that advertises itself as a great airline. Which is understandable.

However we do know of several airlines that advertise themselves as great restaurants. Which is absurd.

For no matter what an airline does (and none do more than we do) the closest it can come to great cuisine is good cuisine. The limitations of serving food at 30,000 feet see to that.

But that isn't the point. The point is, you don't get on an airplane to eat in the first place. No matter how good the food is. You get on an airplane to go somewhere.

And if that somewhere happens to be over 3,000 miles of ocean to a place you've never been, you need more than a pleasant plane ride.

You need help and advice before you leave.

If you've traveled a lot you know that planning things out thoroughly, before you leave, can mean the difference between a so-so vacation and a great vacation.

Over 7,000 Pan Am. travel agents, all across the country, have the knowledge and experience to make sure yours is the latter. From a complete Pan Am tour (having invented the air tour, we offer a wider selection to more countries than anyone) to simply making air and hotel reservations for you wherever you're going.

In addition, there are more than 50 Pan Am offices in the U.S. alone, staffed with people willing and able to help you with everything from what to pack to where to stay. Or where not to.

You may need help and advice once you're there.

There's one thing you can always expect when you travel. The unexpected.

You run a little short of cash. You don't receive your mail from home. You want to change plans. If you're a Pan Am ticket holder you can walk into any of our offices throughout the world and get help with the unexpected.

You can cash a personal check in an emergency, arrange to pick up your mail through our special "Postal Service," change hotel or flight reservations and get assistance on other problems that may come up.

And you don't pay us anything extra for any of these services. The pre-trip planning or the help you get once you're there. Further, your air fare on Pan Am is no more than it is on any other scheduled airline.

There's one other thing you don't pay extra for at Pan Am.

Our experience.

We've opened more of the world to air travel than all other airlines combined.

We've introduced (and helped design) virtually every major commercial aircraft of the last 40 years. Including the 747.

Our experience and knowledge is so vast, in fact, that last year alone, 17 of the world's airlines sent their pilots and crews to us for advanced training.

Come to think of it, 7 airlines had us prepare a good share of the meals they served aboard.

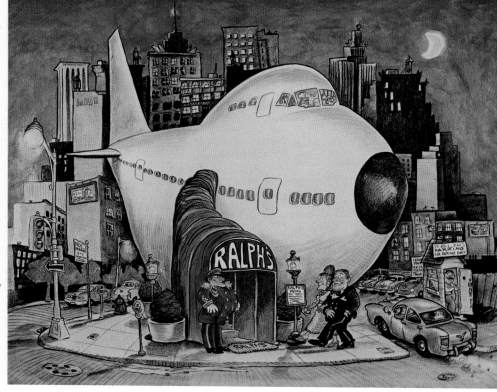

⊕ Pan Am
The world's most experienced airline.

Pan Am Airlines, 1972

American Airlines New 747 LuxuryLiner.
The plane with no competition.

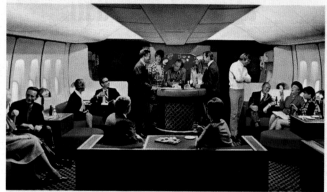

Coach Lounge.

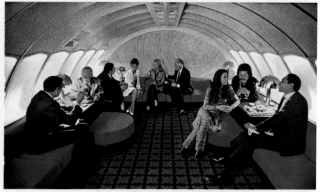

First Class Lounge.

No matter where you've been in the world, you've never gone in comfort like this. From our spacious new Coach Lounge, with its stand-up bar, all through the plane and up the stairs, to our totally redesigned first class lounge. It's a new standard in flying comfort. The American Airlines 747 LuxuryLiner. First of all, in coach, there's a lounge bigger than most living rooms.

It's a place where you can mingle, make new friends, have a snack, have some fun. Enjoy being sociable, or just enjoy the space. No other airline has anything like it. And back down the aisle at your seat, we've rearranged the rows. So besides getting **more leg room and sitting room,** you'll have more getting up room when you try out the lounge.

If you're flying first class, why not call ahead and **reserve a table for four.** You can wine and dine with friends, do a little business, or maybe play some bridge. And a floor above is our beautiful new first class lounge. A plush, intimate spot where you can socialize over after-dinner liqueurs or champagne. And for everybody on transcontinental flights,

there's an added service. Flagship Service. Featuring Polynesian food. Special warming wagons to keep your food piping hot. And pretty new outfits for our stewardesses. So if you like going places to see things, this new airplane is something to see. Every one of our 747s is now a LuxuryLiner. And all of the extra comforts won't cost you an extra cent. For reservations call us or your Travel Agent.

American Airlines 747 LuxuryLiner

American Airlines, 1971 ◄ *American Airlines, 1971*

► *Pan Am Airlines, 1972*

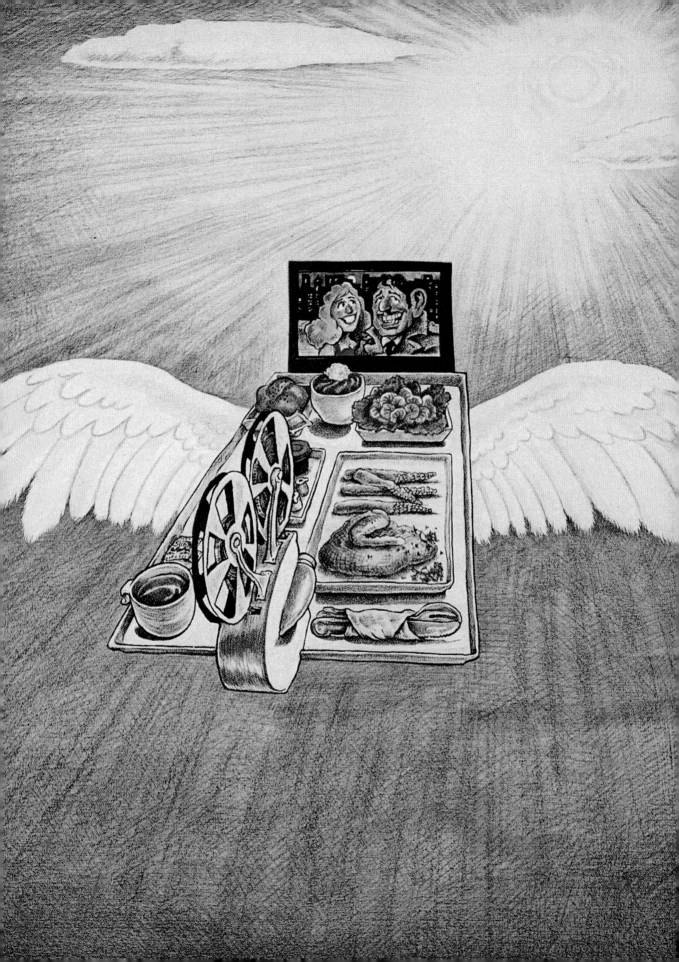

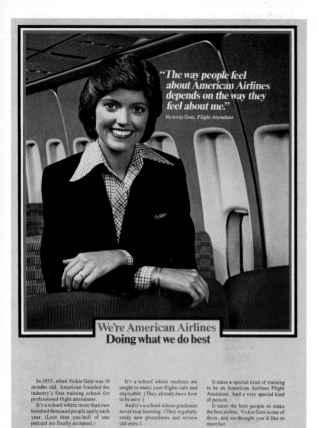

> "The way people feel about American Airlines depends on the way they feel about me."
>
> Victoria Getz, Flight Attendant

We're American Airlines
Doing what we do best

In 1955, when Vickie Getz was 10 months old, American founded the industry's first training school for professional flight attendants.

It's a school where more than two hundred thousand people apply each year. (Less than one-half of one percent are finally accepted.)

It's a school where students are taught to make your flights safe and enjoyable. (They already *know* how to be *nice*.)

And it's a school whose graduates never stop learning. (They regularly study new procedures and review old ones.)

It takes a special kind of training to be an American Airlines Flight Attendant. And a very special kind of person.

It takes the best people to make the best airline. Vickie Getz is one of them, and we thought you'd like to meet her.

American Airlines, 1979

Continental Airlines, 1970

We fly the world
the way the world wants to fly.

Every day we fly the world.

We take Americans to Tokyo and the Far East. We take tourists from Australia to the American West. Business travelers from London to Frankfurt. We take Texas oil people to the oil capitals of the world. All on the world's largest fleet of 747s and 747SPs.

And because we have a whole world to fly, we have a good idea what the world wants from an airline.

They want attention. And they want to be left alone. They want to put their trust in long experience. And they want a lot of new ideas.

They want an airline committed to making air travel available to everyone.

And they want an airline that stays great by knowing how to get better.

See your Travel Agent, and suggest Pan Am, the airline that flies to seventy-one cities in forty-seven countries around the world. Every day.

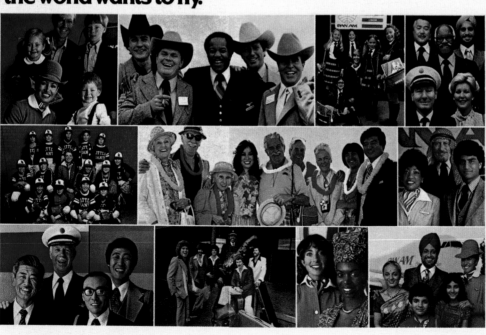

PAN AM

Pan Am Airlines, 1979

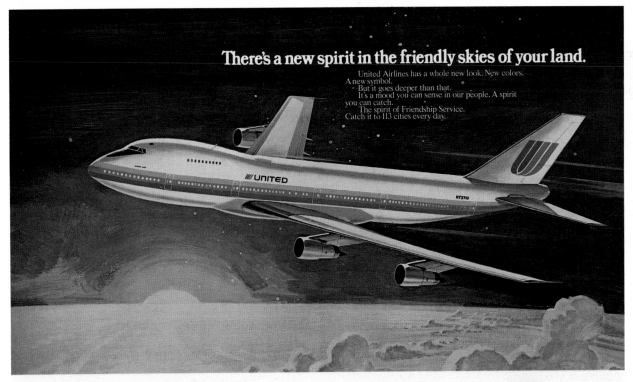

There's a new spirit in the friendly skies of your land.

United Airlines has a whole new look. New colors.
A new symbol.
But it goes deeper than that.
It's a mood you can sense in our people. A spirit
you can catch.
The spirit of Friendship Service.
Catch it to 113 cities every day.

UNITED AIRLINES

United Airlines, 1974

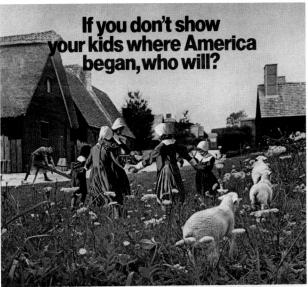

If you don't show your kids where America began, who will?

Plymouth, Mass. Where the Pilgrims landed. See it on an American Airlines Fly/Drive Vacation.

Your children have probably read about places like Plymouth and Jamestown and Valley Forge.

Wouldn't it be nice, while they're still young, to go back East and see these places together? To give your children a chance to really learn about their country, and to share in the experience with them?

This summer, American Airlines has made it easy to do just that.

We've put together some of the best Fly/Drive Vacations any airline has ever offered.

They run $187-$193 for a week. And they all include an Avis or Hertz car with unlimited mileage. (You pay for gas.) Plus 6 nights' accommodations at Sheraton Hotels and Holiday Inns. Air fare, of course, is extra (e.g. Los An-

geles to New York is $234* for adults and we have special fares for children).

Our $193 vacation, for example, gives you an Avis car for a week and 6 nights' accommodations for up to a family of four at Holiday Inns up and down the East Coast.

So you can do as you please, see whatever you please for as long as you please.

Why not talk to your Travel Agent. And get all the details about American's Fly/Drive Vacations to New York, Boston and Washington, D.C. (If you like, you can fly into one city and fly home from another.)

There's nothing we'd like better than to make this summer's family vacation one you'll always remember. And one your children will never forget.

American Airlines
To The Good Life.®

"The Good Life." © 1963, Paris Music Co. Inc. Used by permission
*Prices quoted are special tour basing round trip coach airfares (including taxes). Subject to change without notice.

American Airlines, 1973

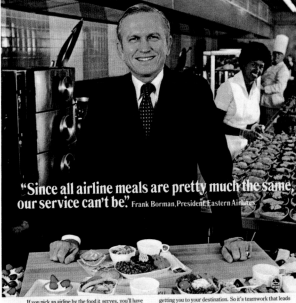

"Since all airline meals are pretty much the same, our service can't be." Frank Borman, President, Eastern Airlines

If you pick an airline by the food it serves, you'll have a hard time deciding. The truth is all airline food is pretty much the same.

This doesn't mean we're not interested in serving the best quality food. It just means we realize that there are other things you're interested in besides what's on the plate.

At Eastern Airlines, we feel it's people that make the difference between airlines.

There's a total commitment to giving you good, comfortable, hassle-free service from all 34,000 of us. That means reservation agents, baggage handlers, mechanics, pilots, flight attendants, departure service personnel and all the rest. Some work behind the scenes and some you meet face to face. But they all play an important part in

getting you to your destination. So it's teamwork that leads to a successful flight.

Eastern people realize you appreciate our being considerate and careful and friendly. And a little hustle doesn't hurt either.

So you see, we not only care about serving good quality food, but we know that how we dish it up counts, too.

Knowing all this has helped us. For the second year in a row, we've flown almost two million more passengers than the year before.

There are other airlines out there that you could fly. So if we want you to fly Eastern all the time, and we do, we have to earn our wings every day.

"The Wings of Man" is a registered service mark of Eastern Air Lines, Inc.

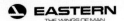

EASTERN
THE WINGS OF MAN

Eastern Airlines, 1978

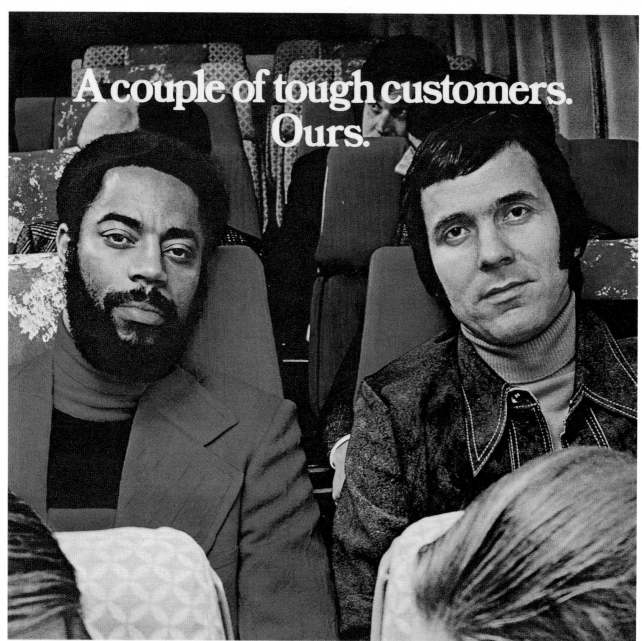

A couple of tough customers. Ours.

Walt Frazier and Jerry Lucas of the New York Knickerbockers.

When the men of the National Basketball Association go out of town on business they expect to have a rough time.

But on the way to and from, they want things made easy.

United understands.

Maybe that's why all 17 NBA·teams fly United to away games. And, in fact, why we fly more pro and college sports teams than any other airline.

Because we don't play games with them.

These guys are travel pros, too. They want convenience, attention, service, without asking. And in the·friendly skies, they've got it.

United knows that business people come in all shapes and styles. So we take them one at a time. And make things easy for all of them. Each in his own way.

The next time you're going out of town, call your Travel Agent, or United.

And say you're a tough customer. We'll take you on, too.

The friendly skies of your land
United Air Lines
Partners in Travel with Western International Hotels.

United Airlines, 1973

United Airlines, 1972

United Airlines, 1973

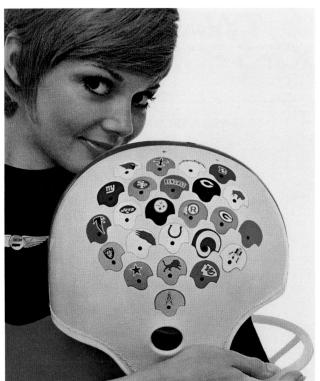

United Airlines, 1972

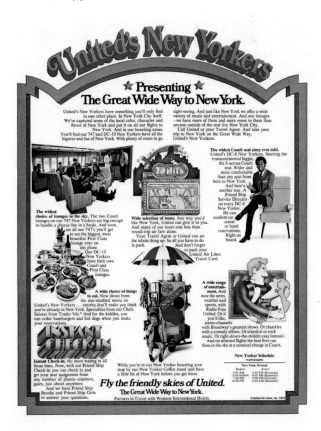

United Airlines, 1972

NOW, A WHOLE NEW WAY TO FLY ACROSS THE UNITED STATES. TWA's NEW AMBASSADOR SERVICE.

If you've suffered through a five hour flight, eating dull food, watching a movie you've already seen, we've got news for you.

TWA's new Ambassador Service.

Everything starts at the front of the terminal. The Skycap takes your bags. You head straight for the gate.

Where you find our new Ground Ambassador. If you have any problem, that's why he's there.

On board, you'll find new colors, new carpet, new seats, more room, better everything.

Especially in coach. Where we ripped the old seats out of our 707's. And put in our new Twin Seats.

You'll find a choice of 3 International meals in coach, 5 in first class. With champagnes, wines and liqueurs from around the world!

After dinner, sit back, and we bring on the entertainment. Eight channels of stereo music, humor and news. And on every movie flight, a choice of two movies!

When you land, you may find your bags waiting for you for a change. We've put in a whole new, faster baggage system.

Next time you're flying across the United States, take a TWA 707 or 747 Ambassador Flight. It's a whole new way to fly.

TWA Airlines, 1970

WHAT TWA DID FOR COACH... TWA NOW DOES FOR 1ST CLASS.

Last Fall TWA introduced Ambassador Service, a whole new way to fly for the coach passenger.

There's the new Twin Seat. If the plane's not crowded, it can be three across, two across or even a couch.

You'll find a choice of three international meals. With wines, champagnes and liqueurs from around the world!

You'll find a choice of two movies on every movie flight! One for general audiences, one for mature.

You'll find new carpets, new colors, new fabrics, new hostess uniforms, new everything.

The only problem was, first class started to look dull by comparison, so...

TWA's NEW AMBASSADOR SERVICE.

...we took out those old overstuffed first class seats.

And put in all new overstuffed first class seats.

We put in a choice of five meals, the best you'll find on any airline, anywhere.

After dinner, settle back, and we present a choice of two movies on every movie flight. One for general audiences, one for mature.

And on top of this (and below it and all around it) you'll find new colors, new carpets, new fabrics, new everything.

Next time you're flying to Boston, Hartford, New York, Newark, Philadelphia, Baltimore, Washington, Columbus, Cincinnati or Chicago take a TWA 707 or 747 Ambassador Flight.

Coach or first class, nobody else gives you anything like it.

TWA's NEW AMBASSADOR SERVICE.

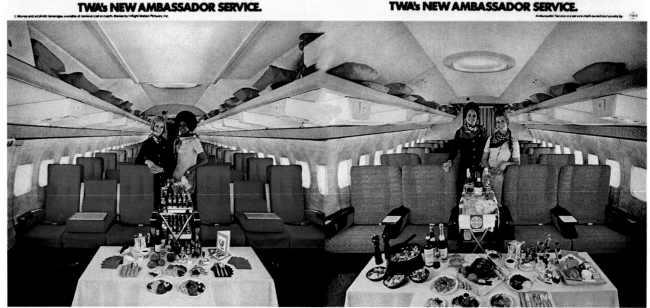

TWA Airlines, 1971

▶ *Western Airlines, 1970*

Legroom enough for six footers at every seat on every flight...

just part of Western's service to Hawaii

Welcome aboard the "Islander," where you'll enjoy First Class comfort at Coach fares. It's our "Deluxe Coach" with plenty of stretch-out legroom, because all seats in Coach and Economy are spaced exactly the same as First Class. And when the number of passengers permits, Western's ingenious "Aloha Table" gives you Two + Two seating—with First Class width, too. If you think "Deluxe Coach" sounds great, wait 'til you see how we pamper you in First Class!

Delicious! Our "Islander" punch is made with sparkling champagne and served from an orchid-laden cart to everyone with our compliments.

Feast "Islander" style. With your choice of gourmet entrees in both Coach and First Class. And special Economy meal service at minimal cost.
It's all served up by stewardesses in the latest Hawaiian fashion—the mini-muumuu.
Plus an Executive Hostess—your inflight expert.

Featuring: wide screen movies and a choice of six stereo channels for your pleasure.

Be a winner! You may win a prize that will remind you of Hawaii and your "Islander" flight in our Inflight Sweepstakes.

WESTERN TO HAWAII
the <u>only</u> way to fly

For reservations and information on low-cost tours, just ask your Travel Agent—he knows!

Yes, there is a Transylvania

-and Moldavia, Walachia and Bucharest... they're all in

Romania

You've seen the Europe everybody knows. Next stop is the Europe you dream about! In Romania, romance still lives. Where else can you find people singing, dancing, dressing, plying handicrafts much as they did centuries ago? In Romania you'll discover these vanishing Europeans in a thousand colorful villages. Or enjoy their folk songs and dances in the restaurants and night spots of Bucharest, while you savor an elegant cuisine and fine wines ... and even the prices remind you of Europe of another time!

True! This year prices in Romania are unchanged. It's still one of the best travel buys around.

Romania! There's nothing like it anywhere. Come explore the mountains and castles of legendary Transylvania. See the fantastic painted monasteries of Moldavia. Take the treatments at a world-famous spa or one of Dr. Ana Aslan's geriatric clinics. Visit Bucharest, a strange and wonderful mixture of "Paris 1900" boulevards, Byzantine onion domes and modern architecture.

Romania is all that and much more ... the last resort of the tourist in search of adventure. There are hundreds of tours to choose from, excellent accommodations and fine restaurants everywhere to make your visit as comfortable as it will be memorable.

Ask your travel agent, or mail coupon today.

ROMANIAN NATIONAL TOURIST OFFICE

573 Third Ave. New York, N.Y. 10016
Tel.: (212) 697-6971

Please send tour brochure and guide to Romania.

Name _____

Address _____

City _____

State _____ Zip _____

TH-MW5/79

Romanian National Tourist Office, 1979

RUSSIA

8 days. All expenses. 662 Rubles.

Visit this ancient and fascinating land.
The Kremlin.
Red Square.
The Bolshoi.
The Hermitage Museum.
And more. Much more.
See it all on Alaska Airlines' unique escorted all-expense paid tours of Russia and Siberia. Fly direct over the North Pole on a luxurious Boeing 707.
The complete 8-day tour of European Russia is only 662 rubles — 798 U. S. dollars.

Other tours take you to the vast Siberian frontier. To Middle Asia, fabled land of Arabian Nights. To the posh Black Sea resorts.
Tours leave every Saturday from Anchorage, Alaska, June 10 through September 9th. Prices include everything. All transportation. First Class hotels. Meals. Theater tickets. Gala banquets. Escorts. Everything!
Tours are filling fast. Call your travel agent, Alaska Airlines or write for our new 16-page booklet that gives you the facts and figures right down to the last kopeck.

**Transportation Consultants International, Dept. A90062
6290 Sunset Blvd., Los Angeles, California 90028**

Please send me your 16-page full-color Siberia/Russia Tour Brochure for 1972. I am most interested in the following tours:

☐ **8 days. European Russia, $798.00**
Leningrad. Moscow. Kiev.

☐ **15 days. The Russias. $1,398.00**
Moscow, Leningrad in European Russia, Khabarovsk, Irkutsk, Lake Baikal in Siberia. The Black Sea resort of Sochi. And Tashkent and Samarkand in Middle Asia.

☐ **8 days. Siberia. $898.00**
Irkutsk. Bratsk. Novosibirsk, Khabarovsk. Lake Baikal.

☐ **22 days. All the Russias. $1,698.00**
The big one! All of the 15-day tour plus Kiev. Tbilisi. Urgench. Khiva. Bratsk.

Name_____

Address_____

City_____ State_____ Zip_____

via **Alaska Airlines**

Alaska Airlines, 1972

Braniff Airlines, 1978

Western Airlines, 1971

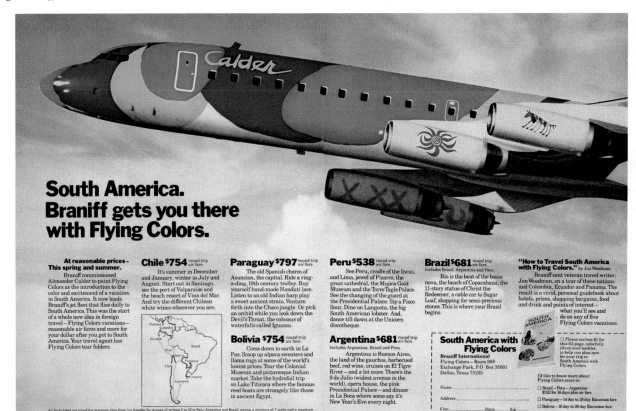
Braniff Airlines, 1974

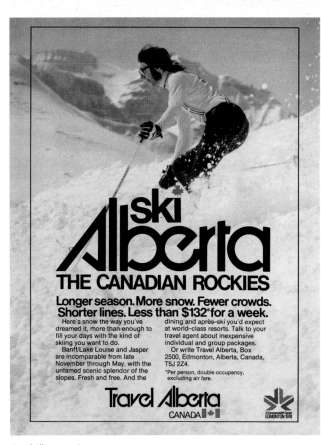

ski Alberta
THE CANADIAN ROCKIES

Longer season. More snow. Fewer crowds. Shorter lines. Less than $132* for a week.

Here's snow the way you've dreamed it, more than enough to fill your days with the kind of skiing you want to do.

Banff/Lake Louise and Jasper are incomparable from late November through May, with the untamed scenic splendor of the slopes. Fresh and free. And the

dining and après-ski you'd expect at world-class resorts. Talk to your travel agent about inexpensive individual and group packages.

Or write Travel Alberta, Box 2500, Edmonton, Alberta, Canada, T5J 2Z4.

*Per person, double occupancy, excluding air fare.

Travel Alberta
CANADA

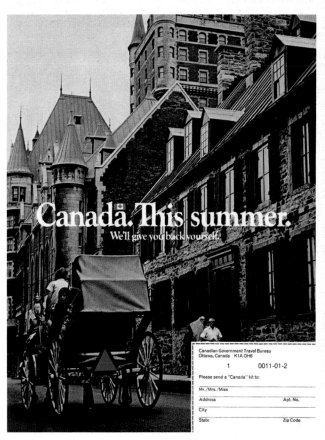

Canada. This summer.
We'll give you back yourself.

Travel Alberta, 1978 *Canadian Travel Bureau, 1972*

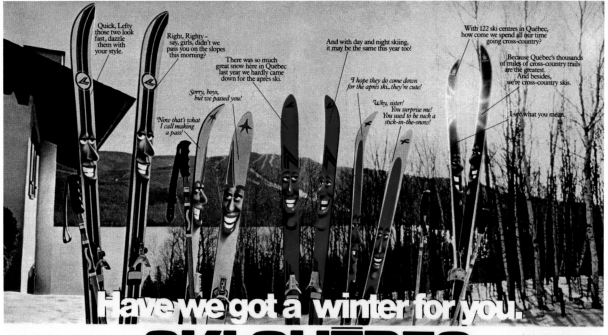

Quick, Lefty those two look fast, dazzle them with your style.

Right, Righty – say, girls, didn't we pass you on the slopes this morning?

There was so much great snow here in Québec last year we hardly came down for the après ski.

And with day and night skiing, it may be the same this year too!

With 122 ski centres in Québec, how come we spend all our time going cross-country?

Sorry, boys, but we passed you!

I hope they do come down for the après ski...they're cute!

Because Québec's thousands of miles of cross-country trails are the greatest.
And besides, we're cross-country skis.

Now that's what I call making a pass!

Why, sister! You surprise me! You used to be such a stick-in-the-snow!

I see what you mean.

Have we got a winter for you.
SKI QUÉBEC

For further information. See your travel agent or write to: QUEBEC TOURISM (8772Q), Quebec City, Canada G1R 4Y3 IN U.S.: QUEBEC TOURISM DEPT (8772Q) 17 West 50th Street, New York 10020

Northstar Ski Resort, 1972 ◄ *Québec Tourism, 1978*

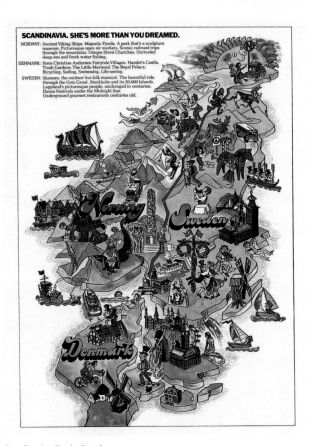
Scandinavian Tourist Board, 1974

Italian Government Travel Office, 1972

Eurailpass, 1979

BritRail Travel, 1979 ▶ Airstream Trailers, 1979

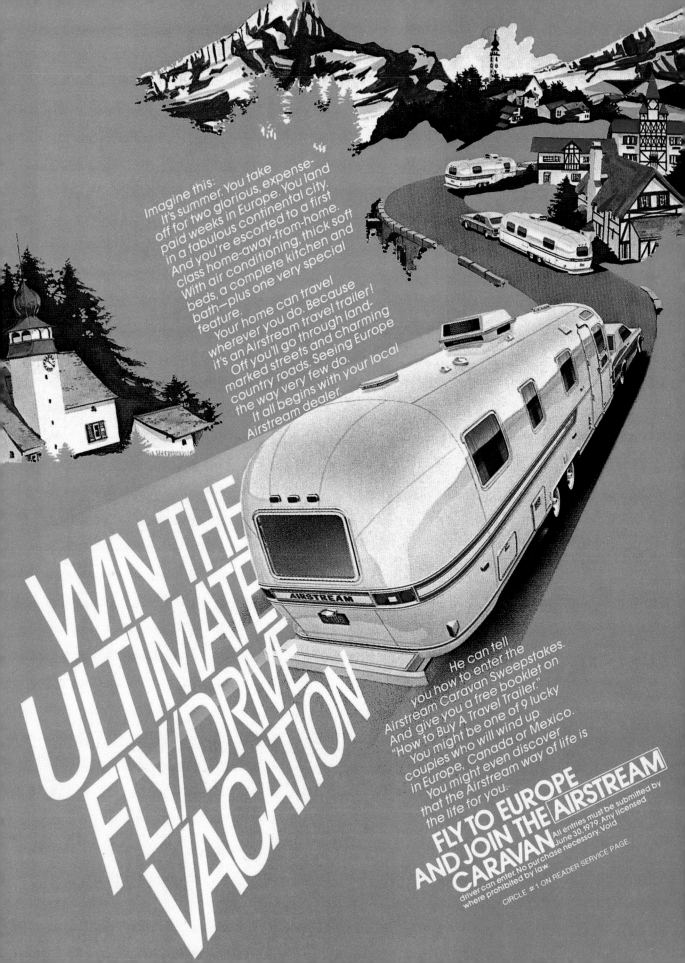

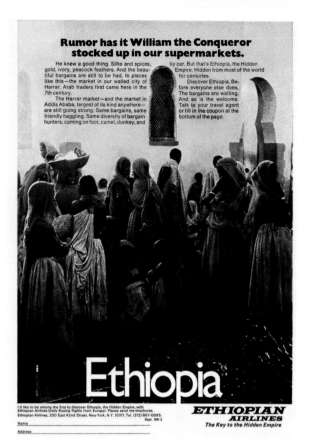

Rumor has it William the Conqueror stocked up in our supermarkets.

He knew a good thing. Silks and spices, gold, ivory, peacock feathers. And the beautiful bargains are still to be had. In places like this—the market in our walled city of Harrar. Arab traders first came here in the 7th century.

The Harrar market—and the market in Addis Ababa, largest of its kind anywhere—are still going strong. Same bargains, same friendly haggling. Same diversity of bargain hunters, coming on foot, camel, donkey, and by car. But that's Ethiopia, the Hidden Empire. Hidden from most of the world for centuries.

Discover Ethiopia. Before everyone else does. The bargains are waiting. And so is the welcome. Talk to your travel agent or fill in the coupon at the bottom of the page.

Ethiopia

I'd like to be among the first to discover Ethiopia, the Hidden Empire, with Ethiopian Airlines (daily Boeing flights from Europe). Please send me brochures.
Ethiopian Airlines, 200 East 42nd Street, New York, N.Y. 10017, Tel. (212) 867-0095. Dept. NW-2

Name
Address

ETHIOPIAN AIRLINES
The Key to the Hidden Empire

Ethiopian Airlines, 1972

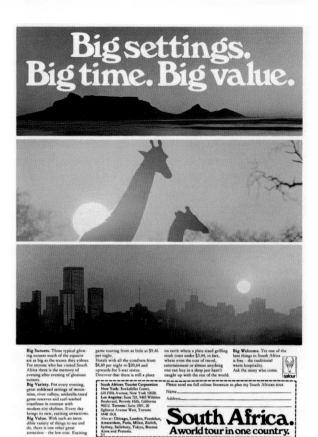

Big settings. Big time. Big value.

Big Sunsets. Those typical glowing sunsets south of the equator are as big as the scenes they colour. For anyone who has visited South Africa there is the memory of evening after evening of glorious sunsets.

Big Variety. For every evening, great reddened settings of mountains, river valleys, umbrella-treed game reserves and surf-washed coastlines in contrast with modern city skylines. Every day brings its new, exciting attractions.

Big Value. With such an incredible variety of things to see and do, there is one other great attraction - the low cost. Exciting game touring from as little as $9.46 per night.

Hotels with all the comforts from $8.60 per night to $20.64 and upwards for 5-star status. Discover that there is still a place on earth where a plate-sized grilling steak costs under $3.44, in fact, where even the cost of travel, entertainment or almost anything one can buy in a shop just hasn't caught up with the rest of the world.

Big Welcome. Yet one of the best things in South Africa is free – the traditional warm hospitality. Ask the many who come.

South African Tourist Corporation
New York: Rockefeller Center, 610 Fifth Avenue, New York 10020.
Los Angeles: Suite 721, 9465 Wilshire Boulevard, Beverly Hills, California 90212. Toronto: Suite 1001, 20 Eglinton Avenue West, Toronto M4R 1K8.
Also at: Chicago, London, Frankfurt, Amsterdam, Paris, Milan, Zürich, Sydney, Salisbury, Tokyo, Buenos Aires and Pretoria.

Please send me full colour literature to plan my South African tour.
Name
Address

South Africa.
A world tour in one country.

South African Tourist Corporation, 1978

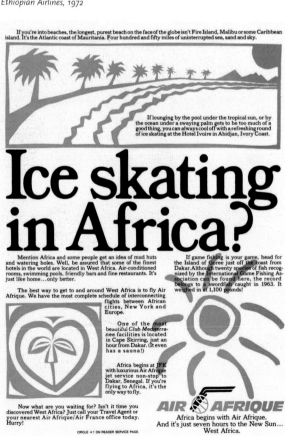

If you're into beaches, the longest, purest beach on the face of the globe isn't Fire Island, Malibu or some Caribbean island. It's the Atlantic coast of Mauritania. Four hundred and fifty miles of uninterrupted sea, sand and sky.

If lounging by the pool under the tropical sun, or by the ocean under a swaying palm gets to be too much of a good thing, you can always cool off with a refreshing round of ice skating at the Hotel Ivoire in Abidjan, Ivory Coast.

Ice skating in Africa?

Mention Africa and some people get an idea of mud huts and watering holes. Well, be assured that some of the finest hotels in the world are located in West Africa. Air-conditioned rooms, swimming pools, friendly bars and fine restaurants. It's just like home...only better.

The best way to get to and around West Africa is to fly Air Afrique. We have the most complete schedule of interconnecting flights between African cities, New York and Europe.

If game fishing is your game, head for the Island of Goree just off the coast from Dakar. Although twenty species of fish recognized by the International Game Fishing Association can be found here, the record belongs to a swordfish caught in 1963. It weighed in at 1,100 pounds!

One of the most beautiful *Club Mediterranee* facilities is located in Cape Skirring, just an hour from Dakar. (It even has a sauna!)

Africa begins at JFK with luxurious Air Afrique jet service non-stop to Dakar, Senegal. If you're flying to Africa, it's the only way to fly.

Now what are you waiting for? Isn't it time you discovered West Africa? Just call your Travel Agent or your nearest Air Afrique/Air France office today. Hurry!

CIRCLE #1 ON READER SERVICE PAGE

AIR AFRIQUE
Africa begins with Air Afrique.
And it's just seven hours to the New Sun...
West Africa.

Air Afrique, 1978

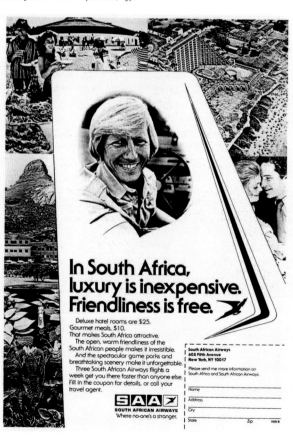

In South Africa, luxury is inexpensive. Friendliness is free.

Deluxe hotel rooms are $25. Gourmet meals, $10. That makes South Africa attractive.

The open, warm friendliness of the South African people makes it irresistible. And the spectacular game parks and breathtaking scenery make it unforgettable.

Three South African Airways flights a week get you there faster than anyone else. Fill in the coupon for details, or call your travel agent.

South African Airways
605 Fifth Avenue
New York, NY 10017

Please send me more information on South Africa and South African Airways.

Name
Address
City
State Zip NW8

SAA
SOUTH AFRICAN AIRWAYS
Where no-one's a stranger.

South African Airways, 1979

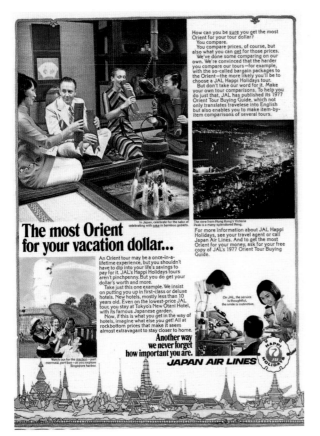

The most Orient for your vacation dollar...

How can you be *sure* you get the most Orient for your tour dollar?

You compare.

You compare prices, of course, but also what you can get for those prices. We've done some comparing on our own. We're convinced that the harder you compare our tours—for example, with the so-called bargain packages to the Orient—the more likely you'll be to choose a JAL Happi Holidays tour.

But don't take our word for it. Make your own tour comparisons. To help you do just that, JAL has published its 1977 Orient Tour Buying Guide, which not only translates travelese into English but also enables you to make item-by-item comparisons of several tours.

In Japan, celebrate for the sake of celebrating with sake in bamboo goblets.

The view from Hong Kong's Victoria Peak is a many-splendored thing.

For more information about JAL Happi Holidays, see your travel agent or call Japan Air Lines. And to get the most Orient for your money, ask for your free copy of JAL's 1977 Orient Tour Buying Guide.

An Orient tour may be a once-in-a-lifetime experience, but you shouldn't have to dip into your life's savings to pay for it. JAL's Happi Holidays tours aren't pinchpenny. But you do get your dollar's worth and more.

Take just this one example. We insist on putting you up in first-class or deluxe hotels. New hotels, mostly less than 10 years old. Even on the lowest-price JAL tour, you stay at Tokyo's New Otani Hotel, with its famous Japanese garden.

Now, if this is what you get in the way of hotels, imagine what else you get! All at rockbottom prices that make it seem almost extravagant to stay closer to home.

On JAL, the service is thoughtful, the smile is instinctive.

Watch out for the *maiko*—part mermaid, part lion—as you explore Singapore harbor.

Another way we never forget how important you are.

JAPAN AIR LINES

Japan Air Lines, 1977

The special Philippine art of mixing East and West.

Discover it first on Philippine Airlines.

World War II was ending, but a whole new life was just beginning for the olive-drab jeep.

Filipinos washed them down, polished them up, painted them over, added slogans on the fenders, streamers on the roof, statues on the hood, and the "Jeepney" taxi was born—American engineering and Philippine free-expression bolted together in a colorful mix of East and West found only in the Philippines.

And on Philippine Airlines.

Every night, one of our wide and wonderful DC-10's jets out of San Francisco across the Pacific to Manila. With a delightful mixture of American language, German tortes,

French champagne, Spanish names and famous Philippine delicacies and hospitality. On the fastest and only daily flights to the Philippines—the country of new hotels and old American friendships, the last bargain in the Orient and the first stop on any Orient tour.

For unforgettable Orient tours that begin in the Philippines on Philippine Airlines—begin with your travel agent or by writing us at 212 Stockton Street, San Francisco, California 94108.

The special Philippine mix of East and West is a once-in-a-lifetime experience. But it's also a once-a-day experience on Philippine Airlines. Don't miss it.

Philippine Airlines
Welcome aboard the Philippines.

CIRCLE # 8 ON READER SERVICE PAGE

Philippine Airlines, 1977

Unhurried Philippine charm in a 600 mph world.

Experience it first on Philippine Airlines.

While everybody's zipping around the world at almost the speed of sound, you can still ride through the Philippine countryside at the speed of a pony; dawdle in the park all Sunday or even have a serenade with each dinner course. In this frantic, impersonal, hurry-up world, the Philippines still takes the time to care.

Our airline offers the fastest, most frequent evening flights from San Francisco to Manila on extra-comfortable DC-10's flying the only daily service. From Manila, all the Orient is close by on our jets.

But along the way, we take a little more time, a little more care to make someone 7,000 miles from home feel at home. In our country. And on our airline.

With menus flavored from around the world, flight attendants who get a special training no other airline can offer: the 1,000 year-old tradition of warm Philippine hospitality. And understanding crews from an English-speaking country.

All of which makes the Philippines the perfect place to begin your Orient tour and Philippine Airlines the perfect way to begin it.

Philippine Airlines
Welcome aboard the Philippines.

Philippine Airlines, 1978

Our wings have angels.

18 angels, to be exact. On every 747B we fly. To all of Asia, throughout Europe—and soon to America itself.

And everywhere our angels

fly, they have a single mission: to serve you with pleasure and with pride. To make each flight the very finest of your life.

Ask any global traveler.

Then ask your Travel Agent or Transportation Manager for a date with the angels.

And fly as you have never flown before.

SINGAPORE AIRLINES

Singapore Airlines, 1978

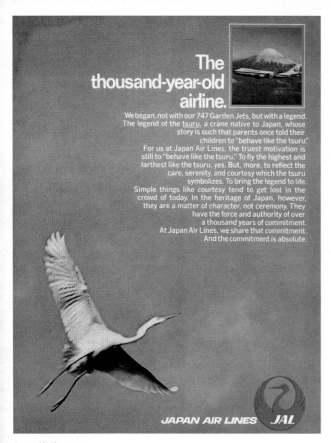

The thousand-year-old airline.

We began, not with our 747 Garden Jets, but with a legend. The legend of the tsuru, a crane native to Japan, whose story is such that parents once told their children to "behave like the tsuru."

For us at Japan Air Lines, the truest motivation is still to "behave like the tsuru." To fly the highest and farthest like the tsuru, yes. But, more, to reflect the care, serenity, and courtesy which the tsuru symbolizes. To bring the legend to life.

Simple things like courtesy tend to get lost in the crowd of today. In the heritage of Japan, however, they are a matter of character, not ceremony. They have the force and authority of over a thousand years of commitment.

At Japan Air Lines, we share that commitment. And the commitment is absolute.

JAPAN AIR LINES JAL

Japan Air Lines, 1971

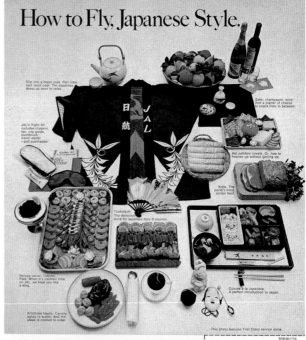

JAL made it to the top by helping tourists know the Orient instead of merely looking at it.

On JAL's Happi Holidays tours of the Orient, you see a world where the sights aren't merely variations of the sights back home. Where wonders are commonplace. Where splendor is taken for granted.

Even more important, JAL's Orient is a place where you gather memories of the people you've met as well as the sights you've seen.

These are the reasons why more people tour the Orient with JAL than with any other airline.

Come to JAL's Orient. See your travel agent or send us the coupon today. And come this year, not next year or the year after. As an old Japanese proverb says, "Time flies like an arrow." Another suggests, "The day you decide to do a thing is the best day to do it."

We never forget how important you are.
JAPAN AIR LINES
Box 618, N.Y., N.Y. 10011
☐ Please send me JAL's ORIENT booklet with complete tour listings and ORIENT TOUR BUYING GUIDE.

Name _____
Address _____ City _____
State _____ Zip _____ Tel _____
My Travel Agent is _____ Key # _____
NS 052278

Japan Air Lines, 1978

Now's the time to make a dream come true.

JAL's Orient. Mysterious and exotic, paradise and adventure, a multitude of cultures, customs, people and languages. It's all there for you to experience.

Come and watch Kabuki, a Japanese drama. Visit gilded palaces in Bangkok, admire ancient temples in Malaysia or just relax on one of Bali's beautiful beaches.

Now stop dreaming. JAL's Happi Holidays tours offer a variety of itineraries at prices that are lower than you may expect.

Choose one. You'll find it's the best way to make a dream come true.

For more information, see your travel agent or write Japan Air Lines, Dept. SQ, P.O. Box 618, New York, N.Y. 10011

This year, the Orient.
JAPAN AIR LINES

Japan Air Lines, 1979

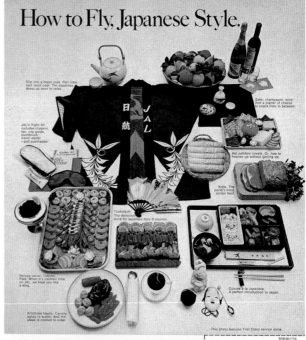

How to Fly, Japanese Style.

We once asked some of our flight guests what they liked most about flying with us.

Surprisingly, it wasn't any of the comforts or delicacies above.

In fact, it wasn't what we did so much as how we did it.

They spoke of being pampered. Of the way our hostesses in kimono smile. Small things, of course. But in a world that worships the mammoth, the small has a way of making up in gleam what it lacks in size.

At JAL, we glory in the small things of life. From our first hello to our last *sayonara*, we take the small attentions and courtesies so much for granted, they are our way of life.

It's a way of life practiced by us and our ancestors of generations beyond number.

In that sense, you could say we've been practicing how to fly for a thousand years and more.

JAPAN AIR LINES

Japan Air Lines
P.O. Box 888
Burlingame, California 94010
I'd like to fly Japanese style. Please send me your free booklet with all the details.

Name _____
Address _____
City _____ State _____ Zip _____
My travel agent is _____
Please have a travel consultant call me at _____

Japan Air Lines, 1974

▶ *Japan Air Lines, 1970*

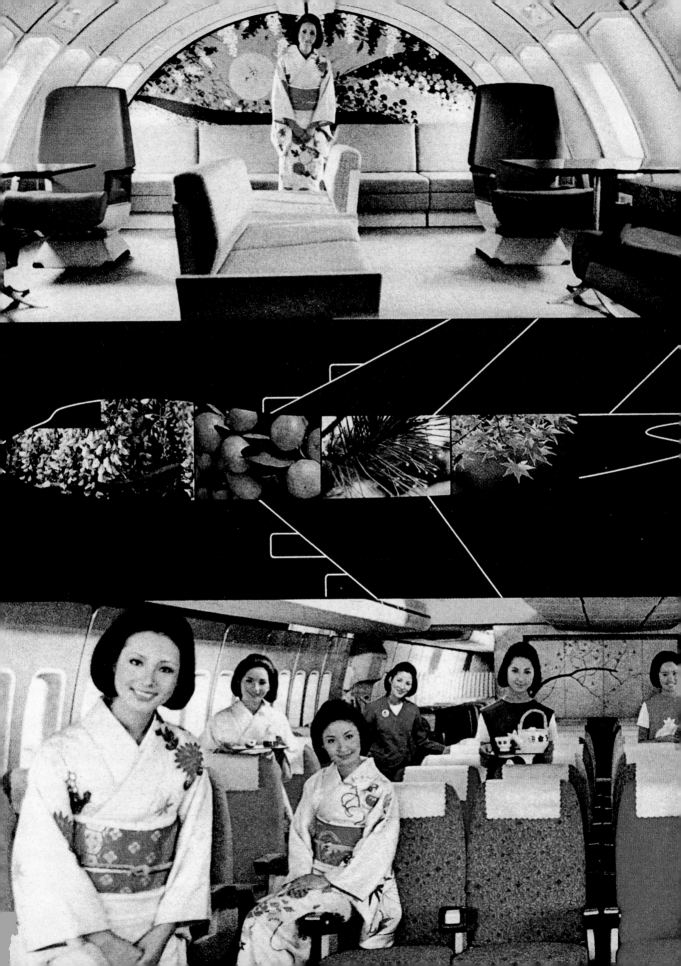

MEXICO &
MEXICANA

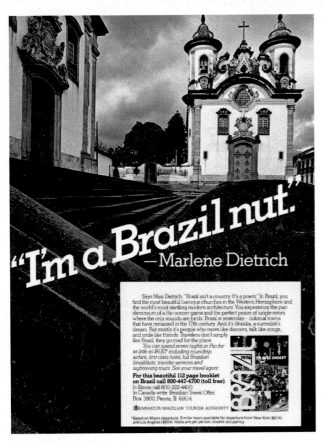

Brazilian Tourism Authority, 1979

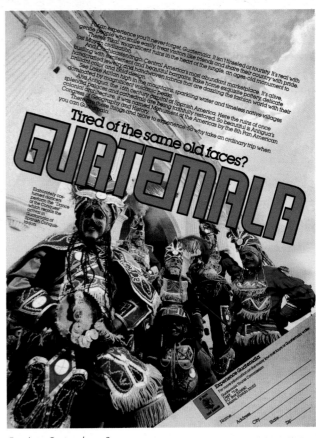

Experience Guatemala, 1978

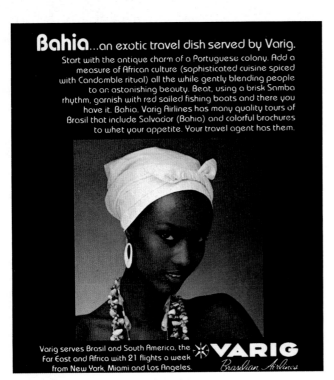

Mexicana Airlines, 1979 ◄ Varig Brazilian Airlines, 1973

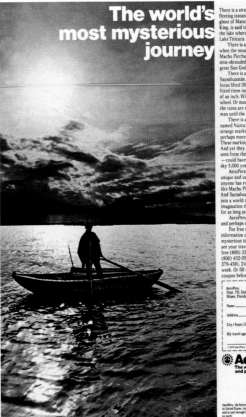

AeroPeru, 1976

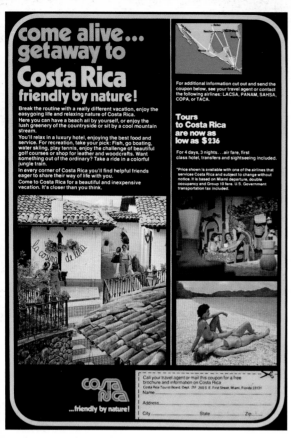

Costa Rica Tourism Board, 1978

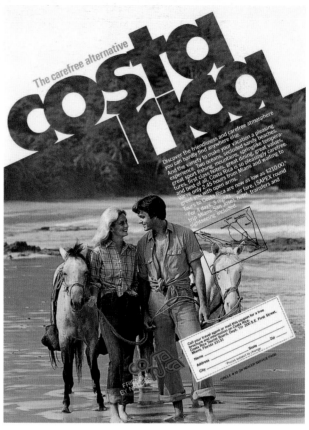

Costa Rica Tourism Board, 1979

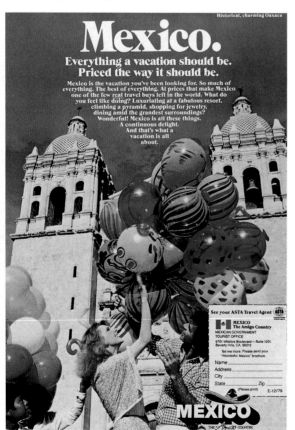

Mexican Government Tourist Office, 1979

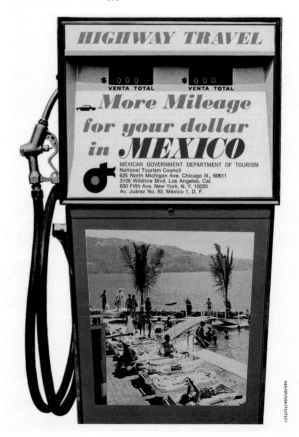

Mexican Government Department of Tourism, 1972 ▶ *Mexicana Airlines, 1972*

Mexico & Mexicana. We're the best things going.

When you're going to Mexico, we'll give you the best thing going. Our luxurious Golden Aztec service. From 8 U.S. cities to all 20 of the best places going. So see your travel agent. Send this coupon. Or call us toll-free at 800-421-8301, (From California, 800-252-0251, toll-free. From L.A. 213-687-6950). And get going yourself.

Mexicana Airlines, P.O. Box 4249, Burlingame, CA 94010. I'd like to get going myself. Send me more information about your tours to:
☐ Cancun ☐ Cozumel ☐ Mexico City ☐ Puerto Vallarta ☐ Guadalajara ☐ Mazatlan ☐ Acapulco ☐ Other_____

Name_____ Address_____ City_____

State/Zip_____ My travel agent is_____ **mexicana** ✈

*NWSC18 The airline most people fly to Mexico.

There comes a time when you need a change as momentous as India.

If travel seems less exhilarating, hardly the change it used to be, it's time you visited India.

India is astonishing. Covered with 5000 years of art and architecture. Full of color and music—the pageantry of many different beliefs. Complex. Contradictory. In a sunlit city Corbusier envisions the future. In a little village the past is now.

So many marvels. Ajanta's caves—a whole Buddhist civilization carved in stone. Jaipur, the rose-pink city. The Sun Temple of Konarak; it took 1200 architects 16 years to build it. Agra and the Taj, that great love story in marble (interestingly enough the lovers were husband and wife).

So many fantasy places. Tropic Kerala. Silver beaches and palm trees.

Kashmir. Soft mountain air, blue lakes, millions of flowers. (You can live on a houseboat in princely fashion for a very small amount.)

Incredible wildlife found only in India. A one-horned rhino. A four-horned antelope. And throngs of birds and animals that are part of daily life and very much respected. (After all, you're told, that flamingo may have been a princess in her previous life.)

Bazaars everywhere, spilling over with bargains; the dollar is still intrepid in India.

And every comfort, too. You can stay in luxury hotels; hire a chauffeured car for less than a self-drive car in most other countries. If you're open to people you'll make many friends. Indians are very hospitable;

tradition makes anything else unthinkable. Besides, English is an official language so it's easy to converse.

Even so, wherever you go in India you'll be struck with the differentness. Here, at last, is a land that can promise you a momentous change.

Government of India Tourist Office, N.Y., 19 E. 49th St.; Chicago, 201 No. Michigan Ave.; San Francisco, 685 Market St. Also Canada.

Name_____

Street_____

City_____ State_____ Zip___

My Travel Agent_____

India.
It's not just another country.
It's another world.

India Tourist Office, 1974

Oddly enough, in strange, elusive India you may come to know yourself better.

When you visit our land, don't rush about. Take it slowly. Let India *happen* to you.

The smallest area is thick with marvels. Start with Delhi and Agra and you've a feast in store for you (take our famous air-conditioned train, the Taj Express; you'll love it).

But you could pick any point on our map. Kerala has palm-swept beaches. In Darjeeling you can see the sunrise over Mt. Everest. Bangalore's all flowers. Assam teems with some of India's rarest wildlife (be adventurous, take an elephant trek).

You can stay at luxury hotels or modestly-priced ones. In modern

motels. In palaces. On houseboats. Wherever you are you'll feel very comfortable; we're friendly, and we speak English.

If you like, we'll gladly give you a firsthand glimpse of our way of life—share our meals, our gossip, recommend our guru, our family astrologer, our tailor, the bazaar we go to for our most beautiful gifts (by the way, India is still bargain country).

Try to absorb something of our culture. It's so old, so different, so rich in spirit, it has to affect you. If you find you're getting to know yourself better, don't be surprised. For so many, India is a voyage of

self-discovery, too.

For more information for your trip to India please see your Travel Agent or send in the coupon below.

Government of India Tourist Office, N.Y., 19 E. 49th St.; Chicago, 201 No. Michigan Ave.; San Francisco, 685 Market St. Also Canada.

Name_____

Street_____

City_____ State_____ Zip___

My Travel Agent_____

India.
It's not just another country.
It's another world.

India Tourist Office, 1974

Singapore the sunny smile isle

Wave down a passing trishaw and take a ride down the tree-lined waterfront. Take in the sunshine, the blue skies and the warm waters. Enjoy it all. And enjoy it any month of the year. Old friends describe Singapore as 'a tropical island world in a clean, green, garden setting'.

The sights and sounds of Singapore are a first-rate introduction to the rest of Asia. A carnival of color and costume at an open-air Chinese opera, the fantasy of a Malay puppet shadow play or the pulsating dance and drama of India. Wherever you go, the color and movement of Asia is just round the corner.

Singapore is a blend of many races, cultures and languages. For all this, English is the language spoken by practically everyone! Plus, there is a language which speaks for itself — a sunny, welcome smile.

Come Share Our World

The Manager, Singapore Tourist Promotion Board, 251 Post Street San Francisco, California 94108. Tel. (415) 391-8476 Please send me FREE illustrated brochure on Singapore

Name_____ Address_____ City_____ State_____ Zip_____

GOR 40

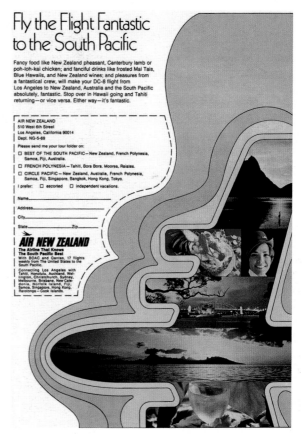

Irving Trust Company, Venezuela, 1970 ◄ *Singapore Tourist Promotion Board, 1974*

Fly the Flight Fantastic to the South Pacific

Fancy food like New Zealand pheasant, Canterbury lamb or poh-loh-kai chicken; and fanciful drinks like frosted Mai Tais, Blue Hawaiis, and New Zealand wines; and pleasures from a fantastical crew, will make your DC-8 flight from Los Angeles to New Zealand, Australia and the South Pacific absolutely, fantastic. Stop over in Hawaii going and Tahiti returning—or vice versa. Either way—it's fantastic.

AIR NEW ZEALAND
510 West 6th Street
Los Angeles, California 90014
Dept. NG-5-69

Please send me your tour folder on:

☐ BEST OF THE SOUTH PACIFIC—New Zealand, French Polynesia, Samoa, Fiji, Australia.

☐ FRENCH POLYNESIA—Tahiti, Bora Bora, Moorea, Raiatea.

☐ CIRCLE PACIFIC—New Zealand, Australia, French Polynesia, Samoa, Fiji, Singapore, Bangkok, Hong Kong, Tokyo.

I prefer: ☐ escorted ☐ independent vacations.

Name_____

Address_____

City_____

State_____ Zip_____

AIR NEW ZEALAND
The Airline That Knows The South Pacific Best
With BOAC and Qantas, 17 flights weekly from The United States to the South Pacific.
Connecting Los Angeles with Tahiti, Honolulu, Auckland, Wellington, Christchurch, Sydney, Melbourne, Brisbane, New Caledonia, Norfolk Island, Fiji, Samoa, Singapore, Hong Kong, Rarotonga—Cook Islands.

Air New Zealand, 1970

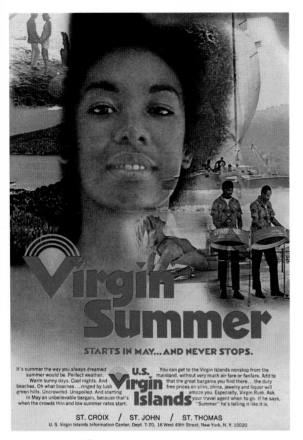

It's summer the way you always dreamed summer would be. Perfect weather. Warm sunny days. Cool nights. And beaches. Oh what beaches...ringed by lush green hills. Uncrowded. Unspoiled. And starting in May an unbelievable bargain, because that's when the crowds thin and low summer rates start.

You can get to the Virgin Islands nonstop from the mainland, without very much air fare or fanfare. Add to that the great bargains you find there...the duty free prices on silks, china, jewelry and liquor will amaze you. Especially, Virgin Rum. Ask your travel agent when to go. If he says, "Summer" he's telling it like it is.

ST. CROIX / ST. JOHN / ST. THOMAS
U. S. Virgin Islands Information Center, Dept. T-70, 16 West 49th Street, New York, N. Y. 10020

U.S. Virgin Islands Information Center, 1970

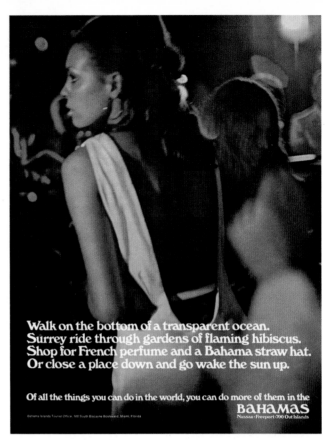

Walk on the bottom of a transparent ocean.
Surrey ride through gardens of flaming hibiscus.
Shop for French perfume and a Bahama straw hat.
Or close a place down and go wake the sun up.

Of all the things you can do in the world, you can do more of them in the

BAHAMAS
Nassau · Freeport · 700 Out Islands

Bahama Islands Tourist Office, 100 South Biscayne Boulevard, Miami, Florida

Bahamas Islands Tourist Office, 1970

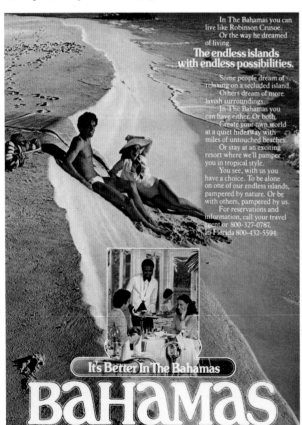

In The Bahamas you can live like Robinson Crusoe. Or the way he dreamed of living.

The endless islands with endless possibilities.

Some people dream of relaxing on a secluded island. Others dream of more lavish surroundings. In The Bahamas you can have either. Or both. Create your own world at a quiet hideaway with miles of untouched beaches. Or stay at an exciting resort where we'll pamper you in tropical style.

You see, with us you have a choice. To be alone on one of our endless islands, pampered by nature. Or be with others, pampered by us.

For reservations and information, call your travel agent or 800-327-0787. In Florida 800-432-5594.

It's Better In The Bahamas
BAHAMAS

Bahamas Islands Tourist Office, 1979

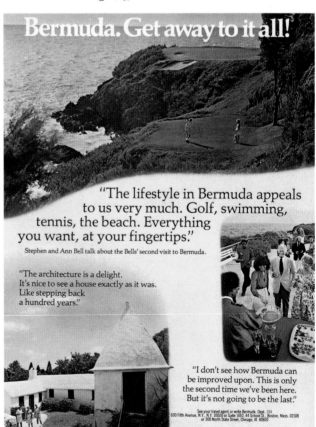

Bermuda. Get away to it all!

"The lifestyle in Bermuda appeals to us very much. Golf, swimming, tennis, the beach. Everything you want, at your fingertips."
Stephen and Ann Bell talk about the Bells' second visit to Bermuda.

"The architecture is a delight. It's nice to see a house exactly as it was. Like stepping back a hundred years."

"I don't see how Bermuda can be improved upon. This is only the second time we've been here. But it's not going to be the last."

See your travel agent or write Bermuda, Dept. 334
630 Fifth Avenue, N.Y., N.Y. 10020 or Suite 1010, 44 School St., Boston, Mass. 02108
or 300 North State Street, Chicago, Ill. 60610

Bermuda, 1979

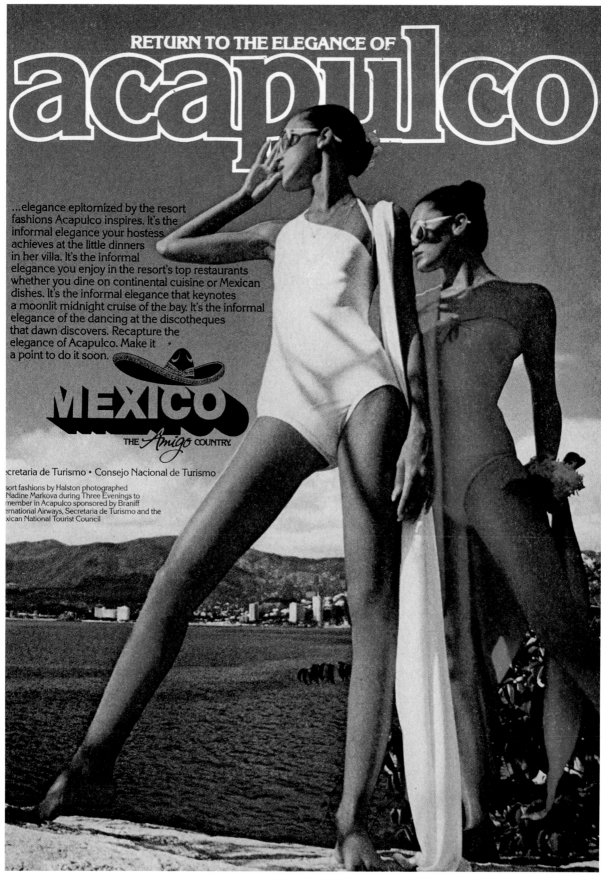

RETURN TO THE ELEGANCE OF
acapulco

...elegance epitomized by the resort fashions Acapulco inspires. It's the informal elegance your hostess achieves at the little dinners in her villa. It's the informal elegance you enjoy in the resort's top restaurants whether you dine on continental cuisine or Mexican dishes. It's the informal elegance that keynotes a moonlit midnight cruise of the bay. It's the informal elegance of the dancing at the discotheques that dawn discovers. Recapture the elegance of Acapulco. Make it a point to do it soon.

MEXICO
THE *Amigo* COUNTRY.

...cretaria de Turismo • Consejo Nacional de Turismo

...sort fashions by Halston photographed
...Nadine Markova during Three Evenings to
...member in Acapulco sponsored by Braniff
...ernational Airways, Secretaria de Turismo and the
...xican National Tourist Council

Mexico Secretary of Tourism, 1977

677

On January 10, 1975 Queen Elizabeth 2 will sail on her first voyage around the world. 80 days, from $4,800 to $86,240.

On a cold Friday night in January, The Greatest Ship in the World will slip from New York harbor to circumnavigate the earth. She will return at nine in the morning on Monday, March 31st.

Around the world in 80 days.

Her itinerary includes the most fascinating and exotic ports of call on four continents and seven seas. She'll sail to Curaçao and Cape Town, Mombasa and Mahé in the Seychelles, Bombay and Bali, Hong Kong and Honolulu and fourteen other ports in between. She will, of course, cross the international date line and the equator, and sail through the Panama Canal.

Queen Elizabeth 2 is the perfect world cruiser. She was built as both a transatlantic liner and cruise ship. As a result she is capable of great port-to-port speed, allowing more time in major ports. It would take slower ships many more days to traverse her glamorous route and would require a proportionately higher fare.

Queen Elizabeth 2 is magnificent inside and out. She's 65,000 tons and 13 stories high. Her staterooms and public rooms have been designed by noted interior designers.

And there is a great variety of things to see and do aboard her; nearly as much as there is in many of the ports to which she can take you.

Queen Elizabeth 2 will provide a dimension of comfort and luxury never before known on a world cruise. Room for room, her staterooms are the largest afloat and nearly three-quarters have a view of the sea. The service is British, and impeccable; with two crew members for every three passengers.

The food will be impeccable as well. You will be travelling with three of the world's most superb restaurants. Each has an ocean view. Each has its own kitchen. Each has only one sitting, so dining is relaxed and unhurried. And the food will be, in preparation and presentation, some of the best the world has to offer.

Because it is her premiere world cruise and space is limited many of the most desirable staterooms are being reserved. If you would like to reserve space, or if you would like more information, simply call your Travel Agent. Or write Cunard, 555 Fifth Avenue, New York, N.Y. 10017. We'll be happy to send you our brochure.

Queen Elizabeth 2

The Greatest Ship in the World

Great Ships of British Registry since 1840.

11

Queen Elizabeth 2, 1974

See the Panama Canal from your living room window.

ROYAL VIKING LINE — YEAR-ROUND TRANS-CANAL CRUISES

Royal Viking Line, 1974

Royal Cruise Line, 1976

Italian Line, 1974

▶ *Great Western Cities, 1970*

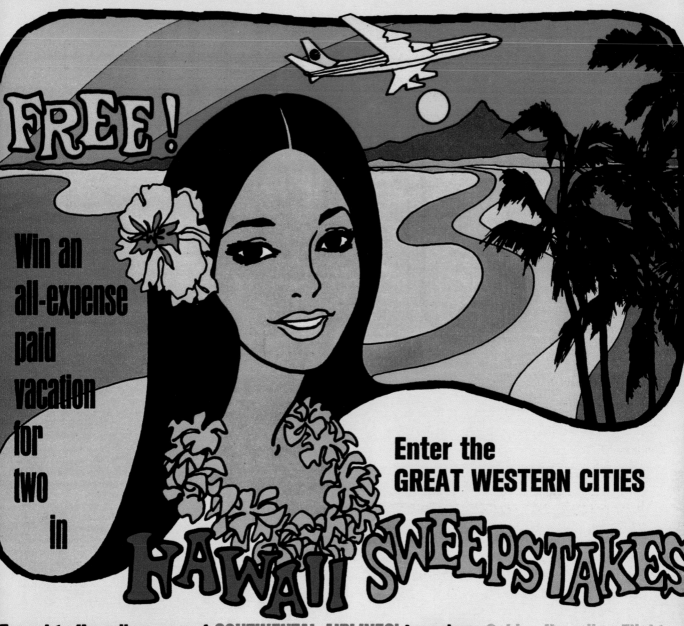

FREE!

Win an all-expense paid vacation for two in

Enter the
GREG WESTERN CITIES

HAWAII SWEEPSTAKES

Travel to Hawaii on one of CONTINENTAL AIRLINES' luxurious Golden Hawaiian Flights

WIN one of our FREE HAWAIIAN VACATIONS for two!

(Three all-expense paid vacations for two via Continental Airlines.)

Or one of the 10,000 FREE vacations in beautiful California City in sunny Southern California. (Food and transportation not included.) FREE lodging, entertainment and unlimited use of recreation facilities.

• •

Please enter my name in the Great Western Cities Inc. Sweepstakes. I assume no obligation by entering this contest.

NAME (Please Print)_____

ADDRESS_____

CITY_____ STATE_____ ZIP_____

AGE_____ OCCUPATION_____ W 1-4

This Sweepstakes is for people who like to travel and do exciting things . . . We want you to know about California City . . . the fabulous *new* vacationland city of the future in Antelope Valley.

OFFICIAL RULES:

1. This entire coupon must be cut out on dotted line or a reasonable facsimile in approximately the same size must be hand drawn and mailed.
2. Complete the entry coupon and mail to: Great Western Cities Incorporated, 6363 Sunset Boulevard, Los Angeles, California 90028.
3. Entries must be postmarked no later than January 31, 1970.
4. Sweepstakes limited to persons 21 years or older.
5. Winners will be determined by random drawings. Drawings will be conducted by an independent judging organization on March 31, 1970. Winners will be notified by mail. One prize per family.
6. Employees and their families of Great Western Cities Inc., their advertising and contest agencies are not eligible. No purchase required. Void where prohibited by law for any reason. All federal, state, and local regulations apply.

Tahiti is getting
away from it all...
or to it all.

Peace On Earth

We grew up in a world of blue skies and lazy afternoons.

Look out almost any window and you'll see flowering plumeria, hibiscus and orchids, growing wild in the yard. The way dandelions might grow in yours. This is our South Pacific. And we'd like to take you there.

We'll show you the magical places that Michener and Maugham wrote about. The colors that Gauguin spent half a lifetime trying to capture.

We'll take you to Tahiti, where the first language is smiles and the second is French.

You'll picnic on deserted coves by a crystal clear ocean. And scuba dive where fish aren't fish at all, but underwater peacocks.

If you can get away from telephones and time clocks for just 10 days, we'll help you escape to Tahiti for as little as $745.*

Or we'll whisk you away to Fiji, the friendliest of all the islands. Or Rarotonga, the most unspoiled paradise of all.

Our luxurious DC-10s fly to the wonders of the South Pacific from Los Angeles.

Call your travel agent. Those Tahitian sunsets are waiting.

*GIT airfare, per person double occupancy.

Air New Zealand, 1978

Raiatea. This is the birthplace of Polynesian culture. On Saturday night, you can meet the population of the whole island. When they all come into town for one big party.

Huahine. This was the center of the Polynesian religion. You'll see an open-air museum with recently restored ruins of 400-year old temples that we call maraes.

Tahiti and Moorea. Two of the most delightful islands in the whole South Pacific. Complete with luxury hotel suites. French, Polynesian, Chinese and American cuisine, and acres and acres of pure peace and quiet.

Rangiroa. You can dive or snorkel all day in one of the world's largest lagoons. It's 22 miles long. You can even catch your own lobster and learn to paddle an outrigger canoe.

Bora Bora. This little island is almost completely surrounded by a barrier reef where you'll see some of the most spectacular coral formations in the world.

SOMEDAY, YOU'LL ESCAPE TO TAHI AND THAT'S ONLY THE BEGINNIN

Right now, Tahiti probably seems like everything could ask for. It has craggy mountains, blue lagoons, golden beaches, French restaurants, torchlit feasts and the most gen fun-loving people in the world. We Tahitians.

What more could you want out of life? You'll find soon enough. Because after you've seen Tahiti, that's only th beginning. There's Moorea with Cook's Bay, which is probal the most photographed spot in the South Pacific. There's Bo Bora. Which James Michener called "the most beautiful islan the world." And Raiatea. Where you can still see our ancient Polynesian fire-walking ceremonies. And Huahine. Where you step back 400 years by visiting the outdoor temples where ou ancestors worshipped. And Rangiroa. Where you can scuba c in a 22 mile-long lagoon.

If you've always wanted to come to Tahiti, this is t year to come. Because now there's so much more Tahiti to se Write us for vacation facts. Tahiti Tourist Board, P.O. Box 3 Hollywood, CA. 90028, Dept. 203.

TAHITI

Tahiti Tourist Board, 1970 ◄ *Tahiti Tourist Board, 1974*

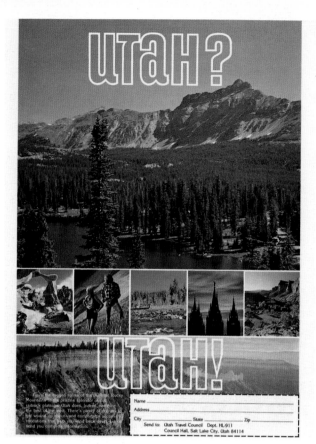

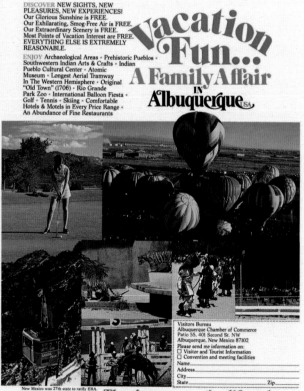

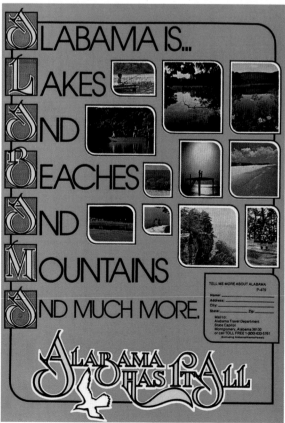

Southern California Visitors Council, 1972

Utah Travel Council, 1978

Albuquerque Chamber of Commerce, 1979

Alabama Travel Department, 1979 ▶ *Delta Queen Steamboat Co., 1978*

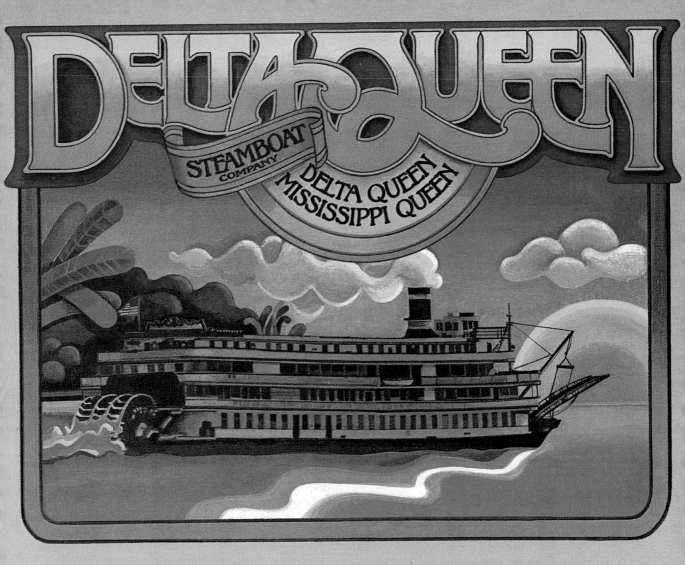

LET US TAKE YOU BACK TO A TIME WHEN STEAMBOATIN' WAS THE ONLY WAY TO TRAVEL. IT STILL IS.

We're The Delta Queen Steamboat Company.

And when you cruise with us, you experience life on the river as it existed over a century ago. On board America's only overnight passenger steamboats.

Antebellum mansions and stately plantations. Sleepy little river towns and bustling cosmopolitan cities. Historic landmarks and magnificent gardens. And a view that changes around every bend.

But the most exciting part is our steamboats themselves.

The luxurious Mississippi Queen. A twentieth century steamboat with all the conveniences and appoint-

ments of today's most modern cruise ships.

The legendary Delta Queen. An authentic turn-of-the-century steamboat that brings all the color, elegance and romance of the steamboatin' era back to life.

So if you're looking for a different kind of cruise from a different kind of cruise line, fill in the coupon below.

And let us take you back to a time when steamboatin' was the only way to travel. We think you'll agree it still is.

CRUISE THE RIVERS OF AMERICA.

America Central, 1979

Hot Springs National Park, 1978

Memphis Chamber of Commerce, 1971 ◄ *South Dakota Division of Tourism, 1974*

Missouri Division of Tourism, 1979

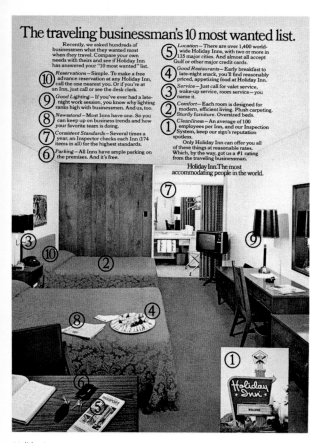

Holiday Inn, 1973

Holiday Inn, 1974

Myrtle Beach Gold Vacations, 1973

Holiday Inn, 1972

Sheraton...
Right on Waikiki Beach.

You're going too far to settle for less.

Waikiki Beach is the center of Hawaiian fun and excitement. And Sheraton has four luxury resort hotels right on Waikiki Beach. A fifth Sheraton is a half block away.

Sheraton offers a wide range of accommodations to suit your budget — from beautiful mountain-view rooms at the Princess Kaiulani for just $20.00* double occupancy, to sumptuous oceanfront Tower rooms at the Royal Hawaiian for $52.00.*

For reservations and complete information see your travel agent or call Sheraton at this toll-free

800-325-3535

And don't miss Sheraton's delightful Neighbor Island hotels: Sheraton-Maui on Kaanapali Beach and Sheraton-Kauai on Poipu Beach.

*$25.00 to $57.00 February-March

Princess Kaiulani *(a half block from the beach)*

Moana

Surfrider

Royal Hawaiian

Sheraton-Waikiki

Stay at one Sheraton, play and charge at all five.

Sheraton Hotels in Hawaii
SHERATON HOTELS & MOTOR INNS, WORLDWIDE
P.O. BOX 8559, HONOLULU, HAWAII 96815 808/922-4422

Sheraton Hotels, 1974

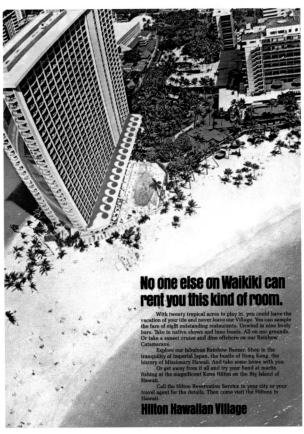

No one else on Waikiki can rent you this kind of room.

With twenty tropical acres to play in, you could have the vacation of your life and never leave our Village. You can sample the fare of eight outstanding restaurants. Unwind in nine lively bars. Take in native shows and luau feasts. All on our grounds. Or take a sunset cruise and dine offshore on our Rainbow Catamarans.

Explore our fabulous Rainbow Bazaar. Shop in the tranquility of Imperial Japan, the bustle of Hong Kong, the history of Missionary Hawaii. And take some home with you.

Or get away from it all and try your hand at marlin fishing at the magnificent Kona Hilton on the Big Island of Hawaii.

Call the Hilton Reservation Service in your city or your travel agent for the details. Then come visit the Hiltons in Hawaii.

Hilton Hawaiian Village

Hilton Hotels, 1978

ONE OF SHERATON'S 10 GREAT HAWAII SHOWPLACES

The Surfrider

Right on Waikiki Beach. One of five great Sheraton hotels in Waikiki.

There's a Sheraton in Waikiki that's your kind of hotel. It might be the Surfrider. Forget coats and ties, the Surfrider's a place to relax — with one door opening to the beach and the other to the action in Waikiki. What a view from your balcony! Great bars, great restaurants, top Waikiki entertainment, sensible prices (rooms run from $33-$52* a night for two people). The Surfrider's for the doers.

The Surfrider might be right for you. Or you might pick the traditional elegance of the Royal Hawaiian . . . the contemporary tropical glamour of the Sheraton-Waikiki . . . the central location and the good value of the Princess Kaiulani . . . the nostalgic, South Seas charm of the Moana. Pick any of these Sheraton hotels, dine and charge at all of them. Ask your Travel Agent. He knows us. And you. He knows there's a Sheraton in Waikiki that's right for you.

Or call us, toll free **800-325-3535.**

The lively informality of the Surfrider Hotel, with Waikiki Beach right at your doorstep. The Surfrider . . . where the action is.

*Rates subject to change without notice.

Sheraton Hotels in Hawaii
SHERATON HOTELS & INNS, WORLDWIDE
P.O. BOX 8559, HONOLULU, HAWAII 96815 808/922-4422

Sheraton Hotels, 1978

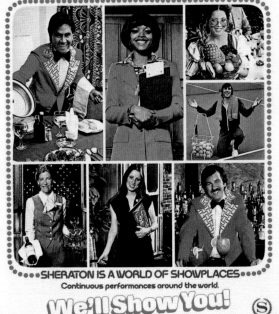

We're Sheraton Showpeople: we'll show you what makes a Sheraton a Showplace!

• SHERATON IS A WORLD OF SHOWPLACES •
Continuous performances around the world.

We'll Show You!

For reservations, call toll-free: **800-325-3535**
In Missouri call: 800-392-3500. Or have your travel agent call.

Sheraton
HOTELS & INNS, WORLDWIDE

Sheraton Hotels, 1979

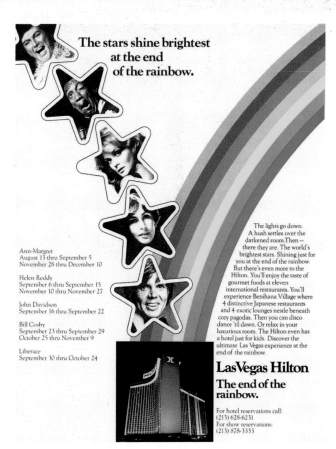

The stars shine brightest at the end of the rainbow.

Ann-Margret
August 13 thru September 5
November 28 thru December 10

Helen Reddy
September 6 thru September 15
November 10 thru November 27

John Davidson
September 16 thru September 22

Bill Cosby
September 23 thru September 29
October 25 thru November 9

Liberace
September 30 thru October 24

The lights go down. A hush settles over the darkened room. Then — there they are. The world's brightest stars. Shining just for you at the end of the rainbow. But there's even more to the Hilton. You'll enjoy the taste of gourmet foods at eleven international restaurants. You'll experience Benihana Village where 4 distinctive Japanese restaurants and 4 exotic lounges nestle beneath cozy pagodas. Then you can disco dance 'til dawn. Or relax in your luxurious room. The Hilton even has a hotel just for kids. Discover the ultimate Las Vegas experience at the end of the rainbow.

Las Vegas Hilton
The end of the rainbow.

For hotel reservations call:
(213) 628-6231
For show reservations:
(213) 878-3333

Hilton Hotels, 1978

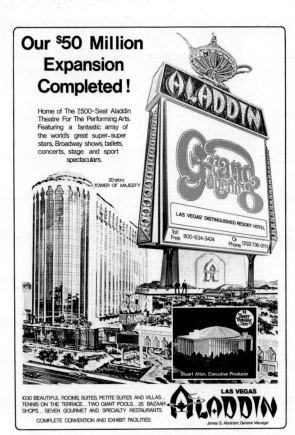

Our $50 Million Expansion Completed!

Home of The 7,500-Seat Aladdin Theatre For The Performing Arts. Featuring a fantastic array of the world's great super-super stars, Broadway shows, ballets, concerts, stage and sport spectaculars.

20-story TOWER OF MAJESTY

ALADDIN

Grand Opening

LAS VEGAS' DISTINGUISHED RESORT HOTEL

Toll Free 800-634-3424 Or Phone (702) 736-0111

Stuart Allen, Executive Producer

1030 BEAUTIFUL ROOMS, SUITES, PETITE SUITES AND VILLAS... TENNIS ON THE TERRACE... TWO GIANT POOLS... 25 BAZAAR SHOPS... SEVEN GOURMET AND SPECIALTY RESTAURANTS.

COMPLETE CONVENTION AND EXHIBIT FACILITIES.

LAS VEGAS
ALADDIN

James G. Abraham, General Manager

Aladdin Hotel, 1976

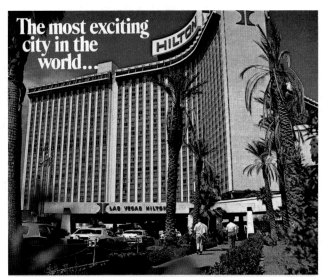

The most exciting city in the world...
...is in the world's most exciting city!!

Las Vegas! The name pulsates with excitement. And the magnificent Las Vegas Hilton has taken it one step beyond. With 2,783 exquisitely furnished rooms and suites, we make sure that you sleep and rest in splendor. Add that to the brightest stars in show business, 11 international restaurants including spectacular Benihana Village, 8 intimate cocktail lounges, our unique youth hotel just for the youngsters, a 10 acre rooftop recreation deck and our world-famous Hilton hospitality and you'll agree — the Las Vegas Hilton truly is the world's most exciting city!

Las Vegas HILTON
The end of the rainbow.

Liberace, and a cast of 60, July 3 thru July 23 / Bill Cosby, Doug Henning, July 24 thru August 6 / Lou Rawls, Milton Berle, August 7 thru August 20 / Paul Anka, August 21 thru September 3 / John Davidson, September 4 thru September 24 / Osmonds, September 25 thru October 15

For information and reservations (702) 732-5111 or call your nearest Hilton Reservations Service

Hertz Rent A Car, 1976 ◄ *Hilton Hotels, 1979*

you'll go for Las Vegas HOOK, LINE, SINKER

Southern Nevada presents a variety of entertainment and sports unequaled anywhere, every season of the year. Sparkling Lake Mead attracts millions of visitors to sightsee at busy Hoover Dam or fish in solitude on the great calm lake. Golf and tennis offer a challenge to professional and novice alike on dozens of courts and greens. This time of year towering Mt. Charleston gives a taste of the high life for adventurous skiers. When the sun goes down on sports the curtain goes up for an evening of music, laughter and applause in dozens of lavish showrooms. To see it all, see your travel agent.

Las Vegas

A Las Vegas Convention Authority Advertisement.

Las Vegas Convention Authority, 1973

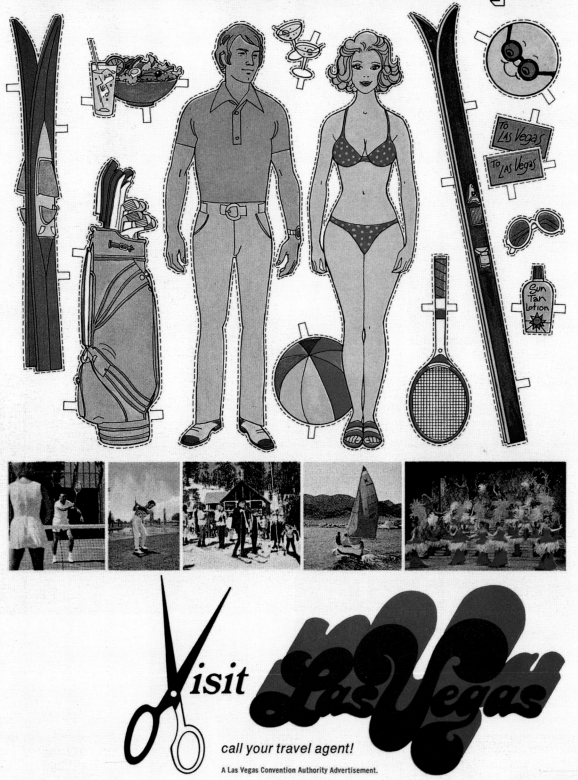

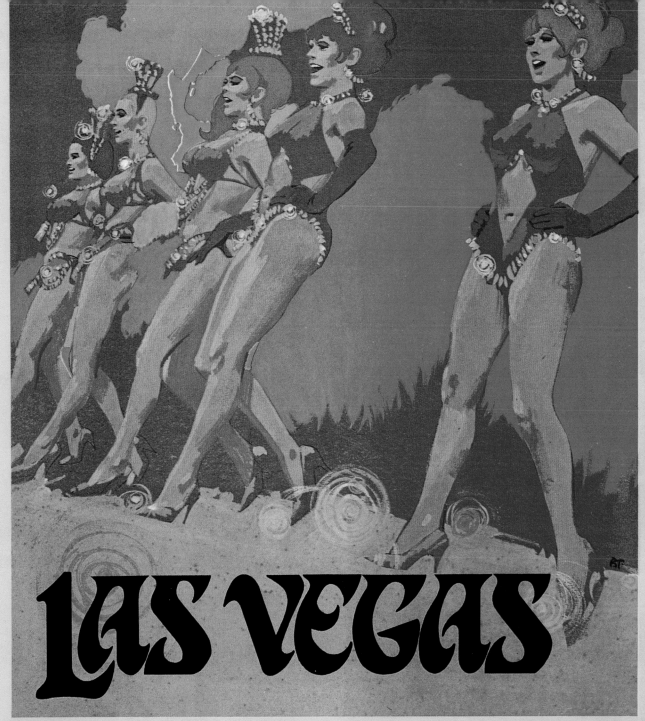

LAS VEGAS

Waiting just over the horizon is a dream vacation of top entertainment, delicious dining, excellent hotel and motel accommodations, all at a moderate cost. Las Vegas is a 24 hour town of sophisticated indoor fun and offers 12 full months of outdoor recreation, ranging from frosty ski slopes at 12,000 foot Mt. Charleston to sunny shores on sparkling Lake Mead. Tennis, golf, fishing, water skiing, horseback riding and swimming complete the Las Vegas sports picture. Downtown Las Vegas, the most photographed street in the world, is a million volt valley of light, brightening the midnight sky, and the famous "Strip" sparkles like a silver ribbon through the moonlit Nevada desert. See Las Vegas, the entertainment capitol of the world...your travel agent can get you in the act. Call him today!

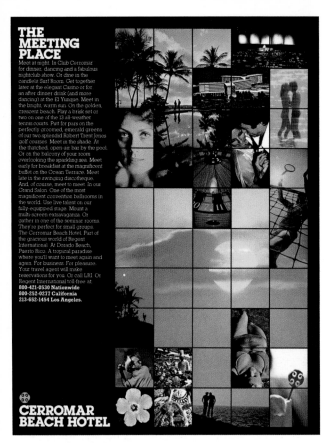

THE MEETING PLACE

Meet at night. In Club Cerromar for dinner, dancing and a fabulous nightclub show. Or dine in the candlelit Surf Room. Get together later at the elegant Casino or for an after dinner drink (and more dancing) at the El Yunque. Meet in the bright, warm sun. On the golden, crescent beach. Play a brisk set or two on one of the 13 all-weather tennis courts. Putt for pars on the perfectly groomed, emerald greens of our two splendid Robert Trent Jones golf courses. Meet in the shade. At the thatched, open-air bar by the pool. Or on the balcony of your room overlooking the sparkling sea. Meet early for breakfast at the magnificent buffet on the Ocean Terrace. Meet late in the swinging discotheque. And, of course, meet to meet. In our Grand Salon. One of the most magnificent convention ballrooms in the world. Use live talent on our fully-equipped stage. Mount a multi-screen extravaganza. Or gather in one of the seminar rooms. They're perfect for small groups. The Cerromar Beach Hotel. Part of the gracious world of Regent International. At Dorado Beach, Puerto Rico. A tropical paradise where you'll want to meet again and again. For business. For pleasure. Your travel agent will make reservations for you. Or call LRI. Or Regent International toll-free at:
800-421-0530 Nationwide
800-252-0277 California
213-652-1454 Los Angeles.

CERROMAR BEACH HOTEL

Cerromar Beach Hotel, 1978

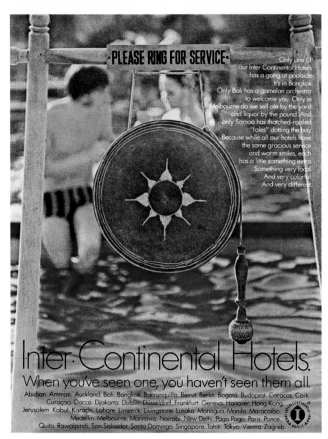

·PLEASE RING FOR SERVICE·

Only one of our Inter-Continental Hotels has a gong at poolside. It's in Bangkok. Only Bali has a gamelan orchestra to welcome you. Only in Melbourne do we sell ale by the yard and liquor by the pound. And only Samoa has thatched-roofed "fales" dotting the bay. Because while all our hotels have the same gracious service and warm smiles, each has a little something extra. Something very local. And very colorful. And very different.

Inter·Continental Hotels.

When you've seen one, you haven't seen them all.

Abidjan. Amman. Auckland. Bali. Bangkok. Barranquilla. Beirut. Berlin. Bogotá. Budapest. Caracas. Cork. Curaçao. Dacca. Djakarta. Dublin. Düsseldorf. Frankfurt. Geneva. Hanover. Hong Kong. Jerusalem. Kabul. Karachi. Lahore. Limerick. Livingstone. Lusaka. Managua. Manila. Maracaibo. Medellin. Melbourne. Monrovia. Nairobi. New Delhi. Pago Pago. Paris. Ponce. Quito. Rawalpindi. San Salvador. Santo Domingo. Singapore. Tahiti. Tokyo. Vienna. Zagreb.

Inter-Continental Hotels, 1970

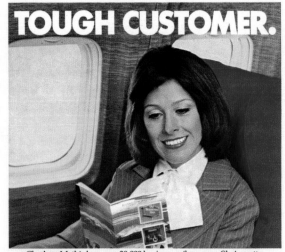

TOUGH CUSTOMER.

Charlene Mathis logs over 30,000 business miles a year. She's pretty choosey about her accommodations and can be a tough hotel customer.

So what keeps Charlene and other business travelers returning to Rodeway Inns?

Our locations, for one thing. Most Rodeway Inns are within 20 minutes of a commercial airport. And convenient to major metropolitan areas and commercial centers.

It's also easy to make reservations. A toll-free call to our Reservations Center can arrange accommodations at Rodeway Inns coast to coast and in Alaska, Canada and Mexico.

So next time you're traveling, for business or pleasure, be a tough customer like Charlene. There's one place that will satisfy you.

For toll-free reservations call **(800) 228-2000**
In Nebraska, Hawaii, Alaska and Mexico, call collect (402) 571-2000. In Canada, call collect or ask the operator for Zenith 06040.

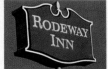

THAT'S A RODEWAY INN!

Rodeway Inn, 1978

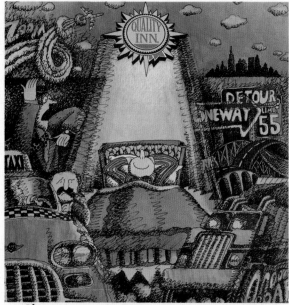

The most comfortable place...under the Sun.℠

Traveling. On the go. It can get to be a grind. But there's one bright spot you can always look forward to. Beneath our big, bright sunburst sign of comfort. The sign of Quality Inns.

Because making you comfortable is what a Quality Inn is all about. From check-in to check-out, we're dedicated to that single idea. We have been for 36 years.

You'll find us in nearly 300 locations all across the country. From dazzling downtown towers to quietly exciting suburban settings, each of our Inns has a look, a style and a special kind of welcome all its own.

At each we offer a comfortable place to stop, relax and refresh yourself at the end of a busy day. Always at a comfortable price. And at most Inns, you can guarantee your reservation with any major credit card.

So, whenever you travel on business or pleasure, make your reservation at a Quality Inn. The most comfortable place...under the Sun.

Call us toll-free for reservations
800-228-5151
or see your Travel Agent

Quality Inns

Quality Inn, 1978

Stay where low cost is one of the comforts. Days Inns.

Don't let rising fuel prices cut down your vacation plans. Take in the sights and take advantage of the savings at Days Inns.

You'll enjoy one of the best values in family lodging today. Including a big, bright, spotless room with two double beds and telephone. Free color TV. A good restaurant. A delightful pool. And friendly service to make you feel at home in 205 cities across the United States and Canada.

You get all this and more for much less than you'd expect. Days Inns are family motels, with rates to match. That goes for Days Lodges, too, offering three-room family suites with kitchens.

And most of our over 300 Days Inns and Lodges even have economy gasoline on the premises.

This year, make your travel costs a lot more comfortable — despite increasing fuel prices. Stay at Days Inns, and your travels may cost even less than last year! For reservations, call toll-free: 1-800-241-3777. Or call your travel agent.

Good nights cost less at Days Inns.

Days Inns of America, Inc., 2751 Buford Highway, N.E., Atlanta, Georgia 30324

Days Inn, 1979

The only international restaurant in Los Angeles with its own airport.

You've seen it a hundred times. The Theme Building at Los Angeles International Airport. You might know there's a restaurant inside. You might not know there's a superb restaurant inside. With convenient, complimentary valet parking outside.

Let us tempt you to try it: Our dinner menu contains sumptuous appetizers, soups, salads, entrees and beverages from twenty-two countries. Prepared by continental chefs from carefully collected and tested international recipes. All served in the classic French manner by a captain and internationally-costumed waitresses.

To complement your meal, you will find a bountiful selection of fine imported and domestic wines.

Our rich Columbian coffee brews slowly at your table while you dine. For an encore, our dessert menu offers a tempting array of world-renowned pastries, ice cream and flaming crepes.

The beautiful harp, piano and violin music you hear throughout the restaurant is live. And the unique view from your table is a continuous airshow provided by 36 airlines. Next time you're looking for an unusually elegant dining experience at moderate prices, don't look in the usual places.

Look for our place right in the center of Los Angeles International Airport.

Open daily 10 am to 12 midnight. Lunch, Afternoon Sandwiches, Cocktails, Dinner and Weekend Brunch. Entertainment in the lounge from 4 pm. Reservations: (213) 646-5471.

Host International Restaurant

Host International Restaurant, 1976

LOS ANGELES

Creative supercity. Where business booms and the sun shines.

Century Plaza
as low as $42*

Mobil 5-star award winner every year since opening. Each room has private balcony, refrigerator-bar, oversize beds.

Five restaurants. Fine shopping. Swimming pool and gardens. Meeting facilities. Grand ballroom for 3,000.

In Century City near Beverly Hills. Across from ABC Entertainment Center, day and night tennis courts.

SAN FRANCISCO

It's everybody's favorite city. For dining. Nightlife. Shopping. Sightseeing. For seafood and sourdough bread.

St. Francis
as low as $32*

In the heart of San Francisco on Union Square. Cable cars stop just outside the front door. Theater and financial districts are close at hand. Fine shopping nearby (and in the lobby, too).

Rooftop dining at Victor's, one of San Francisco's finest restaurants. Swinging entertainment at The Penthouse. Six restaurants and lounges in all.

Twenty-two meeting and function rooms and a grand ballroom for up to 1,500.

MEXICO CITY

Heartbeat of a great nation. Full of ceremony, pageantry and tradition.

Camino Real
as low as $34.40*

Camino Real. On seven and a half spacious acres, the only complete resort hotel in the center of Mexico City.

Four swimming pools. Two rooftop tennis courts. Ten exciting restaurants and night spots. Complete meeting facilities.

Chapultepec Park with its famous National Museum of Anthropology is just across the way.

CHICAGO

Exciting, surprising city by Lake Michigan. Commerce and transportation center of the nation.

Continental Plaza
as low as $38*

On North Michigan Avenue at Hancock Center. The Magnificent Mile with its great shopping and entertainment is just outside the door.

Three restaurants and lounges. Health club and sauna. Complete meeting facilities for up to 2,000.

ATLANTA

New mecca for business, industry, the arts. But as always, down home southern hospitality.

Peachtree Plaza
as low as $30*

World's tallest hotel. 1,100 guest rooms. 39 meeting rooms and a grand ballroom for 2,540. Pool. Health club. Shops. Even a half-acre lake in the lobby and a revolving restaurant up top.

A super hotel in the heart of Peachtree Center. Designed by architect John Portman.

THE WORLD

UNITED STATES
Anchorage Anchorage-Westward
Atlanta Peachtree Plaza
Chicago Continental Plaza
Costa Mesa, Southern Cal.
. South Coast Plaza
Denver Cosmopolitan
Detroit Detroit Plaza (Feb. 1977)
Detroit (Southfield) Michigan Inn
Honolulu Ilikai
Houston Houston Oaks
Kansas City, MO Crown Center
Los Angeles Century Plaza,
. Los Angeles Bonaventure (Jan. 1977)
New York The Plaza
Pittsburgh Carlton House
Portland, OR Benson
San Francisco Miyako, St. Francis
Seattle Olympic, Washington Plaza,
. Space Needle Restaurant
Washington, D.C. Mayflower
AUSTRALIA
Sydney (Affiliated) Wentworth
CANADA
Calgary Calgary Inn
Edmonton Edmonton Plaza
Montreal Bonaventure
Toronto Hotel Toronto
Vancouver Bayshore Inn
Winnipeg Winnipeg Inn
DENMARK
Copenhagen Hotel Scandinavia
EL SALVADOR
San Salvador Camino Real
GUATEMALA
Antigua Hotel Antigua
Guatemala City Camino Real
HONG KONG
Kowloon Miramar
JAPAN
Kyoto Miyako
Tokyo . . . Takanawa Prince, Tokyo Prince
MEXICO
Cancun Camino Real
Guadalajara Camino Real
Mazatlan Camino Real
Mexico City . . Alameda, Camino Real
Puerto Vallarta Camino Real
Saltillo Camino Real
Tampico Camino Real
NORWAY
Oslo Hotel Scandinavia
PHILIPPINES
Manila Philippine Plaza (Sept. 1976)
SINGAPORE
Singapore Shangri-La
SOUTH AFRICA
Johannesburg Carlton
THAILAND
Bangkok Dusit Thani

CALL 800-228-3000 OR YOUR TRAVEL AGENT.

Great destinations. Great hotels.

WESTERN INTERNATIONAL HOTELS
Partners in travel with United Airlines

*Price based on single occupancy, per night. Subject to applicable taxes.

Western International Hotels, 1974

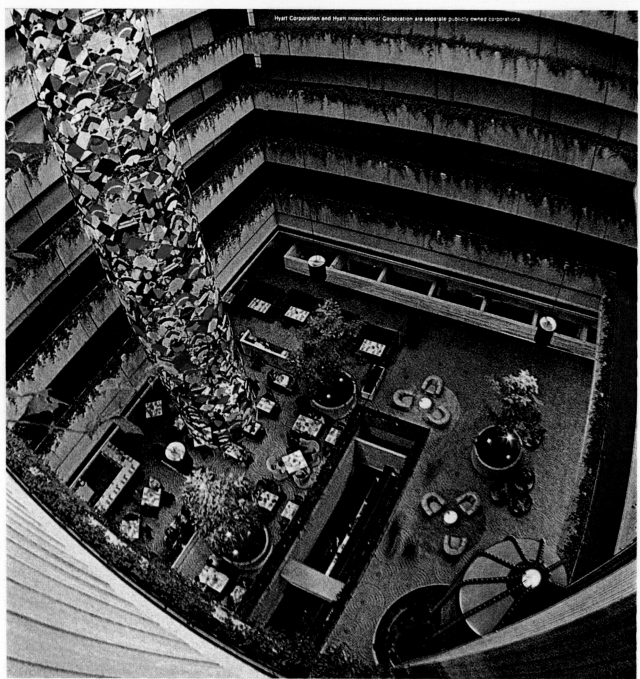

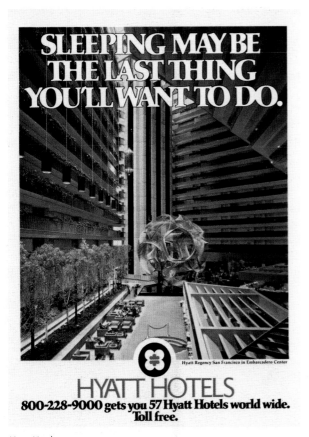

Hyatt Hotels, 1975

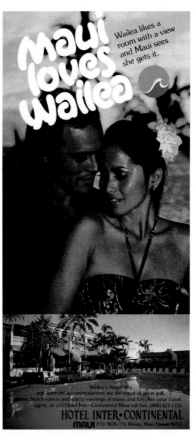

Hotel Inter-Continental, 1978

Hyatt Hotels, 1972 *Desert Inn, 1978*

And the winner is...

End of an Era

Before the Shah of Iran fled into exile in 1979, the exotic Middle East destination was serviced by numerous international carriers. Iran Air promised the most convenient way for travelers to arrive in the capital city of Tehran. With the deposed Shah replaced by Ayatollah Khomeini and an anti-Western policy firmly in place, travel to Iran diminished. A flight to Iran became one that few Americans wanted to board. Sooner *or* later? How about never?

Abschied von einer Ära

Bevor der Schah 1979 aus dem Iran ins Exil floh, wurde dieses exotische Reiseziel im Nahen Osten von zahlreichen internationalen Fluggesellschaften angeflogen. Iran Air versprach eine bequemere Reise in die persische Hauptstadt Teheran als alle anderen. Als der verjagte Schah durch den Ayatollah Khomeini ersetzt und eine militant antiwestliche Politik eingeführt worden war, nahm das Reiseaufkommen in den Iran dramatisch ab. Ein Flugzeug nach Iran war eines, das nur die allerwenigsten Amerikaner zu besteigen wünschten. Früher oder später? Wie wäre es mit nie?

La fin d'une époque

Avant que le Shah d'Iran ne fuit en exil en 1979, de nombreuses compagnies internationales se disputaient les destinations exotiques du Moyen-Orient. Iran Air assurait être le moyen le plus pratique pour se rendre dans la capitale iranienne. Après la destitution du Shah et l'instauration d'une politique fermement antiaméricaine par l'ayatollah Khomeiny, Téhéran cessa d'être une destination touristique de choix pour les Américains. « Tôt ou tard » proclame le texte. Disons plutôt « Jamais ! ».

El final de una era

Antes de que el sha de Irán huyera al exilio en 1979, Oriente Próximo era un destino exótico que cubrían múltiples líneas aéreas internacionales. Iran Air prometía a los pasajeros el modo más rápido de llegar a la capital del país, Teherán. Cuando el sha depuesto fue reemplazado por el ayatolá Jomeini, quien impuso en el país una política firmemente antioccidental, los viajes a Irán cayeron en picado. Muy pocos norteamericanos deseaban subir a bordo. Así que, ¿por qué preguntarse, como hacía el eslógan, si antes o después? Mejor nunca.

一つの時代の終焉

1979年にイラン国王が国外に亡命してしまうまで、いくつもの航空会社が、異国情緒あふれる中東に就航していた。そして、首都テヘランに向かう旅行客にとって、もっとも便利なのはイラン航空ですよ、とこの広告は請け合っているわけだ。退位した国王に代わってアヤトラ・ホメイニが国の実権を握り、強固な反欧米姿勢が打ち出されてからというもの、イランへの旅行そのものが激減した。イラン行きは、ほとんどのアメリカ人が搭乗を望まない便になった。早いか遅いかだって？　行かないっていうのはどう？

There are two ways to get to Tehran.

Sooner. Or later.

Iran Air

Pan Am
KLM
Air France
SAS
Alitalia
British Airways
Sabena
Lufthansa
Swissair
El Al
Aeroflot

The reason why you get to Tehran sooner on Iran Air is simple.

Iran Air is the only airline that flies you from New York to Tehran non-stop.

Our non-stops leave New York at 9:00 PM Mondays and Fridays. And they arrive in Tehran at 4:45 PM the next afternoon. In daylight. (Not in the dark, like the others.) In plenty of time for you to have a leisurely dinner and a good night's sleep.

So that you're on your toes for business or sightseeing the next day.

Our new 747SP's are the only planes on the North Atlantic *capable* of flying you non-stop to Tehran. In addition, they fly a mile higher than other 747's. Which means you enjoy a smoother flight.

Iran Air is very proud of its American-built 747SP's. And, in this way, we're growing your way, America. But, we give you our own personal Persian touch in on-board service, care and consideration.

One example is our new lounge in first class. It's sumptuous. It's Persian. We call it our Persian Room, the most opulent nightspot around.

Today Iran Air is growing faster than any other airline in the world.

Besides our non-stop flights, our jets fly to Tehran via London and Paris. With our schedule, in fact, you can depart for Tehran any day of the week. And all are direct flights, so you never have to change planes. What's more we've convenient connections to Isfahan, Shiraz, other Persian Gulf States and the Far East.

For reservations or further details, call the ultimate authority, your travel agent. Or call Iran Air. In New York phone (212) 949-8200; Houston (713) 629-1720; Chicago (312) 663-3680; Los Angeles (213) 274-6336.

IRAN AIR
Growing. Your way.

Iran Air, 1977

Index

The Communist superhero

Mao's starring role in Chinese propaganda art

"An army without culture is a dull-witted army, and a dull-witted army cannot defeat the enemy."

—Chairman Mao Tse-Tung, Peking 1966

CHINESE PROPAGANDA POSTERS
from the collection of Michael Wolf; with essays by
Anchee Min, Duoduo, Stefan R. Landsberger /
Softcover, format: 24.5 x 37 cm (9.6 x 14.4 in.), 320 pp.
ONLY € 29.99 / $ 39.99
£ 19.99 / ¥ 4.900

With his smooth, warm, red face, which radiated light in all directions, Chairman Mao Zedong was a fixture in Chinese propaganda posters produced between the birth of the People's Republic in 1949 and the early 1980s. These infamous posters were, in turn, central fixtures in Chinese homes, railway stations, schools, journals, magazines, and just about anywhere else where people were likely to see them. Chairman Mao, portrayed as a stoic superhero (a.k.a. the Great Teacher, the Great Leader, the Great Helmsman, the Supreme Commander), appeared in all kinds of situations (inspecting factories, smoking a cigarette with peasant workers, standing by the Yangzi River in a bathrobe, presiding over the bow of a ship, or floating over a sea of red flags), flanked by strong, healthy, ageless men and "masculinized" women and children wearing baggy, sexless, drab clothing. The goal of each poster was to show the Chinese people what sort of behavior was considered morally correct and how great the future of Communist China would be if everyone followed the same path to utopia by coming together.

Combining fact and fiction in a way typical of propaganda art, these posters exuded positive vibes and seemed to suggest that Mao was an omnipresent force that would lead China to happiness and greatness. This book brings together a selection of colorful propaganda artworks from photographer Michael Wolf's vast collection of Chinese propaganda posters, many of which are now extremely rare.

The collector:
Michael Wolf has lived in Hong Kong for eight years and works as a photographer for international magazines. He collects posters and photographs from the period of the Cultural Revolution till today. (http://www.photomichaelwolf.com)

The authors:
Anchee Min was born and raised in Mao's China. A staunch party supporter, she was awarded the lead role in a film to be made by Mao's wife, Jiang Ching, but the death of Mao soon

after caused the film to be canceled. In 1984, Min emigrated to the United States and later wrote the bestselling biography *Becoming Madame Mao*.
Poet and fiction writer **Duoduo** was born in Beijing in 1951 and emigrated in 1989, later settling in the Netherlands, where he became a writer in residence at the Sinological Institute of Leiden University. He is considered one of the most outstanding poets to emerge after the Cultural Revolution.
Stefan R. Landsberger holds a PhD in Sinology from Leiden University, the Netherlands. He is a Lecturer at the Documentation and Research Centre for Modern China, Sinological Institute, Leiden University, and one of the editors of the journal *China Information*. He has published extensively on topics related to Chinese propaganda, and maintains an extensive website exclusively devoted to this genre of political communications (http://www.iisg.nl/~landsberger).

"This was advertising as an art in its own right, not the plagiarising magpie industry of today. And its ceaseless sunny optimism in the face of adversity is something from which we jaded cynics could learn." —*World of Interiors*, London

ALL-AMERICAN ADS OF THE 30s
Steven Heller, Ed. Jim Heimann / Flexi-cover,
format: 19.6 x 25.5 cm (7.7 x 10 in.), 768 pp.
ONLY € 29.99 / $ 39.99
£ 19.99 / ¥ 4.900

"Sexist, crude and effective."
—*The Sunday Telegraph Magazine*,
London, on *All-American Ads of the 60s*

Colorful capitalism

Ads that read like pulp fiction

Hard times, hard sells

At the dawn of the 1930s, modernism started to influence American advertising as waves from the European avant-garde movement made their way across the Atlantic. The trend of literal, uninspired print ads was shaken up by new stylized, symbolic, and even abstract advertisements that relied more on aesthetics than copy. These techniques worked well at first, and ultimately paved the way for advertising as we know it today, but were overshadowed by the need of a country in depression

for hard-sell, shirt-sleeve advertising. Subtlety and irony could hardly sell products to a nation struggling to feed itself. Surprisingly, however, the ads of the 1930s reveal nothing of the hard times, painting instead an optimistic picture of affluent American family life. Cheerful and colorful, these ads served an important role as morale boosters, promising happiness and success to a country in crisis.

The editor: **Jim Heimann** is a resident of Los Angeles, a graphic designer, writer, historian, and instructor at Art Center College of Design in Pasadena, California. He is the author of numerous books on architecture, popular culture, and Hollywood history, and serves as a consultant to the entertainment industry. The author: **Steven Heller** is the co-Chair of the MFA/Design program at the School of Visual Arts in New York and author of over eighty books on design and popular culture.

"Heimann's collection takes us from Tupperware (heralded as a 'wifesaver') to psychedelia swirls in gloriously seductive Technicolour."

—*Times Chronicle Series*, London

All-American Ads of the 40s
W.R. Wilkerson III, Ed. Jim Heimann
Flexi-cover, 768 pp.
€ 29.99 / US$ 39.99 / £ 19.99 / ¥ 4.900

ALL-AMERICAN ADS OF THE 50s
Ed. Jim Heimann
Flexi-cover, 928 pp.
€ 29.99 / US$ 39.99 / £ 19.99 / ¥ 4.900

ALL-AMERICAN ADS OF THE 60s
Steven Heller, Ed. Jim Heimann /
Flexi-cover, 960 pp.
€ 29.99 / US$ 39.99 / £ 19.99 / ¥ 4.900

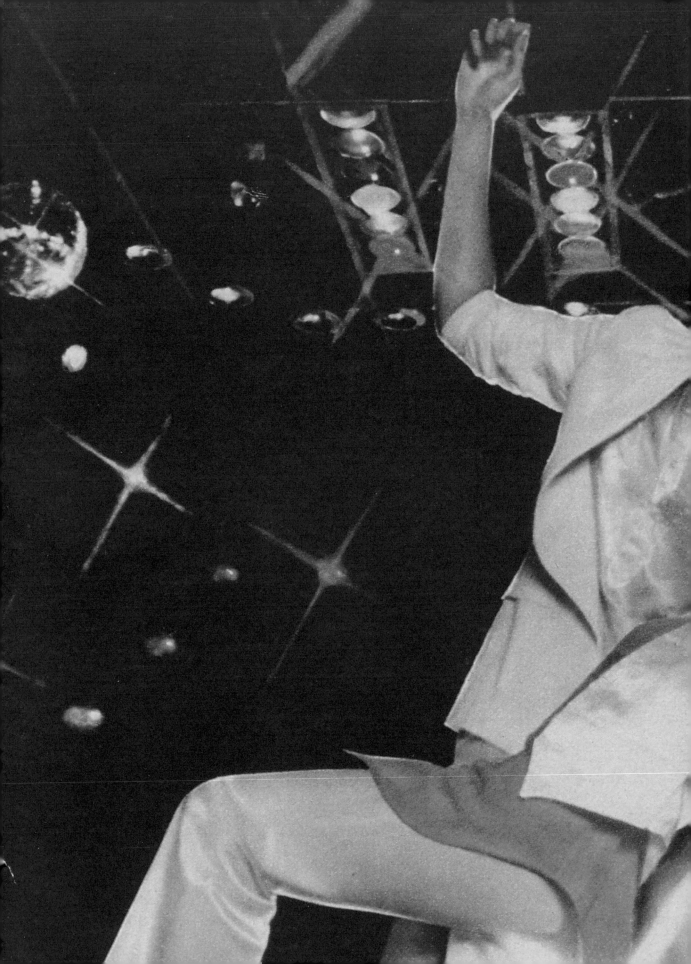